BETWEEN

Raphael

AND

Galileo

Published with the support of

THE GETTY FOUNDATION

BETWEEN

Raphael

AND

Galileo

———

MUTIO ODDI

and the

MATHEMATICAL

CULTURE

of

LATE RENAISSANCE

ITALY

Alexander Marr

THE UNIVERSITY OF CHICAGO PRESS

CHICAGO AND LONDON

ALEXANDER MARR is associate professor of art history at the University of Southern California.

The University of Chicago Press, Chicago 60637
The University of Chicago Press, Ltd., London
© 2011 by The University of Chicago
All rights reserved. Published 2011
Printed in China

18 17 16 15 14 13 12 11 1 2 3 4 5

ISBN-13: 978-0-226-50628-9 (cloth)
ISBN-10: 0-226-50628-2 (cloth)

Library of Congress Cataloging-in-Publication Data
Marr, Alexander, 1978-
 Between Raphael and Galileo : Mutio Oddi and the mathematical
culture of late Renaissance Italy / Alexander Marr.
 p. cm.
 Includes bibliographical references and index.
 ISBN-13: 978-0-226-50628-9 (cloth : alk. paper)
 ISBN-10: 0-226-50628-2 (cloth : alk. paper)
 1. Oddi, Muzio, 1569–1639. 2. Mathematics—Italy—History—16th
century. 3. Mathematics—Italy—History—17th century. 4. Mathematical
instruments—Italy—History—16th century. 5. Mathematical
instruments—Italy—History—17th century. 6. Art and science—History—
16th century. 7. Art and science—History—17th century. I. Title.
QA27.I8M35 2010
306.4'5—dc22 2009051604

Contents

Figures

Acknowledgments

In researching and writing this book I have incurred many debts, which I am pleased to acknowledge here. Early versions of parts of chapters 4 and 6 first appeared as "The Production and Distribution of Mutio Oddi's *Dello squadro* (1625)," in *Transmitting Knowledge: Words, Images, and Instruments in Early Modern Europe*, ed. Sachiko Kusukawa and Ian Maclean (Oxford: Oxford University Press, 2006), and "'Others see it yet otherwise': *Disegno* and *Pictura* in a Flemish Gallery Interior," *Burlington Magazine* 149, no. 1247 (2007), the latter article coauthored with Michael John Gorman.

My work has been generously supported by funding from the Arts and Humanities Research Council; the Carnegie Trust for the Universities of Scotland; the University of St Andrews; the Scouloudi Fellowship in Historical Research at the Institute of Historical Research, London; the Clifford Norton Studentship in History of Science at The Queen's College, Oxford; a Visiting Research Fellowship at St John's College, Oxford; the Frances Haskell Memorial Trust Scholarship for Art History (administered by *The Burlington Magazine*); a Visiting Fellowship at the Max Planck Institute for History of Science, Berlin (Department I); and a Philip Leverhulme Prize (administered by the Leverhulme Trust). I am exceptionally grateful to all these bodies and institutions for having provided me with the means to complete this book.

I have been blessed with patient and inspiring mentors. Warren Hearnden and Adriana Turpin first encouraged me to work on interdisciplinary early modern material—without their guidance I might never have ventured into such territory, so I owe them both a great deal. In Oxford, David Parrott was an unfailingly generous supervisor. His impact on my academic life has been enormous, and I can only hope that this book lives up to his high standards, which have long served me as a model. Stephen Johnston, too, kindly took me under his wing and helped to steer my work in the history of science; his perspicacious comments and criticisms have made this book far better than it might otherwise have been. I am grateful also to Jim Bennett, whose lessons (delivered, memorably, in Elias Ashmole's old study in the Museum of the History of Science) inducted me into the world of mathematical practice, and to Ian Maclean, who opened my eyes to

the history of the book, and whose work in Renaissance intellectual history has been a beacon. Colleagues at The Queen's College provided much needed companionship and intellectual stimulation. Jackie Stedall and Peter Neumann, in particular, not only discussed with me the history of mathematics but have also been wonderfully supportive. To Tim Chesters, whose spirit haunts (benignly) the pages of this book, I say this: *Je me fusse certainement plus volontiers fié à luy de moy qu'à moy*; and to Noël Sugimura—a constant friend, at one time across the road in New College—*Vix sibi quisque parem de millibus invenit unum*.

In St Andrews, my former colleagues Julian Luxford, Fabio Barry, Paul Joannides, and Peter Humfrey aided me in innumerable ways, as did Norman Reid and the staff of the University Library. Likewise, Federico Marcucci of the Biblioteca Universitaria di Urbino and the staffs of the Biblioteca Oliveriana (Pesaro), the Biblioteca Trivulziana and Biblioteca Ambrosiana (Milan), and the Archivio di Stato (Lucca) graciously assisted me in my archival research. Werner Oechslin welcomed me to his remarkable library in Einsiedeln, where I was allowed to consult Oddi's copy of Commandino's Euclid—a rare treat. I owe a special debt to the people with whom I have worked on the *Linder Gallery Interior*. Ron and Barbara Cordover have been unstintingly supportive and enthusiastic about my research on their painting and have generously permitted it to be reproduced in this book, while Michael John Gorman has been a genial scholarly collaborator, from whom I have learned much. Rhona Macbeth, of the Conservation Department at the Museum of Fine Arts, Boston, kindly undertook a technical analysis of the painting and shared her findings with me. Alberto, the late Evelina, and Michele Subert were kind enough to let me see and reproduce their double portrait of Oddi and Linder. In Berlin, I benefited greatly from the hospitality of Department I of the Max Planck Institute for History of Science. I am much obliged to my host there, Jürgen Renn, for having extended the invitation to be a Visiting Fellow, and to Peter Damerow, Matthias Schemmel, Wolfgang Lefèvre, Matteo Valleriani, Jochen Büttner, Maarten Van Dyck, Antonio Becchi, and the Library and secretarial staff for having made my stay such a pleasant and productive one.

Many people read and commented on multiple draft chapters of the present work. I am grateful to the two anonymous readers for the University of Chicago Press, whose suggestions helped me to (I hope) rise above the detail and reach out to a wider audience. Like Oddi, I have had moments when I feared this book would be "a muddle worse than that of Monte Baroccio," but thankfully I have always been able to turn to Deborah Harkness for succor and advice. Deb read the entire manuscript and has been, in myriad ways, my inspiration and scholarly rock. Sabine Eiche, whose work on Oddi is foundational to my study, also read the whole book, saved me from many errors, and welcomed me into Oddi's world with considerate *politezza*. Stephen Clucas, Martin Kemp, Sven

Dupré, Matteo Valleriani, Roger Gaskell, J. V. Field, Nick Wilding, Michael John Gorman, Mario Biagioli, Eileen Reeves, Robert Goulding, Steven Walton, Elio Nenci, and Mordechai Feingold all provided valuable comments and constructive criticism; needless to say, any errors that remain are my own.

For advice, assistance, and sustenance I thank Anthony Turner, Noel Malcolm, Rhodri Lewis, Pascal and Jean-Jacques Brioist, Roberto Mantovani, Paula Findlen, Pamela Smith, Michael Korey, Ian Verstegen, Alessandro Pipitone, Michael Bury, Elly Dekker, the Accademia Raffaello, Gabriele Reina, Clemency Henty, Anthony Grafton, Sachiko Kusukawa, Enrico Gamba, Filippo Camerota, Mary Henninger-Voss, Kevin Stevens, Simon Podmore, Adam Mosley, Robert Evans, George Rousseau, Robert Fox, Wes Williams, Genevieve Warwick, Bill Sherman, and (for compiling the index) Michael Tombs. I am grateful to my commissioning editor, Christie Henry, for having seen the book's potential at an early stage, and profoundly thankful that in Karen Darling I have had a sympathetic editor. Karen has seen this book through the press with marvelous efficiency and consideration, and without the ministrations of the illustrations editor Anthony Burton it would have been aesthetically much the poorer. Joel Score copyedited the manuscript with great diligence, for which I thank him.

By far my greatest debt is to my family. Daphne, Christopher, Tango, Tom, Mike, Pooh, Bear, Ben, Eck, Aoife, Katie, and Jess have put up with me with greater forbearance than I deserve. Without the enduring love and support of my parents, Liz and Steve, I would be lost. I cannot express properly the thanks that are due to them, nor emphasize enough the degree to which any success I might enjoy is attributable to them. The arrival of my daughter, Poppy, in October 2008 brought such joy into my life that the tribulations of finishing the book melted away, and for that—and so much besides—I will always be grateful. No one, though, deserves my gratitude more than my wife, Christie. My best friend and my dear love, she has lived—without complaint—with Mutio Oddi as an interloper in our household for many years. Her council, support, assistance (not least in helping to reconstruct Oddi's diagram), and unflagging kindness are at the very heart of this book. For that, and for the happiest years of my life thus far, I dedicate it to her.

Note on Quotations

Due to constraints of space, I have been obliged to remove from the notes the original Italian of all quotations. They have, however, been published online, at the stable link http://www.press.uchicago.edu/books/marr. Quotations are given in the order they appear in the text and may be identified by the number, preceded by the letter W, immediately following the relevant primary-source reference in the footnotes, e.g. "Mutio Oddi to Giovanni Antonio Magini, from Milan, 11 August 1610. OCP, 284r. W45.1."

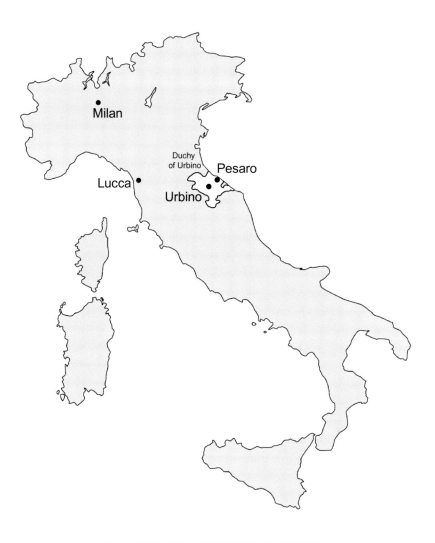

ITALY, SHOWING LOCATIONS PERTINENT
TO MUTIO ODDI'S LIFE

Quell'otio della prigione

In 1610, after more than forty months imprisonment, the mathematician and architect Mutio Oddi (1569–1639) walked free from the Rocca Costanza di Pesaro in his homeland, the Duchy of Urbino (fig. 1).[1] The unfortunate and most probably innocent casualty of a febrile court intrigue, he had lost, as he later recalled,

> not only the benefits of fortune, sanity, and even, for the duration of four whole years, the light of the sun, but also—and it is this that weighs on me most heavily—irretrievable forever, the light of my lord's favor.[2]

Oddi's release was doubtless bittersweet. Not only was his once promising career in ruins, but he had been sentenced to indefinite banishment from his beloved *patria* by his erstwhile patron, the powerful Duke Francesco Maria II della Rovere (1549–1631).

Born to a respected Urbinate family, brought up in the duke's own household, and appointed to the prestigious post of ducal architect in 1596, Oddi's fall from favor was dramatic and total. Yet although undoubtedly a personal tragedy, Oddi's disgrace and exile—served first in Milan and then, from 1625, in Lucca—transformed him into a uniquely valuable figure through whom to study late Renaissance mathematical culture. For in order to regain his lost honor and rebuild his shattered life, Oddi was forced to intensify and diversify his social and professional pursuits—he worked as a lecturer and tutor in the mathematical arts, as an architect, as a fortifications engineer, as an instrument and art broker, and as an author of practical mathematics books. These activities brought him into contact with an enormously wide range of individuals, artifacts, and environments, substantially different from those he would have encountered had he remained in Urbino with a comfortable court post.

It is Oddi's imprisonment, though, rather than his subsequent life that has hitherto earned him a prominent place among Urbino's *uomini illustri*. Stories of the remarkable mental resilience and inventiveness that enabled him to endure the privations of prison, and even to flourish during his sentence, began to circulate shortly after his death. Most accounts emphasize the awful conditions

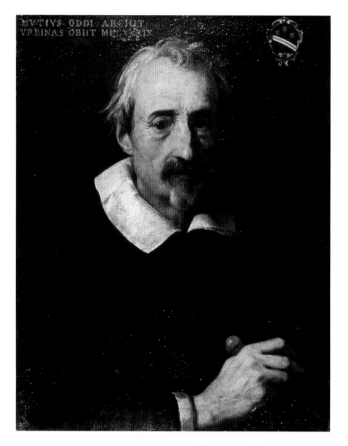

FIGURE 1. Anonymous, *Portrait of Mutio Oddi*, ca. 1630s.
Oil on canvas. Accademia Raffaello, Urbino.

in which he was kept: without light, without company (or, indeed, any contact
with the outside world), and, according to some of the reports, without access to
most types of object, including books.[3] On the face of it, such conditions would
appear infelicitous for any form of scientific or artistic activity, yet by drawing on
the *ingegno* (ingenuity or special talent) for which his countrymen were famous,
Oddi managed to manufacture—from scratch—writing and drawing materials.
As the nineteenth-century historian Carlo Grossi explained:

> Thus, Oddi, having neither paper, nor ink, nor pen, nor mathematical instru-
> ments, substituted this gross poverty with great ingenuity. Because he knew
> how to give a certain substance to a kind of rough or absorbent paper, which
> he had through good fortune acquired, by pressing it in water with skins. . . .
> He made ink from soot gathered artfully with some paper placed over the fire,
> or to be more precise charcoal ground up and dissolved in water; then with
> little tufts of wool taken from a pillow he placed it in a nutshell which held the

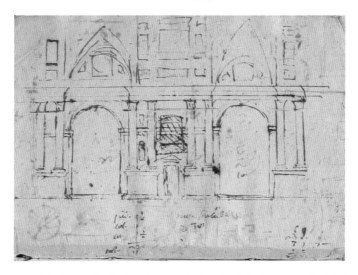

FIGURE 2. Mutio Oddi, *gheribizzi* no. 13, "Church of the Compagnia del Corpus Domini," 1609. Pen and ink on paper. Private collection, Le Marche

ink. . . . Either a hollow reed or a piece of charcoal served as a pen, and with a forked olive twig, or one sharpened with a blade, he was able to make his geometrical compass.[4]

Oddi used his newly fashioned implements to write treatises—which he later published—on surveying, gnomonics, and measurement, and to compose a remarkable set of *gheribizzi* (fantasies or caprices) for the complete architectural redevelopment of Urbino (fig. 2).[5]

The subjects of Oddi's prison writings, not to mention the creativity he displayed in producing them, are what we might expect of an Urbinate polymath. The duchy was a renowned center of artisanal and scholarly excellence. Indeed, Oddi's teachers—the painter Federico Barocci (ca. 1535–1612), the mathematician Guidobaldo del Monte (1545–1607), and his own uncle, the artisan-scholar Niccolò Genga (fl. 1570s–80s)—represent the disciplines for which Urbino was most celebrated: the visual arts and architecture, mathematics and mechanics, and the military arts. Inside his prison cell, Oddi replicated the professional world he had inhabited as a free man; in fact, the decidedly hands-on nature of the treatises he composed there betrays his hopes of rejoining the practical-mathematical community. Yet he was motivated also by that most persistent theme of imprisonment—consolation. As he explained in his treatise on surveying, *Dello squadro trattato* (1625):

Contemplation, and placed within it these little thoughts concerning the *squadro* [a device used in surveying], served as a raft to which I could fix my-

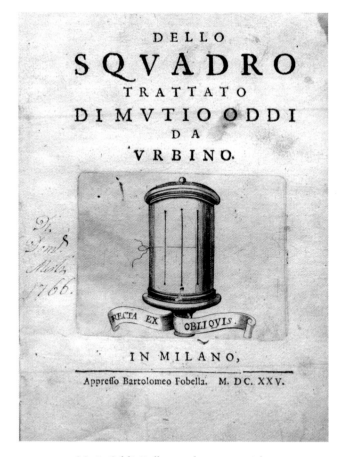

FIGURE 3. Mutio Oddi, *Dello squadro trattato*, title page, 1625.
University of St. Andrews Library.

self, so as not to remain submerged by the stormy waves of bitter hardships
in a wretched shipwreck, which truly made my disgrace.[6]

The mental rigor and certainty offered by geometry (for although practical, Od-
di's text was a sophisticated work of mathematics) evidently delivered a form
of succor.[7] Moreover, the acts of writing and designing themselves gave him,
in the simplest terms, something to do to escape the *otium* of prison life. Oddi
alluded to this quality in the frontispiece to his book, which featured an image
of the *squadro* with the motto "Recta ex obliquis" (right from oblique) (fig. 3).
The phrase referred not only to the workings of the instrument, which produces
correct measurement via oblique angles, but also to the treatise itself, a positive
outcome accomplished in circumstances that were far from promising. As Oddi
explained to a friend when preparing the treatise for the press:

I anticipate with a desire that you can imagine the return of the book with Your Lordship's corrections; I hope to see the sketch of one of my poor pictures retouched and brought to perfection by another Apelles. . . . Concerning the motto for the *impresa*, I have had a word with Monsignor Paolo Aresi, who is staying in Milan for many days, asking whether he can make clear in a better way my intention, which is to say that from the ill that has been done to me I have managed to take something good.[8]

Thus, even in prison, in the depths of despair, Oddi was able cunningly to fuse his mathematical and artisanal talents to produce a valuable commodity for a competitive patronage environment.

Freedom, however, brought as many tribulations as the prison cell, especially for a disgraced exile. In 1611, just two years after his release, Oddi was struggling to scrape together a living as a mathematics tutor in Milan. His situation was desperate. He was impoverished, and constant work had exhausted him. So dire were his circumstances that he wrote to his brother, the architect Matteo (1576/77–1626), that Milan was a place "where I hoped to have found peace and respite from the long travails that I have suffered; now, though, I envy that leisure of prison" (*quell'otio della prigione*).[9]

What follows is an account of Oddi's life in mathematical culture beyond bars. The image presented is necessarily partial and idiosyncratic—Oddi is, after all, just one of a host of similar figures dispersed across Europe in the late Renaissance. Yet the virtue of such partiality is that it offers, in Deborah Harkness's words "a view from somewhere," or rather from *someone*.[10] Science, like all other fields of endeavor, was affected by place and circumstance in the late Renaissance. The peculiarities of Oddi's biography ensured his incursion into multiple aspects of mathematics, the visual arts, commerce, and craft, enabling us to see clearly how networks, communities, individuals, and ideas overlapped and interacted. Exile, and the intense search for rehabilitation and patronage that ensued, ensured that his involvement in these worlds and processes was more vigorous, varied, and visible than it might otherwise have been. If the themes addressed in this book seem diverse, it is because the field of mathematics in the late Renaissance was, like Oddi's life, messy and richly plural. Focusing our attention on him unveils a mathematical culture that was multivalent and contested, governed by friendship as much as principle, located in materials as well as the mind, and determined by place as much as purpose.

Introduction

In the early 1620s, the noted Milanese artist Daniele Crespi (b. 1597–1600, d. 1630) painted a fine double portrait of Mutio Oddi and his closest friend, the German merchant Peter Linder (fl. 1620s–30s), seated in a *studiolo* (fig. 4).[1] In front of the figures is a desk, covered by a sumptuous Near Eastern rug, on which rest an ornamental inkwell, a beam compass (used for drawing arcs of large-radius circles), and an adjustable concave mirror in an elegant wooden frame. Oddi, on the left, gestures to a sheet of paper bearing a geometrical diagram, held at one edge by Linder, who stares at it in concentration. Evidently, we are witnessing a lesson in progress. The fact that a mathematics lesson—more precisely, a lesson about geometrical optics—has been taken as a suitable subject for a work of art is both striking and novel, highlighting the profound intermingling of science and art in Oddi's world. In this image teaching (traditionally considered a humble, though worthy, activity) of mathematics (a subject of historically ambivalent social and intellectual standing) has been elevated to become an emblem of one of the most valued humanist virtues—*amicizia* (friendship)—and recorded for posterity in paint.[2]

The significant implications of such a strong visual statement are traced in this book. Indeed, Crespi's painting neatly encapsulates the key themes addressed in the pages that follow—namely, the social and material underpinnings of mathematical culture, the ways in which mathematics was practiced and disseminated, the communal bonds forged by the sharing of mathematical knowledge, and the relationship between mathematics and visual culture in late Renaissance Italy.[3] The men the picture represents were both members of the period's energetic and diverse mathematical community. The objects it depicts (not to mention the picture itself) constitute part of the material culture of mathematics commissioned, manufactured, collected, and employed by this community to various ends. The subject it portrays—a geometry lesson—illustrates how mathematics could be shared within this community, using the devices at its disposal. Thus, in this image mathematics and materials, scholarship and trade, science and art come together in a distillation of some of the major interactions observable between disciplines and professions in the sixteenth and seventeenth centuries.

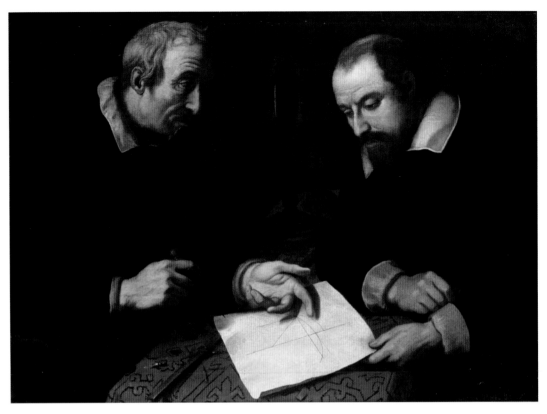

FIGURE 4. Studio of Daniele Crespi, *Mutio Oddi and Peter Linder*, early 1620s.
Oil on canvas. Private collection, Milan.

In the figure of Mutio Oddi we find, as in Crespi's painting, a coalescence of
various major strands of late Renaissance culture. Architect and mathemati-
cian, teacher and author, geometer and draftsman, courtier and consumer,
Oddi mediated between worlds both commercial and intellectual, scientific
and aesthetic. He is, in a sense, a bridge between the artistic traditions rep-
resented by his great Urbinate predecessor, Raphael (whose drawings he col-
lected avidly), and the scientific culture of his contemporary—and sometime
foil—Galileo. Of course, both of these figures, as recent scholarship has shown,
merged art and science: Raphael through his mastery of perspective, Galileo
through immersion in *disegno* (design).[4] Yet neither embodied the blend of
professions that Oddi did.

 Why, then, is Oddi obscure to all but the most specialist student of the his-
tory of late Renaissance science or architecture? The answer lies, in part, in the
fact that he falls historiographically between two stools. Despite pioneering
work by Enrico Gamba (the only modern scholar to have devoted serious at-

tention to Oddi's scientific work) and Sabine Eiche (the most important student of his architecture), he has never been considered in the round, as an exemplary representative of his period's polymathy.[5] Just as significantly, though, Oddi has been neglected because he was not one of the "great men" of art or science. Not quite productive or innovative enough as an architect to merit a place in the artistic canon and insufficiently revolutionary in science to join the ranks of men such as Galileo, Oddi has been overlooked in favor of his better-known contemporaries. In fact, he is chiefly known to historians of art as the restorer of Raphael's birthplace, while historians of science will have encountered him principally through the bit part he played in the priority dispute over Galileo's geometric and military compass.[6]

That Oddi is best known as an adjunct to the scholarly industries devoted to great men testifies to a persistent trend in the histories of both art and science, in which excessive attention to canonical individuals has led to the marginalization of supposedly lesser contributors. This problem has been particularly acute in the history of science, in which a focus on revolutionary discoverers and pivotal moments has tended to obscure the role of conservative—or just plain ordinary—figures.[7] Despite recent work in the sociology of science that has sought to address this issue, it is especially evident in the history of late Renaissance Italian science, in which the enormous weight of Galileo—both his intellectual contribution and the sociocultural phenomena of his remarkable life—upsets the balance of the historical record to such an extent that scholarship seems to slide inexorably towards this great man and his works.[8] As a result, Galileo has become something of a scientific everyman for the period, studied from all conceivable angles, and the vehicle for myriad historiographical reappraisals, as reflected in the modern scholarly works that bear his name.[9] In fact, Mutio Oddi's career bears striking similarities to that of his better-known contemporary: both were clients of Guidobaldo del Monte, both were mathematics teachers who invested heavily in instruments, and both were deeply involved in the culture of *disegno*. Yet Oddi, unlike Galileo, achieved no major intellectual breakthroughs. He did not become a hero of modern science, and his life and works have not been endlessly pored over by generations of historians.

The significance of these differences should not be underestimated. Galileo's elevation in 1610 from mathematics professor in Padua to Mathematician and Philosopher to the Grand Duke of Tuscany was exceptional for his age, but the vast majority of mathematicians—indeed, most scientifically active individuals—never reached the sidereal heights of success at court. Nevertheless, they played a crucial role in the establishment of a vibrant and enduring scientific culture, representing what Thomas S. Kuhn called "normal science."[10]

This is not to suggest that Oddi is in some way the mean representative of all late Renaissance mathematicians; his life and career are sufficiently unusual themselves to prohibit such an assertion. What he does offer, though, is the opportunity to consider in depth the worlds of a mathematical practitioner comparatively free of the historiographical baggage that comes with canonical figures, for while his mathematical career has been roughly summarized and his architectural work treated briefly, he has not received the in-depth study that his life deserves.

It has long been acknowledged that mathematics formed a major part of the so-called Scientific Revolution, and numerous studies have traced the ways in which the growth of mathematical activity—what Peter Dear has called the "mathematical way"—contributed to new ways of appraising and using nature.[11] Yet it is perhaps surprising that, despite the impact of Marxist-inspired studies of the sociology of sixteenth- and seventeenth-century science (which, in particular, cast a spotlight on the impact of the rise of merchant capitalism and the contribution of artisans), we still know relatively little about individuals such as Oddi, whose significance consists not in major discoveries but in their roles as supporters, facilitators, brokers, disseminators, consumers, and users of scientific knowledge.[12] The professions and classes from which these figures were drawn varied widely, and included patricians, merchants, printers, artists, and university scholars, to name but a few. Indeed, as Mordechai Feingold has observed, the mathematical community of late Renaissance Europe was notably and necessarily catholic and inclusive, for in an age in which the "profession" of mathematics was (at least outside the universities) fluid and in a formative state,

> although certain men were far more talented and devoted mathematicians than others, many who never reached the frontiers of the field were still deemed respectable members of the scientific community by their colleagues and considered capable of the process of the dissemination of ideas.[13]

My use of the term "mathematical community" throughout this book should not be taken to imply a coherence that did not exist in the period.[14] While it is important to recognize the points of contact that brought individuals together in the sharing of mathematical knowledge, it is equally necessary to acknowledge the tensions—in terms of differentiated status, professional affiliation, and so on—that distinguished such figures from one another. Thus, by mathematical community I mean a loose network of very different kinds of individual brought together in various ways by a common concern for mathematics, its practice, and its uses.[15] In presenting a detailed account of a largely overlooked member of this community, I seek to enrich our understanding of the contexts in which mathematical activity took place. Moreover, I aim to tease out some of the ways in which these contexts were actively fashioned—as

much as inhabited—by individuals who worked across and between differing fields, whether scientific or artistic. In so doing, we may arrive at a deeper, more rounded, and more nuanced view of what it meant to be a mathematician (and of what mathematics *was*) in the sixteenth and seventeenth centuries. Indeed, by offering a study of a boundary-crossing figure such as Oddi, I hope to encourage a better appreciation of late Renaissance mathematics as a culture rather than simply a discipline.

Where, though, should someone like Oddi be placed within the mathematical community, and on the map of knowledge more generally? What was his contribution? And what makes him such a useful case study in the history of mathematical culture? A brief glance at his biography shows that the answer to the first question is by no means straightforward. Born in Urbino—one of the most illustrious of Italy's courts and a key locus for the Italian renaissance of mathematics—to a long-established Urbinate family of soldiers, artisans, and courtiers, Oddi was initially apprenticed as a painter to the famous local artist Federico Barocci. This early involvement with the visual arts led to a lifelong commitment to *disegno*, but Oddi's apprenticeship was abruptly cut short when it was discovered that he suffered from defects in his vision. This led him to abandon painting in favor of mathematics, which he studied under the so-called "Archimedes of Pesaro," Guidobaldo del Monte, along with a host of related skills (such as dialing, architecture, and instrumentalism) learned within Urbino's artisan community. A brief stint in one of the companies that fought in the Burgundian campaign—which provided Oddi with military expertise upon which he would draw later in his career—resulted in serious injury and a return home, but he had evidently distinguished himself sufficiently to attract the approbation of Francesco Maria II della Rovere, Duke of Urbino, who appointed him court architect on 14 June 1596.[16]

Over the next few years Oddi undertook numerous commissions for the duke, including work on the festivities celebrating Pope Clement VIII's visit to Pesaro in 1598, elements of which were supervised by Oddi's mathematics tutor, Guidobaldo (fig. 5).[17] However, his tenure of this prestigious post was volatile. In 1599 Oddi was fined for illegally bathing naked in the river Metauro, and two years later he was investigated for fighting and neglecting to follow orders concerning work he was undertaking for Francesco Maria at the duke's principal residence, Casteldurante (present day Urbania).[18] The investigation was prompted by an argument between Oddi and a ducal *depositario* (secretary), Giuseppe Azzolino, who had apparently insulted Oddi's honor on a visit to the building site.[19] In a sequence of events worthy of Caravaggio, the offended Oddi wounded Azzolino before, rightly fearing his lord's wrath, fleeing to Venice—a well-known safe haven for fugitives.[20] Worried by the consequences of returning

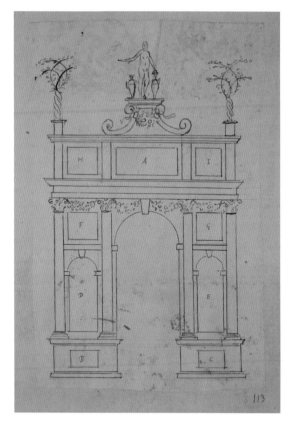

FIGURE 5. Mutio Oddi, design for a triumphal arch with Della Rovere devices,
1590s. Pen and ink on paper. Biblioteca Medicea Laurenziana,
Florence. Codex Ashburnham 1828 App., fol. 80r.

home but wanting to be close to friends and family, Oddi found employment
at the pilgrimage site of Loreto, just beyond Urbino's western border, becoming
Architect of the Santa Casa in April 1603.[21] As Loreto was in the Papal States,
and thus under the jurisdiction of the Church, such a position offered relative
protection as well as a salary and prestigious title. In fact, just two years later,
the birth of Francesco Maria's son and his baptism in Loreto provided an op-
portunity for reconciliation between Oddi and the duke, but their accord proved
short-lived.[22] By October 1605 Oddi had been arrested and sentenced to indefi-
nite incarceration.

 The details of Oddi's fall from grace are obscure but arose from the febrile
atmosphere of the suspicious Francesco Maria's court. Apparently, an incriminat-
ing letter mentioning Oddi's name, written by Marchese Ippolito della Rovere,
the duke's cousin and the father of his young wife, Livia, had been found in the
duchess's pocket. Ippolito, whom Francesco Maria seems to have suspected of se-

dition, fled to Rome, leaving only poor Oddi—still mistrusted at court—to bear the duke's retribution.[23] Lobbying from the mathematician's family and friends resulted in his eventual release from prison, and in 1609 his sentence was commuted to exile from his homeland—a situation that enflamed an already deep commitment to his *patria*.

In order to rebuild his shattered life, Oddi moved (or perhaps was sent) to Milan, where he worked as an informal mathematics tutor and as a public lecturer at the Scuole Piattine (also known as the Scuole Palatine), published the treatises on dialing and surveying he had begun in prison, worked sporadically as an architect-engineer and surveyor, and traded in mathematical instruments—especially those made by Urbino's renowned Officina di strumenti matematici.[24] His diverse but intense activities attracted the support of powerful patrons, including the Trivulzio, Serbelloni, and Borromeo families (indeed, he was closely associated with Cardinal Federico Borromeo's Ambrosian Library, Gallery, and Academy), through which he quickly became a key member of Milan's artistic and intellectual communities, befriending painters such as Crespi and mathematicians such as Galileo's disciple Bonaventura Cavalieri (1598–1647). During his Milanese period, Oddi forged a particularly strong relationship with one of the city's leading merchants, Peter Linder, who later became head of the Fondaco dei Tedeschi in Venice. This friendship not only resulted in the double portrait shown above (fig. 4) but also led to the creation of a remarkable allegorical painting of *disegno* and the mathematical arts that contains a coded critique of Galileo and telescopic observation (fig. 68). This painting places Oddi squarely within one of the most exciting and significant scientific debates of the period: the veracity or otherwise of the competing cosmic systems.[25]

In 1625 Oddi was invited to replace his brother, Matteo, as chief fortifications engineer to the Republic of Lucca, an attractive prospect that offered the benefit of permanent employment, a generous stipend, and a step up in social status. He worked for the Republic for just over a decade, completing major parts of Lucca's defences, but he continued to take on private architectural commissions, sustained his mathematical studies, maintained his role as an instrument broker, and published a third book (on the polimetric compass, otherwise known as the sector). Throughout his exile, Oddi persistently sought a pardon from Francesco Maria that would enable him to return to his beloved homeland. The duke's obstinate refusal was the cause of profound sadness, only alleviated when, in 1636 (a few years after Francesco Maria's death in 1631), Oddi was allowed to return permanently to Urbino. Once there, his disgrace was overturned. He was made a *gonfaloniere* of the city, and in the years prior to his death in 1639, used the considerable wealth he had amassed throughout his career to indulge the love of the *patria* from which he had been separated for so long.[26] In addition to publishing an enlarged and revised version of his book on sundials, Oddi purchased and

renovated the house in which Raphael—Urbino's most famous son—had been born, erected memorials to the city's renowned artisans, and solidified his mathematical legacy by becoming Urbino's first public lecturer in mathematics.

Oddi's final act was an attempt to perpetuate the mathematical and artistic practices for which Urbino was rightly renowned: in his will, he ordered that his substantial collection of books, instruments, drawings, and statues be kept as a working *studiolo*, which would serve as a study resource for the young mathematicians and artisans of the city. His idea was that Urbino's youth should be trained according to the principles that Oddi had inherited and professed—a blend of rigorous, late-humanist geometry and craft aptitude. Sadly, his family ignored his wishes, his collection was broken up, and the long mathematical tradition to which he was heir disintegrated and gradually disappeared. Thus, in an ironic twist, the material culture in which he had invested so heavily throughout his life, and to which he had entrusted his legacy, failed him at the last.

This brief biography shows clearly that Oddi spent much of his life mediating between mathematics and material culture. His early formation within Urbino's twin communities of mathematicians and artisans ensured that he was equally comfortable with the demanding scholarship of the so-called Urbino school of mathematicians as with the messy craft practices of painters and metalworkers. He emerged with a capacity to move effortlessly between worlds, across social and professional divides. Throughout his career Oddi would be a go-between, a broker who used objects to encourage mathematical thinking and who embedded mathematics within artifacts: his was a fluid position between science and art, theory and practice.[27] Even his contemporaries recognized that Oddi's professional and intellectual identity was mixed. In a portrait medal cast in his honor in the 1620s (fig. 6) he is designated Mathematician *and* Architect, an appellation reflected by the various official titles he held throughout his career: Architetto Ducale, Professore di Matematica nelle Scuole Palatine, Ingegnere della Serenissima Repubblica di Lucca.[28]

What, though, should *we* call Oddi? Given his deep commitment to pure mathematics, "architect-engineer" will not quite do. Indeed, while the professions of architecture and engineering grew increasingly distinctive and autonomous in the Renaissance, designing and building were often regarded as part and parcel of the mathematical arts.[29] In rhetorical terms (for the supposed certainty of mathematics offered intellectual credibility) and in practice (for architectural design relied explicitly on measurement), architecture was regularly considered to be a branch of mathematics.[30] Yet to call Oddi simply a "mathematician" is to obscure the thoroughly hands-on, practical aspects of his worlds.[31] Turning to a popular compendium of late Renaissance professions—Tommaso Garzoni's *La piazza universale di tutte le professioni del mondo* (1585)—we find that contem-

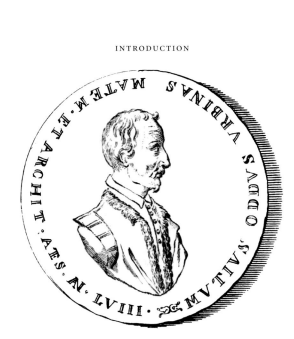

FIGURE 6. Portrait medal of Mutio Oddi, 1627. From P. A. Gaetani,
Museum Mazzuchellianum (1761–63). British Library, London.
Shelfmark 680.i.10. © British Library Board.

poraries struggled to define what it meant to be a mathematician in the period. Garzoni's entries clearly delineated the professions of "arithmetician, or abacus master," and "astronomer and astrologer," but when it came to "mathematicians" he offered only a vague, general account of the scope of mathematics (he actually called the entry *matematici, in genere*), culled from well-known classical sources.[32]

This was partly due, no doubt, to the increasingly ambitious claims scholars in the period were making for mathematics—in terms of its intellectual range and status, and its applicability to diverse arts. These claims were encapsulated in print in works such as John Dee's "Mathematicall Praeface" to the first English edition of Euclid's *Elements* (1570) or the Italian cosmographer Egnazio Danti's "mathematical tables" (1577), both of which set out, in schematic form, the remarkable disciplinary reach of which Renaissance mathematics was seen to be capable.[33] Indeed, as Michael Mahoney has pointed out:

> Throughout the sixteenth and seventeenth centuries, mathematics meant many different things to many different people. Various sixteenth-century treatises discussing mathematics as a whole show that there was widespread difference of opinion on what mathematics is or should be, on the end to which it should be pursued, on the problems to be investigated, on the methods to be used in solving them, and on standards of achievement.[34]

It was possible, of course, to bear the actual title "mathematician" in several are-

nas—universities, schools, and courts, for example—where the term often (but by no means exclusively) referred to somebody retained to undertake research or teaching of the quadrivial arts—arithmetic, geometry, music, and astronomy—which were seen as propaedeutic to the study of natural philosophy.[35] But as Dee's and Danti's works suggest, by the early seventeenth century the "mathematician's role" (to adapt Robert Westman's phrase) extended increasingly to the *practice* of mathematics, a development that led to the emergence of a distinctive but highly diverse group of individuals referred to collectively in recent scholarship as "mathematical practitioners."[36] Although not a period term, and despite the fact that it was initially coined to refer specifically to English figures, this comes closest to describing Mutio Oddi. Although his unpublished papers reveal a lifelong commitment to the study of speculative geometry, for the most part he was concerned with the uses of mathematics in the world, particularly through instrumentalism. All of his published works, for instance, are devoted to instruments which use practical geometry for the purpose of measuring.

Mathematical practitioners such as Oddi have come to occupy an important place in the history of early modern science—as technical innovators, disseminators of mathematical knowledge, and challengers to orthodox natural philosophy.[37] The last of these roles derived principally from their engagement with domain-specific problems, in gunnery or navigation, for example, the solution of which resulted in observations and conclusions in conflict with prevailing scholarly (or, more precisely, scholastic) opinion.[38] Moreover, mathematical practitioners have been perceived as socially and intellectually subversive by virtue of the fact that they came in many guises. They could belong to recognizable professional groups, such as surveyors, navigators, instrument makers, or gunners, but they could equally be—and regularly were—multiskilled practitioners lacking unambiguous professional affiliation, individuals who worked across a wide range of roughly related fields bound together by a common reliance on mathematics, and in which some form of instrumentalism was usually required. The multiplicity of roles mathematical practitioners undertook was matched by the diversity of locations in which their brand of mathematics was practiced, such as the court, the battlefield, the marketplace, the workshop, and the studio. This mobility was possible largely because of the utility, regularly embellished as a rhetorical trope, that they professed their arts offered.[39] In invoking this usefulness, however, they risked their social status; the manual requirements and worldly ends of most mathematical practice invited association with the mechanical arts, which were widely regarded as inferior to the more speculative subjects of the liberal arts.[40]

Oddi represents an ideal opportunity to chart the social fortunes of a late Renaissance mathematical practitioner: he was a gentleman who trained as an artisan,

entered the court, fell from favor, worked in a range of middle-status positions (all of which were related to mathematical practice), and gradually recovered his standing through a respected position in the employ of a republic (not, notably, a court), leading eventually to reestablishment in the upper echelons of his homeland's society. Moreover, the richness and scope of his professional activities render Oddi an excellent case study through which to investigate the multiple worlds of mathematical practice and thus the relationship between social context, materiality, and cultural/intellectual production.[41] Given the copiousness and range of Oddi's extant papers and related artifacts it would even be possible to produce a day-by-day account of this mathematical practitioner's life, were one to adhere rigorously to the methods of microhistory.[42]

Although an exhaustive account is not sought here, the microhistorical methods of scholars such as Carlo Ginzburg and Natalie Zemon Davis underlie some of the approaches evident in this book, not least my deployment of a seemingly marginal figure to trace major processes and my use of extensive archival evidence.[43] However, while a deep account of Oddi's worlds reveals the importance of relatively overlooked, non-elite figures (such as instrument makers), mine is not a history from below. Furthermore, it should be made clear that when writing about "material culture" I am explicitly not concerned with what Douglas Bruster has called the "new materialism" in Renaissance studies—an approach to criticism focused on the "everyday" and the "common"—because the objects with which Oddi engaged in interesting ways were, by and large, high-status, luxury artifacts.[44] Rather, I use this term to denote a suite of objects which, taken together, cannot be described simply as "works of art" (for some, such as books and instruments, did not necesssarily have a primarily aesthetic function), but which nevertheless embody or represent distinctive cultural and intellectual trends or attitudes, of significance beyond the market.

The notion that the production, use, and classification of objects in a given place and time serve as an index to the societies and cultures to which they were born has a long history, traceable primarily in anthropology and stretching at least to the mid-nineteenth century.[45] Yet in recent years, work in the history of collecting—now a discipline in its own right—and a renewed focus on craft processes has brought the study of material culture to the attention of historians of science, showing the ways in which a growing fascination for things and their manufacture in the sixteenth and seventeenth centuries framed, directed, and, in some cases, limited the practice of science.[46] To a certain extent, this type of history has evolved from Marxist scholarship (and its critics), which placed major emphasis on the role of markets and consumption as forces that significantly shape society.[47] Indeed, an emerging trend in the history of science presents early modern commerce as a defining feature of the changing landscape of intellectual endeavor in that age, particularly in relation to the expansion of European

markets overseas.[48] While this book is not directly concerned with the impact of newly global trade, the growth of consumption and the dynamics of what Richard Goldthwaite called "the empire of things" provides the backdrop for my exploration of mathematical culture.[49] Goldthwaite has argued persuasively that a form of what would later be called "conspicuous consumption" is evident in Italy at a particularly early stage, and that by the sixteenth century it gripped Italian society to such an extent that desire for the explicit display of wealth (and hence status) significantly affected spending patterns and cultural production.[50] Drawing on Goldthwaite's findings, I seek in particular to trace some of the ways in which this craving for ownership and the status it conferred helped to disseminate and socially habilitate mathematics via the consumption of its objects.[51]

In many ways the mathematical communities to which I refer operated in a fashion similar to the market: via familiar systems of credit and exchange in which objects were used as currency, and in which a degree of competition is evident in the consumption of mathematical goods and services related to those goods.[52] Yet while cash transactions are evident in the material exchanges that took place within mathematical communities—notably in the purchase of instruments from workshops—what emerges most clearly from a study of the circulation of mathematical objects in the late Renaissance is the fact that social relationships formed an integral part of this type of trade.[53] Commissioning, purchasing, or being given an object involved entering into a tangled web of relationships; when the object being acquired was mathematical, particular intellectual transactions were also frequently required—either in learning how to make or to use the object, or in understanding what it was intended to represent. Thus, following the movement of artifacts enables the historian to access better the nexus of social, intellectual, and economic issues at stake in the workings of mathematical communities, but a close focus on individual objects likewise yields rich rewards.[54] By studying in depth a specific artifact or a small cluster of related objects it is possible to, as Lorraine Daston has observed, "knit together matter and meaning," showing properly the fine grain of context in which identities are formed, disciplines shaped, and practices undertaken.[55] In placing under the microscope select examples of the material culture of mathematics in which Oddi figures (both literally, in portraiture, and metaphorically, as creator or designer), I am particularly concerned with what these things say about how mathematics was perceived and represented in the period, how art was deployed on behalf of science, and how objects served to fashion a particular image of mathematics and its practitioners.

In so doing, I hope to contribute not only to the history of science, but also to an important trend in the history of art that has witnessed the integration of visual studies with intellectual history. Drawing on the legacy of scholars such as Erwin Panofsky and Michael Baxandall, recent studies by, among others, Svetlana

Alpers, Martin Kemp, Thomas DaCosta Kaufmann, Horst Bredekamp, and Eileen Reeves have carefully probed the complex relationship between artistic and scientific domains in the Renaissance and early modern period.[56] This type of work has sought to embed visual products of the fifteenth to seventeenth centuries within the mathematical and natural philosophical contexts that were frequently fundamental to how such objects were conceived, made, and received. Indeed, it has been shown that, when dealing with an era of nascent professionalization during which the boundaries of disciplines were fuzzy and porous, we separate out the "scientific" from the "artistic" at our peril. Oddi's case offers further compelling evidence of the thoroughgoing blending of these fields in his age, but he enables us also to examine the relationship between them both in greater detail and across a broader range of objects and issues than is usually permitted by the surviving evidence. Through him, we may better appreciate not only the (now well recognized) significance of mathematics for artistry in the practice of, for example, perspective drawing or the construction of buildings, but conversely the pervasive impact of new artistic notions—such as emerging ideas about style—on science. For instance, while mathematics informed the harmonious, regular manner in which Oddi laid out his architectural plans, aesthetics and local traditions governed how he approached and practiced science; his geometry, as we shall see, aimed at elegance and classicism, qualities entirely redolent of the Urbino school to which he belonged. Likewise, when it came to the thorny issue of assessing the heavens and representing one's results, we find that Oddi drew upon contemporary artistic debates about the nature of *disegno* to articulate his stance and that he used a painting, no less, to present his ideas.

In order to explain most clearly how Oddi lived his life in mathematical culture, and where he sits in the social and intellectual currents of the late Renaissance, this book is arranged thematically rather than chronologically. In part I—"Locating Mathematics"—I seek to show that the character of Oddi's science was determined by a particular place, the Duchy of Urbino. Far from engaging in an unbiased search for truth, Oddi's mathematics was regionally inflected, to such an extent that it may be described as specifically Urbinate in style. Chapter 1 examines those elements of Oddi's worlds that contributed to the formation of this style, namely his relationship to his *patria*, the conditions of his exile, and his obsession with the legacy of Urbino's famous men. A mixture of intense longing for his homeland and national pride ensured that Oddi's mathematics conformed to his forebears' intellectual conservatism, but equally that it partook of Urbino's traditional merging of mathematics and craft, especially in instrumentalism. Thus, Oddi emerges as a self-conscious perpetuator of the mathematico-material legacy of his homeland's *uomini illustri*.

Part II—"Teaching Mathematics"—assesses the ways in which Oddi sought to

disseminate Urbinate mathematics through pedagogy. This section begins with a survey of the various types of mathematics teaching available in Italy at the time, which ranged from mercantile arithmetic in abacus schools to advanced geometry in universities, before turning to the local conditions of the city in which Oddi taught: Milan, which boasted two teaching institutions, the Collegio degli Architetti et Ingegneri, and an academy run by an entrepreneurial engineer called Bernardo Richino. Chapter 2 analyzes Oddi's provision of mathematics tuition, using rare evidence that permits a detailed reconstruction of whom he taught, what he taught, how he taught it, and the rewards he received for doing so. Oddi's teaching records unveil a highly diverse mathematical community comprised of officers, nobles, merchants, and artists, interested in a wide range of mathematical subjects, from rudimentary geometry to military architecture. The fact that Oddi received gifts as well as cash payments from his pupils indicates that much of his teaching took place within the culture of *amicizia*, which helped to move mathematics away from the mechanical arts and into gentlemanly realms of credit and propriety.

Amicizia is at the heart of chapter 3, which examines in detail a painting made by one of Oddi's pupils—the artist Daniele Crespi—of a lesson in geometrical optics delivered by Oddi to the merchant Peter Linder. The painting is a record both of mathematical sociability and of the relationship between mathematics and material culture in Oddi's world, for it seems to depict Oddi explaining to Linder the properties of a concave mirror. Oddi's correspondence, particularly with his pupil Giovanni Battista Caravaggio, shows that the mathematician and his colleagues undertook extensive optical experiments, many of which focused on the fabled "burning mirror" of Archimedes and on new mirror and lens technologies. Having set out the various mathematical and technical challenges that Oddi and his friends encountered in investigating such devices, the chapter concludes with a reconstruction of a diagram depicted in the double portrait, and an assessment of what the image can tell us about how mixed-mathematical knowledge was shared in the period.

Part III—"Consuming Mathematics"—elaborates on the materiality hinted at in the Oddi-Linder portrait by investigating the workings of the late Renaissance instrument economy, a commercial world that mixed the production and circulation of books and instruments with socio-intellectual issues such as priority, credit, and prestige. Chapter 4 focuses on one aspect of this economy— instrument books—to see how, in treatises on measurement and gnomonics, Oddi sought to democratize the renaissance of mathematics by publishing in the vernacular, and also to promote the famous mathematicians of his *patria*, thus bolstering his own standing. Oddi's instrument books are, however, especially interesting for what they can tell us about the economics of producing and distributing practical mathematics in print. As with his teaching, Oddi left detailed

accounts for the making of his books, and the chapter concludes with a consideration of what these records can tell us about the constraints and possibilities inherent in mathematical publishing in the late Renaissance. Oddi's distribution list for *Dello squadro*, his treatise on surveying, shows, for example, that this book crossed social and professional divides to reach both humble artisans and illustrious patricians, helping to forge an integrated mathematical community.

This community was fashioned as much by instrumental practice as by reading. For this reason, chapter 5 traces the manufacture and circulation of mathematical instruments, which, like books, were versatile ambassadors in mathematical circles. Oddi's involvement in the instrument trade was highly diverse—he acted as a broker for Urbino's Officina di strumenti matematici, served patrons as a technical consultant, and even made instruments himself. Indeed, Oddi occupied a position that—like instruments themselves—was mediatory; he exemplifies the ambiguous relationship between the mind and the hand that was such an important aspect of ingenuity in the period. In particular, Oddi's accounts show that instruments' mediatory power derived from their relationship to *disegno*, which could be both a courtly art and a geometrical exercise, binding together professional mathematician and *virtuoso* alike.

Part IV—"Mathematics and the Arts of Design"—shows that *disegno* was at the very heart of Oddi's world. Starting with an account of the relationship between mathematics and artistic theories of design in Oddi's era, this section traces the mathematical practitioner's life in *disegno*, from his collecting of drawings to his invention of a grand allegory of design in paint. Like Vasari, Oddi collected drawings to serve as models, but also as desirable objects in their own right. Chapter 6 shows that his fondness for works by Quattrocento architects such as Leon Battista Alberti and Francesco di Giorgio Martini should be related to his mathematics, for they exhibit precisely those qualities—restraint, classicism, and geometrical elegance—that define Urbinate scientific style. The chapter concludes with an analysis of an important Flemish painting devised by Oddi for his closest friend, the merchant Peter Linder. In the *Linder Gallery Interior*, Oddi used instruments and paintings, sculptures and diagrams to present an allegory of *disegno* that articulates his view of how mathematics should properly be practiced. Delving into this work, we find that it contains a coded critique of Galileo and telescopic observation, as well as being a carefully organized representation of Oddi's friendships, intellectual outlook, and ambitions. Thus, this painting not only sums up Oddi's life in design but also pinpoints where he stood in relation to late Renaissance mathematical culture.

Locating Mathematics

In October 1626, after sixteen arduous years of exile, Oddi wrote to his brother-in-law about the longing for his lost *patria* that continued to afflict him. Recently appointed to a prestigious and lucrative engineering post in the pleasant town of Lucca, he had much to celebrate. Yet despite this *buona fortuna*, any hope that his suffering might be alleviated was dashed by the persistent memory of his homeland:

> I will make every effort to see if I can free myself from all the trouble of Urbino and to live peacefully at Lucca, yet because of my disgrace I must remain absent from the *patria* all of my days, and forever at the hands of servants, with the suspicion and great fear that if some other ill should befall me unexpectedly, I might die of shame [*morire di disagio*].[1]

No matter where he was and whatever his fortune, Oddi's mind wandered back to Urbino. Indeed, his experience of exile inflamed an already strong sense of regional identity, an identity that was fostered in large measure by acute awareness of the history of his homeland, and by his own place within that history.[2] In particular, Oddi was conscious of the *fama* (renown) of preceding generations of accomplished individuals, the *uomini illustri* of Renaissance Urbino, with whom he identified, by whom he was educated, and of which he is one of the last notable examples.

For the Urbinate mathematician, the "intimations of immortality" offered by shared identity took on special significance due to his separation from the place that had fashioned him.[3] Far from causing him to reject the scientific traditions of his *patria*, banishment and disgrace further entrenched in Oddi the highly particular attitudes of the "Urbino school" (on which the interested reader may see the historiographical note appended to this book) and a determination to perpetuate the style of mathematics its members practiced. He thus represents an ideal case study through which to examine how specific social contexts could shape science. As the last significant Renaissance exemplar of a resolutely local mathematico-artistic tradition, Oddi epitomizes the importance of place for the history of science.[4] His epistemological outlook was thoroughly parochial,

his aesthetic preferences were regionally conditioned, and his mathematics was firmly located in the intellectual conventions of his homeland.

Taken together, these elements help us to locate Oddi in conservative regions of the map of late Renaissance mathematical culture.[5] To call Oddi's science conservative is not to imply that he refused to engage with contemporary issues and practices, nor that his brand of mathematics made no impact on how science developed—as we shall see, he made important contributions to the dissemination of mathematical knowledge and instrumentalism. Rather, it means that his veneration of past generations of cautious, classicizing mathematicians inculcated a commitment to a style of thinking and doing, which, even when it was formulated around the third quarter of the sixteenth century, faced backward. Oddi, perhaps as a result of the trauma suffered by a cataclysmic fall from favor, sought to capture honor and credit not—as Galileo did—through radical, highly visible claims certain to provoke conflict and controversy, but by peddling certainty, authority, and continuity.[6] Indeed, Oddi's commitment to the methods and principles of his *patria*'s famous men helps explain why, despite having comparable knowledge available to him (especially in mechanics), despite working in the same practical environment with the epistemic challenges it presented, and despite his participation in contemporary scientific debates, he did not make the same intellectual moves as Galileo.[7] Thus, if we are interested not only in paradigm shifts but also in the continuation and very gradual evolution of established—but still rich—traditions, Oddi and Urbino have much to teach us.[8]

That traditions, in particular those embodied by celebrated individuals, weighed heavily on the Urbinate approach to science is revealed by Oddi's teacher Guidobaldo del Monte's eulogy of his master, Federico Commandino (1509–1575). According to Guidobaldo, Commandino was the progenitor of a renaissance in the mathematical arts:

> Yet in the midst of that darkness (though there were also some other famous names) Federico Commandino shone like the sun. He by his many learned studies not only restored the lost heritage of mathematics, but actually increased and enhanced it. For that great man was so well endowed with mathematical talent that in him there seemed to have lived again Archytas, Eudoxus, Hero, Euclid, Theon, Aristarchus, Diophantus, Theodosius, Ptolemy, Apollonius, Serenus, Pappus, and even Archimedes himself, for his commentaries on Archimedes smell of the mathematician's own lamp. And lo! just as he had been suddenly thrust from the darkness and prison of the body (as we believe) into the light and liberty of mathematics, so at the most opportune time he left mathematics bereft of its fine and noble father and left us so prostrate that we scarcely seem able even by a long discourse to console ourselves for his loss.[9]

Guidobaldo did not claim that his master had revolutionized science through controversial arguments or discoveries. Instead, he cast Commandino as a diligent improver, an augmenter of an august discipline—mathematics—that could itself boast of an illustrious heritage, having been established by some of the most famous scholars of antiquity. Strikingly, Guidobaldo's highest praise of his tutor is that Commandino's commentaries on Archimedes "smell of the mathematician's own lamp." Through his thorough possession of classical knowledge, Commandino surpassed emulation to become an ancient geometer *redivivus*, the true heir of Euclid and Archimedes, an archetypal mathematician for the modern age.[10] Guidobaldo reinforces this imagery of lineage by describing Commandino as a mathematical father figure, a remark that alludes to the strong genealogy endemic to, indeed consciously constructed by, the Urbino school. Commandino, heir to the greatest mathematical scholars of antiquity, passed the torch on to his pupils, Bernardino Baldi (1553–1617) and Guidobaldo, the latter of whom inculcated a very specific, Urbinate style of mathematics in his own student, Oddi.[11]

It is important to remember, however, that while the Urbino mathematicians shared a recognizable scientific manner, they were not part of an academy with rules and regulations; nor were their scholarly aims directed by rigid institutional goals. In fact, although the term "school" is useful shorthand for the group (since they shared an intellectual attitude predicated in part upon master-pupil relationships), they were as much a family as anything. Such a designation is entirely appropriate given Guidobaldo's use of familial language to describe Commandino, the close social relationships between the group's members, their shared *patria*, and their demonstrable interest in intellectual genealogy. In this family, inherited resemblance, rather than identicality, is discernable; differences between members are expected but do not negate kinship; and subtle changes in conduct and outlook are natural across the generations. Thus, the dynasty's founder, Commandino, was particularly concerned with mathematical certainty, Guidobaldo sought an Aristotelian-Archimedean synthesis in mechanics, Baldi investigated the potential of pseudo-Aristotle's *Mechanical Questions*, and Oddi specialized in instrumentalism, but each worked according to the principles of rigor, elegance, and ancient authority, enhancing their studies through the development and deployment of instruments. These are the qualities that define what we might call Urbinate scientific style.

I use the term "style" advisedly, for the similarities between the Urbino school's members reside as much in the *way* in which they approached and practiced science as in the content of their work. Significantly, Renaissance Urbino was one of the key locations in which notions of stylishness were first developed and enacted, for it was the setting for Baldassare Castiglione's idealized account of Renaissance court life, *Il libro del cortegiano* (1528).[12] Thus, Commandino and

his followers fashioned their mathematics within a sophisticated, elite setting, in which, as Castiglione indicates, concern for deportment, grace, and manner were paramount. Indeed, we should not forget (as Oddi certainly did not) that Urbino was the birthplace of Raphael, the supreme exponent of *grazia* (grace or elegance) in art.[13]

Of course, the elusive nature of style as a category, its associations with intuitive rather than analytical judgments, and its tendency to homogenize differing individual manners into "schools" render it a potentially problematic historical tool—particularly in the assessment of cultures of fact.[14] Indeed, some scholars have rejected the very idea of style in science as, in the words of Gerald Geison, a "hopelessly vague and outmoded idea borrowed from a passé version of art history."[15] But, as Karl Mannheim and others have suggested, when treated as a thoroughly contextual rather than extrahistorical entity, style has the capacity to render visible the sociological elements that determine the ways in which knowledge is made and presented.[16] If it is reasonable to assume that in science, as in other fields of endeavor, choices (whether conscious or unconscious) about how to pursue and present work are determined by social factors, the complex constitution of identity, and aesthetics, then style offers a historically sensitive way in which to recover the motivation for these choices, while providing a language with which to explain it.[17]

There is every reason to suppose that Oddi was familiar with the idea of style, even if he would not have called it by that name.[18] He made what we would now call connoisseurial judgments about the attribution of paintings, he was involved in the design of a picture that consciously plays with issues of discernment, and he had read one of the most important literary contributions to the development of style as a concept: Vasari's *Le vite de' più eccellenti pittori, scultori e architettori* (first edition, 1550).[19] In fact, his involvement in the visual arts—as architect, perspective master, collector, and artistic adviser—means that the relationship between aesthetics and science is particularly apparent in his world, and it came to the fore when he engaged with the material culture of mathematics. To take just one example, Oddi described the instruments made by Simone Barocci (1525–1608)—Commandino and Guidobaldo's artisan collaborator—as "beautiful, and as well made as can be," and demonstrated a keen desire to acquire examples of his workmanship that represented the best of Urbinate *ingegno*.[20] Among these devices is an artifact that indicates just how pervasive and particular Urbinate scientific style was.

In 1634, when it seemed that the contents of Guidobaldo del Monte's *studiolo* might be sold and dispersed, Oddi wrote anxiously to his friends in Pesaro asking them to purchase the mathematical books annotated by his master, and in particular that "no expense should be spared" in acquiring the remarkable refracting water-dial invented by Guidobaldo and constructed by Barocci (fig. 7).[21] This

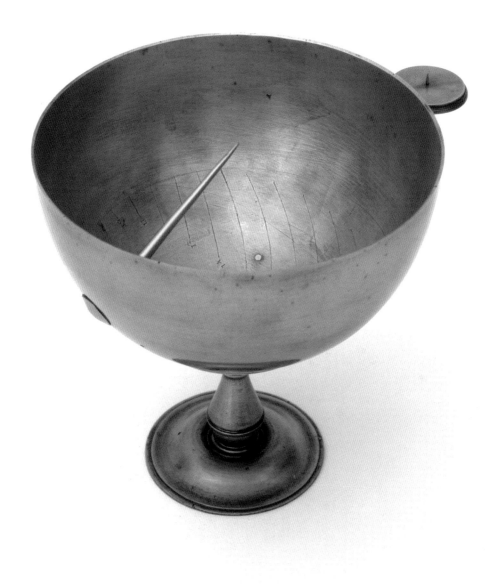

FIGURE 7. Simone Barocci (design by Guidobaldo del Monte), "scaphe" dial, ca. 1570. Brass. Istituto e Museo di Storia della Scienza, Florence. Inv. no. 241.

material manifestation of Guidobaldo's mathematical preoccupations exhibits precisely those qualities that governed the sciences in Urbino. Quite unlike the vast majority of period instruments, Barocci's work is refined, classicizing, and almost completely unadorned.[22] Its elegance derives not from superficial ornamentation but from an intrinsic harmony within its proportions equivalent to the classical geometrical proofs of which Commandino and his followers were so fond. Barocci's device was, for Oddi, a tangible manifestation of the science of his homeland. Considered thusly, Urbinate scientific style pertained as much to the material culture of mathematics as to mathematics itself.[23] It was displayed and disseminated not only in lectures and books, but also in objects: Urbino's instruments were bearers of identity, emblems of a distinct tradition forged through communal bonds of *patria*.

In chapter 1, we shall see what this somewhat nebulous term, *patria*, actually meant in the period, why it took on such immense significance for Mutio Oddi, and how it affected his science. Because of his banishment, the ideal of Urbino and the tradition of *uomini illustri* became especially important for this particular mathematical practitioner. Geography and regional identity maintained their grip on Oddi throughout his exile, structuring his emotional and intellectual worlds and ensuring that—although displaced from his home—his mathematics remained resolutely Urbinate in style. Thus, his case casts a spotlight on the importance of place in the construction and maintenance of scientific traditions in the late Renaissance. Through him, we may better appreciate that period styles of thinking and doing were regionally inflected, and that only by locating mathematics may we identify properly its character.

Patria, Exile, and *uomini illustri*

Mutio Oddi's mathematics came from a particular place: Urbino. All of his worlds—social, professional, artistic, and scientific—were molded by the city of his birth, a small, elegant, hilltop town in a once great duchy (fig. 8).[1] By the time of Oddi's death in 1639, the very name Urbino was synonymous with ingenuity. In one of the earliest histories of the region, *Istorie dello stato d'Urbino* (1642), Vincenzo Maria Cimarelli observed, "This land, because of the goodness of the air, has in every age produced men of sublime *ingegno*," commenting that each of its towns and villages contained "soldiers of great valor, and important captains and engineers."[2] The birthplace of Raphael and Bramante, Federico Commandino and Bernardino Baldi, the duchy had produced a seemingly endless line of *uomini illustri*, particularly in the fine and mathematical arts.

Oddi's birthright was the inheritance of this tradition. He had a foot firmly in each of the fields that, since Urbino's golden age under the mercenary-duke Federico da Montefeltro (1422–1482) in the second half of the fifteenth century, had made the duchy both prosperous and famous: military capability and artisanal excellence.[3] His father, Captain Lattantio, was a military man and a minor noble with a position at court, while his mother, Lisabetta, was descended from the celebrated Genga dynasty of artists and architects, the best-known member of which was Girolamo, architect of the Villa Imperiale at Pesaro.[4] Both the military arts and craft continued to flourish in the Urbino of Oddi's era. Francesco Maria II della Rovere, the last Duke of Urbino, followed in the footsteps of his forebears by holding a *condotta* with the Spanish Crown, and vigorously supported the duchy's artisans in the hope of revitalizing its flagging economy.[5] He even commissioned from Simone Barocci a sumptuous manifestation of his stature as a noble warrior: a miniature silver fortress housing a compass.[6] Doubtless intended as a princely emblem of Urbinate pre-eminence in the arts of war, the fortress signified not only the martial heredity of the ducal line but also, through the compass, the discipline widely credited for much of warfare's modern progress and intellectual nobility: mathematics.[7]

From the mid-fifteenth century onward, mathematics enjoyed a special place in the artistic and intellectual life of Urbino. Duke Federico da Montefeltro, a

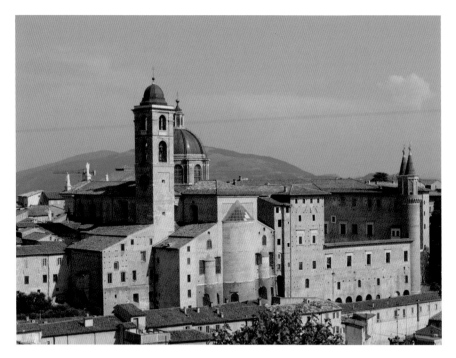

FIGURE 8. View of the Palazzo Ducale, Urbino. Author's photograph

keen scholar who had studied geometry under the humanist Vittorino da Feltre, expressed his fondness for this discipline by surrounding himself with works of art and architecture of a profoundly mathematical character: Piero della Francesca's perspectivally complex *Flagellation* and *Brera Altarpiece*, Francesco di Giorgio Martini's geometrically harmonious church of San Bernardino, the trompe l'oeil *intarsie* of his *studiolo* (complete with geometrical solids and mathematical instruments in perspective), and a library rich in works of ancient mathematics (fig. 9).[8] He even expressed his belief (redolent of Leon Battista Alberti, who visited his court) that architecture was explicitly founded upon mathematics, writing in a letter patent for his court architect, Luciano Laurana:

> We deem as worthy of honour and commendation men gifted with ingenuity
> and remarkable skills, and particularly those which have always been prized
> by both Ancients and Moderns, as has been the skill of architecture, founded
> upon the arts of arithmetic and geometry, which are the foremost of the seven
> liberal arts because they depend upon exact certainty.[9]

As a further sign of his commitment to the mathematical arts, Federico arranged for his son and heir, Guidobaldo (1472–1508), to study mathematics with the renowned scholar Luca Pacioli (1446/47–1517), whose lessons to the future duke

FIGURE 9. Trompe l'oeil *intarsia* from Federico da Montefeltro's *studiolo*.
Palazzo Ducale, Urbino. Galleria Nazionale delle Marche, Urbino.

are recorded in a remarkable double portrait attributed to Jacopo de' Barbari, with which Oddi was almost certainly familiar (fig. 10).[10]

The support and promotion of mathematics and its application that began under Duke Federico flourished in Urbino throughout the sixteenth century, not least because the duchy's wealth, independence, and status derived ultimately from its rulers' success as *condottieri* (roughly translated, "mercenaries").[11] This led directly to Urbino's emergence as a center of excellence in military engineering and the arts of war, the machines of which were prominently displayed in the *Fregio dell'arte della guerra* that once lined the façade of the Palazzo Ducale.[12] Mathematics and the associated discipline of mechanics were central to these pursuits. New types of artillery demanded a new system of fortifications—the

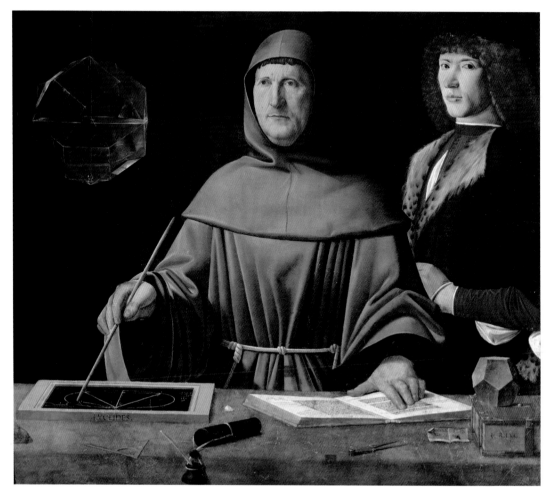

FIGURE 10. Jacopo de' Barbari (attrib.), *Luca Pacioli and Guidobaldo da Montefeltro(?)*, 1495. Oil on panel. Museo di Capodimonte, Naples. Photo: Erich Lessing/Art Resource, NY.

trace italienne—based on regular geometrical figures; heavy artillery required lifting machines for their transportation and installation; and bombardeering itself had recourse to mathematics and its instruments for range-finding through triangulation.[13]

Thus, mathematical practice—an instrumental, applied form of geometry and arithmetic—was central to the professional environment of Renaissance Urbino. Moreover, the material culture of mathematics was especially prominent in the region. As the distinguished Urbinate man of letters Bernardino Baldi explained in his translation of Hero of Alexandria's *On Automaton-making* (1589), Urbino was in the vanguard of mathematico-mechanical craft. The instrument maker Giovanni Maria Barocci, he tells us, presented many automata to Pope Pius V;

Bartolomeo Campi of Pesaro (then the duchy's capital) made a silver tortoise that walked by itself on the table, moved its head, and waggled its tail; and the Pesarese mechanician Pietro Griffi was renowned as "a very singular man in the art of moving devices, and of most marvelous ingenuity."[14] The courtly objects the duchy's mechanicians devised—redolent of the *sprezzatura* (roughly translated, "nonchalant elegance") associated with elite cultural life in Urbino as described by Castiglione—were the spectacular cousins of the useful, precision instruments manufactured in large numbers by Urbino's Officina di strumenti matematici.[15]

By the turn of the sixteenth century, this workshop had established a reputation as one of the leading instrument *botteghe* in all Italy, largely thanks to the skills of its master artisan, Simone Barocci.[16] As Baldi explained in the "Encomio della patria" that prefaces his *Memorie concernenti la città di Urbino* (published posthumously in 1724):

> No less competent in his art than Federico, his brother, is Simone [Barocci], he who with greatest talent makes compasses and mathematical instruments, such that he has no equal, one can state without arrogance that his workshop is the workshop of the world, which I am not embarrassed to affirm myself nor fear be taken for a liar; this fact is very well known to those who attend to these works, in Italy and abroad.[17]

At the time Baldi was writing, the Officina's reputation was so high that mathematicians, engineers, and *virtuosi* from across the Italian peninsula eagerly sought its wares.[18] Galileo, even, when he wished to have prototypes of his geometric and military compass produced, turned to Urbino's workshop.[19] In doing so, he engaged in a distinctly Urbinate tradition in which scholars and artisans collaborated in the design and manufacture of mathematical artifacts, such as the refracting dial that Oddi so eagerly sought to acquire.[20]

From a very early age, Oddi partook of this world of inventiveness. He spent his youth learning about instruments from his maternal uncle, Niccolò Genga, in the family workshops in the center of town; indeed, he must have developed much of his practical mathematical and artisanal skill (especially his architectural *nous*) informally, through contact with friends and family in and around the duchy.[21] We know, too, that Oddi began an apprenticeship with Simone Barocci's brother, the painter Federico, although he curtailed his artistic studies after discovering defects with his vision. Oddi's first biographer, Giovanni Vittorio Rossi, claimed in *Pinacotheca imaginum* (1643) that because Oddi was nearsighted, "he was not able to color in that which he drew" (*non posset, quia prospiceret parum, id, quod delineasset, coloribus vestire*)—an ironic situation since Barocci was regarded as one of the finest colorists of the age.[22] Nevertheless, in the brief time he spent in Barocci's studio Oddi would have been exposed to the material life of a painter (i.e., his recipes and methods) as well as to the

practice of *disegno*, for which his master was highly esteemed.[23] As we shall see, Oddi was especially interested in *disegno* in all its forms—draftsmanship, collecting drawings, and the theoretical nature of design—and we may assume that his first taste of this field was in Barocci's workshop. We might speculate, even, that the mathematician's defective vision played a role in his later commitment to *disegno*, the linear (and central Italian) antagonist of *colorito*.[24]

Clearly, Oddi's youth in Urbino was a stimulating succession of artisanal experiences, in which he was exposed to practical mathematics, craft techniques, and the visual arts. A major turning point, though, came when he abandoned painting as a career. At an unknown date (most probably in his teens) Oddi moved from the artistic *facilità* of Barocci to the mathematical *ingegno* of Marchese Guidobaldo del Monte, leaving the city of his birth to study mathematics under the "Archimedes of Pesaro."[25] The circumstances that led to Oddi's studying with Guidobaldo are not entirely clear, but it seems that the Duke of Urbino may have had a hand in the move. In 1631 Oddi, then an old man, recalled his youth in a letter to his longtime friend Piermatteo Giordani. Reflecting on the news of Francesco Maria's recent passing, he explained:

> The death of our duke has saddened me more than I could have imagined, given the consequences that will follow. And although when he was alive he treated me very badly, he could not, nevertheless, through any of the harm that I have received make me forget the great debt that I shall always owe him, for raising me in his household, giving me the opportunity to learn, and embellishing me by honoring me with the title of Architect.[26]

This suggests that, for reasons that remain obscure, the duke took a special interest in Oddi at a young age.[27] If this is the case, that Francesco Maria should have called on Guidobaldo del Monte to tutor Oddi is not surprising, for the duke and the marchese had been fellow pupils of Federico Commandino, studying mathematics together under the renowned humanist.[28] Whatever the reasons for his pupilage, and despite the fact that we know neither what precisely he learned from Guidobaldo nor the duration of his studies, Oddi certainly lived out his later years as an encomium to the mathematical culture of his *patria*.[29]

PATRIA

Patria was demonstrably fundamental to Oddi's epistemic outlook, but what did the term mean in the period? In a classic article on Italians' self-perception in the Renaissance, Denys Hay provides a succinct definition: "For most Italians, *patria* meant, not the entire peninsula, but those narrower localities with which they had immediate sentimental and political ties."[30] For Oddi, this meant the city of Urbino first and foremost. As this was his birthplace, it may quite legiti-

mately be called his *patria*, given the literal translation of the word: fatherland. Indeed, when trying to decide where to settle after his exile had come to an end, Oddi expressed a sentimental attachment to Pesaro yet confirmed that the city of his birth was his proper *patria*. Life in the little hill town, he wrote to Camillo (brother of Piermatteo) Giordani in 1632, pleased him

> as much for the air as for the rise and fall of its streets, although I had always thought to live in Pesaro, where the wind blew me, where—one might say—I was brought up, where I passed my youth with pleasure and satisfaction, where I learned mathematics and received infinite courtesy, which I never felt in my own *patria*.[31]

Thus, in emotional terms, Oddi was deeply attached to both towns. Moreover, his political loyalty was to the Duke of Urbino and to the wider region over which he ruled, suggesting that we might reasonably consider the ducal territories as a whole to be his *patria*.[32] As such, throughout this book I use the term "Urbinate" to refer to the duchy, not just the city of Urbino.[33]

What, though, of *patria* and "national" identity? As Hay points out:

> However oblivious in practice to the demands of larger loyalties, literate Italians were forever referring to the land as a whole. It is hard to find a poet or historian, or writer of any kind, who does not offer observations or reflections which might be used to illustrate a view of Italy.[34]

Despite open hostility among the peninsula's various principalities, duchies, and republics, Italy as a geographical expression (to borrow Prince Metternicht's notorious phrase) was becoming increasingly fixed during the Renaissance, through publications such as Abraham Ortelius's *Theatrum orbis mundi* (1570) or Pietro Bertelli's *Teatro della città d'Italia* (1616).[35] Oddi, a keen student of geography and cartography, was undoubtedly aware of these developments.[36] At the same time, the recognition—though not without debate—of "an educated Italian language, based on Florentine and Tuscan," and its growing ubiquity through the spread of printing, helped to foster a sense of linguistic unity and *italianità*.[37] Familiar as he was with the writings of Petrarch and Boccaccio (both important early proponents of the vernacular) Oddi probably saw himself through this linguistic lens as Italian in a vague way, but his principal loyalty was to a particular place—Urbino—and to a specific man, the duchy's lord.[38] In fact, his relationship with Francesco Maria affected so profoundly the course of his life and career that it needs to be considered in some detail.

In a sense, Francesco Maria *was* Urbino, the human manifestation of the nation over which he ruled, the *pater patriae* (fig. 11).[39] Oddi's exile, therefore, entailed not only a geographical displacement from his homeland, but also a rupturing of the bonds of fealty that made him Urbinate. This situation was made

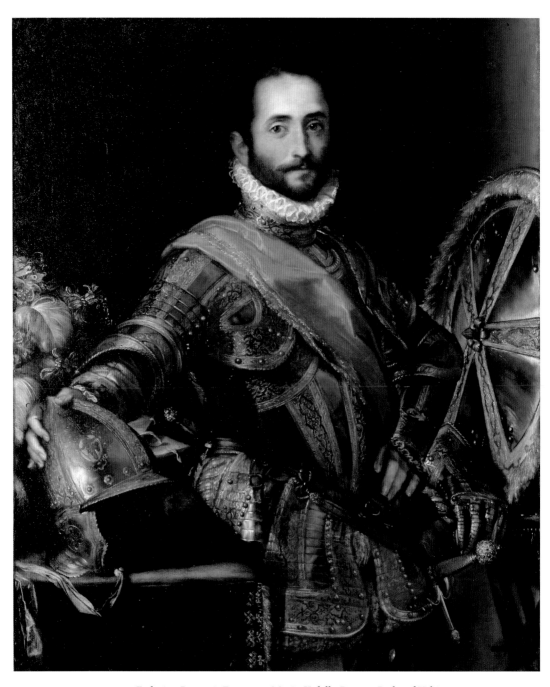

FIGURE 11. Federico Barocci, *Francesco Maria II della Rovere, Duke of Urbino*, 1572. Oil on canvas. Galleria degli Uffizi, Florence.

FIGURE 12. Mutio Oddi, *Degli horologi solari*, title page, 1614.
National Library of Scotland, Edinburgh. Shelfmark Fin.85.
© Trustees of the National Library of Scotland.

even more agonizing by its apparent injustice and the confusion surrounding the cause of his lord's displeasure: "As far as I knew," Oddi wrote in a letter to Camillo Giordani of 1631, "I was condemned to prison for having disturbed the peace of His Highness."[40] Whatever the precise reasons for Francesco Maria's ire (which seems to have been aroused as much by a whispering campaign against Oddi as by any specific action on his part) we can sustain no doubt as to the mathematician's sense of desolation at being, as he put it, "cut off from the light" of his prince. Notably—and here we have an early example of the link between *patria* and mathematics in his work—Oddi chose to depict this state of affairs emblematically in the frontispiece to his first publication, *Degli horologi solari* (1614) (fig. 12). The image he designed, influenced by the frontispieces to earlier publications by mathematicians of the Urbino school (fig. 13), deploys the material culture of mathematics—a sundial, no less—to signify his plight.[41] Thus, in addition to living his professional life in instrumentalism, Oddi re-

FIGURE 13. Guidobaldo del Monte, *Mechanicorum liber*, title page, 1577.
British Library, London. Shelfmark 1263.f.37. © British Library Board.

hearsed its dramas via the devices that were his stock in trade. So immersed was
Oddi in the traditions of his *patria* that he channeled his *mala fortuna* through
practical mathematics and *disegno*, creating a richly evocative yet highly precise
emblem of his sorry situation.

In the revised and expanded version of his sundials treatise, published in
1638, Oddi explained the meaning of the 1614 *impresa* in a letter to his friend
Peter Linder, then seeing the book through the press in Venice:

> In that [*impresa*] which I made in my first book, the Sun represents the Duke
> of Urbino, and the Horizontal Sundial my own self, rendered useless because
> the rays of that Lord's grace are blocked by certain wicked actions of nonenti-
> ties, represented by clouds, for various reasons, in particular due to the simi-
> larity of their birth, one from the mud of the earth, the other from the scum
> of common people.[42]

The frontispiece, then, was designed to show not only that the reason for the

FIGURE 14. Mutio Oddi, *De gli horologi solari*, title page, 1638. British Library, London. Shelfmark 536.e.27. © British Library Board.

duke's wrath was nebulous, but also that its origins lay in vile scandal and rumors spread by Oddi's enemies. The author's decision to depict himself as a useless device—an inversion of the utility professed by scores of mathematical practitioners in the instrument book genre—reflects his self-perception as a vassal, a mere instrument of the duke's will. The image is accompanied by a motto: *Qual'hor rimosse* (Removed at what time?)—doubtless a reference to the mathematician's hope that, through time or some other means, Francesco Maria might restore his grace and pardon his subject, enabling Oddi to function correctly in the world, be of service to his prince, and capture anew his Urbinate identity.

Oddi reprised the themes of *mala fortuna*, exile, and his conflicted relationship with the duke in the frontispiece of his 1638 treatise (fig. 14), in which we find again a sundial representing the author. This time, though, the instrument is vertical, feebly illuminated by the rays of a setting sun. In fact, the image responds to the question posed in the motto of his 1614 *impresa*, as Oddi explained:

> In this other one . . . in which the clouds have dispersed, I wanted to express
> that although in the end all of this rabble was scattered and removed from the
> world, this has happened too late for me, by now old—represented by the Ver-
> tical Sundial facing the West—and when the Sun—that is, His Highness—had
> nearly set, with the motto *Intempestivo e tardi* (Ill-timed and too late), taken
> from Petrarch's sonnet, *Che fai, che pensi?* It seems to me that this not only
> explains vividly my sentiments, but also replies very well to the motto of the
> first: *Quall'hor rimosse.*[43]

Thus, drawing on the restless longing of Petrarch's vernacular verse, Oddi
forcefully articulated that the calamity that befell him in Urbino cast a long
shadow. Educated readers of the mathematician's tract would doubtless have
recognized that the first line of the poem from which Oddi's motto is taken—
Sonnet 150 of the *Canzoniere*—reads in full: "Che fai alma? che pensi? avrem
mai pace?" (What are you doing, my soul? What do you think? Will I ever have
peace?). Through the frontispiece, then, Oddi alluded to the discord within
his own soul, perpetuated by his lord's relentless hostility. For although by
the 1630s Oddi's resolve and hard work had enabled him to regain sufficient
honor to stand, like the vertical sundial of his *impresa*, upright among his
peers, his eventual pardon most definitely came "too late." By the time it was
granted—in 1636, five years after Francesco Maria's death—Oddi had spent
most of his adult life in exile.[44]

EXILE

The internecine struggles between Italy's numerous states and principalities en-
sured that exile was not unusual on the peninsula during the Renaissance.[45]
However, as Christine Shaw has demonstrated, the conditions of banishment
varied from region to region, even ruler to ruler, and were heavily dependent
on the circumstances that had led to the sentence. No documents have come to
light that specify the precise conditions of Oddi's banishment; in fact, it seems
that at the beginning of his exile the mathematician himself was not entirely clear
about his situation. We know, though, that by the summer of 1610 he had made
his way north to Milan, presumably on the orders of the duke, for he wrote in
August to the astronomer Giovanni Antonio Magini (1555–1617), then Profes-
sor of Mathematics at Bologna:

> I have arrived at last in Milan, the place of my confinement, where, with God's
> grace, it seems that air should be granted to me, and even make me strong
> again, and improve my complexion. I shall see if it is possible to arrange my
> affairs a little, and grab some peace to attend to mathematics, and serve out
> this exile with less hardship than perhaps many believed possible.[46]

The terminology of imprisonment—Milan is "the place of my confinement"—suggests that the city was specified by Francesco Maria as the spot in which Oddi's sentence should be served.[47] Yet Oddi evidently expected a degree of liberty: to be granted "air" that might, literally, improve the health that had been shattered by a long incarceration and, figuratively, provide the freedom to pursue his great passion, mathematics.[48]

The disorientation brought on by banishment is laid bare, however, in a letter Oddi wrote to his brother, Matteo, during his first months in the city:

> I understand that you have already had, by another route, my opinion concerning my supplication, and of your coming here with that gentleman—I do not approve of either, as for my own part it is doubtful that I should receive anything to the contrary, or rather I should be bound with tighter knots . . . if I must serve in the army, what does it matter if I should have or not the security of staying in the state of Milan? . . . I shall go if the Governor [of Milan] commands me in writing, because I am obliged to obey. I chiefly think that if His Highness [Francesco Maria] is content that I should not have to leave, it seems unlikely that he will make any other charge [against me], and ultimately I am in Milan—which is neither a little palace nor a hovel, and is somewhere I can stay, and as such I am resolved to not form any other plan and to await the charity of time. . . . I trust in the innocence of my conscience, and I hope that God will help me to overcome even those betrayals that are plotted against me in those parts, and that when His Highness should have, either through time or some other means, or having convinced himself, a better opinion of me, he will find that I am a loyal subject and servant, and that I am avowedly indebted to him and that I will always willingly give my life to his service.[49]

Unsure of the capricious duke's feelings toward him, or whether the Milanese authorities, who must have been in contact with the Urbinate court, would grant him residency, Oddi decided against supplicating for a pardon—and thus running the risk of exacerbating Francesco Maria's wrath. He evidently hoped that by living in the extreme north of Italy he would be sufficiently remote from his *patria* that the duke would not meddle further in his affairs.[50]

By the end of 1612, though, the matter was settled; he was to remain in Milan indefinitely, as he explained to Matteo:

> God knows our needs and what is good for us much better than we ourselves, and very often certain opportunities that at first glance seem very positive turn out to the contrary, and that is why I want to believe that His Highness's not having wanted to alter yet my confinement might be good for me. . . . I am in a city [that is] almost the most populous metropolis of Italy, and through the grace of God I am cherished by several *cavalieri* of rank. Indeed, I would be quite content were it not that I find myself without His Highness's grace, but the

feeling toward me that he has demonstrated in this instance obliges me to pray to Our Savior more fervently that he should be granted long life, and I hope that in the fullness of time my devotion and faithfulness will become clear.[51]

One of the most striking aspects of this and the earlier letter is Oddi's protestation of loyalty to his lord, even though Francesco Maria's suspicious character and whimsical temperament were the cause of his hardships. Had these missives been addressed to a state official, we might reasonably suspect Oddi of insincerity, but the fact that the recipient was his brother, someone to whom he regularly confided his most intimate thoughts, suggests genuine affection for the man in whose hands his fate rested.

Understandably, such generous sentiments turned sour when it became apparent that the duke was not only obstinately unwilling to pardon Oddi, or even to hear his plea, but that as the years went by he grew ever more vindictive.[52] By the late 1620s Oddi had rescinded his wish that the duke should enjoy long life, concluding (correctly, as it turned out) that only Francesco Maria's death would enable a return to his *patria*: "The day before yesterday there was spread about the word that His Highness had gone to paradise, then it waned, and with it the plans I had made to go sometime to the *patria*, and see my friends again."[53]

Perhaps, as the letter to Linder printed in *De gli horologi solari* implies, Oddi's enemies in Urbino persisted in their efforts to discredit him, urging the duke not to show his subject clemency. Whatever the reason, Oddi lamented his lord's meanness of spirit and its effects:

> Concerning my repatriation, what more can I do? For not only does the Most Serene Duke not want me for a subject, but also shows the inclination that I should not even consider him my master, and that I have no right to those meager things which I have in that state [of Urbino], which count for nothing except in the abstract—"One should be satisfied if the ass and the wall are quits," says Boccaccio. It is madness to think of doing ill to those one knows to be innocent.[54]

The severity and longevity of the duke's ire can probably be attributed to the fact that he had shown Oddi special favor—raising him, as Oddi tells us, "in his own household" and making him ducal architect. Oddi's emotionally charged relationship with Francesco Maria was, indeed, almost filial, and his banishment as much personal as political, as implied by the somewhat peculiar quote from Boccaccio (which refers to a moral tale in the *Decameron* about the virtues of a moderate temper and not indulging a vindictive spirit). Oddi's comments show, too, just how wide-ranging an impact exile had on his life: the cost was professional, social, and financial, as well as emotional.[55]

Naturally, Oddi's attitude toward his exile was inconsistent. His letters depict

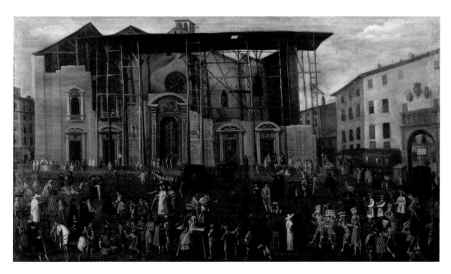

FIGURE 15. Lombard School, *The Piazza del Duomo, Milan, at Carnival Time*, mid-seventeenth century. Oil on panel. Veneranda Fabbrica del Duomo, Milan.

an individual chained to fortune's wheel, at times acquiescent, at times full of spleen. On occasion—as in the quote above and in the Petrarchan mottos to his books—he reflected on the vagaries of *fortuna* via Italian works of literature.[56] More frequently, however, he expressed his changing mood in relation to the cities in which he served his exile, apparently supporting Randolph Starn's claim that in Renaissance Italy "it was the city that usually defined the exile's loss and the *patria* to which he bent his efforts to return."[57] Yet although we find Oddi frequently lamenting his absence from the Duchy of Urbino and bemoaning the hardship of life in foreign cities, his first abode, Milan, at times proved an acceptable—even invigorating—substitute. In particular, the city was ripe for his particular blend of mathematics and material culture.

A number of factors combined to make early seventeenth-century Milan—then a vassal state of Spain—an attractive prospect for a disgraced mathematical practitioner hoping to rebuild what had been, before his imprisonment, a promising career.[58] As Oddi observed, Milan was "almost the most populous metropolis of Italy," a bustling, mercantile city with a thriving community of learned theologians, physicians, lawyers, artists and mathematicians, offering companionship, scholarly stimulation, and employment opportunities (fig. 15).[59] As a major trading center, the city played host to scores of merchants, both native and foreign, and its celebrated manufacturing industries presented ample entrepreneurial opportunities for someone with Oddi's artisanal background.[60]

Significantly, Milan was also home to many prominent aristocratic families, holding out the prospect of lucrative patronage, especially in relation to the martial arts.[61] The long conflict between Spain and the United Provinces had made

Lombardy a hive of military activity, full of soldiers, gunners, armorers, captains, high-ranking officers, and fortifications experts from across Europe.[62] Despite claims that the Twelve Years' Truce (1609–1621) "greatly diminished the need for expert officers" and prompted "growing indifference to technical matters . . . in the Spanish high command," such concerns, if Oddi's circle is anything to go by, were very much to the fore of aristocratic and artisanal life in the region.[63] Indeed, as we shall see, Oddi taught practical mathematics, instrumentalism, and military architecture to Milan's officer class and was employed as an engineer by the Spanish Crown.[64]

Spain's military ambitions were not, however, the sole driving force of professional and intellectual life in Milan. In the third quarter of the sixteenth century, Carlo Borromeo (1538–1584) had turned the city into a bastion of the Counter-Reformation Church, a position consolidated by his cousin and successor as archbishop, Cardinal Federico Borromeo (1564–1631).[65] Federico, who became one of Oddi's most important patrons, was an artistic and intellectual, as well as a spiritual, leader. The Ambrosiana complex he constructed in the first few decades of the seventeenth century—comprising a gallery, library, and art academy—was the cultural and scholarly hub of Milan, attracting artists and men of letters from across Europe. Oddi—who donated manuscripts and books to the Biblioteca Ambrosiana and taught perspective at the Accademia—was thoroughly enmeshed in this enterprise.[66] Indeed, Federico's interests and character played a major role in Oddi's experience of life in his "place of confinement." Although intellectually curious, the cardinal was scientifically cautious, as we shall see when we examine Oddi's instrumentalism and attitudes toward cosmology. He was thus naturally receptive to the Urbinate mathematician's conservatism. In fact, Borromeo's special interest in the sciences helped Oddi to form friendships with local scholars, such as the mathematician Bonaventura Cavalieri (one of the cardinal's clients), while through his employment at the Accademia Oddi became acquainted with artists, such as the painter Daniele Crespi, and connoisseurs, such as the cardinal's art agent, Ercole Bianchi.[67]

How, though, was Oddi—a disgraced exile—able to secure the support of such a major patron? The answer derives again from *patria*, and more specifically from Oddi's family connections. The mathematician was almost certainly introduced to Borromeo by Guidobaldo Vincenzi, the brother of his sister's husband. Vincenzi—an old man by the time Oddi arrived in Lombardy in 1610—was a powerful figure in Milanese society: confessor of Carlo Borromeo, president of the Collegio Borromeo in Pavia, and comptroller of the Fabbrica of Milan's Duomo. It must have been he who helped Oddi to find his feet in Milan, securing the mathematician a job teaching geometry to the Duomo's young stonecutters.[68] Vincenzi even gave Oddi the run of his house, and we may be sure that he

used his influence to gain his kinsman entry into the upper echelons of Milanese society—a reminder of just how closely linked were social networks, in particular those of the extended *famiglia*, to professional success in the period.[69]

In fact, so successful was Oddi's debut that he was able to write contentedly to one of Vincenzi's sons in 1612:

> I am first staying in the same house [Guidobaldo Vincenzi's], and if I should have a place to live, which has been promised to me free of charge [by the Scuole Piattine], perhaps I shall decide to stay here [in Milan] forever, in which case I shall not supplicate His Serene Highness to alter my confinement.[70]

For many reasons, then, despite his continual search for stable patronage through activities that have rightly been described as "intense but diffuse," exile in Milan proved bearable.[71] Indeed, over the course of this book we shall see that Milan afforded Oddi the opportunity to indulge his curiosity for all things mathematical and material, from teaching geometry to book production, instrumentalism to the art trade.

However, the situation in Lucca—the city in present-day Tuscany to which he moved in 1625, having replaced his ill brother as chief fortifications engineer—was very different. Like Milan, Lucca was a mercantile town, home to several wealthy, noble families, a handful of which employed Oddi as an architect.[72] Yet in comparison to the Lombard city, the fiercely independent republic seemed to the mathematician small and provincial. As he wrote to Piermatteo Giordani shortly after his arrival there:

> I have been in Lucca for just one month, greatly cherished by those gentleman that I serve, for whom I have already made a great bastion, two curtain walls, two half-bastions, and a counterscarp with a covered walkway. . . . The Governor of Milan has suddenly called me back, and those same gentlemen [of Lucca] begged him not to take me away, for it is a very difficult thing for them to free me while retaining their honor. . . . If I were to speak honestly, I feel deeply troubled at having abandoned Milan and the great friendship of so many people that I acquired over many years. . . . In Piacenza, the Maestro di Campo Rò presented me with an invitation to become the Duke of Parma's mathematician, but my desire is more for Milan than anywhere else—I value greatly the freedom of living in that city, and its magnificence. . . . In this city [Lucca] there are no curious books nor is there anyone who is a mathematician, so Your Lordship may think that solitude will be mine. Here one cannot get news that isn't stale; the gentlemen do not talk with foreigners [*forestieri*], out of concern for their discretion; the air is very hot, full of horseflies and mosquitoes; the wine bad because of last year's intemperate weather. The women are truly beautiful, but because my days are old and I am taken by great

illness, and because it is necessary for me to strap on the sword and the clothes of youth, I am writing with a new addition to my miseries.[73]

The contrast Oddi draws between Milan and Lucca could not be greater, and those elements he singles out as bothersome in the latter are particularly note-worthy. In Milan, news and ideas flowed thick and fast, and *amicizia* between individuals who differed in nationality, class, and profession was the norm.[74] In Lucca, not only was the weather dismal, but representatives of the council avoided discussion with "foreigners" to preserve the secrets of the republic's defenses, which Oddi was then overseeing.

Of course, we should not assume that the friendships Oddi forged with the counts and *cavalieri* of Milan were entirely free and disinterested—as Mario Biagioli and others have shown, late Renaissance *amicizia* carried with it a set of obligations and was governed by strict rules of etiquette and reciprocity.[75] Nevertheless, Oddi makes plain not only that such relationships had emotional value (he felt "deeply troubled" at leaving his friends behind), but also that the social structures of Milan were more relaxed, and hence more conducive to in-formation exchange, than those of Lucca.

Material as well as social factors also shaped Oddi's experience of exile in the two cities. Milan's vibrant trade in books and instruments provided him with ample resources for mathematical work. In contrast, the absence of "curious books," and the lack of mathematical companionship, rendered Lucca a sterile environment for the pursuit of science. There can be little doubt that one of the reasons Oddi produced so little mathematical work between his move to Lucca in 1625 (also the year in which he published his second treatise, *Dello squadro*) and his return to Urbino in 1636 was this paucity of resources for advanced scientific study (the instrument trade, too, was negligible). Again, we see clearly how place directly affected the practice of science. Cut off from the necessary books, artifacts, and individuals required to stimulate the mind and the hand, Oddi struggled to work as a mathematician.[76]

The demands of a full-time engineering post also took their toll. Oddi's dis-pleasure with Lucca was compounded by the fact that his exceptionally heavy workload as fortifications engineer—hinted at in the beginning of the above letter—prevented him from pursuing what he considered to be his true calling: mathematics. In Milan, despite having to scurry about for patronage, cobbling together a living from a mixture of jobs, he had at least worked consistently as a mathematician, enjoyed the company of like-minded friends, and had been afforded some leisure time for study. In Lucca, Oddi repeatedly lamented his solitude, being "truly occupied with this business of fortification [and] being in a city where not a single person knows the principles of mathematics."[77] Not only was he obliged to design new fortifications—which meant making models

as well as drawings—but he also had to meet regularly with the Offitio sopra le fortificatione (a subcommittee of the republic's Council) to explain and discuss his plans. Worst of all, he had to supervise work at the building sites.[78]

In a typically moaning letter to Piermatteo Giordani, Oddi complained:

> I, then, have not yet begun any studying and I doubt that the very coarse and vulgar matters of fortifications will allow me, at least not without considerable effort, to return to mathematics.[79]

Comments such as these should not, perhaps, be taken at face value. After all, Oddi was perfectly willing to accept the generous offers the republic made to secure and retain his services, even though the extension of his contract meant "dismantl[ing] all those castles in the air of returning to the *patria*."[80] Nevertheless, his professed attitude toward military architecture does reveal his willing acceptance of an unambiguous, and very traditional, intellectual hierarchy. On more than one occasion he referred to architectural and engineering work in disparaging terms, expressing revulsion at the vulgarity of building. When working at Loreto in 1605, for example, Oddi wrote in frustration:

> I cannot underestimate the resolution I have made in wanting to philosophize, and to lay aside the restlessness which pertains to this business of Architecture, which is better done by conceited men than by the learned.[81]

For Oddi, architecture was a poor substitute for "philosophy" (by which he means the intellectually noble labor of the pure mathematician) when it was the base work of arrogant men who presume to know much but are in fact just intellectually shallow.[82] It might seem strange that Oddi, a full-time architect in Urbino prior to his exile, should have expressed such sentiments, but we need here to appreciate the subtle but important difference in status between being a duke's personal *Architetto* and other, less prestigious types of employment. Oddi's disgrace forced him into a situation in which he was obliged to become a man for hire; his exile transformed him from a courtier into a servant, from a gentleman with ample *otio* in which to pursue mathematics into an overworked employee. Indeed, toward the end of his life he complained bitterly that the humdrum work of the engineer was inhibiting his attempts to prepare himself properly for death:

> I have no time to attend to bastions, but only to make designs for living in the other World, and reaching again my mooring after such a long voyage, and after such hardships and troubles, winning at least a month of freedom and whatever peace the world can give.[83]

There was, however, a redeeming aspect to Oddi's employment as Lucca's fortifications engineer. Aside from the sizable salary he commanded, the post helped

him to maintain a pleasing link to his *patria*, for a disproportionately high number of his predecessors—which included his own brother—had also hailed from Urbino.[84] Thus, even in Lucca, Oddi perpetuated a distinctly Urbinate practical-mathematical tradition. Indeed, through his highly successful tenure of the post he managed (ironically, given his comments about the profession of architecture) to recoup some of the credit lost in his fall from favor.

In fact, Oddi's case highlights the tension between the two traditions he embodied. From his mathematical master, Guidobaldo del Monte, he inherited a decidedly ambivalent attitude toward manual labor. As Mary Henninger-Voss has demonstrated, even though he worked in a discipline—mechanics—that mixed mathematics and materials, Guidobaldo's nobility led him to adopt, rhetorically at least, a decidedly hands-off approach to his subject that preserved its socio-intellectual integrity.[85] As the pupil of Barocci and Genga, however, Oddi was far closer than the marchese to the world of *fabrica*, of making and doing, and he appreciated, indeed revered, Urbino's long-standing position as a land of artisanal *ingegno*. Thus, Janus-like, Oddi looked in two directions at once, and although he combined mathematics and materials to produce knowledge, he never managed—unlike other celebrated figures of his era, such as Simon Stevin or Galileo—to combine them in novel ways to make *original kinds* of knowledge. The reason for this resides largely in *patria*, and more particularly in Oddi's exaggerated concern for the maintenance of traditions traceable through specific individuals: Urbino's *uomini illustri*.

UOMINI ILLUSTRI

The *uomini illustri* tradition, an important aspect of the humanist concept of history, was much in evidence in Renaissance Urbino.[86] The Urbinate historian Polydore Vergil's influential encyclopedia of the arts and sciences, *De inventoribus rerum* (1499)—a work Oddi read—had essentially been conceived as a genealogy of ingenious men.[87] About a decade earlier Raphael's father, Giovanni Santi, had inserted into his *Cronaca* (1482)—a verse eulogy of Urbino's most renowned duke, Federico da Montefeltro—a list of twenty-six famous painters of the modern age; indeed, Federico's *studiolo* in the Palazzo Ducale contained one of the period's most important "friezes of famous men."[88] Most importantly, though, toward the end of the sixteenth century Oddi's friend and fellow member of the Urbino school, Bernardino Baldi, wrote his *Vite de' matematici*, the first chronological history of mathematics, arranged as a sequence of biographies of *uomini illustri* from antiquity to the present.[89]

Oddi's particular interest in the "famous men" genre is attested to by the fact that he compiled his own list of *uomini famosi*, now regrettably lost.[90] Moreover, in the *gheribizzi* he created in prison, Oddi decorated the interior of his

imaginary Ducal Library with "portraits of famous scholars . . . and soldiers"—a clear reference to the Palazzo Ducale's *studiolo* frieze—and devised a new public loggia in the center of Urbino, "to be decorated with portraits of all of Urbino's famous citizens, inciting others to aspire to similar greatness."[91] Thus, even prior to his exile, Oddi was highly conscious of the need to live up to the legacy bequeathed by his illustrious forebears, and he believed that this could best be achieved through the emulation of exemplary individuals: a late Renaissance form of hero worship.[92]

The seepage of this hero worship into Oddi's attitude toward mathematics was almost certainly encouraged by his reading of Baldi's *Vite*. In response to a letter from Alberico Settala, in which the Milanese gentleman had asked Oddi for information about the mathematician Guglielmo Zelandino and his wondrous sphere, Oddi wrote:

> I say, then, that when I was young and read the books of Cardano, I came across Zelandino and was curious to know certain things about him and about his sphere. But I did not learn much about him, because I did not find him in the list of *uomini eccellenti* in Petrus Ramus's *scuole matematiche* [*Scholae mathematicae* (1569)], nor in the lives of the mathematicians written by the Abbott of Guastalla, Bernardino Baldi; it seems to me that the only thing said [about him] is certain things by Paul of Middelburg.[93]

Thus, Oddi was familiar not only with the best-known published chronology of mathematical luminaries—the list in Ramus's influential *Scholae*—but also with his countryman's far more compendious manuscript. Baldi wrote his *Vite* in several stages throughout the 1580s and 1590s, but it seems to have been substantially complete by 1592, as in that year both the author and Alessandro Giorgi—another Urbinate scholar—expected it to be printed in the near future.[94] It is thus probable that Oddi read the work at around the time he was studying with Guidobaldo del Monte, who had himself guided Baldi's studies in mathematics after the death of Commandino.[95]

Even if he did not own a copy of the manuscript (which we should not rule out), Oddi's interest in the *Vite* accords perfectly with his wider historical interests. In 1610, for instance, he discussed the writings of the Florentine chronicler Giovanni Villani with Piermatteo Giordani and mentioned that he had read historical works by Paolo Giovio and Francesco Guicciardini, as well as Vasari's *Vite*, which was almost certainly one of Baldi's models.[96] Oddi was also familiar with the work of Tacitus, Plutarch, and Machiavelli, and he was a keen student of Petrarch, whose *De viris illustribus* did much to establish the *uomini illustri* tradition in Italian history writing.[97]

When we combine these particular historical interests with Oddi's upbringing in Urbino and separation from his *patria*, it is not difficult to see how and

why he developed such an interest in famous men.[98] What is more, the Urbinate mathematicians on whom he modeled himself presented their work, as we have seen, within the context of a strong genealogy of scholars from antiquity to the present, casting themselves as the true instigators of a mathematical renaissance. For Oddi this renaissance was, notably, brought about not only by scholars but also by artisans. Following his return from exile in the mid-1630s, Oddi set about erecting monuments to the famous craftsmen of his home town, including a memorial tablet to the Barocci dynasty (commissioned by Ambrogio III Barocci but composed by Oddi) in the church of San Francesco. This tablet not only celebrated Oddi's former teacher, Federico Barocci, and his brother Simone, master of the Officina di strumenti matematici, but also pointedly compared the clockmaker Giovanni Maria Barocci—inventor of a remarkable astronomical clock—to one of history's greatest mathematician-technicians:

> To God the Greatest, the Best, Ambrogio Barocci caused this [monument] to be erected to Simone and Federico Barocci [both] distinguished for the greatness of their talents, pre-eminent for their handiwork, of whom the former shed luster upon the art by inventing and artistically designing new instruments for mathematics, the latter by the living colours of his painting put nature into the shadows—to his father, to his uncle, and to their cousin, Giovanni Maria, master designer of clocks who, rivalling Archimedes, artfully enclosed in a little case all the celestial movements for the convenient use of Pius V, the Supreme Pontiff, and of his successor.[99]

This type of concern for emulating the ancients, and especially for the legacy of Archimedes, is abundantly apparent in the scholarly writings of the Urbino school.[100] Bearing in mind the Urbino mathematicians' reverence for Archimedes, it is no accident that the last life of Baldi's *Cronica de' matematici* (an epitome of the *Vite*, probably completed in 1596) was that of Guidobaldo del Monte, the "new Archimedes." By concluding his chronology of illustrious mathematicians with Guidobaldo, his friend and mentor, Baldi cast himself as the son of a mathematical father figure who could trace his ancestry back, via Commandino, to the great scholars of antiquity. Strikingly, Oddi did something similar, but in visual form. Shortly after his return to Urbino in 1636, he hung newly framed portraits of none other than Commandino and Guidobaldo in his recently acquired townhouse, the Casa Santi, birthplace of Raphael (fig. 16).[101] Thus, Oddi presented himself as the true inheritor and perpetuator of Urbino's mathematical traditions.[102]

Even a short sketch of Oddi's life in mathematics serves to indicate just how closely he followed the precedents set by previous generations of Urbino's mathematical *illustri*. While at first glance his small-format, vernacular instrument tracts might seem a world apart from the weighty Latin editions of ancient math-

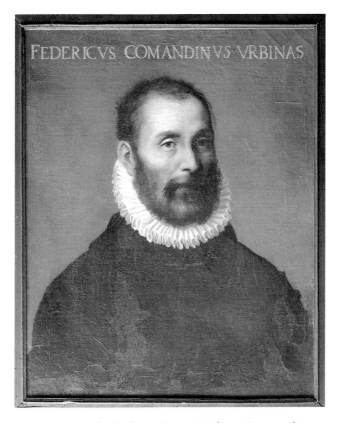

FIGURE 16. After Federico Barocci, *Federico Commandino*,
1570s? Oil on canvas. Museo Civico, Urbania.

ematical works produced by the likes of Commandino, he organized his material
according to the humanistic principles of his forebears—as though his books
were themselves classical geometrical texts, with demonstrations, *scholia*, and
commentaries. Oddi did not shy away from providing full, lengthy proofs but
rather delighted in taking a practical problem as a starting point for mathemati-
cal elaboration, eagerly referring his reader to supporting or complementary
material in the works of ancient mathematicians.[103] Furthermore, like his pre-
decessors, Oddi was deeply concerned with the genealogy of the disciplines he
treated—his second book on dialing, for instance, is prefaced by a lengthy ac-
count of the history of gnomonics from antiquity to his own time, providing his
work with an august pedigree and a humanistic sheen.[104]

Oddi's unpublished works, which have been almost entirely neglected by mod-
ern scholarship, conform even more closely to Urbino's mathematical manner.[105]
Among the confusion of working papers, half-finished treatises, lecture notes,
and letters that survive, we find Oddi grappling with all manner of problems in
classical geometry. His mathematical program was as much an engagement with

the *uomini illustri* of antiquity—especially Euclid and Archimedes—as with the modern incarnations of those figures, Commandino and Guidobaldo. To take just one example, at an unspecified date he undertook a thorough study of books 7 and 8 of Euclid's *Elements*, complete with theorems, *lemmata*, and corollaries redolent of Commandino's edition of that text.[106] Indeed, Oddi (who owned a substantial tranche of Commandino's papers) was exceptionally learned in Euclidean geometry, able to use his comprehensive knowledge of the *Elements* to solve all manner of mathematical problems.[107] Notably, he read Commandino's Euclid—which he used as a textbook in his mathematical teaching—as any good Urbinate mathematician would: with an eye to the highest standards of rigor and through the work of other ancient mathematicians.[108] His annotated copy of the Latin edition is replete with his own additional proofs and peppered with directions to complementary material in the works of Pappus and Apollonius, thus amplifying the rigor of the text.[109]

Oddi's character was in certain repects markedly similar to that of his mathematical grandfather. In his "Life of Commandino," Baldi notes that his master died from an excess of melancholy brought about by too much study. Oddi, according to the mathematician Bonaventura Cavalieri, was likewise a "person consumed by the study of mathematics, and very knowledgeable about theory as well as practice."[110] Yet although the fields of mathematics with which Oddi was most concerned were those Commandino had established as the mainstay of Urbinate studies—namely classical geometry and mensuration (which included the use of instruments and "practical" subjects such as gnomonics)—he was influenced equally by Commandino's pupil, Guidobaldo del Monte.[111]

For instance, like his tutor, Oddi was fascinated by machines of all kinds, not least because he had regular recourse to them in his architectural and engineering practice.[112] Indeed, in his work as a military engineer Oddi followed professionally in Guidobaldo's footsteps, for the marchese had served the Grand Duke of Tuscany as surveyor of fortifications and was considered an expert in architectural matters. Furthermore, although he left no systematic study of mechanics (the marchese's specialty), Oddi was clearly well read in the subject and may have taken part in mechanical experiments with Guidobaldo in the 1590s.[113] Certainly, his letters make frequent reference to Guidobaldo's *Coclea* and *Mechanicorum liber,* and he was fully aware of debates about equilibrium, to which Guidobaldo made important contributions.[114] Most significantly, though, Oddi inherited Guidobaldo's scientific conservatism, for he expressed thorough satisfaction with his master's Aristotelian-Archimedean synthesis.[115] An example of this conservative attitude may be found in a letter of 1634, in which Oddi lambasted the distinguished Jesuit mathematician Cristoph Clavius for having dared to impugn the work of Archimedes, Pappus, and Guidobaldo himself:

among all the many works that he [Clavius] has written, not a single state-
ment is his own. I esteem him highly as a man who has expressed several good
things and reduced them to a good order, and if this Father had not said to
me that the sixth book of Archimedes's *On Floating Bodies* does not end well,
and that in one of his own books he has contradicted that proof which Pap-
pus has given—in his eighth book—about weights and inclined planes (as has
been shown by so great a man as signor Guidobaldo [del Monte]), I would
undoubtedly consider his ingenuity to weigh far more.[116]

Such patriotic conservatism extended to areas of Oddi's science other than me-
chanics. Oddi was exceptionally skeptical about what he called the "artifices" of
Galileo and, although he obtained a license to read works on the Index of Pro-
hibited Books about terrestrial motion, he restricted himself to what he clearly
saw as the proper limit of mathematics—measuring the heavens with appropri-
ate, mathematical instruments, as opposed to natural philosophical speculation
founded on devices of uncertain epistemic status, such as the telescope.[117]

Unsurprisingly, then, the works Oddi chose to publish were on comparatively
uncontroversial topics: measuring instruments and their geometry.[118] Both were,
as we have seen, Urbinate specialties, and there can be little doubt that in treating
these subjects in print Oddi sought to bolster the *fama* of his *patria*.[119] In fact,
the instruments treated in two of Oddi's four books—the *squadro* (a device used
in surveying) and the *compasso polimetro* (otherwise known as the sector)—had
been perfected, if not necessarily invented, by mathematicians and practitioners
from his homeland, and each was especially applicable to the arts of war. More-
over, his other two treatises dealt with a topic that was a mainstay of the Urbino
mathematicians: gnomonics, which had been singled out by Vitruvius—one of
the Urbino school's great heroes—as a concern of architects.[120]

Like Commandino, Guidobaldo, and Baldi, Oddi treated instrumentalism in
an exceptionally rigorous manner. Although he was keenly alert to the uses to
which instruments could be put, and while he was esteemed highly as a techni-
cian, Oddi's treatises deal as much with complex geometry (especially in con-
ics) as with mathematical practice per se.[121] However, it should again be noted
that Oddi was also cognizant of his obligation to Urbino's artisans. Indeed, his
decision to produce *Fabrica et uso del compasso polimetro* was firmly rooted
in regional sentiment—he published the book, he explained, "in particular for
those masters of Urbino who manufacture mathematical instruments so excel-
lently, who have shown a desire to learn how to inscribe that instrument which I
have called *polimetro*."[122] Thus, Oddi's instrument books were printed *pro patria*
in two ways: to celebrate the mathematical talents of the Urbino school, and to
make their knowledge available to the master artisans who maintained their
legacy through the production of high quality instruments.

Pointed examples of the former aim, the enrichment of the Urbino school's renown, crop up repeatedly in Oddi's tracts. In his treatise on the *compasso*, for instance, Oddi delicately avoided a firm attribution of the device's invention to any one individual (its origins had been the subject of a bitter priority dispute between Galileo, Baldassare Capra, and others) but emphasized that Commandino, Guidobaldo, and the master artisan Simone Barocci were all key figures in the development and improvement of this marvelous multi-functional instrument.[123] Likewise, he inserted into his second book on sundials a lengthy discursus extolling the singular virtuosity of his master, Guidobaldo del Monte:

> Among many fine and admirable things which in regard to sundials have been found up to now, none is equal, I believe, to that of having them made in the bowl of a basin, with such skill that the shadow does not show the correct hour except when the bowl is filled with water. It is amazing to see how the water, by refracting the rays, diverts the shadow of the gnomon, straightening it to some degree, and making it show the true hour. Who was the inventor of such a curious thing I cannot say for sure, not knowing whether any of the ancients left a record of it. Of the moderns, I know well that in the year 1572 the illustrious signor Guidobaldo de Marchesi del Monte had one made by Simone Barocci, an excellent craftsman, in a half sphere of Brass, and I have had it in my hands many times. It then served as the model for one commissioned by Duke Francesco Maria II, which was built in the basin of the hanging gardens in his magnificent palace in Urbino, where it can still be seen today. And at about the same time Giovanni Battista Benedetti published his *Gnomonica*, in which he described this same dial in a special chapter; and one day, as I was speaking with father Christoph Clavius in Rome, he told me that Giovanni da Montereggio [Regiomontaus] had also made one, for a certain German prince. I still have in my possession some sheets with drawings by Commandino, who, as far as I have been able to conjecture, was seeking the reason for the difference in the angles of refraction, considering that the shadow cast by the gnomon does not withdraw in a uniform manner when the sun is near the horizon, as when it is high above the earth, although equal intervals have elapsed. Perhaps he intended to draw up tables to this effect, different from those of Alhazen and of Witelo. Neither Benedetti nor signor Guidobaldo made them [refracting dials], but only suggested how they should be made; but the manufacture of these things is, these days, reduced to a mere practice.[124]

This passage summarizes effectively a number of the key themes perceptible in Oddi's engagement with Urbino's *uomini illustri*. First, he was notably eager to celebrate the collaborative nature of the Urbinate mathematical enterprise: the "admirable" refracting dial (otherwise known as a "scaphe" dial) was devised by Guidobaldo, who understood the complex geometry required to make it function correctly, but manufactured by the artisan Barocci. Thus, Urbino could be

held aloft as a sparkling example of the
integration of intellectual attainment and
craft skill. Second, Oddi suggests that in
creating such a thing Urbino's *illustri* sur-
passed, or at the very least equaled, the
ancients, since he could find no record of
it in classical writings.[125]

We should observe, however, that
Urbino's reputation in the late Renaissance
did not rest solely upon the achievements
of the Urbino school of mathematicians
and the Officina di strumenti matematici.
Indeed, for Oddi the promotion of his
patria was not exclusively a mathemati-
cal enterprise, and his love of the duchy
was not predicated solely on the scientific
achievements of its offspring. We know,
for example, that a treasured possession

FIGURE 17. Cristoforo Caradosso
Foppa or Donato Bramante, portrait
medal of Donato Bramante (obverse),
1505. Copper alloy. National Gallery
of Art, Washington, DC. Samuel H.
Kress Collection. Inv. no.
1957.14.786.a.

was his portrait medal of Bramante (fig. 17), the internationally fêted, supremely
classicizing Urbinate architect, whose works Oddi greatly admired.[126] Likewise,
it was no accident that the house he purchased in 1636 was the birthplace of
Urbino's most famous son: Raphael. As we have seen, Oddi hung portraits of
his mathematical forefathers in this house, but these images were accompanied
by a portrait of the painter Barocci, Oddi's first and much celebrated master.
Evidently, Oddi assembled his own, select gallery of paintings and medals that

depicted *uomini illustri urbinati*, placing
himself visually within a robust, unam-
biguous genealogy in which mathematics
and the arts were inextricably linked.[127]

Throughout this book we shall see that
Oddi championed his countrymen—dead
and alive, mathematician and artist—
in all sorts of ways. He circulated draw-
ings by Raphael to his *cavalieri* patrons
and friends, renovated the great paint-
er's house, erected memorial tablets to
Urbino's artisans, distributed fine instru-
ments made in the Officina di strumenti
matematici, composed treatises to help
improve the skills of the Officina's work-
men, sold copies of Commandino's books

FIGURE 18. Medal struck in honor of
Mutio Oddi by the Republic of Lucca,
on completion of the Bastion San
Donato, 1627. Gilt bronze. Private
collection, Lucca.

to his pupils and donated the scholar's manuscripts to libraries, and maintained the Urbinate traditions of mathematical and artisanal excellence simply by working as an outstanding practitioner—in both mathematics and architecture. Indeed, while Oddi's fame might not have equaled Guidobaldo's or Bramante's, he was sufficiently successful in military engineering, that notable Urbinate specialty, for the Republic of Lucca to strike a medal in his honor (fig. 18). Oddi, evidently thrilled at the luster this cast upon him and his *patria* (not to mention the sum of 220 *scudi* that came with it), wrote excitedly of his achievement to Camillo Giordani, "I know that this will please Your Lordship, signor Piermatteo [Giordani], and other friends and patrons."[128]

To some extent, Oddi's efforts to perpetuate the memory of his homeland's great men, and through them to promote Urbino as a font of ingenuity, may have been motivated by a nagging sense that the duchy's glory was fading.[129] His final act was an attempt to ensure—despite the devolution of his *patria* to the Papal States—that the intellectual and artistic traditions that had continued unbroken in the duchy for two hundred years would persist. In his will, he left his collection of books, instruments, and drawings to the city of his birth, hoping that an informal academy might be founded to create a new generation of outstanding mathematical practitioners.[130]

Yet even if the backdrop to his fascination with *uomini illustri* was Urbino's slow slide into obscurity and provincialism, this was one of the few ways in which he was able to maintain a grip on his own identity. Despite the trauma he had suffered at the hands of its ruler, Urbino remained for Oddi an ideal land. Though physically separated from the duchy as an exile, the mathematician was able to inhabit his *patria* vicariously through its famous men and their works. Indeed, by virtue of his having been banished, Oddi was able to export Urbinate mathematics and its material culture abroad. Even though his plans for an academy failed, Oddi kept Urbino's mathematical style alive through the objects he created and traded, the friendships he formed, the books he wrote, and especially—as part II shows—through his teaching. As an educator, Oddi passed on (as Commandino had to Guidobaldo, and Guidobaldo to him) the rigorous yet practical, classical but tangible mathematics of Urbino: a mathematics of place.

Teaching Mathematics

Of the various ways in which mathematical knowledge was disseminated and shared in the late Renaissance, teaching was one of the most important and ubiquitous (fig. 19).[1] Mathematical instruction, including direction in the use of instruments, took several forms: it could be formal and institutionalized (as was generally the case in university education) or informal and bespoke (such as the teaching that took place in courts and within families), or it might come in the shape of an apprenticeship in a workshop.[2] These varied types of teaching helped to spread different kinds of mathematics to an ever wider and more diverse public than before; indeed, the late sixteenth and early seventeenth centuries witnessed a major expansion of mathematical education, creating a bedrock of mathematical knowledge across the social spectrum, from nobles to artisans, soldiers to merchants, upon which the edifice of a mathematized understanding of nature could be constructed.[3]

Yet the importance of mathematical education consisted not only in the transmission of knowledge. Teaching, particularly of the informal variety, played a key role in the formation of networks and communities bound together by a shared interest in mathematics. These networks, which overlapped with those in which mathematical goods were consumed, acted as a conduit for the patronage of mathematics and mathematicians, framed the development of practitioners' social and professional identities, and created opportunities for the exchange of nonmathematical knowledge, objects, and services. In short, teaching served to establish relationships—some of which developed into fully fledged friendships—of a special kind: the intimacy of instruction and explanation helped to forge a bond between master and pupil that endured beyond the classroom. For middle-ranking figures such as Oddi, teaching was a means of gaining access to elite society, of establishing reputation (for intelligence, reliability, virtuosity, and so on), and of trading on the credit established through successful instruction to garner more rewarding forms of patronage. But teaching also, as the diversity of his student body shows, enabled Oddi to enter alternative communities eager for mathematical instruction, or obliged by their patrons to study mathematics—those of artists and merchants, for example. Thus, teaching emerges as a vehicle

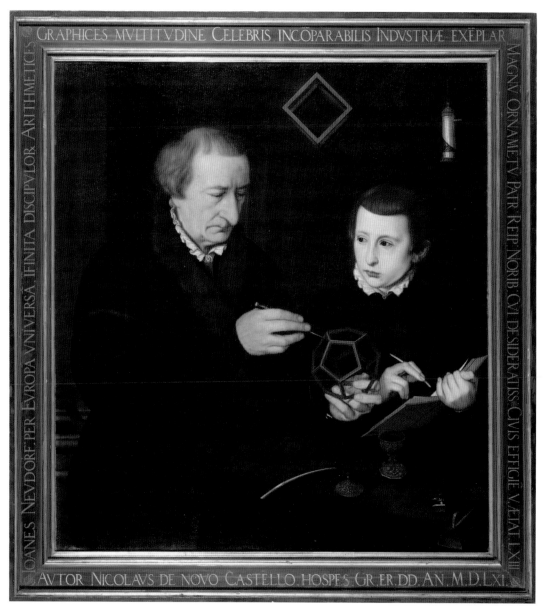

FIGURE 19. Nicolas Neufchâtel, *Portrait of Johann Neudörfer and a Pupil*, 1561.
Oil on panel. Munich, Bayerisches Staatsgemäldesammlungen, on loan
to the Germanisches Nationalmuseum, Nuremberg.
Photo: Germanisches Nationalmuseum.

that carried the mathematician across social and professional boundaries, reaping diverse rewards as he traveled.

A great deal of valuable work has been undertaken on the more formal aspects of mathematics teaching in the Renaissance, but surprisingly little attention has been directed to the kind of ad hoc teaching of practical mathematics with which Oddi was predominantly concerned. Thomas Settle has observed, in an important article on mathematical education in Renaissance Florence:

> Naval engineers, map makers, instrument designers and navigators . . . architects and engineers . . . must have learned and honed their mathematical skills somewhere. We have yet to find out in any detail where and under what circumstances.[4]

That this should be the case for the tradition of tacit knowledge-exchange in the workshop is unsurprising. The embedded nature of practical mathematics teaching within the *botteghe* renders the recovery of the methods employed and the knowledge transmitted difficult at best.[5] In the case of more explicit types of instruction, scholars have likewise been hampered by a lack of surviving archival evidence—a gap that Oddi's papers help to fill. Yet numerous early modern printed treatises on bombardeering, fortification, surveying, and the like allude to a flourishing culture of informal education in practical mathematics, usually expressed as a dialogue between the author and either an individual patron or a group of high-ranking military men. Instances of these exchanges are to be found in (among others) Niccolò Tartaglia's famous *Quesiti et inventioni* (1554), Iacomo Lanteri's *Due dialoghi* (1557), and Luigi (Luis) Collado's popular *Practica manuale di arteglieria* (1586), the last of which includes a dialogue between a master gunner and his aristocratic "pupil" set in the nobleman's garden in Milan, Oddi's first place of exile.[6] The authors of these texts were keen to present themselves as socially equal to their interlocutors, even if they were not (as was certainly the case with Tartaglia, whose dialogue is with none other than Francesco Maria I della Rovere, Duke of Urbino). Nonetheless, such works indicate that this kind of education formed an important bridge between middle-ranking, hands-on practitioners and their noble patrons and, significantly, that military concerns were a major motivating factor in fostering this sort of shared knowledge.[7]

To date, our understanding of the ways in which practical-mathematical knowledge was transmitted in the period has relied largely on printed books such as these. In addition to treatises on the military arts, instrument books, arithmetic manuals, architectural tracts, and books of machines all provide glimpses into this educational world. (While some of these works could be used in an autodidactic fashion, their efficacy when read by a novice without additional instruction from a suitably qualified teacher would be dubious.) Indeed, printed treatises constitute an extremely valuable guide, especially in terms of teaching

content, but they must be treated with caution. Most, if not all, were written in a highly rhetorical manner, recounting exchanges that are frequently polemical, having been carefully manipulated to suit the purposes of the author.[8] As such, printed dialogues constitute a skewed, imperfect record of late Renaissance education in practical mathematics; to achieve a rounded, accurate image of this culture we require additional, archival evidence. Similarly, the statutes of institutions that catered to the mathematical needs of practitioners (the Florentine Accademia del Disegno, for example) offer a useful overview of curricula, but since much instruction in practical mathematics seems to have been undertaken outside institutional settings (so beyond the scope of most formal records), and according to private agreements between tutor and tutee, any reconstruction of this type of education must be based also on personal papers. Such documents survive only infrequently, and even then rarely contain the relevant evidence.[9]

In this light, the records of mathematics tuition that Oddi maintained between 1612 and 1624 (i.e., roughly the duration of his Milanese period) are particularly valuable. They allow us to map, in detail, private, informal practical-mathematical education in a major Italian center of scholarship, commerce and craft over a sustained period.[10] These records can be used to address a set of questions concerning how certain types of mathematical knowledge were transmitted and shared in the period: What kind of individual taught practical mathematics? Why did they teach it? Whom did they teach, and to what end? Where did they teach? What did they teach, and how? What rewards did they receive for their services? How similar or disparate were the programs offered by different mathematics tutors? And, perhaps most importantly, what can this type of tuition tell us about the cultural world in which mathematics was disseminated, and about how mathematical communities were formed and functioned in the period?

An account of Oddi's teaching demonstrates the vibrancy and variety of this largely overlooked educational culture, its importance for the patronage dynamics of mathematical practitioners, and, crucially, the extent to which informal tuition installed a common mathematical knowledge base across the social and professional spectrum. Informal instruction was not, however, the only route through which one could acquire practical-mathematical knowledge in the sixteenth and seventeenth centuries, and thus Oddi's teaching much be considered in the light of more formal types of mathematical learning within schools, universities, Jesuit colleges, and academies.[11] The level and type of mathematics teaching offered varied significantly according to an institution's geographical location, statutes, and supposed function. In the reformed universities of Germany, for instance, Melanchton's promotion of the quadrivium prompted a new dedication to mathematics teaching, while in English universities the situation was apparently less felicitous.[12] Moreover, there was often a degree of overlap—in

terms both of content and of individual teachers—between the "formal" teaching that took place in institutions and the "informal" education in practical mathematics that transpired beyond their confines. Galileo is a case in point: he delivered lectures in geometry and arithmetic as Professor of Mathematics at the University of Padua but at the same time offered private tuition in practical mathematics and instrumentalism to students enrolled at that institution.[13] Similarly, Oddi held the Chair of Mathematics at the Scuole Piattine in Milan while also, throughout his tenure, instructing a large number of private pupils in a wide range of mathematical subjects.[14]

One of the most pragmatic options for mathematical education in the Renaissance, favored by the business and, to a lesser extent, artisan communities, was the abacus school. Abacus schools, which flourished in Italy (particularly Florence) and other parts of Europe from the late Middles Ages, were closely associated with the world of commerce and taught a form of arithmetic suited to the needs of merchants and bankers.[15] In these schools (which were also, tellingly, sometimes called *botteghe*), *maestri d'abbaco* gave lessons, in the vernacular, that focused on calculation and reckoning, often up to an advanced level.[16] Lessons were based on and taught through *libri d'abbaco* that were, in essence, collections of mathematical problems that might be encountered in everyday trading, such as the division and multiplication of cash amounts.[17] Especially in their earlier incarnations, some abacus schools also taught practical geometry and other arts related to the quadrivium.[18] Antonio de' Mazzinghi, for example, who taught at the famous Florentine school of Santa Trinità in the fourteenth century, was renowned as an expert "in building and in perspective," while Luca Pacioli (see fig. 10)—active in a number of abacus schools (and at the court of Urbino) at the turn of the fifteenth century—taught and published on a wide range of practical geometrical subjects applicable to the arts of war, as well as to painting, sculpture, and architecture.[19] Indeed, as Filippo Camerota has argued, up to at least the beginning of the sixteenth century abacus schools were central to the transmission of practical geometrical knowledge (including aspects of Euclid's *Elements*, in particular book 6), and there can be little doubt that the proliferation of these schools significantly increased the mathematical competence of certain sections of Italian society. In short, they played an important role in widening participation in mathematics.[20]

However, the development of alternatives to the abacus schools in the second half of the sixteenth century —notably the increasing prominence of private mathematics tuition and the founding of military/artisanal academies—suggests that by this time such schools were not deemed wholly sufficient or appropriate for the education of individuals such as courtiers, engineers, artists, and architects, who increasingly required knowledge of geometry and instrumentalism. The reasons for the decline in abacus schools' status and significance are varied

and complex. It stemmed partly from the growing perception that such schools were socially inferior, by virtue of their close association with business and trade, and partly from (not unrelated) changes to the intellectual landscape of sixteenth-century Italy. A major aspect of the latter was the so-called renaissance of mathematics, which, promulgated especially by the Urbino school, called for a more rigorous approach to the discipline, founded on the keen study of ancient texts as opposed to "mere" practice and rules of thumb.[21] Of considerable importance also was the context of warfare and the military arts, for, as Mario Biagioli has argued, even though points of contact existed between the mathematics employed by the *milites* and by the bookkeepers, a distinction in social status obtained between courtly "military" mathematics and the business knowledge of the merchants. This led actual or aspirant *bellatores* to define themselves increasingly in opposition to the abacus tradition, an opposition both informed and echoed by the increasingly sophisticated understanding and presentation of geometry exemplified by Commandino and his followers, which made—in some cases on purpose—the modest practical geometry of the abacus tradition seem intellectually weak, inelegant, and outdated.

Oddi, unsurprisingly given his Urbinate background, certainly held the abacus schools in low esteem. Shortly after his arrival in Lucca as fortifications engineer, he became embroiled in a dispute with a *maestro d'abbaco*, who had impugned his honor by claiming that his recently published treatise on surveying, *Dello squadro*, was full of errors. The impertinence of the claim was made even worse, Oddi explained, as his accuser, who "keeps an abacus school . . . does not even understand the definitions of the First Book of Euclid, nor anything else."[22] This is a succinct illustration of why the abacus schools declined. Although Oddi and the abacus master were concerned with the same subject matter (in this case surveying), their approaches to it were radically different: Oddi drew on and, in his treatises, boldly displayed his erudite comprehension of classical mathematics, upon which, he claimed, his practice rested.[23] This provided him with a form on intellectual authority that could be transmuted into social currency: he could convince his readers and his pupils that the kind of mathematics he purveyed might be useful and practical but was also founded on sound principles and, crucially, of august pedigree. Thus, figures of Oddi's ilk gradually became the educators of choice not only for artisans wishing to improve their practice through knowledge of correct mathematical demonstration but also for elite families wishing to distance themselves from the world of commerce and intellectual fallibility represented by the abacus schools.

Because the bulk of Oddi's pupils came from socially elevated families—what J. R. Hale called the "officer class" of early modern Europe—it is worth considering the contours of the elite's mathematical education in the Renaissance.[24] Elite families chose to have their sons educated at humanist schools, universities, Je-

suit colleges, or academies, at court, or at home with personal tutors (and some-times combined several of these options). Because the humanist schools offered little in the way of mathematics education, being concerned largely with the liter-ary arts, instruction by a tutor at court seems to have been a relatively common way for the socially elite to acquire mathematical knowledge and skills.[25] Urbino is a good example: at the turn of the fifteenth century Luca Pacioli was engaged as mathematics tutor to the future Duke Guidobaldo da Montefeltro, and half a century later Commandino taught mathematics to the then duke, Francesco Maria II della Rovere, who studied alongside the noble Guidobaldo del Monte.[26] Likewise, Oddi's education in mathematics took place within a courtly milieu. Having been (as he tells us) "brought up in the household" of Duke Francesco Maria, he was personally tutored in mathematics by Guidobaldo. Because the court was often the focus of enterprises that demanded practical mathemati-cal skills (large-scale building projects, for instance), we find in certain courts a pronounced—albeit intermittent—effort to institute the teaching of practical mathematics to princes and their entourage, but also, in particular, to the young *paggi* (pages) who were likely to enter the military professions and commission works of art and architecture when they came of age.[27] Although no systematic study of mathematics education at court has been undertaken to date, there is sufficient scattered evidence—in court rolls, the dedications of treatises, and so on—to suggest that this type of educational culture was flourishing at the turn of the sixteenth century, although of course the scope and level of mathematics instruction that was organized depended upon both a given prince's own intel-lectual inclinations and local traditions.[28]

The court offers a further indication of the sometimes blurred boundaries between formal and informal mathematics education. Court mathematicians were often paid a regular stipend, much like their university counterparts, but the type of instruction they offered was not subject to a specific curriculum, nor was their teaching regulated by statutes. As such, in terms of structure, this kind of teaching should probably be considered as more closely related to informal, private mathematical education (such as that offered by Galileo and Oddi) than to university lecturing or abacus school lessons. Indeed, the individuals em-ployed as educators at court often undertook teaching as part of a wider suite of skills useful or appealing to the prince—such as the design and manufacture of instruments—and many combined mathematics instruction with architectural and engineering practice. In some cases, it seems that polymathic practitioners used mathematics teaching as a step toward more prestigious and lucrative pa-tronage opportunities, targeting lesser patrons (the sons of princes) in order to attract the attention and approbation of a major patron (the prince himself).[29] As we shall see, this is a tactic that Oddi employed successfully in his own teaching. While Milan, as a vassal state of Spain, did not have a fixed court during Oddi's

residence there, his mathematics teaching shared certain similarities with courtly education: in addition to instructing the sons of noblemen he taught at least one page: Amadeo Vernardo Delascamo, page of the Duke of Feria—Don Gomez Suarez de Figueroa y Córdoba, then Governor of Milan.[30]

Education at court was, however, limited to the highest echelons of society and, as I have suggested, mathematics instruction there was by no means ubiquitous. A far more common way to acquire a rudimentary knowledge in mathematics in the late Renaissance, and one that was open to both middle- and high-ranking individuals, was the university. While most European higher-educational establishments had traditionally offered limited instruction in mathematics, in Italy the situation was comparatively commodious: from the middle of the sixteenth century on, both the universities and the Jesuit colleges were reasonably committed to mathematics teaching; indeed, by around 1600 the traditional division of university chairs into "astrology," "astronomy," and "mathematics" had been replaced by a single, composite chair (simply titled "mathematics"). The shift reflected the growing stature, breadth, and applicability of mathematics and suggested, perhaps, an increased sense of cohesion among its constituent parts.[31]

The core texts used in university teaching, which remained largely unchanged from the early to the late Renaissance, were Euclid's *Elements*, Sacrobosco's *Sphere*, Ptolemy's *Almagest*, and the *Alphonsine Tables*. Occasionally, these largely theoretical works were supplemented by more practical texts—for example, works by authors such as Oronce Fine and Georg Puerbach—but by and large the teaching was speculative even if the knowledge conveyed was intended for professional use. This was certainly the case with the astrological component of teaching, which was regarded as applicable to medicine.[32] A few centers of learning offered instruction in applied mathematics and instrumentalism, and although the degree of overlap should not be overemphasized, it is becoming increasingly clear that a continuum existed between the teaching that took place in the lecture hall, the classroom, and the workshop, and on the battlefield. Biagioli has argued persuasively that the advent of the cannon and the resulting new system of fortifications, based on the angled bastion, played a significant role in prompting not only an increased demand for engineering expertise but also a major shift in mathematics teaching at Italian universities. He points, for example, to new chairs of mathematics, such as the ordinary chair "ad praxim mathematicae" established at Bologna in 1557 and held by a succession of mathematicians with applied interests (Egnazio Danti, Pietro Cataldi, and Oddi's friend Giovanni Antonio Magini), which catered to the geometrical and instrumental needs of students destined for military careers.[33]

Other important factors in the changing landscape of mathematics education included the major engineering projects orchestrated by increasingly centralized

FIGURE 20. Francisco Villamoena, *Christoph Clavius*, 1606.
Copperplate engraving. Metropolitan Museum of Art,
New York. Photo: © Metropolitan Museum
of Art/Art Resource, NY.

states, ambitious architectural schemes, and the growth in overseas trade, all
of which required of their overseers a higher degree of practical mathematical
knowledge (in mechanics, navigation, and cartography, for example) than had
previously been the case.[34] Indeed, Galileo's lectures at the University of Padua
included fortification and mechanics.[35] Of particular significance, however, was
the impetus provided by the Jesuits, in particular Christoph Clavius's educational
reforms at the Collegio Romano in the 1580s and 1590s. Even before Clavius's
intervention there existed at the Roman College an Academy of Mathematics
where, during the 1550s, one could learn "perspective for four [months] . . . prac-
tical arithmetic for one and a half months, the sphere in two and a half months
. . . the astrolabe for two months . . . dialing and ecclesiastical calculation for the

FIGURE 21. Johannes Troschel, *Mutio Oddi*, 1625. Copperplate engraving.
National Library of Scotland, Edinburgh. Shelfmark Fin.85.
© Trustees of the National Library of Scotland.

time that remains."[36] The notably practical bent of these studies was massively enhanced by Clavius, who argued forcefully and persistently for the absolute necessity of rigorous mathematics for the proper study of natural philosophy and, significantly, sought to entrench the position of mathematics within the *Cursus* through an appeal to utility, including the multiple uses to which instruments could be put.[37] Clavius himself published widely read works on practical geometry and arithmetic, dialing, and the astrolabe. In the famous portrait by Villamoena he is depicted, compass in hand, surrounded by instruments as well as books, much as Oddi (who knew him personally) would be portrayed two decades later (figs. 20 and 21).[38]

From his appointment as director of studies in mathematics at the Collegio in 1563 onward, Clavius tried to persuade his superiors to establish a distinct, two- or three-year course in mathematics for the most promising students, but the Academy of Mathematics remained informal until 1594, by which point his standing and influence had grown sufficiently that he was able to implement significant reform. Thereafter, the Academy, which attracted foreigners and non-Jesuits, functioned as a locus for high-level mathematics teaching across a very wide range of subjects, and as a forum for the exchange of information and objects associated with the mathematical arts. Among the more practical subjects studied, alongside Euclid and Archimedes, were "elementary arithmetic and its applications . . . theory of measuring instruments . . . theory and use of the astrolabe . . . gnomonics [and] practical geometry."[39]

The motivations of the Jesuits' strategy for promoting practical mathematics teaching were varied but included the order's need for technical specialists and the everyday challenges faced in missionary work.[40] One notable aim was the need to appeal to socially elite students, the sons of Italian nobles, who flocked to the Jesuit schools in large numbers and who would use practical mathematics in their future careers as officers, administrative officials, and patrons. In this regard, the relation of Jesuit teaching to the type of mathematics teaching offered by men such as Oddi and Galileo is especially strong. In fact, Oddi's personal acquaintance with Clavius and his documented visits to Rome in the 1590s suggest that the structure and curriculum of the Academy of Mathematics may well have informed his own teaching in Milan.[41] But while the general institutional context outlined above is an important background against which to set Oddi's mathematics teaching, the specific context of Milan must also be taken into account, for mathematics teaching in this city was firmly established (and practical mathematics more so than in many other Italian locales) by the end of the sixteenth century. It is to this context, and to the details of Oddi's teaching, that we shall now turn.

Public Lectures and Private Pupils: Mathematics Teaching in Milan

Although Milan did not boast a university, mathematical education was available there through the offices of the Scuole Piattine. The Scuole were part of a charitable foundation established by the bequest of the Milanese humanist Tommaso Piatti, who left his estate to the Ospedale Maggiore upon his death in 1499, providing funds for lectureships in Greek and dialectic and a composite chair in arithmetic, geometry, and astronomy (held by Oddi from 1613 to 1624).[1] Thus, from the very beginning of the sixteenth century, public lectures in mathematics—comparable to those later established in many of the Free Imperial Cities in the German territories, in Paris, and (toward the end of the century) in London—were available in Milan.[2] The content of the Scuole's mathematics lectures was roughly equivalent to those of the universities, but education in practical mathematics was available from two further sources by the time Oddi arrived in Milan: the Collegio degli Ingegneri e Architetti (founded in 1563) and the architect-engineer Bernardo Richino's Pubblica Accademia del Ricchino Ingegnero.

The Collegio (called initially the Università degli Architetti e Agrimensori) was established in part in response to the dominance and superior skill of foreign architects and engineers, who were drawn to Lombardy in large numbers in the first half of the sixteenth century by the intensive fortifications projects initiated by the Holy Roman Empire in the 1530s.[3] Early statutes granted the Collegio the right to examine candidates in relevant fields and to grant licenses to those who passed to practice as architects, engineers, or surveyors within the Duchy of Milan. The examinations demanded a mixture of local and universal knowledge: those wishing to work as architects or engineers, for instance, were obliged to answer questions pertaining to Milanese regulations on waterways, roads, and the like, as well as demonstrating proficiency in mathematics and geometry—all subjects that could be studied through training with a member of the college. The statutes explicitly forbade foreigners from practicing the professions for which the Collegio was responsible, although the Milanese Senate could (and did) bypass this prohibition by granting extraordinary licenses to foreign masters, such as Oddi.[4] In effect, the Collegio was more a guild than a teaching

institution. Membership required proof of having worked for four years under a current fellow of the Collegio and payment of a membership fee (reduced, as in most guilds, for the progeny of fellows).

The academy founded by Bernardo Richino around the turn of the sixteenth century was a far more novel institution. Academies for the education of noblemen emerged across Europe in the second half of the sixteenth century in response to the new demands of social and military life.[5] Social factors revolved around the need for aristocrats to exhibit graceful behavior at court (derived largely from early sixteenth-century Italian models, such as Castiglione's *Libro del cortegiano*); military factors included the challenges presented by the new type of siege warfare—namely cannonry and the angled bastion—and a desire to shore up the waning bellicosity of the officer class, a cause of considerable concern in sixteenth-century Italian elite circles.[6] The curricula taught at academies varied from institution to institution, but the majority focused on a combination of the military arts (including fortification, fencing, and horsemanship), physical exercises designed to instill *sprezzatura* in the pupil, and a smattering of book learning.[7] It seems likely that Richino, whose biography is somewhat obscure, established his academy in opposition to Milan's Collegio, for he failed his first attempt at that institution's examination, having answered incorrectly questions on surveying. Ironically, by 1610, when he failed for a second time, his academy was flourishing.[8]

An idea of the subjects taught at the academy may be gleaned from a letter written by Richino to the King of Spain, in which he offered to serve His Majesty by providing teaching, "both theoretical and practical," in

> letter writing, arithmetic of all kinds, single- and double-entry bookkeeping, practical geometry, civil and military architecture, engineering, surveying, various ways of measuring the earth, leveling and measuring water, forming pitched battles in every proportion, setting up and moving out armies, taking distances, heights, and depths, setting countries on paper proportionally and otherwise, the practice of artillery, and the profession of the bombardiers.[9]

Richino's Accademia, then, probably operated as something between an abacus school, a military academy, and an architectural college.[10] Certainly, the subjects listed in his letter are consistent with the topics treated in his extant papers, which include a *Trattato di Finezze, Legature, & Saggio de Metalli, Oro & Argento* (1604), the undated *Pratiche, per Ingegneri*, and *Pratica di Geometria con l'operatione di compasso* (1602).[11] The *Trattato di Finezze* deals mainly with the composition and weighing of metals, while the *Pratiche, per Ingegneri* is a compendium of tasks that Richino estimated an engineer might reasonably be called upon to perform in his day-to-day work, such as the organization of public roads, the maintenance of fountains, and other varied projects related to surveying and hydraulics.[12] *Practica di Geometria*, although apparently unfinished, is particularly interesting,

as it was clearly prepared as a workbook for one of the academy's pupils. Written in a mixture of Italian and Spanish (suggesting that the pupil for which it was made was one of Milan's Spanish overlords), it comprises a series of elementary geometrical problems, which increase in difficulty as the manuscript progresses, selected from books 1 to 6 of Euclid's *Elements*. Richino presents the problems to the student at the beginning of the manuscript, providing blank space below his text for the pupil to construct the relevant diagrams with ruler and compass, but provides also, at the back of the manuscript, illustrated demonstrations (i.e., answers) to the problems set. That these geometrical problems were intended for practical application is made clear by the inclusion of a short section, at the very end of the manuscript, on surveying using the astrolabe, with particular reference to fortifications—an indication that Richino's pupils were motivated by the same sort of military concerns as were many of Oddi's, and that they required instruction in the use of instruments as well as geometrical principles.

Some thirty-five pupils are recorded as having studied at Richino's academy, which was located "above the street at Porta Romana" in the parish of San Nazaro. Many of them were drawn from the Milanese and Spanish nobility: pupils included members of the Archinto, Mandelli, and Gonzaga families.[13] In this respect, too, Richino's patrons were comparable to Oddi's; indeed, it is notable that the latter's teaching of the mathematical arts began at about the time that Richino apparently ceased to be active. Oddi, who started taking on private pupils around 1611, must initially have been the Milanese practitioner's competitor, but Richino's death, circa 1613, provided him with a significant patronage opportunity: Oddi was able to fill the gap left by the closure of the Accademia and offer training in precisely the kinds of knowledge and practice sought by members of the officer class.[14]

PROFESSOR ODDI

Before we consider Oddi's informal teaching, it is important to note that a few years into his exile he was appointed to one of Milan's most prestigious teaching posts: the Chair of Mathematics at the Scuole Piattine. By the time of his appointment—on 13 May 1613—the Scuole had been delivering mathematical instruction for more than a century.[15] Previous holders of the post included such luminaries as Girolamo Cardano, so it is not surprising that Oddi proudly had himself depicted in professorial guise, surrounded by mathematical books and instruments, in an engraved portrait cut to accompany his treatise on surveying (fig. 21).[16] However, although Oddi seems to have been quite content with his annual stipend of 50 *scudi* and free housing, it was notably meager next to the 1,000 *scudi* per annum stipend that Galileo received as Natural Philosopher to the Grand Duke of Tuscany upon his appointment in 1610.[17] While Galileo's

stipend was exceptional (as a result of the remarkable "gift" of the Medicean Stars that won him the position), the stark discrepancy between the two sums indicates the still massive gap in status between a mathematician and a philosopher in the early seventeenth century, and between positions in educational establishments and at court. Indeed, this difference explains why Oddi, although initially delighted to have obtained his chair, moved swiftly to take up the higher-status—and certainly better paid—position of Chief Fortifications Engineer to the Republic of Lucca when it became available in 1625, despite his apparent abhorrence of this type of "vulgar" work.[18]

Oddi's papers reveal very little about how he managed to capture the chair, but we may be sure that the influence wielded by his high-ranking private pupils in mathematics—on whom more below—played a part. We do know he was obliged to lecture twice per week, and it is possible that some of his surviving mathematical papers were lecture notes: his writings on books 7 and 8 of Euclid's *Elements* and a summary of book 7 of Tartaglia's *Aritmetica*, for instance, are certainly consistent with the type of material taught at this level.[19] Another document sheds some light on what the election process might have been. Inserted into his correspondence is a single manuscript leaf, written in Latin, announcing the appointment of Oddi's successor to the Piattine professorship upon his resignation.[20] The appointee was one of Oddi's close friends, the architect-engineer Giuseppe Barca, who was one of two candidates for the post, the other being one Iacopo Terzago.[21] Both candidates were examined in the subjects the chair comprised (geometry, arithmetic, and astronomy) by a pair of Jesuit fathers—Donato Frisiano and Guglielmo Galavero, described as "very discerning men and very expert in the said sciences"—in the presence of the appointment committee, made up of the Very Reverend Aloigi Bossio and the Milanese noble Marchese Giovanni Maria Visconti, the latter, notably, one of Oddi's tutees.[22] Although the document states that Barca was appointed due to his superior knowledge of the relevant subjects, it must surely be the case that his association with Oddi, and, by proxy, the patrician Visconti, helped him to secure the post. Evidently, by the time Oddi left Milan his teaching had helped him to form an effective network of patrons and clients: the "great friendships" he was so loathe to leave behind when moving to Lucca.[23]

In addition to lecturing at the Scuole, which played a major part in his decision to remain in Milan, from March 1613 Oddi was also employed by the Fabbrica of the city's Duomo to teach architecture to the young *scalpellini* (stonecutters) working at the cathedral, who required basic training in practical geometry.[24] Oddi's tenure of this post was brief—he ceased teaching at the Camposanto in November 1615—but potentially highly significant for the history of architecture, for the years in which Oddi was employed by the Fabbrica overlap with those during which the young Francesco Borromini was apprenticed as a *scalpellino* in the

Duomo. Although there is no concrete evidence to prove a connection between the two men, the possibility that Borromini received instruction in mathematics from Oddi has led some scholars to suggest that the former's interest in complex geometrical shapes was sparked by the lessons delivered by the Urbinate mathematician, who was an expert on conic sections.[25]

HOW TO MAKE FRIENDS AND INFLUENCE PATRONS

Oddi's formal teaching was very varied: it comprised practical geometry and technical skills for artisans, as well as, for the high-status pupils at the Scuole Piattine, arithmetic, classical geometry, and astronomy. But Oddi also offered a bespoke service to private clients, a service designed to gain him entry into Milan's elite circles, in the hope of capturing more lucrative, sustained, and prestigious patronage.[26] In this he was remarkably successful, for his first private pupils were drawn from the very highest tier of Milanese society. Between 2 and 13 March 1612 Oddi began to teach mathematics to Ercole Bianchi (art agent of Cardinal Federico Borromeo), Count Teodoro Trivulzio, Count Francesco Bernardino Marliani, and Enrico Birago, Marchese of Candia, all of whom proved to be major supporters throughout his Milanese period.[27] In this same month he also recorded that the Marchese Sfrondato—one of Milan's most powerful nobles—had "returned" to his studies of Euclid, implying a prior relationship with the aristocrat.

In fact, not long after his arrival in Milan, Oddi had identified Sfrondato as a prime target for patronage and adopted a classic strategy in order to gain his favor: lavishing gifts upon the nobleman's family. In December 1610 Oddi asked his brother, Matteo, to order from Lorenzo Vagnarelli—successor to Simone Barocci at the Officina di strumenti matematici, and thus Urbino's premier instrument maker—

> a medium-sized compass with three points, and one in the shape of that which is in my *stuccio* [a cased set of instruments], and to accompany them an adjustable square of the same size, along with a little stylus and a ruling pen with balluster shafts and six faces . . . as well as a case of pencils which can make a *stuccio* for the son of Marchese Sfrondato.[28]

Oddi's real target was, of course, the father, but the son was evidently more accessible at first. By presenting the young nobleman with a fine gift, Oddi hoped to attract the marchese's attention and secure employment within the family. His strategy was successful—up to a point. By May 1611 he noted that he had left Sfrondato's service, writing to his brother:

> Marchese Sfrondato remains unhappy, as I have left him high and dry . . . he would like someone who knows how to teach mathematics, has the hand for

writing and copying all the day long, and to serve also in his chamber, or in certain other jobs if he is able.[29]

The tone of the letter implies that Oddi either had been asked to serve in this capacity and declined, or—which seems more likely—had begun to work and left when the low-status activities his patron expected of him became clear.[30]

What is notable about this episode, aside from what it tells us about Oddi's perception of his own status as a gentleman rather than a servant, is that he drew on Urbinate *ingegno* to fulfil his aims, using mathematical goods crafted in his *patria* to gain a patron.[31] Oddi's teaching and presentation of instruments were interrelated parts of an integrated patronage strategy. In some cases he used instruments to entice pupils, but he also smuggled instrumentalism into his lessons, encouraging tutees to purchase the equipment necessary to pursue their studies effectively. Thus, Oddi—like Galileo—used his teaching as a means of stimulating trade in the material culture of mathematics, from which he benefited in terms of credit and prestige, as well as employment.[32]

The question of if and how the instruments Oddi circulated were used in the lessons he delivered is vexed. Indeed, the issue of instrument use in teaching was much contested in the period, but Adam Mosley has recently summarized the variety of possibilities:

> Were mathematical instruments such as astrolabes, armillary spheres, sundials and globes, introduced into lessons and texts simply as aids to the teaching of subjects such as astronomy and geometry? Were they focused on in order to convey knowledge about these fields surreptitiously, perhaps as a clever way of maintaining the interest of the student? Or were they indeed the real object of the lessons, the purpose being to convey their various operations to the student, without necessarily communicating anything about the underlying mathematics? [These] possibilities . . . might be summed up as teaching (or learning) *with*, *through*, and *about* instruments.[33]

As we shall see in chapter 3, Oddi's teaching conformed to all three of Mosley's categories, in combination. For instance, in certain subjects—such as military architecture—it was evidently commonplace for students to acquire and use instruments, as indicated by the correspondence between Oddi and his erstwhile pupil, the military engineer Giovanni Battista Caravaggio. In June 1631 Caravaggio wrote to Oddi from Pavia (where he was temporarily stationed following the siege of Casale), saying, "The Duke of Lerma, who has developed an interest in learning something about fortification, equally would like a *stuccio* of instruments made in Urbino," which Caravaggio hoped Oddi could procure.[34] Yet military architecture was not the only subject Oddi taught that required instruments. On the folio of his "teaching notebook" that records Countess Giovanna Bor-

romeo's commencement of instruction in geometry and arithmetic, Oddi listed a payment for a *stuccio* ordered from the Urbino workshop by his pupil.[35]

As a woman, Giovanna Borromeo—who studied mathematics at the request of her uncle by marriage, Cardinal Federico—was something of an anomaly in Oddi's teaching.[36] According to his records, he taught a total of forty-two pupils in Milan between March 1612 and October 1624 (see appendix A).[37] All but one were male and the majority were drawn from noble, or at least high-ranking, Milanese families. Many of Oddi's pupils (such as those from the Sfrondato, Trivulzio, and Sforza families) contributed to the governance of the city, some (such as the physician Senatore Settala) were professionals, and a large proportion were involved in military affairs. In addition to local *illustri*, Oddi taught a number of foreigners resident in the city. Unsurprisingly, given that the Duchy of Milan was a vassal state of Spain at the time, several Spaniards (Marchese Valdefuentes, Carlo Giovanni, and Giovanni di Sosia) and one Portuguese (Francesco d'Oncastor) are listed among Oddi's students, along with one German, the merchant Peter Linder. It is notable, however, that Oddi also taught a few pupils of relatively modest social status. Three of his students (Daniele Crespi, Carlino [Carlo] Biffi, and Francesco di Berlagne) were artists, and at least one (Giovanni Battista Caravaggio) was an aspiring architect-engineer.

Many of Oddi's pupils, especially the high-status ones, may well have been studying mathematics as part of a rounded education—by this date it was expected that elite members of society should have at least a basic knowledge of mathematics.[38] However, most, especially those drawn from the officer class, studied with him as part of their training for military service.[39] As we have seen, knowledge of mathematics was, at the time, becoming increasingly important on the battlefield, notably for the practice of cannonry and the complex art of fortification. Moreover, as Pascal Brioist has recently demonstrated, throughout the second half of the sixteenth century Italian military engineers pressed the need for a sound knowledge of Euclid as the basis for these practices.[40] The question of whether a proper understanding of Euclid actually assisted the practice of war is and was debatable.[41] In any case, the social and intellectual conditions of the late Renaissance forged an environment in which it was in the best interests of mathematicians and engineers to stress the necessity of a thorough understanding of mathematics and classical geometry.[42] The evidence of Oddi's extensive teaching in these fields suggests that hardened military men—such as his Milanese patrons—were convinced by their arguments.

Oddi's own military experience, in the Burgundian campaign of the early 1590s, must have helped in fostering good relations with the Milanese *milites*: he could claim to be a man of action as well as of contemplation.[43] Yet the detail of his relations with his private pupils—whether as friends, clients, or patrons—is often so complex and bound up with other services rendered and favors sought,

that establishing what he gained from his teaching activities, materially or other-
wise, is extremely difficult. Throughout his teaching notebook, Oddi listed hap-
hazardly occasional payments, not all of which relate to his teaching. For some
of his pupils he undertook architectural work, for others he employed his craft
skills, and to several he provided instruments.[44] For Giovanna Borromeo, for
example, Oddi "repaired the porphyry head of Our Savior," fixed a brass clock,
made a sundial (having purchased material from a "French clockmaker"), and
made a number of architectural drawings.[45] The situation is further confused by
the fact that Oddi did not receive a regular salary from his employers; instead, he
records intermittent payments of varying amounts and in a range of currencies
(Milanese *lire*, Venetian ducats, Spanish doblets, and so on).[46]

Yet another complicating factor is the fact that Oddi frequently received gifts
of varying kinds for his work.[47] Indeed, his teaching operated firmly within the
vibrant gift economy of late Renaissance Italy, which allowed payment for ser-
vices to be made in the gentlemanly form of useful or rare presents as well as
the more vulgar, but no less useful, form of currency.[48] Oddi's accounts show
that he received practical gifts (such as food, candles, clothes, and wine) and
standard items such as gold chains, as well as an array of more unusual items.[49]
Some of these were art objects, such as a "small painting of Christ on the cross"
received from Iacomo Filippo Prato, or a silver *tazza* and portrait medals of the
Holy Roman Emperors Rudolph, Matthias, and Ferdinand, given to him by Pe-
ter Linder.[50] Oddi also received gifts useful for his professional activities, such
as an "astrological instrument made at Cremona by signor Giovanni Francesco
Deviciolo," thoughtfully given to him by his pupil Girolamo Possoni.[51]

The giving and receiving of gifts placed business transactions within the ritu-
als of *amicizia*. This served to bolster relationships between patrons and clients
and to cement the bonds between friends and colleagues, bestowing honor and
prestige on the parties involved. As Genevieve Warwick—drawing on the influ-
ential work of Marcel Mauss—has explained, the gift economy

> is distinguishable from other types of trade in that the return takes both a
> material and an immaterial form. The material benefit, or object received, is
> like that of any trade; the immaterial is prestige, power, honour, or status ac-
> cumulated through this aestheticized form of exchange.[52]

It is significant that a considerable portion of Oddi's teaching activities operated
within this economy, for gift-giving helped to reposition both teacher and the
subjects taught away from the realms of mechanical labor, with which much of
practical mathematics could be associated, and into the respectable gentlemanly
spheres of credit, propriety, and friendship.[53]

In fact, teaching was a perfect means through which to forge a close relation-
ship with one's patrons precisely because it provided two key elements of friend-

ship: common ground and intimacy. We can glimpse both through the various terms Oddi used to describe the ways in which he delivered his teaching—"to hear," "to read," "to learn," "to understand," "to give"—and by the fact his private tutoring took place not in a lecture hall, but in the home.[54] For example, Oddi recorded that he taught Senatore Settala, Iacomo Filippo Prato, and Girolamo Pozzo "in the house," a reference either to Oddi's modest dwelling or the rather grander *palazzi* of his pupils.[55] If and when he taught pupils in his own home, Oddi partook of a well-established tradition. For instance, in the sixteenth century the famous mathematicians John Dee and Oronce Fine regularly welcomed noblemen to their houses to discuss mathematics and demonstrate marvelous feats of technical ingenuity. Indeed, the Frenchman Fine

> so impressed the royal family that they did not decline to enter his house many times; similarly many Dukes, Cardinals, numerous noblemen, and ambassadors came to converse with him and to see what, by his own hand, he had painted, or sculpted, or described—I say not only maps or books, but also a thousand mathematical instruments, and devices of other sorts.[56]

Some mathematicians, such as Galileo, even provided board and lodging for their pupils (and their servants) for either part or the entire duration of their studies.[57] Given the intermittent nature of Oddi's mathematics teaching (he seems to have delivered a series of occasional lessons rather than intensive courses) and the fact that most, possibly all, of his pupils were residents of Milan, it is highly unlikely that he offered a similar service to Galileo, who was able to provide a comprehensive package comprising accommodation, tuition, and teaching resources (i.e., manuals and instruments).[58] Moreover, as Matteo Valleriani has argued, Galileo's teaching seems to have been designed primarily as a course in fortification.[59] Oddi's teaching, while sharing a certain affinity with Galileo's in terms of its patronage objectives and content, was less cohesive, served a more diverse clientele, and was broader in scope.[60]

ODDI'S MATHEMATICAL CURRICULUM

Oddi's teaching records enable us to take in at a glance more or less the entire sweep of the late Renaissance mathematical arts. In his notebook, he used eleven different terms to describe the subjects he taught: Mathematics, Euclid, Military Architecture, Perspective, Geometry, Sundials, Arithmetic, Mechanics, Drawing, Algorithms, and the Sphere (see appendix A).[61] This list is striking for its mixture of speculative and practical subjects, as well as disciplines that hover somewhere in between, such as perspective and military architecture.[62]

That Oddi taught such a range of subjects testifies both to the varying needs of his pupils in Milan and to his mathematico-artisanal upbringing in Urbino;

indeed, there is strong evidence to suggest that his Urbinate roots affected how, as well as what, he taught. Although keen and able to teach hands-on, practical-mathematical subjects, Oddi adhered to the principle of propaedeuticity that was such a hallmark of Urbinate mathematics. For example, he taught the Portuguese Don Francesco d'Oncastor the "rudiments of geometry, then drawing, then the Sphere." The "rudiments of geometry" were most probably the principles of lines and angles found in book 1 of Euclid's *Elements*.[63] These would have been followed by instruction in the use of ruler, compass, and other drawing instruments before the student was ready to master the astronomy and cosmology of Sacrobosco's text.

Similarly, Oddi's records for Tommaso Trutti and his cousin Carlo Alessio state that both began studying "mathematics in order to advance to military architecture."[64] This is consistent with the ideal educational regime described in printed treatises on military engineering, in which students were encouraged to learn Euclid's fundamental geometrical principles (or at least an approximation thereof) before proceeding to practical applications such as drawing forts. In reality this process was routinely reversed, as many students began with practice in advance of theory.[65] In fact, students in fortification often bypassed entirely the geometry on which bastion design was based, beginning by learning how to use the requisite drawing and measuring instruments, then proceeding quickly to the design of fortifications.[66] Oddi, however, insisted on a proper progression from geometry to its applications, a process that smacks of the Urbino school and, especially, of Commandino's arguments for the propaedeuticity of mathematics to other disciplines.[67] Rather than indulging his students, Oddi insisted on instilling geometrical rigor before allowing them to proceed to applied subjects.[68]

Urbino was present also in Oddi's teaching materials. As we have seen, several of his pupils acquired through him instruments made in Lorenzo Vagnarelli's Officina. Oddi also used as a textbook the vernacular translation of Commandino's edition of Euclid's *Elements*: Giovanna Borromeo purchased a copy from Oddi at around the time she began her studies in geometry and arithmetic, and he lent a copy to Amadeo Vernardo Delascamo for his instruction in "mathematics."[69] Notably, Oddi's decision to use the Italian translation of Commandino's Euclid suggests that his teaching was undertaken in the vernacular, rather than in Latin. This is commensurate with the practical slant of much of his curriculum and the fact that, despite their high status, many of his pupils may have had only a shaky grasp of Latin. Indeed, it is possible that Oddi's experience of his students' limited linguistic abilities affected his decision to publish his own works in the vernacular rather than Latin, despite his Urbinate predecessors' emphasis on ancient languages. In certain respects Commandino's edition of Euclid is a surprising choice, given the type of teaching and pupil with which Oddi was concerned. He could have opted for a more accessible vernacular edition of the *Elements*

(such as Tartaglia's) or one of the numerous summary geometries available by the 1610s, but instead he chose the most rigorous, challenging edition available.[70] Yet rigor was not the sole criterion for his choice. By using Commandino's text, Oddi consciously sought to enhance the *fama* of his countryman and, by extension, to bolster the prestige of his own mathematical lineage and the general reputation of Urbino as the progenitor of a renaissance of mathematics: this was a choice determined by *patria* as much as pragmatism.[71]

With the exception of Commandino's Euclid, Oddi did not specify the books he used for teaching. However, printed sources for the teaching of elementary mathematics and geometry were so numerous by the beginning of the seventeenth century that he could, in addition to using his own wide-ranging knowledge and the draft treatises he composed in prison, draw on a large body of affordable literature in his lessons.[72] Specific records of books used in private mathematics teaching are rare, but it is reasonable to assume that a teacher's choice would have depended to some degree on geographical location, local traditions, and the linguistic proficiency of the students, not to mention the idiosyncrasies of personal preference. For example, there developed in sixteenth-century France a very particular tradition of vernacular instrument books and practical geometries centered on the publications of Oronce Fine and his pupils.[73] And Galileo's tutor—the engineer Ostilio Ricci—opted for Alberti's *Ludi matematici*, a practical work largely concerned with surveying and related branches of instrumental mathematics, and highly appropriate to the Florentine context in which he was working and teaching.

It may be assumed that Oddi used one of the many vernacular editions of Sacrobosco's *Sphere* to teach the one pupil studying that topic with him; he may also have used an actual armillary sphere, as was customary at the time.[74] Oddi's first publication on dialing—*Degli horologi solari*—is surely representative of the instruction he gave to Peter Linder in sundials, and it seems likely that he would have drawn on material in his treatise on surveying, *Dello squadro*—drafted in prison, so available to his Milanese students even before its publication—when teaching practical mathematics and military architecture.[75] It is hard to ascertain precisely what Oddi taught to the Marchese Valdefuentes, who began studying "mechanics" with him in 1619, because the purview of the subject was, at that time, both broad and hotly contested. However, it is likely to have reflected the interests of Oddi's own master, Guidobaldo del Monte, which were largely focused on equilibrium in simple machines.[76] When it came to military architecture—a subject in which Oddi had practical experience as well as bookish knowledge—the Urbinate mathematician may have devised his own teaching materials. His incomplete manuscript treatise on military engineering, which covers an enormously wide range of topics, may well have served as the textual basis for lessons, but he might also have devised visual study aids.[77] Among

FIGURE 22. Mutio Oddi, labeled fortifications design, possibly used as a teaching aid,
ca. 1610–1630. Pen and ink on paper. Royal Library, Windsor Castle.
Vol. 183, no. 10143. © 2009 Her Majesty Queen Elizabeth II.

Oddi's drawings preserved in the Royal Library at Windsor Castle is a single
sheet (fig. 22) that illustrates a large, bastioned fort in plan, to the side of which a
sequence of drawings shows various types of ditches, earthworks, and gun place-
ments in elevation. This would have been an ideal, didactic image for guiding
his pupils through the maze of military engineering and should alert us to the
significance of the visual aspects of late Renaissance mathematical education.

INTERDISCIPLINARY INSTRUCTION: TEACHING *DISEGNO*

Images of various kinds—geometrical diagrams, fortifications in elevation and
plan, and cosmographical charts—certainly played a role in Oddi's mathematical
teaching, but he also offered instruction in the theory and practice of drawing
itself: *disegno*. While only one pupil is listed as studying drawing specifically,
many of his pupils, particularly those studying "military architecture" and "per-
spective," would have needed to develop proficiency in draftsmanship in order
to progress in their studies, and even those studying "Euclid" and "geometry"

would have been obliged to master the use of ruler and compass in the construction of plane figures.[78] Indeed, as Lorini explained in his treatise on fortification, drawing in perspective is

> not only useful but very necessary, as much in this profession of fortification as in all the other arts. . . . Whoever does not know how to make a drawing also does not know how to learn well . . . and therefore drawing is necessary to everyone, and particularly to great men, who should ensure that their sons learn how to draw.[79]

In emphasizing that great men and their sons should learn how to draw properly, Lorini reprised a theme established by one of Oddi's heroes, the fifteenth-century humanist Leon Battista Alberti. In his influential treatise on painting, *De pictura* (1435), Alberti pointed out that instruction in drawing was commonplace among the nobles of antiquity, for it enhanced the mental precision and discernment expected of the elite.[80] By the time Oddi was teaching, proficiency in draftsmanship had become a generally desirable courtly skill, as evinced by Castiglione's popular book of manners, *Il libro del cortegiano*.[81] It is likely that Oddi—born in Urbino, where the book was set—would have been familiar with the passage that deals with the subject of *disegno*, just as he was familiar with Alberti's treatise. The main protagonist of Castiglione's tract, Count Ludovico, claims—following Alberti—that understanding *disegno* befits the ideal courtier as it enables him to judge the merits of "ancient and modern statues, of vases, buildings, medallions, cameos, intaglios." Yet it could also be applied to military pursuits, for "a knowledge of the art gives one the facility to sketch towns, rivers, bridges, citadels, fortresses and similar things." Most importantly, though, *disegno* was a tool of knowledge, enabling the courtier to understand God's creation, the heavens and the earth.[82]

Disegno, then, hovered somewhere between practice and theory. It was a manual skill, learned through imitation, but it also demanded knowledge of perspective—a geometrical art—in order to imitate nature effectively. Most proponents of *disegno* stressed the importance of perspective as a bridge between mathematics—normally categorized as an aspect of *disegno interno*—and drawing, a manifestation of *disegno* in the world.[83] Perspective could be, and was, studied purely as an intellectual exercise. Indeed, it flourished as a speculative discipline during the Renaissance quite apart from its potential applications in the visual arts.[84] Oddi's mathematics teacher, Guidobaldo del Monte, is particularly prominent in this tradition; he has even been described as the "father of mathematical perspective."[85] Although Guidobaldo's treatise on the subject, *Perspectivae libri sex*, was published in 1600, some years after Oddi's pupilage, and despite the fact that Guidobaldo had not formulated a coherent approach to the topic when Oddi studied with him, it is highly likely that Oddi was introduced

to perspective by the marchese. In all probability, the instruction that Oddi received reflected the content of two manuscripts composed by Guidobaldo circa 1588–92, which draw heavily upon Commandino's treatment of the subject (a mathematically rigorous method of perspective projection related to figures) but hint at novel ideas (notably the concept of a general vanishing point).[86]

Oddi was, therefore, well equipped to teach perspective as a purely mathematical exercise. However, there is compelling evidence to suggest that this aspect of his teaching was in fact directed toward the practice and appreciation of art. Oddi taught perspective to four pupils: Daniele Crespi, Francesco di Berlagne, Carlino Biffi, and Alessandro Monti. The first two, identified as "painters," were students at Federico Borromeo's Accademia del Disegno. The third, Carlino, was the son of Gian'Andrea Biffi, "sculptor of Campo Santo," a noted artist who undertook extensive work on the Milanese Duomo (where Oddi, as we have seen, tutored the young *scalpellini*) and who was employed also as the sculpture master at the Accademia.[87] The fourth, Alessandro Monti, was a Milanese patrician active in artistic circles, who was acquainted with his fellow pupil, the painter Crespi.[88]

It seems most likely that Monti studied perspective with Oddi to improve his understanding of the visual arts, as there is no evidence of his having professed an interest in any other branch of mathematics. This kind of learning was increasingly common among the elite in the late Renaissance. Perspective, as the Lorini quote above implies, was routinely taught to princes, and there is ample evidence of young aristocrats practicing perspective drawing—often with the aid of instruments—as a courtly pastime from the early sixteenth century onward.[89] Moreover, connoisseurship was burgeoning in early seventeenth-century Milan, thanks in no small measure to Federico Borromeo's enthusiastic championing of Flemish painting. Indeed, several of Oddi's pupils—notably Borromeo's art agent, Bianchi, and the merchant Linder—assembled impressive art collections and were actively interested, as was Oddi himself, in issues of aesthetic discernment and judgment.[90]

If Monti was not studying perspective for professional purposes, Oddi's other pupils in that subject most definitely were. By Oddi's era it was not unusual for professional artists to learn mathematics. The statutes of the Florentine Accademia del Disegno, for instance, made ample provision for its pupils' instruction in the mathematical arts—including general mathematics, geometry (both speculative and practical), mechanics, and perspective—as part of a systematic program aimed at installing the theoretical principles upon which good *disegno* was based.[91] The artists that Oddi taught were enrolled in Milan's own academy: the Ambrosian Accademia del Disegno, founded in 1620 by Borromeo for the purpose of training young, promising artists in the aesthetic principles underlying his program of reform for the visual arts, which was but one section of an ambitious set of diocesan reforms based on the tenets of the Council of Trent.[92] Borromeo firmly

believed that the contemplation of the correct sort of visual image had the potential to move the viewer spiritually. To this end, he established the Pinacoteca Ambrosiana, the largest and most distinguished collection of paintings, sculptures, and drawings in early seventeenth-century Milan, one purpose of which was to serve as a teaching collection for the Accademia.[93] Given Borromeo's emphasis on the importance of legibility and naturalism in the visual arts, training in perspective—a discipline that could aid the convincing representation of three dimensions on a plane—must have been a *desideratum*. Yet although the Accademia's statutes made provision for lectures in a wide range of subjects, from color theory to copying from the antique under the direction of three masters (for, respectively, painting, sculpture, and architecture), training in perspective is conspicuous by its absence. Oddi—who developed a rewarding patronage relationship with the cardinal—evidently filled this gap in an informal capacity.[94]

The type of perspective that Oddi taught Crespi, Biffi, and Berlagne most probably focused on *prospettiva prattica* rather than the theoretical perspective epitomized by Guidobaldo del Monte's work. "Practical" perspective was, as its name suggests, geared toward use and spawned a genre of illustrated treatise aimed at artists and architects, artisans of various kinds, military engineers and officers, and prince-practitioners.[95] However, sound geometry remained firmly at its root (even if, in some cases, only rhetorically), and most treatises stressed the need for a thorough understanding of Euclid before useful perspective techniques could be mastered. Given Oddi's particular emphasis on mathematical rigor (and Euclid in particular), it is notable that his pupil Crespi owned copies not only of the practical perspectives of Sirigatti, Barbaro, and Barozzi but also a copy of Commandino's Euclid, listed in his probate inventory as the "elementi d'Urbino."[96] Moreover, he was responsible for creating a painting (discussed in detail in the next chapter) that captures Oddi teaching Peter Linder about geometrical optics (a branch of the *perspectiva* tradition), suggesting that Oddi's perspective teaching might well have extended beyond the practical knowledge useful to artists.

With this in mind, one of the most striking features to emerge from Oddi's hastily written teaching records is the sheer diversity of his educational activities. Oddi's mathematics teaching was not confined to simple arithmetic, of the type one might expect to find being taught in a *scuola d'abbaco*. Instead, it ranged widely from rudimentary mathematics to reasonably advanced geometry, from the principles of sundials to mechanics, and included aspects of *disegno*. In this regard, his curriculum is similar to the novel program of mathematical instruction offered at the Collegio Romano under Clavius's direction and indicates that, while important, the Collegio was by no means the only place in Italy in which theoretical and practical mathematics were taught side by side. Yet while the program of the Collegio's Academy was integrated and orchestrated with clear aims in mind, the range of

subjects that Oddi taught reflects, in large measure, the diversity of his student body and the extent of their intellectual interests and professional needs. It suggests, moreover, that mathematical education did not need to be simply utilitarian. Although some of Oddi's students—the artists, for instance—learned mathematics as a prerequisite of their professional development and daily practice, others, such as the merchant Linder, clearly studied mathematics out of curiosity and as part of their involvement in erudite culture. Indeed, by the beginning of the seventeenth century it was generally expected that gentlemen should have sufficient mathematical knowledge to discuss the subject in polite conversation, as evinced by the essayist William Cornwallis's suggestion that "a gentleman should talk like a gentleman . . . if thou meetest a fellow that would fain show he is a mathematician . . . be content to talk with him of circles and quadrangles."[97]

Yet in addition to polishing a gentleman's education, the kind of mathematics Oddi taught could be put to a range of uses, from designing a fort to appreciating (or creating) a work of art, from accountancy to gunnery. This pluralism, consistent with the range of professional activities expected of a late Renaissance mathematical practitioner, tells us something about how mathematics was used and understood in the period. Mathematics was a flexible, dynamic subject that could readily be adapted for use in a host of different situations and environments. This adaptability was founded on a set of core, immutable principles that, when passed between individuals of varying status and profession, created a distinctive network bound together by shared knowledge: a mathematical community. Oddi's teaching records provide us with useful insights into the constitution of one such community, in late Renaissance Milan: its members were young and old, male and (very occasionally) female, noble and artisan, artist and scientist. Mathematics could thus provide the basis for social and intellectual discourse between individuals from very different backgrounds and of diverse occupations.

It is in this regard that Oddi's teaching assumes particular importance for our understanding of late Renaissance science. Some of the pupils Oddi instructed were—as we shall see in the next chapter—actively engaged in the pursuit of natural knowledge viewed through the prism of mathematics. Others, in particular his patrician pupils, were the book-buying public for treatises on the mathematical arts and natural philosophy, not to mention potential patrons for these books' authors. All had recourse to mathematical devices, and it is clear that mathematical education helped to support the fledgling instrument economy. Through his teaching, then, Oddi provided both the rudimentary and advanced knowledge, theoretical as well as practical, required to engage properly in mathematically based subjects such as mechanics, astronomy, and optics.[98] He widened participation in those fields that played such a vital role in the transformation of science, fashioning the mathematician's role as he did so.

Amicizia and Optics:
A Mathematics Lesson Portrayed

In July 1625, less than a year into his job as Lucca's fortifications engineer, Oddi wrote to his old friend Piermatteo Giordani. Responding to the Pesarese scholar's request for assistance in acquiring a picture, Oddi explained:

> I would like to be in Milan to have the opportunity to serve the person so inclined toward painting [*il soggetto tanto inclinato alla pittura*], about whom Your Lordship writes, because there there are the two Procaccini, Cerano [and] Morazzone, all famous painters, and the most able and perhaps the best dealing of them, for that which one might desire, is called Daniele Crespi; he is young, certainly, but talented, of good character, and extremely diligent, and as he is my friend he has assured me that he will do everything possible to satisfy me.[1]

Oddi's familiarity with the world of painters was to be expected. He was himself a practitioner of the arts of *disegno* and had in his youth been apprenticed (albeit briefly) to one of the most famous artists of the age, Federico Barocci.[2] Moreover, in Milan he had been deeply immersed in the culture of collecting and connoisseurship, acquiring drawings for the city's *cognoscenti*, establishing—through his teaching—a close friendship with Federico Borromeo's art agent, Ercole Bianchi, and serving the cardinal as informal tutor in perspective at the Accademia del Disegno, where he numbered Crespi among his pupils.

As his letter to Giordani suggests, Oddi's relationship with Crespi extended beyond that of master and pupil, being instead a proper friendship.[3] It is fitting, then, that it was Crespi who painted a lasting testament to the most profound and productive friendship of Oddi's life: the double portrait of the mathematician and the merchant Peter Linder engaged in a lesson about geometrical optics (fig. 4).[4] Painted in the early 1620s, the image shows the two friends seated in a small, intimate space, which, judging from the desk scattered with writing implements, must be a *studiolo*. Lurking at the rear of the desk, which is covered by a richly patterned rug, is a typical *studiolo* object: a figurative bronze inkwell bearing a quill pen, indicating that this is a place reserved for writing and study,

for engaging the higher faculties.[5] Just in front of the inkwell stands an adjust-able mirror on a turned-wood stand, a sliver of light reflecting off its left-hand edge. The mirror's position, in between the figures and at the very axis of the painting, suggests that it is central to the picture's content. Indeed, it is no acci-dent that it has been placed just behind the geometrical diagram being studied by Linder, to which Oddi points as though explaining its meaning. As we shall see, the diagram likely represents some of the optical properties of the instru-ment between the mathematician and the merchant. Thus, just as the professions and social profiles of the figures represented in the portrait were mixed, so too was the subject they discussed, for optics—a subject that pertained both to ef-fects observable in nature and to geometry—was a form of mixed-mathematical knowledge.[6] Crespi's painting thus encapsulates for us the growing proximity between mathematics and materials, the fascination for instruments and their effects that underpinned much of the period's mathematical curiosity, the ex-pansion of the mathematical community, and the crucial role of teaching in that expansion. Indeed, it is a rare image that illustrates vividly an important point about late Renaissance mathematical culture. Far from being an entirely cerebral, colorless, and solitary exercise, for Oddi and Linder mathematics was a tangible, sociable discipline, the pleasurable pursuit of which deserved to be celebrated in paint by an up-and-coming artist.

Picturing mathematics in this way ennobled and bequeathed to posterity the *amicizia* that both arose from and underpinned Oddi and Linder's geometrical discussions and instrumental practices, but the painting is also a valuable record of Oddi's teaching. First, the depiction of the mirror and beam compass (the long instrument lying along the length of the desk) confirms that Oddi used instruments in his teaching: in this lesson one instrument is employed to make a diagram demonstrating the geometrical principles embodied in another. Sec-ond, the subject being taught (optics) does not conform precisely to either of the subjects (sundials and military architecture) listed by Oddi in his records of Linder's studies, which implies that some of his pupils studied more widely with him than his notebooks state.[7] The painting thus takes us beyond Oddi's hastily scribbled teaching records, offering a more extensive image of his pedagogy and mathematical world.[8]

THE ODDI-LINDER PORTRAIT

Before examining the content of the double portrait, it is necessary to consider briefly the circumstances that gave rise to its production and the material evi-dence upon which its interpretation is based. The image actually exists in two versions, one complete, the other a pair of fragments depicting only the heads of the sitters, now in the Koelliker Collection, Milan (figs. 23 and 24). At some

FIGURES 23 AND 24. Daniele Crespi, *Mutio Oddi* and *Peter Linder*
(fragments of a double portrait), early 1620s. Koelliker Collection, Milan.

point in the second half of the eighteenth century, the two Koelliker fragments
were cut from the original composition (the cropped edge of the mirror and
inkwell are just visible in the "Linder" fragment) and added to the portrait gal-
lery assembled by the Milanese nobleman Giacomo Melzi (1721–1802).[9] The
Koelliker fragments are undoubtedly autograph works by Crespi, but the at-
tribution of the complete version (the provenance of which cannot be traced
earlier than the twentieth century) is disputed. Attributed to Crespi by Neilson
in her catalogue raisonnée of the artist's work, it has recently been described
as an "old copy," which documents faithfully the composition of the mutilated
original.[10] While the Koelliker fragments are certainly superior in quality to
the complete version, the attribution of the latter to Crespi remains plausible.
The work is undoubtedly of the period, it does not deviate from the imagery of
the Koelliker fragments, and, while not quite so polished as those pieces, it is
sufficiently assured to be associated with Crespi himself, although it was most
likely completed by an assistant under the master's supervision. Throughout
this chapter, then, I shall treat the complete double portrait as a faithful, period
record of Crespi's original.

 The reason that two, nearly identical versions of the work exist, and for the
difference in quality between them, may lie in the context of the commission—
namely, its celebration of friendship. As we shall see, Oddi developed a profound

friendship with Linder, doubtless deepened through his instruction of the merchant in mathematics. Over the years the two men served one another in all sorts of ways, sourcing instruments and other luxury goods, and supervising the publication of treatises.[11] Perhaps the most powerful expression of the bond between the two friends, though, is the last letter Oddi wrote, from his deathbed in 1639, addressed to Linder:

> Signor Pietro, I am at the very end of my life, and before departing this world I wanted to write this my last letter to thank you for the great kindnesses and favors you have done for me in all the time I have known you, and to reiterate that in all my life, the obligations that I have professed to you have remained the greatest. . . . I pray with my last breaths that you should not forget me and the good that I wish for you.[12]

In light of such a statement and the wealth of evidence in Oddi's correspondence, it is clear that Crespi's double portrait should be considered within the context of learned sociability and humanist *amicizia*. It would have been natural, therefore, for each sitter to have owned a version of the work, as a reminder of their mutual regard and affection, and of the topic that brought them together and sustained their friendship: mathematics. Once the original version (which I take to be the Koelliker fragments, probably owned—and I suspect commissioned—by the wealthy Linder) had been approved by the sitters, it is entirely possible that a copy (for Oddi) was made in Crespi's studio.[13] The use of portraits to commemorate *amicizia* in this way was not unusual in the period. Galileo and Sagredo, for example, exchanged portraits of one another as a memento of their friendship, although Crespi's double portrait is far more particular and unusual in depicting the friends together and sharing mathematical knowledge.[14]

When we add to the relationship between Linder and Oddi the fact that Daniele Crespi was a member of their mathematical circle, it is evident that we are dealing with a purposeful, visual manifestation of the social and intellectual relationships that underpinned late Renaissance mathematical communities. Although the spread of elite individuals' interest in mathematics prompted a vogue for generic portraits of ancient mathematicians in the first half of the seventeenth century (such as those by Jusepe de Ribera or Domenico Fetti; fig. 25), representations of modern mathematicians practicing their art remained scarce, and highly specific double portraits such as Crespi's are exceptionally rare.[15] Indeed, the Oddi-Linder portrait is unusual even within Crespi's oeuvre, suggesting that the sitters helped to guide the format and composition. In fact, it is highly likely that Oddi was familiar with a painting that is a plausible model for Crespi's work: the famous double portrait of Luca Pacioli and a pupil (sometimes identified as the young Guidobaldo da Montefeltro, later Duke of Urbino) attributed to Jacopo de' Barbari

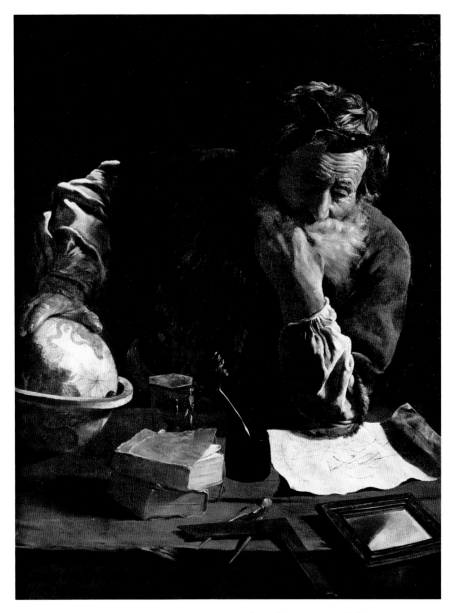

FIGURE 25. Domenico Fetti, *Archimedes*, 1620. Staatliche
Kunstsammlungen Dresden. Gal. no. 692.

and securely dated to 1495 (fig. 10). This painting, recorded as part of the Della
Rovere collections in Urbino during Oddi's lifetime, is similar to Crespi's work in
that it depicts a mathematics lesson effected through the use of instruments and
diagram (Pacioli is shown demonstrating a proposition of Euclid's *Elements*).[16]
Assuming this work was hanging in one of Urbino's princely residences prior to

Oddi's disgrace and exile from the duchy, it is quite possible that his memory of it shaped the instructions given to his pupil, Crespi.

Although, as we have seen, the lessons in perspective that Oddi gave to Crespi were probably centered on geometrical techniques for creating the illusion of three dimensions on a plane, the discipline of *perspectiva* often included the study of optics in general, and it was not uncommon for private mathematics tutors to deliver lessons in this subject. Indeed, as Sven Dupré has argued convincingly, the private tutorials given to courtiers and painters by Galileo's teacher, Ostilio Ricci, included a discussion of optics and catoptrics alongside linear perspective.[17] It is likely, then, that Crespi was at least partially familiar with the optical knowledge treated in his portrait of Oddi and Linder, a notion supported by the precision with which the diagram the two men are discussing has been rendered.[18] Moreover, the depiction of reflection—assuming that is what the diagram shows—is itself notably reflexive, for here the artist employs the very principles of foreshortening (particularly evident in the diagram) that Oddi would have taught him during their lessons in *prospettiva prattica*, making the picture itself part of the material culture of mathematics that it represents.

When, though, was the painting made? Like Crespi, the merchant Linder studied mathematical topics with Oddi, beginning to learn about military architecture and dialing in November 1621, the same year that Crespi started his studies. As there is no record of a relationship between the three men prior to 1621, and as Oddi was away from Milan from the summer of 1624 onward, it seems reasonable to suppose that the commission was undertaken sometime between the end of 1621 and the middle of 1624. Intriguingly, this corresponds almost exactly with the Jesuati mathematician Bonaventura Cavalieri's Milanese period. Cavalieri, a client of Federico Borromeo and disciple of Galileo, became a deacon and assistant to Borromeo at the Monastery of San Gerolamo in Milan in 1621, teaching theology there until 1623, when he left to take up a post in the Studio at Bologna.[19] We know that Oddi and Cavalieri became acquainted during this time, for in his short but learned treatise on burning mirrors, *Lo specchio ustorio* (1632), Cavalieri refers to an ingenious method of drawing conic sections with rulers—in fact a trammel designed by the Urbinate *virtuoso* Felice Paciotti—that Oddi had shown him "many years ago."[20]

It may well be that Cavalieri's presence in Milan at this time was a factor in Oddi's teaching Linder about optics, although there is no record of what, if any, optical topics Oddi and Cavalieri might have discussed. Unlike his knowledge of instruments and the (often complex) mathematics that underlay dialing and surveying, Oddi has left very little trace of his optical learning beyond that which can be gleaned from a few letters and the portrait in question. It is to the optical context of the image that we will now turn.

CHALLENGING MATERIAL:
PRACTICAL OPTICS AND BURNING MIRRORS

Although Oddi left no systematic treatment of optics, his interest in the subject probably began during his studies with Guidobaldo del Monte in the 1580s, for we know that he was especially interested in the principles of refraction according to which Guidobaldo's "scaphe" dial operated.[21] Furthermore, Oddi's correspondence reveals that he read major optical works such as Della Porta's *De refractione optices* (1589) and Aguilon's *Opticorum libri sex* (1613), and that he was thoroughly familiar with major classical texts relevant to the subject, such as Apollonius's *Conics*. In fact, his letters provide glimpses of his engagement with optical phenomena and the mathematics used to explain them.[22] For example, on 31 May 1634, Oddi wrote to Piermatteo Giordani concerning a topic of mutual interest: burning mirrors (or burning glasses, as they were sometimes known). This was a subject of great antiquity, widely revived in the Renaissance and treated in print by such well-known authors as Oronce Fine, Della Porta, and Oddi's friends Magini and Cavalieri.[23] Given the potential—though in fact illusory—military application of burning mirrors, the technical and mathematical challenge of devising a reflector that could burn with precision and fierce heat, and across a great distance, received considerable attention from geometers, artisans, and gentlemen alike in the sixteenth and seventeenth centuries.[24] Much of the discussion of burning mirrors centered on the shape (spherical, parabolic, or elliptical), number, and configuration of mirrors needed to bring about effective burning at a distance. Indeed, this was the subject of Cavalieri's *Specchio ustorio*, which Oddi, when writing to Giordani, had recently received.[25]

The book prompted an exchange of letters between the two Urbinate friends about the plausibility of the famous legend that Archimedes, using a single mirror, had burned the ships of Marcellus during the attack on Syracuse, at a distance "further than an arrow's shot away" (fig. 26).[26] Following a brief discussion about the contents of one of Guidobaldo del Monte's treatises on mechanics (the *Coclea*) and the problem of squaring the circle, Oddi wrote:

> Of burning at a great distance with the mirror I have not yet been able to conduct any other experiments because that *cavaliere* who has one of mine, which is also polished on the convex side, is not in Lucca; but reason tells us that it could not have been possible for Archimedes, with just one mirror, to set alight the ships from further than an arrow's shot away. How this may be done I will try to explain very briefly because for those who understand their matter a few words will suffice. Your lordship knows very well that the rays of the sun are supposed to be equidistant from the axis according to the size of

FIGURE 26. Giulio Parigi, *Archimedes Burning the Ships of Marcellus at Syracuse*, 1590s.
Stanzino delle matematiche, Palazzo Vecchio, Florence.

the body of the sun, and that in the concave part of a parabola they reflect in
one point whose distance, from the vertex of the parabola, is a quarter of the
latus of the said section, which may be proven easily.[27]

Oddi then proceeded to provide a lengthy proof, accompanied by a diagram (fig.
27),[28] which started with the law of reflection ("the angle of incidence is always
equal to the angle of reflection") and went on to apply proposition II.8 of Euclid's
Elements (on the areas of related rectangles created by cutting a line at a given
point) to explain why the reflected ray *AB* in his figure meets the mirror's axis
CG at a specific point.

He concluded his letter by stating:

With these principles if a concave mirror is modified so that its axis is directed
to the center of the sun and close enough or far enough from the convex sur-
face that the point of incision will be the point *B*, it cannot be doubted that
the reflections will burn everything in a physical line (*linea fisica*), or better
still material (*materiale*), very well indeed, along the axis *CG*. I have delayed
so much in writing that I am unable to correct the errors which I have made
in this demonstration, written sloppily; I ask for Your Lordship's indulgence

of my deficiencies, and you must forget any excessive things in the first part where it is dealt with by the 8th [proposition] of the 2nd [book of Euclid's *Elements*]. Father Cabeo says that if the convex mirror would be able to withstand the violence of the fire of the concave one, that one could carry the fire from much further away. If this is true it wouldn't take me long to clarify although it would be impossible that the convex part, which I had polished in Venice without that intention, could be made sufficiently exact.[29]

Oddi's letter represents a highly traditional form of knowledge exchange: epistolary, rooted in the shared reading of specific texts, and governed by the scholarly conventions of the Republic of Letters. Its content, however, is rather more novel, revealing the rapidly increasing proximity, not to say interrelationship, between knowledge attained through the observational experience of experiment and knowledge gained through mathematical reasoning: namely, the process of mathematization—particularly evident in subaltern, mixed-mathematical disciplines such as optics—to which Oddi was such a consistent contributor. It is clear from the letter that Oddi, who evidently owned at least one parabolic mirror, wanted to test the possibility of burning effectively at a significant distance, but believed that geometry should be used to describe and explain the effects observed, because it offered certainty of demonstration and (as Oddi had turned to Euclid for his proof) authority.[30] Thus, and in true Urbinate fashion, geometrical reasoning could, when properly applied, be used to resolve contemporary debates over the plausibility of popular tales about ancient technical ingenuity, but in the right hands it could also enable the moderns to equal or surpass the ancients.[31]

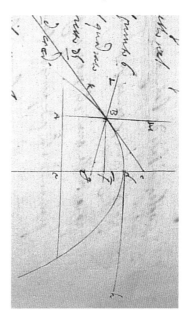

FIGURE 27. Mutio Oddi, diagram showing the reflection of an incident ray in a parabolic mirror, from a letter to Piermatteo Giordani, 1634. Biblioteca e Musei Oliveriani, Pesaro. Ms. 413, fol. 243v.

A striking feature of Oddi's letter, however, is that for him, geometry alone does not provide the answer to the challenge of burning at a great distance, for the efforts of the geometer are hampered by the material limitations of his instruments. The doubts Oddi expresses over Cabeo's (and Cavalieri's) method for "carrying the fire further" concern the feasibility of polishing a convex

parabolic mirror with sufficient precision that it could accomplish its task. Oddi doubted that even the master mirror makers of Venice—arguably the leading center for the production of optical devices in the period—could achieve such a feat, and besides, his own mirror, though polished on the convex side, had not been manufactured for the purpose of burning in conjunction with a concave one, and was therefore redundant in that matter.[32]

Oddi was by no means alone in expressing such doubts. Several members of his mathematical circle shared his misgivings over the material problems presented by Cavalieri's suggestion, including the Jesuit Niccolò Cabeo (1586–1650), mentioned in the letter quoted above, and Oddi's sometime pupil, Giovanni Battista Caravaggio.[33] For example, at around the same time that Giordani and Oddi were exchanging letters on the subject of *Specchio ustorio*, Caravaggio wrote to his erstwhile tutor:

> I honestly confess that when I read the book of Father Cavalieri concerning that speculation [about burning with a combination of parabolic mirrors] I understood it very differently to that which I had gathered from the letter of Your Lordship; because I saw that the author intended that the focal point [*punto del fuoco*] of the concave parabolic mirror opposite the sun should meet the focal point of a very small mirror in order to reflect those focused rays to any great distance, if not heating exactly the same then at least only a little differently, and because I doubted that the small mirror could resist the scorching heat of those rays, I thought about having [one] made with pieces of glass, concave in one part and convex in another, because they would reflect those rays among themselves and carry them wherever one wants, but I attributed the impossibility of realizing this to the carelessness of the work of artisans.[34]

Caravaggio went on to propose a method of correcting this artisanal failure, namely an instrument comprising two hemispheres of glass in a tube, with water between them, which was intended to amplify the intensity of the solar rays and the distance to which they could be projected.[35]

Oddi's epistolary exchanges with Giordani and Caravaggio came during a phase of rapid development in optics, in terms of both the geometry underlying perceived optical effects and the associated technology—lens grinding and mirror making. This had resulted in the successful development of telescopic and microscopic instruments, if not effective burning mirrors.[36] More specifically, his letters were written at a watershed moment in the history of catoptrics (the science of reflected light and image formation), namely the aftermath of Cavalieri's highly influential treatise, which largely settled the question of whether Archimedes used a single mirror or multiple ones (although it did not dampen enthusiasm for burning glasses among mathematicians and *virtuosi*). Thus,

Oddi's circle's discussion of optical phenomena partook thoroughly of the shared knowledge of mathematicians and practitioners in late Renaissance Europe. Indeed, from 1623 onward Oddi and Caravaggio corresponded extensively about a range of optical devices and effects that were widely discussed by the European mathematical community, including mirrors (both spherical and parabolic) and lenses for burning and enhancing vision, the properties of reflection and refraction, and Caravaggio's remarkable *cannochiale hydraulico* (water telescope).[37]

One theme in particular stands out in Caravaggio's letters to Oddi on optical subjects: the material problems faced by those who would manufacture optical instruments to perform the feats promised by geometry. Caravaggio encountered these very difficulties, for example, when it came to constructing his "water telescope," explaining to his friend:

> I have not written anything else to Your Lordship . . . about the water telescope, which I have already hinted at, for not having produced anything precise; this is more for the deficiencies in the polishing of the material that should contain the water, than for the poorness of the form, which was a half lens composed of two pieces of glass, the convex [one] of which came out quite well formed, the same as the little outline of Your Lordship's parabolic mirror, and this piece came out of the furnace quite clear, but because there was attached to it a soft piece of badly polished glass, it followed that, full of water to the same point, when pointed to the sun it produced burning, when placed to the eye it enlarged things wonderfully, but in such a muddled way that one could not discern what was there.[38]

Crafting efficient burning mirrors was similarly challenging because it was difficult to fashion the metal from which they were made into the correct parabolic shape. In the spring of 1627 Caravaggio wrote to Oddi, "I am sending to Your Lordship the mirror, I don't know whether to say parabolic or rather, by virtue of its deformity, to call it diabolical."[39]

In the sixteenth and seventeenth centuries the most common method of making curved mirrors involved casting in metal a portion of a sphere, which would then be hammered or polished until a parabolic shape (as close as possible to the spherical section originally used) was achieved.[40] The process was rife with opportunities for error, as Caravaggio explained to Oddi in a letter of 1623. Prompted by some unspecified "doubts" expressed by Peter Linder, Caravaggio had decided to return to

> the result of the parabolic mirror, which, encouraged by my leisure, I have begun to polish, an aim which I have not, however, been able to achieve entirely, as much for the deterioration of the quality of the metal in various successive casts, as for the same deficiencies in the final cast; but truly I am hopeful of achieving a decent result if I resolve to make another, for this one, because of

the failings of the metal, has not kept well to the outline, and because it has deteriorated the resulting material cannot be polished highly; it burns, however, with a feeble brightness at a distance of more than forty inches instantly, I'm not saying a piece of wood, but other more combustible material, and this effect of burning [wood] it does at a distance of more than six inches.[41]

The technical difficulty of managing the materials thus produced a mirror capable only of rather feeble burning. In fact, Caravaggio's efforts are reminiscent of other, similar attempts to re-create the fabled mirror of Archimedes, such as the Venetian Sigismondo Alberghetti's thwarted efforts in the mid-1630s.[42] Significantly, though, Alberghetti's attempts were undertaken in the wake of Cavalieri's systematic study of burning mirrors, whereas Caravaggio's trials took place almost a decade prior to the publication of *Lo specchio ustorio*. This suggests that Oddi's mathematical circle had been especially engaged with this type of optical material well before Cavalieri's seminal publication, and that this Milanese community actively pursued the sort of optical knowledge that excited Galileo, Paolo Sarpi, Sagredo, and their friends in Venice in the early decades of the seventeenth century.[43] It is in this context that we must set the double portrait of Oddi and Linder.

DEMONSTRATIVE REASONS?

When interpreting an image such as Crespi's double portrait, it is important to bear in mind the audience for which it was originally intended. Given the painting's function as a record of *amicizia*, we may assume that its role was predominantly private in nature. This work was a collaborative effort between three friends connected by the ties that bound together teachers and students. It represents, as Michael Baxandall put it, the "deposit of a social relationship," and speaks to an intimate world of shared experience that is accessible to the modern viewer only in fragments.[44] Indeed, we are hampered in our efforts to understand precisely its meaning simply by virtue of the fact that we were not present at the lesson portrayed. Oddi did not refer to the image in his correspondence, so we lack (in contrast to his explanation, to Piermatteo Giordani, of reflection in a parabolic mirror) an exposition of the proof that the mathematician is so clearly providing to his pupil, Linder. This, coupled with the fact that the complete image survives only in a second version of the work, renders any interpretation of the painting's centerpiece—the geometrical diagram—problematic (fig. 28).

In fact (and somewhat ironically), Crespi's confident demonstration of the perspective techniques taught to him by Oddi has made our task more difficult. By foreshortening the piece of paper on which the diagram is inscribed, the artist has distorted its shape, making it hard to tell whether the figure's curved lines are

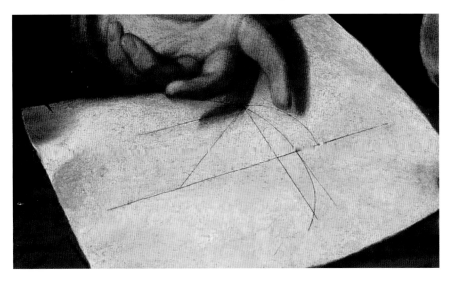

FIGURE 28. Studio of Daniele Crespi, *Mutio Oddi and Peter Linder* (detail), early 1620s. Oil on canvas. Private collection, Milan. For complete image see figure 4.

circular arcs or conic sections. Perhaps this formed part of the picture's appeal. By having the diagram set at an oblique angle, Oddi and Linder could admire their "talented" friend's skill, delighting in a visual joke in which a geometrical figure's legibility is skewed by virtue of the mathematical technique employed to depict it accurately.

The painting does, though, offer several clues that may help us understand what the diagram is intended to represent. The first and most important is the mirror in the background, positioned (like the geometrical diagram) between the two men, so presumably pertinent to their discussion. We can tell, given the shape of the reflected sliver of light at its left edge, that it is not an ordinary plane mirror but concave, although we cannot determine from its appearance whether it is a section of a sphere or a cone, nor whether it is made of metal or glass. Notably, though, the mirror is fixed at a point on each of its sides to a semicircular metal bracket, so that it may be swiveled, altering the angle at which light hits its surface. Evidently, then, this is a concave reflector devised for use in experimentation. Bearing in mind what we know about Oddi and his circle's optical interests, we may safely assume that this unusual object is no mere studio prop. Surely it indicates that the diagram the two friends are discussing relates to optical experiments undertaken by the master and his pupil in one of their *studioli*. As we have seen, at the time the portrait was painted such experiments often addressed the challenges presented by burning mirrors, but Oddi and Linder might also have been investigating reflection in general.[45] Giovanni Battista Caravaggio (who had discussed the manufacture of

parabolic burning mirrors with Linder) described the delights of such practices
in one of his letters to Oddi:

> On the variety of the images that from the same distance appear in it [a para-
> bolic mirror], to somebody who raises or lowers themselves slightly, or bends
> right or left, I joke . . . that I have discovered among the images several friends
> (I am speaking of images, not the substance of friendship), which according
> to the motions of fortune are now squashed or enlarged, now reduced, now
> elongated.[46]

The fact that the mirror in Crespi's portrait could be swiveled made it ideal
for conducting this sort of experiment. Indeed, the portrait's diagram probably
formed part of Oddi's mathematical explanation of the effects it produced (fig.
28A).

Several features of the diagram suggest that this might be the case. For ex-
ample, if arc *BCDEF* is taken to represent the curvature of the concave mirror
depicted in the painting, then line *AC* may be an incident ray parallel to the axis
of that mirror (*GH*), meeting it at point *C*. Notably, such a configuration cor-
responds approximately to the disposition of the room in which the portrait is
set, for we can tell by the fall of shadows that light is entering the room from the
left-hand side and meeting the mirror in a manner comparable to that shown in
the diagram.[47] What optical properties, though, could the diagram be intended
to show? Presumably—if line *AC* is indeed an incident ray—it is concerned with
reflection. But what is the shape of the mirror? Is it spherical, parabolic, or even
elliptical? Given that Oddi owned a parabolic mirror, it is tempting to believe
that the device shown in the painting and represented in the diagram is his own
conic instrument.[48] As he himself tells us, this object was polished on both the
concave and the convex side, so it could presumably have been adjusted like the
instrument depicted in the portrait.

If the mirror in the painting is Oddi's parabolic mirror, it would follow that
the diagram to which he gestures concerns reflection in a parabola. In fact, the
diagram in the portrait is similar in certain respects to the figure Oddi drew for
Piermatteo Giordani (fig. 27), which demonstrated—in the context of a discus-
sion about burning mirrors—how proposition II.8 of Euclid's *Elements* may be
used to prove that the distance from the vertex to the focus of a parabola is a
quarter of its *latus rectum*. If, however, arc *BCDEF* in the portrait's diagram is a
parabola, its focus is not shown, for the path of reflected incident ray *AC* can be
neither the line *CI* nor the line *CE* if the parabola's vertex is *D*. This does not, in
and of itself, mean that the diagram is not concerned with the optical proper-
ties of a parabolic mirror—the path of the reflected ray may not be indicated for
some reason—but it should prompt us to consider alternative interpretations.

The drawing instrument on which the diagram rests—a beam compass—may

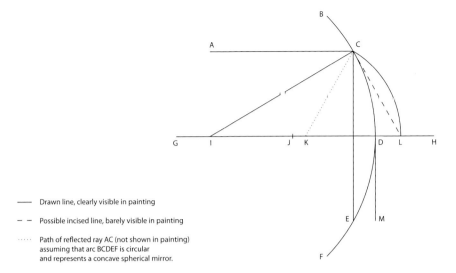

Drawn line, clearly visible in painting

Possible incised line, barely visible in painting

Path of reflected ray AC (not shown in painting)
assuming that arc BCDEF is circular
and represents a concave spherical mirror.

FIGURE 28A. Hypothetical reconstruction of geometric diagram in figure 28.

assist us.[49] As was common in these instruments, which were usually used to draw large-radius circles, the device in the portrait features movable cursors that can be slid along the beam, thus altering the radial length of the arc drawn and rendering the compass particularly useful in scaling drawings up or down.[50] The elegant metal instrument in the painting has an additional feature: interchangeable nibs and points that could be fixed to the cursors with a screw, then used for drawing lines of varying thickness, or even "invisible" construction lines. (Indeed, the portrait's diagram may include "invisible" construction lines that are not readily apparent in the painting: although it is difficult to make out, there is a very faint straight line between points C and L.) The fact that a selection of the beam compass's attachments lie scattered at the left-hand side of the desk implies that the instrument has recently been used, presumably by Oddi in drawing the diagram he is showing to Linder. While it would have been unusual to have drawn so small a diagram using a beam compass, the scattered nibs indicate that this was the case. If this is so, we may infer that the diagram displayed features circular arcs, suggesting that the mirror in the portrait might be spherical rather than parabolic, or any other shape.

Spherical reflection was not a new topic in the late Renaissance. Discussed by authors such as pseudo-Euclid, Witelo, and Alhazen, it received renewed attention in the mid-sixteenth century from figures such as Della Porta and the Venetian mirror maker and practical mathematician Ettore Ausonio, who produced an important summary of the spherical mirror's optical properties, the *Theorica speculi concavi sphaerici*. The *Theorica*, composed in the 1560s, circulated widely in

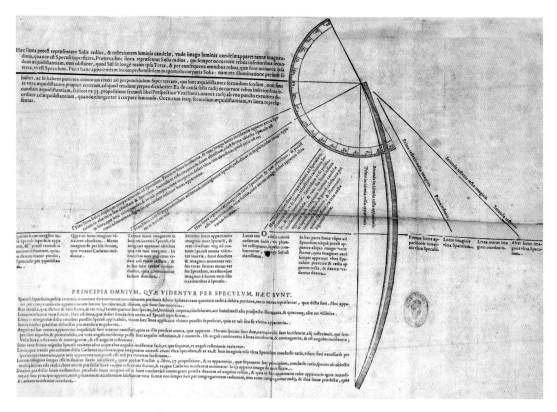

FIGURE 29. Giovanni Antonio Magini (after Ettore Ausonio), *Theorica speculi concavi sphaerici*, 1602. Biblioteca comunale dell'Archiginnasio, Bologna.

manuscript before being printed posthumously in a modified version by Magini in 1602 (fig. 29). It showed a diagram of a solar ray hitting a concave spherical mirror and located, somewhat roughly, the approximate focus (approximate because rays reflected in a concave spherical mirror, in contrast to a parabolic mirror, do not meet at a single point) and various loci of images in that mirror.[51] The figure in Ausonio's *Theorica* is strikingly similar to the diagram in the Oddi-Linder portrait, although the latter features a circular arc (*CL*) and a straight line (*DM*) that are not present in the *Theorica*, and it lacks several of the lines Ausonio used to indicate the mirror's approximate focus and the locations of reflected images.[52] In fact, if we take arc *BCDEF* in the portrait diagram to be circular, with radius *IC*, and assume that sub-arc *CDE* is a concave spherical mirror, the path of the reflected incident ray *AC* is again not shown. For if ray *AC* meets mirror *CDE* at point *C*, the angle of incidence—known from the line tangent *CL*—appears to be thirty degrees, making the angle of reflection thirty degrees also. In this mirror, therefore, ray *AC* would be reflected along line *CK*, crossing the mirror's axis (*GH*) at point *K*, which is not marked on the diagram in the painting.

However, it should be pointed out that such an interpretation of the diagram matches Oddi and his circle's particular interest in devising effective burning mirrors. For if sub-arc *CDE* represents the surface of a specific concave spherical mirror with radius *IC*, all solar rays parallel to the mirror's axis (*GH*) will be reflected so that they meet the axis between points *K* and *J*, the distance of the latter from the mirror being half the radius, which in the period was usually given—as in Ausonio's *Theorica*—as the approximate focus of a concave spherical mirror. Thus, mirror *CDE* would produce highly efficient burning by focusing a sufficient quantity of solar rays to a small space as far from the mirror as possible. Precisely this topic had been treated by the Hellenistic geometer Diocles, who provided a geometrical proof of it in his treatise *On Burning Mirrors* (although Oddi could not possibly have known this, as proposition 3, which contains the proof, was not included in Eutocius's paraphrase of Diocles, which formed part of the former's commentary on Archimedes's *De sphaera et cylindro* and had been published in the mid-sixteenth century).[53]

The specific angular section of a given sphere that Diocles describes would produce a burning mirror capable of *almost* the same effect as a parabolic reflector (in which all solar rays are reflected to exactly the same point), but—because it is a portion of a sphere—such a mirror would be easier to manufacture than a parabolic one. In fact, more than a decade after the Oddi-Linder portrait was painted, Galileo—who was particularly interested in Ausonio's *Theorica*—observed that spherical mirrors could be used to overcome some of the technical difficulties involved in manufacturing parabolic ones.[54] Writing in 1637, in response to Alberghetti's failed attempts to produce an effective parabolic burning mirror, Galileo explained:

> Concerning the parabolic mirror, I always considered it very difficult, if not impossible, to reduce it to such a shape; but if it is a spherical one and a portion of a very large sphere, the shape around its center differs so little from the parabolic one, that, since the spherical one can be built perfectly, as opposed to the parabolic one, the effect of burning would turn out to be stronger with the spherical one than with the parabolic, even though the latter joins the reflected rays in only one point, which the other does not.[55]

Thus, if the mirror in Oddi's diagram is of the Diocletian type, the portrait may show the Urbinate mathematician offering a solution to a technical difficulty encountered by members of the mathematical community, such as Linder and Caravaggio, who wished to make effective burning mirrors but were unable to master the challenge of fashioning parabolic reflectors.

Of course, we should also consider the possibility that the diagram in the painting is not a ray diagram at all. For example, if the mirror in the portrait is actually Oddi's parabolic one, it may be that the mathematician is portrayed

explaining to Linder a method for drawing that instrument's outline using the beam compass. Such an explanation is consistent with his interest in Paciotti's trammel (the "rulers" method of drawing conic sections that he explained to Cavalieri), and we may note that, in his correspondence, Caravaggio referred to Oddi's method of drawing the parabola using an ordinary compass and "supports" (*pontelli*), writing:

> I would give Your Lordship a report of the results of the parabola, if the gentleman of Lucca who had to build the small compass had given it to me several days ago, and I would discuss with you the method of handling the length of the leg of the compass without bending it, but your way of keeping that leg in the correct way by means of supports, and handling it on a plane, is very difficult, for it needs a large space in which to work. I cannot approve of this easily, because it seems to me that one can more easily achieve the same end if the leg is fixed at one end to a stable nail (at a certain height) in a wall; you then provide movement using a space which is a little bigger than the space that you need to describe the parabola, and I had the idea of using this method in order to completely avoid the reasons why the leg bends. . . . If Your Lordship does not consider this thought of mine to be good, please do me the favor of telling me. Speaking about the instrument that the Lucchese [instrument maker] is constructing for Don Gonzalo, I believe that it is his invention to make it in such a way that, while the scale of one side of the instrument moves only one degree, the index of the opposite side shows in a greater space the minutes of [that degree], and it seems to me also that one can see such an artifice very clearly expressed in the fourth problem of the first book of the *Problemi Astronomici* of Signor Guidobaldo del Monte. Your Lordship, who certainly knows what the invention of the said Lucchese is and which the problem [of Guidbaldo] is, should judge it.[56]

It is clear from Caravaggio's letter than the Milanese engineer considered Oddi an expert in instrumental techniques for drawing conic sections. He even described, in another letter, Oddi's method of drawing the parabola as "very elegant" (*gentilissimo*), and thanked his master for providing him with instructions on how to make a device that could "draw precisely the parabola" (*descrivere esattamente la parabola*), which was to be made by a master artisan of Milan.[57] However, we should treat Caravaggio's testimony with caution when attempting to interpret the Oddi-Linder portrait and its diagram. About a month after he had written to Oddi about the instrument for drawing parabolas, Caravaggio sent another, somewhat sheepish missive to his tutor:

> It is three days since I had the very kind [letter] of Your Lordship of the 17th of the last [month], through which I have been made more aware of the blunder that I made concerning the parabola. I did not realize the trouble that would

follow from believing that the parabola was the same as the circle in return-
ing to itself, and rejoining itself uniformly. Therefore I wish to know whether
the method that I used for that little parabola I sent to you is that which your
lordship showed me, or whether it is wrong in any way. I thank your lordship
for demonstrating well the weakness of my intellect.[58]

Evidently, Caravaggio had confused the parabola with the ellipse, so the instruc-
tions Oddi provided to him were probably for making a simple cross-shaped
trammel, similar to those routinely included in *stuccio* sets of instruments (see,
e.g., fig. 43).

What we can extract, however, from Caravaggio's correspondence with Oddi
is that the latter gave lessons in how to draw conic sections correctly using ap-
propriate instruments.[59] It is in this teaching context that we should set the
diagram of the Oddi-Linder portrait, whether it is concerned with reflection
or drawing or both. In *D'una nuova invenzione d'uno specchio* (the manuscript
notes on which the *Theorica* was based), Ausonio concluded that "of all these
[optical] things we have their demonstrative reasons which give the causes of all
the said appearances, but because this would be a thing of the greatest specula-
tion, it is enough for now, as I have said, to know the effects thereof."[60] Crespi's
portrait clearly shows Oddi explaining to Linder "demonstrative reasons" of
this very nature, with the aid of a diagram that had been made using a beam
compass. Given the mirror in the background of the portrait, the effects of light
reflected in this instrument must have been the basis for their mathematical
discussion. Indeed, we may well suspect that Oddi used the mirror and the "ap-
pearances" it produced as a means of encouraging mathematical curiosity in his
pupil. Certainly, Caravaggio's description of the pleasure he derived from optical
experiments—distorting his own facial features in a parabolic mirror—indicates
that this type of practice could be jocular as well as serious, rewarding the senses
as well as the intellect.[61]

The Oddi-Linder portrait is, then, a rare representation of mathematics at the
very moment of its dissemination, illustrating the process by which observation
progressed to representation and explanation. Indeed, given the relationship
posited in the image between mathematics and sensory data produced through
the manipulation of instruments, the portrait places Oddi and Linder squarely
within contemporary scientific culture. By experimenting with the optical prop-
erties of a given instrument, then using mathematics either to demonstrate the
results obtained or to explain how the instrument used could be drawn and
made, the two friends echoed the activities of scores of other figures involved
in mathematization.

Notably, the portrait reminds us that this process took place within a culture
that was oral and personal as well as printed and distant. Like so many over-

looked or undocumented practitioners of the age, Oddi never committed his optical work to print, confining his discussion of this topic to a small group of intimates. Of course, there is no evidence in the mathematician's papers to suggest that his optical work was sufficiently systematic or extensive to justify a publication, which (as we shall see in part III) took considerable time, effort, and funds. However, and just as importantly, it is a mistake to assume that publication was the ultimate goal of every ambitious practitioner of the period. Print could certainly result in success and recognition, but sharing mathematical knowledge in the late Renaissance was often governed by subtler, less immediately evident (but not necessarily less rewarding) concerns, such as the obligation of service demanded by friendship or patronage, which did not need to translate into the public spectacle of book production.[62]

Indeed, Crespi's portrait affirms, much like the manuscript evidence for Oddi's teaching, that publication was by no means the sole engine for the dissemination of mathematical knowledge at the time. In dozens of *studioli* across Europe, individuals such as Oddi shared with their friends and patrons modern, practical mathematical knowledge, using instruments that—like the records for so many of these cases—are now lost. Thus, the Oddi-Linder portrait is a fortunate survival: a mirror that reflects brightly those social and material aspects of late Renaissance mathematical culture that have become, over time, dim and obscure, but which were fundamental to the expansion of the mathematical community, the transmission of mixed-mathematical knowledge, and to processes of mathematization.

Several valuable conclusions may be drawn from the painted and manuscript records of Oddi's teaching that we have explored in this and the preceding chapter. First, in addition to providing new and specific evidence about the content and contexts of mathematical education in the period, the documents and the portrait tell us something about the profession—if it can be dignified with such a name—of informal mathematics teaching. In Oddi's case, teaching mathematics was not sufficient to forge a successful career. Instead, all the available evidence suggests that he taught mathematics to supplement his income, to enhance his prestige (and that of his *patria*), to establish and maintain friendship networks, and to provide himself with patronage opportunities for other professional activities, some, but by no means all, of which were related to mathematics. In this regard Oddi's evidence is consistent with what little we know about other instances of informal mathematical tuition in the period, such as the teaching undertaken by Galileo. Furthermore, Oddi's records indicate the extent to which informal mathematics teaching could be tailored to meet the individual requirements of pupils rather than offering a prescribed curriculum. The variety of payments and gifts Oddi received support this view, demonstrating that different

kinds of teaching merited different rewards, although this also depended upon the type of pupil being taught.

Finally, the evidence of Oddi's teaching provides a glimpse of the ways in which mathematics and material culture were becoming intertwined in the early seventeenth century. The mathematics Oddi taught could be applied to instrumental techniques useful in the world of action, but the material culture of mathematics was also abundantly present—as the double portrait shows—in the more contemplative lessons of the *studiolo*. Objects were not only the focus *of* study but were also used *in* study—to produce effects that could be assessed mathematically, and in the geometrical work necessary to undertake such analyses effectively. In the next section, we shall examine the workings of the economy in which these objects circulated: the late Renaissance instrument economy.

Consuming Mathematics

Outside the walls of the universities and the court, the acquisition of mathematical knowledge was bound up with what was—traditionally, at least—that most vulgar of worldly activities: commerce.[1] Across Italy, in market squares, workshops, and even gentlemen's houses, mathematics was hungrily being consumed by a swiftly expanding public eager for its material manifestations, which came in two principal forms: books and instruments.[2] The two were closely intertwined—so much so that it is difficult to say whether the flourishing trade in instruments encouraged the production of instrument books or vice versa.[3] Regardless, it is clear that both responded to the growing demand for devices that could be deployed in the practical mathematical subjects taught by figures such as Oddi, and that working in one domain usually signaled some form of involvement in the other. Indeed, Oddi himself published several instrument books, all the while acting as a broker in the trade of the types of artifacts his works discussed.[4]

In a fiercely competitive patronage environment and equally challenging market—for the volume and range of books and goods available to consumers grew exponentially in the sixteenth century—bundling together similar, mutually enhancing services and objects was a sensible strategy.[5] Oddi was not alone is recognizing the opportunities inherent in conjoining the instrument and book trades. Many booksellers sold instruments in their shops, and it was common to find mathematical instruments advertised in printed tracts that described their manufacture and operation. Put simply, the joint-promotion of instruments and books about them was a marketing strategy consciously employed by those with a vested interest—whether intellectual, commercial, or social—in encouraging the spread of practical mathematics. The stakeholders, like the products concerned, varied in terms of profession and motivation, but they shared a commitment to the promulgation of mathematics in a material, saleable form. Thus, what we might call the "instrument economy" brought together teachers, mathematical practitioners, merchants, and artisans in a new configuration capable of taking advantage of the growing consumerism evident in the late Renaissance.

Oddi's engagement in this instrument economy provides an ideal opportunity to explore what Karl Polanyi has called "patterns of integration," that is, the mul-

tiple, frequently overlapping ways in which goods and services are exchanged in societies.[6] Indeed, in charting the means by which instruments and instrument books were produced and distributed in Oddi's world, we may perceive not only the complex processes that lay behind the dissemination of mathematics in materials, but also how a particular kind of scientific economy was integrated into wider patterns of labor, consumption, and credit in a rapidly changing society. For although neither the instruments Oddi handled nor the books he authored were especially novel, his case is rare in that it permits us to peer behind the scenes of mathematical practice and uncover the networks that made up the instrument economy of late Renaissance Italy—a tangled web of gifts, countergifts, and cash transactions between artisans, agents, businessmen, patrons, clients, and friends, in which the strength of instruments as currency is readily apparent.[7]

Mario Biagioli has observed that scientific networks of the late Renaissance were "often embedded in noble patronage," and much work has been undertaken on the relationship between practitioners of science and their (usually) socially superior supporters to show the ways in which the production and reception of knowledge was influenced by perceptions of hierarchy and the obligations of etiquette.[8] These networks are often characterized as operating via a gift economy in which honor and social status are preserved through the avoidance of base cash transactions and reliance on brokerage or indirect exchange. We have already touched briefly on this type of exchange in the context of Oddi's teaching—as we have seen, he received varied noncash rewards from his students. When it came to books and instruments, Oddi participated vigorously in gift-giving himself. Indeed, his papers allow a detailed reconstruction of how a middle-ranking mathematical practitioner sought to navigate the delicate—and potentially perilous—gift economy using the books and instruments at his disposal. His account books and correspondence also cast a spotlight on parts of this world that are normally hidden from view: namely, the activities of lower-register players such as instrument makers, printers, and booksellers, and the ways in which their economy intersected with the higher register of the socially elite via the agency of middle men.

The chapters that follow, then, are in essence a microhistory of the instrument economy, tracing the movement of mathematical goods and services and the currency, whether cash or credit, that flowed between the individuals involved. While it would obviously be an exaggeration to claim that the entire edifice of the scientific enterprise of late Renaissance Europe was built on such transactions, these small (and at first glance deceptively trivial) exchanges enabled the gradual move to a more mathematical, more instrumental society. They constitute the fine grain of making knowledge in a world of markets and materials, and it is only by recovering them that we can properly appreciate the interconnectedness of epistemic change and the ever-enlarging world of goods in processes of mathematization.

Practical Mathematics in Print

In the late summer of 1601 Oddi, then in hiding in Venice, wrote an agitated letter to his father, Lattantio. On the run from the ducal authorities and lamenting his predicament, Oddi's short epistle is concerned mainly with where he might find a safe haven, but his mind was evidently fixed on the possessions in Casteldurante that he had been forced to abandon by his rapid flight. "Please keep safe everything in that place," he asked urgently, "and especially my books."[1] Books, like instruments, were firmly at the heart of Oddi's world; indeed, his correspondence is replete with notes on works read, bought, or sought.[2] In addition to assembling a large library of mathematical texts—which included treatises by the likes of Regiomontanus, Cardano, Magini, and Galileo—he read widely on topics outside his own areas of expertise, from the poetry of Petrarch and Boccaccio to Cervantes's *Don Quixote*, historical works by Guicciardini to tracts on statecraft by Botero.[3] Moreover, Oddi was acquainted with several noted literary figures of the age, such as Gian Vincenzo Imperiale and Francesco Birago, so his social circle (at least in Milan) was a lively mix of mathematicians, artists, and literati.[4]

In this bookish world, print was a medium through which mathematicians could establish reputation, assert authority, and disseminate knowledge, while as tangible things mathematical books could be used as gifts to develop patronage relationships and friendships.[5] Of course, manuscripts by no means lost their currency following the invention of the printing press. Oddi himself amassed a significant manuscript collection, and we should not forget that correspondence—not to mention conversation, as we have seen in the Oddi-Linder portrait—was a vital means through which mathematics could be communicated.[6] Nevertheless, printed books, and in particular works in the vernacular, were a defining feature of mathematical practitioners' culture. This was certainly the case for Oddi, given his upbringing and education. Although the Duchy of Urbino was not a major center of printing, it had long enjoyed a reputation as a great seat of learning focused on the written word.[7] Since the days of Federico da Montefeltro, the Ducal Library had been regarded as one of the finest collections of books in all Italy, if not the world, and during Oddi's lifetime the scholarly Duke Francesco Maria II della Rovere enriched its contents by acquiring

the latest scientific works.[8] More particularly, Oddi's mathematical grandfather, Federico Commandino, had been in the vanguard of publishing new, scholarly editions of ancient mathematical texts—he even installed a press in his home to see through his ambitious project of restoring mathematics through the medium of print.[9] Likewise, Oddi's teacher, Guidobaldo del Monte, was a renowned author—his *Mechanica* and *Perspectivae libri sex* were landmark publications in the mathematical arts.[10] Oddi inherited from his master an impetus to publish, but while he retained Guidobaldo's mathematical rigor, the books he produced were significantly different to those of his tutor.

DEMOCRATIZING THE RENAISSANCE OF MATHEMATICS: INSTRUMENT BOOKS AND VERNACULAR PUBLISHING

All of the works that Oddi wrote belong to a clearly recognizable genre: the instrument book.[11] Instrument books came in many guises. Some, such as Tycho Brahe's *Astronomiae instaurata mechanica* (1602)—a work Oddi admired greatly—were lavish, folio publications, written in Latin and replete with fine copperplate engravings.[12] By the early seventeenth century they tended, however, to be modest products, written in the vernacular and of a quality that rendered them affordable to the increasingly wide cross-section of society that purchased them—a group that included artisans as well as gentlemen.[13] Oddi's publications are entirely of this kind. Although the frenetic nature of his employment in Milan and a heavy workload as fortifications engineer in Lucca prevented him from publishing as much as he might have liked, he managed to produce four instrument books during his lifetime: *Degli horologi solari* (1614), *Dello squadro trattato* (1625), *Fabrica et uso del compasso polimetro* (1633), and *De gli horologi solari* (1638), this last book being a revised and expanded version of his first treatise.[14] In addition to these texts, he published, in 1637, a pamphlet called *Risposta . . . ai dubbi di Rafaello Grimani*, which was a brief rebuttal of an Orvietan mathematician's claim to have discovered errors in his work on dialing.[15] He also, as a memorial to his brother (who died in the summer of 1626), edited some of Matteo Oddi's papers to produce the *Precetti militari* (1626), a slim volume of precepts relating to the arts of war, which was seen through the press by his friend and pupil, the art agent Ercole Bianchi.[16]

While practical mathematical content did not prohibit writing in Latin (Clavius, for example, published exclusively in that tongue), Oddi's choice of Italian for his works accords with a general trend observable in Italy from the publication of Pacioli's *Summa de arithmetica, geometria, proportioni & proportionalita* (1494) onward: the increasing acceptance, not to say prevalence, of the vernacular as a suitable vehicle for the dissemination of practical material in print.[17] Oddi was a perfectly competent Latinist, so his decision to publish in

the vernacular—a rare departure from the traditions of the Urbino school—was a clear statement of intent that warrants investigation.[18] A brief episode from his life as an author will help us to understand why he deviated from the principles of Commandino and Guidobaldo, despite the fact that, for certain of his countrymen, such a move risked undermining the foundations of the status he and his forebears strove so hard to achieve.

In the "letter to the reader" of his first book on sundials, *Degli horologi solari*, Oddi calls the treatise an *opusculo*, a "little work," explaining that another, longer treatise "full of the same material" but dealing also "with curved [dials], both concave and convex; and the making of many others, including those which are called *Mobili* or *Viatorij*," had for the moment been withheld from the press.[19] The letter does not state exactly why the longer text was not published in 1614, but his correspondence provides an explanation. The first, simple reason was expediency. As we have seen, in the early years of his exile in Milan Oddi worked furiously to reestablish himself in society. The pressures of a highly diversified portfolio of jobs strictly limited the spare time available for writing, and Oddi—well aware of the credit that could accrue from publication—was eager to see his work in print. The second, rather more intriguing reason stemmed directly from his program to enhance the fame of Urbino's *uomni illustri*, for Oddi initially intended to include in his first book some of Guidobaldo del Monte's unpublished mathematical work. In particular, he wanted to put forth Guidobaldo's geometrical explanation of how refracting dials—such as the instrument discussed in chapter 1 (fig. 7)—actually worked. This was clearly intended as an Urbinate mathematical counterblast against what Oddi called the "mere practice" to which the manufacture of such instruments had lamentably been reduced, but one that deployed the language of practice—the vernacular—to achieve its aims.

Guidobaldo himself seems to have planned to publish some of his minor works (which included a now lost treatise called *De radiis in acqua refractis*, presumably the tract Oddi intended to use) together in a single volume. His son, Oratio, revived this idea shortly after his father's death, writing to Guidobaldo's protégé Galileo in June 1610, in the hope that the distinguished mathematician might be able to help with the publication.[20] Oddi, though, was anxious about Oratio's plans (and may have been irked that Oratio approached Galileo rather than him), writing to Guidobaldo's friend and mathematical collaborator, Piermatteo Giordani, in the late summer of 1612:

> Your Lordship's letter has taken a real weight off my mind, namely the concern I had that those signori del Monte, guided only by high esteem for the profound knowledge of Guidobaldo, of blessed memory, and desirous only of fatherly glory, mightn't persist in wanting to publish his minor works. For truly, although they are about fine and beautiful things, which would make

the world a better place, I do not think that published *ex professo* they would add either honor or credit to him, for there are other things published by him that are serious and on important subjects, and of greater weight than these. I am not saying that the other things should be left dead and buried, but they could be published with some inventiveness [*con qualche inventione*]. I, in my book on sundials, am inserting two, and I showed them to signor Oratio last year when he was in Milan.[21]

The works in question were, as Oddi went on to explain, Guidobaldo's demonstration of an obscure but ingenious method of constructing meridian lines (devised by the ancient author Hyginus) and a text on the mathematical principles of the refracting dial. Publishing the former (which in fact makes a brief appearance in *Degli horologi solari*), was not a problem because, as Oddi noted, "in this [demonstration] I have followed neither the ordering nor the words of the said signor [Guidobaldo], I have only availed myself of the angles for the demonstration and the invention of those triangles for adjusting my proposition."[22] The explanation of how the refracting dial worked was, however, more problematic, since Oddi apparently wished to quote Guidobaldo verbatim:

I have thought about publishing this little work in my book since [my time in] Loreto and I wrote to signor Guidobaldo about it, and among my papers there will be the reply in which he gives me permission [to publish it] . . . :

"Guidobaldo del Monte to his Mutio,

The interest that I have seen you take in the dial with rays refracted in water, which I invented for our most serene patron, has moved me to send you the little work I wrote about this subject. I hope that you will appreciate it, and because of the material which it treats, and the affection I hold you in, I am giving it to you. Read it and, if you wish to, share it with [Simone] Barocci, or with the other learned men of your *patria*, and stay in good health."

. . . or something similar as thought best by Your Lordship, by those signori [del Monte] and by signor Capi.[23]

Unfortunately, Guidobaldo's letter itself could not be found, as Oddi explained in his next missive to Giordani:

My brother wrote to me some time ago that, despite all his diligence in searching for the letter that signor Guidobaldo, of blessed memory, wrote to me at Loreto, concerning the printing of his little work on the dial with rays refracted in water, he has not been able to find it, and I, not wanting to be out of favor with his sons, have totally dismissed the thought that I had about it. I could not imagine what could possibly have moved them to this position, and what

detriment they think can be caused to the fame of that gentleman by print-
ing and reprinting his works in diverse languages. Speaking to signor Oratio
when he was in Milan, he presented no obstacle except he asked me to put
"de' Marchesi del Monte" so that nobody would think that it was by anybody
else—"ex Marchionibus Montis." . . . In the next few days I am printing Hy-
ginus's invention of the meridian line, in a very little work that I have written
about plane sundials, without asking for another license from [Guidobaldo's]
sons. I will not refer to the words of the said gentleman, but instead write the
following . . .[24]

Oddi, anxious to preserve his *amicizia* with Guidobaldo's heirs, was thus evi-
dently forced to withold the marchese's geometrical explanation of refracting
dials, even though this hampered his efforts to embellish his erstwhile tutor's
reputation.[25]

This minor spat with the del Monte family is revealing for what it tells us about
where authority and credit rested—or was seen to rest—in publishing practical
mathematics, while highlighting also the anxietites about the vernacular that
persisted in certain sections of society. Notably, Oddi made a distinction between
availing himself of the results of Guidobaldo's research, in his account of the
Hyginus method, and quoting his master word for word, in his explanation of
refracting dials. In both instances, the gentlemanly code of conduct demanded
that due credit be given to Guidobaldo, yet while in the former case this could
be achieved simply by noting that the results were his, in the latter formal per-
mission was required. Thus, Oddi's loss of the letter from Guidobaldo that, in
his account, granted this permission opened the door to a dispute over what
kind of authority was required to publish the marchese's *opuscoli*. Guidobaldo's
children evidently believed that they owned the intellectual property rights to
their father's work—as well as physically possessing his manuscripts—because
they were his genetic heirs. However, Oddi, Guidobaldo's pupil, cast himself as
the marchese's true *intellectual* heir, implying that he alone had the requisite
mathematical skills to present the master's accomplishments properly.

Oddi was convinced that Oratio and his siblings would damage Guidobaldo's
reputation if they published his writings "*ex professo*" and without "inventive-
ness." That is to say, he believed that a proper elucidation of the mathematical
content of Guidobaldo's work was far more important than the format in which
it was presented, equating the preservation of status with *inventione* above all
else. Additionally, given that Oddi intended specifically to use Latin ("ex Mar-
chionibus Montis") for the permission that Oratio del Monte requested, it seems
he was sensitive to the issue of the language in which Guidobaldo's works were
to be published. This was a topic which—as Mary Henninger-Voss has amply
demonstrated—exercised Guidobaldo del Monte especially. During his lifetime,

the marchese had been fixated on the notion that publishing in ancient languages was most appropriate for a man of his aristocratic status and humanist pedigree.[26] Although Oddi's sole aim was, as his letter implies, to increase the fame of his master by "printing and reprinting his works in diverse languages," there seems to have been a lingering concern among Guidobaldo's progeny that their late father's work would be demeaned by being published in the vulgar tongue and in a format—a modest instrument book—unbefitting his high status.

This does not, however, appear to have bothered Oddi, or indeed another member of the Urbino school, Bernardino Baldi. In the late sixteenth century Baldi—also one of Guidobaldo's pupils, possessed of impeccable scholarly credentials, and, as Abbott of Guastalla, a member of the social elite—was quite unabashed to publish a vernacular translation of Hero of Alexandria's treatise on automata.[27] Oddi, described in his will as a "nobleman of Urbino," was similarly at ease in using Italian for his mathematical work. Indeed, it might be said that the dissemination of scientific knowledge in the vernacular was a defining feature of Urbinate science in its late period—a democratization of the Urbino school's renaissance of mathematics.[28] For Oddi, this was part and parcel of his role (both self-crafted and imposed on him by the circumstances of exile) as a "go-between," bringing mathematics to a wide cross-section of society, to individuals of varied professions and differing competences.[29] Yet while his deployment of the vulgar tongue could open up certain types of mathematical material—such as Guidobaldo's work—to new strata of society that were not learned in Latin, at the same time it restricted it geographically by abandoning the international language of scholarship.

In a classic study of the development and impact of printing in early modern Europe, Elizabeth Eisenstein highlighted this very dichotomy. Writing about a rather amorphous genre that she dubbed "technical literature," Eisenstein observed that publishing in the vernacular

> often owed much to an insular, patriotic outlook.. . . It was partly propelled by the desire to profit from an invention or an instrument that could be bought at a given author's home. Nevertheless vernacular science-writing enlarged and democratized the Commonwealth of Learning. It extended the range of talents that were tapped, linked instrument-making with mathematical theorizing and helped to propel data collection in many new directions.[30]

Despite this passage's broad brushstrokes, and bearing in mind the major problems inherent in many of Eisenstein's assumptions about print culture as a whole, these assertions ring true for Oddi.[31] His vernacular writings were directed firmly toward Italians, they were linked to profit from teaching and the distribution of instruments manufactured in his homeland (if not his actual home), and his papers—as we shall see when we come to look at his treatise on the *squadro—*

offer direct evidence for an audience of readers more diverse than could have been expected a century earlier.

One of the reasons that vernacular texts, such as Oddi's, in the instrument book genre found such a wide readership is that they brought together different types of mathematical material, eroding status barriers and, perhaps most importantly, entangling text with objects. Oddi's works on sundials are a case in point, for although gnomonics had a classical—not to mention Urbinate—pedigree, it was a subject in which theory and practice, and ancient and modern learning, fruitfully coalesced.[32] Of course, gnomonics had been a mainstay of late medieval and Renaissance mathematics, for it presented intriguing geometrical challenges considered worthy of high scholarship. In addition to Commandino's *De horologiorum descriptione* (1562), for example, celebrated mathematicians such as Benedetti and Clavius published major Latin works on the subject.[33] During the sixteenth century, however, there developed also a large vernacular literature on dialing, which ranged widely in terms of scope, mathematical content, and production values. Such works formed part of a remarkable surge of innovation in practical gnomonics that witnessed the design and manufacture of dozens of new types of dial, retailed in what was undoubtedly the largest section of the mathematical instrument market.

In his books on dialing, Oddi—who, as we shall see, made sundials as well as writing about them—carefully negotiated between theory and practice, and between words and things.[34] He demonstrated that gnomonics was a subject worthy of wide interest by carefully unfolding for his Italian readers not only the ways in which different types of dial could be constructed and operated but also their sound mathematical principles. In doing so, he managed to bring the intellectual concerns of the Urbino school to a new audience without diluting the caliber of that group's scholarship. Indeed, the main virtue of Oddi's books was that they explained, patiently and lucidly, the mathematics of instruments, providing clear instructions on how to make and operate such devices while at the same time offering rigorous geometrical exercises backed up by classical erudition.

Oddi's treatises were thus, in a sense, a bridge between the study and the workshop, between the humanistic, Latin scholarship of figures such as Commandino and Guidobaldo and the manual skill of the artisans in Urbino's Officina di strumenti matematici. As such, they appealed to a highly diverse audience: they could be read by practitioners wishing to learn about the geometry on which their art rested or by mathematicians seeking advice on how instruments were made and used; they were attractive to the *virtuosi* who collected mathematical artifacts, satisfying their curiosity about how instruments functioned, and to military men eager to gain an advantage on the battlefield. Even the manufacturers of instruments benefited from his publications, for Oddi published *Fabrica et uso del compasso polimetro* especially for the master instrument makers of Urbino.[35]

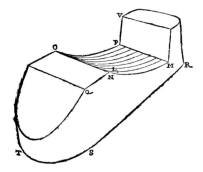

FIGURE 30. "Shoe" sundial, from Mutio
Oddi, *De gli horologi solari*, 1638. British
Library, London. Shelfmark 536.e.27.
© British Library Board.

Writers such as Oddi were instru-
mental in tranforming mathematics'
reputation by trading on its material
associations, helping to turn it from
what many perceived as a laborious,
fussy, and abstract discipline into a
useful form of tangible knowledge
that could please the senses through
its artifactual manifestations.[36] For
instance, in his books on dialing
Oddi encouraged his readers to ex-
plore the mathematical principles
of devices familiar to them in their
everyday lives (i.e., sundials) for both
profit and pleasure. As Sara Schechner has observed in an important article on
the material culture of astronomy in daily life, although they were the standard
time-telling devices of the age, sundials were not sought simply as utilitarian
objects:

> People acquired sundials, like other consumer goods, for many reasons: be-
> cause they needed or desired them; or because the goods had symbolic value
> or projected a particular image of their owners. As material goods, sundials
> offer instances of social hegemony, class structure, and regional taste. Their
> diverse mathematical forms and designs reveal how people spent their time
> and the degree to which religion and politics were valued.. . . Mathematicians
> designed and instrument makers produced sundials to serve and please cus-
> tomers. These three groups—mathematicians, makers, and consumers—were
> not in mutual isolation. Material culture was the link between theory, produc-
> tion, and consumption, and it sheds light on all.[37]

Sundials came in all shapes and sizes, from simple "plane" dials, such as those
treated in Oddi's first treatise, to multifaceted, curved, irregularly shaped, and
ring dials, many examples of which are discussed in *De gli horologi solari* (1638)
(fig. 30). Devising novel and versatile (yet still accurate) dials was considered a
virtuosic demonstration of mathematical *ingegno*, while the correct presentation
of the often complex geometry through which such devices functioned showed
mental acuity and intellectual rigor—hence Oddi's eagerness to present Guido-
baldo's work in this field.

It is important to note that just as Oddi's diverse audience was keen to explore,
make, and practice mathematics through instruments—objects that could be
handled and coveted—so too it was sensitive to the material qualities of instru-
ment books. For while Oddi's correspondence conforms to a familiar picture of

print as a bearer of knowledge, it also emphasizes forcefully the fact that books were things to be consumed, along with all the delights, disappointments, and challenges associated with the late Renaissance world of goods. Oddi's mathematical circle—many of whom were ardent bibliophiles—corresponded regularly on topics such as the look and feel of this or that edition, how good or bad the printing was, which characters or method of illustration had been used, when a work might be published, how much it might cost, which bookseller had copies available, and so on.[38] These material aspects of the book world form the backbone of the remainder of the present chapter. Although Oddi's case offers little to alter or enhance our image of what kind of knowledge was disseminated through mathematical books in the period, it does permit a detailed view of those factors without which they could not have been circulated at all—namely, the economy of production and distribution.

BETWEEN *AMICIZIA* AND *AFFARI*

This economy was not merely financial, it was also social. Sourcing books, for example, was a typical gesture of *amicizia* in the Republic of Letters, not to mention a necessary service given the still-local nature of the book trade, even when the impact of international markets such as the Frankfurt Book Fair is taken into account.[39] Moreover, it was common to rely on friends and acquaintances in the business—the *affari*—of book production, calling on them to aid in laborious jobs such as editing and proofreading, or even enlisting their help in the day-to-day transactions with printers necessary to ensure the swift progression of a given work's production. For example, Peter Linder saw Oddi's *Compasso polimetro* and *De gli horologi solari* through the press, in Milan and Venice respectively, although, as their author discovered, publishing at a distance was not always a smooth operation.[40]

In November 1636 Linder wrote to Oddi with an update on the printing of the sundials treatise:

> On my return from the villa, where my fondness for planting and other matters kept me longer than I thought, I found the books had arrived along with the crucifix dials.. . . I also found two printed folios enclosed, and in future I hope that the printing will be expedited, as regards the figures, which cause me to worry that they will not be as sharp as you should like, but in correcting [the proofs] many that I have marked are missing. In any case, I hope that Your Lordship will be pleased with it—if the manuscript is not flawed then the printing will be adequate, besides the Greek, which I doubt will be understood either by me or the printer. My hope that some nobleman would like to undertake the corrections proved to be in vain. I did not find them to be interested, and those who are are so occupied with other matters that they cannot help.[41]

Evidently, tardiness in the printing house, insufficient linguistic aptitude on the part of both printer and merchant, and the unwillingness of classically learned noblemen to undertake corrections to the Greek letters of the diagrams, were delaying the production of Oddi's work.

In fact, the situation deteriorated rapidly, as Linder reported in February 1637:

> Among all of the printers to be found here, master Ginami is the most suitable for printing Your Lordship's book, such are the works printed by him. As for the grace and civil manner of the fellow, besides the printing, his profession is that of a stationer, and unless I am deceived, and ultimately he is misleading as a man, he is no longer able to stand the impertinence of his workers in the printing house, and he has dismissed them all in one day. . . . In case Your Lordship should dismay about this, I hope that next week, by way of Father Fulgenzio [Micanzio] the Theologian of the Republic, and a very learned man, to have found a way to bring it to completion.[42]

The manner is which Linder chose to frame this potentially disastrous news is notable. By casting the printer Ginami's sacking of his entire workforce—which effectively brought the production of Oddi's book to a halt—as a matter of honor, he placed the bad news within a gentlemanly context of propriety that it was difficult for Oddi to criticize.[43] As Linder had initially selected and recommended Ginami to his friend, he was responsible for the stationer's shortcomings, thus entangling *amicizia* with *affari*. The merchant's explanation of Ginami's motivation allowed him to save face, while his swift solution of the problem preserved his friendship with Oddi—notably, by trading on his friendship with another man, the resourceful Micanzio.

Linder's letters to Oddi serve to indicate how the wider community that made up the Republic of Letters operated when it came to book production.[44] But the friendship on display in making *De gli horologi solari* is equally evident when we turn to the distribution of Oddi's works. Despite the obvious importance of such transactions for the history of premodern mathematics, surprisingly little casework has been undertaken to establish precisely how, by whom, and for whom practical mathematics books were produced in the sixteenth and seventeenth centuries.[45] As with teaching and the instrument trade, this is largely due to the paucity of surviving evidence. Biographical information about the authors and printers of such works is often scanty, while evidence about the expenses and labor involved in producing the books rarely survives. Likewise, library lists for a large portion of the audience for these treatises are scarce, and only a highly fragmentary reception history can be constructed from occasional ownership inscriptions in extant copies.[46] Oddi's case is very different, for his papers provide information not only about the making of instrument books, but also about

their audience. His records—in particular those for *Dello squadro*, discussed below—show that although a portion of the print run of his works was sold on the open market, many copies of his books circulated as gifts within a carefully determined but diverse group of friends, pupils, and patrons, reinforcing the significance of friendship for this aspect of mathematical culture.

The status and occupation of the individuals who received Oddi's books ranged widely, from illustrious aristocrats to humble artisans, ambassadors to engineers.[47] Accordingly, the motive for the gift varied according to the recipient, but it is clear that his publications should be thought of as essentially local in scope and personal in intent rather than as trade-oriented treatises produced for international consumption and maximum cash profit.[48] A case in point is Oddi's first book, *Degli horologi solari*—the work that was to feature Guidobaldo del Monte's explanation of refracting dials. Having drafted the treatise in prison, Oddi turned his thoughts to its publication almost as soon as he was released, writing to a family friend, Hippolito Capi, in November 1610:

> I have received at last from the messenger Your Lordship's parcel, with the corrections made to my little book on sundials, which I have not yet been able to attend to properly as I no longer have the treatise to hand, having asked signor Camillo Giordani to make a copy.[49]

By January 1614 printing had begun, as Oddi explained to Camillo's uncle, Piermatteo: "Currently five folios have been printed, and I hope that by the beginning of Lent the whole thing will be done, and I shall *send many copies to be given to friends*."[50] Evidently, Oddi intended his book to be an Easter present, conforming to the custom of giving gifts on or around important dates in the ecclesiastical calendar.[51] Indeed, the book was published in March, and by the end of that month copies were winging their way toward Oddi's friends in the Duchy of Urbino, helping to maintain his scholarly and emotional ties to his *patria*.[52]

The most important recipient of the book, though, was its dedicatee, Count Teodoro Trivulzio—a particularly influential supporter of Oddi during his first years in Milan, and one of his first pupils in mathematics. Given, as Oddi noted in his dedication, the count's "diligent and very assiduous" studies in mathematics and his "expression of great interest . . . in that part of [mathematics] called gnomonics," the author could be confident that the intellectual content of his book would be well received, which indeed it was.[53] Trivulzio even demonstrated his glad acceptance of the dedication by permitting a woodcut of his family arms to be inserted at the beginning of the book, displaying in a bold, visual form the work's noble *imprimatur*. The timing of Oddi's dedication seems to have been carefully calculated, for in Lent of 1614 he hoped to "stay in Milan . . . and begin to make the Count's *palazzo*."[54] The dedication, then, must have been intended to seal the commission for potentially lucrative architectural work, highlighting the

fact that publishing was often intimately connected with professional advance-
ment in spheres only loosely related to a given book's content.

Oddi thus sought to build on a patronage relationship already carefully es-
tablished through teaching and other small services. Even though the gift was
not entirely successful—in the end the count gave the building work to someone
else—the dedication did produce a reward, for on 16 March 1614 Oddi noted
that Trivulzio had agreed to reimburse him for all of the costs he had incurred
in producing the book.[55] Although this might appear a magnanimous gesture,
Trivulzio was in fact merely obeying the rules of *amicizia* by providing a typical
countergift. His gift, moreover, sharply distinguished between the respective so-
cial status of the two men: the mathematician presented the count with a noble,
scholarly object, but he was effectively rewarded with cash.[56]

What, though, did Oddi's money buy him? The 338 *lire* he spent on producing
the book resulted in a decidedly modest work—a small quarto, just over a hun-
dred pages long and illustrated throughout with woodcut diagrams, the cheap
alternative to copperplates. Undoubtedly, Oddi's straitened financial circum-
stances were partly to blame for the comparative mediocrity of his product, but
he was also affected by the place in which he published. In the early seventeenth
century, Milan's publishers were relatively few in number, mainly producing
religious works that reflected the city's status as a bastion of the Counter-Ref-
ormation Church. Indeed, it has been estimated that at its peak, in the second
half of the sixteenth century, Milan boasted no more than thirty printing shops,
compared to between fifty and seventy-five in cities such as Paris, Antwerp, and
Venice.[57] In fact, the small scale of the Milanese print trade combined with fi-
nancial stringency forced Oddi to employ what he considered to be substandard
workmen, as he explained to Camillo Giordani:

> Concerning that which I have written in *Horologi solari*, it is important to note
> that the engraver is a half-peasant from Varallo who barely knows how to read,
> and therefore he has made many errors in the lettering [of the diagrams].[58]

Likewise, the artisan Oddi chose to print his work—one Giacomo Lantoni—was
only just embarking upon his career in 1614; indeed, *Degli horologi solari* seems
to have been his first independent publication. We may assume that, in his ea-
gerness to compete for business, Lantoni offered Oddi (who was eager to keep
production costs down) a good deal.[59]

A MICROHISTORY OF MATHEMATICAL PUBLISHING

Oddi's selection of Lantoni as printer serves as an important reminder that in
publishing their works late Renaissance mathematicians became enmeshed in
the volatile world of business, and hence of money. Making and distributing

printed books in the late Renaissance required a range of materials and special-ist skills, all of which had to be negotiated and purchased. Indeed, the financial constraints of a given author or the perceived market for a certain type of publi-cation significantly affected the format in which knowledge was presented and, consequently, transmitted. When assessing how mathematics was disseminated in Oddi's age it is thus essential to keep in mind Ian Maclean's observation that "it is traditional to assume that ideas emanating from scholars are freely received and exchanged; but these ideas are communicated in the material form of books, by a process which involves money at all levels."[60]

Studying the financing of Oddi's instrument books enables us to capture, in a very precise fashion, not only the intersection of ideas and commerce but also interactions between scholarship and craft. This financing falls into three main categories: materials, labor, and distribution, which were associated with a range of distinct but interrelated trades, including papermaking, engraving, printing, and bookselling. Because the book trade was a world of collaboration and sociable commerce, frequent, direct contact between authors (or sometimes their proxies, as was the case with Linder) and the artisans and businessmen involved in making and selling their books was not uncommon. In tracing the flow of money between these various parties we may better understand why certain authors published as they did, what the market for their works might have been, and who benefited (financially, intellectually, and socially) as a result. In short, we can map the fiscal motions that powered scholarship and science in the late Renaissance.

Oddi's papers permit us to reconstruct the financing and production process of his book on surveying, *Dello squadro trattato*, in generous detail. With the exception of the size of the print run (which, as we shall see, may be calculated easily), he itemized complete expenses for paper, engraving, and printing costs incurred. Furthermore, he compiled a list (appendix B) indicating where copies were sent for sale, to whom copies were sold, and to whom copies were sent as gifts, thereby revealing many of the book's earliest consumers and potential read-ers. Oddi's accounts for *Dello squadro* enable a rare thing: a microhistory of an instrument book, from the inception of the work in prison, through its printing, to its eventual use as saleable commodity and credit-laden gift.[61] In taking this treatise as a case study, we may track closely the process of making and dissemi-nating bookish, practical-mathematical knowledge in the late Renaissance.

In many ways, *Dello squadro* is similar to Oddi's first publication, *Degli horologi solari*. It was begun in prison, produced as a small quarto, printed by Giacomo Lantoni, and dedicated to one of Oddi's noble Milanese pupils: Count Francesco Bernardino Marliani.[62] Moreover, it was rooted in Urbinate math-ematical traditions. The instrument it discusses was manufactured in Urbino's Officina di strumenti matematici and in writing his book Oddi drew on unpub-lished manuscript works about the device written by Guidobaldo del Monte and

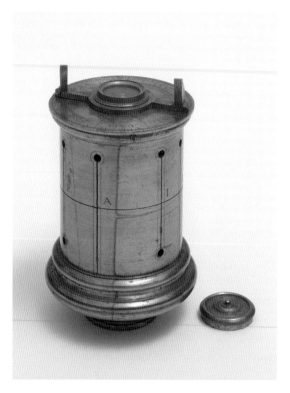

FIGURE 31. *Squadro* made in Urbino's Officina di strumenti matematici, 1654.
Brass. Istituto e Museo di Storia della Scienza, Florence. Inv. no. 680.

the architect-engineer Francesco Paciotti.[63] The *squadro* (fig. 31; see also fig.
3), a versatile instrument that could be adapted for use on many types of ter-
rain and could be deployed to solve a great many practical problems, appealed
to all sorts of practitioners—notably surveyors, architects, and military men.[64]
A spherical or cylindrical object, made of either brass or wood, it featured four
equally spaced exterior slits, running vertically from top to bottom.[65] Two of
these, called by Oddi "master slits" (*tagli maestri*), were at a ninety-degree angle
to one another, a third was at a forty-five-degree angle to the master slits, and
a fourth was at a thirty/sixty-degree angle. Mounting the instrument on a staff,
the user took sightings through these slits, which could then be used in exercises
such as triangulation and the calculation of areas (fig. 32).[66]

Although *Dello squadro* was conceived, as Oddi explained in the "letter to
the reader," during the *otio* of his prison sentence, he did not find time to attend
to its production until late 1624, when printing was begun by Lantoni, who is
named in the colophon (the local stationer, Bartolomeo Fobella, is named in the
imprint).[67] As we have seen, only a small number of printing houses were active
in Milan at this time, but dozens of *librai* (booksellers) plied their trade in the

FIGURE 32. Surveying using the *squadro*, from Mutio Oddi, *Dello squadro trattato*, 1625. University of St. Andrews Library.

city, clustered around the bustling Piazza della Loggia dei Mercanti (Merchant's Square), serving the reading needs of an ever-growing, literate population of artisans, merchants, churchmen, nobles, and officers. Despite the dominance of Venetian stationers in this period, Milan managed to sustain a steady, local trade in books, prints, and paper, occasionally boosted by projects such as Federico Borromeo's Biblioteca Ambrosiana, founded in 1607.

Oddi evidently found all of the labor and material required to produce his book in Milan, for in February 1625 he compiled a "Note of the expenses made in the printing of the book of the *squadro*," which lists a string of local artisans:[68]

Signor Maretionne Follandro for 17.5 reams of large paper at L5 s5 per ream: L89 s5[69]

Lantoni the printer for his wages, on account [or "as agreed"]: L133 s5

Signor Giuseppe Mutago, for the little pictures of the compass (*bussolo*): L6

To the person who lives at Porta Ticinese, for the wood: L12

Signor Girolamo Rocca, for the engraving: L80

Copperplates from the coppersmith: L5[70]

Signor Gio[vanni?] Paolo Bianchi [for unspecified work]: L20

Hans Droschel, for the engraving: L30

Signor Giuseppe [presumably Giuseppe Mutago], for printing the copperplates: L28

The cumulative total for these expenses is 403 *lire*, 10 *soldi*, although Oddi recorded a number of further costs (23 *lire*, 1 *soldo*, 6 *denari*) at the bottom of the list, bringing the total spent on producing *Dello squadro* to the substantial sum of 426 *lire*, 11 *soldi*, 6 *denari*.[71]

Before delving into the accounts proper it is necessary to provide a brief expla-
nation of the monetary terminology used in Oddi's accounts (which are scattered
across several pocket-size notebooks), as Italian currency in this period was no-
toriously complicated.[72] Not only did each region mint its own coinage, but the
value of this coinage fluctuated dramatically owing to the steadily rising inflation
experienced across the peninsula throughout the sixteenth century. In Milan the
standard money of account was the *lira imperiale*, which was divided into 20
soldi, each of which was made up of 12 *denari*. All of the transactions listed in
Oddi's accounts related to producing, buying, or selling books are in this format.
However, a large variety of coins were in circulation in early seventeenth-century
Milan. Throughout Oddi's accounts we find payments made in Genovese and
Spanish ducats, Venetian *lire* (called *paoli*) and *scudi*, silver ducats (*ducatoni*),
and gold ducats (*zecchini*). Other Milanese coins also appear occasionally, such
as the Milanese ducat, worth (according to Oddi) 6 *lire*, 6 *soldi*, and the doublet
(*doblo*), worth 14 *lire*.[73] To give a simple indication of the relative value of this
money in Oddi's time, in the mid-sixteenth century a regular soldier received
between 10 and 12 Milanese *soldi* per day, while a master bookbinder, working
on commission, could make anything between 30 and 80 *lire* per week.[74]

As Oddi's accounts show, paper was one of the largest expenses in the pro-
duction of a late Renaissance book. However, the extent to which the price of
paper determined the cost of printing in Italy is controversial, as little evidence
survives that bears directly on this issue.[75] In the few known examples, printing
and paper costs were approximately equal. For instance, the Calzolari account
book lists itemized expenses for the preparation and printing of the *Musaeum
Francisci Calceolarii* (1622). For this book, the cost of paper was Veronese 1,153
lire, 10 *soldi*, while the total for type, woodblock, and copperplate printing was
1,208 *lire*, 2 *soldi*, 7 *denari*.[76] In the case of *Dello squadro*, however, of the ap-
proximately 380 *lire* spent on paper and printing (including materials and labor)
only 24 percent was spent on paper while 76 percent was spent on printing.
Kevin Stevens has estimated that for most Milanese books of the sixteenth cen-
tury, paper "accounted for 50 to 60 per cent of production costs and sometimes
doubled the expenses involved for labour."[77] Yet according to the expenses list
for *Dello squadro* paper was only a small portion of the production costs, mainly
due to the large sums spent on engravings.

Oddi bought seventeen and a half reams of paper for his book from Fol-
landro.[78] One ream (*risme*) consisted of five hundred sheets of paper, which
varied according to type, size, and quality. Evidence from notarial records sug-
gests that in late sixteenth-century Milan a member of the book trade could
expect to pay between 1 *lira*, 10 *soldi*, and 4 *lire*, 10 *soldi*, for standard quality
printing paper; thus, Oddi paid over the odds for his paper, which, despite be-
ing large, was expensive at 5 *lire*, 10 *soldi*.[79] As a small quarto, and on the basis

of estimates drawn from sixteenth-century Milanese books, it may be estimated that *Dello squadro*'s one hundred eighty-four pages (ninety-two leaves) would have required approximately twenty-three sheets of paper.[80] Therefore, the seventeen and a half reams of paper purchased (totaling 8,750 sheets) would have produced a maximum of approximately 380 copies of the book, although wastage and proofs would reduce this number slightly.

Oddi's costs were significantly increased by his decision to include a large number of illustrations in his work, which features some fifty-nine woodcuts and thirteen engravings (including the title page), although it should be noted that the same plate has been used for two of the engraved illustrations, making the total of copperplates actually used twelve.[81] He invested a considerable amount (at least 143 *lire*) in materials and labor so that he could include copperplates, evidently seeking to ensure that his second publication was a cut above *Degli horologi solari*, which featured woodblock illustrations only.[82] As Biringuccio tells us in his treatise on metallurgy, the *Pirotechnia* (1540), copper was sold either in ingots or as already hammered-out sheets.[83] Oddi purchased the metal from an unnamed *calderaio* (coppersmith or copper seller), most likely in a hammered-out state, ready to be engraved. This material was relatively inexpensive, costing just 5 *lire*. Oddi payed substantially more, however, to have the plates engraved and then to have them printed.

The inclusion of engravings in *Dello squadro* meant that two types of printing press were required: one for type and woodblocks, another for copperplates.[84] Giuseppe Mutago, a copperplate printer, was paid (according to the two entries in the expenses list) a total of 34 *lire* for his services. The first entry, 6 *lire* for the "tavolette di Bussolo," may refer to the cost of printing the title-page engraving of the *squadro* (fig. 3), as 28 *lire* for "printing the copperplates" is listed separately in another record.[85] In a note dated 29 December 1624 Oddi wrote, "I Mutio Oddi have agreed a new contract with signor Giuseppe the printer of copperplates to print the figures of my book, that is 12 copperplates at 8 *lire* per hundred books, on account of which I have given one ducat in the presence of his wife."[86]

Two features of this record are notable. The first is the relative informality of the agreement. Mutago's wife witnessed the ducat given as a down payment, presumably securing the copperlate printer's services, so we may assume that the deal was agreed at his print shop or family home (most probably the same location) with no notary present.[87] This is a vivid example of the kind of relaxed, sociable commerce that powered the production of so many publications in the period, but which has been obscured by the orality of the exchanges concerned. Oddi's business with the letterpress printer was similarly informal. For example, on 11 June 1625 we find an entry in one of Oddi's notebooks, written in a shaky hand, that reads, "I Giacomo Lantoni confess on this day to having received the amount stated, that is 62 *lire*, 10 *soldi*, on 11 June."[88] It is rare to find a note of

such a transaction recorded casually in this fashion, by the printer himself, in an author's notebook—yet it allows us to reconstruct a type of everyday exchange between authors and book-trade professionals that has otherwise been almost entirely lost. This particular exchange could have been made at any number of locations throughout Milan, from Lantoni's workshop to Oddi's study.[89] Thus, just as the content of Oddi's books bridged the *bottega* and the *studiolo*, so too did the process of producing the works.

The second notable feature of Oddi's payment to Giuseppe Mutago is that it enables us to establish the total print run of *Dello squadro*. If we take the figure of 28 *lire* recorded by Oddi in his "note of expenses" to be the entire wages cost of printing the twelve copperplate illustrations featured in the book, then under the agreement cited above Mutago would have printed enough sheets for 350 copies of the book, a figure that tallies approximately with the 380 copies that the paper purchased from Maretionne Follandro could have produced. This was a strikingly modest print run, considering that most books printed as commercial ventures in Milan at this date had a run of between fifteen hundred and three thousand copies, which confirms that one of Oddi's key aims was the social credit that could be achieved through gift-giving rather than financial rewards.[90]

The inclusion of decent-quality illustrations helped the author to secure this credit. Oddi's expenses list features two separate payments to named individuals for cutting the engravings: Girolamo Rocca (the "half-peasant" who cut the figures of *Degli horologi solari*) was paid 80 *lire*, and Hans Droschel 30 *lire*. None of the copperplates, including the title page, is signed, so we cannot attribute their design or cutting to either engraver with any certainty. However, it seems likely that the larger of the two amounts, paid to Rocca, was for the engraved illustrations, whilst the smaller amount was for a fine portrait engraving of Oddi, dated 1624 and signed "Johann Trosch[el] Fec[it]" (fig. 21). Johannes Troschel, who moved to Rome in the year the portrait was cut, was the eldest son of Hans Troschel the elder (d. 1612), a burgher of Nuremberg and member of the city's *compassmacher* guild.[91] We know from a number of sources that Oddi made several trips to Rome, which would have enabled him to sit to this artisan for a portrait.[92] It is not clear why Oddi chose the Nuremberg émigré for this task, although it is plausible that the two men were introduced by Peter Linder. Linder hailed from Nuremberg himself and, given his interest in mathematical instruments, may well have known the Troschel *compassmacher* family prior to his move to Italy.

Linder, in fact, ended up owning the copperplate of the portrait, which exists in two states: a 1624 version and a later version in which the date of Oddi's death and an epitaph have been added to the cartouche surrounding the portrait (fig. 33). The 1624 date of the portrait and the payment of 30 *lire* to Troschel in the *Dello squadro* accounts strongly suggest that the image was commissioned

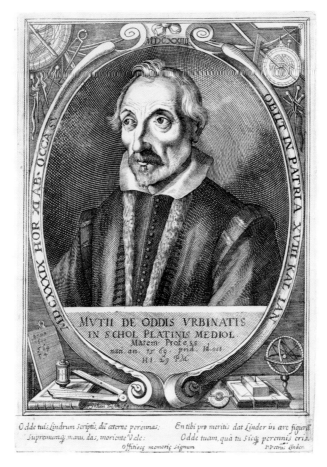

FIGURE 33. Johannes Troschel, *Mutio Oddi*, second state, after 1639. Copperplate
engraving. Bibliothèque Nationale de France, Paris. Shelfmark V-8656.

for inclusion in the book, even though it does not routinely appear in extant
copies. For some reason, the portraits were held back and were only distributed
many years later, following the publication of Oddi's second treatise on sundi-
als. In March 1638 Linder, then seeing *De gli horologi solari* through the press
in Venice, wrote to Oddi:

> I am not sending the portrait of Your Lordship with [the book], nor will I do
> anything against your will. . . . You should rest assured that it will not be sent
> out with the book, but rather I shall send it to certain friends, and the cop-
> perplate will remain with us, in memory of our friendship, [which is] founded
> on virtue and disinterested.[93]

Indeed, Linder used the copperplate in the service of their *amicizia* following

Oddi's death, reissuing the portrait with a Latin epitaph he had composed, presumably so that it could be circulated among the mathematician's friends as a memento.[94]

As we shall see, one of the ways in which Oddi used *Dello squadro* was to maintain and augment friendships of varying kinds, but the book was also sold commercially by the publisher who is named in its imprint: Bartolomeo Fobella. It seems that Fobella's role lay not only in retailing the book, but also in guiding its production. For example, an entry in Oddi's notebook shows that he acted as a go-between for Oddi and one of his printers, Lantoni: "I have given to signor Iacomo by the hand of signor Bartolomeo Fobella 8 *lire*, 5 *soldi*, for settlement and complete payment of all that has been done for me in the printing of the *squadro*."[95] Oddi recorded regular business dealings with Fobella (who was apparently both a stationer and a bookseller), usually four or five transactions per month, concerned with the purchase, selling, and binding of books.[96] The payments are not, however, entirely straightforward, for they include frequent records of transactions taking place on account, and even instances of Oddi having lent money to Fobella.[97] There is also evidence that Oddi purchased and sold books on Fobella's behalf, normally when his travels took him beyond Milan. Fobella repaid Oddi's gesture of friendship in cash, books, or binding services, making for an extremely complicated set of accounts.

In the case of *Dello squadro*, Fobella's primary role must have been as a retailer; there is no record of his having financed Oddi's book. It is not clear how many copies he sold, nor what he charged for them, but it must have been more than the 1 *lira*, 8 *soldi*, Oddi estimated each copy cost him to produce.[98] Peter Linder, too, seems to have sold the book on Oddi's behalf, for the merchant returned to Oddi some forty unsold copies in 1637, along with a few copies of the sundials books and Matteo Oddi's *Precetti militari*.[99] We know, though, that a sizable portion of the print run was distributed as gifts. Indeed, Oddi's papers provide us with an excellent source to chart the movement of *Dello squadro* immediately after its production: a list entitled simply, "Account of the books of the *squadro*."

This distribution list (appendix B) consists of fifty-two individual names (including one place-name, "Lucca," and two titles, "Pàdre Inquisitore" and "Ambasciatore di Lucca"), next to which Oddi intermittently inscribed Arabic numerals, indicating the number of books sent. A total of seventy-nine copies of the book are recorded in the list, comprising twenty-six bound and fifty-three unbound copies.[100] Since Oddi marked four copies specifically as "sold," we may assume that the remaining seventy-five copies listed were distributed as presents. Although there can be no doubt that various types of friendship were at stake, all of the gifts documented by the list would have been presented within the context of *amicizia*. The strictly observed code of reciprocity that governed

late Renaissance friendship could certainly permit of genuine affection between individuals, but friendship meant obligations, and the receipt of a gift required a countergift. This does not imply that the recipients of *Dello squadro* would have responded immediately with a material reward, for a debt could be repaid in myriad ways over a long period of time. Rather, it means that in distributing copies of his treatise Oddi energized his patronage relationships, boosted his credit with professional colleagues, demonstrated affection for his countrymen, and presumably settled his own debts of friendship. As a result, although he had sunk considerable capital into his book, Oddi's reward was not primarily fiscal. Instead, it was social and intellectual, strengthening ties to all sorts of acquaintances while establishing him as an authority on a certain type of device and method of practice.

For the most part, copies were dispatched to the social and intellectual circles in which the mathematician had moved during his Milanese period. However, the book's circulation was not limited to Milan. A number of copies were sent to acquaintances in Rome, Piacenza, Pesaro, and Urbino, while six were sent to one Hierolamo Oliviero of Perugia, presumably a merchant or bookseller. A total of eighteen unbound books were sent to Lucca, so that Oddi—who was just starting his job as the republic's fortifications engineer when *Dello squadro* was published—could distribute them to influential *cavalieri* in his new home.

Oddi's pupils in mathematics are well represented in the distribution list. In addition to the book's dedicatee, Count Marliani, copies were sent to Ercole Bianchi, Giovanni Battista Caravaggio, Peter Linder, Amadeo Vernardo Delascamo, and Giovanna Borromeo. A copy was also sent to Giovanna's uncle by marriage, Cardinal Federico Borromeo, for his Biblioteca Ambrosiana. In fact, the list hints at the Milanese artistic circles, centered on Borromeo, in which Oddi moved, for in addition to the art agent Bianchi, the noted connoisseur Galeazzo Arconati—most famous for having collected codices by Leonardo da Vinci—received a copy. Given *Dello squadro*'s emphasis on military activity, it is not surprising to find members of the officer class listed among its recipients. Marliani (who was a colonel as well as a count) typifies this audience, but the list records lower-status military practitioners as well as officers. The architect-engineers Giuseppe Barca, Giovanni Battista Caravaggio, Giovanni Angelo Crivelli, Carlo Paciotti, Giulio Magone, and one member of the Bisnati dynasty all were sent copies, as was an unidentified fortifications engineer. Even instrument makers received the book—namely, the master of Urbino's Officina, Lorenzo Vagnarelli, who himself manufactured examples of the instrument treated in Oddi's text.

It is instructive to note which individuals received their copy of *Dello squadro* bound and which loose. Most of the recipients of bound copies were high-ranking nobles—the Governor of Milan, for instance—or were drawn from high-status professions, such as Doctor Boldone, whom Oddi wished to impress.

The copies that were sent loose, by contrast, were generally destined for Oddi's friends in Urbino, or for individuals close to the author in social status, such as the architect-engineers. Only one extant copy of *Dello squadro* bears an indication of early provenance that can be directly related to the distribution list. The British Library's copy has been inscribed by Oddi, in a careful script, to Camillo Giordani of Pesaro, the Duke of Urbino's ambassador in Venice and one of the mathematician's closest friends.[101] Giordani is one of the recipients listed in the right-hand column of the *Dello squadro* distribution list, so he evidently received his copy unbound. In this particular instance of gift-giving, Oddi's gesture of friendship was clearly made not through conspicuous material display but by offering the learning and labor that had gone into his book.

The history of *Dello squadro* is a forceful reminder that the transmission of mathematical knowledge in late Renaissance Italy was not only scholarly; it was also rooted in skilled manual labor, governed by commerce, and oriented toward patronage and friendship. Crucially, Oddi's instrument books were part of an economy of social as well as intellectual credit, a world in which practical mathematics could be used to enhance status and further one's career. In order to reap these rewards, however, the mathematician needed both cash and contacts. Indeed, the accounts for *Dello squadro* demonstrate that making instrumental knowledge was a mercantile and practical affair.

Oddi could not expect to make a profit on a book with high production costs and a low retail value. Moreover, unlike some authors he simply could not afford to produce an expensive, folio publication—ventures such as Tycho's *Astronomiae instaurata mechanica* were entirely out of his league. Properly framed and presented, however, treatises such as his could appeal to a wide cross-section of society, enlarging and enhancing—much as he did with his teaching—the mathematical community. Thus, Oddi ensured that his instrument books were mediatory: they were learned, yet practical; finely illustrated and set in elegant type, but written in the vernacular; produced to a sufficiently high standard to appeal to aristocrats, but not so plush as to be out of the reach of artisans. Indeed, the very fact that instrument makers like Vagnarelli formed part of Oddi's audience for works such as *Dello squadro* and *Compasso polimetro* serves to indicate that mathematics moved ever more freely between print and practice in the late Renaissance. Yet books were but one facet of the instrument economy; it is to the devices themselves that we shall now turn.

Instruments, Markets, and Mediators

In 1629 the Milanese scholar Alberico Settala sought Oddi's help in acquiring a particular instrument he had seen in one of Guidobaldo del Monte's books, the *Planisphaeriorum universalium theorica* (1579). Oddi's former pupil, the engineer Caravaggio, brokered the request, writing that Settala desired

> a favor of Your Lordship, which is to commission the manufacture, in Urbino, of an instrument similar to that which signor Guidobaldo del Monte describes in his *Planisferio* for drawing, given three points, any part of a circle in the said *Planisferio*. When Your Lordship judges which master should make it, he should be of a different disposition to that of our artisans here [in Milan], because no matter who pays them in whatever way, either the work is never done or it has been done badly. I should be pleased to be advised, as soon as it can be sent, the price that Your Lordship deems reasonable for this instrument. . . . I have decided that it is not necessary to send any drawing of the instrument, as it will be shown sufficiently intelligibly in the same treatise on the *Planisferio* of signor Guidobaldo.[1]

Thus, late Renaissance mathematical books not only explained how instruments were used but served also as templates for their manufacture: no drawing was required in this transaction as the instrument was shown "sufficiently intelligibly" in Guidobaldo's treatise.[2] However, faced with what was evidently a somewhat truculent set of artisans in Milan, Settala looked to the mathematical community for help. Specifically, he turned to a friend possessed of both the technical knowledge and personal contacts needed to fulfil his desire, using *amicizia* to ensure *buona fattura*. Settala's case illustrates succinctly Oddi's role in the instrument economy: he was a technical consultant, a broker who traded on his relationship with his countrymen to source wares made in Urbino's Officina di strumenti matematici—a workshop renowned for reliability, quality, and stylishness. Thus, he was able to serve his friends and patrons in exile, to provide much-needed business to his *patria*'s craftsmen, and to improve his own fortunes in doing so.[3]

Instruments, as Oddi well knew, were a form of currency in late Renaissance

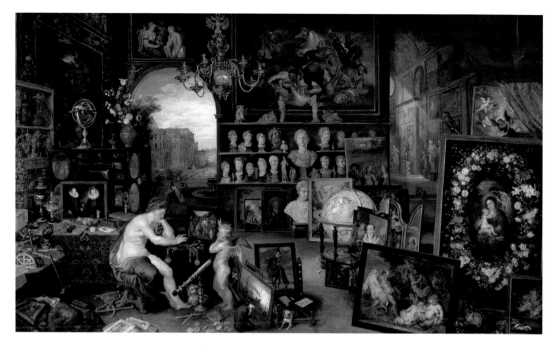

FIGURE 34. Peter Paul Rubens and Jan Brueghel the Elder, *The Sense of Sight*, ca. 1618. Oil on panel. Museo Nacional del Prado, Madrid.

mathematical circles.[4] They were a versatile means of mixing mathematics with the world of goods that combined, in a winning formula, intellectual with aesthetic appeal. Instruments could be used to co-opt individuals into mathematical communities, for although sought after by scholars such as Settala and practitioners such as Caravaggio, they also, as subtle and finely wrought artifacts, attracted princes and nobles to the world of mathematics. These devices then took their place alongside other desirable objects, such as pictures, books, and natural curiosities, as evinced most spectacularly in period depictions of *Kunst- und Wunderkammern* (fig. 34). Images of this kind are a powerful testament to the fact that, by the beginning of the seventeenth century, mathematical instruments were as much a part of the conspicuous consumption and ostentatious display expected of the courtier as were other luxury goods.[5]

It is often stated that despite the ubiquity of instruments in high-status collections, the elite appreciated such objects mainly for their preciousness, for their symbolic power, and for the veneer of polymathic knowledge they conferred upon the owner.[6] Adam Mosley has even gone so far as to claim that it was "rare for a noble to have any genuine affinity for the study of such [mathematical] subjects" in which instruments could be used.[7] There are doubtless examples for which this assertion is true. However, as we have seen in the preceding chapters,

during the late Renaissance the socially elite became increasingly mathematically competent and active, thanks largely to the teaching and publications of men such as Oddi. Moreover, the strong military impetus that lay behind much of their interest in mathematics was a powerful motor to the instrument economy: by the end of the sixteenth century the officer class had bought into the notion that owning appropriate technical kit was a necessary aspect of the art of war, purchasing—in large numbers—measuring and drawing instruments useful in mapping, fortifying, and planning.[8]

However, instruments were also valued as markers of erudition, as indicated by Gabriel Naudé's suggestion, in his *Advis pour dresser une bibliothèque* (1627), that any decent library should be furnished with "mathematical instruments, globes, world maps, spheres"—an extension of Alberti's recommendation in the mid-fifteenth century that a planetarium or astronomical clock should ideally feature as part of a library.[9] The library of the Venetian patrician Giacomo Contarini is a good example of this type of high-status assemblage. As Sansovino's popular guidebook, *Venetia descritta* (1581), explains:

> The library of Jacomo Contarini at San Samuele is worthy of note. At inexpressible expense he has brought together all the printed manuscript histories of the city both general and particular, along with a great quantity of books on the sciences. In addition there are drawings, mathematical instruments and other objects executed by hand including the most excellent pictures, sculptures and pieces of architecture that our age has possessed. He has always had these from his patronage of favoured and treasured minds.[10]

Contarini's collection, although famous, was by no means exceptional. Alongside men of high rank, other members of the Republic of Letters owned instruments with increasing ubiquity in the late Renaissance. Indeed, collecting was a communal activity that facilitated interactions not only between disciplines but between differing strata of society; Sansovino's description could be applied equally to the collections formed by the merchant Peter Linder, the Giordani in Pesaro, or Oddi himself.[11]

In fact, Oddi helped a member of the Giordani family—Piermatteo—to acquire precisely those instruments that Naudé specified as essential (fig. 35). Responding to his friend's request for assistance in obtaining a pair of globes, Oddi explained:

> Here, in Milan, there are many globes of small, medium, or large size, marked with Tycho's observations, and one can find them mounted, or paper versions that are not yet mounted. And at Turin there is a priest who makes these globes with great ease and delicacy. Those that come from Flanders are quite beautiful, and in Amsterdam, because you can obtain them cheaply, a pair of average ones will not cost more than 18 Milanese *scudi*. The problem is in transporta-

FIGURE 35. Hondius celestial globe, 1600. Wood and paper.
National Maritime Museum, Greenwich. Inv. no. G.167.

tion, because it costs just as much again to send them overland, and, which
is worse, some have arrived broken and shattered. At Genoa a friend of mind
has a pair of them, very small, which you can have for about 18 or 20 *scudi*,
and here there is a German merchant who has two identical ones that are not
bad. At Sant'Ambrogio, the abbott of the monastery has acquired a pair of large
[globes]; he told me the price but I am not writing it because I don't believe it.
If Your Lordship would like to have a pair I will write to Turin, because that
priest [there] has a great love of manufacturing, and I will have them sent to
me; because, whether for the horizon and the meridian, one in wood and the
other in brass, I know that in that city they make better ones than those made
in Flanders, or here.[12]

Oddi's letter highlights several key points about the instrument trade—it was
international, it relied on local knowledge, its goods were supplied by a mixture
of professional, semiprofessional, and amateur makers, and its customers were
keenly aware of the relationship between price, availability, and quality.[13] More-
over, it emphasizes the proximity between scholarship and manufacturing, as
well as between gentlemanly leisure and artisanal work.

In fact, one of the most important aspects of the material culture of mathematics in this period is that it brought practitioners closer to gentlemanly realms of *virtù* and gentlemen closer to the world of craft, albeit in a suitably courtly form. For while the growth of instrumentalism at many levels of society does not mark a decisive break with the traditional polarity between *epistemē* and *technē*, it does represent, at the very least, a weakening of boundaries.[14] The very thing that marks out instruments as particularly versatile ambassadors in the formation of mathematical communities is the fact that they could be both contemplated and operated.

During the course of the sixteenth century instruments became a focus for discussions and debates about the relationship between knowing and doing precisely because they mediated between the intellectual and the material worlds.[15] In Francis Bacon's oft-quoted second aphorism in his *Novum Organum* (1620) we find a telling slippage in the terminology of instruments, from the manual to the mental:

> Neither bare hand nor unaided intellect counts for much; for the business is done with instruments and aids, which are no less necessary to the intellect than to the hand. And just as instruments of the hand stimulate or guide its motion, so the instruments of the mind prompt or look out for the intellect.[16]

The notion that instruments could improve, and perhaps perfect, man's capacity to understand the world was illustrated most dramatically in the period by the revelations offered by telescopic or microscopic observation, but more traditional, mathematical instruments also played their part. For example, it is through the manual operation of the compass (one of the most ancient mathematical devices) that the immaterial geometry of the mind is made visible, and potentially useful, in the world. Indeed, in the late Renaissance mathematical instruments were a very obvious means of applying mathematics to worldly ends, be it the use of triangulation in a *squadro* for surveying, or the principle of proportionality in a *compasso polimetro* for altering the scale of a fortifications plan, to take just two examples from Oddi's repertoire.[17]

Alongside the attraction of instruments' utility (a trope constantly stressed in instrument books) lay the comparative ease with which many of them could be operated. Instruments reduced—or at least their advocates *claimed* they reduced—the complexities of mathematics to manageable proportions, and they were often presented (and herein lay much of their commercial appeal) as a shortcut to using mathematics without needing to understand fully its more complex aspects.[18] This might imply that instruments were actually an impediment to the comprehension of mathematics and its dissemination. Certainly, many scholars of the period were deeply concerned that instrument use was

rapidly replacing the mathematical knowledge that was really required to benefit both philosophy and the state.[19] Mindful of this issue, Deborah Harkness has described mathematical instruments of the late Renaissance as the original "black boxes," that is to say, pieces of equipment that could profitably (and contentedly) be used without "fully understanding their construction or operation."[20]

This is true—up to a point. As we have seen, men such as Oddi made strenuous efforts to ensure that instrument use was accompanied by a proper grounding in mathematical principles, while his books—notably *Fabrica et uso del compasso polimetro*—explained how instruments could be made as well as used. Moreover, even if mathematical knowledge was to a certain extent black-boxed by some instruments, it does not automatically follow that these artifacts curtailed the circulation and sharing of mathematics, or that they played no role in the shifting status of the subject and its practitioners. Because mathematical knowledge was embedded within instruments, the use and collecting of such objects—even if unaccompanied by a thorough comprehension of the principles according to which they operated—inculcated reliance on mathematics as a discipline. Indeed, one of the leading champions of *disegno,* Benedetto Varchi, went so far as to suggest that when using the level or the square, even the mason and the carpenter tacitly carried in their art the geometry of the first book of Euclid's *Elements.*[21] Other authors claimed that instruments themselves transported Euclid and the great geometers of antiquity. For example, Ralph Agas, writing about the theodolite in his *Preparative to the Plattinge of Landes* (1596), claimed:

> I tell you truly the same Ingine carrieth in it selfe Euclide, Pythagoras, Archimedes, Architas, and the rest, with their points, Draughtes, Lines, Theoremes, Theoricks, Propositions, Figures, and Mathematical conclusions, not in Elements, shewes, spectacles, and demonstrations, but in the work & operation itself.[22]

But the spread of instrumentalism also meant increased reliance on the swelling ranks of artisans and practitioners who designed, manufactured, and repaired instruments, who acted as agents in their acquisition, and who offered instruction in their use.[23] Thus, the credit that could be obtained from instruments derived not only from the discoveries that could be made with them (although this was, as demonstrated by the case of Galileo and the telescope, arguably the most potent type) but also from their consumption.

THE INSTRUMENT TRADE

Given the significance of the instrument economy for such a diverse range of social and intellectual transactions in the late Renaissance, it is surprising that comparatively little work has been undertaken on the particulars of the instru-

FIGURE 36. Oronce Fine, paper equatorium, 1526.
Houghton Library, Harvard University.

ment trade, as opposed to the frequently treated topic of instrument use. As
with mathematics teaching and book production, this is partially due to a lack
of surviving evidence, but an account of the market is a necessary foundation
upon which to construct a proper understanding of the spread of practical math-
ematics, for it establishes which sorts of people acquired instruments, the type
of object they amassed, how they came to own them, and why they sought them
in the first place.

Although always a somewhat specialist trade in comparison to other areas
of skilled manufacture, by the end of the sixteenth century instrument making
had grown from a handful of small workshops serving the scholarly community
and a few courts to become a pervasive feature of European culture.[24] Instru-
ments proliferated in a wide range of types and media, from inexpensive paper
devices to costly clockwork models of the heavens fashioned from precious met-
als (figs. 36 and 37). This diversity helped to establish a prominent place for such
artifacts in the world of goods, with a host of makers—both professional and
amateur—spread across the continent and in England. To take just one example
of the range of objects available in various locations, the engineer Caravaggio,

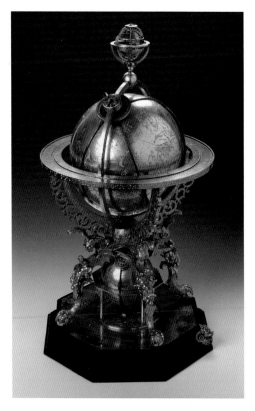

FIGURE 37. Johannes Reinhold and Georg Roll, mechanical celestial globe, 1586. Gilt brass. Matematisch-Physikalischer Salon, Staatliche Kunstsammlungen Dresden. Inv. no. E II 2.

Oddi's pupil, purchased fine compasses from the Urbino Officina, had mirrors made for him in Lucca (which he used in optical experimentation), and bought surveying instruments while campaigning abroad:

> I am carrying with me two instruments that I bought in Salzburg from some-
> one who told me he had made them himself, but the low price for which he
> sold them to me made me realize that he himself had not made them. One is
> a magnetic compass for taking points on the horizon, with that half circle at
> the base, and those sights [*traguardi*] that I was having divided in a wooden
> one from Milan, but with the finest base that you've ever seen, because what's
> more, to be able to fix it in whatever uneven place, with three screws put on
> the three rods that form the triangle of the base it can be set perfectly on the
> level, and also the whole is divided well, and well engraved; the other, similarly
> made with equal diligence, is one of those *trerighe* [three-ruler-instruments]
> greatly valued by that master of Lucca, and the one and the other of these I
> had for 14 talers in total.[25]

FIGURE 38. Italian School, compass with a straight screw, of the kind
made by Lorenzo Vagnarelli, ca. 1600. Brass. Istituto e Museo
di Storia della Scienza, Florence. Inv. no. 634.

Caravaggio's letter highlights an issue of vital importance in the instrument
trade: price. Much of the period evidence available, Caravaggio's included, sug-
gests that instrument makers struggled to make ends meet—even successful ones
such as Lorenzo Vagnarelli of Urbino. As Oddi explained to his brother in 1612:

> Of Vagnarelli's visit to Rome I do not know what to say. Having seen by experi-
> ence how these two [Lorenzo and his brother, Giovanni Benedetto] work and
> give instruments for a good price, they will not, for all of that, make much,
> and they will make much less now given the death of Father Clavius. I will not
> invite him to Milan, because here people also spend reluctantly, but I will see if
> I can secure for him [the commission of] four or six cases of thirty pieces each,
> to ensure that he has enough work to get by over the next while, and because
> his works take such a good form.[26]

Despite these comments, while the instrument trade was certainly not vast, Od-
di's records of his activities as a broker for the Urbino workshop suggest that
neither was it marginal, indeed they rather disprove his comments about Mila-
nese stinginess.[27] Between 1620 and 1629 he handled more than 250 Officina
instruments, ranging in price from 6 *paoli* for a "small compass" to 60 *paoli* for a

"compass for the astrolabe," most of which were sold to Milanese customers (see appendix C) (fig. 38).[28] The total cost of these objects was around 3,800 *paoli*, which, at about six and a half times the amount Oddi spent in publishing his treatise *Dello squadro*, was a sizable sum.[29]

Oddi's business with the Officina represents a valuable opportunity to reconstruct the activities of a major instrument *bottega* and to examine the contexts in which its products were distributed, collected, and employed.[30] During his years in Milan and Lucca (and especially the former, where his employment was neither steady nor constant), Oddi used the Urbino workshop as a major component in his attempts to secure patronage and to maintain friendships, presenting instruments to important supporters while using his knowledge of the instrument trade to guide prospective purchasers through the labyrinthine complex of new devices, workshops, distribution networks, and prices.[31]

In so doing, Oddi tied the instrument trade to his provision of other services and goods, namely teaching and mathematical books. Among the names listed in his accounts we find several of his pupils and readers, including the nobles Count Teodoro Trivulzio, Countess Giovanna Borromeo, and Marchese Valdefuentes, the merchant Peter Linder, and the engineer Giovanni Battista Caravaggio. Evidently, as with his other mathematical activities, the artifacts Oddi supplied appealed to consumers from across the social spectrum and of varying professions, from individuals interested in the leisurely pursuit of mathematics to those who urgently required instruments for their everyday work. What, though, were the economics of Oddi's transactions with Vagnarelli, and how did his relationship with the Officina actually work?

To answer this question it is useful to compare Oddi's relationship with Vagnarelli to that between Galileo and the instrument maker Mazzoleni. As we have seen, during his years in Padua Galileo subsidized his university salary by offering private lessons in practical mathematics, to which he attached the provision of instruction manuals and instruments (mainly his geometric and military compass) made by his in-house artisan, Mazzoleni (fig. 39). Galileo provided Mazzoleni with board and lodging, advanced him the sums required for raw materials, and purchased instruments from him directly upon completion before reselling them—at a modest markup—to his students. Thus, the instrument maker's entire workshop operation was dependent upon one individual's finances and wider patronage ambitions.

In contrast, Vagnarelli was an independent artisan (both financially and spatially), serving a diverse range of clients, intimately connected to—and supported by—a ducal court, and geographically remote from one of his main brokers, Oddi in Milan.[32] Moreover, in the case of Galileo and Mazzoleni the relationship between commissioner and maker was direct. By contrast, Oddi often relied on intermediaries, asking his brother, Matteo, or the Giordani in

FIGURE 39. Giuseppe Mazzoleni, Galilean geometric and military compass, ca. 1600. Brass. Istituto e Museo di Storia della Scienza, Florence. Inv. no. 2430.

Pesaro to chivy along the artisan, arrange payment, or place an order. When we add to these circumstances the fact that Oddi's transactions with Vagnarelli were often conducted through credit, which might only be paid off months—sometimes years—after the commissioned instruments had been manufactured and delivered, it will be apparent that the relationship between the two Urbinati was far more complex than that between Galileo and Mazzoleni.[33] In fact, although Oddi's papers provide precious evidence of retail prices, the type and number of instruments manufactured by Vagnarelli, and the owners of the devices, practically no evidence of the cost of the artisan's materials or labor has so far come to light. Thus, although it is clear that the Officina benefited significantly from Oddi's brokerage, precise details of the instrument maker's profits and losses remain obscure.

While the rewards that Oddi received for giving instruments or arranging purchases were likewise complicated, it is nonetheless evident that his instrument brokerage was essentially motivated by the obligations of *amicizia* and *patria*, both of which, as we have seen, placed him under certain obligations while offering opportunities for personal advancement. Like Galileo, Oddi used instruments in conjunction with teaching as part of a multivalent patronage strategy. In this respect, the profit made was the enrollment or retention of students and the money that flowed subsequently from lessons delivered, as well

as the potential that this teaching bond might blossom into a more lucrative patronage relationship.

Galileo, however, also made a very straightforward cash profit by selling the instruments made by Mazzoleni at a 5 *lire* markup. There is no evidence that Oddi did the same. Moreover, Oddi was not, quite unlike Galileo, trading explicitly on innovation in his role as an instrument broker. Galileo was marketing a (supposedly) new device of his own invention—the geometric and military compass—which, he boasted, offered a "royal road" to the quick and easy solution of laborious geometrical problems.[34] In contrast, although the difficulty of acquiring Vagnarelli's wares may have rendered them novel to Oddi's Milanese patrons (for Urbino's artisans worked at a notoriously slow pace), the instruments he procured from the Officina were, by and large, highly traditional. Oddi traded on inventiveness in other regions of his mathematical world, but when it came to Urbinate instruments he turned instead to something equally potent: the recognized mathematico-technical excellence of his countrymen, a skill in design and manufacturing that—in the artistic sphere—had propelled men such as Raphael and Bramante to international fame.

THE WORKSHOP OF THE WORLD

By the turn of the century, the Urbino workshop was one of the foremost in all Italy. Indeed, Bernardino Baldi called it "the workshop of the world," a nod both to the supreme quality of its products and to its international reputation (fig. 40).[35] The workshop's founders, the Barocci family, were a distinguished dynasty of artisans, established in Urbino in the fifteenth century by the stonecutter and mosaicist Ambrogio I Barocci, who was called to Urbino from Milan to work on Federico da Montefeltro's Palazzo Ducale.[36] Simone Barocci, who established the Officina, learned his trade from his father, Ambrogio II (a multitalented artisan who made clocks and instruments, engraved gems, and cast relief models and seals from molds), but it has been claimed that he also studied mathematics under Commandino.[37]

That such a productive and innovative instrument workshop should emerge in a comparatively small principality may be attributed directly to two distinctly Urbinate traditions: an emphasis on the military arts deriving from successive dukes' activities as *condottieri* and the (not unrelated) concentration of mathematical expertise in the duchy.[38] The first stimulated demand for the type of measuring and surveying instruments associated with fortification and gunnery, contributing also the practical experience of a succession of architect-engineers familiar with the rapidly changing requirements of battle. The second presented mathematical challenges and the scholarly ingenuity required to refine instruments and develop new devices, as evinced by Simone

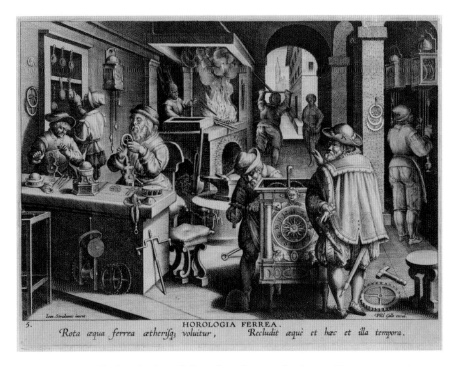

Ioan.Stradanus invent. HOROLOGIA FERREA. Phls' Gille excud.
5. 'Rota æqua ferrea ætherisq₃ voluitur , Recludit æquè et hæc et illa tempora .

FIGURE 40. Clockmaker's workshop, from Jan van der Straet, *Nova reperta*, 1600.
British Museum, London. © Trustees of the British Museum.

Barocci's collaboration with Commandino in the construction of the reduction compass, or with Guidobaldo del Monte in manufacturing the celebrated "scaphe" dial.[39] These, though, were singular products. The mainstay of the Officina's business was the manufacture of mechanical clocks and, in particular, standard geometrical and drawing instruments such as compasses, rulers, and pens (see appendix C).

Simone's instruments were, however, in greater demand than those made elsewhere because of his superb metallurgical skills, which he passed on to his pupil and successor, Vagnarelli.[40] Barocci was famous for his ability to combine different materials—mainly silver, brass, and steel—in the production of refined, elegant artifacts that offered an unparalleled degree of precision.[41] As we have seen (fig. 7), those few examples of his work that have come down to us are characterized by an austerity that favors formal elegance above elaborate decoration, qualities abundantly apparent in the sole surviving clock securely attributable to the master artisan (fig. 41).[42]

This aesthetic reflects the taste of Barocci's principal patron and protector, the Duke of Urbino. Indeed, the workshop's success may be attributed in so small part to Francesco Maria II della Rovere's support, which derived from a combination of personal predilection and state policy. In the latter part of the sixteenth

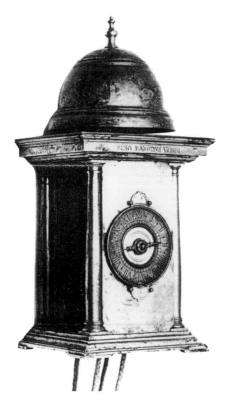

FIGURE 41. Simone Barocci, mechanical table-clock,
ca. 1580. Mixed metals. Private collection.

century the duke made a concerted effort to revive his realm's flagging economic fortunes by promoting Urbino's manufacturing industries, notably the production of maiolica and various kinds of metalware.[43] Although this policy did not achieve its overall aim, it did establish an environment conducive to the maintenance and enlargement of an instrument *bottega*, an environment bolstered considerably by Francesco Maria's personal penchant for mathematics. A letter written in 1585 neatly summarizes the duke's studious character and particular fondness for the mathematical arts:

> Although it can be said that at present he may live at ease, and that things rest quiet in Italy now, nevertheless to be so virtuous and learned as he is, the duke hasn't had many leisure hours: he not only understands languages, but has the full knowledge of not only history but also sciences, such as philosophy, astrology, music and particularly mathematical subjects, and of the arts of Design; he is always looking to acquire new machines for this or that effect.[44]

Francesco Maria's acquisitiveness extended not only to machines but also to

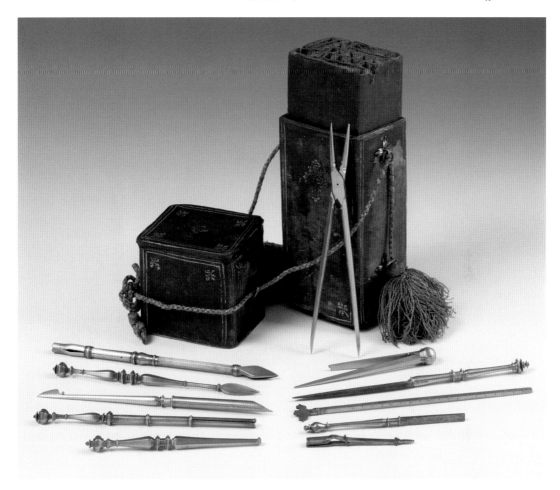

FIGURE 42. Italian School, *stuccio* of drawing instruments, early seventeenth century. Mixed metals. Istituto e Museo di Storia della Scienza, Florence. Inv. no. 671.

instruments. For example, a 1623 inventory of the ducal *Guardaroba* includes the following:

> Candlesticks and various brass items, among which are also mathematical instruments, and in particular compasses, lancets, little penknives of brass, which are works of Barocci and placed in a small case or *studiolo* with four little boxes, covered with black leather with pieces of brass at the corners, a lock and key, handles of brass at the sides; it is lined inside, as is the door, in green taffeta.[45]

The Officina specialized in the production of this type of *stuccio*, cased sets of instruments that varied in size, sophistication, and decoration, but generally

FIGURE 43. Christoph Schissler, *stuccio* of instruments, late sixteenth century.
Mixed metals. Istituto e Museo di Storia della Scienza, Florence.
Inv. nos. 2532, 2542–2543, 3726.

comprised a selection of compasses, pens, and, in larger sets, rulers, squares, and mason's levels (fig. 42).[46] The instruments were normally contained in a wooden traveling case, covered with stamped leather and inlaid—at least in the more costly examples—with velvet, within which receptacles molded to the instruments' precise shapes served to minimize their movement during travel (fig. 43).[47] Some *stuccio* sets were even designed to be worn on the person. For example, in 1613 Oddi commissioned as a Christmas gift "a little *stuccio* of silver instruments that can be carried in the stockings, one with a pair of scissors, a little knife, an awl, and a compass" (fig. 44).[48]

In distributing the Officina's instruments as gifts, Oddi was following a well-established Urbinate tradition. Duke Francesco Maria I, for example, had sent to Emperor Charles V in Naples a "ring containing a miniature watch movement that struck the hours," while his successor, Guidobaldo II, had commissioned a stupendous astronomical clock for Pope Pius V.[49] Guidobaldo's son, Francesco Maria II, likewise presented geometrical instruments, magnetic compasses, and clocks to friends and allies. For instance, in 1586 one of the duke's Portuguese correspondents wrote that

His Lordship the Cardinal [has received] the case of drawing instruments that you sent him . . . and it gave His Lordship greater satisfaction than from any

FIGURE 44. French School, "etui case" of instruments. Silver. Collection of Historic Scientific Instruments, Department of the History of Science, Harvard University.

other thing he ever had. It was a gift of very great worth because of the perfection of the instruments and the variety of metals used and for being a gift from Your Lordship's hands.[50]

It was usual to give gifts such as these on or around feast days, a custom that Oddi followed. For instance, on one occasion he noted that he had been left "embarrassed with those *cavalieri* to whom I have promised for the feasts the works of Vagnarelli."[51] Vagnarelli's instruments were highly appropriate presents for the mathematician's *cavalieri* friends. They were not only highly prized for the quality of their manufacture but could be deployed in the pursuit of the military arts. A Vagnarelli *stuccio* set comprised precisely those instruments required of the aspirant officer: a range of compasses for measuring fortification plans, rulers and pens for making such drawings, and even—on occasion—instruments for surveying the battlefield. They were, moreover, the instruments used in mathematical lessons of the type Oddi delivered, being necessary for drawing regular figures, inscribing and dividing circles, and so on. However, a major aspect of their appeal was that they could equally be used in courtly activities such as sketching and calligraphy.

The first of these was, as Oddi's teaching testifies, a *virtuoso* pastime connected to the mathematical arts by virtue of its relationship to perspective. The second—*bellissima letterata*—might seem a world away from mathematical practice, but in Oddi's era fine penmanship rubbed shoulders with geometry. Indeed, it was not uncommon for practitioners to give lessons in both arts—Oddi's competitor in Milan, Bernardo Richino, being a case in point.[52] As David Rosand has

shown, while the Renaissance calligrapher's ultimate aim was to be able to write characters with effortless skill—comparable to that employed by the best artists of the modern manner—there existed a long tradition that stressed the relationship between good calligraphy and geometrical harmony. In works such as Dürer's *Underweysung der Messung* (1525), for example, the aesthetic appeal of correctly written characters is seen to rest on the proportionality found in regular figures, adding weight to mathematicians' claims the geometry is the parent of all good arts and sciences, including those liberal arts for which the written word is key.[53] In fact, in their exquisite artistry, versatility, and elegance, Vagnarelli's instruments embodied the multifaceted principles of *grazia* so sought after by the late Renaissance courtier.[54] In the Officina's products we find a striking match between the quality, look, and feel of instruments, the aesthetics of geometry, and the fashioned grace of the nobility.[55] The precious materials from which these artifacts were constructed gave an added luster to an already polite art, establishing such simple tools as the ideal, portable emblems of elite dexterity.

This is certainly the case, to take just one example, with Count Teodoro Trivulzio who, Oddi noted in June 1612, was still waiting avidly "for one of those ruling pens, this great gentleman is eager to make figures with precise diligence and civility (*politezza*), and very subtle lines." Oddi thus repeated his request to Vagnarelli for a pen and a pair of compasses so that his patron might fulfil his desire.[56] Evidently, in order to draw geometrical figures properly and in a gentlemanly fashion, displaying the *politezza* required of a nobleman, it was necessary to own appropriately sophisticated equipment. While the count's mathematical studies with Oddi furnished him with the ability to perform this duty diligently, the instruments he acquired through his tutor allowed him to perform the mathematical aspects of *disegno* precisely and with a dash of *sprezzatura*.

We should not lose sight, though, of the fact that the Officina's instruments could equally be used for more advanced mathematical work. For example, in 1631 Oddi wrote to his notary, Andrea Brancalini, that he wanted Vagnarelli to complete a "*stuccio* as full of instruments as possible, not only for scraping lines or similar things, but for mathematics."[57] Oddi has provided us with a list of the instruments he deemed necessary for more profound mathematical work: a nautical compass, an astronomical quadrant "of the kind which Orontius writes about and which Magino has published," a geometrical quadrant, astronomical rings, and an armillary sphere.[58] That Vagnarelli was capable of producing this kind of larger and more sophisticated instrument is evinced by the sole traceable instrument securely attributed to him: a fine surveying device signed and dated 1639 (fig. 45).[59]

This object, which is essentially a combination of a simple theodolite and

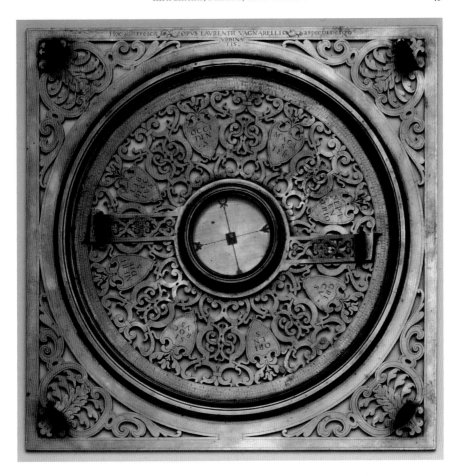

FIGURE 45. Lorenzo Vagnarelli, surveying instrument, 1639. Brass.
Museum für Kunst und Gewerbe, Hamburg. Inv. no. 1893.259.

a surveyor's cross, is an excellent example of the type of azimuthal surveying
instrument popular at the turn of the century. It could be used for measuring
horizontal angles in several ways: by using the four fixed sights at each corner of
the square frame, or by moving the alidade across the circular degree scale (the
magnetic compass in its center was included for orientation rather than for tak-
ing measurements).[60] In essence, the instrument could perform the same variety
of operations discussed in Oddi's *Dello squadro* using identical principles of tri-
angulation. In fact, Vagnarelli's device is very similar to numerous instruments of
the period—notable for the variety of measuring options they provide to the user
and distinguished by the very high quality of their manufacture—which derived
ultimately from Gemma Frisius's *instrumentum planimetrum*, itself based on the
astrolabe.[61] We should note, however, that Vagnarelli's artifact was an elite mea-

suring instrument. This is reflected not only in its sophistication but by the fact that the master artisan used the Latin form of his name when signing it, along with a motto—"Hoc adhaerescit aspectus ergò"—doubtless in reference to the precision offered by the instrument.[62]

Precision measuring instruments were highly sought after by practitioners—as Caravaggio's Salzburg purchases, mentioned above, show—but courtiers also acquired tools of *misura* (measurement) alongside their instruments of *disegno*. Teodoro Trivulzio's purchases are a good example, as one of Oddi's letters to his brother indicates:

> In one and the same day I have had the package of signor Tommaso Landriani with the commentaries on the 5th [book of Euclid's *Elements*], and that with the drawings of the [Holy?] Mother of signor Roberto [and] with the two ruling pens, which I am taking good care of because of the desire that has seized signor Count Teodoro concerning the *stuccio*, for which I need various things, namely a compass of three points, being of the ordinary shape that can be put in a *stuccio* along with the others; and it has to be one of those with the points of pencil, for writing, and for pricking. That of steel should be somewhat larger than that which signor Narcisso is sending me, but not any bigger than those which are ordinarily made. The dividers must be those which I call *feconde* and should be made in that manner such that they are divided into 120 little equal parts; beginning from the center, make the numbers—with a punch if possible—in grades of 5 or 10, whichever you think best, and if the divisions become too small make it in [grades of] 60 only.[63]

Although Oddi called the final instrument he requested "dividers," it is clear from the description (not least the term *feconde*, which he uses in *Compasso polimetro*) that he was asking for a polimetric compass (fig. 46). Notably, Oddi proceeded to provide precise instructions as to how the device was to be designed:

> From the center you should make all the subtending lines of the degrees of half a circle, making first a semicircle with a diameter the size of the line from the center to the points, and once its circumference has been divided into 180 parts, and having made the center one of the extremities of the diameter, with each interval you should trace the circumference until the said diameter is cut—mark them like the others with the characters going up in 5s or 10s, as you judge best, and be sure to mark also the places of the sizes of the sides of the regular figures. I mean that where there will be the subtending line of grade 60 you should make, in a place which will not impede the other numbers, the sign of the hexagon, either as a 6 or however seems to you most intelligible, and also where there is the subtending line of grade 72 the sign of the pentagon, and also three or four more of the principal figures. With this, so that

FIGURE 46. Italian School, polimetric compass, ca. 1600. Gilt brass, similar to
the kind discussed in Oddi's *Fabrica et uso di compasso polimetro*.
Istituto e Museo di Storia della Scienza. Inv. no. 3685.

you can understand well without needing to use many words, I will draw here
below an example in which can be seen the manner of inscribing. In the *stuccio*
there should be ordinary ruling pens, and another like that of Don Virgilio for
outside the *stuccio* but with the scoops of very durable steel. . . . I want for this
Christmas a silver ruling pen with scoops, with the points only of steel, the
rest like that of Don Virgilio, but first I will send the money.[64]

Evidently Matteo Oddi was expected to convey his brother's wishes and explain,
step by step, the method used to Vagnarelli, who apparently was not—unlike his
master Barocci—particularly well versed in geometry.[65]

This highlights a very important point about Oddi's relationship with the Of-
ficina: he was a remote technical director of the instrument-making process. In
his letter, Oddi was at pains to specify precisely both the geometrical methods
and the techniques required to construct instruments, indicating the size de-
sired, the materials to be used (very hard steel, for instance, for the scoops of one
instrument), and even the tools to be employed (a punch for making numbered
scales). It seems that while under Simone Barocci's guidance the Urbino work-
shop was a melting pot that mingled technically competent mathematicians with

mathematically aware artisans, thereby producing novel instruments, Vagnarelli lacked both the education and the personnel necessary to achieve similar feats.[66] Indeed Oddi, as much as the master artisan, was a bearer of "ingenious aptitude," a man who could mediate between the mind and the hand, between mathematics and manufacturing.[67]

INGENIOUS APTITUDE

No assessment of Oddi's place in the instrument economy would be complete without considering where he stood in relation to processes of designing and constructing mathematical objects. In fact, he is an important case study, for he exemplifies the ambiguity that surrounds the nexus of manufacturing and the sciences in the late Renaissance, a topic that has received considerable attention in recent years. On the one hand, Oddi was not a professional artisan—he did not maintain a workshop, nor did he sell wares for a profit. On the other, he came from a craft background (having been apprenticed to a painter), he worked as an architect (which involved managing building sites), and he supervised the construction of a wide range of cunning devices.

In 1634, for instance, he conceived and commissioned a fountain-cum-instrument based upon Guidobaldo del Monte's "scaphe" dial and the famous fountain in the Giardino Pensile of Urbino's Palazzo Ducale (fig. 47), for which the dial had served as a model:

> I have written to Your Lordship about buying back the books of signor Guidobaldo, because of the news, or rather the bad news, that they have already been sold, and for next to nothing. I hope it might be possible that, during my stay in Pesaro, I could make friends with signor Giovanni Mosca, and with this deserve to be allowed to see what little remains in his [Guidobaldo's] *studiolo*. It has already occurred to me to make one of those dials with reflecting rays in a marble basin, which will serve as a fountain—I have already ordered the marble from Carrara, and in several days I hope it will be here, not having been able to refuse it to signor Bernardo Buonvisi, my very close friend.[68]

Thus, Oddi bridged Guidobaldo's mathematical ingenuity and the craft skill of the *bottega*, designing his instrument, choosing the materials, and directing the work's construction.

This was, of course, very similar to his routine work as an architect. By the late Renaissance, nobody would have expected a master architect to sully his hands by actually constructing the walls he designed—that was the job of the *muratori*, the bricklayers. The architect was, however, obliged to enter the world of practice by making both drawings and three-dimensional models—as Oddi did, for example, in his work as fortifications engineer. Yet even beyond the realm of

FIGURE 47. "Fountain dial" in the Giardino Pensile of the Palazzo
Ducale, Urbino. Galleria Nazionale delle Marche, Urbino.

architecture, the mathematician was deeply involved in designing and manufacturing. For example, in addition to instructing and supervising Vagnarelli, Oddi invented and made his own sundials, complaining in 1611 that work on *Degli horologi solari* was progressing slowly because he had been obliged to make four sundials for the Milanese Theatines.[69]

Similarly, among the mathematician's papers there is a suite of fine (but unfinished) drawings of plane sundials, presumably intended as a gift to a patron, and Oddi's letters contain numerous instances of his having designed dials as an exercise in mathematical virtuosity.[70] In 1627, for example, he wrote to Camillo Giordani about an astronomical dial he had recently created:

> I have made an astronomical sundial, in which the equinoctial is a straight
> line as in all others, the parallel of Taurus and Virgo is a Hyperbola, that of
> Gemini and Leo is a parabola, and that of Cancer is an ellipse.[71]

In this paper instrument—which is highly reminiscent of Kepler's diagram of conic sections—Oddi cleverly deployed his advanced knowledge of conics, producing a printed artifact designed to amuse and impress his friend (figs. 48 and 49).[72] He demonstrated both his *ingegno*, at conceiving the instrument in the first place, and his skill as a master of *disegno* in its execution.[73]

In creating instruments in this way, on a nonprofessional basis, Oddi is thoroughly representative of the taste for designing and making that seized

FIGURE 48. Astronomical sundial of conic sections, from Mutio Oddi,
De gli horologi solari (1638), p. 179. British Library, London.
Shelfmark 536.3.27. © British Library Board.

the Republic of Letters in the sixteenth and seventeenth centuries. All across
Europe, from Oddi's Torinese priest who had a "great love of manufactur-
ing" globes to princes who engaged in alchemical experiments, *cognoscenti*
were participating more deeply and frequently in the maker's knowledge tra-
dition—the notion that one can arrive at a proper understanding of a thing
only if one comprehends intimately how it is made.[74] This tradition has a long
history, but its prominence increased markedly in the Renaissance. Spurred
on by humanist interest in the power of *ars*, scholars and courtiers now not
only entered the workshop to acquire new knowledge—as Vives had recom-
mended—but themselves began to learn and practice the mechanical arts.[75]

As William Eamon, Paula Findlen, and others have shown, the cultivation
of virtuosity was a key aspect of this process.[76] Manufacturing, when disassoci-
ated from the vulgarity of commerce, presented an opportunity to demonstrate
such courtly virtues as dexterity and creativity; it enabled the maker to display a
healthy curiosity about the workings of the world; and it led to a knowledge of
artificial things—in particular the strange and wondrous—through which one
might better comprehend nature.[77] The individuals with whom Oddi mingled,

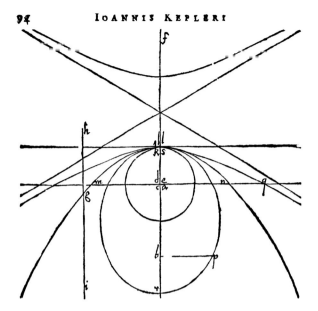

FIGURE 49. Johannes Kepler, diagram showing conic sections, from
Ad Vitellionem paralipomena . . . (1604). British Library, London.
Shelfmark C.75.C.13. © British Library Board.

especially in Milan, were actively engaged in this world, as one particular epi-
sode—his involvement with a lathe and the *ars tornandi*—reveals.

On 23 May 1614 Oddi wrote from Milan to an unknown recipient:

> Signor Ercole Bianchi returned yesterday evening from Flanders and says that
> he has brought me a book of fortification by Simon Stevin, an outstanding
> mathematician of fortifications, being the *maestro* of Count Maurice in Hol-
> land; he says that it is in Flemish but one can still understand a lot from the
> illustrations, and if there is anything new in it I shall write to you straight away.
> He has also brought a lathe which cost 200 ducats, with which more than
> twenty diverse and most extraordinary things have been made, such that I will
> no longer have any need for either Bernabei or Francesco Gremani.[78]

We have already encountered Ercole Bianchi as one of Oddi's pupils in the
mathematical arts and as the friend who saw Matteo Oddi's book—the *Prec-
etti militari*—through the press of Mutio's behalf. Yet in addition to his math-
ematical and military interests, Bianchi was a key figure in the art world of late
Renaissance Milan.[79] Heir to the renowned Milanese painter Ambrogio Fig-
ino, Bianchi was a noted collector and, in particular, a connoisseur of Flem-
ish paintings.[80] From at least 1606 he was Federico Borromeo's art agent in
the Southern Netherlands, traveling regularly between Antwerp and Milan to

deliver the cardinal's instructions to Flemish painters and to arrange commissions, purchases, and the transportation of works of art.[81] Bianchi's familiarity with Antwerp's artisanal *milieu* evidently enabled him to obtain the precious lathe, which, as we shall see, Oddi desired for a very particular purpose: the manufacture of oval turnings.

Turning was one of the mechanical arts most widely practiced by the elite in the late Renaissance, for once mastered the turner could fashion his chosen material—normally softwood or ivory—into an enormous array of capricious forms.[82] These creations share many formal similarities with the extravagant inventions of sixteenth-century perspective treatises: turnings were often explicitly founded on geometry but, in their cunning configurations of unusual shapes, broke the rules and exceeded the norm, thus indicating the maker's imaginative prowess and skill. Indeed, by mastering the representational challenges posed by such complex shapes, the makers demonstrated that they had overcome what Vasari and other commentators on the arts called *difficoltà*, and had progressed toward perfection.[83]

Turning was especially prominent in the elevated Milanese circles in which Oddi operated during the first half of the seventeenth century. The noted collector Manfredo Settala (1600–1680), for example, was a renowned practitioner of the art; indeed, he was portrayed by Oddi's pupil Daniele Crespi proudly holding an ivory turning of his own making (fig. 50).[84] Joseph Connors has even gone so far as to argue that Milanese fascination with the *ars tornandi* helps to explain the fantastical architectural caprices of Borromini, who may well have been Oddi's student when the mathematician taught at the Fabbrica of the Duomo.[85] Milanese interest in turning derived in no small measure from the fact that one of the most celebrated turners of the age, Giovanni Ambrogio Maggiore (ca. 1550–after 1598), was himself from the Lombard city. This artisan is credited with the invention (possibly based on a design by Leonardo da Vinci, who had spent time in Milan in the employ of the Sforza family) of a lathe that was capable of producing not only the usual round turnings, but also oval forms, a technique that he took to Munich, where he was engaged as a turner by Crown Prince William, later William V, Duke of Bavaria (fig. 51).[86] Maggiore seems to have returned to Milan in the 1590s, shortly before his death, but to date it has not been known whether he passed on the highly prized secret of the art of oval turning to artisans there.

Two letters from Oddi to Piermatteo Giordani, pertaining to Bianchi's lathe, suggest that he did not. The first, dated 7 May 1614, is predominantly concerned with a discussion of geometrical problems, including extracts from the Flemish Jesuit François d'Aguilon's *Opticorum libri sex* (1613), recently delivered to Oddi from Antwerp by Bianchi. Having discussed Aguilon's treatment of triangles, the mathematician wrote:

FIGURE 50. Daniele Crespi, *Manfredo Settala*, ca. 1630.
Oil on canvas. Pinacoteca Ambrosiana, Milan.

FIGURE 51. Giovanni Ambrogio Maggiore (turner) and Georg Hoefnagel (painter), *Stacking Boxes*, mid-1580s. Turned ivory. Kunsthistorisches Museum, Vienna.

As for Bernabei, it won't be necessary for him to make anything else, since I have discovered a way to make the oval, and also very much more ingenious things, besides the fact that there happens to be in Milan a person who, as far as I understand, is very well versed in the manner of turning.[87]

In the second letter, dated 22 May, Oddi elaborated further:

[Bianchi] has returned from Flanders and, among the other beautiful things that he has brought, more or less predicting my desire, he has brought a lathe, which cost him 200 *scudi*, with which the oval, and even more common and large things, can be made, such that neither Your Lordship nor the brother of Monsignor the Bishop should wear yourselves out to overcome the discourtesy of Bernabei, as the inventions of his lathe have been found out by another route, and my friend has made the lathe, and he himself is using it. I will send as well as I can something made with this new arrival from Flanders, and Your Lordship will see for certain that they surpass by a long way all the other fine and extraordinary [*diligenze e stravaganze*] things seen to this point.[88]

It is clear from these letters that Oddi sought a lathe like Bianchi's in order to solve two problems: first, to turn ivory or wood in an oval form comparable to those objects produced at the end of the previous century by Maggiore; second, to bypass (both for himself and for his friends) the troublesome and discourteous "Bernabei." Bernabei, we may infer, was an artisan working in the Duchy of Urbino who had somehow learned the method of oval turning and wished to keep it a secret.[89]

However, what is especially striking about these passages is the way in which Oddi's engagement with the *ars tornandi* intersected with aesthetics that were mathematically determined. Oddi's interest in the oval likely pertained to his mathematical curiosity, for such a shape is related to conic sections: an ellipse may be defined as a special case of an oval, one that possesses two axes of symmetry. Conics was a branch of mathematics that particularly appealed to Oddi—it was at the heart of his optical experiments, his astronomical sundial used conic sections in an inventive manner, and the part of *De gli horologi solari* of which he was most proud was that on "conic lines."[90]

Conic sections and ovals both presented particular representational challenges in that they could not, unlike regular polygons or circles, be drawn easily with only a ruler and compass. As a result, many late Renaissance practitioners devoted considerable time to the development of methods and instruments that would render their construction swifter and easier.[91] Oddi himself published a short account of a trammel designed by the Urbinate engineer Felice Paciotti that facilitated the drawing of conic sections, and he corresponded extensively on the subject with his pupil Giovanni Battista Caravaggio.[92] The motivation

for this deep interest in the ability to draw such figures—and thus to explain them visually and apply them to materials—was in part artistic. In perspective, a foreshortened circle becomes an ellipse, hence practicing artists' interest in instrumental means to achieve this shape. Elliptical forms also began to fascinate architects from around the middle of the sixteenth century, and were favored especially by seventeenth-century Italians, such as Borromini and Bernini, for the quality of movement implicit in their shape.[93] Oddi's agenda, however, was also scientific, for conic sections were becoming increasingly relevant to optics, ballistics, and astronomy.

Two branches of optics—dioptrics (the science of refracted light) and catoptrics (the science of reflected light)—had recourse to conics in attempts to understand and devise effective lenses for telescopes and efficient burning mirrors; in each case, the merits of parabolic and elliptical shapes were much discussed.[94] In ballistics, the shape of the arc of a cannon's shot became a hotly contested subject in mathematics and natural philosophy, with some (notably Galileo) arguing that it was parabolic, thus impugning Aristotelian arguments about violent and natural motion.[95] Finally, in astronomy Kepler's discovery of the elliptical shape of planetary orbits (his "First Law") brought conics to the heavens.[96]

Oddi's oval turnings may be understood as part and parcel of this broad mathematical culture in which visualization—even materialization—was a vital feature not only of the intellectual work undertaken, but also of mathematicians' efforts to demonstrate their findings and persuade audiences of the veracity of their claims. Oddi was evidently keen to produce *stravaganze* curiosities, as befitted the *virtuoso*, yet he approached the challenge of oval turning not through geometrical reasoning alone, but also through his hands—by manufacturing. Yet while his involvement in making served to advance his own knowledge, he was also keenly aware of his duties as a technical advisor. We have already seen that he provided precise instructions to the instrument makers of Urbino—an obligation driven by love of his *patria*—but he also used his instrumental abilities to serve patrons in their own manufacturing projects, as one final example of his role in the instrument economy shows.

INSTRUMENT DESIGN AND DIDACTICISM:
A WONDROUS SPHERE

In a letter to Piermatteo Giordani of 1627, Oddi referred in passing to a "sphere . . . such as that which I made from silver for Cardinal Borromeo to show the motions of the moon."[97] Given his use of the phrase *ho fatto* (I made), we might reasonably assume that Oddi had crafted the sphere himself. However, a second reference to the instrument shows just how ambiguous the language of making could be in his era. Writing to Piermatteo's nephew in 1628, Oddi stated:

Were I in our country I would show Vagnarelli how to make a sphere of the motions of the moon, such as that one of silver which *I had made* [*feci fare*] in Milan for signor Cardinal Borromeo, who is curious [about such things].[98]

True to form, Oddi was not the hands-on producer of Borromeo's sphere, but rather its designer. He possessed the astronomical knowledge necessary to invent such a device, but not the metallurgical skill to fashion it, turning to a Milanese artisan in order to serve his patron. Although the sphere has not, so far as one may tell, survived, it was most probably a variant of an armillary sphere, similar perhaps to Girolamo della Volpaia's 1557 *Model of the Lunar Sphere*, a demonstrative device that shows the moon's geocentric orbit (fig. 52).[99] The fact that the instrument was fashioned from such a prestigious material—silver, rather than the more usual brass of Volpaia's device—places it squarely within the court culture of elite consumption.

It is not clear whether Borromeo commissioned his silver sphere or Oddi presented it as a gift, but whatever the case the mathematician's provision of this instrument sits comfortably both with his patronage strategy and with the cardinal's particular interest in astronomy and mathematics. Borromeo, as we have seen through his employment of Oddi as a tutor in geometry and perspective, was a keen supporter of the mathematical arts, while his zeal to reform the Catholic Church encouraged him to take a special interest in debates about the cosmic systems, including the evidence of telescopic observation.[100]

The cardinal's "curiosity," as Oddi calls it, about the motions of the moon doubtless formed part of this broad concern with cosmology. Indeed the silver sphere was connected directly to Borromeo's plan to construct, in a room next to the Biblioteca Ambrosiana, an enormous, self-moving, wooden sphere. This remarkable project—perhaps based on a similarly large instrument created for the Medici by Antonio Santucci in the 1580s—was designed to demonstrate in an awe-inspiring, material form the truth of the Ptolemaic world system and, thus, the implausibility of its most dangerous rival (at least from the perspective of reformed Catholicism), the Copernican system. As Adam Mosley has explained, in late Renaissance Europe astronomical models played an important role "in the presentation and evaluation of world-systems . . . and did feature in the attendant cosmological debates and disputes over priority."[101] Moreover, astronomers of the period frequently took advantage of the "erosion of boundaries" between the characteristics of a model and the thing being modeled in order to support their own arguments and hypotheses. Borromeo's project fits this mold perfectly. The cardinal clearly aimed to use a model of the heavens, rendered especially powerful by its enormous size and startling verisimilitude, to argue his conservative, cosmotheological position—a conservatism that Oddi shared and, as we shall see in chapter 6, actively pursued in Borromean Milan.

FIGURE 52. Girolamo della Volpaia, model of the lunar sphere, 1557. Gilt brass.
Istituto e Museo di Storia della Scienza, Florence. Inv. no. 118.

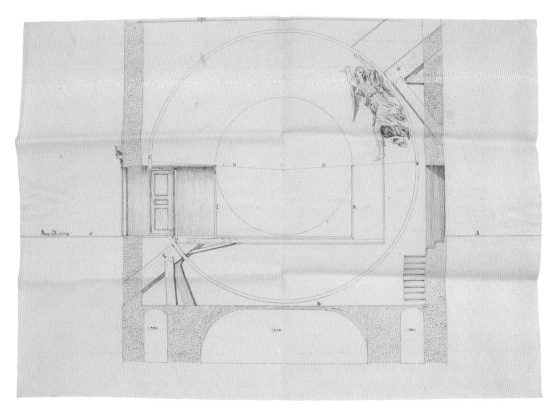

FIGURE 53. Federico Borromeo's *sfera mirabile*, ca. 1620s.
Pen and ink on paper. Biblioteca Ambrosiana, Milan.

Documents related to the planned sphere, which probably date to the early to mid-1620s, are preserved among Borromeo's papers, including a drawing of the projected instrument (fig. 53) and the cardinal's own detailed instructions for its construction, installation, and maintenance.[102] Entitled *La sfera mirabile spiegata a bocca in diversi discorsi dall'Illustrissimo Signore Cardinale Federico Borromeo, Inventore del artificio*, Borromeo's instructions explain, in thirty-two short chapters, that the sphere was to demonstrate the motions of the sun, moon, planets, and fixed stars around the immobile earth.[103] It was to be 20 Milanese *braccia* in diameter, with a circumference of 70 *braccia* (thus far exceeding the extant sphere manufactured for the Medici by Santucci) and made of wood by one "Maestro Antonio, carpenter." Once constructed, the sphere was to be colored and gilded, and powered by an ingenious system of weights and clockwork.[104]

Borromeo intended to have the sphere installed in a special room next to the Ambrosiana seemingly in order to replicate the true position of the heavens relative to the earth, perhaps so as to embellish the verisimilitude of the gigantic machine.[105] The device was to be looked after by a custodian, who would have

to be "able to read well" and who should be "Milanese, not foreign." Although charged with admitting any interested parties, the custodian would be under strict instructions not to reveal the "secret" of the sphere's movement, lest the wonder it was designed to engender be snuffed out.[106]

The degree of detail in these instructions suggest that Borromeo considered the project an important component of his Ambrosiana complex. It is clear that the instrument was intended to be far more than a standard library fixture, such as the globes and spheres that Naudé promoted as complements to scholarly spaces. Its scale and decoration, combined with Borromeo's insistence on both guarding the "secret" of the sphere's movement and making it accessible to all comers, leave no doubt that it was designed to make a polemical point about the "truth" of the cosmic system it represented. The cardinal clearly hoped that the wonder and pleasure induced by observing such a beautiful and overwhelming device in motion would render the veracity of the Ptolemaic system self-evident.[107]

What, though, was Oddi's role in this project? His silver sphere evidently served as a model for part of the large machine, as the cardinal's instructions for determining the motions of the moon in the wooden instrument state:

> For the Moon there should be described on the same Zodiac the line of its voyage conforming to that which one sees on the interior part of that silver celestial sphere, and in another azure model made in the form of a circle.[108]

From the cardinal's description of what the *sfera mirabile*'s moon was to do, we may surmise that Oddi's instrument showed the moon's four phases, represented by "four bodies conforming to the various appearances and mutations of the said moon," along with its trajectory.[109] Unfortunately, as Oddi's silver sphere seems not to have survived, we cannot know what precisely it looked like, nor whether it was stationary or, like its wooden cousin, self-moving.[110]

Given his strong patronage relationship with Borromeo and his intimate knowledge of both astronomy and technology, it is likely that Oddi offered further advice on the *sfera mirabile* project. Indeed, he might well have been the author of an unsigned and undated secretarial copy of a letter that provides detailed instructions for the construction of the sphere's chamber. This *avviso*, addressed to the cardinal, includes the drawing of the projected device referred to above, which shows the sphere being pushed by an angel—an unambiguous reference to its theological motivation.[111] Whether or not Oddi composed this document, the mathematician was certainly qualified to give advice about the type of device Borromeo wished to construct.

In a letter written in 1628 to Alberico Settala—the Milanese scholar who requested a drawing instrument described in Guidobaldo del Monte's *Planisphaeriorum*—Oddi related his knowledge of self-moving spheres and their makers,

drawn from the works of Cardano, Baldi, Ramus, and others.[112] Although Settala's half of the correspondence has not come to light, he had apparently written to Oddi seeking information about metal self-moving spheres of the kind produced in large numbers in the Free Imperial Cities of central Europe, which capitalized on the growing fascination among the European elite for both mathematical instruments and automata (see fig. 37).[113] The Urbinate mathematician proceeded to list the wondrous devices of Regiomontanus, Juanello Turriano, and Oronce Fine (all of which were well known, having been described in print), as well as Lorenzo della Volpaia, Cherubino da Reggio, and his countryman Pietro Griffi.[114] Thus, Oddi not only possessed the mathematical knowledge the cardinal required, but he could also place the *sfera mirabile* project within an appropriate literary-historical context.[115] His agency in the instrument economy was material, technical, and intellectual: an important reminder that mathematics was a cultural, not just a scientific, field.

In an important essay on the multifariousness of Renaissance instruments of science, Martin Kemp has observed:

> According to criteria of style, sixteenth-century armillary spheres and related instruments belong more comfortably with a connoisseur's bronze than they do with a nineteenth-century sextant.[116]

His analysis of sixteenth-century instruments therefore posits that we need to understand such devices not according to rigidly fixed and carefully demarcated disciplinary categories, but as objects that occupied a middle ground. The artifacts Oddi brokered mediated, just as he did, between worlds that are now unambiguously designated as "artistic" and "scientific" but which were, in the period, profoundly interconnected.

How, though, can we make sense of this fecund mix, comprehend its contours, and trace its motions? One element of the instrument economy stands out as a unifying theme: *disegno*. Mathematical devices were instruments of design in several respects. Most straightforwardly, they could be used in plotting, delineating, and mapping (that is, in the creation of objects belonging to the *tre arti del disegno*: painting, sculpture, and architecture) and, through measurement, in the mathematical reasoning upon which mental models could be constructed. But they were also, when deployed as part of a patronage strategy, implements in the execution of a plan for social success and professional advancement, a type of socioprofessional *disegno*. Mathematicians regularly presented novel instruments to potential patrons in the hope that their cunning devices might win the approbation of their social superiors and lead to suitable rewards. Indeed, Biagioli has argued that Galileo used his geometric and military compass and the telescope to win credit in precisely this manner

but, significantly, that the telescope eventually enabled the broker to move from a largely artisanal economy (where he traded on purely mathematical devices such as the compass) to one based on discovery and natural philosophy, thus shifting to a higher system of gift and reward.[117]

While *disegno* was commonly viewed as vital to practical mathematical activities such as fortification and desirable as a courtly accomplishment, it also lay increasingly at the heart of debates about the nature, interpretation, and presentation of evidence about the natural world. From the role of paper museums in the burgeoning discipline of natural history to Galileo's drawings of the moon, *disegno* was beginning to assume significance beyond the realms of art theory and the academy, yet it remained intimately associated with visual practices. This discipline—and the theories that surrounded it—thus represents a crucial link between the worlds of art and science. As the next section of this book demonstrates, for Oddi it created a space in which ideas, objects, and individuals could travel and mingle, producing vivid ways of seeing and knowing in the process.

Mathematics and the Arts of Design

Throughout his long and eventful life, Mutio Oddi engaged directly in a strikingly diverse range of practices. In addition to being a professor of mathematics, an author of practical mathematical books, and an instrument broker, he traded and collected paintings, drawings, prints, and objects of *virtù*, while as an architect-engineer (thus, notably, a practicing draftsman) he designed and supervised the construction of churches, chapels, palaces, villas, fortifications, fountains, and gardens and regularly worked as a surveyor of such sites.[1] Although these varied pursuits would become, through complex processes of professionalization, increasingly distinct as the seventeenth century progressed, Oddi approached them as a coherent body of knowledge and practices bound together through their common reliance on—or relationship to—geometry. In so doing, he was the clear inheritor of a tradition dating back to the mid-fifteenth century, in particular to the Vitruvianism of Leon Battista Alberti.[2] In this tradition, scholars and artisans sought to improve the standing of the visual arts by arguing for their geometrical foundations, thus defining painting, sculpture, and architecture as liberal rather than mechanical in nature.[3] Yet by the mid-sixteenth century, writers such as Benedetto Varchi, Giorgio Vasari, and Vincenzo Danti, while acknowledging the fundamental importance of mathematics (at least as it pertains to measurement) for the visual arts, argued that true *grazia* in an artificial creation derived from its maker having mastered and moved beyond rules and precepts to produce, through innate *giudizia* (judgment) honed by practice, an elegant, seemingly effortless artifact.[4]

That such *sprezzatura* was effectively antithetical to the explicit dependence of earlier Renaissance art on geometry is summed up neatly by Michelangelo's injunction, as reported by Vasari, that the true artist should have the "compass in the eyes," not in the hand.[5] Oddi, portrayed twice in his lifetime clasping this very instrument (figs. 1 and 4), thus represents an intriguing case study in the intricate connections between geometry and the visual arts in the late Renaissance, not least because he was palpably both mathematician and artist. Although it has become commonplace to accept a double identity of this kind as natural to the polymathic "Renaissance man," in Oddi's age the

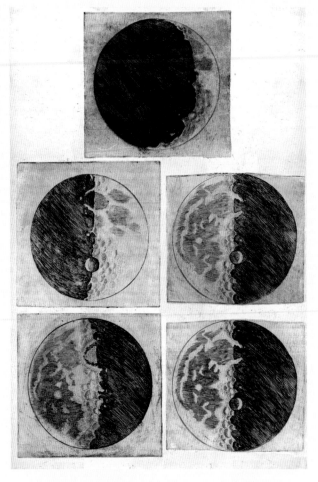

FIGURE 54. Composite image of copperplate engravings of the moon,
presumably after drawings by Galileo, from Galileo Galilei,
Sidereus Nuncius (1610).

development of a theoretical discourse about *disegno*—literally translated as
drawing but possessed of far broader meaning—resulted in the relationship
between mathematics and the arts becoming convoluted and contested. For
while *disegno* could act as a bridge between these two fields, its increasing as-
sociation with invention and fantasy drove a wedge between the rules-based
world of mathematics and the free imagination of artistic creativity, despite
mathematicians' attempts to retain the primacy of their discipline. Put simply,
while many artists and art theorists sought to promote themselves and their
practices by asserting that *grazia* in art derived from the "effortless organizing
of forms and proportions not limited by mathematically defined regulations,"
mathematicians pointed out that without the sure and certain foundations of

geometry (which provided correct proportions, the capacity to render objects in perspective, and so on) the arts remained imperfect, thus claiming superiority on the basis of propaedeuticity.[6]

Nevertheless, it is clear that by Oddi's era *disegno* had become profoundly important to the sciences, a fact made starkly apparent through one of the most hotly debated issues of the time: telescopic observation. Scholars such as Samuel Edgerton, Filippo Camerota, and Horst Bredekamp have argued that Galileo's ability to interpret, and then explain visually, the findings of his lunar observations using the telescope rested firmly on his proficiency in drawing, which resulted from his having drunk deeply at the font of Florentine *disegno* (fig. 54).[7] An indication of the seriousness with which we should take such a claim is the painter Cigoli's criticism of Christoph Clavius, who had dared to impugn the reliability of Galileo's lunar observations. Cigoli defended Galileo by stating that Clavius's failure to accept the truth of his friend's findings stemmed from the Jesuit father's lack of proficiency in draftsmanship. "Without *disegno*," Cigoli wrote witheringly, Clavius was "not only half a mathematician, but also a man without eyes."[8] This comment was doubtless an exaggeration devised to please Galileo; nevertheless, it indicates that there existed the conditions necessary for a striking reversal of fortunes: apparently, mathematical credibility now relied on art rather than the other way around.

In light of the argument advanced for the significance of design in Galileo's achievements, Oddi's relationship to *disegno* is particularly intriguing. For if, as Camerota has suggested, Galileo's drawings of things observed through the telescope "reveal a trained eye and an artistic talent that was uncommon among the mathematicians of the period," who lacked the ability to "objectively represent" what they saw with that instrument, what are we to make of a mathematician who was arguably better versed in *disegno* than Galileo, yet rejected certain of his findings as "artifices"?[9] That Oddi took this approach is evinced by his having devised the allegory of an important painting—discussed in chapter 6—in which a highly mathematical form of *disegno* is used to rebuff what he perceived to be the flawed and unreliable results of telescopic observation. *Disegno* was fundamental to Oddi's perception of the scope and proper application of mathematics, and an exploration of his profound immersion in its culture serves to locate him on the messy map of practices, theories, and identities that make up the mathematical and visual arts in the late Renaissance. Thus, it provides not only a fitting context for Oddi's apparent skepticism toward Galileo's cosmological work and the telescope, but also shows how such a varied range of disciplines could reside comfortably in a single mathematical practitioner.[10]

The power and significance of *disegno* derived in no small part from its lexical and conceptual versatility.[11] Indeed, the notorious slipperiness of the term reflects the sometimes bewildering scope of Oddi's polymathic career, for in

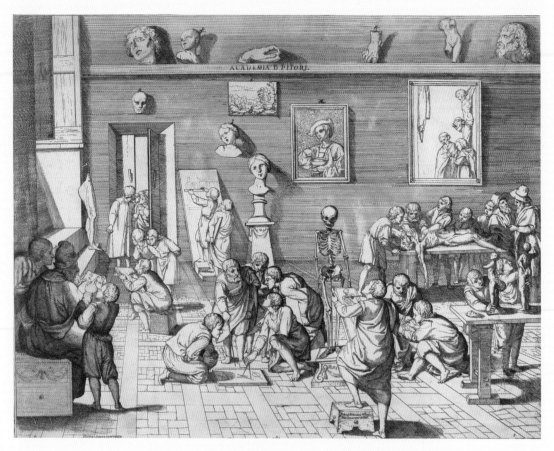

FIGURE 55. Pietro Francesco Alberti, *The Academy of Painting*, ca. 1620.
Copperplate engraving. Rijksprentenkabinet, Amsterdam.

addition to its reference to objects and the physical act of designing or circum-scribing (to use Alberti's term), in the sixteenth century it took on distinct philosophical and metaphysical connotations.[12] While the term frequently sig-nified—especially in Florence, where commitment to *disegno* was at its stron-gest—drawing as a copying practice (after the antique, the model, or nature), it could also refer to drawing from the imagination, providing a connection to the immaterial world of invention and cognition that enabled sixteenth-century theorists to position it as part of philosophy rather than "mere" practice (fig. 55).[13] Because this move was largely responsible for rupturing the bond between mathematics and the visual arts that had proved so effective to the latter's apolo-gists in previous centuries, and because Oddi seems to have been uncomfortable with certain aspects of the new conception of design, we need to consider the trajectory of *disegno* in his age in some detail.

DISEGNO BETWEEN THEORY, PRACTICE, AND OBJECT

The association of *disegno* with philosophy, and in particular with discussions about the operation of the intellect, originated in Benedetto Varchi's public lectures on the nature of artistic production, held at the Accademia Fiorentina in 1547 (and later published as *Due lezzioni*, 1549).[14] In order to elide the distinctions between painting and sculpture—debated extensively in the *paragone* disputes of preceding decades—Varchi described *disegno* as the common "principle" of both arts.[15] This not only had the benefit of providing a critical and conceptual category that could unite the various branches of the visual arts, it also enabled Varchi to position his discussion within the framework of Aristotelian philosophy, in which "principles" referred to the origin or source of something.[16]

Starting from this point, Varchi proceeded to consider the arts in relation to Aristotle's account of cognition, placing them (and therefore *disegno*) within the intellective part of the human soul, which Varchi called "universal reason." He then divided this universal reason into "superior" and "inferior" parts, the former being concerned with speculation, the latter with practice or production. Following Aristotle's paradigm in the *Nicomachean Ethics*, Varchi placed the arts in the inferior part of universal reason, because they are neither necessary (i.e., they can either be or not be) nor do they have their origins in themselves (unlike natural objects, for example). Significantly, this distinguished the arts from "superior," speculative disciplines such as geometry (which is both necessary and self-originating), breaking their traditional association with mathematics.[17]

Varchi had placed the arts in the inferior, intellective part of the soul but nonetheless within the domain of universal reason, thereby identifying *disegno* as a habit of the intellect. Thus, what the arts lost through being disassociated from geometry and the sciences, they gained in being directly related to cognition, and without, crucially, their manual, practical aspects being downplayed or obscured. Varchi's treatment of the arts drew implicitly upon Aristotle's treatment of the hand as an instrument and emblem of human intelligence, and he was keen to stress that where the sciences depended for their nobility upon certainty of demonstration, the arts should be judged—quite properly and without prejudice—according to their ends. As Karen-edis Barzman has explained, "While the end of science was to know the causes of things and to contemplate truth, the end of art was to do or to make (that is, to produce, which involves manual labour)."[18]

Although this approach celebrated making and materiality as possessing nobility, Varchi's attitude was potentially problematic for figures such as Oddi, whose commitment to both mathematics and the visual arts ensured a vested interest in maintaining a close connection between the two. In fact, as Martin

Kemp has observed, by the late sixteenth century there was a growing sense that the "technical elaboration" of mathematics that lay behind works such as Dürer's *Underweysung der messung* (1525) or Egnazio Danti's *Due regole della prospettiva* (1583) had become tiresome to many practicing artists, and irreconcilable to the theories of artistic creation promoted by the new definition of *disegno*.[19] Varchi's program was potentially even more divisive, as it dealt principally with painting and sculpture, to the exclusion of architecture—Oddi's own profession—long regarded as the most mathematical of the arts. It is at this point that a consideration of Vasari's attitude toward *disegno* is necessary, not only because his was arguably the most influential account of the issues at stake, but because Oddi certainly knew the work (the *Vite*) in which he set out his theories.[20]

Although influenced by Varchi's *Due lezzioni*, Vasari departed from that text by incorporating architecture as one of the *tre arti del disegno*, explaining in the famous passage that begins the section "Della Pittura" in the second edition of the *Vite*:

> For *disegno*, father of our three arts of architecture, sculpture, and painting, proceeds from the intellect, drawing from many things a universal judgment similar to a form or idea of all the things of nature, which is most singular in its measurement, for not only in the bodies of humans and of animals, but in plants also and in buildings and sculptures and paintings, design is aware of the proportion of the whole to the parts, and of the parts to each other and to the whole. And from this knowledge a certain conception and judgment is born, such that there is formed in the mind something that can be expressed with the hands, which is called *disegno*, so that one may conclude that this *disegno* is none other than a visible expression and declaration of the concept that there is in the soul, and of that which is also imagined in the mind and made in the idea. . . . This *disegno* desires, when it has drawn from judgment an invention of something, that the hand, guided by study and practice of many years, should be able to draw and express well whatever nature has created, with pen, with silverpoint, with charcoal, with chalk, or with anything else; because, when the intellect puts forth concepts refined and [made] with judgment, those hands that have practiced *disegno* for many years show the perfection and excellence of the arts, and the knowledge of artists also.[21]

Vasari's definition of *disegno*, therefore, has need of the senses (it draws "from many things" its universal judgment), but he is keen to emphasize the process of abstraction from particulars to concepts or ideas, which are then rendered by the properly trained artist, on the basis of judgment, as original works of art. In relation to mathematics, it is notable that Vasari refers to the significance of measurement, but also that his forms of *disegno* share a certain similarity to the material manifestations of geometry.[22] For, just as geometrical figures are the instantiation

of something immaterial, prompting the mind to speculate on universal truth, so the products of *disegno* are only a "*visible* expression . . . of the concept that there is in the soul," that is they stand in for the images of the mind.[23]

It is important, too, when considering the possible relationship between mathematics and *disegno,* to remember that in his conception of design Vasari privileged line over color, for only line could represent forms "refined and made with judgment" (he refers here to Aristotle, for whom color was the "accidental" quality of objects perceptible through the sense of sight). Thus, by removing color and replacing it, through judgment and with a well-trained hand, with line, the artist "perfected" nature, demonstrating his capacity for cognition and proving his "knowledge." Such a stance must have been particularly appealing to Oddi, whose defective vision, as his first biographer tells us, meant that "he was not able to color in that which he drew."[24]

Although the general tenor of the *Vite* is hostile to an excessive concentration on geometry and mathematics (evident especially in its somewhat disparaging comments about Paolo Uccello), Vasari's emphasis on line could, to the champion of mathematics, be construed in a positive light, namely because it is with the properties of lines that the foundational text of geometry, Euclid's *Elements*, begins.[25] In fact, as exemplified by the statutes of the Florentine Accademia del Disegno—of which Vasari was a founding member—mathematics was a crucial part of the curriculum devised to train artists in the principles of design. The Accademia employed a succession of renowned practical mathematicians to provide instruction in Euclid and perspective, even purchasing a set of instruments to facilitate these studies.[26] There is every indication, then, that Vasari and his followers were not hostile to mathematics in and of itself, merely opposed to an excessive or pedantic emphasis on geometry that resulted in graceless works of art.

In fact, up to the end of the sixteenth century we find writers who retain a strong commitment to mathematics as the necessary basis for the arts—most notably the Milanese Giovanni Paolo Lomazzo, who, in his *Trattato dell'arte della pittura* (1584), claimed that *disegno* was concerned with numerical relationships that exist in nature.[27] However, a hardening of attitudes toward mathematics in relation to design is found in what is undoubtedly the most exhaustive treatment of *disegno* of Oddi's age: Federico Zuccaro's *Idea de' scultori, pittori, e architetti* (1607). It is very possible that Oddi was familiar with this work, for the book was based on discussions in the academy Zuccaro founded in Rome with the support of Federico Borromeo, one of Oddi's principal patrons during his Milanese period. With its references to theologians such as Thomas Aquinas and its metaphysical speculations, Zuccaro's text is entirely consistent with the Counter-Reformatory context of the arts in Borromean Milan, to which Oddi was highly receptive.[28]

Borromeo was certainly not hostile to mathematics, and his employment of Oddi as tutor in perspective at his Accademia indicates that he supported the geometrical training of artists, but Zuccaro is explicit in his rejection of the view that mathematics is the foundation of painting:

> I say strongly, and I know I say the truth, that the art of painting does not derive its principles from the mathematical sciences and has no need of recourse to them to learn the rules and means for its practice; for art is not the daughter of mathematics, but of nature and design. . . . If you wish to attempt to investigate all things and to understand them by means of theory and mathematics, working in conformity with them, this would be intolerably prolix and would represent a waste of time with no fruitful results.[29]

Zuccaro was not actually averse to the use of mathematics, in perspective, for purposes of representation, but the demands made upon the arts by the Counter-Reformation led him to a metaphysical understanding of *disegno* (what he called *disegno interno*), which gave priority to the direct manifestation of the divine and the need to inspire the faithful, rather than the trickiness of perspective, signaling an abhorrence of the fussy study of complex mathematics for its own sake.[30] This was in part, perhaps, a reaction against the mannered, elaborate, perspectival constructions featured in treatises such as Wentzel Jamnitzer's *Perspectiva corporum regularum* (1568) or Daniele Barbaro's *La prattica della prospettiva* (1569), which served principally to demonstrate artistic virtuosity and encourage curiosity in the viewer. Yet despite Zuccaro's trenchant views and the very obvious rejection of this aesthetic in much Italian painting of the later sixteenth and early seventeenth century, a highly mathematized kind of *disegno* continued to fascinate Italian princes and *virtuosi*, who, as we have seen, persisted in creating bizarre *alla grottesca* forms in turned ivory and other media.[31]

The reasons for this are straightforward. First, it is doubtful that Zuccaro's long, convoluted, sometimes obscure treatise was imbibed in toto by either practitioners or their patrons, nor that those who read it agreed with its strident attitude toward mathematics. Indeed, while *disegno* was certainly a much debated topic of the period, it is not at all evident that the often subtle differences between the views of the various authors concerned were apparent to all; it is far more likely that a more general, diffuse understanding of what *disegno* meant (garnered most probably through having read Vasari) was held in most artistic and intellectual circles.[32] Second, and perhaps most importantly, the mathematical community was constantly expanding in Oddi's era, due to the spread of mathematics tuition, the vogue for practical mathematics books, and the growth of the instrument trade. Thus, even as Zuccaro was lambasting mathematics in art, mathematical knowledge and practice were becoming

every more widespread, not least among the elite patrons on whom artists relied for patronage. Moreover, while the particular demands of the Counter-Reformation had a decisive impact on certain regions, individual artists, and types of art, their influence was not universally pervasive. There existed numerous branches of the arts in which mathematics retained its currency and justified its claim to be at the heart of *disegno*: most obviously in the production and use of mathematical instruments, but also, and quite explicitly, in military architecture—an art in which Oddi was particularly active, for he designed and supervised the construction of a major part of Lucca's fortifications between 1625 and 1636.

Although the line separating military from civil architecture in the late Renaissance was by no means clear-cut, military engineers were keen to stress that their proper knowledge of mathematics distinguished them from—and in certain respects made them superior to—other architects. For example, in his *Due dialoghi* (1557), Giacomo Lanteri presented a dialogue in which two young *cavalieri* had come to take lessons with the fortifications master, Girolamo Cattaneo (author of *Libro nuovo di fortificare*, 1567). When one of the pupils states that he has never heard it said by architects that the angles of bastions are smaller than the angles of a fort's walls, Lanteri has Cattaneo reply scoffingly:

> They read freely Vitruvius, who is more martyred by them than a new Saint Stephen, and they see what it is that he says. But it is enough that they can say, "Vitruvius says this, Vitruvius says that." They do not understand anything but that which is said in a literal sense. Therefore, do not be surprised if I laugh when you say that they do not know how to use Euclid, because they have so little understanding of him.[33]

As Mary Henninger-Voss has argued, while treatises such as Lanteri's and Cattaneo's regularly digressed to extol the "glories of mathematics that go back to Plato and Aristotle, and bear striking similarities to the eulogistic prefaces of Euclid editions," what is most notable about military engineers' appropriation of mathematics is that in their works "mathematics takes on characteristics . . . distinct from verbal knowledge."[34] In military architecture, the visible geometry of the fortifications plan was often deemed sufficient to persuade its audience of its utility and intellectual virtues, for such designs were clearly based on the sure and certain principles of Euclid. Indeed, for many Cinquecento engineers, a mathematical form of *disegno* was the key to the much sought after goal of uniting theory and practice, art and science in a single discipline. As Lorini explains:

> The science [of military architecture] is without doubt, for it has its foundations and every perfection from mathematics, which is indeed known for the

certainty of its demonstrations. In this way, while it teaches it is science; while it then puts forth—with certain and determined rules—the undoubted end of fortification (which is to defend a site), it is an art.[35]

The "putting forth" of military architecture's mathematically based science was notably rooted in *disegno*, which, Lorini explained in a particularly rhapsodic passage, mediated between the intellect and the material world:

> On this [*disegno*] depends the true essence of all things: it enables one to show that great perfection which the *ingegno* of man may have, which both imitates the wonderful works made by Nature and by Art, and also shows to everyone and makes them understand each of his concepts. And although *disegno* is of such value, whoever masters it well can truly say that it is very easy to express perfectly all works that he would like to do. Because with this not only are all inventions shown, and their foundations (approving the good and emending the bad), but also the sites of countries are represented, that is, the land, the sea, and whatever natural and artificial things are at work there, and all are shown on a simple piece of paper, where one makes one's demonstrations as they really are, or should be. It would be possible, also, to see how things are explained, and to make known our concepts.[36]

Measured, mathematical design thus mediated—much like mathematical instruments—between the mind and the hand, and in drawings specifically, one witnessed this convergence between the material and immaterial worlds.[37] It is to this aspect of Oddi's relationship to *disegno* that we shall now turn.

Disegno: From Drawings to the Cosmic System

As an architect, Oddi worked at the coalface of *disegno*. The official papers that record his work as fortifications engineer for the Republic of Lucca, for example, show that he was obliged to spend much of his time preparing drawings that demonstrated to the gentlemen of the Offitio sopra le Fortificatione both his idea—his *concetto*—and how his schemes might be executed (fig. 56).[1] Where, though, does Oddi stand vis-à-vis *disegno* more broadly, in both theory and practice? He was certainly familiar with treatises that were explicitly concerned with theoretical aspects of *disegno*, most notably Vasari's *Vite*. He was also, as we have seen, directly involved in one of the earliest art academies to adopt (albeit in a modified form) Vasari's principles: Federico Borromeo's Accademia del Disegno.[2]

While Oddi did not write directly on the theoretical nature of design, he was heavily involved in its practice. In addition to his regular work as an instrumentalist and architect, painting and sculpture played an important role in his social and professional worlds. Scattered references in his papers testify to his interest in sculpting and to his involvement with statuary in his architectural practice: for many commissions he was obliged to design and supervise the construction of ornamental sculptures—which required a knowledge of materials and familiarity with the appropriate artists—but he also collected statues and taught young stonecutters at the Fabbrica of the Duomo in Milan.[3] Moreover, he had, in his youth, been apprenticed to one of the leading painters of the age—Federico Barocci—and he retained a strong interest in picturing throughout his life.[4] Indeed, Oddi taught and forged friendships with artists, used paintings to represent his friendships and conception of mathematical practice, and was an active participant in the art trade, collecting pictures himself and arranging commissions for acquaintances.[5]

In fact, it seems that Oddi was reckoned something of a connoisseur by his friends, as a letter from his pupil Giovanni Battista Caravaggio suggests:

> I have seen that signor Gian Vincenzo Imperiale has sought old pictures from Your Lordship; the very same gentleman has seen fit to entrust me with

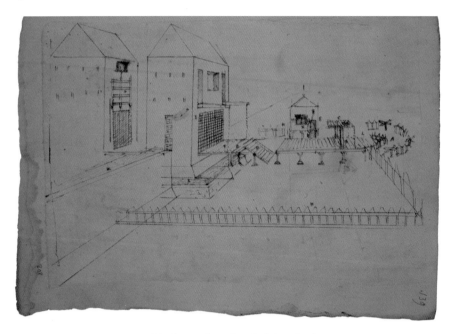

FIGURE 56. Mutio Oddi, design for a fortified drawbridge, ca. 1625–1635.
Pen and ink on paper. Biblioteca Medicea Laurenziana, Florence.
Codex Ashburnham 1828 App., fol. 139r.

acquiring some of the paintings of signor Calchi, which are the two that Your
Lordship judges are by Tintoretto, and that of Our Lady, which the patron
[Calchi] says is by Bellini, but the patron will not budge from the price of 150
scudi for each one, which leaves me unable to resolve anything.[6]

It is likely that Imperiale was the "*cavaliere* who has the ability to spend a great
deal," mentioned by Oddi in a letter to Camillo Giordani in relation to objects
for sale in Urbino. Oddi told his Pesarese friend that letters from acquaintances
in Pesaro had led him to understand

that His Highness [Duke Francesco Maria II della Rovere] has put everything
up for sale, and in particular the *Guardaroba*; I am friends with a *cavaliere* who
has the ability to spend a great deal, such that he wishes to know whether the
pictures will be sold altogether and if there will also be any sculptures, and if
the armory is being sold in its entirety.[7]

Oddi regularly acted in this way, as a middleman in the art trade.[8] For exam-
ple, in March 1618 he wrote to his brother, Matteo, mentioning that one signor
Costantino was leaving Milan for Rimini, and that he was carrying with him
Matteo's marine compass, along with a medal of Bramante and some sculptures
that belonged to Oddi. He explained that he (Oddi) desired "a large picture"
(presumably for the decoration of some *cavaliere*'s residence), "and you should

see whether the heirs of signor Girolamo Olivieri want to sell a copy of the Saint Agatha by Fra Sebastiano [del Piombo], which His Lordship has in Pesaro, or whether in Urbino one can find anything similar."[9]

SIGNORI CHE SI DILETTANO DI DISEGNI: ODDI AND THE WORLD OF DRAWINGS

Despite his defective vision, then, Oddi was evidently well equipped to judge paintings and sculptures, and was familiar with the workings of the market in which they circulated. His most regular involvement in the arts of design, though, was through drawing, the literal translation of *disegno*. Oddi drew more or less every day, as both architect and mathematician, yet he was concerned not only with making drawings, but also with collecting them. For instance, in June 1612, a few years into his Milanese period, Oddi wrote a brief letter to his brother, Matteo, in Lucca. Although he was not yet firmly established in Milan, the mathematician had already gained entry into the elite circles of patricians, ecclesiastics, and officers who made up the city's ruling class and had managed to secure the patronage of one of its most influential nobles, Count Teodoro Trivulzio. After noting a visit to the count's villa at Cologno, and having pressed Matteo with the usual requests to Vagnarelli for instruments, Mutio turned to one of the great passions of his life: collecting. "Padre Don Iacomo di San'Antonio, a Theatine, and my great friend, has died," Oddi explained,

> and he has left various beautiful things, which I have here in the house to sell, which if I had the money I would not leave, but open my hand [in order to acquire them]. Could you send me, from that volume of signor Guidobaldo, two or three sketches by Raphael, of certain compositions of Madonnas, or whatever else there is, as I want to show them to certain gentlemen who delight in drawings?[10]

In this passage we see Oddi trading, as he so often did, on contacts in his *patria* in order to impress, through objects representing the best of Urbinate *ingegno*, his social circle in exile. In this particular case the objects were not Vagnarelli instruments but drawings, and by no less a figure than Raphael—the supreme exponent of *grazia* in *disegno* (fig. 57). In using drawings in this way, Oddi partook of an emerging culture of connoisseurship in which drawings were, for the first time, singled out as collectable in their own right. While drawings had long played a crucial role in artistic training and invention, circulating within workshops and between artists, it is only in Oddi's era that they were systematically amassed by nonprofessionals (referred to variously as *dilettanti*, *cognoscenti*, *amateurs*, *virtuosi*, and *liefhebbers*), whose collections served as the focus for a multitude of social and intellectual transactions, from discussions about style

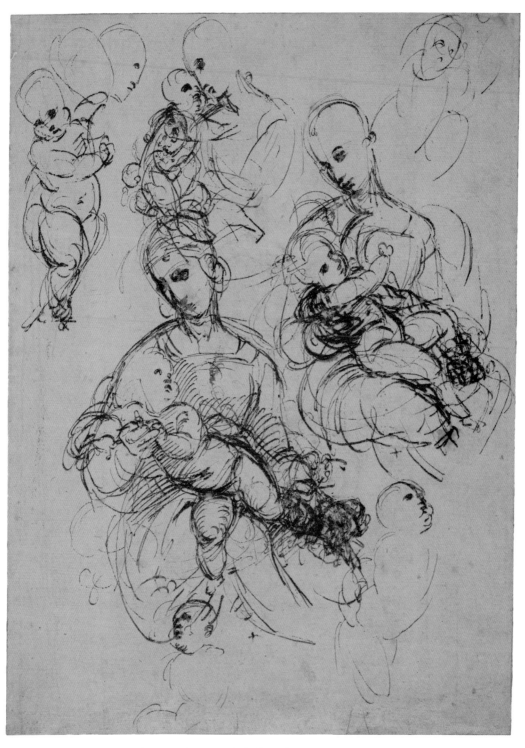

FIGURE 57. Raphael, *Madonna and Child Studies*, ca. 1505–1508. Pen over traces of red chalk on paper. British Museum, London. © Trustees of the British Museum.

and attribution to self-conscious displays of erudition in the form of conversations about iconography.[11]

Oddi himself assembled a large collection of drawings and prints (predominantly, but not exclusively, architectural) by masters he particularly admired, including a great many by Francesco di Giorgio Martini's school and what is today the only surviving drawing by Leon Battista Alberti. The significance of this collection is twofold. First, it suggests that Oddi took to heart Vasari's injunction that the practice of *disegno* was improved by studying the best models.[12] To this end, Vasari assembled an exemplary collection of drawings (the famous *Libro de' disegni*), and Oddi's collection should be located firmly within this tradition.[13] Second, it reveals that Oddi especially sought out works representative of an earlier, more explicitly mathematical manifestation of *disegno*, which relied for their aesthetic appeal on restrained geometrical elegance and proportionality rather than the courtly *sprezzatura* of Vasari and his ilk.

What survives of Oddi's collection—including many of his own designs—is preserved in a pair of albums in the Royal Collection at Windsor Castle and a single album in the Biblioteca Medicea Laurenziana in Florence.[14] These do not comprise the entirety of Oddi's drawings collection; we know that in addition to the large quantity of architectural drawings preserved in Windsor and Florence he owned works that are not present in these albums, including "disegni" (possibly prints) by Stefano della Bella, architectural studies by Girolamo Genga, and figure drawings by Raphael.[15] For example, in November of 1611 Oddi wrote to his brother:

> I would like you to obtain, if it is possible to have them back, the works of Saint Augustine and those of Biondo of the Staccoli [family], books which I lent to the priest of the Cimitri, and to Don Aloigi in Urbino one of Medicine, [and] from Signor Ventura Mazza certain of my drawings by Raphael that he has, which he had from Ludovico the painter, and particularly three little *putti* which I know that he has; and to him you should return certain trophies which are in the house, and you should be sure to return to the said signor Ventura from signor Propisto certain printed designs.[16]

In fact, Oddi's prints and drawings were but one part of a large and diverse collection that included paintings, furniture and silver, a handful of natural curiosities, and a large number of mathematical instruments.[17]

The fortunes of this collection following Oddi's death in 1639 are somewhat convoluted, but in essence some of his goods—mainly furniture and a few paintings—were distributed among his heirs; his books, sculptures, prints, drawings, manuscripts, and instruments were kept together for a time but were gradually dispersed over the years. No proper inventory was ever taken, but we know that in the 1640s his nephew and executor, Niccolò Vincenzi,

FIGURE 58. Mutio Oddi, *Gateway in the Horti Bellaiani, Rome*, ca. 1592.
Pencil and colored chalks on paper. Royal Library, Windsor Castle.
Vol. 182, no. 10074. © 2009 Her Majesty Queen Elizabeth II.

gathered together Oddi's collection of drawings.[18] It is difficult to establish
whether he placed them in any particular order, as the current arrangement,
in the Windsor and Florence albums, is not likely Vincenzi's.[19] The extant ar-
rangement is notably haphazard, and comparatively little care has been taken
toward the drawings' preservation. For example, as Gustina Scaglia has ob-
served of the Laurenziana album, "The drawings are on paper, which has been
barbarously cut around the drawings, then pasted on new folios, making it
impossible to decipher any watermarks."[20]

In all of the albums, Oddi's autograph works are distributed apparently at
random among the drawings by other artists. The Windsor albums contain
some 212 drawings, 142 of which are by Oddi, comprising studies of struc-
tures that he saw in Rome, Venice, Loreto, and Lucca, survey drawings, and
his own designs for buildings and ornaments (figs. 58 and 59).[21] Most of the
remaining works are attributed to an anonymous follower of Gian Giacomo
della Porta, although a few drawings attributed to Civitali, Dosio, Brandani,
and after Pellegrino Tibaldi, as well as a single drawing by Francesco di Giorgio
Martini (fig. 60), are also present.[22] Most of the Windsor drawings by artists

FIGURE 59. Mutio Oddi, *Façade of the Palazzo Apostolico, Loreto*, ca. 1604.
Pen and ink on paper. Royal Library, Windsor Castle. Vol. 182,
no. 10081. © 2009 Her Majesty Queen Elizabeth II.

other than Oddi are of architectural details such as doors and windows, that is to say motifs that could be deployed in everyday architectural practice, suggesting that Oddi's collection was—at least in part—a working one.

The contents of the Laurenziana album are more diverse; it is likely that Oddi collected these works not only as models for his own architectural practice but also out of antiquarian interests. The album comprises some 333 drawings on 226 folios, 73 of which are by Oddi.[23] The remainder are mostly by Quattrocento Italian draftsmen and include the Alberti drawing, three autograph works by Francesco di Giorgio, and numerous works by Sienese artists in Francesco's circle, including several by Giovanbattista Alberto.[24] The subjects range widely and include drawings both in plan and elevation. The Alberti drawing (fig. 61) is of a "bath house," those by Francesco di Giorgio are of monasteries, and the Sienese works include studies of ancient buildings, Renaissance churches, temples and palaces (both identifiable and imaginary), and architectural ornaments.

Although, as Scaglia has observed, authorship of the Laurenziana drawings is heavily biased toward Sienese artists, some of the works may be directly

FIGURE 60. Francesco di Giorgio Martini, designs for church façades, ca. 1480s. Pen and ink on paper. Royal Library, Windsor Castle. Vol. 183, no. 10181. © 2009 Her Majesty Queen Elizabeth II.

connected to Urbino.[25] Howard Burns has argued convincingly that Alberti's "bath house" may have been designed for Federico da Montefeltro as an addition to the Palazzo Ducale; one of the Alberto drawings is of the tribune and nave of the Church of San Bernardino (often attributed to Francesco di Giorgio); and several of the imaginary temples appear to be related to the "Ideal City" panel now in the Galleria Nazionale delle Marche, which (although its authorship and provenance are disputed) has often been associated with artists and architects working at the Montefeltro court in the second half of the fifteenth century (figs. 62 and 63).[26]

It is not difficult to see why Oddi should have acquired these works, given his profound interest in the history of Urbino, in particular its artistic heritage. Oddi would have known from reading Vasari (and doubtless through local tradition) that Francesco di Giorgio had contributed to several buildings in and around Urbino.[27] In fact, Oddi engaged with Francesco's architecture in his own practice, for in 1604 the octagonal cupola of Urbino cathedral was

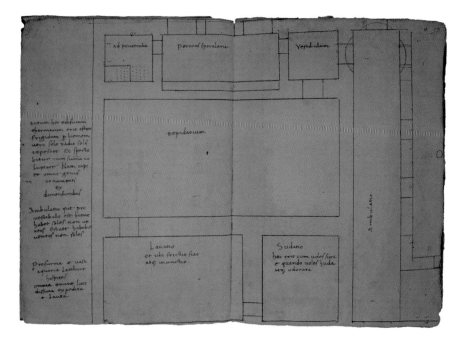

FIGURE 61. Leon Battista Alberti, design for a bath house, possibly for the Palazzo Ducale, Urbino, ca. 1460s. Pen and ink on paper. Biblioteca Medicea Laurenziana, Florence. Codex Ashburnham 1828 App., fols. 56v and 57r.

completed according to his designs—recorded in a magnificent pair of draw-ings in the Windsor albums (figs. 64 and 65)—which were apparently based on a preexisting program by the Sienese architect.[28] Oddi's drawings include a detailed scheme for the scaffolding inside the dome and around the lantern—a reminder of the technical aspect of architectural practice in which he, some-what grudgingly, was obliged to engage. Even here Oddi may have learned something from Francesco, for he owned a fifteenth-century manuscript book of machines, the majority of which are after devices in Francesco's influential *Opusculum de architectura*, which reflects the intersection of his interests in mechanics, architecture, and drawing.[29]

Oddi's interest in Alberti was comparable to his engagement with Francesco. Quite aside from Alberti's putative contribution to the Palazzo Ducale, Oddi was thoroughly familiar with his architectural theory. In one of his notebooks, for example, Oddi inscribed maxims pertaining to the "most virtuous architect," extracted from Alberti's *De re aedificatoria*, and one of his drawings is after a study of entablature in that treatise. What is more, in a proposal for embel-lishing the Church of San Martino in Lucca, set out in a long letter to Matteo Bernardini, he turned to Alberti to justify his plans, explaining that although the church was generally well designed, it was insufficiently high and too light.

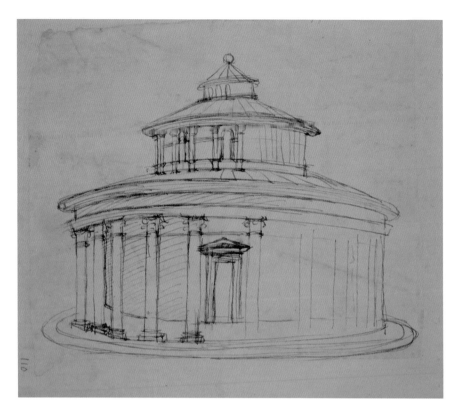

FIGURE 62. Giovanbattista Alberto, design for a temple, ca. 1500.
Pen and ink on paper. Biblioteca Medicea Laurenziana, Florence.
Codex Ashburnham 1828 App., fol. 77r.

FIGURE 63. Italian School, *Ideal City*, late fifteenth century. Tempera on panel.
Galleria Nazionale delle Marche, Urbino. Photo: Scala/Art Resource, NY.

FIGURE 64. Mutio Oddi (after Francesco di Giorgio Martini), design for the cupola of the Duomo, Urbino, ca. 1604. Pen and ink on paper. Royal Library, Windsor Castle. Vol. 183, No. 10126. © 2009 Her Majesty Queen Elizabeth II.

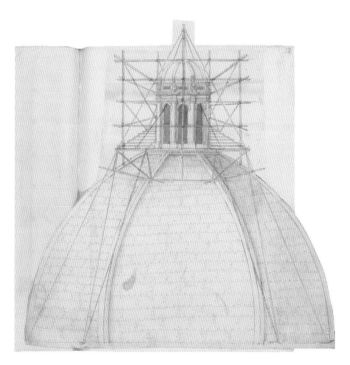

FIGURE 65. Mutio Oddi (after Francesco di Giorgio Martini), design for the cupola of the Duomo, Urbino, ca. 1604. Pen and ink on paper. Royal Library, Windsor Castle. Vol. 183, no. 10146. © 2009 Her Majesty Queen Elizabeth II.

FIGURE 66. Mutio Oddi, design for an apse, in perspective, ca. 1609–1630s.
Pen and ink on paper. Royal Library, Windsor Castle. Vol. 183,
no. 10186. © 2009 Her Majesty Queen Elizabeth II.

"Magnificence in architecture," he wrote, "consists principally" in height, while
the interior's brightness

> greatly lessens the opportunity to arouse devotion, and to keep the mind fo-
> cused, for as Alberti says in chapter 12 of book 7 of *De re aedificatoria*: The
> window openings of a temple should have modest dimensions and should be
> placed high up, where they have a view of nothing but the sky, which will not
> divert the minds of celebrant or supplicant from divine matters. The awe that
> is naturally generated by darkness encourages a sense of veneration in the
> mind; and there is always some austerity about majesty. What is more, the
> flame, which should burn in a temple, and which is the most divine ornament
> of religious worship, looks faint in too much light.[30]

FIGURE 67. Mutio Oddi, freehand perspective view, before 1639.
Pen and ink on paper. Royal Library, Windsor Castle. Vol. 182,
no. 10019. © 2009 Her Majesty Queen Elizabeth II.

In fact, both Francesco's and Alberti's styles and approaches to architecture seem to have influenced Oddi's own architectural work, for although some of his drawings exhibit a degree of exuberance commensurate with other architects of his age, on the whole Eiche's description of his architecture as "classical and restrained" is entirely apt (fig. 66).[31]

These qualities derived in part from the architectural taste established in the Duchy of Urbino by successive Della Rovere dukes, in part from Oddi's interest in Quattrocento architecture of the kind praised by Federico da Montefeltro for its explicitly geometrical foundations.[32] They also sprang, though, from the Urbino school of mathematicians' obsession with proportion, which Guidobaldo del Monte considered to be "the foundation of the entire discipline of mathemat-

ics."[33] Whenever he wrote about architecture, Oddi expressed a deep concern that a building's elements—its windows, columns, doorways, moldings, and so on—should be arranged symmetrically and in correct, precise, mathematical proportion to one another. Indeed, as Eiche has noted, the prevalence of regular, harmonious ground plans by Quattrocento architects in Oddi's drawings collection emphasizes his particular interest in buildings arranged as a series of interrelated geometrical shapes; a mathematical form of *disegno* that harked back to the *concinnitas* of an earlier era.

However, despite this apparent fondness for the (literally) fundamental importance of geometry in architectural planning, many of Oddi's extant architectural drawings show little evidence of having been created with ruler and compass. Even some of his views in perspective have been undertaken freehand (fig. 67).[34] Thus, the mathematician had Michelangelo's "compass of the eyes" when working as a draftsman, for although mostly rough and rapidly made, his drawings are always proportionate, executed with a confidence that derived from a thorough comprehension of geometry, which he effortlessly transmitted to paper via a trained, well-practiced hand.[35]

Evidently, Oddi's hand and eyes could be, when married to his mathematical mind, effective substitutes for geometrical instruments. Yet although the compass of the eyes was sufficient for a quick sketch of a monument or for jotting down an idea for a new bastion, this kind of innate judgment was insufficient when it came to mathematical work. As we have seen, Oddi promoted instrumentalism—whether through Paciotti's trammel, Guidobaldo's *Planisphaeriorum* instrument, or the simple beam compass—in the practice of *disegno*. In fact, *disegno* was not only at the heart of his architecture and his mathematical work, it was also the basis of his attitude to one of the most critical areas of scientific debate in the period: telescopic observation and the competing cosmic systems.

ALLEGORIZING *DISEGNO*:
AESTHETICS, MATHEMATICS, AND THE COSMIC SYSTEM

In his groundbreaking essay *Galileo as a Critic of the Arts* (1954), Erwin Panofsky offered an account of why Galileo rejected Kepler's *Astronomia nova* (1609), and with it the notion that planetary orbits are elliptical rather than circular. As Horst Bredekamp has explained, Panofsky's essay was prompted by Einstein's puzzlement that such an apparently forward-thinking scientist as Galileo should have refused to acknowledge so evident a truth. Galileo's stance, Panofsky suggested, may be understood when seen as a product of his aesthetics. For Galileo, like Oddi, was heavily involved in the art world, was considered an authority on painting by his contemporaries, and left numerous writings in which his "aes-

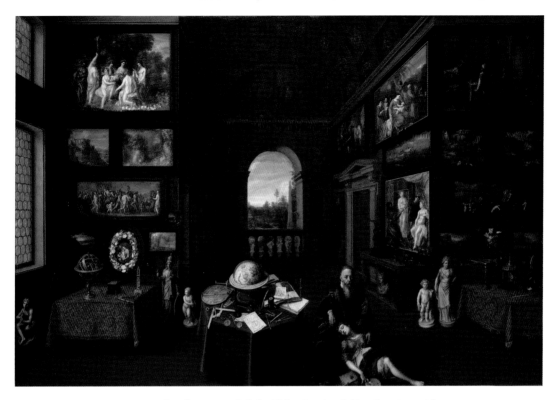

FIGURE 68. Circle of Jan Brueghel the Elder, *Linder Gallery Interior*, mid-1620s.
Oil on copper. Private collection, New York.

thetic judgments . . . appear to be dictated by a consistent principle or, if you
will, by an insurmountable prejudice: a classicist prejudice in favour of simplic-
ity, order, and *séparation des genres*, and against complexity, imbalance, and all
kinds of conflation."[36]

As we have seen, Oddi's aesthetic preferences shared precisely these qualities.
In fact—with the exception of one early design in which he used an ellipse—he
opted for plans based on the circle, square, and (occasionally) regular poly-
gons.[37] Thus, we might conclude that Oddi was sympathetic to Galileo's anti-
Mannerism, and that he might have agreed with the latter's expression, in the
Dialogo, of a belief in the perfectly ordered nature of the heavens, in which the
circle, the most perfect of all mathematical shapes, reigned supreme.[38]

Although Oddi was principally concerned with terrestrial rather than ce-
lestial science, and despite the fact that he has left very little written evidence
of having worked extensively in astronomy, his serious interest in the fierce
debates over the cosmic system that occupied the Republic of Letters in his era
is apparent from a remarkable painting—the *Linder Gallery Interior*—the alle-
gory of which he helped devise (fig. 68).[39] Commissioned by Oddi's friend and

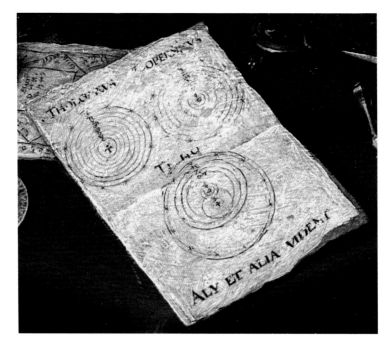

FIGURE 69. Detail of figure 68: diagram of the world systems.

pupil Peter Linder in the mid- to late 1620s, the picture is a powerful testament
to the ways in which Oddi understood the relationship between mathematics
and material culture, indicating his commitment to the notion that *disegno,*
above all else, unites the various branches of the visual arts, instrumentalism,
and nature itself because of its fundamentally mathematical character. Draw-
ing on my previous work with Michael John Gorman, I aim to show here that
the painting should be considered a visual manifesto of Oddi's—and presum-
ably Linder's—conception of the scope and function of *disegno,* mathematics,
and their associated practices, displaying a sumptuous collection of instru-
ments and art objects within a *Kunstkammer* setting in order to remind the
viewer of the intricate relationship between consumption and ideas about sci-
ence in the late Renaissance.[40]

 That the painting was intended as a serious contribution not only to de-
bates about *disegno* but also to those concerning the cosmic system is apparent
through its prominent inclusion of a diagram showing the main three competing
world systems (Ptolemaic, Copernican, and Tychonic), with the cryptic motto
ALY ET ALIA VIDENT ("Others see it yet otherwise," or perhaps "Different people
see it differently") (fig. 69). The meaning of this statement, as we shall see, may
be linked directly to Oddi's and Linder's attitude toward the respective roles of
mathematics, observation, and representation—themes embodied by the varied

artifacts displayed in the gallery interior itself—and might also be considered an oblique criticism of Galileo's faith in telescopic observation.

The painting is not, however, solely of interest as an indicator of Oddi and his circle's intellectual and aesthetic inclinations. The *Linder Gallery Interior* is a highly important, though unusual, example of the "pictures of collections" genre, which rose to prominence in the Southern Netherlands during the first few decades of the seventeenth century (see, e.g., fig. 34).[41] This genre, perhaps the most distinctive emblem of the culture of curiosity and wonder that pervaded late Renaissance Europe, has long been associated with an increasingly self-conscious attitude to collecting and displaying the world of goods, and with the burgeoning culture of connoisseurship that developed in the city of Antwerp (where the genre was almost certainly invented), most notably among the *liefhebbers der schilderyen* (lovers of painting).[42] As Linder's commission and Oddi's involvement in it show, the highly specific concerns of the Antwerp artistic elite were warmly received and employed by leading members of Milan's intellectual and mercantile communities in the 1620s—indeed, Linder's painting should be placed squarely within the context of Federico Borromeo and his circle's enthusiastic support of Flemish painting during those years.

The association of the *Linder Gallery Interior* with Mutio Oddi rests on several types of evidence, some visual (including evidence within the picture itself), some textual. The primary piece of textual evidence is a letter from Giovanni Battista Caravaggio to Oddi, dated 29 May 1629, that describes a visit to the house of their mutual friend, Linder:

> Three days ago, spurred on in part by my duty and in part by curiosity, I went to visit signor Pietro Linder, where I doubt that I would have failed in the first for the great occasion I had to satisfy the second. He offered to show me various beautiful objects in his study, where, as well as the little ivory statues and others of less noble material, and the casket arranged beautifully with various mathematical instruments, I saw in particular, among many other paintings which had appeared since I was there last, a truly large painting in which a gallery is shown in perspective, adorned with various paintings, depicted with no less study than skill, both in the extreme diligence used in them, and in that one can see there the styles of different individual painters imitated. Three tables are then depicted in a well-proportioned position, on which are various beautifully feigned mathematical instruments, concave mirrors, crystal lenses, pieces of prints, demonstrations and mathematical figures, and finally various medals, among which I saw the one with the image of Your Lordship represented there with better fortune than the good signor Pietro had with the cast, as in addition to displaying an extremely good likeness of Your Lordship, there are also the letters that spell your name, carried out with such precision that, however small they may be, they can be read without difficulty. In sum it ap-

peared to be that this painting, both for the subject matter, which I understood to be in a large part due to Your Lordship, and for the work, was worthy of the cabinet of any great Prince. He also showed me the singular pains he had taken for the success of the medal of Your Lordship, and assured me that he wished to make further efforts to achieve the desired result. I can say with truth that as I admired his singular affection to find a way to compense Your Lordship's great merit, I blushed at myself that having so many great obligations [to Your Lordship] I have not shown the demonstration of the least gratitude, although I consoled myself in part by thinking that there is no sin *nisi voluntaria*, where I have no lack of will, I can believe that a discreet person like Your Lordship will have sympathy for my powerlessness.[43]

Caravaggio's letter reveals that the picture described therein was made to be displayed in Linder's *studiolo*, where it would (in a pleasing conceit) echo its surroundings, re-creating in paint the instruments and art objects that comprised the merchant's rich and varied collection.[44]

We have already encountered Linder as one of Oddi's students in mathematics and as the friend who saw two of his publications through the press in Venice. He hailed originally from Nuremberg, was one of Milan's leading merchants, and eventually rose to become head of the Fondaco dei Tedeschi in Venice, having moved to the Most Serene Republic in 1635, presumably as a result of Milan's economic decline (although he apparently returned to that city in 1642).[45] In addition to his interest in gnomonics, optics, and military architecture, Linder was notably curious about astronomy. In 1639, for example, he sought information from Galileo about observations made with the telescope.[46] Far from being an ignorant consumer, then, the merchant was fully a member of the Republic of Letters, curious about new discoveries and inventions, and—as we have seen from his optical studies with Oddi—keenly sensitive to the close relationship between materials and experimentation.[47] We may assume, therefore, that Linder played an important role in determining both the visual and the intellectual content of the work he commissioned.

However, it is evident that Caravaggio believed, presumably as a result of Linder having told him, that the *inventione* (subject matter) of the gallery interior was "in a large part" attributable to Oddi. It should be pointed out straight away that this does not mean Oddi was in any way responsible for the execution of the painting. Rather, I take Caravaggio's statement to mean that Oddi, almost certainly in conjunction with Linder, devised the allegory and chose certain specific visual features that are integral to the symbolism deployed. Indeed, evidence from both the letter and the painting itself suggests that the *Linder Gallery Interior* is a highly personal image—not only a statement of the merchant and the mathematician's shared intellectual interests but also, like

Crespi's double portrait of the two, a bold declaration of their friendship and mutual regard.[48]

In fact, both men are present in the gallery. Oddi appears, as Caravaggio explains, in the form of a portrait medal (visible near the middle of the central table), which itself had been cast through the offices of Linder (fig. 70; compare to fig. 6).[49] Portrait medals appear frequently in pictures of collections, usually as generic symbols

FIGURE 70. Detail of figure 68: Oddi portrait medal.

of erudite culture, but this is the only known instance of a fictive portrait medal being used to personalize unambiguously such an image.[50] Oddi himself refers to the casting of the medal in a letter to Camillo Giordani, dated 19 May 1627, describing

> the *impresa* which has been made on the reverse of the medal made in Milan to honor me, which is a heaven, on its own little ropes, with a motto taken from Dante: *Ne per mille rivolte ancor son mosso* [Despite turning a thousand times, I have not moved at all]; this very *impresa* was commended to me by Monsignor Paolo Aresi with one of his letters, and it seemed good.[51]

Evidently the medal was, like the *Linder Gallery Interior*, a collaborative effort between Oddi, who provided the *impresa*, and Linder, who supervised (and presumably paid for) the casting. That the medal was made "to honor" Oddi shows that it was a typical manifestation of late-humanist learned sociability, while its inclusion—in fictive form—in the picture was doubtless intended to serve several purposes: to indicate Oddi's contribution to the painting, to celebrate his ingenuity as a master of mathematics and *disegno*, and to allude to the powerful friendship between the mathematician and the merchant. The fact that his medal is located, in the painting, among medals honoring famous masters of design and mathematics—Albrecht Dürer, Michelangelo, the physician, astrologer, and mathematician Girolamo Cardano, the jurist and emblematist Andrea Alciati, and Oddi's countryman, the architect Donato Bramante (fig. 17)—suggests that the merchant aimed to place Oddi in the pantheon of great men, a nod perhaps to the *uomini illustri* tradition of which the Urbinate mathematician was so fond.[52]

Although no extant examples of the medal have been identified, the *Linder Gallery Interior* and an illustration in an eighteenth-century catalog of the Mazzuchelli collection show that Oddi was depicted in profile accompanied by the inscription MVTIVS ODDVS VRBINAS MATEM[ATICUS]. ET ARCHIT[ECTUS]. AE[TATE] S[UAE] AN[NI]. LVIII.[53] Oddi's age (fifty-eight) as given in the inscrip-

tion and the date of his letter to Caravaggio tell us that the medal was first struck in the winter of 1626 or spring of 1627, thus providing a *terminus post quem* for the painting, although Caravaggio's reference to the poor quality of the cast and Linder's desire to make "further efforts to achieve the desired result" suggest that a second cast may have been attempted.[54]

Oddi's account of the reverse of the medal is curious in several respects. First, there is the problem presented by the visual part of the *impresa*, which is hard to interpret. Given the reference to "turning" in the motto, it may be that the "heaven" (*cielo*) to which he refers is the celestial sphere. This would be appropriate, given its proximity in the painting to the diagram of the cosmic systems (an interpretation reinforced, perhaps, by the phrase "not moving at all"—possibly a reference to the ongoing argument over whether or not the earth moves), but it is difficult to envisage how a heaven might be "suspended on its own little ropes."[55] This might indicate that the image was based on some sort of theatrical device, or perhaps even on Borromeo's *sfera mirabile* which, as we have seen, was meant to be powered by a system of weights and ropes.[56] Second, there is the motto, which Oddi mistakenly attributed to Dante; it is, in fact, the last line of Sonnet 118 from Petrarch's *Canzoniere*. I take the misattribution to be a simple slip on Oddi's part, for he used Petrarch's poetry in the *imprese* to his books on sundials and, as we have seen, moved confidently in literary circles.[57] Given Oddi's tendency, in his printed books, to use *imprese* as an oblique method of publicizing the *mala fortuna* of his exile and his conflicted relationship with Duke Francesco Maria II della Rovere, it is reasonable to suppose that the *impresa* of the medal refers to similar issues.[58]

In its original context—one of the so-called anniversary poems—the line Oddi used is generally interpreted as a reference to the immutability of Petrarch's love for Laura, which remains constant, despite the poet's oscillating thoughts and the march of time, but serves to perpetuate his anguished state.[59] For Oddi—an exile separated from his prince (whom he loved) and his *patria,* forced to move from city to city and from patron to patron in search of employment, continually oscillating between hope for a pardon and despair at its denial by his lord—the motto is entirely fitting. Indeed, his reference to the *impresa* in the above-quoted letter appears in the context of a more general discussion of his attempts to return to Urbino, and immediately follows a statement declaring that the greatest "of all the things that could make me happy is the possibility of seeing His Highness [Francesco Maria II] while he lives."[60] Thus, Oddi's lost *patria* was smuggled into the *Linder Gallery Interior,* a wry comment on the mathematician's exile understood only by his closest friends, for the reverse of the medal is not shown in the painting. Clearly, then, we are dealing with a work of art that could be read on many levels. The casual observer would see Oddi placed among some of the luminaries of the age, but those intimate acquaintances who made

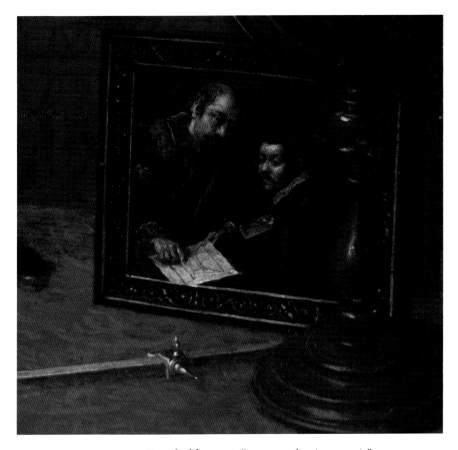

FIGURE 71. Detail of figure 68: "patron and artist portrait."

up the mathematician's circle would know that the reverse of the portrait medal implied a more complex scenario: as the motto beneath the diagram of the world systems states, "Different people see it differently."

Like Oddi, Linder is present in the gallery interior, but in two different forms. The first, visible in the top left-hand corner of the painting, is a stained-glass armorial of the Linder coat of arms.[61] As with the portrait medal, this type of device appears in other pictures of collections, but this is the only clear example of its having been used to identify the patron of the painting concerned. Linder's second appearance is in the opposite corner of the work, where, resting on the table, there is a small double portrait of a balding, fur-robed man holding and pointing to a drawing (fig. 71). He is accompanied, on his right, by a younger man, holding brushes and a palette and studying the drawing. The composition of this picture within the picture is strikingly similar to that of Crespi's double portrait of Oddi and Linder, a connection reinforced by the appearance—in front of the gallery interior's portrait—of the very same concave mirror and beam

compass that are depicted in the earlier painting (fig. 4). These similarities, the appearance of the coat of arms, and the close resemblance between the right-hand figure in the Crespi portrait and the left-hand figure in the gallery interior portrait, indicate that we should identify the balding man in the fictive double portrait as Linder. On close inspection, the drawing he holds and to which he points (perhaps mimicking Oddi's gesture in Crespi's portrait) is seen to be a perspectival layout of the room depicted in the *Linder Gallery Interior*. We may assume, therefore, that the fictive portrait shows the patron providing the painter (who, with pigments on his palette, is depicted ready to start work) with details of the commission.[62]

The inclusion of these varied personalized symbols suggests that, unlike the vast majority of "pictures of collections," the *Linder Gallery Interior* seeks to convey a highly specific set of messages in allegorical form. Most pictures of collections of the first half of the seventeenth century may be assigned to one of four subgenres: encyclopaedic still lifes (*Preziosenwände*), "portraits" of collections,[63] imaginary collections, and allegorical/satirical cabinets.[64] The *Linder Gallery Interior* does not fit neatly into any of these categories but is instead a hybrid of several recognizable types. The artist (or artists) who created it seems to have been thoroughly familiar with the various exempla of the genre circulating in Antwerp at the time. Thus, tropes common to pictures of collections are detectable in the work, such as the celebration of modern art's diversity and quality, the *paragone* between different art forms, the curiosity of the *virtuoso*, and the juxtaposition of scholarship and sensual pleasure via books and paintings, instruments and sculptures. The image even includes the emblem par excellence of late Renaissance curiosity: a Drebbelian *perpetuum mobile*, barely visible in the shadows in the far right-hand corner of the room.[65]

Likewise, the genre's presiding theme of connoisseurship is prominently displayed in the picture, for, as Caravaggio explained in his letter, one could discern clearly "the styles of different individual painters imitated"—predominantly works in the manner of the Antwerp cabinet painters favored in Milanese circles, such as Jan Brueghel the Elder, Hendrik van Balen, and Frans Francken the Younger.[66] Caravaggio was obviously aware that the picture was designed to encourage discernment and judgment, to train the eye, and to test the connoisseurial skills of the viewer through the artist's cunning imitation, in miniature, of the manners of recognizable contemporary painters. Might this, too, be part of the picture's motto? We can imagine Linder, Oddi, and members of their circle gathered in front of the painting, testing their skills of identification, ruminating in friendly conversation on the allegorical significance of the objects the picture contains. Their differences of opinion and varying attributions would be summed up neatly by the phrase "Aly et alia vident."

Undoubtedly, the *Linder Gallery Interior* is (and here it echoes again Crespi's

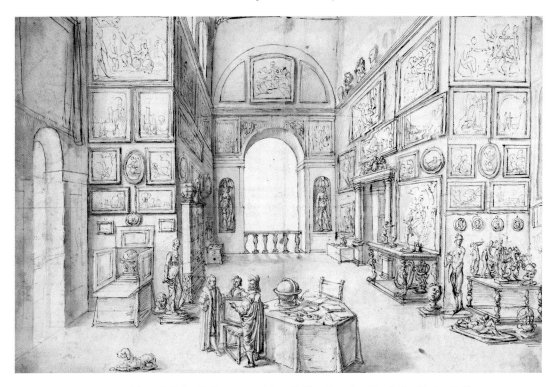

FIGURE 72. Flemish School, *Cognoscenti in a Gallery Interior (Study for Linder Gallery Interior)*, early 1620s. Pen and ink on paper. Royal Library, Windsor Castle. Inv. no. 12983. © 2009 Her Majesty Queen Elizabeth II.

double portrait) a work about vision, about the relationship between the sense of sight and the acquisition or production of knowledge, which, as we have seen, lay at the heart of Vasarian notions of *disegno*. Yet this relationship is not clear-cut, for the very qualities of *imitatio* that render it pleasing to the eye and admirable to the mind serve to undermine any claims it might profess to sure and certain knowledge. Through its mimicry and trickiness, the painting plants the suggestion that judgments based on observation alone might be neither wise nor reliable—a theme to which we shall return.[67]

Furthermore, given the greater than usual emphasis on mathematics and its instruments in the work, the *Linder Gallery Interior* makes a special claim for *disegno* (through which nature is artificially represented in the world) as particularly mathematical in character, a stance that must have derived from Oddi rather than the artist who painted the image. That this is so is revealed by the relationship between the painting and a drawing in the Royal Collection at Windsor Castle, which shows a group of *cognoscenti*—including Linder (on the left) and a *virtuoso* who bears a striking resemblance to Rubens (on the right)—in a picture gallery, discussing a painting that rests on a chair in front of them (fig. 72).[68] The

perspectival scheme of this drawing is practically identical to that of the *Linder Gallery Interior*, while the pictures that line its walls are, on close inspection, seen to be rough, compositional sketches for those that hang in Linder's painting.[69] However, there are also some major differences between the two works, notably the prevalence of mathematical instruments in the *Linder Gallery Interior* and the fact that in that work the conversing *cognoscenti* have been replaced by a pair of allegorical figures—a bearded old man representing *disegno* and a female figure representing the "three arts of design": *pittura*, *scultura*, and *architettura*.

Intriguingly, in a letter to Oddi's friend and pupil Ercole Bianchi, dated 29 October 1621, Jan Brueghel the Elder—one of Antwerp's most famous cabinet painters, avidly collected by Federico Borromeo, and the probable inventor of the pictures of collections genre—wrote, "I have an invention in mind for a painting with *Pittura, Scultura*, and *Architettura*."[70] Although Jan the Elder is an unlikely candidate for the authorship of the *Linder Gallery Interior* (he died in 1625, two years before the *terminus post quem* provided by the Oddi portrait medal), his reference to this allegory in the letter to Bianchi, the presence of imaginary pictures in his style in Linder's painting, and the fact that his son, Jan the Younger, was in Milan in the 1620s (staying in the house of none other than Bianchi), strongly suggest that the Brueghel family was involved in some way in the commission.[71] The youthfulness of the "artist" in the fictive double portrait within the painting tells us that the painter responsible was not one of the older, established masters of the Flemish art world—such as Hendrik van Balen or Frans Francken the Younger—and although Jan Brueghel the Younger was approximately the right age in the 1620s to be a plausible candidate, during his visit to Italy he was still very much an apprentice painter (indeed, he had been sent abroad by his father as part of his artistic education), and as such was too inexperienced to have produced a work as complex and confident as the *Linder Gallery Interior*.[72]

Nevertheless, despite the frustrating uncertainty as to who painted the *Linder Gallery Interior*, the picture contains a host of clues that can be employed in its interpretation. Most obviously, the objects that identify Oddi and Linder tell us that the work is an evocation of their friendship, even more elaborate than Crespi's double portrait. The fact that this instantiation of *amicizia* is made up of the material culture of mathematics fits perfectly their common interest in collecting and experimentation through artifacts, emphasizing that a shared love of this discipline, in particular, brought the two men together, just as the arts are brought together via *disegno*.[73] Moreover, the goods spread across the tables and hanging on the walls of the gallery speak directly to both men's professions: Oddi as *disegnatore* and instrumentalist, Linder as merchant. Indeed, given Linder's wealth and Caravaggio's description of his lavish *studiolo*, we might interpret the objects in the picture as having been purchased with the rewards of his labor.

Unambiguously, the Antwerp origins of the work and the presence on its walls

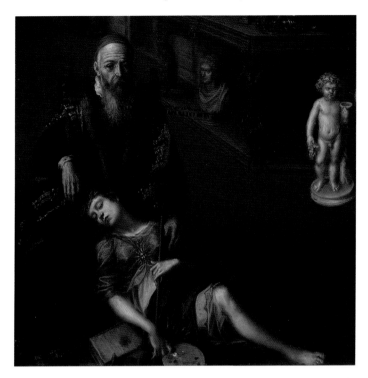

FIGURE 73. Detail of figure 68: personifications of *Disegno* and the Arts and Virtue.

of paintings in imitation of the likes of Brueghel and van Balen refer to the artistic climate of Federico Borromeo's Milan. Oddi and Linder, both in the cardinal's orbit, had imbibed—indeed they contributed to—the development of connoisseurship detectable in the city at that time, and in particular the taste for Flemish cabinet paintings spearheaded by Borromeo, Bianchi, and others.[74] Thus, the *Linder Gallery Interior*, perhaps more than any other work of the period, exemplifies the rich interaction between the Italian and Flemish cities: both great trading centers in which the arts—both mathematical and pictorial—flourished.

Yet in addition to these themes, the viewer is alerted to a layer of meaning beneath the picture's finely wrought surface by the pair of allegorical figures that dominate the foreground of the work. Although they are not, somewhat surprisingly, mentioned in Caravaggio's letter, just to the right of the central table is a bearded old man wearing a tabbard, in whose lap rests a female figure in classical garb, holding paintbrushes, mallet, maulstick, and a book and wearing a laurel wreath and a sun pendant (fig. 73). This pair of figures appears in only one other gallery interior: a work attributed to Hieronymus Francken the Younger and Jan Brueghel the Elder, currently in a private collection, for which Matthias Winner identified the male figure as *Disegno* and the female figure as *Pictura* (fig. 74).[75]

The identification of the bearded man as *Disegno* holds for the *Linder Gallery*

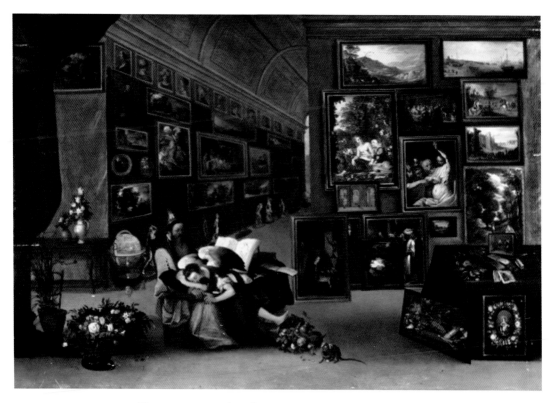

FIGURE 74. Hieronymus Francken the Younger and Jan Brueghel the Elder (attrib.),
Gallery Interior with Personifications of Disegno and Pictura, ca. 1620.
Oil on panel. Private collection.

Interior—this is the traditional manner in which *Disegno,* described by Cesare
Ripa in his *Iconologia* (first edition, 1593) as the "father of Painting, Sculpture,
and Architecture" is usually portrayed. However, the reclining female figure
should perhaps not be described simply as *Pictura*, as in addition to the tools
of painting a sculptor's mallet rests by her feet.[76] This, along with the numerous
references to architects and architecture in the *Linder Gallery Interior*, suggests
that she is a personification of the "three arts of design," a subject of obvious
relevance to Oddi but also to the Flemish milieu of the *liefhebbers*. For example,
in 1610 the Antwerp Guild of Saint Luke struck a medal celebrating the inter-
relationship between the three arts of design, depicting them as three allegorical
figures, while in his *Allegory of War*, Rubens represented the arts as the three
Graces in a drawing trampled underfoot by a blundering Mars.[77]

However, according to Ripa's *Iconologia* (one of the most popular guides to
emblems of the period), a figure with a sun pendant and a laurel wreath should
be identified as Virtue. This implies, as Michael John Gorman first observed, that
the female figure in the *Linder Gallery Interior* has a double identity—indeed the

sense of the painting's allegory can probably be rendered as "The Arts and Virtue Rest on *Disegno*."[78] There are at least two puns at work here: the double sense of "to rest on" and the sense of *disegno* as not only drawing and the associated arts but also purpose, and thus the basis of moral judgment. For, as Zuccaro wrote in *L'idea de' scultori, pittori e architetti*:

> Practical *disegno* can be divided into moral and artificial, and although this distinction might appear chimerical or at least novel, it is nonetheless true and ancient in the writings of moral philosophers. Moral *disegno* is the parent, so to speak, of all the virtues . . ., artificial *disegno* is the parent of all works of art. . . . *Disegno* is the cause of every virtue.[79]

The inclusion of Virtue in a painting that is demonstrably about friendship is to be expected. In particular, we should remember that Linder described his friendship with Oddi as "founded on virtue and disinterested."[80] Moreover, as Matthew Jones has demonstrated, the study of mathematics and the amicable sharing of mathematical knowledge was considered essential to the cultivation of virtue in the early modern Republic of Letters.[81] Less conventional, though, is the fact that in the *Linder Gallery Interior* the mathematical arts are portrayed as being of primary importance to—and even constitutive of—*disegno*.

This is evident if we look more closely at the objects resting on the three tables of the painting's foreground. The two oblong tables on the left- and right-hand sides of the picture (figs. 75 and 76) juxtapose related mathematical instruments: the measurement of time is represented by a pair of similar German table clocks, measurement in geometry by two different kinds of compass (one with a curved screw, the other the beam compass from the Odd-Linder portrait), and measurement applicable to the art of war by a gunner's level and a triangulation instrument used in surveying.[82] An armillary sphere on the left is opposed to a concave mirror on the right, pitting the study and representation of the cosmos against introspection and self-assessment (a necessary requisite of both virtue and judgment in the neo-Stoicism popular at the time).[83]

The central table (fig. 77), tilted on purpose to increase its legibility and thus perspectively inconsistent with the rest of the painting, similarly bears a variety of mathematical and art objects. In the middle is a large celestial globe that can probably be attributed to Henricus Hondius, surrounded by an Arsenius astrolabe, a Jacob's staff (used for astronomical measurements), a surveying compass, and a Galilean geometric and military compass.[84] Of particular interest, given the precise perspective used in the construction of the gallery's space—and, indeed, the fact that Oddi was a tutor in *prospettiva prattica*—is a perspective instrument similar to that invented by the master goldsmith Wentzel Jamnitzer of Nuremberg, with a view of a colonnade.[85] At the rear of the table, partially hidden by the globe, are three books: Kepler's *Tabulae Rudolphinae* (1627) and

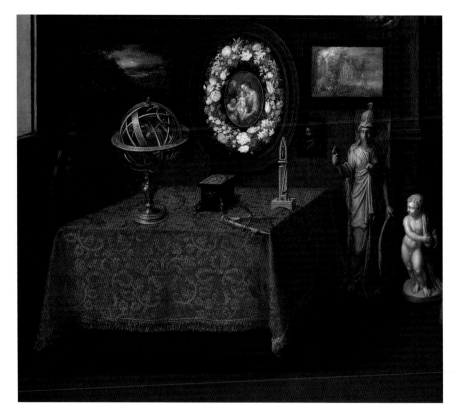

FIGURE 75. Detail of figure 68: left-hand table.

Harmonices mundi (1619) and Napier's *Mirifici logarithmorum canonis descriptio*
(1614)—the potential significance of which we shall come to presently.[86]

At the front of the table is the diagram depicting the three world systems, be-
hind which (and partially obscured) is an astrological geniture.[87] A selection of
drawing and measuring instruments—comparable in kind to those produced in
Urbino's Officina—lie scattered across the table, including several different types
of compass, a pen, and a stylus.[88] A pair of lenses, both wood- and metal-framed,
an inkwell, and an hourglass sit next to an open book of prints and drawings,
resting upon which is an engraving that may be identified as *The Martyrdom of
Saint Catherine* by the Master MZ.[89] Toward the front of the table is the group of
portrait medals depicting Oddi alongside other mathematicians and recognized
champions of *disegno*.

It is notable that this suite of objects may be directly connected to Oddi's own
collection. As we have seen, Oddi amassed a substantial collection of drawings,
prints, and instruments but, more specifically, he owned at least five portrait
medals, including that of Bramante, and a number of lenses like those on the
table.[90] Moreover, the concave mirror and beam compass that appear in the

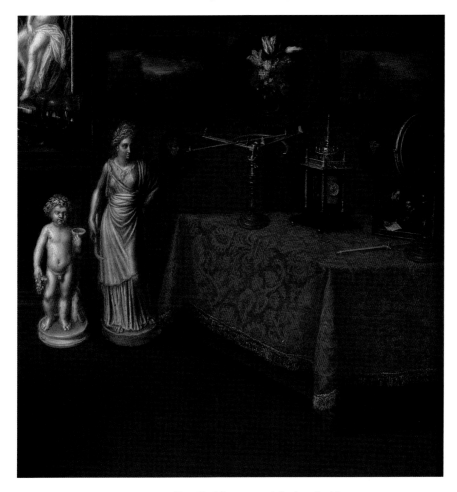

FIGURE 76. Detail of figure 68: right-hand table.

Linder Gallery Interior and the Oddi-Linder portrait must have been owned by one of these two individuals. Thus, a striking feature of the artifacts included in the *Linder Gallery Interior* is their variety, not only in terms of the type of object depicted but also in terms of their varying degrees of specificity: objects certainly owned by Oddi and Linder, known period objects that they might have owned, and imaginary objects are all represented.

Despite their diversity, however, taken together the objects in the painting provide a visual catalog of both the mathematical arts and of *disegno*. The prominently displayed astronomical instruments, world systems, compasses, mathematical books, perspective device, portrait medals of noted mathematicians, and astrological geniture are presented alongside paintings, sculptures, pens, drawing books, and portrait medals of painters, sculptors, and architects, effectively merging the mathematical arts and design. The blurring of boundaries

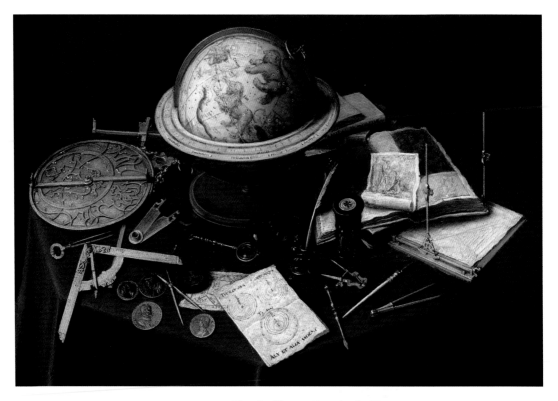

FIGURE 77. Detail of figure 68: central table.

between the two (which, as we have seen, would have been contentious to certain contemporaries) must be a result of Oddi's intervention and should most probably be understood in relation to the common association of each with *misura* (measurement), which was regularly identified as a crucial feature of *disegno*.

For example, the 1613 Siena edition of Cesare Ripa's *Iconologia* portrayed *disegno* as a young man with a pair of compasses, to show that "*disegno* consists in measurements."[91] Similarly, in his *Schilder-boek* (1604), Karel van Mander wrote, "The Father of Painting can be called Drawing . . . the Art of Drawing embraces all things and holds all the arts in the grip of measurement."[92] In fact, there is some evidence in Flanders for a tradition that associates *disegno* with *misura* and the mathematical arts, for in 1599 Adam van Noort produced a drawing that shows *Pictura* guided by Minerva, who holds a pair of compasses (fig. 78). At the feet of the figures lie scattered instruments associated with mathematical forms of measurement, emphasizing that this type of instrumentalism was a crucial aspect of design.

In presenting such a bold statement about the dependence of the arts of design on mathematics, the *Linder Gallery Interior* is, in essence, a grand summary in paint of the principles that guided Oddi's career, framed his intellectual out-

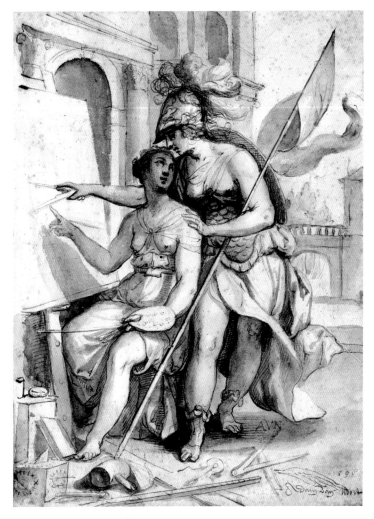

FIGURE 78. Adam van Noort, *Painting and Minerva*, 1598. Pencil on paper.
Boijmans Van Beuningen Museum, Rotterdam.

look, and determined which arts he practiced, and how. Although informed by
Cinquecento writers such as Vasari (whose understanding of judgment involved,
as we have seen, the ability to measure using the intellect), Oddi's conception of
disegno was particularly influenced by the earlier milieu of Alberti and his peers,
the material creations of which were abundantly on display in the Urbino of his
youth. Indeed, Oddi's mathematized *disegno* should, in no small part, be read as
a product of his deeply embedded sense of Urbinate identity, not least his sym-
pathy for the emphasis placed on geometry as the "Queen of Arts and Sciences"
by figures such as Commandino and Guidobaldo del Monte.

What, though, are we to make of the diagram of the world systems presented

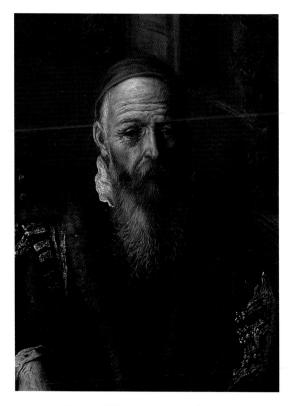

FIGURE 79. Detail of figure 68: personification of *Disegno*.

so boldly in the foreground? As Eileen Reeves and Horst Bredekamp have con-
vincingly demonstrated, the relationship between astronomy and painting was
especially close in the early seventeenth century.[93] Not only did painters employ
astronomical discoveries made through telescopic observation in their paintings
but astronomers regularly used pictorial references and metaphors in their pub-
lished works. Thus, late Renaissance audiences were used to making connections
between the worlds of painting and cosmology, not least because astronomers
such as Galileo relied as much on images as on words in persuading their public
about the validity of their observations and claims.[94]

It is not, therefore, extraordinary to discover a cosmological allegory at the
heart of the *Linder Gallery Interior*. The astronomical and mathematical books
depicted on the central table may play a role in this, although claims for their
significance should be treated with caution. Unlike the very careful lettering of
the diagram of the world systems and motto, the titles of the books by Kepler
and Napier seem rather clumsily painted. It might be, then, that these titles
were added as an afterthought, in which case importance for the overall mean-
ing of the painting should be questioned. There can be no doubt, however, that
Kepler's *Tabulae Rudolphinae*, one of the books shown, represents the kind of

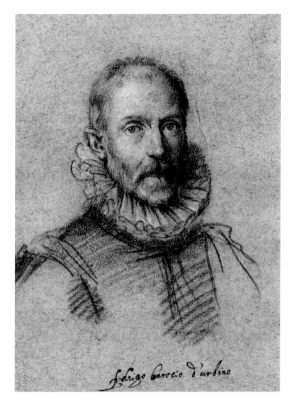

FIGURE 80. Ottavio Leoni, *Portrait of Federico Barocci*, early seventeenth century.
Black and white chalk on paper. Morgan Library and Museum.

astronomy to which Oddi was most sympathetic, in that it was thoroughly math-
ematical and based on observational data compiled through Tycho Brahe's use
of traditional mathematical instruments rather than newfangled ones like the
telescope.[95]

Michael John Gorman has suggested that the figure of *disegno* in the *Linder
Gallery Interior* may even be a portrait of Kepler, pointing to the similarity be-
tween the manner in which this figure is presented (wearing a skull cap and
tabbard) and the depiction of Kepler in the frontispiece to his *Tabulae Rudolphi-
nae*.[96] The specificity of *Disegno*'s features (fig. 79), and the evident care that has
been taken in painting him, suggest that he may well be intended as a portrait,
but the resemblance to Kepler (as judged by extant portraits of the Imperial
Mathematician) is by no means unequivocal.[97] Indeed, while the mathematical
and astronomical elements of the painting certainly make Kepler a plausible can-
didate, an alternative possibility is that the figure of *Disegno* was in fact modelled
on Oddi's first tutor in the visual arts, the famous painter Federico Barocci of
Urbino. Barocci's features, as depicted in his self-portrait of circa 1600 and, in
particular, the drawing by Ottavio Leoni of circa 1610 (fig. 80), are very close to

those of *Disegno* in the *Linder Gallery Interior* (if we imagine *Disegno* as a slightly older, and more extensively bearded Barocci), down to the pose of the head and its shadowing. Barocci would have been an ideal model for *Disegno,* given the highly personal nature of the *Linder Gallery Interior* and Oddi's desire to promote the *uomini illustri* of his *patria.* The painter was internationally renowned as a master of design and was the brother of the celebrated mathematical instrument maker, Simone Barocci, whose works Oddi distributed in Milan to patrons and friends—including Linder. In fact, as recently demonstrated, Federico used his brother's instruments (notably the reduction compass) in making his drawings and paintings.[98] Thus, Barocci could be thought of as a figure for whom mathematics underpinned drawing, and the arts in general, which seems to be one of the key messages of the *Linder Gallery Interior.*[99]

Regardless of the identity of *Disegno*, we may be sure that for Oddi and Linder a painting would have been a natural vehicle through which to express their particular stance on cosmological controversies, for it could allude to the wider cultural contexts of design and materiality in which such debates were set. Moreover, the particular issues raised by "pictures of collections" highlighted something that lay at the heart of the furor surrounding telescopic observation: the fallibility of the sense of sight when natural vision had been manipulated or "deceived" by optical instruments.

Given the three competing world systems carefully drawn above the cryptic motto, there can be little doubt that the *cartellino* on the central table refers directly to the international debate over the Copernican hypothesis and its alternatives, in which Galileo's telescopic observations played a major role. Recent scholarship has demonstrated that in early seventeenth-century Milan, Federico Borromeo and his circle were actively engaged in wide-ranging investigations into the celestial phenomena (such as comets, sunspots, and the irregularity of the lunar surface) that were pivotal to debates of this nature.[100] Given Oddi's close connection to Borromeo (not least his involvement with the projected Ambrosian *sfera mirabile*), the cardinal's attitude toward contemporary astronomy and cosmology provides a fitting backdrop against which to set the cosmological allegory of the *Linder Gallery Interior*, which, appropriately, is a Flemish work of the kind Borromeo championed so vigorously in the first few decades of the seventeenth century.

Borromeo himself acquired a telescope in 1614, which he used personally to undertake celestial observations, recording and analyzing what he saw in relation to ancient and modern astronomy, natural philosophy, and theology.[101] Although described by contemporaries as "very curious about these new [celestial appearances]" and "a very learned prince and admirer of new celestial things," Borromeo remained deeply ambivalent about the effectiveness of the telescope for observing the heavens. According to Oddi's friend Cavalieri, writing to Galileo in 1621, Borromeo was

of the opinion that telescopes do not enlarge remote objects the same as nearby ones, based on the fact that the fixed stars appear smaller when viewed with the telescope than without; but I had better proceed cautiously in making him understand the truth, because one cannot demonstrate it in any other way than through sensory experience, and because I do not think he understands the mathematical principles.[102]

Borromeo based many of his objections to Galileo's *Sidereus Nuncius* on these doubts over the veracity of the telescopic image, and he maintained—as his project for an enormous, Ptolemaic sphere shows—a strictly anti-Copernican stance.[103] Yet undoubtedly, his attitude was also largely determined by a highly orthodox approach to Sacred Scripture, which, he believed, confounded a priori any assertion that the earth moved.[104]

It may be, of course, that the motto in the *Linder Gallery Interior*—"Aly et alia vident"—is a call for dialogue, a plea to the scholarly and ecclesiastical communities to treat the competing world systems as hypotheses to be debated openly and in a friendly manner rather than condemned (as supporters of Copernicanism came to be) as heretical.[105] Different people might, it suggests, see the heavens differently, but the Republic of Letters' code of decorum and virtuous behavior (alluded to in the female personification of the Arts and Virtue) demands moderation and tolerance. However, an alternative, more caustic interpretation concerns the reliability, or otherwise, of telescopic observation and what should be the "correct" way of assessing the heavens—an issue that pertained as much to *disegno* (for measurement and judgment were involved) as to philosophy or theology.

Although Oddi obtained a license to read books on the Index about "the motions of the earth" and was familiar with Galileo's *Sidereus Nuncius*, he paid only limited attention to cosmological controversies, focusing instead on terrestrial mathematics. We know, nonetheless, that he, like Borromeo, held serious doubts about the conclusions reached by Galileo and others on the basis of telescopic observations. For example, in a letter to Piermatteo Giordani of 1622, which refers to the nature of comets and other cosmological issues, Oddi, having mentioned that he had read a 'little work' on the new star of 1604 by a Jesuit of Ingolstadt (presumably Christoph Scheiner's *De maculis solaribus* [1612]), stated:

> because the foundations of these things consist in observations [made with the telescope], that is why all of my suspicion remains, and because of this I have not wanted to waste my time with it.[106]

Similarly, in 1634 he exclaimed triumphantly, again to Giordani, that Scipio Chiaramonti, in his *Difesa* of the previous year, had "revealed to all the world the artifices of Galileo [*hà scoperto al mondo gli artifitii del Galileo*]."[107] What

were the reasons behind Oddi's skepticism—which was, of course, by no means uncommon in the period—given that, unlike Borromeo, the charge of being mathematically ignorant could not be leveled at him?

It may be the case that his scorn for the "artifices" of Galileo did not extend to the outright rejection of the telescope. Indeed, we know that, at least toward the end of his life, Oddi was sufficiently familiar with the technicalities of telescope manufacture for Linder to ask his advice on how such an instrument should be made. In March 1638 the merchant wrote to his friend:

> I am having made the tubes for the lenses that I mentioned, more beautiful than seems possible, and I would be advised. I am thinking of having one made of shagreen, the other of ivory; following which, at Your Lordship's leisure, it would be good to know how far away one lens has to be from the other; to make it well it should be neither too long nor too short.[108]

By August the shagreen telescope had been constructed and was being placed "in the hands of the goldsmith" for completion.[109] Linder asked whether he should send it to Oddi as soon as it was finished, but it seems that in the end Oddi acquired the ivory telescope, for such an instrument is recorded in one of his notebooks and features in the list of his goods compiled after his death by Niccolò Vincenzi.[110]

It is plausible, therefore, that shortly before he died Oddi considered afresh the possibility that the telescope might be of some value, but an explanation for his apparent suspicions about the reliability the instrument in the 1620s—when the *Linder Gallery Interior* was created—is provided by his treatise on surveying, *Dello squadro*.[111] In the book's chapter on "distance," Oddi discussed the relationship between terrestrial and celestial measurement. Although there exist differences between terrestrial distances (of which, he wrote, we can have "sensory experience [*sensata sperienza*]") and celestial distances (which are "very remote from us [*da noi remotissime*]"),

> the one and the other rest on the same foundation of the proportions of the homologous sides of equal angled triangles, and because the diversity of instruments with which this works do not differ in the reason for their working . . . and for the precision of the instruments with which we can know these things, all made with great mastery and art; as we see in the *Mechanica* of Tycho, being great armillaries, staffs, quadrants, sextants, and many others.[112]

It is these sorts of mathematical instruments, then, the kind displayed on the table behind the diagram, and not the telescope (conspicuously absent from the *Linder Gallery Interior*, though present in other examples of the "pictures of collections" genre), that should be used to measure the heavens.[113]

Others may indeed, Oddi suggests with a note of disdain, see the heavens oth-

erwise, but the way to treat the problem of conflicting cosmic systems was not through the fallible sensory data provided by optical instruments (which relied, as the mathematician knew from his experience with mirrors, on an imperfect technology that resulted in imprecise devices), but instead through the certainty that resulted from geometry and the instruments that rest, just as the arts rest on *disegno,* upon its secure foundations.[114] Even judgments made with the "compass of the eyes" are not sufficient in this context, for unlike works of art that may rely on innate ability honed by practice, when it came to the heavens mathematical instruments were an absolute necessity, in terms of both concrete measurement and accurate representation.

Ultimately, therefore, despite his adoption of certain elements of Florentine *disegno,* Oddi firmly rejected this tradition as insufficient when it came to the evaluation of God's great work of art—the cosmos. Just as his architectural taste was conservative, so too was his approach to cosmology. As Castiglione noted in his *Libro del cortegiano, disegno* was a tool of knowledge, enabling the courtier to understand the "universal fabric," which is no less than "a great and noble picture painted by nature's hand and God's."[115] For Oddi, however, while a drawing of the moon based on telescopic observation might exhibit such qualities as *grazia, sprezzatura,* and *facilità,* it could be in the end, as he said of Galileo's findings concerning comets, nothing more than an "artifice." Unlike a geometrically constructed diagram founded on proper measurement, such an image was bound to be error-prone, could not be mathematically tested, and thus fell well short of requisite standards of proof—a stance fully commensurate with Urbinate mathematical style.[116]

Given the depth of Oddi's mathematical knowledge, his comprehension of artisanal practices, and the evidence for his own optical investigations, his stance on how to undertake celestial science is noteworthy. Here we have a respected mathematical practitioner who seems to have suggested that the early telescope—like the *Linder Gallery Interior,* with its imitations of celebrated masters and its cunning perspective—distorted natural vision to an unacceptable degree. Far from perfecting the fallible sense of sight (for which Aristotle claimed primacy and upon which the entire edifice of natural philosophy had for centuries been contructed), the telescope was, for Oddi, no substitute for traditional geometrical instruments.[117]

This might appear, with the benefit of hindsight, to be a "retrograde" position, yet Oddi is representative of dozens of like-minded individuals—learned, actively engaged in astronomy, and mathematically competent—who seriously questioned the findings and methods encapsulated in the *Sidereus Nuncius.*[118] Indeed, while inventions and discoveries mattered—there could hardly have been debate without them—the *Linder Gallery Interior* makes a crucial point

about mathematical culture in the late Renaissance, regardless of the truth, or otherwise, of the Copernican hypothesis. It shows that a conservative, Aristotelian, non-Galilean attitude could coexist quite happily with a thoroughly modern celebration of the material culture of mathematics, commitment to instruments in knowledge making, promotion of connoisseurship, and immersion in *disegno*. The last of these—*disegno*—was in many ways the point around which the worlds of Mutio Oddi revolved, for he taught drawing, was a *disegnatore* himself, and traded instruments of design. Indeed, for the Urbinate mathematician *disegno* was, as Vasari put it, "none other than a visible expression and declaration of the concept that there is in the soul, and of that which is also imagined in the mind and made in the idea."

The Return of Mutio Oddi

In April 1636 Oddi wrote to his old friend Camillo Giordani with important news:

> I have been granted a license to leave forever the service of these most excellent gentlemen [of Lucca]; unbelievably I no longer have to attend to stone bastions, but can make designs for living in the other world, and find a haven again after such a long voyage, and after such privations and hardships enjoy, in less than a month, liberty, and that peace which the world can give.[1]

Released from his obligations, and with the Duke of Urbino dead, the way was finally clear for a long dreamed-of return to his *patria*.[2] Made wealthy by many years of service as a master of fortifications, Oddi purchased a large but dilapidated house in the center of Urbino—the Casa Santi, birthplace of Raphael—and set about securing the legacy of the Urbinate traditions to which he was heir (fig. 81).[3] With the support of the local authorities, he instituted and delivered a series of public lectures in mathematics and, on a more personal level, inducted his favorite nephew—Niccolò Vincenzi—into the world of instrumentalism, *disegno,* and practical mathematics that had been taught to him by *his* uncle, Niccolò Genga.[4] Oddi also set about conserving carefully those parts of his new home that still bore traces of its former, illustrious occupant, including a fresco of *The Madonna and Child* that he attributed to the young Raphael.[5] Fittingly, one of the jewels of the collection the mathematician brought with him to the Santi residence was a book of drawings by the master artist, thus returning some treasured possessions *ad fontes.* In fact, Oddi intended that his substantial collection of works of art, books, and instruments should form his legacy, hoping that material culture might serve him as well in death as it had done in life.

In his will—dated 7 October 1639, just a few months before his death on 15 December—the mathematician asked that his corpse be interred, *senza pompa,* in the tomb of his ancestors in the parish church of San Francesco, just yards from the Casa Santi. Most of the remainder of the document is taken up with details of a *canonicato* left to the Duomo of Urbino, which was to pay (in part from the sale of his property) for two new canons in perpetuity, but he also left

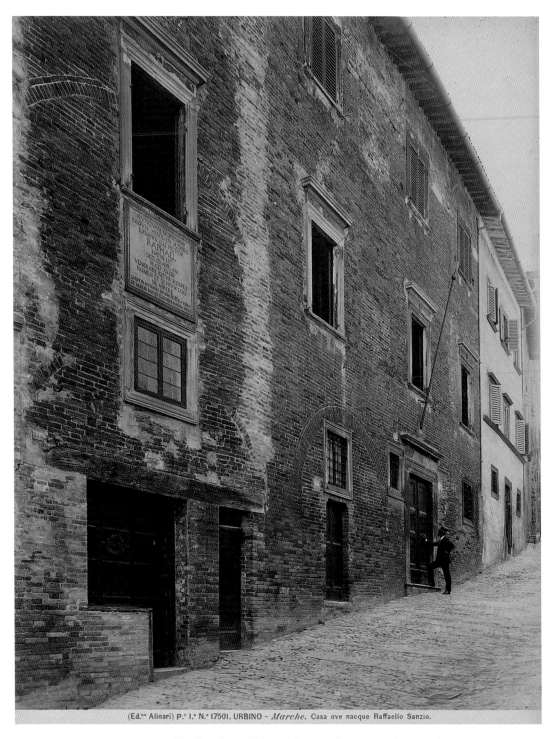

(Ed.ⁿᵉ Alinari) P.° I.ᴬ N.° 17501. URBINO - *Marche*. Casa ove nacque Raffaello Sanzio.

FIGURE 81. The Casa Santi, Urbino. Nineteenth-century photograph.
Collection of the author.

precise instructions about the fate of his prized collection. In memory of their "great friendship" with Oddi, the merchant Peter Linder and the Lucchese nobleman Bernardo Buonvisi were to select "one or two things from the *studiolo*."[6] Portraits of Oddi and his brother, Matteo, were to be kept together in the house of his heirs, the Vincenzi. The decent paintings that remained—which included *Madonnas* by Correggio and Battista Franco and a portrait by Barocci—were to be sold, and the price fetched added to his ecclesiastical beneficence,[7] He asked that a very precise inventory of his "mathematical instruments, statues, and drawings" be made for Niccolò Vincenzi and his brother, Guidobaldo, such that they "cannot sell a single item but they must all remain and be kept in the house of the testator until it is sold, and then in the house of the Vincenzi." Ensconced in the family home, the items were to serve the needs of his nephews, who would be obliged to open the collection also to "any young person [of Urbino] who wishes to learn how to draw."[8]

Oddi, who had no children of his own, evidently had high hopes that by entrusting his collection to his kinsmen and the youth of his *patria*, he might yet perpetuate Urbino's scientific and artistic heritage. But this was not to be. While initially the Vincenzi made good use of their late uncle's possessions, when they ran into financial difficulties in the 1650s they sold the lot to clear their debts and to pay the rent of their house in Cagli, having moved from Urbino to this nearby town. As the instrument maker Fabio Liera, Lorenzo Vagnarelli's successor at the Officina di strumenti matematici, explained in a letter of 1666:

> I saw many times that they [Niccolò and Guidobaldo] had a handful of books on architecture, mathematics, surveying, and arithmetic, and other [subjects], with a book of drawings of ornaments for altars . . ., and furthermore *archipendoli*, *squadri*, *compassi*, with other measuring instruments, devices for taking aspects, and for making sundials, which were mainly of brass, but also of iron, and some of ebony, and of wood. I understood from [those gentlemen] that they were the possessions of the great signor Mutio Oddi, their uncle, being the legacy left to them . . . and that they were sold . . . to pay their rent, and to clear their debts and other expenses.[9]

We should not, perhaps, be too hard on the Vincenzi. The ultimate failure of Oddi's efforts to maintain his *patria*'s traditions owes as much to the devolution of Urbino from a vibrant, independent duchy to a crumbling province of the Papal States as it does to his family's disregard for their kinsman's wishes.[10] Urbinate mathematics limped along for a few decades after Oddi's death—the Officina even managed to continue operating profitably—but the unique confluence of individuals and ideas that had made Urbino such a stimulating location for scientific work had all but evaporated by midcentury.[11] Thus, although he eventually made it home, Oddi's return was not enough to save Urbinate

scientific style; the world was moving on from compasses and quadrants to telescopes and air pumps.

One of the aims of this book has been to demonstrate that men such as Oddi—ingenious but not geniuses, representative rather than radical—were as much a part of late Renaissance science as a Galileo or a Boyle. While their influence might have been felt but subtly, they nonetheless demand our attention, if indeed we care about the cultural landscape of science in its so-called age of revolution. In returning Oddi to the historical record, I hope to have shown not only how attending to a broad range of sources—to things as well as words—can produce valuable rewards, but also why the study of noncanonical figures is essential for the history of science. When placed under the microscope, we find that Oddi's life and works lead us not only into issues such as mathematization and cosmological controversies, but also into the wider world in which such things took place—into the effects of *patria*, the grind of the market, the practice and collecting of art, all of which bore upon the character of late Renaissance scientific endeavor.

Such diversity can, of course, be a hindrance. The sheer range of activities and contexts Oddi presents is one reason figures like him have tended to slip through the net of history. Yet the last few decades have witnessed the development of methods that should render such multidisciplinarity accessible, apprehensible, and—most importantly—relevant. It has become commonplace to point out that the disciplinary boundaries we take for granted today did not exist (or did so only in embryonic form) in Oddi's era. Even so, if we fail to acknowledge the extent to which the arts and sciences mixed and mingled in the late Renaissance, we risk radically misunderstanding the trajectories of each. Oddi, who merged *disegno* with mathematics, teaching with trade, publishing with *amicizia*, should alert us to the genuine need to place ideas in contexts both social and cultural.

Oddi certainly saw himself as part of a tradition that was as much artistic as it was scientific, hence his legacy of drawings as well as instruments, and his preservation of those parts of the Casa Santi redolent of its famous former resident (fig. 82). Raphael's place in history may have been guaranteed well before Oddi's antiquarian project, yet the mathematician still felt motivated to conserve any remnant, no matter how slight, of his *patria*'s most famous son. This obsession with Urbino's glorious past goes some way toward explaining why Oddi fell into such obscurity following his death in 1639. Despite his exile, he had never—unlike Raphael—really been able to leave Urbino behind. The great painter, Oddi tells us in the memorial plaque he fixed to the façade of his townhouse, was not (unlike the mathematician) "destined to die in this small abode."[12] Yet

FIGURE 82. Pestle and mortar (for mixing pigments) purportedly used by the Santi workshop, in the courtyard of the Casa Santi. Author's photograph.

the remainder of the inscription pertains equally to Oddi, buffeted as he was by the winds of fortune. Indeed, it serves as a fitting memorial to him:

> Hence, dear guest, respect the name and the genius of this place and let not wonder seize you, for divine powers joke in human vicissitudes and humble appearances are wont to hide the sublime.[13]

Historiographical Note on the Urbino School of Mathematicians

It has long been recognized that the Urbino school made a major contribution to the sciences in late Renaissance Europe, although the nature and significance of this contribution have been much debated. Put simply, Commandino and his followers shared a commitment to recovering ancient—especially Greek—mathematical works, to rigor, to the promotion of mathematics and mechanics as intellectually noble disciplines, and to the improvement of results through the use of appropriate instruments. Their most important contributions lay in editing, translating, and publishing accurate (and as complete as possible) works by canonical classical authors, in composing commentaries on these works, and in the invention and perfection of mathematical and mechanical instruments that could enhance precision. In so doing, they helped to prepare the ground for the major scientific developments of the seventeenth century—especially the work of Galileo—indeed, they have been characterized as highly important contributors to the tradition of mixed mathematics, which played a key part in processes of mathematization.[1]

On these things most scholars tend to agree, but opinion varies widely on the precise motivation and nature of the activities of the various individuals concerned. Nevertheless, the recent historiography of the Urbino school is quite clear. The most significant interventions, in chronological order, have been those by Stillman Drake, Paul Lawrence Rose, Enrico Gamba, Mario Biagioli, and Domenico Bertoloni Meli.[2] While the focus of these authors differed—mechanics for Drake and Bertoloni Meli, mathematical humanism for Rose, sociocultural context for Gamba and Biagioli—each acknowledged substantial similarities between the members of the Urbino school, similarities that emerged from a shared homeland and direct, personal interaction. Drake seems to have been the first scholar to present Commandino, Guidobaldo, and Baldi as a coherent unit, establishing them—in *Mechanics in Sixteenth-Century Italy* (1969)—as a "central Italian" group that "concentrated its interest on works of classical antiquity and on the rigorous application of mathematics to mechanics." This triumvirate stood in opposition to a "northern group" comprising Tartaglia, Cardano, and Benedetti, "all of whom were conspicuously interested in practical aspects of mechanics."[3] Both groups recognized the significance of Archimedes's work for the tradition of mechanics, but they differed significantly in their approach to medieval authors on dynamics, such as Jordanus. While the northern group, Drake claimed, was generally sympathetic to the work of medieval writers, the Urbinate mathematicians' obsession with rigor and ancient authority led to a rejection of the less mathematically rigorous work of Jordanus, making it very difficult for them to "go beyond the ancients in mechanics."[4] For Drake, therefore, the Urbino

school, while made up of talented mathematicians, was ultimately highly conservative in its approach to science.[5]

Rose, whose *The Italian Renaissance of Mathematics* (1975) remains the starting point for any serious work on the Urbino school, presented Commandino, Guidobaldo, and Baldi as late humanists skilled in the study of history and philology as well as science. His was a far more wide-ranging study than Drake's, concerned with developments in mathematics in addition to mechanics, and he went beyond previous accounts in arguing that a humanist sensibility explained the school's commitment to ancient authority, for its members were demonstrably conscious of the historical development of mathematics and of their own place within a clear genealogy of illustrious mathematicians.[6] Rose also elaborated on Drake's observation that geography was a major factor in shaping the careers and identities of the school's members. The local conditions of Urbino—namely its small size (which encouraged intimate interaction between scholars), the predisposition of its rulers toward practical mathematical and mechanical pursuits suited to architecture and the arts of war, and its vibrant artisan class—all influenced what kinds of science were pursued there, and how.[7]

A similar approach was taken by Enrico Gamba; indeed, the great virtue of his *Le scienze a Urbino nel tardo Rinascimento* (1988), which covered much of the same intellectual ground as Rose's monumental study, is its fleshing-out of the Urbinate context, and the author's expansion of the Urbino school to include not only Commandino, Guidobaldo, and Baldi but a host of overlooked contributors to scientific life in the duchy, such as the Paciotti, Giordani, and Buonaventura families, the instrument makers Barocci and Vagnarelli, and—most important of all—Mutio Oddi.[8] Whether consciously or otherwise (for no consistent methodology is discernable in the text, which has a tendency to lapse into whiggishness), Gamba placed Rose's humanists in a far messier, more diverse, and certainly more material context than before. Moreover, he entrenched the significance of genealogy for Urbinate mathematics. Oddi, a member of what Gamba calls the "third generation" of Urbinate scientists, is treated as an exemplar of a "diaspora" of scientific and technical expertise, brought about by the gradual impoverishment of the region under successive Della Rovere dukes and the fragmentation of the master-pupil relationships that had sustained the Urbino school.[9] For Gamba, then, the wider socioeconomic context of Urbino has a distinctive role to play when analyzing the science of its mathematicians, a theme transformed into a strong sociological program by Mario Biagioli in a seminal article: "The Social Status of Italian Mathematicians, 1450–1600" (1989).

While Biagioli is not concerned exclusively with Urbinate figures, the Urbino school occupied a key position in his account—indeed he used it as a case study in his sociological approach. Looking back to Drake's still resonant division of scholars in mechanics into two opposing groups, Biagioli sought to explain the Urbino school's disdain for Tartaglia, Cardano, et al. not through a particular "intellectual paradigm" or, to cite Rose's term, "humanist *explanans*," but rather through the issues of place and inherited status. The court in which members of the Urbino school operated and the high social status of their families produced, he suggested, a "courtier gestalt" which framed the mathematicians' intellectual activities and identities. Courtly concerns about social status, etiquette, and restraint help to explain, then, not only the group's apparent intellectual conservatism but also its members' dedication to ancient (and thus high-status) mathematicians and classical languages, which underpinned their criticism of the linguistic "barbarism" of Drake's "northern group."[10]

Like Drake and Rose, Biagioli considered the Urbino mathematicians' attitude toward (or rather, obsession with) Archimedes to be particularly revealing, writing:

> *Archimedes became their Cicero.* By associating themselves with him (or the mythical representation of him) they were able to present themselves as "abstract," "classical," and "pure" as opposed to "mechanical," in the same way that the elegant exercises of the martial arts put the crude reality of war far in the distance. In a sense, they wanted to introduce courtly *sprezzatura* into their professional identities.[11]

This description of Urbinate scientific style is apposite, but we should note that the Urbino scholars' attitude toward *sprezzatura* was deeply ambivalent. On the one hand, they were devoted to instruments that could refine mathematical work by reducing the labor it required.[12] Indeed, as Jessica Wolfe has observed, both Guidobaldo and Baldi praised Archimedes's *facilità*, celebrating the ancient engineer's cunning ability to move great weights with little force and through the simplest of machines.[13] However, although much in evidence among Urbino's elite, the "artful artlessness" or "aristocratic nonchalance" implied by *sprezzatura* is in many ways the very opposite of the Urbino school's mathematical manner.[14] As Count Ludovico explains in Castiglione's book, to embody *sprezzatura* is

> to conceal all art and make whatever is done or said appear to be without effort and almost without any thought about it . . . to labor and, as we say, drag forth by the hair of the head, shows an extreme want of grace, and causes everything no matter how great it may be, to be held in little account.[15]

In mathematics, the Urbino school instead sought *esquisitezza* (precision) above and beyond *sprezzatura*, as demonstrated by their obsessively exact editions of classical scientific texts, painstakingly recovered from fragmented manuscripts and replete with extensive *lemmata* and *scholia*. Their exhaustive search for mathematical rigor was the very antithesis of the casual—albeit consciously fashioned—carelessness of the ideal courtier. Indeed, as Baldi observed, Commandino died from an excess of melancholy brought on from his intense labors on mathematical problems—hardly the "effortless" work demanded by Count Ludovico![16]

Yet even if Archimedean *facilità* was at best an inconsistent attribute of Urbinate science, the Urbino scholars' fascination with the ancient scholar's works goes some way toward explaining, as Biagioli has observed, their lack of "philosophical aggressiveness." Archimedes was an authority on statics, but he did not cross disciplinary boundaries and seek, as Jordanus had done, to tackle dynamics. In this regard he could be perceived as similar to Aristotle: in the *Mechanical Questions* (now ascribed to pseudo-Aristotle but thought at the time to be an authentic work of the master) the Philosopher did not transgress disciplinary boundaries by treating statics mathematically; rather he dealt with physical issues appropriate to natural philosophy.[17] But were the Urbino scholars united in their mechanical conservatism? In an avowedly revisionist article—"Guidobaldo del Monte and the Archimedean Revival" (1992)—Domenico Bertoloni Meli sought to debunk the notion that the Urbino school was a coherent, unified group who shared closely corresponding intellectual attitudes:

> Besides the shared admiration for Archimedes, the fascination with rigour, the satisfaction in restoring a brilliant demonstration in a corrupt text, it is possible to discern genuinely different projects even within the Urbino school. Despite

some undeniable common traits, the Urbino mathematicians cannot be seen as a monolithic group promoting the same project.[18]

To condense a highly nuanced argument into a few simple sentences, for Bertoloni Meli the key tension within the Urbino school is this: Commandino's commitment to mathematics and the certainty it provided was of such magnitude that he was prepared to assert its applicability and superiority to other disciplines, including natural philosophy. This apparently radical position (for it ran contrary to orthodox Aristotelianism) was not shared by the more conservative Guidobaldo del Monte, who was committed to a more traditional division of competences. In his *Mechanicorum liber*, for example, Guidobaldo presented himself as a scholar in mechanics rather than a pure mathematician, thus enabling him to "find in Aristotle a source and a 'noble ancestor' since the *Quaestiones Mechanicae* were then attributed to the Philosopher."[19] Commandino, then, aimed to subvert the traditional disciplinary hierarchy whereas Guidobaldo sought an accommodation between a relative newcomer—Archimedes—whose mechanical works could potentially upset the established order, and the most important, long-established philosophical authority—Aristotle.

Bertoloni Meli is certainly right to point to varying programs among the Urbino mathematicians.[20] However, we should not be surprised that they did not conform absolutely to a fixed intellectual agenda. Despite being referred to as a "school," Commandino, Guidobaldo, Baldi, and Oddi were, as I have suggested, more a family than an academy. My own contribution to the historiography of Urbinate mathematics aims, therefore, to be twofold. First, I have sought to build upon Gamba's work by providing a detailed and freshly interdisciplinary account of the "school's" last member, Mutio Oddi, delving more deeply into the archives to bring to light aspects of his world that have thus far been hidden from view. Second, I have attempted to show—like Biagioli, only with a different conclusion—that an exclusive focus on intellectual paradigms leads to a skewed perception of Urbino's mathematical world in the late Renaissance. In order to understand properly the relationship between Commandino, Guidobaldo, Baldi, and Oddi, the ramifications of their work, and how their approaches were fashioned, we need to attend to cultural contexts such as the pull of *patria*, the practice of *disegno*, and, in Oddi's case, the hand of *Fortuna*.

Mutio Oddi's Pupils in Mathematics, 1612–1624

This appendix, compiled from entries in OPU-FCC IV, lists by date the students referred to in Oddi's pedagogical records, along with the subjects in which they received instruction. Some of the entries are difficult to decipher due to the speed with which they were written or because names and dates are frequently abbreviated. Elements for which there is uncertainty have been marked a question mark.

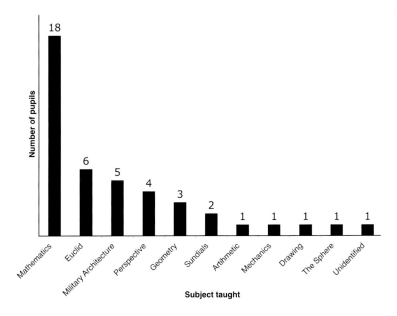

MUTIO ODDI'S PRIVATE MATHEMATICS TUITION, 1612–1624.
Note that although Oddi taught only forty-two pupils, two
took more than one subject.

1612

2 March Ercole Bianchi—Euclid [started]
 Milanese mathematician, art agent for Cardinal Federico Borromeo;
 recipient of copy of Oddi's *Dello squadro*

3 March	Benedetto Sigismondo Sfrondato—11th book of Euclid [returned]
	probably Don Sigismondo Sfrondrato, 2nd Marquis of Montafia[1]
12 March	Conte Teodoro Trivulzio—mathematics [started]
	Count Ercole Teodoro Trivulzio, prince of Val Mesolcina (son of Gian Giacomo II Trivulzio)
13 March	Conte Francesco Bernadino Marliani, in the presence of signor Conte Ruggiero, his father—Euclid [started]
	Count Francesco Bernardino Marliani, Milanese colonel; dedicatee of *Dello squadro*
	Count Ruggiero Marliani, Milanese noble
16 March	Enrico Birago—Euclid [started]
	possibly Enrico Birago, Marchese of Candia
25(?) May	Danielle de Capitani—Euclid [started]
	unidentified
26 June	Don Girolamo Pozzi, son of signor Presidente—Euclid[2]
	Girolamo dal Pozzo, son of Emanuele dal Pozzo, Presidente del Magistrato Ordinario e Regio Ducale Consigliere
26 June	Senatore Settala, accompanied by Iacomo Filippo Prato and Girolamo Pozzi—mathematics [started]
	Senatore Settala, Milanese physician
	Iacomo Filippo Prato (of Lecce?)
	Girolamo dal Pozzo (see preceding entry)
17 August	Signor Enrico Birago—six books of Euclid's geometry and algorithms [completed]
	see 16 March 1612

1613

29(?) January	Signor Conte Giovanni Marliani—mathematics [started]
	Milanese noble
27 June	Pietro Francesco Scaranfi—sundials [started]
	possibly Pierfrancesco Scarampi (1596–1656), later papal envoy to Ireland

1614

8 April	Signor Danielle [De Capitani]—Euclid [returned]
	see 25 May 1612
20 April	Signor Sforza Melzi, son of signor Aloigi—mathematics [started]
	probably Sforza Felice Melzi (1597–1657), 3rd son of Luigi Melzi (1554–1629)[3]

1615

| 13 February | Signor Lazarro Crivelli, son of signor Antonio, at the request of signor Erasmo Caimo—mathematics [started] |
| | unidentified[4] |

| 2 July | Signor Pompeo Castiglione, son of signor Giovanni Battista—mathematics [started] |
| | unidentified |

1616

17 March	Signor Giovanni Battista Caravaggio, son of signor Giuseppe —mathematics [started]
	Giovanni Battista Caravaggio, military engineer; friend and correspondent of Oddi
20 March	Signor Guid'Antonio Landriani, son of signor Ludovico—mathematics [returned]
	Guid'Antonio Landriani (d. after 14 April 1641), son of Milanese patrician Ludovico Landriani[5]
18 May	Signor Cav[aliere(?)] della scala Erasmo Caimo, accompanied by signor Giuseppe Scisti(?)—[unspecified]
	Erasmo Caimo, unidentified[6]
	Giuseppe Scisti, unidentified

1617

8 July	Luigi Solaro(?)—rudimentary arithmetic
	unidentified
1 August	Signor Don Carlo Gallio, brother of signor Duca d'Alvitto—mathematics [started]
	Don Carlo Gallio, 2nd Marchese d'Isola, brother of Francesco Gallio, 3rd Duke of Alvito

1618

| 28(?) January | Signor Mercurio Galecase(?), sergeant major of the Third of Cavaliere Peci(?)—mathematics [started] |
| | unidentified sergeant major[7] |

1619

8 January	Signor Marchese di Valdefuentes—mechanics [started][8]
	Marchese of Valdefuentes, Spanish noble
14 January	Signor Girolamo Possoni—mathematics [started]
	unidentified
18 November	Signor Tommaso Trutti, son of signor Senatore, and signor Carlo Alessio, his cousin—mathematics, in order to proceed to military architecture [started]
	unidentified; possibly a misspelling of Trotti, a patrician family of Milan[9]
18 November	Signor Cav[aliere(?)] Ricci—military architecture [started]
	unidentified

24 (14?) November Signor Alessandro Monti—perspective [started]
 Alessandro Monti, Milanese patrician, noted collector and patron of
 Daniele Crespi (see 12 June 1621)

27 November Signora Contessa Donna Giovanna Borromeo, wife of signor Conte
 Giulo Cesare, at the request of signor Cardinale Borromeo, his uncle—
 geometry and arithmetic [started]
 Countess Giovanna Borromeo (née Cesis), Milanese noblewoman; mar-
 ried Count Giulio Cesare Borromeo (d. 1638) in December 1614[10]

1620

1 May Signor Don Carlo Giovanni, Spaniard—rudimentary mathematics
 unidentified

1 May (1622?) Signor Don Francesco d'Oncastor Portughese—rudimentary geom-
 etry, then drawing, then the *sfera*
 unidentified

2 May Carlino, son of Giovanni Andrea Biffi, sculptor of Camposanto—per-
 spective [started]
 Carlo Biffi, son of Gian'Andrea Biffi, sculptor and sculpture-master at
 Ambrosian Accademia del Disegno

10 May Signor Hieronimo Stranio(?) d'Alessandria, nephew of signor Abbate
 Stranio(?)—rudimentary mathematics
 unidentified

1621

1 May Signor Alberico Settala—rudimentary mathematics
 Alberico Settala, Milanese scholar; member of the family of physicians
 (see 26 June 1612); friend and correspondent of Oddi

12 May Signor Alfiero Rugiero Ponzoni—fortification [started]
 unidentified

24 May Signor Alfiero Ruggiero Ponzoni—fortification [started]
 see preceding entry (discrepant spellings in original)

12 June Signor Daniele Crespi, painter—perspective [started]
 Daniele Crespi (b. 1597–1600, d. 1630), Milanese painter, student at
 Ambrosian Accademia del Disegno; painted double portrait of Oddi
 and Linder

20 November Signor Pietro Linder, German—military architecture and sundials
 [started]
 Peter Linder, German merchant resident in Italy, with shops in Milan
 and Venice; close friend and business associate of Oddi; recipient of
 copies of *Dello squadro*; commissioned *Linder Gallery Interior*

1622

1 May (1612?) Signor Giovanni di Sosia, Spanish captain—rudimentary geometry
 and fortification
 unidentified Spanish captain

1 April (1620?) Signor Don Ottavio Gonzaga—fifth book of Euclid [started]
Milanese patrician

12 November (1620?) Signor Francesco di Berlagne, French painter—perspective
[started]
Francesco Bellone (presumably François de Boulogne), student at Ambrosian Accademia del Disegno

1624

22 October Don Amadeo Vernardo Delascamo(?), paid for by signor Duca di Feria—mathematics [started]
unidentified, but a recipient of *Dello squadro*
Gomez Suarez de Figueroa y Córdoba, Duke of Feria, Governor of Milan (1618–25, 1631–33)

27 October Signor Bernardo Cassati—rudimentary mathematics
probably Bernardo Casati, Milanese patrician

Distribution List for
Dello squadro trattato (1625)

Conto dei libri dello squadro (Account of the books of the *squadro*). OPU-FCC II, fols. 27v–28r. In this list, Oddi only intermittently indicated the number of copies sent to the named recipients.

(fol. 27v, left-hand column)

LEGATI (BOUND)

Signor Conte Francesco Bernardino Marliani—1
> Count Francesco Bernardino Marliani, Milanese colonel; studied geometry with Oddi 1612–17; dedicatee of *Dello squadro*

Monsignor Illustrissimo Cardinale per la libreria—1
> Cardinal Federico Borromeo, Archbishop of Milan (1595–1631); copy donated for Borromeo's Biblioteca Ambrosiana

Il signor Duca di Feria—1
> Don Gomez Suarez de Figueroa y Córdoba, Duke of Feria, Governor of Milan (1618–25, 1631–33); paid for Oddi to teach mathematics to Amadeo Vernardo Delascamo in 1624

Il signor Gen.(?) della Can.(?)—1
> unidentified

Pàdre Inquistore—1
> unidentified inquisitor

Signora Contessa Donna Giovanna Borromeo—1
> Countess Giovanna Borromeo, wife of Count Giulio Cesare Borromeo (nephew of Cardinal Federico Borromeo); studied geometry and arithmetic with Oddi 1620–21, at the request of Cardinal Borromeo

Signor Galeazzo Arconati—1
> Count Galeazzo Maria Arconati, Milanese noble and collector; owned several notebooks of Leonardo da Vinci, including the *Codex Atlanticus*, donated to the Biblioteca Ambrosiana in 1637[1]

Signor Conte Carlo Francesco Serbelloni—1
> Count Carlo Francesco Serbelloni, Milanese noble; arranged for remaking of the base of the Colonna del Leone at Piazza Santa Babila, Milan, in 1628; one of Oddi's early patrons[2]

Signor Gen.(?) dell'Arena—1
> probably Ghilino dell'Arena, military officer in the service of Count Luigi Trotti
> (Sforza Felice Trotti served in the Third Company of Ghilino)

Signor Ercole Bianchi—1
> Milanese scholar, art agent of Cardinal Federico Borromeo; studied Euclid with
> Oddi 1612–13

Signor Ambasciatore di Lucca—1
> Republic of Lucca's ambassador to Milan

Signor Giuseppe Barca
> Milanese architect-engineer; close friend of Oddi and his successor to the Scuole
> Piattine chair[3]

Signor Giovanni Battista Caravaggio—1
> Milanese architect-engineer; collaborated with Oddi on several projects; began to
> study mathematics under Oddi in 1616

Monsignor Setala—1
> possibly Monsignor Girolamo Settala, Canon of the Duomo of Milan from 1630
> (Hier[olamo?] Septala is listed in the "Imprimatur" of *Dello squadro* as one of the
> book's censors)

Pàdre Mecate—1
> possibly Giovanni Mercati, custodian of the Biblioteca Ambrosiana

Signor Dottore Boldoni—1
> probably Niccolò Boldoni of Milan; founded an academy there in 1639

Signor Marcantonio Capra—1
> possibly a relative of Baldassare Capra (d. 1626), Milanese mathematician involved
> in the priority dispute over Galileo's geometric and military compass. Oddi under-
> took architectural work for Marcantonio in Milan.

Signor Giovanni Angelo Crivelli—1
> Giovanni Angelo Crivelli, Milanese architect-engineer

Signor Hier.o Rosso—1
> unidentified

(fol. 28r, left-hand column)

Al signor Hierolamo Rosso
> unidentified

Signor Bisnate Ingegniere
> possibly Giovanni Paolo Bisnati (see below) or Alessandro Bisnati, Milanese
> architect

Pàdre Matteo Toccalini Roma
> unidentified

Signor Monti(?)—Piascenza
> unidentified, but possibly Alessandro Monti, Milanese patrician and Oddi's pupil in
> mathematics

Signor Benedetto Pittore(?)—Piascenza
> unidentified painter from Piacenza

Signor Pasquale—Piascenza
> unidentified

Signor Ingegnere della fortezza
 unidentified fortifications engineer

(fol. 27v, right-hand column)

<div align="center">

SCIOLTI (LOOSE)

</div>

Signor Giovanni Maria Visconti—1
 Giovanni Maria Visconti, Milanese noble[4]
Signor Conte Cristoforo Marliani—1
 Count Cristoforo Marliani, father(?) of Francesco Bernardino Marliani (dedicatee
 of *Dello squadro*)
Pàdre Inquisitore—1
 unidentified inquisitor
À Lucca—18
 unknown recipient in Republic of Lucca
Al signor Pietro Linder—3
 Peter Linder, German merchant resident in Italy, with shops in Milan and Venice;
 close friend of Oddi; studied military architecture, dialing, and optics with Oddi
 1621–24
Signor Francesco Velescalchi
 unidentified
Signor Giovanni Battista Pelegrini
 Milanese architect, possibly descended from Pellegrino Pellegrini; worked with
 Oddi on Certosa of Pavia, ca. 1618–19
Signor Hierolamo Oliviero Perugia—6
 Hierolamo Oliviero of Perugia, possibly a merchant or bookseller
Signor Camillo Giordani—1
 Camillo Giordani of Pesaro, Duchy of Urbino's ambassador to Venice; close friend
 of Oddi
Signor Giuliani, Pesaro—1
 unidentified
Signor Giulio Basignani—Pesaro—1
 unidentified
Lorenzo Vagnarelli—1
 Lorenzo Vagnarelli of Urbino, mathematical instrument maker, master of the Offi-
 cina di strumenti matematici
Signor Livio Bronzetti, Urbino—1
 unidentified
Conte Carlo Paciotti, Urbino—1
 Count Carlo Paciotti, military architect and engineer; relative of Francesco Paciotti,
 whose treatise on the *squadro* served as a model for Oddi's book
Pàdre Matteo Toccalini Roma—1
 unidentified
Signor Mutio Anderli—Loreto—2
 unidentified
Signor Pietro Linder—3
 see above

Signor Giovanni Angelo Crivelli—1
 see above
Signor Giulio Magone—1
 Milanese architect-engineer
Signor Giovanni Paolo Bisnati—1
 Milanese architect-engineer
Signor Don Amadeo Vernardo—1
 presumably Amadeo Vernardo Delascamo, studied Euclid with Oddi in 1624 at
 request of the Duke of Feria (see appendix A)
Signor Giovanni Battista Carravaggio
 see above
Signor Filippo Perlasca—1
 unidentified
Al Capitano Pietropaolo Flaminia—1
 unidentified Flemish(?) captain

(fol. 28r, right-hand column)

VENDUTI (SOLD)

A Monsignor Neri—2
 unidentified
Al signor Ottavio Fisiano
 unidentified
Al signor Busca—
 relative(?) of Gabriello Busca, Milanese architect-engineer

Instruments of Urbino's Officina di strumenti matematici

OFFICINA PENS AND COMPASSES

Given the numerous types of pens and compasses manufactured in the Officina, an explanation of the uses to which they could be put is necessary in order to explain their relevance to late Renaissance practical mathematics. Particular kinds of ruling pens (such as the *tiralinea*, T3 in the key that follows) were necessary in the preparation of drawings to scale and, as Maya Hambly has observed, were of particular importance "once the thickness of each line formed part of the syntax of drawing."[1] Lorenzo Vagnarelli also made stylus-type instruments (such as the *spuntone* [S1] and *temperatoio* [T1]), used for inscribing "invisible" construction lines in the creation of geometrical diagrams (as we may see in the Oddi-Linder portrait) and fortifications. He also manufactured a variety of standard writing pens, either with a baluster shaft (P3) or made up of several parts. Oddi described both the silver and brass pens (P3 and P4) as "a quattro pezzi," that is to say pens with multiple attachments for different kinds of drawing. Alongside these pens were quill and pencil holders (the *canella* [C1] and *toccalapis* [T4]) for elegant freehand drawing or calligraphy.[2]

Vagnarelli's standard compasses (C2–8), which came in three sizes, were the most basic sort of dividing instrument used in geometry, the size to be used for a particular operation being determined, quite simply, by the scale of the object or drawing to be measured.[3] For very accurate measurements a compass with a straight screw (C15) could be used; this allowed a high degree of precision in the adjustment of the leg aperture and could also be used to scale figures up or down.[4] A compass for sea charts (C10) was, as its name suggested, used in navigation to plot a course; these devices usually featured a curved section at the top that enabled the user to open them with one hand.[5] As Oddi explained to Camillo Giordani, "The compass of marine charts is so called because it was first had by certain pilots who had it made to serve them; it is no different to common ones, and it does not have any other operations, only that it opens in the middle of the turned parts and it closes better."[6] Related to this device were the "compass for right angles" (C11) and the "compass with three points" (C13). The latter, which Oddi sometimes described as "for angles," could be used in bisecting angles but could also be deployed in drawing various types of curve, and in the reproduction of maps and charts.[7]

The "compass with four points" (C14) probably refers to a simple reduction compass, which operated according to the principle of proportionality to scale measurements and drawings up or down in a fixed ratio and to divide lines in proportion (the relatively modest price for this instrument—20 *paoli*—suggests that it was not the more

INSTRUMENT	PRICE *(paoli)*
Small compass	6–10
Medium compass	10–18
Large compass	10–24
Compass one-half size	12–15
Compass one-third size	12–15
Compass for sea charts	12
Dividers	12
Compass for right angles	10
Compass with two springs	25
Compass with three points for angles	15–20
Compass with four points	20
Compass with a straight screw	20–24
Compass for the astrolabe	60
Compass with grooved brass	10
Polimetric compass	40

Compasses made by Lorenzo Vagnarelli, and their prices.

sophisticated kind with a sliding, central pivot). The "compass for the astrolabe" (C16), the most expensive single item in the accounts, probably refers to the articulated arm attached to the reverse of a universal astrolabe. The fact that it appears only once in the accounts suggests that this was an unusual, bespoke piece, not part of the Officina's everyday production.[8] Finally, there is the polimetric compass (C18), to which Oddi devoted an entire treatise and which had a wide range of applications.[9] The kind manufactured in the Vagnarelli workshop was most probably the "Guidobaldo-style" compass preferred by Oddi, which had various scales inscribed upon each of its arms that could be used for dividing a line into equal parts, calculating the weights of different metals, or constructing regular polygons.[10]

Key and Glossary

A1 *aelo calamitato* (lodestone)
A2 *archipendolo* (mason's level)
C1 *canella* (quill holder)
C2 *compasso* (compass)
C3 *compasso d'argento* (silver compass)
C4 *compasso piccolo* (small compass)
C5 *compasso mezzana* (medium compass)
C6 *compasso grande* (large compass)
C7 *compasso dalla meta* (compass, one-half size)
C8 *compasso dal terzo* (compass, one-third size)
C9 *compasso dalle divisioni* (dividers)
C10 *compasso della carta marina* (compass for sea charts)
C11 *compasso dall'angolo retto* (compass for right angles)

C12 *compasso dalle due molle* (compass with two springs)
C13 *compasso da tre punte per gl'angoli* (compass with three points for angles)
C14 *compasso da quatro punte* (compass with four points)
C15 *compasso dalla vite diritta* (compass with a straight screw)
C16 *compasso per l'astrolabio* (compass for an astrolabe)
C17 *compassi piccoli col scanelli d'ottone* (small compass with brass grooves)
C18 *compasso polimetro* (polimetric compass)
C19 *compasso a ballustri* (compass with balusters)
C20 *coltellino col manico d'argento* (compass with silver case)
C21 *coltello* (knife)
F *forbice* (scissors)
N *noci* (nuts for instruments)
P1 *pelatoio* (ruling pen[?])
P2 *penna a ballustri* (baluster pen)
P3 *penna d'argento* (silver pen)
P4 *penna d'ottone* (brass pen)
P5 *puntirolo* (awl)
R *riga* (ruler)
S1 *spuntone* (sharp point)
S2 *squadra* (set square or quadrant)
S3 *squadra zoppa* (folding square)
S4 *stuccio* (cased set of instruments)
S5 *stuccio-cassa* (case for a *stuccio*)
T1 *temperatoio* (stylus)
T2 *temperino* (little knife)
T3 *tiralinea* (ruling pen)
T4 *toccalapis* (pencil holder)

MUTIO ODDI'S DEALINGS WITH THE OFFICINA, 1620–1629

Compiled from Oddi's records in OPU-FCC II and III. The accounts in these notebooks are not a complete record of Oddi's business dealings with the Officina. He occasionally mentioned other transactions in his correspondence; however, as these references are vague and imprecise, they have been omitted from the present appendix.

1620

Contessa Giovanna Borromeo: S5
Daniele Ala: N(2)
Mutio Oddi: P3(4), C2(21)

1621

Carlo Resino: P3(2)
Mutio Oddi: C2, C3, C4(2), C12(2), C14, C17(2), F, N(2), P1, P3(10), P4(10), P5, F,
 T3(2), N(unspecified number)
Pietro Antonio Basilio: C2(2)

1622

Mutio Oddi: A1(2), A2, C1, C4(2), C5(2), C6(3), C7, C8, C10, C12, C13, C15, C18, F,
 P3(4), P5, R, S2, S3, S5 [containing A2, C1, C4(2), C5(2), C6(3), C7, C8, C10, C12,
 C13, C15, C18, C20, C21, F, P5, R, S2, S3, T3, T4], T2, T3, T4(25)
Peter Linder: P3(2), P4(3), C2, C4(2), C5, C6(2)

1623

Conte di Cozzertanie(?): S4, C[various sizes](unspecified number)
Giovanni Battista Arconati: P3, P4
Mutio Oddi: A1, P3(2), P4(2), C4(3), C5(6), C6(3)
Peter Linder: C4, C5
Peter Linder (for "the Fleming"): C4, C5
Pietro Antonio Basilio: C13, C15, S4 [containing C2, F, P5, S1, T2, T3, T4]

1624

Francesco Cantori Cessiero(?): S4 [containing A2, C2(3), C4(2), C5, C6, C7, C8, C9,
 C12, C13, C15, C19(2), F, P5, R, S2, S3, T1, T3, T4, P2, S5]
Giovanni Maria Visconti: C5, C6
Marchese Valdefuentes: C2(2), A2, C12, R
Mutio Oddi: C4(2), C16, P4(3)

1626

Antonio Mucata(?): C2(3), C2[of various sizes](unspecified number), C11, C13

1627

Giovanni Battista Pinzi: P5
Mutio Oddi: P5, T3

1628

Mutio Oddi: P4(3), S4
Peter Linder: C2(2)

1629

Mutio Oddi: C2(13), C4, C19, P4(3)
Signor Don Antonio Brancazzi(?): S4

Notes

ABBREVIATIONS

Archives

BAM Biblioteca Ambrosiana, Milan
BOP Biblioteca Oliveriana, Pesaro
BUU Biblioteca Universitaria, Urbino:
 FC Fondo Comune
 FCC Fondo Congregazione Carità

Oddi papers

OCP Oddi Correspondence, Pesaro. Biblioteca Oliveriana, Pesaro, MS 413, fols. 1–285.

OCU Oddi Correspondence, Urbino. Biblioteca Universitaria di Urbino, Fondo Congregazione Carità, Busta 47, fascicolo. V, fols. 510–1067.

OPU-FC Oddi Papers, Urbino. Biblioteca Universitaria, Urbino. Fondo Comune.

OPU-FCC Oddi Papers, Urbino. Biblioteca Universitaria, Urbino. Fondo Congregazione Carità, Busta 53:
 I: Fascicolo 1: Libretto dei conti del signor Muzio Oddi, fols. 1–18.
 II: Fascicolo 2: Libretto dei conti del signor Muzio Oddi, fols. 1–132.
 III: Fascicolo 3: Libretto dei conti del signor Muzio Oddi, fols. 1–30.
 IV: Fascicolo 4: Libretto di memorie diverse del signor Muzio Oddi (Diario), fols. 1–46.
 V: Fascicolo 5: Libro di amministrazione del signor Muzio Oddi tenuto da Andrea Brancialino, fols. 1–52.
 VI: Fascicolo 6: Libro di memorie dei censi ed altri conti di casa Oddi, fols. 1–88.
 VII: Fascicolo 7: Libro dei conti e censi di Muzio Oddi e memorie diverse, fols. 1–90.
 VIII: Fascicolo 8: Inventario e vari conti della famiglia Oddi, fols. 1–74.

Printed Books

IRM Paul L. Rose, *The Italian Renaissance of Mathematics: Studies on Humanists and Mathematicians from Petrarch to Galileo* (Geneva: Librairie Droz, 1975).

LSU Enrico Gamba and Vico Montebelli, *Le scienze a Urbino nel tardo Rinascimento* (Urbino: Quattroventi, 1988).

Museums

IMSS Istituto e Museo di Storia della Scienza, Florence.
MHS Museum of the History of Science, Oxford.

Transcriptions in the original Italian of quotations from primary sources have been published online, at http://www.press.uchicago.edu/books/marr. Relevant passages are indicated in the notes by numbers preceded by "W" immediately following the reference, e.g. "Mutio Oddi to Giovanni Antonio Magini, from Milan, 11 August 1610. OCP, 284r. W45.1."

PROLOGUE

1. Throughout this book I use "Mutio," rather than the modern spelling "Muzio," as Oddi's first name, since that is how he signed himself.
2. Oddi 1625, sig. a2r. W2.1. For the cause of Oddi's imprisonment, see p. 37.
3. Oddi's contemporary and first biographer Giovanni Vittorio Rossi provided the initial, bare-bones version in a short account of the mathematician's life. See G. V. Rossi 1643. This was repeated (sometimes with embellishments) by all the chroniclers of Urbino's famous men from the seventeenth through to the nineteenth century. Oddi himself rarely alluded to this awful period of his life—he clearly wanted to forget it—but those few remarks he did make tend to support later accounts. See, in addition to the passage from *Dello squadro* quoted above, Mutio Oddi to Piermatteo Giordani, from Lucca, 10 June 1631, in which Oddi referred to his "imprisonment of four years, with great constraints, as Your Lordship knows." OCP, fol. 202r. W3.1.
4. Grossi 1856, 213. W4.1.
5. The survival of these drawings helps to authenticate the accounts of Oddi's imprisonment, for they are inscribed on exceptionally poor quality paper. See Eiche 2005.
6. Oddi 1625, sig. a2r. W6.1. Grossi compares Oddi to Boethius, whose *De consolatione* was itself written in prison: "[Oddi], like Boethius, turned his soul toward philosophy, and with this comforted and strengthened himself against adversity, and mocked and derided the wickedness of envy and of fortune." Grossi 1856, 213. W6.2. For comparative accounts of prison life in the period see, e.g., Tedeschi 1991; Headley 1997, esp. 53–54; Harkness 2007, chap. 5.
7. This was a common theme in geometrical treatises of the period, neatly distilled by John Dee in his "Mathematicall Praeface" to the first English edition of Euclid's *Elements*: "And for us Christen men, a thousand mo[re] occasions are, to have need of the help of Megethodicall [i.e., geometrical] Contemplations: whereby, to trayne our Imaginations and Myndes, little by little, to forsake and abandon, the grosse and corruptible Objects of the outward senses: and to apprehend, by sure doctrine demonstrative, Things Mathematicall. And by them, readily to be holpen and conducted to conceive, discourse, and conclude of things intellectual, spirituall, aeternall, and such as concerne our Blisse everlasting." Dee 1570, sig. ajr. It is worth noting that in

1563 Dee visited Urbino and discussed mathematics with one of Oddi's mathematical heroes, Federico Commandino.

8. Mutio Oddi to Piermatteo Giordani, from Milan, 24 May 1624. OCP, fol. 117r. W8.1. Aresi is presumably the Theatine Bishop of Tortona, on whom see Ardissino 2001. He was the author of a highly influential seven-volume work on *imprese*, the *Imprese sacra* (1615–1635).

9. Mutio Oddi to Matteo Oddi, from Caravaggio, 24 October 1611. OCU, fol. 555r. W9.1. For Matteo Oddi's biography see Promis 1874, 812–13.

10. Harkness 2007, 1.

INTRODUCTION

1. The painting is discussed in detail in chap. 3.

2. On mathematics teaching see part II. The intellectual status of mathematics was intimately bound up with its complex relationship to mental discipline, practicality, and personal virtue, on which see, e.g., M. L. Jones 2006. On the social status of mathematics and mathematicians in the period see, e.g., Biagioli 1989. On friendship see, e.g., Lytle 1987; Langer 1994.

3. I use the term "late Renaissance" rather than "early modern" partially because Oddi's lifetime is roughly commensurate with the time span usually denoted by the former term, but also because of his strong connection to (and continuation of) intellectual and craft practices born in the Renaissance, i.e., he spent much of his time looking backward. Oddi's relationship with earlier trends is discussed especially in part I and chap. 6. See also Cochrane 1970; Welti 1998; and, for a particularly eloquent justification of the use of the term "late Renaissance," Chesters 2010, introduction.

4. For Raphael and perspective, see, e.g., Maltese 1987; Kang 2006. For Galileo and *disegno,* see esp. Bredekamp 2007.

5. Several biographies of Oddi were written in the nineteenth century, the most detailed of which is Promis 1848. The first analytical account of Oddi's life and works is Servolini 1932. To date, the only significant study of Oddi's scientific activities is the short but excellent summary by Enrico Gamba in *LSU*, 106–69. See also Gamba and Montebelli 1995; Gamba 2007. Oddi is slightly better known to the history of architecture, his work in that realm having been explored by Isa Belli Barsali (who studied only his Lucchese period) and Sabine Eiche. See Barsali 2000; Eiche 1993, 1996, 2003, 2005. For Oddi's military architecture see pp. 46–48, 177.

6. Bonaventura Cavalieri mentioned Oddi in a letter to Galileo discussing the former's treatise on burning mirrors, *Lo specchio ustorio* (1632). See Galileo 1968, 14:337, and, for its context, Renn et al. 2001. On the polimetric compass's development and the priority dispute over it (for which there exists a sufficiently large literature that it need not be discussed here), see Rose 1968; Rosen 1968; Belloni 1969; Galileo 1978; Gamba 1994; Meskens 1997; Camerota 2000; Biagioli 2006a, 2006b.

7. This despite persistent attempts to avoid such biases. Ironically, as James Secord has observed, "A construct founded on the primacy of method, genius, progress and discovery continues (albeit awkwardly) to organise a body of specialist literature devoted to criticizing the coherence of such concepts." Secord 1993, 388.

8. As John Henry has noted, many historians of science now seek to "distance themselves from [a] postivistic attitude to science" and the "great men and great works" style of history. Henry 2008, 555. Galileo, though, is no straw man when it comes

to Italian science of the late sixteenth and early seventeenth centuries, as the phe-
nomenal output of the "Galileo industry" testifies. For a survey of (comparatively)
recent work in the sociology of science see Shapin 1987.

9. See, e.g., Redondi 1989; Biagioli 1993; Bredekamp 2007; Valleriani 2008. See also, for
the historiographical legacy of Galileo, Biagioli 1992, esp. 11–13; Finocchiaro 2005;
Segre 1991, esp. chap. 2.

10. See Kuhn 1962.

11. Kuhn; *IRM*. For the sake of convenience I use the term "science" throughout this
book, rather than the more cumbersome "natural philosophy" or "physico-math-
ematics," mindful of its potential ahistoricity. For a discussion of the problematic
nature of the term in the period, see McMullin 1990. For mathematization see Conti
1992; Dear 1995.

12. See, e.g., Hessen 1931; Zilsel 1942, 2000; A. C. Keller 1950. Works that have attempted
to remedy this neglect include P. Rossi 1970; Evans 1973; Webster 1976; Smith 1994,
2004; Long 2001; Ash 2004; Harkness 2007.

13. Feingold 1984, 17.

14. Useful studies of mathematical communities in the period include Feingold 1984;
Mosley 2007a.

15. Indeed, to a certain extent my account may be characterized as a story about the ap-
propriation of mathematics by different groups and how this was enabled, produc-
ing "differentiated practices and contrasted uses." Chartier 1998, 13. For intersections
between mathematics and literature see Saiber, forthcoming.

16. Della Rovere 1989, 85.

17. Oddi also supervised the construction of ebony furniture for Francesco Maria in
1599, and in 1601 he submitted designs for enlarging the Oratoria della Croce in
Senigallia. See Eiche 1996. The Oratorio was actually enlarged between 1604 and
1608. See *LSU*, 111, 111n8. Servolini notes that Oddi's name features frequently in the
records of the Confraternita della Croce. See Servolini 1932, 18–19n8.

18. See Eiche 2005. The duke moved his court permanently from Pesaro to Castel-
durante circa 1599.

19. The insult probably related to the issue of seniority at the building site—a matter
about which Oddi was evidently sensitive. In a letter concerning a dispute be-
tween Oddi and the Senigallese authorities about who should undertake measure-
ments—Oddi (as presiding architect) or the "maestro muratore" (the builder)—at
the Palazzo Comunale, Oddi stressed that the "position and rank His Most Serene
Highness deigned to confer upon me" carried authority in the matter. Mutio Oddi
to unknown recipient, no place or date (presumably ca. 1604). OCU, fol. 644r.
W19.1.

20. For details of the Casteldurante investigation and its consequences see Vernarecci
1889; *LSU*, 111.

21. Oddi succeeded Ventura Ventura, whom he mentions as being in Urbino in early
1602. See Mutio Oddi to Matteo Oddi, from Macerata, 11 January 1602. OCU, fol.
529r. For details of the work undertaken in Loreto see *LSU*, 112; Eiche 1996. It is
notable that as late as 1624 Oddi was still being addressed as "Architetto della Santa
Casa [di] Loreto." Cardinal Bagni to Mutio Oddi, from Fermo, 29 July 1624. OCU,
fols. 670–71.

22. See *LSU*, 112; Eiche 2005.

23. For full details and bibliography see Eiche 2005.

24. For an overview of Oddi's activities in Milan see Marr 2005. For the circumstances of his banishment and determination of his place of exile see chap. 1.

25. See chap. 6.

26. *Gonfaloniere* (literally "standard bearer") was a prestigious civic position in Italian cities and states. Although a powerful office in the medieval period, by the early seventeenth century the role had become largely ceremonial, but it remained a marker of considerable esteem.

27. In this regard he shares a certain similarity to those whom Eric Ash has called "expert mediators." See Ash 2004, esp. 213–16. It seems Oddi was also made librarian of the Ducal Library on his return to Urbino, as noted in Clough 1963, 70.

28. The portrait medal is discussed in detail in chap. 6.

29. On the profession of architecture in the Renaissance see, e.g., Ackerman 1991; Pepper 2003; Burioni 2008.

30. The tradition of associating architecture with mathematics has a long history. It is evident, for example, in Vitruvius's *De Architectura*, it is tacitly present in the geometrical competence of medieval masons, and it was rendered explicit in the dozens of treatises—beginning with Leon Battista Alberti's *De re aedeficatoria* (1452)—that poured from the presses of Renaissance Europe. Moreover, as Jens Høyrup has proposed, there is some evidence to suggest that in the fifteenth century influential writers such as Alberti and Luca Pacioli conceived of architecture as a mathematical science, a view to which Oddi was receptive. See Høyrup 1994, 148–49; [Henninger-] Voss 1995.

31. The literature on "architect-engineers" is vast, but see, e.g., Promis 1874; Parsons 1939; Gille 1964; Lamberini 1990, 2007; Vérin 1993; Galluzzi 1996; Fiocca 1998; Fiocca, Lamberini, and Maffioli 2003, especially the useful "Guida Bibliografica" (277–84); Valleriani 2008. On the emergence of the professional "military engineer"—a group that sought to distinguish itself from civil architects by virtue of greater mathematical competence—see [Henninger-]Voss 1995.

32. Garzoni 1599, 129–31. It is notable, too, that Garzoni struggled to distinguish between the professions of architect, engineer, and mechanician, opting instead for a category entitled *De gli Architetti . . . overo Maestri d'edificij, e Fortificatori di Fortezze, e Maestri di machine, & Mecanici in comune overo Ingegneri* (756–64). Such individuals were, like Oddi, concerned with buildings of all kinds, but also with devices of "miraculous effects," such as "cunning clocks, celestial spheres, [and] instruments to raise weights" (762).

33. On Dee's "Mathematicall Praeface" see Clulee 1998, chap. 6. Stephen Johnston (1994, 1–49) provides a useful map of the mathematical arts and sciences in the early modern period.

34. Mahoney 1994, 2. Mahoney goes on to propose six broad categories of mathematician in the period: "the classical geometers, the cossist algebraists, the applied mathematicians, the mystics, the artists and artisans, and the analysts." While such types are certainly identifiable, and bearing in mind Mahoney's caveat that "the work of many individuals falls into several categories," these groupings should be treated with caution. Too many mathematicians of the period—Oddi included—crossed the supposed boundaries between Mahoney's categories for them to have real explanatory power. The English mathematician Thomas Harriot is a case in point. See Clucas 2000 and Bennett 2000.

35. The best account of the mathematical professions in Italy in the period is Biagioli

1989. As Andersen and Bos note, in the early modern period "mathematicians did not form a well-defined group that earned their living from mathematics." Andersen and Bos 2006, 697. See also Schneider 1981. Court mathematics tended to be more flexible and less coherent than that at universities and schools, because princely patronage often removed the constraints imposed by the fairly rigid statutes and curricula of educational institutions. See, e.g., Eamon 1991.

36. Westman 1980. Mathematical practitioners tend to be examples of what Westman calls "discipline bridgers." Indeed, the emergence of their role should be considered "not as a fixed set of static relations and structures, but as a dynamic, evolving, 'negotiated' process in which analogies to diplomatic exchange, military encounter, legal negotiation, and competition for social status are not out of place" (106).

37. The term "mathematical practitioner," first coined in E. G. R. Taylor 1954, has received extensive treatment in the scholarship on early modern science, most notably in studies of instrumentalism in sixteenth- and seventeenth-century England. See, e.g., Bennett 1986, 1991a, 1991b, 2002; Johnston 1991, 1994, 1996; Hill 1998. Eric Ash (2004) has questioned whether the practitioners designated by this term would have identified themselves as a coherent community; nonetheless, the category remains, as Johnston has observed, "widely useful" for the assessment of early modern science, despite the various roles that fall within its embrace. See Johnston 2007. See also Adam Mosley's (2009) critique of the term.

38. A good example is ballistics, in which practical observations of the trajectory of a projectile, coupled with attempts to understand this trajectory mathematically, resulted in various challenges to Aristotelian natural philosophy. See, e.g., Henninger-Voss 2002; Büttner et al. 2003.

39. On the rhetoric of utility in relation to mathematical practice see, e.g., Neale 1999; Marr 2006b.

40. The literature on this subject is substantial. For an overview see Bennett 2006. See also Bennett 1986. In fact, mathematical practitioners persistently, and in many cases effectively, rebuffed the denigrating accusation that their arts, and they themselves, were merely mechanical by appealing to their practices' foundations in geometry—a part of the quadrivium, and therefore liberal.

41. I take my lead here from Mario Biagioli, who, by "linking patronage to the social process of self-fashioning," adopted a similar approach to the analysis of the relationship between cultural production and social context in the life and work of Galileo. As he suggests, "Rather than looking for paradigms, we may focus on the study of the client's identity in all its sociocultural dimensions, as well as on a scrutiny of the processes through which such an identity is shaped." Biagioli 1993, 14.

42. Oddi left a remarkable documentary legacy through which his life and works may be almost comprehensively reconstructed. Exile required him to correspond extensively in order to maintain ties with the friends and family he left behind in Urbino—notably the Giordani of Pesaro, a patrician family with strong mathematical interests. Approximately one thousand of his letters have survived. Complementing this correspondence are working papers, notebooks, financial accounts, and several hundred drawings. In working upward from this archive and following, as faithfully as possible, some of the most pressing issues of Oddi's worlds, this book aims to present a holistic account of a late Renaissance life in mathematics and its materials, unencumbered—in so far as this is possible—by the polemics and partiality associated with better-known scientists of the age.

43. See, e.g., Ginzburg 1980, 1993; N. Z. Davis 1983. I have been influenced particularly by the work of Deborah Harkness, see, e.g., Harkness 1997, 2007.

44. See Bruster 2001, esp. 232–33 and, for a bibliography of relevant secondary literature, n20.

45. See Buchli 2002, 3. For an account of some of the issues at stake in modern historical scholarship, see Bermingham 1995.

46. For an overview of the issues and literature see Marr 2006a.

47. It is also indebted to debates about the relationship between scholarship and craft in the Renaissance, for which see, e.g., R. Hall 1959; James and Field 1993.

48. See, e.g., Cook 2007; Goldgar 2007. See also, for a wide-ranging study of the relationship between science and commerce in the period, Smith and Findlen 2001.

49. See Goldthwaite 1987, 1993. Goldthwaite's research drew on earlier work charting the spread of consumption in the eighteenth century, for which see, e.g., McKendrick, Brewer, and Plumb 1982.

50. For a succinct overview of Goldthwaite's arguments see O'Malley and Welch 2007a. The term "conspicuous consumption" was first coined in Veblen 1912, to describe nineteenth-century elite individuals' use of wealth to create power, both real and perceived.

51. In this regard my work is part of a broader movement charting patterns of consumption in Renaissance Italy, for which see, e.g., Findlen 1996, 1998; Jardine 1996; Thornton 1998; Welch 2005.

52. See, e.g., Biagioli's study (2006b) of Galileo and the scientific marketplace.

53. Indeed, my findings are comparable to those presented in O'Malley and Welch 2007b, in which it is claimed that "social relationships, rather than objective price factors, were central to every aspect of Renaissance market activity, for quotidian as well as for luxury goods" (2).

54. For further cases that use artifacts in this way, see Dupré and Lüthy 2010.

55. Daston 2004, 10. My analysis of objects—and of Oddi's life in general—draws on Clifford Geertz's "thick description" to recover context and illuminate meaning. See Geertz 1973.

56. See, e.g., Panofsky 1956, 1968; Baxandall 1972; Alpers 1983; Kemp 1990; Kaufmann 1993; Bredekamp 1995, 2007; Reeves 1997.

PART I

1. Mutio Oddi to Francesco Maria Vincenzi(?), from Lucca, 5 October 1626. OCU, unfoliated (between fols. 650 and 651). W1.1. In a rare moment of levity, Oddi went on to explain that his disgrace would surely prevent him from finding a wife, but that "even if I were to find one, I would hasten my own death and remain without a woman." Ibid. W1.2.

2. As Oddi wrote to his kinsman, Ludovico Vincenzi, "Your Lordship may well believe that in me also is that natural affection, which is in all others, to love one's *patria*, and that great longing to see again and to enjoy [the company of] my friends and family." Mutio Oddi to Ludovico Vincenzi, from Lucca, 14 April 1632. OCU, fol. 651r. W2.1. On identity in the period see, e.g., Diefendorf and Hesse 1994; Hadfield 1994. I have found Peter Mandler's reflections on how historians should approach identity formation particularly useful. See Mandler 2006.

3. For "intimations of mortality" and shared identity, see Anderson 1983. In my focus

on the inextricable link between identity and the ways in which knowledge is perceived and pursued I draw upon Polanyi's investigation of the relationship between personal commitment and scientific work. See, e.g., M. Polanyi 1958, 1966.

4. On which see, e.g., Porter and Teich 1992; Livingston 2003.

5. On conservatism in science see, e.g., Gay 1977. See also Kuhn 1971.

6. See, e.g., Biagioli 1993. It should be noted that while we know little about Oddi's religious beliefs, all of the available indicators—his service at the Santa Casa of Loreto, the favor shown to him by Federico Borromeo, and so on—point toward orthodox Catholicism, which may well have encouraged his intellectual conservatism. On several occasions Oddi referred to placing his fate in God's hands and he seems to have made a vow to return to finish his work at the Santa Casa. See epilogue, n2.

7. Oddi's path through what Matthias Schemmel and others have called the "shared knowledge" of the period was, therefore, deeply cautious. See Schemmel 2006, 2008.

8. The notion of the "paradigm shift" was first advanced in Kuhn 1962. See also Hoyningen-Huene 1993.

9. Guidobaldo del Monte, *Mechanicorum liber* (1577), quoted (in translation) in *IRM*, 185. Guidobaldo's comments about the "prison of the body" relate to Commandino's early studies in medicine. Oddi expressed similar sentiments about the death of Guidobaldo, writing in 1621 that the passing of Felice del Monte—one of Guidobaldo's sons—had "reawoken the grief I felt on the death of signor Guidobaldo." Mutio Oddi to Piermatteo Giordani, from Milan, 21 October 1621. OCP, fol. 102r. W9.1.

10. On Commandino see, e.g., Napolitani 1997, 2001; Sorci 2006.

11. Gamba considers Oddi a far better representative of Urbinate mathematical traditions in the early seventeenth century than Baldi, a view with which I concur. See *LSU*, 107. Baldi initially studied with Commandino but after his master's death completed his mathematical education under Guidobaldo's guidance. See *IRM*, 244.

12. See, e.g., T. Kennedy 1996.

13. See, e.g., MacCarthy 2009.

14. The fullest exploration of these issues is Daston and Otte 1991. See also Van Eck, McAllister, and van de Vall 1995; Henry 2005. Michael Cole's perspicacious review of Bredekamp 2007 illuminates recent developments; see Cole 2009. For an overview of "style" in the history of art, see Elkins 1996.

15. Geison 1998, 236. It should be noted that Geison's own view is that style does have a place in the history of science.

16. See Wessely 1991.

17. See, e.g., Buchdahl 1970; Crombie 1994; McAllister 1996.

18. Style, even if it did not reach maturity as a concept until the eighteenth century, had its genesis in the Italy of Oddi's era. See Sohm 2001. Like Sohm, I view style as "less important as a concept than as a heuristic that enables us to perform certain analytic functions" (9)—in this case assessing how a certain brand of science was practiced and presented.

19. See p. 299n2.

20. Mutio Oddi to Piermatteo Giordani, from Lucca, 12 July 1634. OCP, fol. 247v. W20.1. The device to which Oddi refers in this passage was an instrument "once in my room at the little workshops" for dividing the circumference of a circle into equal parts, made by Barocci for Fabrizio Mordente (OCP, fol. 247r, W20.2). See Camerota 2003, 36. For further discussion of instrument aesthetics, see chap. 5.

21. OCP, fol. 247v. W21.1. See also Mutio Oddi to Camillo Giordani, from Lucca, 27 September 1634. OCP, fol. 249r–v.

22. Turner describes the dial as having a "plain, unadorned style in which virtually all decoration is eschewed." A. Turner 2007, 66. In this regard it corresponds with the only extant mechanical clock securely attributed to Barocci (fig. 41), on which see Panicali 1988; Bedini 2001, 67–71. The refracting dial is discussed in greater detail in chap. 4. A mechanical clock ("un horologio di sonare quarto")—quite possibly made by the Barocci—was among Oddi's possessions on his death. See OPU-FCC VII, fol. 67v.

23. Indeed, this style extended to the very books in which members of the Urbino school set out their work. Commandino, Guidobaldo, and Oddi all went to considerable lengths to ensure that, in terms of appearance, their treatises were as exact and polished as the subject matter they contained. See *IRM*; Brancati 2001. Gamba observes that Oddi, like Guidobaldo, "paid great attention to the clarity of the lettering, the correctness of the text and the figures, and the quality of the paper." *LSU*, 123–24. W23.1. This is discussed in greater detail in chap. 4. One of Oddi's principal complaints about Baldi's posthumously published *Exercitationes* was that it was produced so badly, on "poor quality paper, written all in bad characters and with appallingly engraved figures." Mutio Oddi to Piermatteo Giordani, from Milan, 20 October 1621. OCP, fol. 101r. W23.2.

CHAPTER 1

1. For the history of Urbino, from its establishment as a duchy to devolution to the Papal States, see the classic (through antiquarian) Dennistoun 1851; Clough 1981a; Baiardi 1986; Arbizzoni et al. 1998–2001; Cleri et al. 2002; Verstegen 2007.

2. Cimarelli 1642, 143, 179. W2.1. On ingenuity in the period see Gensini and Martone 2002.

3. Urbino was particularly well known throughout Europe for craftsmanship, as the art of maiolica manufacture had been perfected in the duchy, and its foremost practitioner—Francesco Xanto Avelli—lived and worked there. See J. V. G. Mallett 2007.

4. Lattantio Oddi (d. 1605) presided over the locality of Pian di Mercato. See *LSU*, 109. That Latanttio died toward the end of May 1605 can be certified through an entry in the Oddi household accounts (dated 23 May) for "wax candles for the death of the Captain." OPU-FCC I, fol. 16v. On the Genga dynasty see Promis 1874; Gronau 1935; Pinelli and Rossi 1971.

5. See, e.g., Allegretti 1998.

6. The fortress/compass cost the considerable sum of 738 *scudi*. See [Henninger-]Voss 1995, 443n16. The duke continued to patronize the Officina di strumenti matematici after Simone Barocci's death, as evinced by a record for his purchase of a *stuccio* (a cased set of instruments) from Barocci's successor, Lorenzo Vagnarelli. See BOP, MS 375, fol. 198r. See also Montevecchi 2001.

7. As Urbino's most renowned mathematician, Federico Commandino, pointed out in the dedication of his edition of Archimedes's *Opera* (1558) to Ranuccio Farnese, not only did mathematics provide certainty of demonstration, it was also especially useful to military science. See *IRM*, 195.

8. On the Ducal Library, which contained manuscripts of works by Euclid, Archimedes, Pappus, and Hero, see Clough 1981b; Simonetta 2007. For Vittorino see W. H.

Woodward 1963. In addition to the works of art mentioned above we should note the presence of Fra Carnevale at court and the fact that in 1467–78 Paolo Uccello produced an important predella panel for the fraternity of Corpus Domini (*The Profanation of the Host*), widely regarded as innovative for its use of perspective. See Christiansen 2005.

9. Patent of Federico da Montefeltro, Count [late Duke] of Urbino, on behalf of Luciano Laurana, 10 June 1468. Published in Chambers 1970, 164–66.

10. The attribution to de' Barbari is based on the *cartellino* on the right-hand side of the table, which bears the inscription "IACO. BAR. VIGENNIS. P. 1495." On the attribution and iconography of the portrait see Mackinnon 1993; R. E. Taylor 1980. On Jacopo de' Barabari see Levenson 1978. The portrait is first listed in a 1582 inventory of the contents of the Palazzo Ducale. See Sangiorgi 1976, 40.

11. The *Vocabolario degli Accademici della Crusca* translates *condottiere* as "capitano. Lat. *dux, doctor* . . . E de' *condottieri* delle masnade de soldetti." Accademici della Crusca 1623, 207. On *condottieri* in the period see M. Mallett 2003.

12. On the *Fregio* see Pezzini 1985; Manno 1986. Urbino's reputation as a center of excellence for the arts of war was significantly enhanced by Francesco Maria I della Rovere, widely acknowledged as an expert in military engineering. See, e.g., Adams 1999.

13. On the military context of mathematics in the duchy see Scalessi 1998; Gamba 2001. See also, for the relationship between mathematics and the arts of war in the Renaissance, [Henninger-]Voss 1995; Bennett and Johnston 1996. The literature on sixteenth-century fortifications is large, but see esp. Hale 1977; Pepper and Adams 1986. For ballistics see B. S. Hall 1997, esp. chaps. 5 and 6.

14. Bernardino Baldi, "Discorso . . . di chi traduce sopra le machine se moventi," in Hero of Alexandria 1589, sig. 8r. For such devices in context see Marr 2006b. For Barocci and his mechanical clock see Panicali 1988. See also Gamba 2001, 85–87. Griffi was known to Oddi, see chap. 5.

15. For a lively account of technology at the Urbino court, see Wolfe 2004, 37–55.

16. The Officina is discussed briefly in *LSU*, 18–20. The best accounts, though neither is comprehensive nor error-free, are Panicali 1988 and Bedini 2001. Important information about the biographies of the various makers associated with the Officina is in Pier Girolamo Vernaccia, "Elogi degli uomini illustri di Urbino," BUU-FC, vol. 59, fols. 175–80. See also Calzini 1916.

17. Baldi 1724, 33–34. W17.1.

18. See, for example, Bedini's account of the Milanese Guido Mazenta, who was obliged to wait ten years for his instruments. Bedini 2001, 20–25.

19. See chap. 5.

20. In the mid-sixteenth century, for example, Commandino worked with Barocci to create a reduction compass. A sketch of the unusually fertile conditions for the development of new instruments in late Renaissance Urbino is provided in *LSU*, 81–88.

21. Oddi (1638, 97) noted that he studied dialing with his uncle, Niccolò Genga, and apparently he continued this family tradition; in a manuscript treatise on sundials Oddi's nephew, Niccolò Vincenzi, wrote, "I learned [this practice of dialing] from Mutio Oddi, my uncle, several days before his spirit went to The Lord." OPU-FC, Busta 118, fasc. 6, fol. 140r. W21.1. It is plausible that Oddi also received instruction from the engineer Simone Genga (ca. 1530–ca. 1596), son of Andrea Genga,

majordomo of Duke Guidobaldo II della Rovere. See Promis 1874, 247–54, 533–61. Vernaccia has suggested that the architect-engineer Francesco Paciotti may have been another of Oddi's teachers. See "Notizie istoriche di Muzio Oddi matematico, raccolte da Alvino Diopeio pastore Arcade," in "Elogi degli uomini illustri," fols. 1–24. Although absent from Urbino for much of Oddi's youth, Oddi owned some of Paciotti's papers and was thoroughly conversant with the instruments invented by the architect-engineer and his brother, Felice. See chaps. 4 and 6. On Paciotti see Pagni 2001.

22. G. V. Rossi 1643, 174. Francesco Maria II similarly recorded that Oddi was "shortsighted with small eyes." *LSU*, 111.

23. He may also have learned additional instrumental techniques there. John Marciari and Ian Verstegen (2008) have argued that Federico Barocci employed the reduction compass to scale up his preliminary drawings.

24. See, e.g., Puttfarken 1991.

25. On Guidobaldo see Micheli 1992, 1995; Gamba 1998; Henninger-Voss 2000; Renn et al. 2001; Van Dyck 2006.

26. Mutio Oddi to Piermatteo Giordani, from Lucca, 10 June 1631. OCP, fol. 202r. W26.1.

27. It is possible that Oddi, a gentleman by birth, may have entered the ducal household as a page, although I have not found any evidence to corroborate this.

28. See *IRM*, 223.

29. Oddi makes a fleeting reference to his studies with Guidobaldo in the context of a discussion about a problem in algebra that he was struggling to solve: "I never undertook very much study [of algebra] except in that short [time] that I stayed with signor Guidobaldo." Mutio Oddi to Camillo Giordani, from Lucca, 8 March 1630. OCP, fol. 188r. W29.1. Oddi must have completed his studies by 1595, as in that year he departed for Burgundy as a military engineer under the command of Alessandro Brunone, forming part of the *Tercio* of Alfonso d'Avalos assembled by Francesco Maria II to aid the Spanish in the war against the French. See Eiche 2005, 63; *LSU*, 109–10.

30. D. Hay 1971. Useful studies of the term *patria* are Eichenberger 1987; Landon 2005.

31. Mutio Oddi to Camillo Giordani, from Lucca, 16 June 1632. OCP, fol. 208r–v. W31.1.

32. On the ducal territories in Oddi's era see Mazzanti 1995.

33. In his "Encomio della patria," Baldi equated his *patria* with the city of Urbino, but he also gestured to the wider dominion ruled over by the dedicatee of his work, Duke Francesco Maria II della Rovere. See Baldi 1724, 1–36, esp. 23.

34. D. Hay 1971, 4. We should not, though, overestimate this supposed sense of unity. Suggestions such as William Kennedy's that, "Despite the diversity of Italy's regional composition and its stubborn particularities, a sense of pan-Italian unity had come to prevail [by the beginning of the seventeenth-century]," are highly questionable given the fierce regionalism exhibited throughout Oddi's era and beyond. See W. J. Kennedy 2003, 12.

35. See, in addition to Hay and Kennedy, Marietti 1990; Tallon 2007.

36. For Oddi's interest in geography see, e.g., Oddi to Piermatteo Giordani, from Lucca, 5 July 1634. Published in *LSU*, 202–5. See also OCP, fol. 157r, in which he discusses the geographical work of Olaus Magnus. In 1623 Oddi described a set of maps that

he had ordered from Flanders and Amsterdam, which he planned to distribute to various *cavalieri*. Mutio Oddi to Piermatteo Giordani, from Milan, 5 July 1623. OCP, fol. 109r.

37. Black 2001, 2. Some scholars (most notably Benedict Anderson) have argued that with the advent of print, linguistic unity provided the basis for a "national senti-ment" emerging from "imagined communities." That is to say, the medium of print has the potential to transcend regional specificity. See Anderson 1983; Chiapelli 1985.

38. For his interest in these writers see chap. 6.

39. On this notion see Molho 2002. Francesco Maria—who had studied under Com-mandino—seems himself to have been intellectually conservative, which doubtless had an impact on the tenor of his court.

40. Mutio Oddi to Piermatteo Giordani, from Lucca, 10 June 1631. OCP, fol. 202r. W40.1.

41. At this time, sundials were regularly used in an emblematic fashion. On emblem-atic frontispieces and the sciences in the period see Remmert 2005. In 1630 Oddi reflected on the merits of the mottos used by Baldi and Guidobaldo in the fron-tispieces to their works on mechanics. Mutio Oddi to Piermatteo Giordani, from Lucca, 24 April 1630. OCP, fol. 192r.

42. Oddi 1638, letter to Peter Linder (unsigned leaf). W42.1. The *impresa* is noted briefly in Servolini 1932, 11.

43. Oddi 1638, letter to Peter Linder (unsigned leaf). W43.1. The motto is from Sonnet 150 of Petrarch's *Canzoniere*, the collection of verse from which Oddi drew also the motto for his own portrait medal (see chap. 6). Oddi had apparently already chosen the motto some years before the book's publication, as he mentions it in a letter to Hippolito Capi, from Milan, 8 December 1610. OCP, fol. 4r.

44. The fact that, in explaining the 1638 *impresa*, Oddi's refers to the duke's light as having *nearly* set implies that the anonymous courtiers who dripped poison into Francesco Maria's ear died before their lord did. However, I have found no evidence to suggest that Oddi and the duke were reconciled before the latter's death.

45. On exile in the period see Starn 1982; Tucker 2003; Shaw 2000.

46. Mutio Oddi to Giovanni Antonio Magini, from Milan, 11 August 1610. OCP, 284r. W46.1. The Oliveriana letter is a copy of the original in Bologna, Biblioteca Comunale dell'Archiginnasio, raccolta Malvezzi de' Medici, cat. 80, no. 1. Oddi went on to express his desire to serve Magini in whatever way he could, express-ing his hope that the astronomer might "have the leisure and peace to spend a little time in contemplating that [geometrical] problem which I asked about when I passed through." W46.2. For details of the problem, which concerned ring dials, see *LSU*, 157n71.

47. As Shaw explains, "Only rarely is it possible to be reasonably sure why a particular place of exile was chosen." Shaw 2000, 89, *passim*.

48. Oddi referred repeatedly to his ill health, which adversely affected his ability to work, in the letters he wrote at the beginning of his exile. See, e.g., OCU, fols. 555v, 557r and 563r (the last for his recovery from a "dreadful fever").

49. Mutio Oddi to Matteo Oddi, from Milan, 21 February 1611. OCU, fol. 545r–v. W49.1. It appears that Oddi half expected to be required to enter the army—other parts of the letter concern which kind of company might be most suitable.

50. At the beginning of his exile it seems that Oddi was courting the Count of Carpegna

(possibly in a bid to reconcile with Francesco Maria). Between January and June 1611 he corresponded with his brother about making and sending to the count a silver sundial with a magnetic compass, which may have been intended ultimately for the duke. In June, however, he wrote that the gift had been returned, with its cover letter "unlooked at." Oddi concluded that his name was still *escommunicato* because of his disgrace. Mutio Oddi to Matteo Oddi, from Milan, 8 June 1611. OCU, fol. 551r. See also, for discussions about the gift, OCU, fols. 539, 541, and 547. Gamba notes that the Count of Carpegna seems to have been especially interested in mathematics. See *LSU*, 96–97.

51. Mutio Oddi to Matteo Oddi, from Milan, 11 December 1612. OCU, fol. 630r. W51.1. See also OCP, fol. 19v, in which he expresses similar sentiments. Oddi cast his re-appointment as fortifications engineer to the Republic of Lucca in much the same terms, saying that although the extension of his contract kept him from his *patria*, "it is the will of God." Mutio Oddi to Piermatteo Giordani, from Lucca, 17 May 1630. OCP, 198r. His reference to an alteration to the terms in his confinement probably related to his unsuccessful attempts to return to Loreto as Architect of the Santa Casa, referred to sproradically in his correspondence from the early years of his exile.

52. As late as 1624 Oddi was still trying to win back the duke's favor, writing to Piermatteo Giordani that he wished to show him "a little oration to the people of Urbino, for a generous and charitable work that I should like to be undertaken on the death of His Highness, and if I am not mistaken . . . it must please and gratify whoever understands it, like Your Lorship, nor should it displease His Highness, as it is a most right and charitable thing." Mutio Oddi to Piermatteo Giordani, from Milan, 16 June 1624. OCP, fol. 119v. W52.1.

53. Mutio Oddi to Camillo Giordani, from Lucca, 21 April 1627. OCP, fol. 149r. W53.1. As he grew older, Oddi's desperation to return home grew increasingly acute as the duke's obstinacy grew stronger. In 1629, for instance, his hope to see again his *patria*, through gaining a *salvo condotto* (safe passage) or in some other way, was blocked by the duke's "very harsh feelings" against him. Mutio Oddi to Camillo Giordani, from Lucca, 24 October 1629. OCP, fol. 171v.

54. Mutio Oddi to Camillo Giordani, from Lucca, 3 November 1628. OCP, fol. 163r. W54.1.

55. As Shaw notes, "Confiscation of all property was the usual corollary of a sentence of rebellion," so Oddi cannot have been particularly surprised at Francesco Maria's act. Shaw 2000, 111. The Boccaccio quote, from the Eighth Day of the *Decameron*, reads, in context: "Se quale asino dà in parete tal riceve, senza volere, soprabondando oltre la convenevolezza della vendetta, ingiuriare, dove l'uomo si mette alla ricevuta ingiuria vendicare."

56. I have found no evidence that Oddi read Ovid, a standard point of reference for most literate exiles. See Tucker 2003, *passim*.

57. Starn 1982, 4.

58. For the history of Milan in this period see, e.g., Fondazione Treccani 1953–62; Cipolla 1952; Sella 1979.

59. Oddi's social circle in Milan was large and diverse, extending from the high noblitiy to engineers, and even to the choir of the Duomo. For further details see part II and, for the choir, Mutio Oddi to Hippolito Capi, from Milan, 8 December 1610. OCP, fol. 4r. Oddi regularly stayed at his patrons' villas at the nearby lakes, which offered

a respite from the bustle of city life and helped restore his health when he fell ill. See, e.g., OCP, fols. 44r, 53r, 123r.

60. For the economic history of Milan in the period see, in addition to Sella 1979, D'Amico 1994. Oddi regularly bought goods—mainly fabrics and furniture—from Milan's shops for his friends and family in Urbino. He also took advantage of the city's renowned metalworkers; for example, in 1617 he procured a fine sword for Camillo Giordani. See Mutio Oddi to Camillo Giordani, from Milan, 28 June 1617. OCP, fol. 71r. See also the collection of Vincenzi letters, sent between residents of Urbino and Milan, published in Sangiorgi 1982.

61. One of the services Oddi offered was the provision of fortifications plans. For example, near the beginning of his exile he wrote to his brother, Matteo, regarding the "plan of the fort of Fuentes" that he was sending to the Count of Carpegna. Mutio Oddi to Matteo Oddi, from Milan, 30 December 1610. OCU, fol. 537v. A plan of the fort survives among the Oddi drawings at Windsor Castle, no. 10174. Oddi's first employment in Lombardy seems to have been at the Casteletto di Bulà, as in September 1610 he wrote that for several weeks he had been "kept away from Milan, in order to supervise some building work" there. Mutio Oddi to unknown recipient, from Casteletto di Bulà, 9 September 1610. OCU, fol. 623r. W61.1. I have not been able to identify this location. Oddi was also employed by one "Bellazza" but rapidly left his service to enter the house of Count Serbellone. See Marr 2005.

62. As Gregory Hanlon has observed, "The surest way to send, train and equip troops for Flanders was to collect them in Lombardy and to march them over the Alps, through Savoy, Franche-Comté and Lorraine." Hanlon 1998, 54. See also pp. 47–91 for a useful overview of Northern Italy's military situation under Habsburg rule.

63. González de León 1996, 84.

64. In 1619, for example, Oddi was sent to Finale by Milan's governor, the Duke of Feria, as the King of Spain wanted a new port to be built there. Notably, this journey required the Duke of Urbino's permission. As Oddi explained, "The Duke of Feria, who is sending me, has found a letter which His Most Serene Highness wrote to Don Pedro [of Toledo, former Governor of Milan] for the license, and he wrote that he gave the decree for my going." Mutio Oddi to unknown recipient, from Milan, 30 January 1619. OCU, fol. 616r. W64.1.

65. See Pissavino and Signorotto 1995.

66. Oddi donated a copy of *Dello squadro* (see appendix B) and, around 1620, a manuscript of Abu-Bekr Muhammed ben Abdelbaqi el-Bagdadi's *De superficierum divisionibus*—the translation given by John Dee to Commandino, which the latter used for his printed edition (now Biblioteca Ambrosiana, MS P 236 sup.; see Rambaldi 1989). Oddi was in possession of a portion of Commandino's papers, some of which are preserved in the BUU, although it is not clear how or when he obtained them. See chap. 4. He also owned, and presumably donated, Ambrosiana MS A 230 inf., which comprises Commandino's Latin translations of Apollonius's *Conics* and Pappus's *Lemmata* on the *Conics*.

67. For Oddi's relationship with Borromeo see chaps. 2, 3, and 6.

68. See chap. 2.

69. In March 1612 Oddi noted, "I have returned to the house of signor Guidobaldo Vincenzi to stay for 12 [months] at the cost of six *scudi* per month." OPU-FCC IV, fol. 1r [misfoliated as 2r]. W69.1. On the Vincenzi family see Sangiorgi 1982, 7–11.

70. Mutio Oddi to Francesco Maria Vincenzi(?), from Milan, 26 December 1612. OCU, fol. 615r. W70.1. For Oddi's post at the Scuole see chap. 2. Vincenzi died on 8 December 1612. Oddi, who evidently stayed in Guidobaldo's Milanese residence for some time after his death, acted as his executor. Much of his corespondence with the Vincenzi of Urbino concerns Guidobaldo's will and distribution of his possessions, including books, paintings and other precious goods. See OCU, fols. 567, 578–90, a set of letters that would repay further attention.

71. *LSU*, 115.

72. See, e.g., Berengo 1965. For Oddi's architectural work in Lucca see Barsali 2000.

73. Mutio Oddi to Piermatteo Giordani, from Lucca, 18 June 1625. OCP, fol. 130r–v. W73.1.

74. Indeed, many of Oddi's letters from the city were effectively *avvisi* (newsletters), relaying information about political, military, and religious occurences to friends and family back in Urbino. On the circulation of news in the period see, e.g., Dooley 1991, chap. 1; De Vivo 2007.

75. See pp. 128–29.

76. We know from Oddi's correspondence with Giovanni Battista Caravaggio that there was at least one mathematical instrument maker working in Lucca at the time. Oddi did form a close relationship with at least one major Lucchese noble—Bernardo Buonvisi—who supplied him with considerable architectural patronage and seems to have been interested in the sciences. See chap. 5. This paled beside the many and varied friendships Oddi had enjoyed in Milan, although he did remember Buonvisi in his will (see epilogue).

77. Mutio Oddi to Camillo Giordani, from Lucca, 19 May 1627. OCP, fol. 151r. W77.1. Oddi's comments may relate to the mathematically incompetent surveyors of Lucca, with whom he argued shortly after his arrival in the republic. See p. 62.

78. In 1628 Oddi complained to Camillo Giordani that he could not attend to "speculative" matters, since "all day I have to contend with the unskilled builders, and lawyers." Mutio Oddi to Camillo Giordani, from Lucca, 19 October 1628. OCP, fol. 161r. W78.1.

79. Mutio Oddi to Piermatteo Giordani, from Lucca, 17 September 1625. OCP, fol. 49r. W79.1. A few years later he wrote, "I am so lonely . . . that I want to find a servant . . . among other things he must know how to write properly, be of good character, and wish to learn my profession." Mutio Oddi to Camillo Giordani, from Lucca, 1 September 1627. OCP, fol. 155v. W79.2.

80. The full passage reads: "Your Lordship will already know, from one of my letters to signor Camillo, that those gentlemen [of Lucca's Council] have extended my contract for another five years . . . and with this are dismantled all those castles in the air of returning to the *patria,* living freely[?], and a thousand other things I had conjured in my mind, all of which is God's design and therefore best for me." Mutio Oddi to Piermatteo Giordani, from Lucca, 17 May 1630. OCP, 198r. W80.1. See also Mutio Oddi to Ludovico Vincenzi, from Lucca, 14 April 1632, in which Oddi explained that, due to honor and a sense of obligation, he had decided to stay on as fortifications engineer for another three years, despite his great desire to return to Urbino and teach mathematics. OCU, fol. 651r. Numerous references to the increases in salary offered to him are in OCU, OCP, and Trenta 1822, 343–65.

81. Mutio Oddi to Matteo Oddi, from Loreto, 18 September 1605. OCU, fol. 531r. W81.1.

82. In his old age, Oddi lamented again the lack of "philosophy" in his life, writing to Piermatteo Giordani: "I read Your Lordship's letter with infinite contentment . . . and that which increased my pleasure was to see that you are spending your old age in good health and also in philosophizing, and living peacefully without fear—something which does not happen to me, for although not nearly so advanced in years, I am always in the hands of the doctors, always poor, with no hope of taking shelter in the port of my *patria* after such a long voyage through a stormy sea of troubles. . . . Always I have tried my utmost to apply myself to mathematics, but I am in a country where there is absolutely nobody with whom one can confer." Mutio Oddi to Piermatteo Giordani, from Lucca, 24 April 1630. OCP, fol. 192r. W82.1. Oddi's use of maritime imagery is comparable to that deployed at the beginning of *Dello squadro*. See pp. 3–4.

83. Mutio Oddi to Camillo Giordani, 1st day of Lent 1630. OCP, fol. 276r. W83.1.

84. Among the Urbinati employed as Lucca's fortifications engineers were Francesco da Pesaro, Baldassare Lanci, Francesco Paciotti, Pietro Vagnarelli, and Matteo Oddi.

85. See Henninger-Voss 2000.

86. See, e.g., Bietenholz 1966; Cochrane 1981, 393–422. On the "famous men" tradition see Joost-Gaugier 1985. Baldi (1724, 28–35) provides an excellent guide to Urbino's famous men in his "Encomio della patria."

87. See Atkinson 2007. See also Bachielli 2003. In 1631 Oddi wrote, "I have seen the passage from Polydore Vergil and I was surprised that he does not cite [text destroyed] that observation of Trismegistus [about the origins of sundials]." Mutio Oddi to unknown recipient, from Lucca, 31 December 1631. OCU, fol. 654r. W87.1. Oddi cites Vergil's *De inventoribus rerum* twice in the preface to *Degli horologi solari* (Oddi 1614, 8).

88. See Santi 1985, 111–15. For the *studiolo* see Cheles 1986. The frieze contained several of Oddi's heroes, namely Aristotle, Euclid, and Petrarch.

89. On the *Vite*, a summary of which was first published as *Cronica de' matematici overo epitome dell'istoria delle vite loro* (Baldi 1707), see *IRM*, 253–69; Nenci 1998. It would be interesting to know whether Baldi—who wrote his own life of Federico da Montefeltro—was influenced by Santi's list of famous men. The literature on Baldi is large, but see, e.g., Serrai 2002; Becchi 2004; Nenci 2006. For Renaissance histories of mathematics see Goulding 2010.

90. It was, however, known to Promis in the nineteenth century. See Promis 1848.

91. Eiche 2005, 88 and 93. W91.1.

92. On which see, e.g., Starn 1986.

93. Mutio Oddi to Alberico Settala, from Lucca, 10 April 1628. W93.1. Oddi owned an algebraic manuscript by Paul of Middelburg. See Vernarecci 1881, 104. The letter, which is BAM, MS G 9(4) inf., fols. 116–17, has been published in *LSU*, 190–93. See also chap. 5. Alberico Settala seems to have been a member of Oddi's Milanese circle as he is mentioned, in a familiar manner, by Giovanni Battista Caravaggio in a letter to Oddi of the 1620s (the final digit of the date is cropped). See OCU, fol. 741r. Oddi was acquainted with numerous members of the Settala family, a prominent Milanese clan. The physician Ludovico Settala was one of Guidobaldo Vincenzi's doctors during his final illness (see Oddi to Francesco Maria Vincenzi[?], from Milan, 5 December 1612, OCU, fol. 610r–v), while Girolamo Settala is listed as a recipient of *Dello squadro* (see appendix B).

94. *IRM*, 255. Alessandro Giorgi, a follower of Commandino, published an Italian translation of Hero's *Pneumatics* in 1592. See Marr 2004b, 210.

95. *IRM, passim.*

96. Mutio Oddi to Piermatteo Giordani, from Milan, 2 September 1620. OCP, fol. 1v. Oddi does not specify the works in question, but it is likely that he was referring to Guicciardini's *Storia d'Italia* and Giovio's *Historiae sui temporis*. It is plausible, given his interest in the *uomini illustri* genre, that he also read the latter's *Elogis virorum litteris illustrium*. Oddi seems to have known the Urbinate historian Homero Tortora, for he expressed sadness at the news of his death. See Mutio Oddi to Piermatteo Giordani, from Milan, 21 August 1624. OCP, fol. 123v.

97. Oddi refers to Tacitus, Plutarch, and Machiavelli in a satirical poem poking fun at Don Pedro of Toledo, sometime Governor of Milan. See Mutio Oddi to Camillo Giordani, from Milan, 18 January 1617. OCP, fol. 60r. For Oddi's interest in Petrarch see above and chap. 6, although he refers only to Petrarch's poetical works. When in Milan, Oddi evidently made use of the Biblioteca Ambrosiana's rich holdings of history books, for in 1617 he wrote to Camillo Giordani about having searched for historical works by the Spanish author Anotino de Herrera in that library. Mutio Oddi to Camillo Giordani, from Milan, 23 August 1617. OCP, fol. 81r.

98. Oddi himself came from a line of famous architect-engineers: the Genga. He was proud of this lineage, revering Girolamo Genga especially, for in 1623 he wrote: "I have received also the drawing of the *Casino del Barchetto* [the famous 'ruined' house in Pesaro] and I am left in no less shame at my poor memory than in awe at Genga, its architect." Mutio Oddi to Piermatteo Giordani, from Milan, 5 July 1623. OCP, fol. 109r. W98.1. Oddi went on to provide his correspondent with a brief discussion of the design and its relationship to the nearby church of San Giovanni Battista.

99. "DOM Simoni et Federico de Barociis animi ingenuitate praeclaris manuum opificio praestantibus quorum ille novis matheseos instrumentis inveniundis fabrifaciundisque artium illustravit his vero vivis picturae coloribus obscuravit naturam Ambrosius Baroccius patri patruo ac eorum patruelli Ioanni Mariae horologium architecto qui Archimede aemulatus in parva puxide coelestes motus Pii. V. P. M. successor commodis artificiose clausit omnes P.C." The translation is taken from Bedini 2001, 91. A draft of the inscription, with crossings out and changes (OPU-FC, Busta 118, fasc. 4 (9), fol. 2v), shows that Oddi composed the inscription not, as Bedini has suggested, Felice Paciotti.

100. See "Historiographical Note."

101. On 10 July 1636 Oddi recorded a payment of 18 *soldi* for "two frames, one for the portrait of Commandino, and the other for that of signor Guidobaldo." OPU-FCC VI, fol. 16v. W101.1. In his record of Oddi's goods, Niccolò Vincenzi records "two portraits of signor Guidobaldo del Monte," as well as that of Commandino and a portrait of "Guido Genga." OPU-FCC VII, fol. 67v. It is plausible that the portrait of Guidobaldo now in the Musei Civici, Pesaro, was once owned by Oddi. The Commandino portrait in the Museo Civico, Urbania, has a Della Rovere provenance—it was in the Ducal Library in Casteldurante in the early seventeenth century—but it is likely that Oddi's portrait was a copy of the lost original. See Dal Poggetto 2004, 491–92.

102. Baldi is conspicuous by his absence from Oddi's gallery wall. It is entirely possible that there existed a certain rivalry between these two Urbinate mathematicians.

Although on cordial terms, Oddi was critical of Baldi's work on mechanics (see below, n115), his annotated copy of which is preserved in BUU. In *LSU*, Gamba—correctly, in my opinion—presents Oddi as the proper custodian of Urbino's mathematical tradition, devoting only a few paragraphs to Baldi's work.

103. Such ancient authors were by no means the only authorities to whom Oddi referred—in all of his works he demonstrated a thorough familiarity with modern mathematics—but he was evidently keen to show off his classical erudition. See, for example, his use of ancient authority in his dispute with the surveyors of Lucca, discussed in chap. 2.

104. Oddi 1638, 1–14. The *proemio* is surely modeled on those of Commandino and Guidobaldo, such as the former's history of mathematics in his edition of Euclid. See *IRM*, 206.

105. Gamba provides a very brief account of Oddi as "pure mathematician" in *LSU*, 164–69.

106. BUU-FC, Busta 120, fasc. 3, fols. 260r–270v. These folios form part of a miscellaneous collection of mathematical papers, the lion's share of which are in Oddi's hand (a partial list of which is provided in Gamba and Montebelli 1989, 38–39). Some, though, are by Commandino (and were presumably owned by Oddi), and others are by Oddi's nephew, Niccolò Vincenzi. Those by Oddi are mainly concerned with the geometry of triangles, circles, and spheres, but fragments of a treatise on fortification and drafts of letters related to architecture are also present. It is possible that the papers on Euclid form part of a longer work, perhaps intended for publication or as a gift to a patron, which has not survived in its entirety. Oddi's fascination with Euclid did not derive solely from Commandino. Although he did not publish on the subject, Guidobaldo's manuscripts—to which Oddi seems to have had access—include commentaries on books 5 and 6 of the *Elements*. See *IRM*, 230. Oddi discussed Guidobaldo's commentary on book 5—*In Quintum Euclidis Elementorum Commentarius* (BOP, MS 630)—with his correspondents. See, e.g., Mutio Oddi to Piermatteo Giordani, from Milan, 16 February 1613. OCP, fol. 15v.

107. In a fragment on number theory, Oddi comments that although "several ancients did not know the rules" about reducing fractions to equivalent fractions with smaller denominators (a process he calls *schisare*), Euclid explains them clearly in book 7 of the *Elements* (althoughy the ancient mathematician treats them in terms of proportions). BUU-FC, Busta 120, fasc. 3, fol. 289r–v. W107.1.

108. Oddi exhibited a keeness, equal to that of Commandino and Guidobaldo, to emulate the ancients. To take just one example, in a letter to Piermatteo Giordani he referred to a geometrical problem on which he had been working that included, "certain imitations of several of the ancients." See *LSU*, 127. Similarly, in coining names for stereometric lines on the polimetric compass, Oddi believed he was following Apollonius, "who invented many names." Mutio Oddi to Piermatteo Giordani, from Lucca, 18 September 1626. OCP, fol. 139v. In the same letter, Oddi mentioned his intention to compose an anagram of his surname, first name, and *patria,* presumably to serve as a nom de plume for the publication of his *Compasso polimetro* (Oddi 1633). The name he fixed upon, the rather unispired "Domidutio da Urbino" (in fact supplied by Camillo Giordani), was never used. See Mutio Oddi to Camillo Giordani, from Lucca, 28 July 1627. OCP, fol. 153r.

109. Euclid 1572 (Werner Oechslin Bibliothek, no shelf mark). I am grateful to Professor Werner Oechslin for permitting me to consult this book, which bears Oddi's owner-

ship inscription on the first page of text. Two distinct ink colors are discernable, suggesting that he may have annotated the book at two separate times. His annotations, which include numerous diagrams, take the form of corrections and amplifications, the latter of which are divided into his own proofs and comments (labeled "MO") and those culled from other ancient authorities. A nineteenth-century manuscript note pasted onto the flyleaf claims that Oddi annotated the book in prison. I have found no evidence to corroborate this, but the apparent stringency of his conditions in the Rocca di Pesaro make it unlikely.

110. Cavalieri 1632, 193–94. Oddi, who had evidently been told of this praise in advance of the book's publication, was thrilled, writing of the "great honor" bestowed on him. Mutio Oddi to Francesco Maria Vincenzi(?), from Lucca, 19 November 1631. OCU, fol. 659r. For Oddi's relationship with Cavalieri, see p. 90.

111. Gamba provides a sound overview of Oddi's mathematical work in *LSU*, 121–69.

112. Both Guidobaldo and Oddi owned manuscript books of machines by Francesco di Giorgio Martini. See p. 185.

113. Oddi certainly knew about the experiments on the parabolic shape of the trajectory performed by Guidobaldo and Galileo. See Renn et al. 2001. Gamba, referring to one of Oddi's letters, claims that Oddi owned a case of instruments for use in mechanical experiments. *LSU*, 122. What Oddi actually writes is, "lasciò à Venezia quella scattola, delle *sperianze mecchaniche*, e quel libro" (emphasis mine). Mutio Oddi to Francesco Maria Vincenzi(?), from Milan, 26 December 1612. OCU, fol. 615r. The term *esperienza* was frequently used at the time to refer to proofs, so it seems to me likely that in his letter Oddi refers to documents rather than instruments. See *IRM*, 228; Dear 1995. Oddi's correspondence contains scattered references to his knowledge of mechanics. He evidently considered himself sufficiently skilled to correct the "errors" in Marino Ghetaldi's *Archimedes Promotus* (1603). See Mutio Oddi to Matteo Oddi, from Milan, 3 June 1618. OCU, fol. 572v. In an unsigned and undated letter to Oddi, one of his correspondents thanked him for his help with a particular natural philosophical problem concerning Aristotle's account (in book 3, proposition 2 of *De Caelo*) of violent and natural motion. See OCU, fol. 1064r.

114. For the equilibrium debate see *LSU*, 215–50.

115. Oddi was worried by Baldi's criticisms of Aristotle in the former's *Exercitationes*. See Gamba's synthesis of Oddi's scattered references to mechanics in *LSU*, 121–27 and the letters published at 187–89 and 202–5. On the *Exercitationes* see Becchi 2004. Oddi's dissaproval of Baldi's work in mechanics supports Domenico Bertoloni Meli's argument (discussed in "Historiographical Note") that, when it comes to mechanics, different programs are recognizable within the Urbino school. On other matters, though, particularly the importance of subjects such as gnomonics, Euclidean geometry, and Vitruvius, Oddi and Baldi were in perfect accord. Both men were especially interested in book 5 of Euclid's *Elements*, and Baldi sought Oddi's comments on his work on sundials. See Serrai 2002, 91n128. Oddi and Baldi certainly corresponded—Oddi mentions his intention of writing to Baldi in relation to Borromeo's Biblioteca Ambrosiana, for instance—but their letters to one another seem not to have survived. See Mutio Oddi to Piermatteo Giordani, from Milan, 26 February 1614. OCP, fol. 23v.

116. Mutio Oddi to Piermatteo Giordani, from Lucca, 26 April 1634. OCP, fol. 239r. W116.1. See also *LSU*, 194. Guidobaldo and Clavius corresponded about Pappus, for which see *LSU*, 179–81.

117. Oddi's attitude toward Galileo, and to astronomy more generally, is discussed in greater detail in chap. 6. See also *LSU*, 128–30.

118. See *LSU*, 130–64; Montebelli 2001. There was a certain amount of controversy over the polimetric compass, but this concerned priority of invention. See Biagioli 2006a.

119. Indeed, as Rose noted, an extreme concern for precise measurement was one of the hallmarks of the Urbino school. See *IRM*, 233. In some respects the contents of Oddi's books are most interesting for what they tell us about the instrumental ingenuity of his Urbinate forefathers. This is a topic that has already been treated at length and as such is not discussed in any great detail here. See *LSU* and, for Oddi's evidence about Guidobaldo del Monte's instruments, Gamba and Mantovani, forthcoming. I am grateful to the authors for allowing me to see a preprint of this article.

120. For gnomonics see chaps. 4 and 5.

121. As such, it does not really make sense to divide—as Enrico Gamba has done—Oddi's mathematical work into "pure" and "applied." I have found no evidence that Oddi himself recognized such a division; in fact, quite the opposite is true. Montucla observed that the geometry of Oddi's instrument books is more profound than one normally expects from such works in his era. See Montucla 1758. Oddi was especially proud of the "little book on conic lines" that forms part of Oddi 1638. See chap. 5.

122. Oddi 1633, unsigned leaf. W122.1. In 1626 Oddi noted that he was having printed a little work on the *compasso polimetro* "to give to Vagnarelli." Mutio Oddi to Piermatteo Giordani, from Lucca, 18 September 1626. OCP, fol. 139r. For further instances of Oddi's instruction of Urbinate instrument makers, see chap. 5.

123. Oddi 1633, 1–4. For Oddi's evidence see Rose 1968; Rosen 1968; Gamba 1994. In other contexts too, Oddi sought to embellish his old master's fame (and by proxy his own standing) by declaring that while the invention of the *compasso* had been claimed by "Galileo, Coignet, Capra and others, I show that it is due to signor Guidobaldo, of blessed memory." Mutio Oddi to Piermatteo Giordani, from Milan, 2 September 1620. OCP, fol. 1v. W123.1.

124. Oddi 1638, 99–100. W124.1. Like the *compasso polimetro*, this instrument has received substantial attention in recent years. See Camerota 2003; Dupré 2003; Gamba and Mantovani, forthcoming. Dupré states that the Commandino drawings to which Oddi refers are lost, but it is possible that a crumpled sheet bearing what appears to be a diagram of a refracting dial, once owned by Oddi and now BUU-FC, Busta 120, fasc. 3, fol. 135r, is one of the images in question. For Oddi's attempts to buy Guidobaldo's dial, see chap. 6.

125. It is, however, striking that despite his fulsome praise for his countrymen, in this passage Oddi sidestepped the issue of who actually invented the refracting dial. His unwillingness to commit to a firm position on this issue reflects the fact that invention, attribution, and the ownership of an early form of intellectual property were incendiary topics within the period's mathematical community. Not only was there considerable potential for financial enrichment from new devices, but reputation and honor were also at stake. An indication of the seriousness with which the rights to inventions were taken in the period is the development of various forms of local protection, which took the form of privileges and patents. See, e.g., De Mullenheim 2002.

126. See p. 380n90.

127. Presumably Oddi's own portrait—whether the bronze medal or a painted image—

was displayed with or near to those of his teachers. For the medals he owned see p. 308n90. On portrait collections and the construction of identity see Klinger Aleci 1998.

128. Mutio Oddi to Camillo Giordani, from Lucca, 1 September 1627. OCP, fol. 155v. W128.1.

129. Oddi was certainly keen to uphold his homeland's honor following the duke's death. In 1636, for example, he wrote that he looked forward to the publication of the Urbinate technician Niccolò Sabbatini's *Pratica di fabricar scene e macchine ne' teatri* (1637) "for his own honor and even more for that which the *patria* will gain." Mutio Oddi to Camillo Giordani, from Lucca, 23 January 1636. OCP, fol. 274r. W129.1. See also Gamba 2001, 104.

130. See epilogue.

PART II

1. Ugo Baldini succinctly summarizes the importance of attending to mathematics education in his study of Clavius's Academy of Mathematics: "A study of scientific creativity cannot be done in isolation from the educative process, from the inherited ontological doctrines and presuppositions, and from the process of socialization that was so crucial to the formation of practitioners." Baldini 2003, 68.

2. In the case of universities, however, it is important to acknowledge the scope that existed for less prescribed study when special arrangements for extracurricular teaching were made between tutors and their pupils. See Feingold 1984. This may be the kind of teaching in which Oddi engaged, given his post at the Scuole Piattine.

3. This is not to suggest that significant sharing of mathematical knowledge was absent in earlier periods (it was not), rather that a variety of factors conspired to render mathematics, and particularly practical mathematics, more attractive and accessible than had hitherto been the case. For the complexities of the transmission of mathematical (and especially instrumental) knowledge in earlier periods, see, e.g., Eagleton 2006.

4. Settle 1990, 26.

5. See, e.g., Smith 2004.

6. The fifth book of the work, which went through several editions, is in the form of a dialogue between "an experienced artillery lieutenant and a newly appointed general who, significantly, is ignorant of the skills of the profession and wishes to be informed. The lieutenant explains that a knowledge of arithmetic, geometry, and perspective is the foundation on which the perfect artillery officer will develop a more specialized understanding of the use of cannon in warfare." González de León 1996, 72.

7. Pascal Brioist has observed that treatises such as Lanteri's were "at the same time a discursive process aimed at flattering eventual employers and at creating a certain rivalry between Italian princes, and a type of advertising for engineers in search of a position." Brioist 2009, 3. For the social inequality between interlocutors in these dialogues see Biagioli 1989, 66 and *passim*. For treatises as "trading zones of knowledge" see Long 2001, 211, 246.

8. This is not to say that they are completely unreliable. As Brioist, discussing an exchange between the Duke of Urbino and Tartaglia in the latter's *Quesiti*, explains: "Since this part of the dialogue imitates Cicero's—or Plato's—style, no doubt the

text falls short of exactly recording a debate that took place five hundred years ago. However, the dialogue form may provide clues to unveiling the social relations between mathematical practitioners or engineers and their patrons." Brioist 2009, 8.

9. On teaching at the Accademia see Dempsey 1980. For a rare and important instance of surviving evidence of informal teaching see Meskens 1996.

10. Oddi's teaching records have been partially published, with several errors in transcription, in Gamba and Montebelli 1989. They have not, however, been systematically analyzed or contextualized.

11. On institutional mathematics education in the period see Rose 1975b, *IRM*; Feingold 1984; Schöner 1994; Goulding 1999; Romano 1999; Presas i Puig 2002; Navarro-Brótons 2006.

12. See Fletcher 1981; Westman 1975. See, however, on the English context, Feingold 1984.

13. See the records of Galileo's private mathematics teaching in Galileo 1968, vol. 19, analyzed in Valleriani 2008, chap. 3.

14. See below, chap. 2.

15. For the abacus tradition and school mathematics see Van Egmond 1976, 1980; Franci and Rigatelli 1982; Cifoletti 1993, 71–102; Hadden 1994; Goldthwaite 1972; Høyrup 2007.

16. Such *maestri* also sometimes worked as estimators for building works, thus bringing them within the compass of architecture and surveying. See, e.g., Adams 1985. For the role of *maestri d'abbaco* in the visual arts see, e.g., Zervas 1975. The best summary of the content and context of abacus education in relation to sixteenth-century developments is [Henninger-]Voss 1995, 225–39.

17. Van Egmond (1976, 13) offers as a common example: "If I double 1 denarius 100 times, how many lire, soldi, and denari will I have?" *Libri d'abbaco* were circulated initially in manuscript form but with the advent of movable type became a popular form of printed book. See Van Egmond 1980.

18. The evidence of surviving manuscript abacus books shows, however, that the geometrical content of abacus school teaching was only a small portion of the curriculum. See Zervas 1975, 487; Arrighi 1982. For a brief overview of some of the practical geometrical content of abacus books, see Simi and Rigatelli 1993.

19. See Camerota 2006. For Pacioli see R. E. Taylor 1991.

20. As an example of the widespread influence of the abacus schools, there existed (according to Giovanni Villani) six such schools in Florence in 1343, teaching more than a thousand students. See Camerota 2008, 23. As Camerota notes, the sections on similar triangles in book 6 of the *Elements* formed the basis of much of the abacus masters' treatment of practical geometry.

21. See Biagioli 1989, for a survey of the factors that prompted this change. See also [Henninger-]Voss (1995, 237), for an explanation of why the new demands of practical mathematics, especially in the military context, required a "persona somewhat embellished from that of a simple *maestro d'abbaco*. The demonstration of theoretical or classical knowledge was a major method of establishing that persona."

22. Mutio Oddi to Piermatteo Giordani, from Lucca, 14 July 1625. OCP, fol. 167r. W22.1. The dispute concerned the best way of measuring uneven, hilly ground. See also *LSU*, 138. Oddi expressed similar sentiments a few years later, again complaining that he was "in a land where nobody understands the First Book of Euclid." Mutio Oddi to Camillo Giordani, from Lucca, 19 October 1628. OCP, fol. 161r. W22.2.

23. Oddi noted that he had inserted into the section on surveying a digression about the authority of classical authors such as Hyginus, Frontinus, and Polybius, to ensure that the Lucchese practitioners could "not argue against things so clear and true." Mutio Oddi to Piermatteo Giordani, from Milan, 21 August 1624. OCP, fol. 123r.

24. Hale 1976.

25. For schooling in the Renaissance see P. F. Grendler 1989.

26. See *IRM*.

27. For mathematics at court see, e.g., Biagioli 1993; Eamon 1994.

28. A few examples will suffice to indicate the relative ubiquity of this culture: in the early seventeenth century Richard Delamain was one of "His Majesty's engineers . . . and his tutor in the mathematical arts" (Hill 1998, 269). Oddi's countryman Bernardino Baldi taught mathematics to Ferrante Gonzaga in Guastalla. The best known example—and a particularly successful one at that—is Galileo's tutoring of the young prince Cosimo de' Medici. See Galileo 1968, 10:144, 149. As noted in chap. 1, Oddi was offered a court teaching position in Parma, but declined it.

29. A good example of this strategy, and its potential for success, is the Frenchman Salomon de Caus, who began his career at the English court as tutor in perspective to Henry, Prince of Wales, and used this connection to become the prince's architect-engineer, to work as garden designer and architect to the queen, and eventually to capture the prize position of architect to the Elector Palatine, brother-in-law of the late Prince Henry. On de Caus see Morgan 2006; Marr 2008a.

30. "Don Amadeo Vernardo Delascamo, page of signor Duke of Feria, has begun to learn mathematics." OPU-FCC IV, fol. 2v [3v]. W30.1. Because the notebook in which Oddi maintained his teaching records has been misfoliated I list, where necessary, the extant foliation followed by the correct foliation in square brackets.

31. Padua and Bologna were, according to Grendler, the "most significant universities for mathematics" in Italy. See P. F. Grendler 2002, 416–22. See also Schmitt 1975, 162–67. For the ambitious scope of late Renaissance mathematics see introduction.

32. See I. Maclean 2002.

33. See Biagioli 1989, 45. Two of these figures—Danti and Cataldi—also taught at the Florentine Accademia del Disegno, further suggesting an overlap between traditional and novel types of education.

34. This point is made forcefully by A. Turner (1973, 51–52). See also, for architectural/engineering projects, the works cited p. 243n31; for navigation and cartography see Guarnieri 1963. Practical mathematics also made an impact upon the legal profession—scattered references can be found to "judge-geometers who dealt specifically with water and land-related lawsuits." Biagioli 1989, 46.

35. See Valleriani 2008, 78–79. On the basis of book lists, notebooks, and the like, Feingold has demonstrated that in the late sixteenth and early seventeenth century the most mathematically inclined pupils at Oxford and Cambridge studied practical aspects of mathematics, occasionally developing proficiency in instrumentalism. See Feingold 1984, chap. 3.

36. "Ordo lectionis matheseos in Collegio Romano, annis 1557–1560," quoted in Romano 1999, 75. It should be noted that different courses were offered to pupils depending on their main subject of study, so the "dialectitians" followed a course slightly different from that of the "logicians" or the "philosophers." Each, however, included a practical mathematical component.

37. The most thorough accounts of Clavius's reforms are Romano 1999, chaps. 2 and 3, and Baldini 2003.

38. Clavius's practical mathematical works are collected in Clavius 1611–12; for a full list see Baldini 2003, 74–76.

39. The curriculum derived from the *Ordo servandus in addiscendis disciplinis mathematicis* of 1580. See Baldini 2003, 59, and 54–56, 61–67, for the vibrant exchanges that took place within the Academy.

40. See Baldini 1983, 2003.

41. For the visits to Rome see chap. 5. For Oddi's opinion of Clavius, see page 53.

CHAPTER 2

1. By the time of Oddi's appointment the schools were located in the Piazza della Loggia dei Mercanti, and some of the professors were housed in the Ospedale itself. On the Scuole Piattine and the Ospedale (known as the Ca' Granda) see Spinelli 1956.

2. Ramus (1569, bk. 2, 65) comments on the tradition of public mathematical lectures in the German territories, lamenting their lack in his native France. However, the situation there was not quite so lamentable as he claimed. See, e.g., Pantin 2009; Sharratt 1966. Interestingly, Sharratt's analysis reveals Ramus's commitment to the teaching of practical mathematics, and his desire that the subject should be studied by artists and architects as well as schoolboys (612). For English mathematical lecturing in public, a tradition initiated by Thomas Hood, see Johnson 1942.

3. The name of the institution changed in 1603. On the Collegio in the sixteenth and seventeenth centuries see Gatti Perer 1965 (esp. bibliography at 52–53n57); Coppa 1977a; Scotti 1983; Maffioli 2003.

4. Scotti gives the example of the Perugian Galeazzo Alessi, who continued to practice as an architect in Milan throughout the 1570s. Scotti 1983, 94.

5. Examples were to be found in Italy, France, Spain, and the German territories by the early seventeenth century. In England, Humphrey Gilbert famously proposed a London academy in 1570, although it was never realized. See Hale (1976, 452–57) for an overview and (by no means comprehensive) checklist of institutions. For Spain (neglected by Hale) and the Colegio Imperial established in Madrid in 1624, see Díaz 1952–59. For the ambiguity of the term "academy" and its multiple meanings see Baldini 2003, 49; Yates 1947.

6. In this respect, social and military factors were two sides of the same coin. See Hale 1976; Motley 1990, 123–24; González de León 1996. González de León provides a particularly rich account of the "ideal officer genre" of treatises on military education.

7. The best account of the academies, although limited to France, is Motley 1990, chap. 3. See also Hale 1983.

8. On Richino's academy see Aldeni 1997.

9. The letter is quoted (without a date) in Gatti Perer 2004, 24. Gatti Perer states, without providing a call number, that the manuscript is in the Raccolta Beltrami, Milan, but it is not listed in Bellini 2006, and I have not been able to locate it in the archive.

10. Richino's Accademia shares affinities with the Accademia Delia of Padua, established in 1608 to provide military training for the young nobles of the Venetian Republic, including the study of practical mathematics and instrumentalism.

Galileo, who in 1610 applied unsuccessfully for the chair there, submitted a list of those topics he thought most necessary to the military arts that is very close to Richino's letter to the King of Spain. See Valleriani 2008, 83; Hale 1983.

11. Biblioteca Trivulziana, Milan, MSS Triv. Cod. 222, 223, and 224. A fourth manuscript, listed in Porro 1884, as "Regole e tractato d'architectura militare" (Triv. Cod. 607), seems to have been lost.

12. *Pratiche, per ingegneri* is a highly local document; throughout, Richino uses Milanese measurements and examples. Notably, Oddi did the same—referring specifically to Milanese surveying techniques in Oddi 1625, chap. 3.

13. Gatti Perer (2004, 25) refers (without specifying the location) to a document entitled "Nomi di alcuni particolari discepoli quali hanno conseguito in parte l'arte militare in questa *Accademia del Ricchino Ingegnero*."

14. The date of Richino's death is usually given as circa 1610/11, but bound in with his manuscript entitled *Pratiche, per ingegneri* is a note of measurements, dated 25 May 1612 and signed "Ricchino Ingegnero pubblico," which shows he was active to at least that date.

15. "Yesterday, which was the most glorious day of Saint Joseph, the appointment of the Lecturer in Mathematics at the Scuole Palatine of Milan was made, and I myself was appointed." Mutio Oddi to Francesco Maria Vincenzi(?), from Milan, 20 March 1613. OCU, fol. 604v. W15.1. Oddi further notes that he has been granted, in addition to his stipend, "two rooms very close to where signor Guidobaldo [Vincenzi] lives, for free." W15.2. Interestingly, a deputation from the Fabbrica granted him new housing on 24 March 1614 after discovering that the rooms in which he lived were "cramped" (*angusti*). See OCU, fol. 635r–v. This suggests that his appointment to the Piattine chair and his teaching at the Duomo (discussed below) were somehow interrelated.

16. See chap. 4 for further discussion of the commission and execution of this portrait. The chair was held in 1534 by Girolamo Cardano, whose father had also taught at the Scuole Piattine. See Gliozzi 1960.

17. The stipend of 50 *scudi* was in fact unchanged since Cardano's time. In March 1612 Oddi was paying 6 *scudi* per month to stay in the house of Guidobaldo Vincenzi (see p. 252n69). For a discussion of the coinage circulated in Milan and the value of money at the time see, e.g., Cipolla 1952. For Galileo's stipend and the context of his appointment see Biagioli 1993, 36–37 and chap. 2.

18. It seems, though, that Oddi continued to take on occasional pupils after moving to Lucca. For example, in 1626 Donna Vittoria Cibo asked him to teach the fourteen-year-old brother of one of her maids of honor. Oddi described him as "a talented [youth] who draws quite well," adding that he was "delighted to be able to serve such a distinguished lady." Mutio Oddi to unknown recipient, from Lucca, 23 December 1626. OCU, fol. 647v. W18.1.

19. "I think that I have obtained a provision of 50 *scudi* a year for lecturing twice weekly in mathematics through the legacy of a great [man] who left a great deal of money to the Ospital Maggiore." Mutio Oddi to unknown recipient, from Milan, 13 March 1613. OCU, fol. 625v. W19.1. That Oddi may have used the manuscripts on Euclid and Tartaglia for his formal lecturing is suggested in *LSU*, 165–66. The manuscripts (BUU-FC, Busta 120, fasc. 3) could, however, have been used equally well in his private tuition. On the content of these papers see p. 256n106.

20. OCU, fol. 636r–v. The document is untitled and in a neat italic script.

21. In all likelihood Iacopo was an ancestor of Paolo Maria Terzago, who compiled the catalog of the Milanese *virtuoso* Manfredo Settala's collection, the *Museum Septalianum* (1664).

22. "Patres Donatum frisianum, et Gulielmus Galaveronum societatis Jesú Viros probatissimos et in dictis scientijs eruditissimos ad presentiam tamen m. ill. et m. reverendi D. Aluisij Bossij et March. Io. Maria Vicecomitis." OCU, fol. 636r. While Barca is not listed in Oddi's notebook as a private pupil (see appendix A), their correspondence makes clear that he studied with Oddi in an informal capacity.

23. According to Barca, Count Bolognino suggested that he should be Oddi's successor at the Scuole. See Giuseppe Barca to Mutio Oddi, from Milan, 10 November 1626. OCU, fol. 672r.

24. Writing of his appointment, Oddi explained that it was such a boon that he was "beginning to think about staying in Milan." Mutio Oddi to unknown recipient, from Milan, 13 March 1613. OCU, fol. 625v. Oddi was appointed to the position at the Fabbrica on 4 March, fifteen days before his appointment at the Scuole Piattine. Documents concerning Oddi's appointment to the Fabbrica are in the Archivio della Fabbrica del Duomo, "Ordinazioni Capitolari," XXIV, fols. 21v–22r and XXV, fol. 86v. See Kappner 1992–93, 146–48; Repishti and Schofield 2004.

25. See Gatti Perer 1997, 16–17; Bianchi 1999, 48–49. Oddi never refers to Borromini in any of his papers or printed works, but this does not preclude the possibility of a connection between the two men.

26. While in a ledger or formal accounts book one would expect to find neat, ordered entries, the records of informal teaching in Oddi's "teaching notebook" (OPU-FCC IV) are scrawled haphazardly and are not in chronological order. The majority are in the format of a date, followed by a brief note stating the name of the pupil (or pupils) with a summary description of what they were taught and, occasionally, whether the pupil in question was beginning or returning to his or her studies. Beneath an entry Oddi, in most cases, noted monetary payments or gifts received for his services, and some of these notations are also dated. Listings of multiple payments or gifts likely indicate that a pupil received multiple lessons. It should be noted, though, that Oddi provided services other than teaching for several of his pupils, and additional money or gifts may represent payments for these services.

27. In his brief biography of Bianchi, Filippo Argelati notes that he was the author of four treatises: *De astrologia*, *De arithmetica*, *De geometria*, and *De architectura*. All four subjects are consistent with Oddi's interests. Argelati claims that these manuscripts passed to Giovanni Pietro de' Crescenzi, author of *Amphiteatro romano* (1648), in which Bianchi is celebrated (p. 125). See Argelati 1745, vol. 1, col. 180. It is likely that Giovanni Pietro was a relative (possibly the son) of Giovanni Battista Crescenzi (d. 1635), a painter, architect, patron, and agent. Giovanni Battista founded an academy for painting from life in his *palazzo* in Rome and was, like Bianchi, involved extensively in dealings with Flemish painters, especially Paul Bril. Notably, he corresponded with Borromeo about the latter's acquisition of a *Marine Scene* by Bril, now in the Pinacoteca Ambrosiana; it may be that Crescenzi became acquainted with Bianchi through this connection. For further information on Bianchi see chap. 5.

28. Mutio Oddi to Matteo Oddi, from Milan, 30 December 1610. OCU, fol. 538r. W28.1.

29. Mutio Oddi to Matteo Oddi, from Milan, 9 May 1611. OCU, fol. 548r. W29.1. Oddi

noted that he had "promised to write" on the marchese's behalf, perhaps to find someone willing to accept the post. For Oddi's estimation of his own honor in relation to "low" work, see chap. 1.

30. As Richino's letter, quoted above, implies, a relationship was seen to exist between mathematics teaching and instruction in fine penmanship in the period. See also chap. 6.

31. See also chap. 6. In linking the provision of instruments and mathematical instruction, Oddi behaved in a more or less identical manner to Galileo in his Paduan period. See Biagioli 2006b, introduction.

32. His teaching was not, however, framed as a coherent course that would end in instruction in the use of a specific instrument. This distinguishes him from Galileo, whose teaching, Valleriani has argued (2008, 82), was oriented toward the geometric and military compass.

33. Mosley 2007b, 295. On disputes over the use of instruments in teaching see, e.g., Hill 1998.

34. Giovanni Battista Caravaggio to Mutio Oddi, from Pavia, 27 June 1631. OCU, fol. 824r. W34.1.

35. The record appears along with other unspecified payments at OPU-FCC IV, fol. 14r [16r]. W35.1. In his "instruments notebooks," Oddi records also purchases by his pupils Peter Linder and the Marchese Valdefuentes (see appendix C), but other students may well have placed orders that went unrecorded. The *stuccio* for Sfrondato junior, for example, is not listed in his notebooks.

36. Teaching of mathematics to women at this time was very unusual. Motley (1990, 81) notes just one example in mid-seventeenth century France: Charlotte-Amélie de La Tremoille, who learned arithmetic as part of a broad education that also included geography and music. Another example is Elizabeth Bacon, for whom Thomas Blundeville (1594, sig. B1r) produced his popular collection of elementary mathematical tracts, the *Exercises*. The teaching of Euclidean geometry, as Oddi taught Countess Borromeo, occurred only in exceptional cases.

37. Oddi's records state that Alfiero Ruggiero Ponzoni began studying fortification with Oddi twice: on 12 and 24 May 1624. I take this to be an error on Oddi's part. By comparison, Galileo taught sixty-one pupils between 1602 and 1604. See Valleriani 2008, 80. See also the list of mathematical academicians at the Collegio Romano in Baldini 2003, 71–74.

38. An early example of a high-status Italian studying mathematics is Federico da Montefeltro, Duke of Urbino, who studied under Vittorino da Feltre in the mid-fifteenth century. Oddi may have been aware of this precedent and certainly knew that his own lord, Francesco Maria II della Rovere, studied under Commandino. Mathematics featured sporadically as part of a humanist education but grew in importance throughout the sixteenth century. By the beginning of the seventeenth century it was a standard part of the educational regimes recommended by most writers on pedagogy. See A. Turner 1973.

39. See, for example, the entries in appendix A.

40. See, e.g., Pepper and Adams 1986; Lamberini 1990; Bennett and Johnston 1996; Brioist, 2009.

41. See, e.g., Cuomo 1997; Henninger-Voss 2002, 2004; Brioist, 2009.

42. See introduction and part I.

43. That he had been wounded could only have bolstered his honor. For the relation-

ship between honor and military service in Italy at the time see, e.g., Donati 1988; Verrier 1997.

44. In addition to teaching records, the notebook contains Oddi's jottings on architectural work carried out at the Certosa of Pavia (OPU-FCC IV, fols. 11r–v [12r–v], 12v [13v]), on various jobs undertaken for signor Caravaggio (perhaps Giovanni Battista Caravaggio), including laying out a garden (fol. 27v [29v]), and on Oddi's dealings with the Vagnarelli instrument workshop in Urbino.

45. Ibid., fol. 15v [17v]. It is notable that Oddi was sufficiently skilled to work with porphyry, a demanding material (although the reference may simply mean he arranged to have the sculpture repaired). See Butters 1996.

46. In a few, exceptional cases it seems that Oddi did receive fairly regular payment. For example, on 16 March 1612 Enrico Birago paid "two *scudi* for the first month," and Oddi records payments of exactly the same amount for subsequent lessons—on 12 May, 4 July, 3 August, 7 November, 29 November, and 24 December 1612 (the last constituting a Christmas gift), and 17 and 23 January 1613. OPU-FCC IV, fol. 19r [21r].

47. In this regard Oddi is comparable to Galileo, although the latter received gifts less frequently (see Galileo 1968, vol. 19), perhaps suggesting a more rigid sense of social separation between Galileo and his pupils than between Oddi and his.

48. Oddi's pupils often thanked him for his services through a mixture of gifts and cash payments, so it is not possible to divide pupils according to rank based on the way in which they reimbursed their teacher. A good example of the gift economy is provided by the accounts for the preparation and printing of the *Musaeum Francisci Calceolarii* (1622). The artists and engravers who worked on this ambitious project were rewarded with practical gifts such as food and candles, thus making it clear that the gift economy was not solely the preserve of friends or socially superior patron-client relationships. See Fahy 1993. For gifts and the sciences see Findlen 1991; Biagioli 1993. For gift-giving between friends see the frequent exchanges between Galileo and Sagredo, recorded in their correspondence. See Galileo 1968; Wilding 2006.

49. For example, Oddi received from Giovanni Maria Visconti (mistranscribed in Gamba and Montebelli 1989 as Giovanni Visco) a chain of gold worth 100 *lire*, as well as candles, clothes, and wine (OPU-FCC IV, fol. 35r [37r]), while from Senatore Settala he received a gift of "things to eat, all together in a silver goblet." OPU-FCC IV, fol. 33r [35r]. W49.1. Gold chains were common gifts at the time, given in standard lengths, which varied according to the premium placed on the service being rewarded. It was expected that the chain would be melted down and converted into cash, thus providing a monetary payment in a civil fashion that maintained the honor of both giver and receiver. See, for other contemporary examples of this practice, Biagioli 1993, chap. 1. Francesco Capra—not one of Oddi's pupils but a gentleman for whom he was undertaking some architectural work—is even cited as having paid him "24 ducats and the opportunity of going to the Baths of signor Ottavio" (OPU-FCC IV, fol. 24r [26r]). W49.2

50. OPU-FCC IV, fol. 33r [35r] and 5r [6r]. W50.1. Some such gifts could be extremely valuable. Oddi estimated that the three medals he received were worth 117 *lire*, 5 *soldi*. Several tazzas are listed in an incomplete inventory of Oddi's goods, made in 1626. See OPU-FCC VIII, fol. 1r.

51. OPU-FCC IV, fol. 38r [40r]. W51.1. It is not clear what this "astrological instrument" would have been, and I have not been able to identify Deviciolo with any known maker.

52. Warwick 1997, 632. The literature on gift-giving is extensive, but see Mauss 1954 and, for the Renaissance, N. Z. Davis 2000.

53. For socially and intellectually pejorative connotations of practical mathematics and mechanics in the period see, e.g., Neale 1999; Henninger-Voss 2000. It is important to note that Oddi was not only on the receiving end of the gift economy. He himself presented gifts to a wide variety of intimates and acquaintances, such as copies of his self-financed book *Dello squadro*. See chap. 4.

54. For example OPU-FCC IV, fols. 18v, 4r, 2v, 14r, 3r [20r, 5r, 3v, 16r, 4r]. W54.1.

55. "I have begun to read mathematics to signor Senator Settala accompanied by signor Iac[omo?] Fillipo Prato, in the house, and accompanied by signor Gi[rolamo?] Pozzi." OPU-FCC IV, fol. 33r [35r]. W55.1.

56. "Is Regibus tantùm fuit mirabilis, / Ut eius aedes ingredier saepissime / Non sunt recusati: pariter multi Duces, / Et cardinales, et numerosi nobiles, / Necnon Legati gentium atque Principium, / Ut cum viro tanto loqui percommodè / Possent: adhaec videre quae manu propria / Vel pinxerat, vel sculpserat, vel descripserat, / Non dico chartas, aut libros, sed mille organa / Mathematica, vel alterius artificij." Antoine Mizauld, "Vita Orontii," in Fine 1556, sig. vr–vir, at vir. For the context see Marr 2009a.

57. See Valleriani 2008, 81–82. It seems to have been standard practice for engineers to teach in the houses of their pupils. In Lanteri's *Due dialoghi* (1557), for example, the lessons in mathematics take place in the earl's castle. See Brioist, 2009.

58. The first page of Oddi's teaching notebook lists the names of pupils with a number next to each name, for example, "Don Carlo Gallio—15." OPU-FCC IV, fol. 1r. It is possible that the numbers indicate how many lessons each pupil took with Oddi: Ercole Bianchi, for example, is paired with the number "4," and later in the notebook (fol. 4r [5r]) Oddi records four gifts from him. Notably, two of Bianchi's gifts (vegetables and bread) came from Flanders, where he was operating as Cardinal Borromeo's art agent (see chap. 5).

59. Valleriani 2008, chap. 3.

60. This may be explained largely by the fact that Galileo's pupils were culled from the University of Padua's student body, whereas Oddi cast his net widely to cover the urban populace of Milan.

61. We should not, though, read too much into the diversity of these terms. Oddi's teaching records are hastily written reminders to himself and, as such, imprecise language and slippage in terminology is to be expected. It seems reasonable to assume, however, that Oddi's teaching methods varied depending on the subject and the pupil he was teaching at a given time. Indeed, a degree of flexibility was undoubtedly one of his selling points. Unlike his lecturing at the Scuole Piattine, or the instruction one might receive at a university, these were courses tailored to meet the pupil's own particular interests and needs, and lessons were presumably organized according to the student's, not the teacher's, timetable and interests.

62. The vast majority of Oddi's pupils studied simply "mathematics." It is difficult to establish precisely what Oddi taught these pupils, particularly given his use, elsewhere in his records, of subdisciplines such as geometry and arithmetic as discrete categories. Even within these narrower domains, there is clearly some overlap: for example, although he sometimes specified that he was teaching Euclid (occasionally indicating the exact book of the *Elements* being studied), it seems highly likely that instances in which he records teaching "geometry" also touched on Euclid.

63. This type of basic geometry was also the starting point for both Buonaiuto Lorini's and Galileo's lessons in military architecture. See Valleriani 2008, 87.

64. OPU-FCC IV, fol. 16r [18r]. W64.1.

65. This is implied by a passage in Lanteri's *Due dialoghi*, in which one of the protagonists, Francesco, states, "I would like you to tell me, according to the order set by Euclid, how it is possible, a side of a plane being given, to draw its other sides to scale. I know it by practice but I would rather have you tell me the rule for doing it according to Euclid." Lanteri, quoted in Brioist, 2009.

66. Motley (1990, 151–52) cites two examples of this trend: Condé's studies at Benjamin's academy and Dubreuil's course on fortifications.

67. See "Historiographical Note."

68. The case of Trutti and Alessio is also consistent with what we know about Galileo's teaching; as Valleriani has observed, Galileo's instruction in Euclid was "propaedeutic to the lessons on military architecture and on the use of the compass." Valleriani 2008, 81.

69. Listed among the accounts for various jobs undertaken for the countess is "a vernacular Euclid of Commandino," which cost 8 *lire*, 10 *soldi*. Similarly, beneath the entry for teaching Delascamo, Oddi notes, "He has had a vernacular Euclid of Commandino on loan." OPU-FCC IV, fols. 15v and fol. 2v [3v]. W69.1. As we have seen, Oddi was thoroughly familiar with the contents of the Latin version of Commandino's edition. See p. 52.

70. For editions of Euclid see Riccardi 1974; Steck 1981.

71. Oddi's dedication to the use of Commandino's translation goes some way toward supporting Rose's claim that the latter's efforts to edit and translate ancient works of mathematics were instrumental in the dissemination of mathematical learning throughout Italy in the late sixteenth and early seventeenth centuries. See *IRM*, 214 and *passim*.

72. For a checklist of printed treatises on elementary geometry in the seventeenth century (based on US library holdings) see Karpinski and Kokomoor 1928.

73. See, e.g., Cifoletti 2009.

74. Sacrobosco's *Sphere* was one of the most widely read works on astronomy and cosmology of the period, treating the structure of the universe, the circles of the celestial sphere, the rotation of the heavens, the earth's climates, planetary movements, and eclipses. See Thorndike 1949. For the use of actual armillaries in teaching the Sphere see Mosley 2007b, 214.

75. *Dello squadro* was dedicated to one of Oddi's pupils, Count Bernardino Marliani, and Oddi refers in the preface to teaching the count and other "cavaliers of [his] quality." Oddi 1625, sig. a2v. For the contents of *Dello squadro* see chap. 4.

76. As Baldini notes, kinematics and dynamics were generally taught as part of natural philosophy, and only equilibrium and the study of simple machines were taught at Clavius's Academy. See Baldini 2003, 62.

77. For the treatise see p. 256n106.

78. For the visual elements of early modern military architecture see, e.g., Henninger-Voss 2004.

79. Lorini 1597, 32. W79.1. Lorini's excursus on the value of *disegno* is discussed further chap. 6.

80. Alberti 1991, 62. For Oddi's familiarity with Alberti's text see chap. 6.

81. See Bermingham 2000, chap. 1.

82. See Castiglione 2002, 58.

83. The classic study is Kemp 1990. See also Field 1997, 2005.

84. For a comprehensive study see Andersen 2007.

85. Ibid., 237.

86. For Guidobaldo's theory of perspective, see ibid., 237–64. For his manuscripts on perspective, see Marchi 1998.

87. It may be assumed that Carlino served an apprenticeship in his father's workshop, receiving additional instruction from Oddi, who doubtless knew Gian'Andrea through their mutual employment at the Fabbrica.

88. In 1625 Sigismondo Boldoni, professor of philosophy at the University of Padua, wrote to Monti requesting his help in procuring a reduced version of one of Crespi's portraits. See Sparrow 1968.

89. See, e.g., Ames-Lewis 1983.

90. See chap. 6.

91. See Presas i Puig 2002, 8–11. Euclid's *Elements*, which formed a major part of the program of study, was read on Sundays. See also Adorno and Zangehri 1998; Barzman 2000.

92. OPU-FCC IV, fols. 32r, 20r, 34r [34r, 22r, 36r]. I take the "Francesco di Berlagne" in Oddi's records to be the "Francesco Bellone" listed as a pupil at the Accademia Ambrosiana. See P. M. Jones 1993. Jones provides a useful overview of the Accademia at 45–51. See also Frangi 1996. At least thirteen students were enrolled in the Accademia over its short life span between 1620 and 1622, including Oddi's pupils.

93. In his two treatises on the visual arts, *De pictura sacra* (1624) and *Musaeum* (1625), a personal guide to the Pinacoteca, Borromeo argued strongly for the validity of Christian art, stressing in particular that sacred art should adhere closely to nature, a stance that drew him toward contemporary Flemish painting.

94. Oddi records no payments from his three artist pupils but did receive numerous gifts from Federico Borromeo himself for unspecified work. For example, he received several gifts of wine and cheese in 1621. OPU-FCC IV, fol. 12r [13r]. He also received the precious gift of an *Agnus Dei*: "Signor Cardinal Borromeo has given me, through the hands of signor Giovanni Battista Benedetti, his confessor, a reliquary with a relic of St Carlo in it." Ibid. W94.1. Gamba and Montebelli mistranscribe this entry as "per lezioni del Signor . . . Benedetti" and do not note the *Agnus Dei*. Gamba and Montebelli 1989, 45. The *Agnus Dei* is listed in a (badly damaged) inventory of Oddi's possessions in Lucca, dated 1626; OPU-FCC VIII, fol. 1v. W94.2. Oddi's high status within the Borromeo circle is indicated by the fact that he was able to secure relics of Saint Carlo for friends and relatives, such as a piece of the sponge used to mop the saint's blood, which he sent to his brother-in-law (see Mutio Oddi to Francesco Maria Vincenzi[?], from Milan, 6 May 1613. OCU, fol. 609r). In 1616 Piermatteo Giordani asked Oddi to secure for him a certain reliquary for a cardinal friend. Oddi could not guarantee its provision and his reply to Giordani is revealing about his relationship with Borromeo: "I have entreated signor Cardinal Borromeo for the reliquary that you desire for your cardinal friend, and he has promised to give satisfaction to me at the feasts, but I do not know for certain that this will happen, because this gentleman (so they say) makes promises easily." Mutio Oddi to Piermatteo Giordani(?), from Milan, Martedi Santo 1616. OCP, fol. 50r. W94.3.

95. See Massey 2003.

96. Lorenzo Sirigatti, *La pratica di prospettiva* (1596); Daniele Barbaro, *La pratica della*

perspettiva (1568); Iacomo Barozzi, *Due regole della prospettiva prattica* (1583). See Neilson 1996b, 88, 90. Crespi's library was rich in works of art theory, including Vasari's *Vite*, Lomazzo's *Idea del tempio della pittura*, Dolce's *Dialogo della pittura*, and Zuccaro's *Idea dei pittori*. He also owned Parmasano's *Aritmetica*.

97. Quoted in Hill 1998, 260.

98. In fact, Oddi was the conduit for the transmission of mathematical knowledge to more than one generation, for not only did Giuseppe Barca follow in his footsteps at the Scuole Piattine, but his pupil Caravaggio became a private mathematics tutor, as shown in the following extract from their correspondence: "If it wouldn't make the letter too large I would send now to Your Lordship the figures, raised in perspective, of the construction and demonstration of that problem [concerning the geometry of the circle] that I sent to you the other day, which is more as a testament to the instruction I have given to that young one [Francesco Valenza] that I told you about." Giovanni Battista Caravaggio to Mutio Oddi, from Pavia, 22 June 1631. OCU, fol. 828r. W98.1. For the context of the problem and the pupil see fols. 809r and 827v. Following Valenza's death from fever, Caravaggio took on a new pupil from the Alberti family, to whom he taught geometry and military architecture. See Giovanni Battista Caravaggio to Mutio Oddi, from Brussels, 6 January 1634. OCU, fol. 914r.

CHAPTER 3

1. Mutio Oddi to Piermatteo Giordani, from Lucca, 14 July 1625. OCP, fol. 167r. W1.1. The painters to whom Oddi refers are Giovanni Battista Crespi (il Cerano, 1575–1632), Pier Francesco Mazzuchelli (il Morazzone, 1573–1625/26), and two members of the Procaccini family. The most likely candidates are probably the brothers Camillo (ca. 1555–1629) and Carlantonio Procaccini (1571–1630[?]), both of whom were active in Milan at the time. It is likely that Oddi knew these painters personally, as they had all worked, like the mathematician, for the Fabbrica of Milan's Duomo. For summary details of these artists' lives and works, see Neilson 1996a, 1996c; Bertoni 1996.

2. He had also read and digested Vasari. See p. 299n2.

3. It is notable that Oddi attempted to guide Giordani toward commissioning a work from Crespi rather than any of the other painters mentioned in his letter. To attempt to arrange such a purchase, even in his absence from Milan, was a gift to both his friends.

4. Oddi may be identified on the basis of similarity to other known portraits of him (see figs. 1, 6, and 21), Linder through the relationship between the portrait and the *Linder Gallery Interior*, discussed in chap. 6 (see figs. 71 and 72). I first made this identification in Marr 2005, 75. The connection of the portrait to the *Linder Gallery Interior* renders redundant Spiriti and Frangi's doubts over the identity of the right-hand sitter. See Spiriti 2006, 42; Morandotti and Frangi 2006, 78.

5. For the typical contents of a *studiolo* see Thornton 1998.

6. For which see Dear 1995.

7. While all three subjects required a similar knowledge of Euclidean geometry and may be grouped under the general heading "mixed mathematics," sundials, military architecture and optics are certainly distinct subjects. Telling the time was, of course, important for a merchant, but the level of instruction Linder received from Oddi must have equipped him with knowledge of dialing well beyond his immedi-

ate professional needs. For the usefulness of dialing in general see Schechner 2001. As Dupré, citing the case of Ostilio Ricci, has noted, even if not formally listed as a component of a practical mathematics course, elementary optics often featured as part of the tutoring offered by informal teachers. See Dupré 2005, 150–51.

8. By the turn of the century the study of the mixed-mathematical science of optics had become a mainstay of the Republic of Letters. For an overview, including the instrumental practices associated with optics, see Dupré 2003.

9. The gallery featured thirty-five portraits of men and women, all in an oval format. See Francesco Frangi's brief but lucid note on the fragments in Morandotti and Frangi 2006, 76–79.

10. See Neilson 1996b, no. 67; Morandotti and Frangi 2006, 78; Spiriti 2006, 42.

11. See chap. 4.

12. Quoted in Promis 1848, 396–97. Promis does not identify the location of the letter and I have not been able to find it.

13. Despite the difference in quality between the fragments and the complete version, it is hard to imagine anyone other than Oddi or Linder requesting a copy of the work, or their asking anyone other than Crespi to execute it.

14. See Wilding 2006.

15. It is worth noting that in addition to his generic portrait of Archimedes (ca. 1630, Prado, Madrid) Ribera painted an *Allegory of Sight* (Franz Mayer Museum, Mexico City), which depicts a gentleman holding a telescope, with a mirror on the table in front of him.

16. The diagram is related to proposition XIII.12 of the *Elements*, concerning regular polyhedra. A painting with similar subject matter, but which could not possibly have been known to Oddi, Linder, or Crespi, is Neufchâtel's double portrait of Johann Neudörfer teaching his son geometry (1561) (fig. 19).

17. Dupré 2005, 149–50.

18. For the treatises owned by Crespi, see p. 269n96.

19. For Cavalieri's biography see Carruccio 1971.

20. Cavalieri 1632, 193. In his sole surviving letter to Oddi, Cavalieri mentions his intention of inserting into *Specchio ustorio* this reference to Oddi's method, stating: "I am writing also in the common tongue a little book on conic sections, not on that which I have done with sundials, but with mirrors . . . added to it is a speculation on the method of describing them [conic sections] with rulers, and I recall having seen in your book on conic lines, that there also it is done with rulers, but in truth I cannot recall how it is done . . . regardless, I shall not forget to name Your Lordship as the author of describing [conic sections] very easily with rulers." Bonaventura Cavalieri to Mutio Oddi, from Bologna, 22 June 1632. OCU, fol. 945v (published also in Procissi 1960). W20.1. In the letter, Cavalieri mentions that he is responding to two previous missives sent to him by Oddi—indicating that they corresponded more regularly than the surviving evidence suggests—and goes on to address topics of mutual interest, including indivisibles, ring dials, and geography. It seems, however, that the two men lost contact in the late 1620s, for in 1629 Oddi thought Cavalieri might still be in Milan, as evinced by a passage in one of Caravaggio's letters: "I have asked signor Perlasca to be diligent in discovering whether Padre Bonaventura of San Geronimo [he means Gerolamo] is to be found in Milan, to participate as Your Lordship desires in [solving] that problem." Giovanni Battista Caravaggio to Mutio Oddi, from Milan, 10 October 1629. OCU, fol. 809r. W20.2.

21. See chap. 4.

22. Oddi refers to having obtained a copy of Della Porta's *De refractione optices* in a letter to Piermatteo Giordani of 1620 (OCP, fol. 1r). In 1614 Oddi was working on two optical problems that had appeared in Aguilon's *Opticorum libri sex* and had been sent to him by an unnamed correspondent. Oddi, busy with teaching and making architectural drawings for the house of Count Trivulzio, sent them on to Piermatteo Giordani and Bernardino Baldi in the hope that they could help solve them: "I have not yet been able to apply myself to the consideration of them, being occupied with the school, and with certain architectural drawings for the house of the count, perhaps Your Lordship could think about them a little, and show them to the Abbott Baldi." Mutio Oddi to Piermatteo Giordani, from Milan, 19 March 1614. OCP, fol. 26r. W22.1. On Aguilon's optics see Camerota 2001, 242–43.

23. See Knorr 1983; Dupré 2009. In addition to Fine's *De speculo ustorio* (1551), burning mirrors are discussed by such scholars as Della Porta in *De refractione optices*, by Magini in *Theorica speculi concavi sphaerici* (1602; an inaccurate version of Ausonio's mid-sixteenth-century manuscript of the same name) and *Breve instruttione sopra l'apparenze et mirabile effetti dello specchio concavo sferico* (1611), and by Cavalieri in *Specchio ustorio*.

24. On burning mirrors in general see Goldberg 1985. Elite interest in burning mirrors is indicated by Magini's presentation of several such devices to, among others, the Holy Roman Emperor Rudolph II and Marie de Médicis, and by Galileo's brokerage of Magini mirrors for Cosimo de' Medici. See Reeves 2008, 146–57; Valleriani 2008, 71.

25. Oddi refers to his receipt of the book—given to him personally by the author—in an earlier letter to Giordani: "In a few days I hope to write several curious things about the mirror of Archimedes, as during his journey to Bologna the Gesuato mathematician of that Studio gave me a copy of his little book on the burning mirror, curious beyond belief, in which he proposes a certain instrument for burning at great length, which if it works will certainly be a fine thing." Mutio Oddi to Piermatteo Giordani, from Lucca, 26 April 1634. OCP, fols. 239v–240r. W25.1. As early as 1613, Christoph Grienberger had argued that elliptical sections offered the best kind of burning mirror, but speculation on the best shape continued throughout the century, mainly in Jesuit circles. See Gorman 2003; Nocenti 2003.

26. On which see Simms 1977. As Simms notes, neither Lucian nor Galen (two of the authorities usually cited for the feat) refer specifically to Archimedes's use of a mirror. The attribution of the supposed conflagration of Marcellus's fleet to mirror technology seems to begin with Apulius's *Apologia* (Simms 1977, 10). By Oddi's time it was received wisdom that Archimedes had used some sort of reflecting device. See, for example, Galileo's comment in *Il Saggiatore* (1623): "Archimedes made a mirror which kindled fire at great distances." Galileo 1957, 246.

27. Mutio Oddi to Piermatteo Giordani, from Lucca, 31 May 1634. OCP, fol. 243r. W27.1. The letter has been published in full (although without any significant analysis) in *LSU*, 198–201. On Cavalieri's treatise see Ulivi 1987; Baroncelli 1983. In July 1634 Oddi mentioned that a "*cavaliere*" of Buonvisi (Bernardo Buonvisi, for whom he undertook extensive architectural work at the *cavaliere*'s villa in Lucca) had borrowed his "parabolic mirror, which is polished also on the convex side." Unfortunately, when it was returned two years later it was in pieces, as Buonvisi's young son "out of curiosity had wanted to see it, and he dropped it from his hand. Nevertheless, I shall

see whether with these pieces it is at least possible to make those reflections equidistant [or parralel?] (*equidistante*) to the axis." Mutio Oddi to Piermatteo Giordani(?), from Lucca, 5 July 1634. OCP, fol. 246v (published also in *LSU*, 204). W27.2. See also, for the identification of Buonvisi as the *cavaliere* in question, OCP, fol. 247v.

28. It should be noted that the diagram reproduced in *LSU* (199) is a rough approximation of Oddi's badly drawn original.

29. OCP, fols. 243v–244r. W29.1.

30. It is notable that Oddi used Euclid rather than, as Cavalieri had done, Apollonius. His point seems to be that Cavalieri's results could be obtained by using elementary geometry rather than resorting to the more complicated conics. Oddi may have acquired another mirror after his parabolic one was broken, for a "steel mirror" (*specchio d'acciaio*) is listed among the goods bequeathed to the Vincenzi on his death. See OPU-FCC VII, fol. 86r.

31. On the revival of interest in Archimedes in general see *IRM* and (for a nuanced account of his reputation) Laird 1991. Oddi's interest in the burning mirror relates to what Laird terms Archimedes's "'humanist' reputation as a practical artificer" (631) as well as his renown as a mathematician. As an Urbinate mathematician, Oddi was particularly concerned with Archimedes's mathematical works, but it is also notable that Archimedes's reputation as an ingenious mechanician is deployed in a memorial to the Barocci with which Oddi was involved (see chap. 1).

32. In 1601 Oddi had spent several months in Venice hiding from Duke Francesco Maria II della Rovere, and he may well have familiarized himself with mirror-making techniques then. He was also acquainted with Magini, one of the leading developers and distributors of burning mirrors in the period.

33. In the same letter to Giordani, Oddi noted that Cabeo had been visiting him in Lucca, describing the Jesuit as someone who "has been writing for many years on that magnetic philosophy, and he is a most lettered person, and universally learned, and particularly so in mathematics." OCP, fol. 239r. W33.1.

34. Giovanni Battista Caravaggio to Mutio Oddi, from Brussels, 6 January 1634. OCU, fol. 913v. W34.1.

35. "I should like to correct this carelessness of artisans by having made in the fire certain pieces of glass, to which (cut into two hemispheres) I want to attach a cloth tube, filling the gap in-between the one and the other with water." *Idem.* W35.1.

36. On lens making in the period see, e.g., Burnett 2005; Ilardi 2007. On mirror making see, e.g., Manzini 1660; Valleriani 2008, 65–69. A useful overview of the issues at stake in these technologies is Reeves 2008.

37. Oddi's half of the correspondence does not survive. The relevant passages in Caravaggio's letters to Oddi are OCU, fols. 737r–v, 738v, 763r, 764r–v, 767r, 777r–v, 913v, 924r.

38. Giovanni Battista Caravaggio to Mutio Oddi, from Milan, 5 July 1628. OCU, fol. 777v. W38.1. Caravaggio hoped that he could acquire a better-polished piece of glass to improve the instrument, because he believed that with the water telescope "the rays transmitted by the sun would go to form a focal point three times further than the rays reflected in a mirror of metal." Ibid. W38.2.

39. Giovanni Batista Caravaggio to Mutio Oddi, from Milan, 27 April 1627. OCU, fol. 763r. Caravaggio's pun (which works better in Italian: "Non so se mi dica Parabolico, ò più tosto dalla di lui difformità lo chiami Diabolico") indicates just how challenging even technically proficient mathematicians found mirror making at the time.

In the remainder of the letter, Caravaggio relates to Oddi the experiments he had undertaken with the mirror, which shows that he was interested in the properties of reflection in general, not solely in burning at a distance. See p. 98.

40. Sometimes, however, external parabolic molds were also employed. See Valleriani 2008, 65–67.

41. Giovanni Battista Caravaggio to Mutio Oddi, from Milan, 16 February 1623. OCU, fol. 737r. W41.1. Evidently, Oddi was temporarily away from Milan at this time. A few months later Carvaggio reported that the "casting of the parabolic mirror is completely finished; nothing remains but its polishing, and when I have finished this I will give you information about the effects." Giovanni Battista Caravaggio to Mutio Oddi, from Milan, 26 July 1623. OCU, fol. 738v. W41.2.

42. See Valleriani 2008.

43. On which see Pedersen 1968; Dupré 2005; Reeves 2008.

44. Baxandall 1972, 1.

45. The relatively small size of the mirror means that, while it could have been used for experiment and demonstration, it would not have been able to burn with any significant heat or distance. In this regard it may be contrasted to the very large seventeenth-century burning mirror in IMSS, inv. no. Ottica M 137.

46. Giovanni Batista Caravaggio to Mutio Oddi, from Milan, 27 April 1627. OCU, fol. 763r. W46.1.

47. Moreover, the shadow of Oddi's hand seems to emphasize the geometrical lines of the diagram. It is surely no accident that the shadow cast by the index finger of his left hand follows the geometrical line *AC* and appears to extend the line *CI* beyond that drawn in the diagram.

48. The only evidence that might bear upon the subject of who owned the mirror and the beam compass shown in the portrait is the *Linder Gallery Interior* (see chap. 6). In this picture, the two instruments appear directly adjacent to a portrait of Peter Linder (see fig. 76), suggesting that he, and not Oddi, may have owned these devices. However, as objects owned by Oddi also appear in the *Linder Gallery Interior*, the evidence is by no means decisive.

49. Beam compasses were popular instruments of the period. Several particularly fine early seventeenth-century examples (far more elaborate than the relatively simple instrument depicted in Crespi's painting) are preserved in the Metropolitan Museum of Art, New York (bequest of W. Gedney Beatty, 1941, 41.160.721) and the National-museet, Copenhagen (inv. no. D. 1507), on which see Vincent 1989. Interestingly, given the subject matter of the painting, Oronce Fine recommended the use of the beam compass in making templates for burning mirrors in his *De speculo ustorio*.

50. With this in mind, it is possible that an aspect of Oddi and Linder's discussion was about scaling up a small mirror, capable only of weak burning, to a much larger, more powerful one, with a longer focal length.

51. See Dupré 2005, 2006. Reeves 2008, 50–58, shows that Galileo and his circle were highly interested in Ausonio's work.

52. See Magini 1602. Although Oddi makes no reference to Ausonio in his printed works or correspondence, it is entirely possible that he was familiar with the Venetian mathematician's optical work, for, in addition to his connection with Magini, he had access to Borromeo's Biblioteca Ambrosiana, which contained several Ausonio manuscripts, including the *Nuova invenzione d'uno specchio* (now BAM, A 71 inf.), acquired as part of the Pinelli collection in 1609. On Borromeo's acquisition of the

Pinelli library see Hobson 1971. For the library in general see M. Grendler 1980. The functions of the circular arc *CL* and the line *DM* in the portrait's diagram are not entirely clear. It is conceivable that the former represents a second mirror with a focus different from that represented by *BCDEF*, suggesting that the problem under discussion may involve the use of multiple mirrors in burning. Furthermore, it is difficult to determine whether Oddi's index finger is pointing specifically to *CL* or to the diagram in general.

53. See Diocles 1976, 56–62. Oddi's diagram may be compared to the diagram constructed there on the basis of Diocles's text (58).
54. For Galileo's copy of the *Theorica* see Galileo 1968, 3:865–69.
55. Galileo Galilei to Fulgenzio Micanzio, November 20 1637. Quoted in Valleriani 2008, 68.
56. Giovanni Battista Caravaggio to Mutio Oddi, from Milan, 21 July 1627. OCU, fol. 768r–v. W56.1.
57. Giovanni Battista Caravaggio to Mutio Oddi, from Milan, 16 December 1623. OCU, fol. 737v.
58. Giovanni Battista Caravaggio to Mutio Oddi, from Milan, 2 June 1627. OCU, fol. 765r. W58.1.
59. This is confirmed by Oddi's pupil Giuseppe Barca, who, in 1626, wrote that he was trying "to remember a problem, which I once learned from Your Lordship, concerning the drawing of the ellipse." Giuseppe Barca to Mutio Oddi, from Milan, 10 November 1626. OCU, fol. 672v. W59.1. For a discussion of the various instrumental methods for drawing conic sections available in the Renaissance, see Rose 1970. See also chap. 5.
60. Dupré 2005, 153.
61. In this respect, we might associate the optical experimentation in which Oddi and his circle engaged with practitioners' rhetorical attempts to justify mathematics through an appeal to pleasure. See, e.g., Hill 1998.
62. On this topic Stephen Clucas's arguments about Oddi's contemporary, the English mathematician Thomas Harriot, are particularly compelling. See Clucas 2000. It is worth noting that Harriot, like Oddi, undertook work on burning mirrors and even had a parabolic reflector made (ibid., 117–19).

PART III

1. On the relationship between the sciences and commerce in the period see, e.g., Smith 1994; Smith and Findlen 2001; Ash 2004; Cook 2007; Goldgar 2007; Harkness 2007. See also, for the growth of consumption more generally, Goldthwaite 1987, 1993; Jardine 1996; Welch 2005; O'Malley and Welch 2007b.
2. It should be noted that sometimes books *were* instruments. Many mathematical publications featured volvelles (moving paper parts) while some contained printed instruments that could be cut out and pasted onto card or wood, where they would serve as cheap stand-ins for more expensive metal instruments. See, e.g., Karr Schmidt 2006; Eagleton 2009. For an overview of the instrument trade in the Renaissance see A. Turner 1987, 57–86; Bennett 1987, 73–82.
3. On the relationship between authorship and instruments see, e.g., Johns 1998; Mosley 2007a; Biagioli 2006a, 2006b, forthcoming. I am grateful to Mario Biagioli for permitting me to consult a preprint of his forthcoming article.

4. On brokerage in the period see Cools, Keblusek, and Noldus 2006; Biagioli 2006b, chap. 1.

5. Biagioli, discussing paper instruments, has suggested that these objects could be seen as "'cheap bait' to attract buyers into a traditional, labour-intensive economy of artisanal and pedagogical services." Biagioli 2006a, 163. Sometimes, the multiple roles necessary for the successful functioning of the instrument economy were undertaken by a single individual, illustrating the overlap between the competences involved in making, writing about, and distributing instruments. Thus, we find artisan-authors—such as Oronce Fine in France, Wentzel Jamnitzer in Germany, and Egnazio Danti in Italy (to cite just a few of the better-known names)—who both wrote about and made instruments, or teacher-merchants—such as Galileo—who ran a successful instrument workshop in his house at Padua while teaching at the university.

6. See K. Polanyi 1944. Polanyi's work has been particularly influential on studies of the gift economy in the Renaissance. See, for example, N. Z. Davis 2000, 129.

7. On the formation and operation of networks in Renaissance Italy see, e.g., P. D. Maclean 2007.

8. See Biagioli 1993, 57 and *passim*; Shapin and Schaffer 1985; Moran 1991; Findlen 1996.

CHAPTER 4

1. Mutio Oddi to Lattantio Oddi, from Venice, 29 September 1601. OCU, fol. 518r. W1.1.

2. For an overview of the book trade in Italy at the time see Nuovo 1998; Richardson 1999.

3. Oddi's library list has not survived (despite his having requested in his will that an inventory of his books be made following his death), so it is impossible to reconstruct his mathematical reading precisely, especially as he makes frequent reference to all manner of mathematical books in his correspondence. See, e.g., *LSU*, 127. His reading notes on Regiomontanus's *On Triangles* are in OPU-FC, Busta 118, fasc. 4(d). Oddi's copy of Magini's *Novae coelestium theoricae congruentes cum observationibus N. Copernici* (1589) is in the Biblioteca Angelica. For his reading of Cardano see pp. 49, 165. For his interest in Petrarch and Boccaccio, see chaps. 1 and 6. Around 1612 Oddi thanked Piermatteo Giordani for a copy of *Don Quixote*. Mutio Oddi to Piermatteo Giordani, no place or date (but from Milan, ca. 1612). OCP, fol. 8r. In 1617 he asked Camillo Giordani for a copy of Botero's *Aggiunte alla ragion di Stato* (1598). Mutio Oddi to Camillo Giordani, from Milan, 1 February 1617. OCP, fol. 63r. Although their whereabouts are not currently known, Servolini records "scritti politici" among Oddi's unpublished works. See Servolini 1932, 25.

4. For his relationship with Imperiale, see chap. 6. The Milanese Francesco Birago (1562–1640/after 1647) was an author of works on the Italian nobility. In January 1624 Oddi mentioned to Camillo Giordani that he had not seen Birago for a while and wondered whether he had published anything new. Mutio Oddi to Camillo Giordani, from Milan, 31 January 1624. OCP, fol. 107v.

5. See in general Eisenstein 1979. For the sciences see Eamon 1994; Johns 1998; Frasca-Spada and Jardine 2000; Mosley 2007a, chap. 3. For mathematics specifically see C. Hay 1988, esp. Whitlow 1988.

6. Notably, Oddi's manuscript collection contained some of Commandino's papers—he refers to this, for example, in *De gli horologi solari* (see below). While it is difficult to determine precisely which of Commandino's manuscripts Oddi owned, I think it likely that they included at least some of those now in BUU, especially those in FC, Busta 120. See p. 256n106). On the continuing significance of scribal culture in the period see, e.g., Love 1993.

7. Printers were active in the duchy, but their skills and materials were not sufficient to satisfy Oddi. In a letter of 1635, written when producing his second book on sundials, Oddi wrote, "I must thank God that I did not find printers or characters to my taste in either Urbino or Pesaro, because when I had an opportunity to transcribe [the work] I added several things and altered it in many places." Mutio Oddi to Camillo Giordani, from Lucca, 17 January 1635. OCP, fol. 257r. W7.1. On printing in Urbino in the Renaissance, see Moranti 1942, 1967. It should be noted that Oddi felt precisely the same way about the printers in Lucca, for he explained that he would not have *Compasso polimetro* printed there as he could not find suitable artisans, especially engravers for the figures. See Mutio Oddi to Camillo Giordani, from Lucca, 28 July 1627. OCP, fol. 153r.

8. See Canino 2002. For contemporary evidence of the duke's studious character, see chap. 5.

9. See *IRM*.

10. As Mary Henninger-Voss has observed, Guidobaldo maintained his house in Pesaro as a place for philosophical visits, and the conversations that took place therein would have focused as much on book learning as on the numerous instruments and machines that filled his *studiolo*. See Henninger-Voss 2007, 13n3.

11. On instrument books in the period see, e.g., Bennett and Bertoloni Meli 1994; De Renzi 2000.

12. Tycho's volume is an important reminder that not all instrument books in this period were small-scale ventures. See Johns 1998; Mosley 2000. For Oddi's estimation of this book see chap. 6.

13. The shift from Latin to the vernacular was—as in other spheres—very gradual. The case of Oronce Fine is representative in this regard. Fine, one of the most widely read authors of instrument books in the sixteenth century, published mainly in Latin. By midcentury, though, his works were beginning to appear in the vernacular, a trend that accelerated as the century progressed. See Marr 2009b.

14. For an overview of the content of Oddi's treatises, including useful information on some of his sources, see *LSU*, 130–61.

15. The rebuttal was evidently successful, as Grimani edited out his criticisms of Oddi in the second edition of his book, published in 1641. Grimani's criticisms of Oddi are Grimani 1635, 26–27.

16. In his *vita* of Matteo Oddi, Promis (1874, 812–13) notes that, in addition to the *Precetti*, a number of his works survive in manuscript. Following Vernaccia's *vita* of Mutio Oddi, he lists these as *Discorso di architettura militare, fatto l'anno 1615; Dell'Architettura militare. Discorsi*; and *Lettere al Gonfaloniere ed Anziani, Signori dell'ufficio del fiume, Signori sopra la forticazioni ed altri magistrati di Lucca*, this last collection discussing the various projects with which he was concerned during his employment as fortifications engineer by the Republic of Lucca. The location of the first two manuscripts is not stated, but Promis claims that the original copy of the last manuscript collection is in Lucca (I have not been able to locate it in the

Archivio di Stato there), with the minutes preserved in Urbino. The minutes are not among the Oddi papers preserved in BUU, but among the Oddi and Paciotti papers in that repository is a fourteen-folio manuscript entitled "Raccolta Compendiosa. Di tutti le parti e misure, ch'occorrano per formare qualsivoglia fortezza. Discorso Primo. Al s[ignore] Mutio Oddi frat[ell]o dell'Autore." BUU, FC, Busta 118, fasc. 3, fols. 56r–69r. The care with which the manuscript has been written suggests that it was probably a presentation copy given to Mutio, or possibly a fine copy that could be given to a scribe to write out as a printer's copy. Vernaccia's description of Matteo's unpublished works, cited by Promis, appears to rule out the "Raccolta." Additional papers of Matteo Oddi are in BUU, FC, Busta 118, fasc 3, with a (badly water damaged) contents list at fols. 117–19. Given these materials, a study of his life and works is a *desideratum*. The *Precetti* were edited by Mutio Oddi but published through the offices of Bianchi, who dedicated them to Gonzales Fernandez de Córdoba, Captain General of the state of Milan. In the dedicatory epistle, Bianchi explains that the *Precetti* had been "entrusted to me by signor Mutio Oddi, very faithful servant of Your Excellency," and that the work was offered to Córdoba on account of his "great knowledge of mathematics." Oddi 1626, dedicatory epistle (signed by Ercole Bianchi, 17 December 1626), sig. A2r–v. It should be noted that the *Precetti* was issued twice. A very small run appeared in 1626, a second issue (without Bianchi's dedication) in 1627. Like Oddi's own works, Matteo's book seems to have been intended mainly for distribution to acquaintances; in 1627 Oddi asked Camillo Giordani to distribute copies to "Vagnarelli, Colonel Paciotti," and others in the Duchy of Urbino as he saw fit. Mutio Oddi to Camillo Giordani, from Lucca, 14 April 1627. OCP, fol. 147r.

17. On the use of the vernacular in science writing of the period see Eisenstein 1979, 2:520–74; P. Rossi 1970; Long 2001. Sprang (2007) presents an interesting account of the English context, linking use of the vernacular to emerging nationalism.

18. For instance, all of his annotations to Commandino's edition of Euclid's *Elements* are in Latin, as are many of his autograph folios on various aspects of geometry in BUU-FC, Busta 120, fasc. 3. On issues surrounding the vernacular in relation to Guidobaldo's work see Henninger-Voss 2000, and below.

19. Oddi 1614, sig. 3v. W19.1.

20. See *LSU*, 54n35. In his letter to Galileo, Oratio listed the works as: "The Screw which raises water, divided in 4 books; Little works: *In Quintum; De motu terrae; De horologijs; De radiis in acqua refractis; In nono opere Scoti; De proporzione composita,* and the manufacture of various instruments rediscovered by him, for all of which things there are engraved figures." Oratio del Monte to Galileo Galilei, 16 June 1610. For the original Italian see Galileo 1968, 10:372. See also Camerota 2003, 64. In 1630, when musing on his hopes of returning home to Urbino, Oddi considered trying to persuade Guidobaldo's heirs to publish his works in one volume. Mutio Oddi to Piermatteo Giordani, from Lucca, 24 April 1630. OCP, fol. 192v.

21. Mutio Oddi to Piermatteo Giordani, no place or date. OCP, fol. 7v. W21.1.

22. Ibid., W22.1. The demonstration appears at p. 19 of *Degli horologi solari*, where Oddi explains that Guidobaldo had been asked to explain Hyginus's method by the Paduan *virtuoso* and bibliophile Gian Vincenzo Pinelli. For Pinelli's reading circle see Henninger-Voss 2007 and, for his library, p. 274n52.

23. Mutio Oddi to Piermatteo Giordani, no place or date (but from Milan, ca. July 1612). OCP, fol. 7v–8r. W23.1.

24. Mutio Oddi to Piermatteo Giordani, from Milan, 8 August 1612. OCP, fol. 9r–v. W24.1.

25. The frustration Oddi felt must have been compounded by the fact that Guidobaldo's heirs' intentions to publish their father's works came to nothing, for Oratio del Monte died prematurely in 1615. One of Oddi's letters to Piermatteo Giordani, dated 27 December 1617, contains a transcription of the military engineer Narcisso Aurispa's epitaph for the young man. See OCP, fol. 84r. On 29 May 1614 Oddi noted that Oratio had acknowledged receipt of two copies of *Degli horologi solari*, one of which would be sent on to Don Flaminio Gazzo. Mutio Oddi to Piermatteo Giordani, from Milan, 29 May 1614. OCP, fol. 35r. For Oddi's complaints about the poor manner in which Oratio del Monte had gone about publishing Guidobaldo's *Coclea*, see *LSU*, 195.

26. See Henninger-Voss 2000.

27. On which see Marr 2006b.

28. In addition to Baldi's work, the Urbinate Alessandro Giorgi published an Italian translation of Hero's *Pneumatics*, while Oddi's nephew and heir, Niccolò Vincenzi, made manuscript vernacular translations of Guidobaldo del Monte's study of book 1 of Archimedes's *On Floating Bodies*, as well as translations of Witelo and Alhazen on perspective. See BUU-FCC, Busta 47, fasc. 2, fols. 57–80.

29. On "go-betweens" in the period see Höefel and von Koppenfels 2005. Peter Burke's essay in that volume (P. Burke 2005) is especially pertinent to the context of vernacular writing.

30. Eisenstein 1979, 2:530–31.

31. For an extended but judicious critique of Eisenstein, see Johns 1998.

32. Oddi stressed the antiquity, and hence nobility, of dialing in a long, scholarly *proemio* to his second treatise on the subject, tracing the development of dialing in different lands and ages, from Baylon to his own era, noting the great men who worked in the field (including, predictably, many *illustri* of Urbino) and celebrating its utility and scholarly worth. See Oddi 1638, 1–14. On medieval dialing see Eagleton 2006. On Renaissance dialing see, e.g., Gouk 1988.

33. Giovanni Battista Benedetti, *De gnomonum umbrarumque solarium usu liber* (1574); Christoph Clavius, *Gnomonices libri octo* (1581). Commandino had been particularly eager that a "renaissance in gnomonics" should be initiated. See *IRM*, 198.

34. Oddi was part of an established tradition in which nonprofessional artisans manufactured sundials. See, e.g., Bennett 1998. For further discussion of nonprofessional instrument makers, see chap. 5.

35. See chap. 1.

36. On the ubiquitous pairing "utility" and "pleasure" in practical mathematics books see, e.g., Neale 1999.

37. Schechner 2001, 189.

38. See, for example, Oddi's comments about Baldi's *Exercitationes* (quoted on p. 247n23) which are thoroughly representative of these issues.

39. Oddi was always on the lookout for books that might please his friends and patrons. In 1620, for instance, he was disappointed to find that Piermatteo Giordani already had a a copy of Della Porta's *De refractione* (1593), since he had "the opportunity to send one, having found it in an old library among other works by Della Porta." Mutio Oddi to Camillo Giordani, from Milan, 2 September 1620. OCP, fol. 1r. W39.1.

40. Oddi entrusted the printing of the latter work to Linder in December 1634, while the

German merchant was still in Milan. Irritatingly for the author, Linder took it with him when he relocated to Venice the following year, leaving Oddi's accounts with the printers in a state of disarray. See Mutio Oddi to Camillo Giordani, from Lucca, 13 December 1634, 25 July and 19 September 1635. OCP, fols. 253r, 264r, and 268r.

41. Peter Linder to Mutio Oddi, from Venice, 15 November 1636. OCU, fol. 959r. W41.1. The process of correcting and printing took several months to complete, for it was not until February 1637 that Linder was able to write to Oddi about the compilation of a list of *errata*, and the *impresa* for the frontispiece was only printed in July of that year. See Peter Linder to Mutio Oddi, from Venice, 13 February and 19 July 1637. OCU, fols. 962r and 967r.

42. Peter Linder to Mutio Oddi, from Venice, 27 February 1637. OCU, fol. 968r. W42.1. Fulgenzio Micanzio was the chief aid to Paolo Sarpi and a friend of Galileo; he was thus well versed in the printing of scientific works. In light of Linder's later interest in Galileo's telescopic observations (for which see p. 304n46), it is interesting to note his acquaintance with a key member of Galileo's Venetian circle. On Micanzio see Favaro 1983.

43. This was not the only bit of bad fortune to befall Oddi in the production of his books. In November 1629, midway through the production of *Compasso polimetro*, the engraver Oddi had employed died, obliging him to cast about for another. See Mutio Oddi to Camillo Giordani, from Lucca, 7 November 1629. OCP, fol. 175r, also published in Gamba 1994, 810. A few months later Oddi asked Camillo whether he had any friends in Venice who could find him those who "cut little figures [*miniature*]," and noted that he planned to send the *impresa* to be engraved in Rome. Mutio Oddi to Camillo Giordani, from Lucca, 19 April 1630. OCP, fol. 190r. W43.1.

44. For the Republic of Letters in general see, e.g., Goldgar 1995; Miller 2000.

45. A notable exception is De Renzi 2000. See also Mosley's detailed account of the production and distribution of Tycho Brahe's works prior to 1602, in Mosley 2007a, 298–306.

46. A few library lists of the middle-ranking, professional portion of the audience for instrument books have come to light, e.g., those of the architect-engineer Giambattista Aleotti and the instrument maker Bernardo Facini. See Fiocca 1995; Bedini 1994a. For an example of a higher-register collector of instrument books (Jean I du Temps, lawyer of Blois), see Marr 2008b.

47. Notably, none of Oddi's books is listed in the catalogs of the Frankfurt Book Fair, none was reissued, and there seems to have been relatively little awareness of his work beyond the Italian peninsula.

48. On books as gifts see, e.g., N. Z. Davis 1989, 2000.

49. Mutio Oddi to Hippolito Capi, from Milan, 8 December 1610. OCP, fol. 4r. W49.1. Oddi sought to limit strictly who had access to copies, writing to his brother in February 1610 that while he was delighted Camillo had made copies, because the book was not yet finished and "full of imperfections" he did not want the work distributed freely. Mutio Oddi to Matteo Oddi, from Milan, 8 February 1610. OCU, fol. 535r.

50. Mutio Oddi to Piermatteo Giordani(?), from Milan, 22 January 1614. OCP, fol. 20r (emphasis mine). W50.1. A copy in a private collection in Milan bears an inscription, in Oddi's hand, "L'Autore al sig. Bartolomeo Aresi." See Spiriti 2002, 102–3. Aresi was a Milanese patrician.

51. On which see N. Z. Davis 2000.

52. Toward the end of March Oddi wrote to Camillo Giordani that he was sending

copies of the book, along with an ebony chest, via a "*cavaliere* of the Visconti" who was traveling to Loreto for Easter. Mutio Oddi to Camillo Giordani, from Milan, 26 March 1614. OCP, fol. 27r. On 7 April he wrote to Piermatteo Giordani that the *cavaliere* in question—Giovanni Maria Visconti—had ten additional copies for the Pesarese mathematician to distribute, "four or five of which should be placed in the hands of my brother, Matteo, who should give them to those who remain." Mutio Oddi to Piermatteo Giordani, from Milan, 7 April 1614. OCP, fol. 29r. W52.1. The letter is addressed "with a packet of books," suggesting that copies of *Degli horologi solari* were enclosed.

53. Oddi 1614, sig. 2r–v. W53.1.

54. Mutio Oddi to Piermatteo Giordani(?), from Milan, 18 December 1613. OCP, fol. 19v. W54.1.

55. By mid-May the count had "taken away the supervision of his building works from me and is giving the building given [to me] to others," an illustration of the fickle, unstable nature of patronage. Mutio Oddi to Piermatteo Giordani, from Milan, 29 May 1614. OCP, fol. 36v. W55.1.

56. "I dedicated the book of sundials to His Illustrious Lordship and it is agreed that he will pay the expenses, which amounts to 338 *lire*, and this money will be restored to me through a payment order made by signor Batt(ist)a Calisetto." OPU-FCC IV, fol. 9v. W56.1.

57. Stevens 1992, 14.

58. Mutio Oddi to Camillo Giordani(?), from Milan, 7 April 1614. OCP, fol. 33v. W58.1. Despite the engraver's deficiencies, Oddi employed the same man in his later publications—probably because he was cheap labor. As discussed below, Rocca was responsible for cutting the illustrations of *Dello squadro*, while a note dated 18 February 1626(?) states that Oddi's bookseller in Milan, Bartolomeo Fobella, was obliged to pay "Hierolamo Rocca da Varallo 50 *lire* for the price of several prints which must be engraved for signor Matteo's book," the *Precetti*. OPU-FCC II, fol. 23r. W58.2. There is one other instance of a payment made to Rocca by Oddi, which predates the production of *Dello squadro* by two years. On 6 December 1623 Oddi paid Rocca 18 *lire* for unspecified work, which, thus far, I have been unable to relate to a particular project. OPU-FCC III, fol. 23v.

59. Giacomo came from a printing family. The earliest dated book from a Milanese press bearing a Lantoni imprint to have come down to us is Giovanni Battista Selvatico's account of the Milanese college of physicians, *Collegii Mediolanensium medicorum origo, antiquitas, necessitas . . .*, published in Milan for Hieronymo Bordoni, Pietro Martire Locarno, and Bernardino Lantoni in 1607. On Locarno see Stevens 1996. Giacomo Lantoni died sometime before 1628, as in this year the *Lettera annua del Giappone* (for 1624) was printed, bearing the colophon "In Milano, Per gli Her[edi] di Giacomo Lantoni" and the imprint "Apresso Gio[vanni] Battista Cerri."

60. I. Maclean 1991, 18. For a further exploration of this theme see the essays in I. Maclean 2009.

61. Even the meticulous work of Stevens on stationers and printers in Cinquecento Milan, largely based on notarial records, leaves significant gaps in our knowledge of costs, distribution networks, and the precise history of individual books. Indeed, the information provided in notarized contracts is more often than not frustratingly incomplete: sometimes the cost of paper, an essential expense, is absent; sometimes labor costs are missing. See Stevens 1992, 48–52.

NOTES TO PAGES 121–124

62. Oddi continued to work on the book immediately following his release, as in December 1610 he wrote to his brother that he was busy writing a treatise on the *squadro*, providing a brief description of the instrument accompanied by an illustration. Mutio Oddi to Matteo Oddi, Milan, 8 December 1610. OCU, fols. 535r–536v.

63. Guidobaldo del Monte discussed the device in his *Meditatiunculae*, and Paciotti penned a manuscript treatise on the subject, fragments of which Oddi owned. See *Meditatiunculae Guidi Ubaldi e Marchionibus Montis S. Mariae de rebus mathematicis* (ca. 1587–92), Bibliothèque Nationale de France, Paris, MS Supp. Lat. 1058, discussed in Gamba and Mantovani, forthcoming. Paciotti's treatise (BUU-FC, Busta 118, fasc. 5, fols. 2–6) is mistakenly attributed to Oddi by Gamba in *LSU*, fig. 8. For the attribution to Paciotti see Ragni 2001, 144.

64. On the contents of *Dello squadro* see, in addition to *LSU*, G. Rossi 1877, 146–65.

65. Oddi 1625, 4–9. For an illustration of the alignment of the "slits," see Marr 2006c.

66. In the letter to Marliani at the begining of the book, Oddi notes that he has included a "way of drawing the regular figures . . . using only right angles," noting that such a method was used in designing the fortress of Sandoval. Oddi 1625, sig. [a3]r. W66.1. A drawing of the Sandoval fort is contained in the collection of Oddi's drawings in the Biblioteca Medicea Laurenziana (see chap. 6), fol. 46r.

67. Oddi noted in December 1624 that he had "started to attend to the printing of the book, and I doubt that it will be long before it is brought down in a muddle worse than that of Monte Baroccio. I have changed many things and God willing I have not made them worse, and I have many doubts . . . so I print this little work with great trepidation." Mutio Oddi to Piermatteo Giordani, from Milan, 18 December 1624. OCP, fol. 113r. W67.1. It is not clear what Oddi means by the "muddle . . . of Monte Baroccio." Presumably he is referring to a work by Guidobaldo del Monte, perhaps the *Coclea*, the printing of which he thought had been botched (see p. 279n25).

68. OPU-FCC II, fol. 21r. W68.1. The expenses list has been published by Gamba and Montebelli (1989, 91) but with several significant errors in transcription.

69. This should amount to just under 92 *lire*, rather than the sum listed. Oddi had purchased the paper by February 1624 as on the 14th of this month he wrote to Camillo Giordani, "I have finished engraving all the figures and have purchased the paper." Mutio Oddi to Camillo Giordani, from Milan, 14 February 1624. OCP, fol. 115r. W69.1.

70. On copper merchants in Renaissance Italy see Bury 2001, 29. On copper production see Kellenbenz 1991.

71. These last additions are largely illegible, with many crossings out, making it difficult to determine precisely what the extra amounts were for. I take the total listed by Oddi at the bottom of the sheet to be the final total of expenses.

72. See, e.g., Cipolla 1952.

73. See, e.g., the values listed in Oddi's accounts: OPU-FCC IV, fol. 9r (misfoliated as 8r).

74. Godoy and Leydi 2003, 506.

75. Bury 2001, 44.

76. On the Calzolari account book see Fahy 1993.

77. Stevens 1992, 20. See also Stevens and Gehl 1994. For a general overview of paper in the Renaissance see Landau and Parshall 1994, 15–21.

78. Regrettably, nothing is known about the paper merchant Maretionne Follandro

beyond what can be gleaned from Oddi's accounts. Presumably he was one of many such merchants plying their trade in the Piazza dei Mercanti in the 1620s. On 12 and 26 March 1625 Oddi records a further two purchases from Follandro, both for nine reams of *carta reale*, at a cost of 81 *lire* for each purchase (OPU-FCC II, fol. 30r). These transactions postdate the printing of *Dello squadro*, so are probably unrelated to its publication.

79. For a comparison with the cost of other paper types see Stevens and Gehl 1992, esp. 86–88. Stevens and Gehl note that we are still "very ill-informed about the sources of the paper used by Milanese printers and publishers" (48–49). The Houghton Library copy of *Dello squadro* bears a watermark of a pair of lions rampant bearing a shield with a cross, surmounted by a crown and with the letters "IA" below.

80. *Dello squadro* consists of a title-page followed by three leaves, then the text on eighty-eight sheets paginated 1–175, with no number on the final page. My calculations are based upon Stevens's estimates of paper consumption for quarto volumes: "8 pages would require 1 sheet of paper; 400 would use 50 sheets." See Stevens 1992, 127–28.

81. The same plate was used for the engravings on pages 65 and 67.

82. Evidence for engravers' wages and copper prices in this period is extremely scarce, but see Fahy 1993. David Woodward (citing Consagra) has noted that "labour costs varied according to medium, complexity and size of image, status of the printmaker, and the extra labour necessary for lettering and backgrounds." D. Woodward 1996, 26 and, for bibliography, n82.

83. See Landau and Parshall 1994, 24; Bury 2001, 29–30.

84. It was not uncommon for printing work to be divided between artisans who owned different kinds of press. See, e.g., Marr 2008a.

85. It is unclear why Oddi uses the term *bussolo*, normally translated as "compass." No images of a compass appear in *Dello squadro*, and I can only assume that Oddi uses this term to refer to the head of the instrument featured in the title-page engraving.

86. OPU-FCC II, fol. 26v. W86.1.

87. As Maureen Bell and others have noted, women (especially widows) seem to have been regularly involved in the early modern book trade. See Bell 1996.

88. OPU-FCC II, fol. 23v. W88.1. The 62 *lire*, 10 *soldi*, Lantoni received is the total of Oddi's original down payment (28 *lire*, 10 *soldi*) and a subsequent payment of four *zecchini* (34 *lire*), dated 10 June 1625.

89. Indeed, the Scuole Piattine, where Oddi taught mathematics, was situated on one side of the Piazza dei Mercanti, the area in Milan that played host to most stationers, booksellers, and printers.

90. Estimated in Stevens 1992. It is likely, however, that most instrument books had smaller runs than other types of publication, such as devotional works.

91. Hans the elder had two sons. The first, christened Johannes, was born in September 1585; the second, christened Hanns, in January 1599. Tracing the brothers' subsequent careers is made difficult by the fact that both signed themselves Johann, Johannes, or Hans Troschel, Dreschell, or Dröschell (hence the difference in spelling between Oddi's "note of expenses" and the portrait's signature), but I think it likely that Oddi's engraver was the elder son. The Nuremberg archives record that one Hans Troschel, a *compassmacher*, bought property in Nuremberg in 1620. On the Troschel family see Chandler and Vincent 1969; Gouk 1988, 59–60. Two sundials,

one (undated) signed by Troschel the elder, another (dated 1620) signed "Hanns Troschel," are in the Metropolitan Museum of Art, New York. Some eight sundials signed "Hans Troschel," made between 1582 and circa 1600 are in MHS.

92. None of Oddi's biographers mention a trip to Rome, but two of his letters, dated 28 August and 15 September 1593, are signed from Rome. OCU, fols. 516–17 and 523–24. Furthermore, as we have seen, Oddi met Clavius in Rome at an unspecified date (see chap. 1). Finally, Oddi's drawings at Windsor Castle include several images of Roman monuments.

93. Peter Linder to Mutio Oddi, from Venice, 6 March 1638. OCU, fol. 972r. W93.1.

94. "Odde tuis, Lindrum scriptis, dū æterne perennas; / Supremumque: manu, das, moriente Vale: En tibi pro meritis dat Linder in ære figurā / Odde tuam, quà tu sicque perennis eris. / Offitiosę memorię signum / P.Petrus Linder." The engraving examined is that bound into the Bibliothèque Nationale's copy of *De gli horologi solari* (1638), V-8656. This state of the portrait is exceptionally rare. It was known to Promis (who commented on its rarity) and to Rossi. See Promis 1848; G. Rossi 1877, Nota XIIa.

95. OPU-FCC II, fol. 23v. W95.1. The date of this payment, 10 February 1625, is the same as that in Oddi's dedication to Count Francesco Bernardino Marliani, printed at the beginning of *Dello squadro*, suggesting that this may have been the actual completion date of the publication. We know that *Dello squadro* must have been printed by the second week in March 1625, as on 14 March Oddi recorded a payment to Bartolomeo Fobella for binding three copies of the book. However, three payments to Lantoni after this date are recorded in Oddi's notebook, bringing the total paid to the type and woodblock printer to 133 *lire*, 5 *soldi*, which tallies with the amount recorded in the cumulative expenses list.

96. More often than not, the entries are of a general nature, taking a form such as "Signor Bartolomeo must have from me 7 *lire*, 17 *soldi*, for as much as he has spent for me at diverse times." OPU-FCC II, fol. 19r. W96.1.

97. For example, an entry dated 8 September 1625: "I have lent to signor Bartolomeo three *zecchini* for buying books." OPU-FCC II, fol. 18v. W97.1.

98. "The 300 come to about 1 *lira*, 8 *soldi*, each, taking account of the various expenses and the binding of those which are gifts." OPU-FCC II, fol. 21r. W98.1. It is not clear why Oddi specfies 300 copies when the paper could produce around 350, even allowing for wastage.

99. Peter Linder to Mudio Oddi, from Venice, 5 February 1637. OCU, fol. 968. W99.1.

100. It is not clear what type of binding was made for the copies of *Dello squadro* recorded as "bound" in the list. Oddi recorded in his notebook two payments to Bartolomeo Fobella for binding copies of the treatise: 1 *lira*, 10 *soldi*, on 14 March 1625 for binding three copies, and 1 *lira* on 25 March for another two copies. In each case the cost was 10 *soldi* per binding (OPU-FCC II, fol. 20r). This small sum would indicate a simple binding using relatively cheap materials. In running a modest binding business in addition to his bookselling and publishing activities, Fobella was typical of late Renaissance stationers. See, e.g., the case of Paolo di Bernardino Bancheli outlined in Hobson 1984.

101. "Perillustris ac nobilis viri omnium virtissí genere ornarissi D. Camilli Jordani Patritij Pisaurensis donú epinium Et carum. Anno Dń: MDCXXV." Oddi, *Dello squadro* (British Library, 1651/250), flyleaf recto. This copy evidently found its way to the mathematician Alessandro Marini, whose ownership inscription is on the title

page. Oddi's correspondence indicates that he was in regular contact with Marini (who also knew Giordani) about geometrical problems.

CHAPTER 5

1. Giovanni Battista Caravaggio to Mutio Oddi, from Milan, 22 April 1629. OCU, fol. 797r–v. W1.1.

2. On the instrumental content of Guidobaldo's *Planisphaeriorum universalium theorica*, see Gamba and Mantovani, forthcoming. The instrument Settala desired had been devised by Guidobaldo to facilitate the drawing of large-area circles. It is thus related to the beam compass that appears in the Oddi-Linder portrait, for which see chap. 3.

3. For this kind of agency see Keblusek 2006.

4. I qualify instruments as "mathematical" rather than "scientific" in this chapter firstly because it is a period category, and secondly because the artifacts with which I am concerned were largely used in measuring, plotting, and calculating rather than in the experimental work of natural philosophy (although this distinction becomes blurred, as we have seen in chap. 3, when dealing with optical instruments). For an account of instrument terminology see Warner 1990.

5. Indeed, instruments were used increasingly to represent princely power, whether through their association with navigation, conquest, and empire; measurement and command of the cosmos; fortification and military technology; or other key aspects of statecraft. It is well known that instruments were regularly deployed in this way in the *Kunstkammern* of northern Europe, notable examples being the collections of Rudolph II in Prague, Wilhelm IV in Kassel, and Elector August of Saxony, whose remarkable Dresden *Kunstkammer* featured at least 950 mathematical or scientific instruments, many of which were actually used by the prince. On the instrument content of these collections see Mosley 2007a, 257–65, esp. the bibliography in 258n163. See also, for Dresden, Korey 2007. For Italian examples, see, e.g., Camerota and Miniati 2008.

6. See, e.g., Pomian 1991; Kaufmann 1993, chap. 7; Bredekamp 1995; Dupré and Korey 2006. For a critique of Pomian's assertion that collected objects are "semiophores . . . of absolutely no use," see Marr 2006a, 8–9.

7. Mosley 2007a, 257. Admittedly, Mosley is principally concerned with central Europe in the sixteenth century, but it would be surprising if the spread of mathematics tuition (and by proxy instrumentalism) observable in Italy at this time was not replicated in a region that boasted the greatest concentration of instrument makers in Europe.

8. Although this phenomenon was spread across Europe, the martial culture that had for centuries defined the Italian concept on nobility (evident especially in the *condottiere* dukes of Urbino), not to mention Italian pride in the skill of its military engineers, meant that the desire to consume mathematical instruments was especially deeply embedded there. For the military context of instrumentalism see, e.g., Walton 2005.

9. ". . . l'on peut faire vicarier les instruments de Mathematiques, Globes, Mappemonde, Spheres." Naudé 1627, 149–50. As Rose explains, "Alberti's ideal library symbolises . . . mathesis universalis. The library's patron is to be continually reminded of this by the display of mathematical instruments, notably an astronomical clock or planetarium

of the kind, which, according to Cicero, Posidonius had built in the ancient world."
IRM, 6.

10. Francesco Sansovino, *Venetia descritta* (1581), quoted in Rose 1976, 120. It is notable that Sansovino described Contarini's collection as a library—a reminder that the relationship between book learning and hands-on instrumental practice was extremely close in the period with which we are concerned.

11. As Mark A. Meadow has observed, "Collecting by its very nature was a communal activity. Princes, scholars, merchants, or apothecaries assembled their collections through complex systems of exchange. . . . To some extent, the activity of collecting provided a social nexus, in which noble, scholar, tradesman, and even craftsman could participate in the same realm." Meadow 2001, 184. On Linder's and Oddi's collections see chap. 6 and epilogue. Frequent references to the collecting activities of the Giordani, too numerous to relate here, are found in Oddi's correspondence.

12. Mutio Oddi to Piermatteo Giordani, from Milan, 7 December 1622. OCP, fol. 103r. W12.1. It is clear from his description that the globes on offer in Milan were celestial *globi Tychonici* based on Tycho Brahe's star charts, such as those produced by Willem Janszoon Blaeu (1571–1638), the most famous globe maker then active in the Low Countries. See Mosley 2007a, 217–56. Oddi's reference to "paper ones that are not yet mounted" refers to "globe gores": printed, specially shaped map sections that could be applied easily to a spherical surface. See, e.g., Dekker 2000a. Besides their obvious representational qualities, globes had further practical functions. They were useful, for example, in the construction of sundials or the casting of horoscopes. See Dekker 2000b; Mosley 2007a, 220. The globes were not the only goods Oddi obtained for the Giordani family. His correspondence contains extensive details about mother-of-pearl and aquamarine tiaras, gilded swords, and other luxury goods that he acquired or commissioned in Milan for his friends. See, e.g., OCP, fols. 17r, 75r and 96r.

13. We should not underestimate the significance of local knowledge, for instrument acquisition was not easy in the period. See, e.g., Giuseppe Gamurrini's letter of 1616 to Andrea Cioli, explaining the difficulty of procuring the mathematical instruments sought by Cosimo II de' Medici: "His Highness wants a master who knows how to make mathematical instruments, and, as I said already, in Flanders one cannot find many and those don't make characters, although there are two who are good men, and in all of Flanders there is but one who makes them, that is cutting, characters or letters, but he is a man of rare skill in this [art], and in making (or cutting) maps of countries." Giuseppe Gammurini to Andrea di Giovanni Battista Cioli, from Paris, 18 October 1616. *Medici Archive Project*, Doc. ID 13892. W13.1.

14. On the complexities of the distinction between *epistemē* and *technē* and its unraveling in the period, see Roberts and Schaffer 2007. The classic study is Zilsel 2000.

15. Bennett has argued forcefully that mathematical instruments of the sixteenth century are largely objects for doing rather than knowing, citing their obvious application in professional activities such as surveying and gunnery. While it may well be the case that mathematical instruments played a marginal role in "discovery," the necessary use of instruments in mathematical pedagogy—particularly the study of geometry—suggests that that they could be tools for making knowledge as well as for problem solving. See Bennett 2003, esp. 131–34. For the tradition, originating with Koyré in the 1930s but later dismantled by Settle and others, that instruments played no role in early modern knowledge production, see Van Helden and Hankins

1994. On instruments as objects of communication and demonstration, see Marr 2004a; Mosley 2006.

16. Bacon 2004, 65. For the ramifications of Bacon's assertion see, e.g., Pérez-Ramos 1988. As Van Helden and Hankins observe, Bacon "considered the instrument to be both a method and a tool." Van Helden and Hankins 1994, 4.

17. See chap. 3. I use the term "applied" mindful of Dijksterhuis's caution over its potential ahistoricity in the seventeenth century, although its use in referring to specific practices such as surveying is less problematic than in broad accounts of mathematization. See Dijksterhuis 2007, 77–78.

18. On instruments as a means of avoiding mathematical learning, see Walton 2005.

19. Debates over this issue were particularly fierce in late sixteenth- and early seventeenth-century England, on which see Johnston 1991, esp. 324–27; Hill 1998; Goulding 1999; Harkness 2007, 130–41. A good example of a device that obscured rather than revealed mathematics is the surveying instrument known as the plane table, on which see Bennett 1991b. See also Tycho Brahe's concerns over the insufficient accuracy of instruments compared to the "scrupulosity of Geometry and Arithmetic," discussed in Mosley 2007a, 222.

20. Harkness 2007, 130. Complaints about the black-boxing of instruments appear from as early as the 1530s. For example, Mosley (2007b, 296) cites Sebastian Münster's concerns, conveyed in his *Canones super novum instrumentarum luminarium* (1534).

21. Varchi 1549, 143. W21.1. As David Summers has observed, Varchi's argument seems to be an extension of the Aristotelian notion that "all men possess the arts *in potentia* . . . thus even the most mechanical arts avail themselves of philosophy to some extent." Summers 1987, 279. For a thorough account of Varchi's work see Devlieger 2005.

22. Quoted in H. S. Turner 2006, 69.

23. See also Mosley's observation that by "acting as a template or prototype, an instrument may convey information about itself, or about the larger classes of objects of which it is a single example, simply because it embodies its own principles of design." Mosley 2007a, 213.

24. For an example of the ubiquity of instruments in European life at this time see, e.g., Schechner 2001.

25. Giovanni Battista Caravaggio to Mutio Oddi, from Innsbruck, 8 October 1633. OCU, fol. 909r–v. W25.1. Oddi reckoned the *trerighe* the "most intelligent instrument" for measuring. See *LSU*, 154n63. For an example of this type of device, see fig. 76;. for the mirrors, see chap. 3. Caravaggio requested from the Urbino workshop replacement instruments for those in his *stuccio* that had broken, see Giovanni Battista Caravaggio to Mutio Oddi, from Milan, 18 July 1629. OCU, fol. 802r.

26. Mutio Oddi to Matteo Oddi, from Milan, 20 June 1612. OCU, fol. 503r. W26.1. References to Giovanni Benedetto Vagnarelli occur sporadically in Oddi's papers, usually in relation to payments.

27. See, e.g., A. Turner 1973, where the instrument trade is called "small but recognisable" (53), and Biagioli 2006a, where it is claimed to have been "too marginal to justify the costs of a privilege application" (159). Such a view is predicated partially on the comparatively low survival rate of instruments manufactured for the non-courtly market (and the resulting scholarly focus on those exceptional artifacts that have survived), but it is also due to the fact that research on the manuscript evidence

for the trade is generally lacking. Useful research on extant instruments includes A. Turner 2007; Van Cleempoel 2005. For a virtuosic example of the reconstruction of an instrument workshop from the material evidence, see G. L'E. Turner 1995.

28. Vagnarelli's prices are very similar to those paid by Galileo to his in-house instrument maker Mazzoleni, who charged just 2 *lire* for a pair of dividers, 8–10 *lire* for a reduction compass, and 25–30 *lire* for brass versions of the geometric and military compass. The complete accounts have been published by Favaro in the *Riccordi Autografi* (Galileo 1968, 19:131–49) and are analyzed in Biagioli, forthcoming. Biagioli estimates that Mazzoleni produced approximately 1,000 *lire* worth of instruments per year. See also Bedini 1994b; Valleriani 2008, 29–32.

29. Despite these numbers, only one instrument securely attributable to Vagnarelli—a surveying device, discussed in the present chapter—is extant. A further two are known by repute, last recorded as being in the collection of the BUU in 1952: "1. Un compasso geometrico e militare di Galileo realizzato in Urbino da Lorenzo Vagnarelli nella prima metà del diciasettesimo secolo. 2. Un quadrante geodetico costruito da Vagnarelli nel 1644." Bedini 2001, 49. The mismatch between Oddi's records and extant instruments suggests either a very low survival rate for Vagnarelli's work or, which is more likely, that the artisan did not regularly sign his works.

30. For the Italian context in which this evidence should be set see Miniati 2000, esp. 284–90; Lualdi 2000. For the distribution of workshops in this period see A. Turner 1987, 53–54.

31. It is clear, therefore, that Oddi's relationship to instrumentalism and the science it produced was profoundly interested rather than disinterested, a distinction of some significance when assessing knowledge and its making in the period. See Cook 2007, 45–46.

32. Little is known about Vagnarelli beyond that which can be gleaned from Oddi's papers. A cache of four letters from him to Camillo Giordani is in BOP, MS 1564, fasc. 67, fols. 1–8, one of which has been published in Gamba 2007, 356. Vagnarelli's house, where he maintained his workshop, survives on present-day Via Barocci in Urbino. See Bedini 2001, 73–85. It seems also that he may have been involved in the establishment of a school in Urbino for the study of instrumentalism, known following the devolution of the duchy as the Accademia di strumenti matematici, although the precise details are unclear. See Mantovani 2006.

33. The general impression from Oddi's correspondence is that cash payment for instruments often passed through several hands before it reached Urbino. It was often routed through Loreto—a natural locus of exchange given its proximity to the duchy and its popularity as a pilgrim destination—carried by whichever reliable individual happened to be traveling that way.

34. For bibliography see p. 241n6.

35. Members of the Barocci dynasty did, in fact, export Urbinate technical expertise abroad. Simone's brother, Giovanni Maria, established a workshop in Rome in the third quarter of the sixteenth century. A small oval-cased clock signed by him in 1563 (his earliest known piece) is believed to have been owned by Filippo Neri, who acquired a substantial number of mathematical instruments. See Bedini 2001, 35. The inventory of Neri's possessions lists more than two dozen sundials (including one "in the shape of a soup plate [*con la forma di un piatto a fondino*]"), an astrolabe, a marine compass, and a brass set-square. See Bedini 2001, 35–36; Vernaccia, "Elogi degli uomini illustri"; Bortolotti 1880. An additional instance of the spread of

Urbinate instrument-making technology is Baldassare Lanci's work for the Medici court, on which see Camerota and Miniati 2008, 119–23.

36. For the establishment of the Barocci dynasty in Urbino see Bedini 2001, 11–16.

37. Bellori, Federico Barocci's first biographer, claimed that Simone was "among the moderns also the most excellent in the making of mathematical instruments, because he studied under the instruction of Federico Commandino." Bellori 1672, 170. W37.1.

38. See part I.

39. See p. 54. A brief sketch of the unusually fertile conditions in late Renaissance Urbino for the development of new instruments is provided in *LSU*, 81–88. Simone Barocci also made objects—such as fine pulleys—used by Guidobaldo in his mechanical experiments. See Renn et al. 2001.

40. Vagnarelli seems also to have been skilled at making wooden objects, as one of Oddi's commissions shows: "Count Teodoro [Trivulzio] kisses your hands, and thanks Your Lordship again for the assistance which he has been given, and he has requested that I should ask to have a similar baton of wood made, and the same in all other ways to that which is in the Armory of Duke Francesco Maria, given to him by the Republic of Venice." Mutio Oddi to Piermatteo Giordani(?), from Milan, 18 December 1613. OCP, fol. 19r. W40.1. The baton to which he refers must be that depicted in Titian's celebrated portrait of the first Della Rovere Duke of Urbino, on which see Wehey and Wehey 1980.

41. In January 1603 Ludovico Vincenzi reported to his brother, Guidobaldo, a conversation between Francesco Maria II and Simone Barocci on the subject of materials. "His Highness Francesco Maria had spoken to Simone for the purpose of having him make silver points for compasses, and Barocci said that he had never heard of such a thing . . . but that they were all made with steel points and that furthermore they lasted longer." Ludovico Vincenzi to Guidobaldo Vincenzi, 2 January 1603. BUU-FCC, Busta 38, fasc. 4, fol. 123r. W41.1. See also Oddi's letter to Matteo Oddi, quoted p. 150. As Bedini explains, "a variety of techniques were executed in the Officina, including all forms of cutting, profile turning, engraving, be-ribboning or threading, divisioning [sic], etc., necessary for producing every type of instrument required." Bedini 2001, 20.

42. The clock, which is weight-driven and signed "Simo. Barotius Urbini," is discussed in Panicali 1988, 67–71, and Bedini 2001, 67–71. Panicali claims that its mechanism includes important innovations in regulation that demonstrate the high degree of Barocci's technical inventiveness. Clocks of a comparable appearance may be found in several of Titian's portraits, which both Panicali and Bedini argue convincingly to be lost examples of Barocci-family devices.

43. See Paci, Pasquali, and Sori 1982.

44. "Ragionamento havuto dal Clarissimo procurator Michel savio del conseglio con l'Ambasciator d'Urbino, circa la persona del S. Duca di servir la Republica," 14 December 1585. Quoted in [Henninger-]Voss 1995, 447.

45. ASF, Urbino, "Inventario del Guardaroba Ducale" (1623), fol. 29v. W45.1. See also Panicali 1988, 44.

46. On cased sets in general see Hambly 1988, 152–73. Numerous *stuccii* of the period have survived. See, for example, the anonymous Italian-made cases in IMSS, inv. nos. 671, 672, and that by Cristoph Schissler (who seems also to have specialized in the *stuccio*), inv. no. 2532, all of which have a Medici provenance. *Stuccio* sets of

mining instruments also emerged in the sixteenth century, particularly in Germany, where this industry was most advanced. See, e.g., MHS, inv. no. 64558, and IMSS inv. no. 2538.

47. A good example of a large Barocci *stuccio* is that noted by Oddi's kinsman Ludovico Vincenzi, which contained "an adjustable square that can be used as a level, a folding square with a magnetic compass that can be used for taking sights; two compasses with steel points with a pen for drawing circles with ink; two small compasses; a compass with a screw; a compass for dividing straight lines and circles; a compass with a point for cutting stiff paper; a lancet with four instruments in it; a ruler and an adjustable square; a pair of scissors; a compass for sea charts; a stylus for drawing invisible lines; a pencil holder; an instrument for making right angles; an instrument for relating angles." Sangiorgi 1982, 18n2. W47.1.

48. Mutio Oddi to unknown recipient, from Milan, 21 November 1613. OCU, fol. 601v. W48.1. Numerous ingenious portable cases like the "stockings *stuccio*" were produced at this time. See, for example, the early seventeenth-century "etui case" in the Harvard Collection of Scientific Instruments, inv. no. DW0723 (fig. 44), or the small dagger-shaped case in IMSS, inv. no. 620.

49. Bedini 2001, 11. Bedini notes that a further ducal gift to the pontiff was a "watch contained in a ring that marked the hours by gently pricking the wearer's finger." For Oddi's celebration of the astronomical clock and its maker, Giovanni Maria Barocci, see chap. 1. It is worth noting that this instrument would have fulfilled Alberti's injunction that any decent library should be furnished with an astrarium or planetary clock (see above).

50. F. Terzi to Francesco Maria II della Rovere, from Lisbon, 1586. BOP, MS 422, fol. 305r. W50.1.

51. Mutio Oddi to Matteo Oddi, from Milan, 3 June 1618. OCU, fol. 572r. W51.1. Oddi's papers are full of requests that Vagnarelli speed up his work and expressions of exasperation that he had not completed an order or responded to letters. Oddi was, it appears, a particularly impatient customer. For example, he wrote to his brother-in-law asking that Vincenzi should "solicit the *stuccio* for signor Count Teodoro [Trivulzio] and you should ask Vagnarelli, in my name, to set aside all other things straight away, and to let me have it as soon as possible." Mutio Oddi to Francesco Maria Vincenzi, from Milan, 9 January 1613. OCU, fol. 583r. W51.2.

52. See chap. 2.

53. See Rosand 2002, esp. 136–44.

54. For the multiple meanings and applications of *grazia* in the period see Emerson 1991 and Castiglione's definition, quoted p. 296n5. Oddi describes Vagnarelli instruments as inscribed with "precise diligence," writing to Matteo Oddi: "I am awaiting the remaining [goods] to be able to serve a *cavaliere*, he wishes to have one of those reasonably large polimetric compasses, but it should be inscribed with precise diligence, as is certain because it will pass through your hands." Mutio Oddi to Matteo Oddi, from Milan, 28 June 1617. OCU, fol. 570r. W54.1.

55. Their stylistic qualities thus reveal their multifaceted socio-intellectual qualities, much like the drawing machines discussed in Kemp 1991.

56. Mutio Oddi to Matteo Oddi, from Milan, 20 June 1612. OCU, fol. 563r–v. W56.1. At the beginning of 1613 Trivulzio was still waiting for a *stuccio* from Vagnarelli, though this may have been a separate, additional purchase. See Mutio Oddi to Francesco Maria Vincenzi, from Milan, 9 January 1613. OCU, fol. 583r.

57. Mutio Oddi to Andrea Bancalini, from Lucca, 19 October 1631. OCU, fol. 595r. W57.1.

58. Mutio Oddi to Camillo Giordani, from Lucca, 7 November 1629, OCP, fol. 175v W58.1. For the list in context see Gamba 1994, 810–12. A similar list appears in one of Oddi's letters to Camillo Giordani of 3 November 1628. OCP, fol. 163v. The relevant publications are Oronce Fine, *Quadrans astrolabicus, omnibus Europae regionibus inserviens* (1534) (which appeared also in Cosimo Bartoli's Italian translation of Fine's collected works, published in 1587), and Giovanni Antonio Magini, *De planis triangulis liber unicus. Eiusdem de dimetiendi ratione per quadrantem et Geometricum quadratum libri quinque* (1592).

59. Museum für Kunst und Gewerbe, Hamburg, inv. no. 1893.259. A description of the instrument is provided in the Spitzer sale catalog, with an estimate of 580 francs. See Collection Spitzer 1893, 8. Although both Panicali and Bedini discuss the instrument, neither knew of its current whereabouts. See Panicali 1988, 61; Bedini 2001, 48–49. See also Rohde 1923, 69–70.

60. The use of the eight winds seems to have originated with Tartaglia, who described a surveying instrument with such markings in his *Quesiti et inventioni*.

61. See, for example, the Habermel surveying instrument and the late sixteenth-century Italian instrument, once part of the Medicean collections (IMSS, inv. nos. 154 and 144), or two comparable instruments of the Louvain school (Van Cleempoel 2005, nos. 51 and 86). See also the instruments described and illustrated in Rohde 1923, 64–73, and in Kiely 1947, 158–62. Vagnarelli's instrument is particularly similar (although more sophisticated) to a simple theodolite by Philippe Danfrie in the Whipple Museum, Cambridge. On the development of this kind of instrument see Bennett 1987, 39–50, and the devices described in Stroffolino 1999, 13–112.

62. The signature reads "OPVS LAVRENTII VAGNARELLI VRBINATIS 1639." Interestingly, given the inscription's claim to precision, Oddi was particularly critical of the Tartaglia prototype of this sort of device, writing that "among all the instruments used by architects, this one is the most unsound and the least certain," because it was difficult to find good needles that worked properly with their lodestone and because the instrument had to be "inscribed and made by an excellent master." Oddi 1625, 59. W62.1. The Vagnarelli instrument may well have won his approbation, given that it does not rely on the compass for its operation.

63. Mutio Oddi to Matteo Oddi, from Milan, 18 July 1612. OCU, fol. 640r. W63.1.

64. Mutio Oddi to Matteo Oddi, from Milan, 18 July 1612. OCU, fols. 640v–641r. W64.1. Oddi's comments about ensuring the divisions do not become "too small" (he means close together) bring to mind the fact that Coignet ran out of space in his version of the instrument, instead distributing the lines over two devices. See Biagioli, forthcoming. Oddi published a set of instructions similar to this letter in the first part of *Compasso polimetro*.

65. Interestingly, it seems that the Galilean geometric and military compasses made for the Medici were manufactured in Florence by one "Maestro Rafaello," then sent to Galileo in Padua for delineation, which, as Oddi's letter shows, required a geometrical competence superior to that of most instrument makers. See Biagioli, forthcoming.

66. While Vagnarelli continued the manufacturing tradition established by Barocci, he did not inherit the Officina's contents on his master's death. This is suggested by a request from Oddi that Simone's son, Ambrogio III, lend Vagnarelli a "brass model"

of a proportional compass once owned by Simone, so that a similar instrument could be made: "Vagnarelli has written to me from Urbino because signor Pino has not yet shown him the compass; I am writing to him to see whether, with the next messenger, it will be possible to borrow from signor Ambrogio Barocci a model of brass that Simone had." Mutio Oddi to Camillo Giordani, from Lucca, 27 January 1627. OCP, fol. 141r. W66.1. Signor Pino eventually sent the compass, but it was not the kind that Oddi wanted. See Mutio Oddi to Camillo Giordani, from Lucca, 10 March 1627. OCP, fol 143r.

67. I have adopted the phrase "ingenious aptitude" from Roberts and Schaffer 2007.

68. Mutio Oddi to Camillo Giordani, from Lucca, 27 September 1634. OCP, fol. 249r–v. W68.1. It seems that Oddi designed the fountain for the garden of Buonvisi's villa in Camigliano, which Oddi remodeled. See p. 000. On the Giardino fountain see Gamba and Mantovani, forthcoming.

69. Mutio Oddi to unknown recipient, from Milan, 27 July 1611. OCU, fol. 598r.

70. The drawings, titled "Primo Modo di Mutio Oddi a Gradi Quarantae e Mezo," are OPU-FC, Busta 118, fasc. 7, fols. 1–35.

71. Mutio Oddi to Camillo Giordani, from Lucca, 1 September 1627. OCP, fol. 156r. W71.1. The dial was eventually published in *De gli horologi solari*, and is discussed in passing in *LSU*, 160.

72. For Oddi's possible interest in Kepler see pp. 208–9.

73. Presumably Oddi did not actually engrave the plate himself—as we have seen, he relied on professional engravers when producing his printed books, so there is no reason to suppose he was possessed of the skills necessary to cut a copperplate.

74. See, for its Renaissance incarnation, Pérez-Ramos 1988. For prince practitioners see Moran 1981.

75. See Vives 1913.

76. See Eamon 1994, esp. chap. 9; Findlen 1996, *passim*, but esp. chaps. 5 and 7. Both Eamon and Findlen have drawn on Walter E. Houghton Jr.'s dated but still impressive account of the English *virtuoso*. See Houghton 1942.

77. On curiosity and wonder in the period see, e.g., Daston and Park 1998; Kenny 2004; Evans and Marr 2006.

78. Mutio Oddi to unknown recipient, from Milan, 23 May 1614. OCU, fol. 628v. W78.1. Oddi's comments on Stevin's treatise are a perfect demonstration of Mary Henninger-Voss's argument that the visual aspect of *disegno* in military architecture is key to understanding contemporaries' recognition of its potential to unite theory and practice. See Henninger-Voss 2004.

79. According to Crivelli, Bianchi was a "Nobile simpatico Milanese . . . amator di pittura e un po' pittore egli stesso." Crivelli 1868, 60. Brief biographical details, including Bianchi's military experience, are in Argelati 1745, vol. 1, col. 180. Porro, in his catalog of the Trivulzio papers, noted a further record of Bianchi's military service: an autograph document simply entitled *Memorie* of Ercole Bianchi, recounting details of his delegation to the Spanish camp at the Po in 1636. Apparently, the *Memorie* also includes "lettere autografe di diversi personaggi a lui [Bianchi] dirette." However, there is no trace of these papers beyond Porro's catalog and they do not survive in either the Biblioteca Trivulziana or in the private Trivulzio family archive. See Porro 1884, 31, and p. 264n27.

80. For the claim that Bianchi was the heir of Figino, see Crivelli 1868, 60; Gould 1952, 293. In 1637 Bianchi donated Figino's *Natività di Maria* and a *Madonna and Child*

to the Milanese Church of Sant'Antonio Abbate. See Coppa 1977b. Bedoni claims that Bianchi himself owned the following Flemish paintings: the *Four Elements*, two *Landscapes*, a *Flower Garland*, a *St Sebastian*, a *Glass of Flowers*, another *Still Life of Flowers*, six *ovati*, and twelve paintings corresponding to the months by Philips de Momper. See Bedoni 1983, 146. According to Padre Sebastiano Resta, after Bianchi's death his sons sold all of the Brueghel paintings to the Marchese di Caracena, Governor of Milan. Bedoni has speculated that several of these works may have entered the Colonna collection. See Bedoni 1983, 146–47. Comincini 2010, published while the present book was in press, includes a period inventory of Bianchi's collection and supersedes all other references.

81. A comprehensive account of Bianchi's role is in Bedoni 1983. In correspondence regarding the cardinal's acquisitions, Rubens (Brueghel's friend and sometime collaborator) acted as secretary, as his Italian was far superior to Brueghel's—a connection that may be pertinent to Oddi (see chap. 6). For Borromeo's collecting see, in addition to Bedoni, P. M. Jones 1993.

82. On which see Maurice 1985, esp. 15–20.

83. On *difficoltà* see, e.g., Summers 1981, 177–85 and *passim*.

84. On Settala as *virtuoso* inventor see Findlen 1996, 325–34; on his museum see Aimi, Michele, and Morandotti 1984.

85. Connors 1990. If Connors is right, Oddi's interest in the *ars tornandi* provides a further, tantalizing connection between the Urbinate mathematician and Borromini.

86. See Diemer 1985, 1996. While in Munich, Maggiore taught the technique of oval turning to George Wecker, whose son, Hans, then brought the technique to Saxony and artisans of the electoral court.

87. Mutio Oddi to Piermatteo Giordani, from Milan, 7 May 1614. OCP, fol. 31v. W87.1. For Oddi's interest in Aguilon see chap. 3.

88. Mutio Oddi to Piermatteo Giordani, from Milan, 29 May 1614. OCP, fols. 35v–36r. W88.1. The "Annibale" to which Oddi refers is a copy of a painting (possibly by Annibale Carracci?) made for Bianchi through the offices of Piermatteo Giordani in Pesaro: "Signor Ercole Bianchi has returned to camp [and] has requested anew that I should pass on to Your Lordship his thanks, with all his heart, for the very beautiful copy of Annibale." Mutio Oddi to Piermatteo Giordani, from Milan, 18 November 1614. OCP, fol. 39r. W88.2.

89. On secrecy in early modern craft practices see Eamon 1994; Long 2001.

90. Oddi's work on what he called "conic lines" (published in Oddi 1638, 147–83) is discussed briefly in *LSU*, 160–61. His pride in this work is indicated by a letter to Camillo Giordani: "I have made a little book, which I composed in Loreto, on sundials, which I have been tempted to burn many times, as many parts of it were copied by a Jesuit and published as his own, and I would have done this had I not removed that which I am now encouraged to publish, which is a treatise on conic lines." Mutio Oddi to Camillo Giordani, from Lucca, 17 September 1631. OCP, fol. 206r. W90.1. The work in which the plagiarism occurred is Giulio Fuligati's *De gli horiule a sole* (1617).

91. See, e.g., Rose 1970.

92. Paciotti's trammel is explained and illustrated in Oddi 1638, 183–92. For Caravaggio's correspondence with Oddi about practical ways in which to draw the parabola, see chap. 3.

93. See, e.g., Summers 1981, 434–35; Chatelet-Lange 1976; Kitao 1974.

94. See chap. 3.

95. See, e.g., Naylor 1976.

96. For Kepler's work on conics see A. E. L. Davis 1975. For a general guide to Kepler and planetary motion see Knight 1965.

97. Mutio Oddi to Camillo Giordani, from Lucca, 7 November 1629. OCP, fol. 176r. W97.1.

98. Mutio Oddi to Camillo Giordani, from Lucca, 3 November 1628. OCP, fols. 163v–164r. W98.1. Oddi's suggestion that he would need actually to be in Urbino to supervise Vagnarelli's manufacture of the sphere implies that it was an unusual and complex device.

99. See Camerota and Miniati 2008, 73.

100. See Baffetti 1994; Barbero, Bucciantini, and Camerota 2007.

101. Mosley 2007a, 268 and *passim.*, for further discussion of these models.

102. My dating is based on Borromeo's other plans for the Ambrosiana complex, for the sphere was designed to be housed in a room adjacent to the Biblioteca Ambrosiana. See chaps. 1 and 2. The project is discussed briefly in Bucciantini 2008, at 366–67, but it would repay further study.

103. The document, written in a neat italic, relates that the instrument is necessary to know "the positions and proper motions of the sun, moon, and other planets, the rising and setting of the stars, and all other marvels of the heavens." *La sfera mirabile spiegata a bocca in diversi discorsi dall'Illustrissimo Sig[no]re Cardinale Federico Borromeo,* BAM, MS G 9 inf., no. 2, fol. 5. W103.1. I have followed the foliation of the manuscript, which runs consecutively without recto or verso. As its title indicates, the document is a transcript of several sets of instructions delivered orally by the cardinal.

104. Ibid., fols. 24 (for the size) and 37–38 (for Maestro Antonio, described as a "man quite expert in his art" [*huomo assai perito nell'arte sua*]). Antonio's brother was to be employed if the master himself had died. References to the decoration of the globe are spread throughout the document, but it is clear that it was to be gilded and painted in oil and watercolor. The planets, for example, were to be colored "following Pliny . . . with very bright and dazzling gold. . . . In any case as is judged best to color them, one should gild them first and then with transparent watercolor solidify the color as desired" (fols. 33–34). W104.1. The method for powering the sphere is discussed at length in chaps. 13–16 of the document, detailing methods using weights and ropes, clockwork mechanisms ("such as those coming from Germany" [*quali vengono da Germania*]), and a combination of the two, which was deemed the best option (fols. 45–69).

105. Borromeo provided precise instructions for the room's size and orientation. Ibid., fol. 6.

106. Ibid., fol. 99. W106.1. The custodian would also be required to clean the room and to make sure no naked flames were allowed inside.

107. In this regard it partakes thoroughly of the appeal to wonder as an aid, rather than a hindrance, to pedagogy, as deployed especially by the Jesuits in this period.

108. *La sfera mirabile*, fol. 38. W108.1. In another of his manuscripts, the cardinal refers to "a sphere made all of silver, which shows very clearly all the motions of the moon, and is a very singular example of its type and made with great skill." Federico Borromeo, "De fabricatis olim typis orbium coelestium libellus." BAM, MS G 9 inf., no. 4, pp. 62–63. W108.2.

109. *La sfera mirabile*, fol. 34. W109.1. The document then provides four small drawings of the different phases to be represented.

110. Indeed, it is not clear whether it was a form of celestial globe, such as the little silver one owned by the Milanese Manfredo Settala, or a type of armillary sphere. For Settala's silver sphere see BAM, MS Z 387 fol. 3r: "globo celeste tutto di argento e tutto intagliato con le figure." It is worth noting that Cornelius Drebbel's famous *perpetuum mobile* usually included a small sphere that showed the motions of the moon, and that one such mechanism appears in the *Linder Gallery Interior* (see chap. 6). On Drebbel's device see Drake-Brockmann 1994; V. Keller 2008.

111. BAM, MS G 309 inf., no. 13, fols. 2–5. The letter, a secretarial copy, is accompanied by a second, far cruder drawing of the sphere and some notes on a "perpetual fountain" in a different hand.

112. See chap. 1.

113. On self-moving spheres of this kind see, e.g., Maurice and Mayr 1980.

114. As Oddi notes, Volpaia "made a very ingenious clock for Lorenzo de' Medici, of which Angelo Poliziano has written at length to Francesco Casa, and Giorgio Vasari in the Lives of the Painters." *LSU*, 192. W114.1. The way in which Oddi describes Pietro Griffi in the letter suggests that he had culled some of his information from Baldi's preface to his translation of Hero's *Automata*.

115. Indeed, the fact that Oddi refers, in somewhat obsequious terms, to his devotion to Borromeo at the end of the letter on spheres suggests that Settala may have made his inquiry at the request of the cardinal. As noted above, Settala's relation, Manfredo, was particularly interested in spheres.

116. Kemp 1991, 39.

117. See Biagioli 2006a, 2006b.

PART IV

1. Oddi's architecture deserves a study in its own right and as such is not treated in detail here. Isa Belli Barsali and Sabine Eiche have made major inroads into charting Oddi's architectural work, for which see p. 241n5.

2. Vitruvianism was itself part and parcel of the Urbino school's intellectual program, which embraced architecture as a mathematical science in the best traditions of the duchy. Notably, both Commandino's and Guidobaldo's fathers were experts in military architecture; indeed, Guidobaldo himself served the Grand Duke of Tuscany as surveyor-general of fortresses. Baldi, meanwhile, published two treatises on Vitruvius and proved himself an astute architectural commentator in his *Memorie concernenti la citta di Urbino*. See *IRM*, 197, 223; Becchi 2006.

3. On the place of the arts in hierarchies of knowledge, see, e.g., Kristeller 1951–52; P. Rossi 1970; Farago 1991.

4. In part, this was an effect of associating painting with letters and, as Farago (1991, 24) notes, "relegating *scienza* to the role of an instrument, not the knowledge of first principles." The relevant works are Benedetto Varchi, *Due lezzioni* (1549); Giorgio Vasari, *Le vite de' più eccellenti pittori, scultori e architettori* (1550; 2nd, expanded ed., 1568); Vincenzo Danti, *Il primo libro del trattato delle perfette proporzioni* (1567). For an overview of Italian art theory in the period see Blunt 1940. See also Summers 1981, 1987; Mendelsohn 1992; Thomas 1996; Williams 1997.

5. For a discussion of the meaning and implications of this statement, made in the second edition of the *Vite*, see Summers 1981, 364–79. Castiglione defined *sprezzatura* thus: "But, having thought many times already about how this grace is acquired

(leaving aside those who have it from the stars), I have found quite a universal rule which in this matter seems to me valid above all others, and in all human affairs whether in word or deed: and that is to avoid affectation in every way possible as though it were some very rough and dangerous reef; and (to pronounce a new word perhaps) to practice in all things a certain *sprezzatura*, so as to conceal all art and make whatever is done or said appear to be without effort and almost without any thought about it. And I believe much grace comes of this: because everyone knows the difficulty of things that are rare and well done; wherefore facility in such things causes great wonder; whereas, on the other hand, to labor and, as we say, drag forth by the hair of the head, shows an extreme want of grace, and causes everything, no matter how great it may be, to be held in little account." Castiglione 2002, 43.

6. Malmanger 2000.

7. Galileo's relationship to *disegno* was first explored by Erwin Panofsky (1956). Subsequent works that have built upon Panofsky's insights include Edgerton 1984 (later expanded as chap. 7 of Edgerton 1991); Reeves 1997; Damianaki 2000; Camerota 2000; Bredekamp 2001, 2007; Dupré 2005. See also Gingerich's (2009) critique of Bredekamp.

8. Lodovico Cigoli to Galileo Galilei, from Rome, August 11 1611. Galileo 1968, 11:168. W8.1. Indeed, as the military engineer Buonaiuto Lorini explained in his *Delle fortificationi*, "Whoever does not know how to make a drawing, also does not know how to understand." Lorini 1597, 32. W8.2.

9. Camerota 2004, 144.

10. On this concept see, e.g., Ciaravino 2004.

11. As Barzman has observed, "*Disegno* was a term of multiple meanings in Renaissance Italy. From city to city, between shop and academy, it took on a range of significations that reflects a layering of contemporary discourse concerning the theory and practice of art." Barzman 1991, 37.

12. See, for example, the definition offered by the Accademia della Crusca in 1612: "Aver disegno, termine de' dipintori, sapere ordinatamente disporre, e ordinar la'nvenzione: e vale anche, fuor del termine de' pittori, avere *ingegno*, e *grazia* nell' operare." Accademici della Crusca 1623, 277.

13. Certainly, this practice was at the heart of study in both the Florentine Accademia del Disegno and Borromeo's Ambrosian Accademia del Disegno, where Oddi taught perspective. For the former see Barzman 2000, 161–78; for the latter, see P. M. Jones 1993 and chap. 2.

14. My discussion of the philosophical development of *disegno* is indebted to Barzman 2000, 145–50, but see also Summers 1987; Williams 1997; Malmanger 2000; Cole 2002, chap. 4.

15. Varchi was not the first to posit such a notion, although his was the earliest philosophical treatment of the theme. In the 1440s, for example, Lorenzo Ghiberti noted that "*disegno* is the foundation and theory" of painting and sculpture. Lorenzo Ghiberti, *Commentarii*, quoted in Holman 1997, 4.

16. See, for example, the *Metaphysics*, in which Aristotle asserts, "It is common, then, to all [principles] to be the first point from which a thing is or comes to be or is known." Aristotle, *Metaphysics*, bk. 5, 1013a17–18.

17. Barzman (2000, 147) provides a useful chart of Varchi's distribution of the arts and sciences, which follows book 6 of the *Nicomachean Ethics*. See also Williams 1997, 36–40.

18. Barzman 2000, 148.

19. This technical elaboration is also particularly apparent in the Milanese Giovanni Paolo Lomazzo's *Trattato dell'arte della pittura* (1584), for which see Kemp 1990, 83–84.

20. See part I.

21. Vasari 1966–87, 1:111. W21.1. On Vasari's conception of *disegno* see, e.g., Williams 1997, 29–72. Williams notes (33) that the description of *disegno* cited above may be indebted partially to Rafaello Borghini, who collaborated with Vasari on the second, 1568 edition of the *Vite*.

22. As Williams (1997, 40) notes, Vasari's concept of *disegno* rests partly on its capacity to apprehend the formal similarities between objects, which are "based on *misura*— numerical relationships, proportion."

23. Emphasis mine. The difference, of course, between the material expression of geometry and the works of art formed by Vasari's *disegno*, is that the latter are born of a process whereby sensible things are selected, judged by the intellect, and fashioned anew by the trained hand, whereas geometry, although accessible through sense, has a predetermined form that can only be replicated (albeit in myriad configurations). By the time Vasari was writing there existed a significant body of literature, much of it Neoplatonic in tone, that addressed the issue of geometry's realization in the world alongside the virtues of geometrical objects. A good example of this is Luca Pacioli's *De divina propotione* (1509), a work which Oddi knew (see appendix B, notes).

24. See p. 33.

25. Vasari begins his life of Uccello by stating that he "would have been the most delightful and imaginative genius since Giotto that had adorned the art of painting, if he had devoted as much pains to figures and animals as he did to questions of perspective, for, although these are ingenious and good in their way, yet an immoderate devotion to them causes an infinite waste of time, fatigues nature, clogs the mind with difficulties, and frequently renders it sterile where it has previously been fertile and facile." Vasari 1980, 1:232–33. Vasari's comments reflect his judgment of the "second age" of art, to which Uccello's work belonged, namely that this period depended too much on *regola* and *misura*.

26. See chap. 2.

27. Lomazzo is also keen to point out in his second, shorter treatise (*Idea del tempio della pittura* [*1590*]), that mathematics is an essential foundation for the study and practice of painting, and that the admirable artists of the age (such as Leonardo, Michelangelo, and Raphael) were learned in geometry. Lomazzo 1590, 33–34, 68–69. Notably, the Urbinate mathematicians Commandino and Baldi feature alongside the likes of Cardano, Tartaglia, and Benedetti in Lomazzo's short list of "modern mathematicians" (69).

28. A concise overview of Zuccaro's rather opaque text is in Williams 1997, 135–50. See also Summers 1987. It is worth noting, *pace* Oddi's receptiveness to Counter-Reformatory values, that in 1623 he thanked Piermatteo Giordani for sending the poetry of one "Rosso" but said that his *cavalieri* friends desired something "less dirty and more witty [*meno sporche et più ingegnoso*]." Mutio Oddi to Piermatteo Giordani, from Milan, 5 July 1623. OCP, fol. 109r.

29. Federico Zuccaro, *L'idea de' scultori, pittori, e architetti* (1607), quoted in Kemp 1990, 85. See also Panofsky 1968, 74–79.

30. This apparently grudging acceptance of the utility of mathematics in artistic practice perhaps explains why Giuseppe Ghezzi's 1696 portrait of Zuccaro in the Accademia Nazionale di San Luca, Rome, shows the artist presenting a tablet on which are inscribed geometrical figures. For further discussion of this image and Zuccaro's stance on mathematics vis-à-vis *disegno,* see Gage 2010, 263–64. We may compare Zuccaro's attitude to Vasari's, whose comments on Uccello reflect, in a sense, Michelangelo's deeply unfavorable observations about Dürer's obsessive codification of proportion, on which see Kemp 1990, 84, and Summers 1981, 380–81.

31. See chap. 5.

32. Williams (1997) and Cole (2002, 121) have noted that Vasarian notions of *disegno* were by no means ubiquitous in late Renaissance Italy. However, the wide circulation of the *Vite* certainly brought Vasari's views to a large audience.

33. Lanteri 1577, 21. W33.1. On this passage see [Henninger-]Voss 1995, 302; Brioist 2009.

34. [Henninger-]Voss 1995, 303.

35. Lorini 1597, 54. W35.1. Lorini's assertion partakes of what Hélène Vérin (1993, chap. 4) has called the "reduction in art" of sixteenth-century mathematized design.

36. Lorini 1597, 32. W36.1. Lorini's passage echoes Castiglione's comments about *disegno,* which "proves useful in many ways, and especially in warfare, in drawing towns, sites, rivers, bridges, citadels, fortresses, and the like." Castiglione 2002, 57.

37. For a fascinating account of the role of drawings in sixteenth- and seventeenth-century military architecture see Van den Heuvel 1991.

CHAPTER 6

1. In the archives of the Offitio sopra le Fortificatione in Lucca, the papers pertaining to Oddi's work for the Republic contain numerous references to his having made models of fortifications to be presented to the Council. In 1633, for example, the Offitio ordered "a model to be made to bring to perfection one of the piazzas of the fortifications, and in the next one month it will be presented, and in 8 days time the opinion of the engineer will be heard. . . ." Archivio di Stato, Lucca (ASL), *Fortificazioni,* vol. 10, pt. 2 (*deliberazioni,* 1628–36), fol. 152r. W1.1. Only a handful of drawings by Oddi related to his fortifications work survive, including a pair of presentation drawings, in his hand, for the Porta San Donato (ASL, *Fortificazioni,* nos. 42 and 43). Documents related to these drawings, presented to the Offitio in 1638, are ASL, *Fortificazioni,* vol. 10, pt. 2, fol. 137r–v. See also Martinelli and Puccinelli 1983, 275–76. Several of the documents concerning Oddi's engineering work in Lucca are reprinted in Trenta 1822, 343–65. For Oddi's military architecture see Martinelli and Puccinelli 1983, 228–79. In a letter to the Council that is undated but was evidently written toward the end of his employment, Oddi explained that to ensure the "new fortifications . . . can be finished without danger of errors being made, I am leaving to this effect writings, drawings, and models." He went on to thank the Council for its kindness in having suffered all of his "imperfections," explaining the reason for his leaving: "I want, before I die, to fulfill a certain vow that I have [made] to serve the Santa Casa of Loreto for a year." Mutio Oddi to the Council of the Republic of Lucca, no place or date [late 1636]. OCU, fol. 631r. W1.2.

2. In 1616 Oddi asked Camillo Giordani (then in Venice) if he would "find from some bookseller the Lives of the Painters, Sculptors and Architects, written by Giorgio

Vasari of Arezzo, and how much it costs; it has been printed in Florence and is in three volumes." Mutio Oddi to Camillo Giordani, from Milan, 12 December 1616. OCP, fol. 56r. W2.1. From his description it seems that the copy referred to is the second edition of 1568, which included a lengthy excursus on the nature of *disegno* (see part IV). For Oddi's involvement in Borromeo's Accademia see chap. 2.

3. The particulars of Oddi's will indicate that his collection contained sculptures (see epilogue). In a letter to Matteo Oddi dated 24 March 1618, Oddi referred to unidentified sculptures that he owned and that were being taken to Rimini by a signor Costantino (OCU, fol. 559r). In 1636 he wrote to Piermatteo Giordani about "two young men of good name from Carrara," whom he had commissioned to make "two nude statues, which I have sent to Paris." Oddi offered to enquire whether they would come and work in Pesaro, but pointed out that in Venice and Rome there were also many (and rather better qualified) *valent'huomini*. Mutio Oddi to Piermatteo Giordani, from Lucca, 2 January 1636. OCP, fol. 136r. W3.1. Following Oddi's return to Urbino, one Girolamo Lumaldo wrote to him on 29 January 1638, concerning his recommendation of the sculptor Pieratti as a candidate for the statue of Christ being considered by the Council of Pesaro (OCU, fol. 1063r).

4. A comparison here may be made with Galileo, who, as his biographer Viviani reported, busied himself "with great delight and marvellous success in the art of drawing, in which he had such great genius and talent that he would later tell his friends that if he had possessed the power of choosing his own profession at that age . . . he would absolutely have chosen painting." Vincenzo Viviani, "Racconto istorico della vita del signor Galileo Galilei," quoted in Bredekamp 2001, 160.

5. For example, in September 1596 Oddi was employed by one Father Guardiano to design a frame for Barocci's *Madonna* in the Church of San Francesco in Urbino, writing to his brother from Pesaro with a request for some measurements that he had left behind. Mutio Oddi to Matteo Oddi, from Pesaro, 16 November 1596. OCU, fol. 525r. A note in pencil on the back of the letter records measurements of the painting, frame, and altar. For the paintings Oddi owned, see epilogue.

6. Giovanni Battista Caravaggio to Mutio Oddi, from Milan, 12 November 1626. OCU, fol. 758r. W6.1. In a follow-up letter, Caravaggio explained that, according to Andrea Biffi (presumably the sculptor of the Campo Santo, who was evidently working as Calchi's agent), the price was fixed at 150 *scudi* each because Calchi held the pictures in "great esteem." He went on to state that he understood Oddi (acting for Imperiale) had offered 120 *scudi* each for the two Tintorettos and a picture of Saint George by Parmigianino. This price was unacceptable as Calchi had been circulating a note of the cost of the pictures, in which the Parmigianino was valued at 250 *scudi* (an inflated price). Negotiations continued throughout December but seem not to have reached a conclusion. See Giovanni Battista Caravaggio to Mutio Oddi, from Milan, 5 December 1626. OCU, fol. 760r, and subsequent letters at OCU, fols. 761r and 762r. No paintings matching those described in the correspondence are mentioned in Martinoni 1983. For Andrea Biffi see chap. 2.

7. Mutio Oddi to Camillo Giordani, from Milan, 31 January 1624. OCP, fol. 107r. W7.1. My conjecture that the *cavaliere* referred to is Imperiale rests on Oddi's mentioning, later in the letter, that he was then reading Imperiale's *Lo stato rustico* (1607). It is not clear how Oddi and Imperiale came to know one another, but both were exiles, which may have encouraged a friendship between them.

8. See, for example, his service to Ercole Bianchi, p. 293n88, and his business with the

estate of the painter Ventura Mazza, a pupil of Federico Barocci, for which see San-
giorgi 1982. In 1637 he handled preparatory drawings by Barocci for the "Deposition
from the Cross, now in Perugia, for the doctor, with two sketches by Procaccini; a
little drawing by Stefano della Bella for signor Vangelista." Mutio Oddi to unknown
recipient, from Urbino, 8 November 1637. OCU, fols. 666r–v. W8.1.

9. Mutio Oddi to Matteo Oddi, from Milan, 24 March 1618. OCU, fol. 559r. W9.1. Later
that year he acted in a similar manner on behalf of Ludovico Vincenzi, noting that
concerning the "old pictures" nothing remained to be done but to see whether Lu-
dovico wanted to have a copy made of "that of Saint Aurelia." Mutio Oddi to Matteo
Oddi, from Milan, 20 September 1618. OCU, fol. 574r. On Sebastiano's *Saint Agatha*
see J. Burke 2006. For Oddi's Bramante medal see p. 308n90.

10. Mutio Oddi to Matteo Oddi, from Milan, 7 June 1612. OCU, fol. 561v. W10.1. It is not
clear who "signor Guidobaldo" is, but Guidobaldo Vincenzi can probably be ruled
out, as he resided in Milan, while Guidobaldo del Monte is not known to have had
any particular interest in collecting drawings of this kind.

11. See Warwick 2003, esp. 3–4.

12. Oddi's drawing collection doubtless served as a model and pattern book for his own
practice, but he probably also intended that it should serve in the training of bud-
ding artists, for which see epilogue.

13. On Vasari's collection of drawings see Collobi 1974.

14. Windsor Castle, Royal Collection, vols. 182 and 183 (A/20 and A/21), nos. 9976–
10188; Florence, Biblioteca Medicea Laurenziana, Codex Ashburnham Appendice
1828. The Windsor drawings, described on the first folio of the first volume as "Pi-
ante e disegni di mano di Muzio Oddi di Urbino," are in vellum bindings bearing
the arms of George III, in whose reign they were acquired. Their precise provenance
cannot be established, but they may once have formed part of the Albani collection.
The paper onto which the drawings are pasted bears a watermark (a fleur-de-lys with
an *L* above and an *S* below) identical to Heawood no. 1571, identified as in circulation
in Rome in the 1690s. See Heawood 1950, 99 and plate 215. The Laurenziana album,
bound in vellum over boards, was acquired in the latter part of the nineteenth cen-
tury from the Ashburnham Library, although its provenance may not be the same as
that of the manuscripts Lord Ashburnham acquired from Guglielmo Libri in 1847.
See Scaglia 1992, 64, 119–20. A few additional architectural drawings by Oddi are in
BUU-FC, Busta 118, fasc. 4e.

15. The Stefano della Bella *disegni* are recorded in one of Oddi's notebooks dated 1637:
OPU-FC, Busta 118, fasc. 4a, fol. 28v. For Genga see p. 255n98. John Shearman has
suggested—on the basis of an inscription that he identified as in Oddi's hand—that
Oddi owned a Raphael drawing of Saint George, currently in a private collection.
On the basis of the reproductions in his article I am not convinced that the hand is
Oddi's. See Shearman 1983.

16. Mutio Oddi to Matteo Oddi, from Milan, 9 November 1611. OCU, fol. 558r. W16.1.
Evidently, in his absence from Urbino certain of Oddi's prints and drawings were
circulated among that city's artistic community.

17. See epilogue.

18. An entry by Vincenzi in one of Oddi's notebooks that was used by the former to
administer the estate, reads, "I have bought many volumes of *carta reale* and *ordi-
naria* to put together all the drawings and prints." OPU-FCC VII, fol. 76r. W18.1.
It has been claimed that the paper on which the drawings of the Laurenziana al-

bum are pasted is of relatively recent origin, so the ordering may not reflect precisely Vincenzi's original assemblage. See http://opac.bml.firenze.sbn.it/Laurenziana.htm&numrec=031919946919170 (accessed August 2008, no longer accessible). Howard Burns was the first to suggest that the Laurenziana codex was "probably put together by the Urbinate architect Muzio Oddi (or one of his heirs), because many of the designs are in his hand." See Burns 1974, 296. Gustina Scaglia, however, has cast doubt on Oddi's ownership, opining (entirely mistakenly) that "arranging drawings in an album seems to have started when Abbate Giuseppe Chiaccheri said he did so (c. 1764)." See Scaglia 1988, 85. Burns discusses briefly Oddi's collection and its dispersal in Burns 1980, 118n2.

19. In addition to teaching Vincenzi mathematics (for which see p. 248n21), Oddi may have passed on to his nephew the notion that the arts of design were mathematical in character. In his unpublished treatise on perspective—an incomplete and undated eighteen-page work, inserted among some of Oddi's miscellaneous papers—Vincenzi asserted that "Architecture and Painting surpass all the other arts which come from the use of the hands . . . the proper dignity of the one and the other is the excellence of the mathematical disciplines." BUU-FC, Busta 120, fasc. 3, fols. 428–36, at 428r–v. W19.1. Although there is not space to discuss this intriguing work here, it would certainly repay further study. Vincenzi was particularly interested in perspective—manuscripts on Alhazen and Witelo are among his papers in Urbino. See p. 279n28.

20. Scaglia 1974, 113–14. The Windsor drawings are rather more carefully preserved than those in the Laurenziana album.

21. For the most part the attributions in the Windsor list are accurate, but 10063, 10142(?), and 10175 should be given to Oddi and 10024, 10045, 10072, 10076, 10082, 10091, 10092, 10094, 10096, 10102, 10113v, 10131, 10148, 10151, 10154, 10156, 10162(?), 10163, 10168, 10170, 10173, 10176, and 10182(?) are not in his hand.

22. A fine drawing of a church façade attributed to Francesco di Giorgio (no. 10181) once formed part of the album but has now been removed and is held separately (see fig. 60).

23. The drawings in the Laurenziana album are numbered sequentially. I attribute the following to Oddi: 3, 4, 5, 6, 9, 13, 14, 17, 27, 28, 32(?), 34, 37, 38, 39, 40(?), 42, 43, 45, 46, 63, 67, 70, 72, 76, 78, 79, 80, 91, 98, 111, 112, 113, 128, 137(?), 138, 144, 157, 163, 168, 172, 173, 176(?), 179 (recto and verso), 180, 181, 182, 193, 202, 208 (the text on fol. 138v is a key to this drawing, in Oddi's hand), 245, 246, 247, 250, 252, 253(?), 255, 258, 262, 265, 266, 271, 273, 276, 276, 277, 279, 280(?), 281, 282, 283, and 332.

24. For the Francesco di Giorgio drawings see Burns 1974; Scaglia 1974 and 1992, 119–20 (these two authors' identifications of the sites represented in the drawings differ). For the Alberti drawing see Burns 1979, 1980. For the Alberto and anonymous Sienese drawings see Scaglia 1978, 1988. In the latter article, Scaglia questions Burns's attribution of the "bath house" drawing to Alberti, proposing instead that the drawing be attributed to an anonymous Vitruvianist working in Rome or Siena.

25. In an attempt to emphasize the Sienese character of the Laurenziana album— partially motivated by a desire to challenge Burns's attribution of the "bath house" drawing to Alberti—Scaglia has been at pains to distance the album from Oddi, even implying that Burns's identification of original Oddi drawings in the album is spurious (see Scaglia 1992, 119). Leaving aside the question of the Alberti drawing, her sidelining of Oddi is completely without merit, based on seeming ignorance

of both his life and his drawing style. For a further critique of Burns's attribution see Biermann 2002.

26. On the "bath house" drawing see, in addition to Burns's articles, Tavernor 1998, 194–200. I agree with Tavernor (248–49n37) that Scaglia's arguments against the attribution to Alberti are unconvincing. For the "Ideal City" panel see, e.g., Krautheimer 1994.

27. In his (not wholly accurate) life of Francesco di Giorgio, Vasari writes, "In architecture his judgment was excellent, showing a thorough grasp of the profession. This is amply displayed in the palace which he built at Urbino for the Duke Federigo Feltro. . . . Francesco was a noted engineer, especially in engines of war, as is shown by a frieze painted by him in the palace of Urbino." Vasari 1980, 2:26. The frieze in question is in fact the sculpted *Fregio dell'arte della guerra*.

28. See Rotondi 1949; Eiche 1993.

29. The manuscript, which also contains drawings after Roberto Valturio's *De re militari* and Mariano Taccola's *Notebook*, is Biblioteca Medicea Laurenziana, Codex Ashburnham 1357* (1281 bis). It was purchased by Lord Ashburnham, along with several other manuscripts, in 1847 from Guglielmo Libri, who had presumably acquired it from an Italian private collection. The Laurenziana acquired it in 1884. The Oddi provenance of this manuscript and the drawings album suggests—*contra* Scaglia—that both probably derived from the same private collection by way of Libri and Ashburnham. See Scaglia 1992, 64–67. Scaglia is quite wrong in stating that a "note 'Mutius Oddis Urbinatis' on the flyleaf is not his signature, merely an attribution written after 1885 when the manuscript came to the Laurenziana" (64). The inscription is certainly Oddi's and may be compared to similar signatures on his copy of Commandino's translation of Euclid's *Elements* and the manuscript of *De superficionum divisionibus* that he presented to the Biblioteca Ambrosiana. Oddi's master, Guidobaldo del Monte, also owned machine drawings by Francesco di Giorgio. See *IRM*, 232.

30. Mutio Oddi to Matteo Bernardini, from Lucca, 30 October 1623. W30.1. Published in Ridolfi 1882, 371. The translation of the quote is from Alberti 1988, 223. Oddi also referred to *De re aedificatoria* in a letter outlining his work at the Certosa of Pavia (published in full in Gamba and Montebelli 1989), and intermittently in *Dello squadro*. See *LSU*, 141.

31. Eiche 1996. It should be noted that Oddi was equally familiar with more recent architectural theory. In a short, badly damaged, undated study, "Del ordine Toscano," he cited Palladio and Barbaro and referred to Bramante as a "famous architect" (OPU-FC, Busta 118, fasc. 4c). In a letter to his brother he noted, "I have seen the *Architettura* of Scamozzi, but because only fleetingly I have not been able to form an opinion of it. I have written to Camillo Giordani who is advising me on the cost." Mutio Oddi to Matteo Oddi, from Milan, 28 June 1617. OCU, fol. 570v. W31.1.

32. See chap. 1. Eiche (1996) has described the aesthetic character of Duke Francesco Maria II's court as austere. See also Bernardino Baldi's comments in his *Encomio* on restraint in architecture.

33. *IRM*, 230. Given its importance to aesthetics from antiquity onward, there is an enormous literature on the principle of proportion. See, e.g., Zöllner 1987; Weber and Larner 1993. For sixteenth and seventeenth-century Italian interest in proportion see Giusti 1993.

34. Fewer explicitly mathematical drawings are present in Oddi's extant oeuvre than in

those of comparable figures, such as Antonio da Sangallo the Younger. See Frommel and Adams 1994.

35. We should note, though, that the characteristics of Oddi's drawn architectural oeuvre are in part an accident of survival. Although a few carefully measured plans and survey drawings are extant, hardly any presentation drawings seem to have survived and only a handful of fortifications drawings is present in the albums.

36. Panofsky 1956, 9. On the role of aesthetics—in particular the properties of the circle and ellipse—in arguments about the cosmic systems, see McAllister 1996, chap. 10.

37. The only use of the oval that I have found in Oddi's architecture is in the *gheribizzi* he drafted while in prison; see prologue. He did, however, exhibit an interest in oval turnings; see chap. 5.

38. See Galileo 1953. On the wide-ranging significance of the circle in early modern astronomy, with particular reference to Kepler's own difficulties in accepting ellipses in the heavens, see Brackenridge 1982. Oddi's papers show that he worked intensely on the geometry of the circle. See, e.g., his mathematical notes in BUU-FC, Busta 120.

39. It should be noted that Vernaccia records a manuscript written by Oddi, now apparently lost, called *Lezioni de' principi della geometria necessari per l'intelligenza delle cose astronomiche.* LSU, 155n66.

40. Gorman and Marr 2007; Gorman 2000. I would like to reiterate my thanks to Michael John Gorman for his scholarly generosity and support in our work on the *Linder Gallery Interior.* The painting, currently in a private collection, once formed part of the Thomas Mellon Evans collection. See Mellon Evans 1998, lot 8. Its provenance can be traced through Baroness Sebag-Montefiore to the Viennese Rothschilds, for which see Gorman 2000.

41. Significant studies on the genre include Wadsworth Atheneum 1949; Speth-Holterhoff 1957; Winner 1957; Alpers 1983; Filipczak 1987, esp. 47–163; Härting 1989, 1993, 1996; Pomian 1991, 49–53; Honig 1995, 1998; Marr 2010a.

42. On *liefhebbers* (who were officially admitted as a particular category of member to Antwerp's Guild of Saint Luke in 1602) see Filipczak 1987. On the art market in the Low Countries in the period see, e.g., De Marchi and Van Miegroet 1994, 2006.

43. Giovanni Battista Caravaggio to Mutio Oddi, from Milan, 28 March 1629. OCU, fols. 793r–v. W43.1. The translation was first published in Gorman and Marr 2007.

44. Although Linder's collection was obviously substantial and embraced a wide variety of objects, it has not been possible to determine its contents with any degree of detail. Documents related to the collection of one Porfirio Linder, active in the second half of the seventeenth century (so perhaps Peter's son), are in Morselli 1998.

45. Several notarial documents related to Linder's personal life and business dealings are preserved in Milan's Archivio di Stato, including details of his creditors (who owed sums in the thousands of Milanese *lire*, an indication of Linder's prosperity), his purchase and sale of land and goods in Cassano d'Adda, his marriage to Caterina Gatti (on 1 May 1635, with a dowry of 5,000 *lire*: 3,000 in cash, 1,000 in jewels, and 1,000 in clothes), his move to Venice in the spring of 1635, and his return to Milan in 1642. The documents state clearly that Linder hailed from Nuremberg and that in Milan he lived in the parish of Maria Segreta. Linder's closeness to Oddi and his family is attested to by the fact that he named Matteo Oddi as his procurator fiscal on 1 February 1625, and that Mutio Oddi named Linder as *his* procurator fiscal on

9 March 1626. All of the notarial documents related to Linder (dated between 1625 and 1648) are in the archive's Fondo Notarile: Valerio Balestreri quondam Giovanni Battista, 27780–27788. I am grateful to Michael John Gorman and Antonio Battaglia for having shared with me their research into these documents. Stefano d'Amico has discovered that Linder was among the leading Milanese merchants who in 1628 protested against a transit duty in Chiavenna, on the trade route between Milan and Flanders. See D'Amico 2001, 708.

46. Practically nothing is known about Linder's astronomical interests beyond that which can be gleaned from the *Linder Gallery Interior*. The only other piece of evidence comes from Galileo's correspondence, in which Linder is referred to as somebody seeking information about his telescopic observations in Naples in 1639. See Fulgenzio Micanzio to Galileo, from Venice, 30 April 1639, in Galileo 1968, 18:45 (no. 3872). The fact that Linder's request came after Oddi's death might suggest that his stance on Galileo and the telescope softened after his friend's demise. For Oddi's interest in cosmology see *LSU*, 127–30.

47. In this regard he exemplifies the merchant-type figures discussed in Smith and Findlen 2001.

48. See chap. 3.

49. This was not the only medal struck in Oddi's honor. Another medal, commemorating his completion of the bastions and Porta San Donato, a key part of the fortifications of Lucca, was struck in 1627 (fig. 18). I think it likely that the same mold of the side showing Oddi's portrait was used for both medals. See Servolini 1932; Martinelli and Parmini 1991, 80. The shape of the table on which the medal rests is not entirely clear. It may be octagonal, but the skewed perspective renders it difficult to make out.

50. Portrait medals were, however, employed in a more general fashion to allude to the context in which "pictures of collections" were produced. Frans Francken the Younger, for example, included a double-portrait medal of the Archdukes Albert and Isabella, whose court was a key focus for artists involved in the genre, in his *Cabinet of a Collector* (1617), Royal Collection, inv. no. 405781.

51. Mutio Oddi to Camillo Giordani, from Milan, 19 May 1627. OCP, fol. 151r–v. W51.1. Oddi goes on to say that he will send one of the medals as soon as he has it. Aresi also helped Oddi with the *impresa* for *Dello squadro*, for which see prologue.

52. For an identification of the medals, and relevant bibliography, see Gorman and Marr 2007, 87. There is disagreement over whether or not the Bramante medal is a self-portrait, as suggested by Luke Syson in Scher 1994, 112–15. Pollard, following Vasari, attributes it to Cristoforo Caradossa Foppa. The medal shown in the *Linder Gallery Interior* is closer to the example now in the National Gallery of Art, Washington (fig. 17), than to the one in the British Museum, which has been gilded. See Pollard 2007, 234. Several of the figures portrayed in the medals may have been included not only as champions of *disegno* but also for their *patria*. Dürer hailed, like Linder, from Nuremberg, while Bramante was Urbino's most famous architect. Michelangelo was likely included as the period's most celebrated practitioner of all three arts of design. For Oddi and the *uomini illustri* tradition see chap. 1.

53. Gaetani 1761–73, 2:20–21. Although the area of the *Linder Gallery Interior* in which the Oddi medal is depicted has been affected by crackling, it is sufficiently legible to determine that the face, at least, is identical to that on the medal illustrated in the Mazzuchelli catalog. Notably, the inscription draws attention to Oddi's *patria* and gives precedence, as he himself did, to mathematics over architecture.

54. I have found no evidence to support the attribution of the medal to a particular maker, although, as Oddi explains in his letter, it was made in Milan.

55. Oddi's cosmology was essentially conservative, as discussed below, so an oblique reference to geocentrism is by no means out of the question. Alciati included a number of *imprese* featuring the heavens in his *Emblemata* (1531, with many subsequent editions), though none conform to Oddi's description. The inclusion of a portrait medal of Alciati in the *Linder Gallery Interior* suggests that Oddi was familiar with his work by the 1620s. In a notebook of 1637 he records having purchased a copy of the *Emblemata* in Venice. See OPU-FC, Busta 118, fasc. 4a, fol. 3r.

56. Oddi may well have employed theatrical devices in his work on festivities for Francesco Maria II in the 1590s. He was evidently familiar with stage technology, as in a letter of 1636 he explains the ways in which one might move "the person in the scene from one corner of the stage to the opposite one in the sky." Mutio Oddi to Camillo Giordani(?), from Lucca, 2 January 1636. OCP, fol. 135r. Oddi goes on to explain in detail two methods in which actors, suspended from ropes, can be moved. The first deploys a clever system of weights. The other ("much easier but less ingenious") involves a system of wooden beams. At the end of the letter Oddi notes that "Sabbatini will print a book of machines of comedy, and I am given to believe that there will be more ingenious things there" (fol. 135v), thus showing that he was aware of the Pesarese Niccolò Sabbatini's *Pratica di fabricar scene e machine ne' teatri*, published two years later in 1638. See Bragaglia 1952; Gamba and Montebelli 1995, 25–29.

57. See chap. 1.

58. See pp. 38–40.

59. See Dutschke 1981 (89–90 for Sonnet 118).

60. OCP, fol. 151r. W60.1.

61. Illustrated in Gorman and Marr 2007.

62. The double-portrait device may also allude to Rubens/Brueghel's inclusion of a double portrait of Archdukes Albert and Isabella in *The Sense of Sight* (fig. 34).

63. "Portraits" of dealers' shops and artists' ateliers have also been proposed. However, as Filipczak points out, the only certain representation of a dealer's shop in this vein dates from the late sixteenth century (Gillis Mostaert or François II Bunel, *The Removal of a Collection*, Mauritshuis, The Hague). Works such as Willem van Haecht's *Apelles Painting Campaspe* (ca. 1630, Mauritshuis, The Hague) are clearly allegorical. See also Marr 2010a.

64. It is not clear whether or not distinctions were made at the time between different types of "pictures of collections," usually referred to as *constkamer* in contemporary Flemish inventories. See Duverger 1984. It should be stressed that the boundaries between the categories listed here are decidedly blurred and porous. I have followed, in part, the typology proposed by Härting 1996. See also Honig 1998, 203–5; Marr 2010b.

65. These self-moving spheres—which were powered by changes in air pressure, making use of the same principles as the later barometer—achieved wide circulation within the Republic of Letters, not least because Rubens kept one in his studio (which contributed directly to their frequent inclusion in pictures of collections). I have found no evidence to suggest that either Oddi or Linder was aware of Drebbel's machine, although Oddi, as discussed in chap. 5, was familiar with other self-moving spheres of the period.

66. In fact, the gallery walls pit *Pictura Sacra* against *Pictura Profana*—a theme of

considerable interest to Federico Borromeo, who treated the subject in print. For an identification of the pictures see Mellon Evans 1998; Gorman and Marr 2007.

67. On vision and deception in the period see, e.g., Clark 2007.

68. The right-hand figure is a very close match to Rubens as he is depicted in the self-portrait in Windsor Castle and the 1630 engraving made from the self-portrait by Paulus Pontius. I have found no direct evidence connecting Linder, Oddi, and Rubens, but the latter's centrality to the Antwerp milieu, and his relationship to Bianchi (see notes to chap. 5) makes it entirely plausible that he was in some way involved in the commission of the *Linder Gallery Interior*. For a more detailed account of the relationship between the drawing and the painting, see Gorman and Marr 2007. Gorman has recently suggested that the third, younger figure might be intended as a portrait of Anthony Van Dyck. See Gorman 2009, 120.

69. Illustrated in Gorman and Marr 2007. For further discussion of the relationship between drawings and paintings in the "pictures of collections" genre see Marr 2010b.

70. Quoted in Bedoni 1983, 137.

71. For this reason, and because of its stylistic affinities to his work, I have attributed it to the circle of Jan the Elder. In my opinion, stylistically the work most closely resembles the anonymous *Cognoscenti in a Room Hung with Pictures* (ca. 1620, National Gallery, London, on which see Marr 2010b), although this work is painted on panel while the *Linder Gallery Interior* is painted on copper and the priming of the supports differs (a vigorous gray wash for the *Cognoscenti*, a flat off-white for the *Linder Gallery Interior*).

72. On Jan Brueghel the Younger's trip to Italy see Vaes 1926–27. The extremely high quality of the work, not to mention differences in style, also rules out other Antwerp painters to whom pictures of collections have been attributed, for which see Marr 2010b.

73. See part IV.

74. This culture of connoisseurship underpinned one of the most celebrated Milanese paintings of the age, the so-called *Quadro delle tre mani* (in fact *The Martyrdom of Saint Rufina and Saint Seconda*, ca. 1625, Milan, Brera), painted in collaboration by Procaccini, Cerano, and Morazzone—all of whose work was known to Oddi (see chap. 3). Collaborations of this type—devised to demonstrate the brilliance of the three artists and to test connoisseurs' ability to identify which sections had been painted by whom—are normally associated with the Antwerp milieu, and in particular with pictures of collections. Evidently, this *liefhebber* motif had traveled to Milan by the 1620s.

75. This work, which has also been attributed to Jan Brueghel the Elder and Adriaen van Stalbemt (see Christie's London, 23 July 1954 and December 13 1974), depicts an old man with a beard and flaming crown (derived from Cesare Ripa's *Intelletto* in his *Iconologia*), whom Winner identifies as *Disegno* combined with *Ammaestramento* (Instruction, represented in the *Iconologia* by a bearded man holding a mirror, though no mirror is evident here). Asleep in the lap of the old man is a winged female figure, with paintbrushes, palette, and maulstick identifying her as *Pictura*. See Winner 1957, 41–60. An almost identical interior, lacking the allegorical figures, also exists, reproduced in Honig 1998, 204.

76. Ripa 1613, 197. Somewhat unusually, in this edition of Ripa's work *Disegno* is depicted as a noble youth. A far more usual depiction, as a bearded old man, is found in Zuccaro's study for an *Allegory of Disegno,* on which see Herrmann-Fiore 1982.

77. In a letter to Justus Sustermans, Rubens explained, "I believe, if I remember rightly, that you will find under the feet of Mars a book as well as a drawing on paper, to imply that he treads underfoot all the arts and letters." Quoted in Filipczak 1987, 121.

78. Ripa 1613, 356. According to Ripa (in the second edition of the *Iconologia*), *Pictura*, should be portrayed wearing the mask of *Imitatio*. I have found no reference to Ripa in Oddi's papers, but it is entirely plausible that he was familiar with the *Iconologia*. Alternatively it is possible that, once Oddi and Linder had decided upon the personifications to be included in the painting, the artist turned to Ripa as a guide to the relevant iconography.

79. Quoted in Winner 1957, 52n163. Similarly, as Michael Cole has shown, for the sculptor Benvenuto Cellini *disegno* "did not allow upward withdrawal, but rather invested conduct, including especially the conducting of art, with cause, purpose, and meaning. *Disegno* was, for him, not the end of knowledge, but the means to virtue." Cole 2002, 121; see 121–48 for a thorough exploration of Cellini's ideas about design and virtue.

80. See chap. 4.

81. See M. L. Jones 2006, esp. chaps. 1 and 3.

82. It is worth noting that the instrument on the right is a *trerighe*, the type of surveying device that Oddi esteemed above all others. See chap. 5.

83. The armillary sphere is similar to an instrument dated 1578 and attributed to Carlo Plato, IMSS, inv. no. 1115. For the identification of all the instruments in the picture see Gorman and Marr 2007.

84. The Hondius globe is, in all probability, comparable to that requested by Camillo Giordani and supplied by Oddi (see chap. 5). That in the painting is very similar to the one illustrated and described in Van der Krogt 1993, 471–72, for which see fig. 35.

85. For Oddi's perspective teaching see chap. 2. Technical analysis of the painting undertaken by Rhona MacBeth in the conservation studios of the Museum of Fine Arts, Boston, has revealed a complex perspectival grid drawn on and incised into the ground. Infrared reflectography also shows that there are practically no *pentimenti*, suggesting that the work was probably executed by a single hand (although some uncertainty surrounds the allegorical figures). Rhona MacBeth, personal communication, 2007.

86. The identification of the Napier book was made only recently by Paolo Galluzzi. See Gorman and Marr 2009.

87. Astrology was at this time considered to be a mathematical art. It has not been possible to identify the individual whose geniture is represented if, indeed, it is intended to be that specific.

88. Following the terminology used by Oddi in his notebooks we can discern a *compasso mezzana*, a *compasso dalle divisioni*, a *compasso dalla vite diritta*, proportional dividers, and pens (see appendix C). The drawing instruments are very similar to those in the seventeenth-century Italian cased sets now in IMSS, inv. nos. I.127 and I.129. See also fig. 42.

89. The *Martyrdom* print is rolled at the bottom, which is consistent with the manner in which prints were stored in the *studiolo*. I am grateful to Michael Bury for this observation. The reason for the inclusion of this particular print is not immediately obvious. Gorman has associated it with Kepler (Gorman 2000), but I think it

more likely that Saint Catherine held some particular significance for either Oddi or Linder.

90. According to Paolo Giovanni, vicar forane of Fermignano, Oddi owned a copy of the Bramante medal: "Flaminio Caccialepi and Innocentio Pagani swear that they have seen a medal, with the impression and effigy of Bramante Asdrubaldino, with letters in the following form: 'Bramante Asdrovaldinus,' and signor Mutio Oddi, currently architect in Lucca, has one of the said medals." Quoted in Sangiorgi 1993, 252. The partial list of Oddi's possessions compiled, after his death, by Niccolò Vincenzi, included "five medals" and "five eyeglasses" ["Cinque medaglie . . . Cinque vetri d'occhiali"], suggesting that the lenses and most of the medals present in the painting might have come from his collection. See OPU-FCC VII, fol. 86r.

91. Ripa 1613, 197. Cf. Lorini's comments about design, quoted above.

92. Karel van Mander, *Schilder-boek* (1604), quoted in Winner 1957, 46. These observations about the *Linder Gallery Interior* were first made in Gorman 2000. On van Mander and *disegno* (loosely translated as *teyckenconst*) see Melion 1991, 95–108.

93. See Reeves 1997; Bredekamp 1995.

94. See, e.g., Biagioli 2006b.

95. Although neither Kepler nor his works are mentioned even once in Oddi's voluminous correspondence (including that portion of it from Linder that survives), his fame was such that Oddi must have been aware of his major contribution to the sciences. Moreover, as we have seen, the astronomical sundial Oddi devised using conic sections bears more than a passing resemblance to a diagram in Kepler's *Ad Vitellionem paralipomena*, suggesting that he may well have read at least some of Kepler's works. See figs. 48 and 49.

96. Gorman 2000, 2009.

97. Aside from the fact that the figure's resemblence to Kepler is not unequivocal, I am skeptical about this hypothesis since it implies an intimate relationship between the astronomer and those involved in the creation of the painting—a connection for which there is as yet no evidence.

98. On Leoni's portrait drawings see Spike 1985. It is not clear precisely when Leoni's portrait of Barocci was executed, nor whether it was taken from the life; it may have been based on Barocci's self-portrait. For Barocci's use of mathematical instruments see Marciari and Verstegen 2008.

99. If it is not a stretch too far, could we even see in the figure of *Disegno* the merging of Barocci and Kepler, that is to say the coming together of art and mathematics, of Oddi's Italy and Linder's Germany?

100. See Barbero, Bucciantini, and Camerota 2007 and, especially, Bucciantini 2008.

101. A payment, dated 2 May 1614, is recorded for "a telescope ordered from Venice for His Illustrious Lordship," and in 1621 Cavalieri reported to Galileo that the cardinal possessed a telescope "eight *braccia* long." Barbero, Bucciantini, and Camerota 2007, 310 and 312. Borromeo arranged his astronomical-cosmological notes into a draft treatise, "Occhiale celeste, sive celestis occultus" (BAM, MS I 52 suss.), parts of which are stridently anti-Galilean. See ibid., 321–41, for a brilliantly annotated edition of the manuscript. Interestingly, Borromeo refers briefly in the manuscript to a "schedule" of Ercole Bianchi, perhaps related to the latter's lost treatise *De astrologia* (see chap. 2). Ibid., 321, 328.

102. Bonaventura Cavalieri to Galileo, from Milan, 13 January 1621. Galileo 1968, 13:55. See also Favaro 1910. W102.1.

103. For the projected sphere see chap. 5.

104. See Barbero, Bucciantini, and Camerota 2007, 318.

105. The inclusion of the ignorant iconoclasts in a grisaille lunette at the rear of the gallery may be adduced in support of this interpretation. See Gorman and Marr 2007. It may be, too, that the motto refers to the fact that some have conceived of alternative systems to the Ptolemaic, Copernican, and Tychonic ones.

106. Mutio Oddi to Piermatteo Giordani, from Milan, 24 August 1622. OCP, fol. 105.v W106.1. See also *LSU*, 128–29. Oddi goes on to say that he may "wait until the nights are clear," suggesting he may have intended some sort of celestial observation. Although there is probably no direct connection between Scheiner's work and the *Linder Gallery Interior*, it is worth noting that the author's pseudonym for the publication was *Apelles latens post tabulam* (Apelles hiding behind the picture), a reference to the subject of one of the paintings that hangs in the gallery interior, and one that usually represents an ideal relationship between artist and patron.

107. Mutio Oddi to Piermatteo Giordani, from Lucca, 17 August 1634. OCP, fol. 241r. See also *LSU*, 128. The "artifice" concerned was the argument that comets are celestial rather than sublunary bodies. Oddi seems to have been on particularly good terms with Chiaramonti. In 1614 he arranged for a picture by Pellegrino (Tibaldi?) to be sent to him in Cesena. See Mutio Oddi to unknown recipient, from Milan, 30 July 1614. OCU, fol. 663v.

108. Peter Linder to Mutio Oddi, from Venice, 6 March 1638. OCU, fol. 972v. W108.1.

109. Peter Linder to Mutio Oddi, from Venice, 20 August 1638. OCU, fol. 978r. W109.1.

110. In a list of accounts payable to Linder, dated 8 July 1639, Oddi noted, "For an ivory telescope and its case—47 *lire* 17 *soldi*." OPU-FCC VII, fol. 30r. On 19 November 1639 Linder wrote to Oddi that he had sent to Urbino "the ivory telescope [l'ochiale d'avoiglio, overe canone]." OCU, fol. 988r. As Oddi died in December of that year he could hardly have had an opportunity to use it. Vincenzi listed this instrument twice, first under the "goods for sale" by Oddi's heirs (it was sold for just 3 *lire*), and again among the "various goods" inherited by the Vincenzi. See OPU-FCC VII, fols. 67v and 86r.

111. Indeed, in 1637 he purchased a concave and a convex lens, presumably to make his own telescope. See OPU-FC, Busta 118, fasc. 4a, fol. 3r. It is, of course, possible that Oddi was mainly skeptical about Galileo's position on comets, not the telescope in general, although his comments in *Dello squadro*, below, suggest a thoroughgoing mistrust of the device.

112. Oddi 1625, 108–9. W112.1.

113. For example, a telescope appears prominently in the foreground of *The Sense of Sight* (fig. 34).

114. For Oddi and mirrors see chap. 3.

115. Castiglione 2002, 58.

116. For the period's differing attitudes toward proof and persuasion, see Serjeantson 2006.

117. Gamba and Montebelli have, with some justification, described Oddi's attitude toward the sciences as an "Aristotelian-Archimedean concordance" (*LSU*, 129). For an elaboration of this point of view in relation to Urbinate conservatism, and the work of Guidbaldo del Monte in particular, see, in the present volume, chap. 1 and "Historiographical Note."

118. Gamba and Montebelli describe Oddi as "retrograde" in his approach to cosmol-

ogy (*LSU*, 129), a whiggish (and misleading) designation that privileges the Galilean view as truthful and innovative, the Tychonic as false and contrived. Contemporaries would not necessarily have taken this view.

EPILOGUE

1. Mutio Oddi to Camillo Giordani, from Lucca, 30 April 1636. OCP, fol. 278r. W1.1.

2. Mutio Oddi to the Council of the Republic of Lucca, no place or date [but late 1636]. OCU, fol. 631r. Oddi had in fact returned to Urbino shortly after Francesco Maria II's death. In 1633 the Republic of Lucca granted him a license to leave his duties temporarily so that he could attend to various family matters in his homeland (he arrived in late August and left toward the end of October). See Anziani e Gonfalonieri della Repubblica di Lucca to Mutio Oddi, from Lucca, 24 June 1633. OCU, fol. 669r. Upon his final release from the Republic's service he did not go straight to Urbino but in fact traveled to Loreto for a short while, in order to fulfill the vow he had made to complete his service to the Santa Casa. See *LSU*, 119. In his letters, Oddi explained that old age and ill health had dulled his ability to supervise engineering work effectively, but that he was willing to leave behind all of his working papers and models to ensure the work could be completed without hindrance. See notes to chap. 6.

3. In his last years, Oddi purchased fertile agricultural land in nearby Monte Fabbri, which effectively provided him with a generous pension. The accounts are in OPU-FCC V.

4. See chap. 1.

5. Oddi's notes on his conservation and restoration project are in OPU-FC, Busta 118, fasc. 4a and OPU-FCC VI. See also Bardovagni 1903.

6. Archivio di Stato, Urbino, Fondo Notarile. Rogiti del notaio Tommaso Martellini, vol. 2211: Testamenti 1627–55, fols. 112–20 (Hereafter *Oddi-Will*), at fol. 116r. W6.1. After Oddi's death, Niccolò Vincenzi recorded expenses for sending an *archipendolo* and books to Buonvisi, and a brass *squadro* and other instruments to Linder, "following the orders of signor Mutio." OPU-FCC VII, fol. 733. W6.2.

7. *Oddi-Will*, fol. 116v. Oddi expected the eight paintings listed to fetch 300 *scudi* each. He also left a painting of the "Madonna del sasso" to Francesco Maria Vincenzi, along with a gold medal worth 5 *zecchini*. *Oddi-Will*, fol. 116r. For the portraits of illustrious Urbinati that Oddi owned see chap. 1. Included in the goods distributed among his family, but not listed in the will, were portraits of Saint Francis di Paola, Saint Anthony of Padua, Saint Francis, and an unidentified woman, an *Adoration of the Magi*, and some "pitture da vigare." OPU-FCC VII, fols. 66r–v, fol. 67r.

8. *Oddi-Will*, fol. 115v. W8.1.

9. Fabio Liera to a member of the Vincenzi family, 30 October 1666. BUU-FCC, Busta 40, fasc. 6, fol. 313r. W9.1. Liera's letter forms part of a cache of documents in the Vincenzi archive dating from the 1660s, when the family was evidently trying to establish precisely what had happened to the contents of Oddi's *studiolo*. Other documents note that his goods were taken to Cagli, then sent on to Venice, presumably for sale (ibid., fol. 276r), and that the *studiolo* was sold in its entirety, including all the "books, mathematical instruments, and drawings by Raphael, and other ingenious things." Ibid., fol. 318r. W9.2. Liera noted that some of the instruments (namely a small pair of brass compasses, a brass level, a wooden quadrant with a magnetic compass, and a brass ruling pen) were sold to one signor Padre. Ibid., fol. 310r.

10. Niccolò and Guidobaldo made use of a loophole in Oddi's will, which stated that if his nephews had "no interest" in practicing the mathematical arts, the contents of his *studiolo* could be sold (*Oddi-Will*, fol. 115r). They were, in fact, scientifically inclined, as Niccolò's mathematical papers indicate, but evidently they were also feckless.

11. See *LSU*, 171–78.

12. Oddi's composition of the memorial tablet, and costs for its materials, are recorded in OPU-FC, Busta 118, fasc. 4a, fols. 2r–3r. The tablet was made in Venice and sent to Oddi by Linder. See Peter Linder to Mutio Oddi, from Venice, 19 November 1639. OCU, fol. 988r.

13. "Venerare igitur hospes nomen et genium loci, ne minere ludit in humanis divina potentia rebus et saepe in parvis claudere magna solet."

HISTORIOGRAPHICAL NOTE

1. On Galileo's relationship with the Urbino school see Favaro 1992; *IRM*; Galileo 1989; Renn et al. 2001; Bertoloni Meli 2006; Gamba 2007.

2. I am concerned here only with those authors who have treated the Urbino school as a whole, but there exist numerous important studies of individual Urbinate mathematicians that substantially nuance the account presented here. For the literature on Commandino, Guidobaldo, and Baldi individually see notes to chap. 1.

3. Drake 1969.

4. Ibid., 15. Drake offers as an example the fact that Guidobaldo rejected Jordanus's correct theory of the inclined plane because it was not sufficiently rigorous or elegant, accepting instead Pappus's incorrect, but aesthetically pleasing and geometrically firm, proof. For Oddi's interest in this see p. 53. It should be noted that Drake's reading of the Urbino school's conservatism was based in part on the highly influential work of Pierre Duhem. See Duhem 1905–6.

5. For sixteenth- and seventeenth-century mechanics in general, see Laird 1986; Bertoloni Meli 2006.

6. Rose differed somewhat from both Duhem's and Drake's assessment of the Urbino school's conservatism, particularly in relation to Guidobaldo, whom he saw as a vital link in the chain from ancient mechanics to Galileo's new science. See, e.g., *IRM*, 234–35.

7. Moreover, when assessing his subjects Rose was careful to include personal factors that might have affected their development, noting, for instance, that Commandino's father had been a student of architecture and had supervised the fortification of Urbino's walls (thus setting a precedent for his son's practical interests), or that Duke Francesco Maria II harbored scholarly pretensions, which led to his encouragement of new editions of classical texts (such as Commandino's edition of Euclid's *Elements*). *IRM*, 185, 203.

8. See Domenico Bertoloni Meli's astute review of *LSU* (Bertoloni Meli 1989). It should be noted that the bulk of the book was written by Gamba; only the section on the equilibrium debate was written by Montebelli.

9. *LSU*, 93–108.

10. Drake (1969) attaches far too much importance to the issue of language. For instance, Baldi noted that while Commandino lamented Luca Pacioli's appalling language, he nevertheless recognized the significance of his mathematics, and even

 planned to publish some of his works. Moreover, Commandino praised Bombelli's algebra and was in contact with both Tartaglia and Cardano. See *IRM*, 208 and (for Baldi's position vis-à-vis Cardano) 253.

11. Biagioli 1989, 60.

12. See, e.g., Gamba and Mantovani, forthcoming.

13. Wolfe 2004, 51.

14. The Urbino mathematicians were not hostile to displays of virtuosity or ingenuity, however—the Della Rovere court ensured that each was a major factor in their science.

15. Castiglione 2002, 32.

16. See *IRM*, 209. It should be noted that in the "Life of Commandino," in which he makes this observation, Baldi also claims that Commandino was a consummate courtier, able to penetrate deep mysteries with very little work. Wolfe (2004, 50) has taken the latter comments as indicative of Commandino's *sprezzatura*, but such a view is not born out by Commandino's extant work.

17. Biagioli's comments should, therefore, be placed in the wider context of the so-called mixed sciences, on which see, e.g., Laird 1983, 1997; Dear 1995; Lennox 1996.

18. Bertoloni Meli 1992, 6.

19. Ibid., 16.

20. Recently, however, Van Dyck has provided a convincing critique of certain aspects of Bertoloni Meli's account, particularly the notion that Guidobaldo was rigidly Aristotelian. See Van Dyck 2006. Moreover, it seems to me that Bertoloni Meli overemphasizes Commandino's challenge to established systems of knowledge on the basis of a handful of quotes, while downplaying the caution and conservatism evident in the mathematician's work as a whole.

APPENDIX A

1. Sigismondo Sfrondato was made a Cavaliere del Toson d'Oro in 1650. He fell at Graveline in Flanders in 1652. See Bagatti-Valsecchi 1875, Sfrondati, Tav. II.

2. Although Girolamo's surname is given as "Pozzi" by Oddi, the note that he is the son of "signor Presidente" leads me to believe that he was the son of Emanuele dal Pozzo. The date in this record is transcribed incorrectly as "26 Luglio" in Gamba and Montebelli 1989.

3. Sforza Felice Melzi, who would have been nearly seventeen when he began studying with Oddi, went on to have a distinguished military career. See Bagatti-Valsecchi 1875, Tav. VI.

4. Giovanni Angelo Crivelli, the Milanese architect-engineer, is listed as a recipient of Oddi's *Dello squadro* (see appendix B). It is not clear if he is related to the Crivellis listed here.

5. According to Felice Calvi, Guid'Antonio, the son of a wealthy banker, had an annuity of around 4,000 *scudi*. He was captain of the city militia in 1636. See Bagatti-Valsecchi 1875, Landriani, Tav. XII.

6. An Erasmo Caimi, son of Gaspare Caimi (Count of Turate from 1623) is listed as "Preposto della Scala ed Ecconomo Pontifico" in Cremonini 2003, 1:223. One Erasmo Caimo is listed among the *cavalieri* taking part in a ball in Negri 1602.

7. The "Peci" listed may be G. B. Pechio, commander of a Third Brigade in the 1620s. See Bagatti-Valsecchi 1875, Melzi, Tav. VI.

8. In Gamba and Montebelli 1989 the date is transcribed as 8 September 1619, yet it is unambiguously 8 January.

9. Neither a "Senatore" nor a "Tommaso" Trotti of appropriate date is listed in Bagatti-Valsecchi 1875.

10. See Bagatti-Valsecchi 1875, Borromei, Tav. XI.

APPENDIX B

1. Payments to Oddi from Arconati are at OPU-FCC III, fol. 23r, and IV, fol. 48v. His ownership of Luca Pacioli's *De divina proportione* (1509) is mentioned by Oddi in a letter to Alberico Settala, from Lucca, 10 April 1628. See *LSU*, 192.

2. See Manaresi 1957, 361–87.

3. Author of *Breve compendio di fortificazione moderna* (1639).

4. Visconti paid Oddi for two Officina compasses on 8 March 1623. OPU-FCC III, fol. 23r.

APPENDIX C

1. Hambly 1988, 57, and 57–68 for a general account of the development of pens and pencils. Ruling pens normally had a pair of blades at the end, sometimes in the shape of a leaf, and "relied on the inflexibility of the metal used to retain the opening to give a constant line thickness" (57). For the syntax of technical drawing see Lefèvre 2004.

2. Thomas Harriot's manuscripts are a good example of the use of the stylus to inscribe "invisible lines," as discussed in Schemmel 2008. See also Henninger-Voss 2004.

3. See, e.g., IMSS, inv. no. I.97.

4. See, e.g., IMSS, inv. nos. I.98, 99, and 100.

5. See, e.g., IMSS, inv. nos. I.94, 95, and 96.

6. Mutio Oddi to Camillo Giordani, from Lucca, 7 November 1639. OCP, fol. 175v. W6.1. Vagnarelli, who made such compasses for Giordani, explained, "Its utility is that it opens with one hand." Lorenzo Vagnarelli to Camillo Giordani, from Urbino, Saint John the Baptist's Day, 1630. BOP, MS 1564, fasc. 67, fol. Oddi's letter is published in full in Gamba 1994, 810–12.

7. See, e.g., IMSS, inv. no. I.107.

8. Oddi does not specify a purchaser so it is entirely plausible that this item was for his own use.

9. Two additional compasses listed once each in Oddi's accounts—the "little compass with brass reading plates" and the "compass with two springs"—cannot be identified with any known extant instrument.

10. See, e.g., IMSS, inv. no. I.92.

Bibliography

MANUSCRIPTS

Florence, Biblioteca Medicea Laurenziana: Codex Ashburnham Appendice 1828, Co-
dex Ashburnham 1357* (1281 bis).

Florence, Biblioteca Nazionale Centrale: *Medici Archive Project*, doc. ID 13892.

London, Windsor Castle, Royal Collection: Vols. 182 and 183 (A/20 and A/21).

Lucca, Archivio di Stato: *Fortificazioni*, vol. 10, part 2.

Milan, Archivio di Stato: *Fondo Notarile*, Valerio Balestreri quondam Giovanni Bat-
tista, 27780–27788.

Milan, Biblioteca Ambrosiana: MSS A 230 inf., A 299 inf., G 9(4) inf., G 9 inf. (nos. 2,
4), G 309 inf. (no. 13), P 236 sup., Z 387.

Milan, Biblioteca Trivulziana: MSS Triv. Cod. 222, 223, 224.

Pesaro, Biblioteca Oliveriana: MSS 375, 413, 422, 630, 1564 (fascicolo 67).

Urbino, Biblioteca Universitaria:
　　Fondo Comune, vol. 59; Busta 118, fascicolo 6; Busta 120, fascicolo 3.
　　Fondo Congregazione Carità, Busta 47, Fascicoli 2 and 5; Busta 53, fascicoli 1–8;
　　Busta 38, fascicolo 4.

PRINTED PRIMARY SOURCES

Accademici della Crusca. 1623. *Vocabolario degli Accademici della Crusca*. Venice:
Iacopo Sarzina.

Adorno, Francesco, and Luigi Zangheri, eds. 1998. *Gli Statuti dell'Accademia del Dis-
egno*. Florence: Leo S. Olschki, 1998.

Alberti, Leon Battista. 1988. *On the Art of Building, in Ten Books*. Trans. Joseph Rykw-
ert, Neil Leach, and Robert Tavernor. Cambridge, MA: MIT Press.

———.1991. *On Painting*. Trans. Cecil Grayson, ed. Martin Kemp. Harmondsworth:
Penguin.

Argelati, Filippo. 1745. *Bibliotheca scriptorum mediolensium*. 3 vols. Milan: Palatinus.

Bacon, Francis. 2004. *Novum Organum* (1620). Ed. Graham Rees with Maria Wakely.
The Oxford Francis Bacon, vol. 2. Oxford: Oxford University Press.

Baldi, Bernardino. 1707. *Cronica de' matematici overo epitome dell'istoria delle vite loro*.
Urbino: Angelo Antonio Monticelli.

———. 1724. *Memorie concernenti la città di Urbino*. Rome: Giovanni Maria Salviani.

———. 1998. *Le vite de' matematici*. Ed. with commentary by Elio Nenci. Milan:
FrancoAngeli.

Bellori, Giovanni Pietro. 1672. *Le vite de' pittori, scultori et architetti moderni*. Rome: Il Success. al Mascardi.

Blundeville, Thomas. 1594. *Exercises . . .* London: John Windet.

Castiglione, Baldassare. 2002. *The Book of the Courtier*. Trans. Charles S. Singleton, ed. Daniel Javitch. New York: Norton.

Cavalieri, Bonaventura. 1632. *Lo specchio ustorio, overo, Trattato delle settioni coniche*. Bologna: Clemente Ferroni.

Cimarelli, Vincenzo Maria. 1642. *Istorie dello stato d'Urbino*. Brescia: Per gli heredi di Bartolomeo Fontana.

Clavius, Christoph. 1611–12. *Opera mathematica*. Mayence: Reinhard Eltz.

Crivelli, Giovanni, ed. 1868. *Giovanni Brueghel pittor fiammingho o sue lettere e quadretti esistenti presso l'Ambrosiana*. Milan: Ditta Boniardi-Pogliani di E. Besozzi.

Dee, John. 1570. "Mathematicall Praeface." In Euclid, *The Elements of Geometrie*, ed. and trans. H. Billingsley. London: John Day.

Della Rovere, Francesco Maria II. 1989. *Diario di Francesco Maria II della Rovere*, ed. Fert Sangiorgi. Urbino: Quattroventi.

Diocles. 1976. *Diocles on Burning Mirrors*. Trans. D. J. Toomer. Berlin: Springer.

Duverger, Erik, ed. 1984–. *Antwerpse kunstinventarissen uit de zeventiende eeuw*. Fontes Historicae Artis Neerlandicae. 13 vols. Brussels: Koninklijke Academie voor Wetenschappen en Letterkunde.

Euclid. 1572. *Elementorum libri XV . . .* Ed. and trans. Federico Commandino. Pesaro: C. Francischinum.

Fine, Oronce. 1556. *De rebus mathematicis hactenus desideratis libri IV*. Paris: Michel de Vascosan.

Frommel, Christoph L., and Nicholas Adams, eds. 1994. *The Architectural Drawings of Antonio da Sangallo and His Circle*. Vol. 1, *Fortifications, Machines, and Festival Architecture*. New York: Architectural History Foundation; Cambridge, MA: MIT Press.

Gaetani, Pier Antonio. 1761–73. *Museum Mazzuchellianum, seu numismata virorum doctrina praestantium*. 2 vols. Venice: Antonio Zatta.

Galileo Galilei. 1953. *Dialogue concerning the Two Chief World Systems*. Trans. Stillman Drake. Berkeley: University of California Press.

———. 1957. *Discoveries and Opinions of Galileo*. Ed. and trans. Stillman Drake. New York: Doubleday.

———. 1968. *Opere di Galileo Galilei*. Ed. Antonio Favaro. 20 vols. Florence: Barbèra. (Reprint of 1890–1909 edition.)

———. 1978. *Operations of the Geometric and Military Compass*. Ed. and trans. Stillman Drake. Washington, DC: Burndy Library and Smithsonian Institution Press.

Garzoni, Tommaso. 1599. *La piazza universale di tutte le professioni del mondo*. Venice: Roberto Meietti. (1st ed., 1585.)

Grimani, Rafaelo. 1635. *Pratica facile e breve di molte sorte di horologi solari, orizontali, e verticali, e declinati*. Orvieto: Rinaldo Ruuli.

Gronau, Georg. 1935. *Documenti artistici urbinati*. Florence: n.p.

Hero of Alexandria. 1589. *De gli automati overo machine se moventi*. Ed. and trans. Bernardino Baldi. Venice: Girolamo Porro.

Lanteri, Giacomo. 1557. *Due dialoghi . . . del modo di disegnare le piante delle fortezze seconde Euclide*. Venice: Vincenzo Valgrisi.

Lomazzo, Giovanni Paolo. 1590. *Idea del tempio della pittura*. Milan: Paolo Gottardo Pontio.

Lorini, Buonaiuto. 1597. *Delle fortificationi . . . Libri Cinque*. Venice: Gio. Antonio Rampazetto.

Magini, Giovanni Antonio (after Ettore Ausonio). 1602. *Theorica speculi concavi sphaerici*. Bologna: Ioannem Baptistam Bellagambam.

Manzini, Carlo Antonio. 1660. *L'Occhiale all'occhio. Dioptra pratica*. Bologna: Benacci.

Montucla, Jean Étienne. 1758. *Histoire des mathèmatiques*. 2 vols. Paris: Antoine Jombert.

Morselli, Raffaella. 1998. *Collezioni e quadrerie nella Bologna del Seicento: Inventari, 1640–1707*. Los Angeles: Getty Institute.

Naudé, Gabriel. 1627. *Advis pour dresser une bibliothèque*. Paris: François Targa.

Negri, C. 1602. *Le gratie di amore*. Milan: Battista Piccaglia.

Oddi, Mutio. 1614. *Degli horologi solari*. Milan: Giacomo Lantoni.

——. 1625. *Dello squadro trattato*. Milan: Bartolomeo Fobella.

——. 1633. *Fabrica et uso del compasso polimetro*. Milan: Francesco Fobella.

——. 1638. *De gli horologi solari*. Venice: Ginnami.

——, ed. 1626. *Precetti di architettura militare* (by Matteo Oddi). Milan: Bartolomeo Fobella.

Ramus, Petrus. 1569. *Scholae mathematicae*. Basel: Eusebius Episcopius.

Ripa, Cesare. 1613. *Iconologia*. Siena: Heredi di Matteo Florimi.

Rossi, Giovanni Vittorio. 1643. *Pinacotheca imaginum*. Cologne: Cornelius van Egmond.

Sangiorgi, Fert, ed. 1976. *Documenti Urbinati: Inventari del Palazzo Ducale (1582–1631)*. Urbino: Accademia Raffaello.

——. 1982. *Committenze milanesi a Federico Barocci e alla sua scuola nel carteggio Vincenzi della Biblioteca Universitaria di Urbino*. Urbino: Accademia Raffaello.

Santi, Giovanni. 1985. *La vita e le gesta di Federico da Montefeltro, Duca d'Urbino: Poema in terza rima (Codice Vat. Ottob. lat. 1305)*. Ed. Luigi Michelini Tocci. Vatican: Bibliotheca Apostolica Vaticana.

Trenta, Tommaso. 1822. *Memorie e documenti per servire all'istoria del ducato di Lucca*. Vol. 8. Lucca: Francesco Bertini.

Varchi, Benedetto. 1549. *Lezzione . . . della maggioranza delle arti*. In *Scritti d'Arte del Cinquecento*, ed. Paola Barocchi. 3 vols., 1:99–106. Milan: R. Ricciardi, 1971–1977.

Vasari, Giorgio. 1966–87. *Le vite de' più eccellenti pittori, scultori e architettori, nelle redazione del 1550 e 1568*. Ed. Rosanna Bettarini. 6 vols. Florence: Sansoni Editore.

——. 1980. *The Lives of the Painters, Sculptors and Architects*. Trans. A. B. Hinds. 4 vols. London: J. M. Dent. (1st ed., 1927.)

Vives, Juan Luis. 1913. *Vives: On Education. De trandendis disciplinis*, trans. with an introduction by Foster Watson. Cambridge: Cambridge University Press.

PRINTED SECONDARY SOURCES

Ackerman, James S. 1991. "Architectural Practice in the Italian Renaissance." In *Distance Points: Essays in Theory and Renaissance Art and Architecture*, 361–416. Cambridge, MA: MIT Press.

Adams, Nicholas. 1985. "The Life and Times of Pietro dell'Abaco, a Renaissance Es-

timator from Siena (active 1457–1486)." *Zeitschrift für Kunstgeschichte* 48, no. 3:
384–95.

———. 1999. "Censored Anecdotes from Francesco Maria I della Rovere's *Discorsi militari*." *Renaissance Studies* 13:55–62.

Aimi, Antonio, Vincenzo de Michele, and Alessandro Morandotti, eds. 1984. *Musaeum Septalianum: Una collezione scientifica nella Milano del Seicento*. Florence: Giunti.

Aldeni, S. 1997. "L'Accademia di Bernardo Richino." In *Alle origini del barocco*, ed. Maria Luisa Gatti Perer, 103–6. Milan: Università Cattolica.

Allegretti, Girolamo. 1998. "Aspetti di vita economica e sociale." In Arbizzoni et al. 1998–2001, 1:167–91.

Alpers, Svetlana. 1983. *The Art of Describing: Dutch Art in the Seventeenth Century*. Chicago: University of Chicago Press.

Ames-Lewis, Frances. 1983. *Drawing in the Italian Renaissance Workshop*. London: Victoria and Albert Museum.

Andersen, Kirsti. 2007. *The Geometry of an Art: The History of the Mathematical Theory of Perspective from Alberti to Monge*. New York: Springer.

Andersen, Kirsti, and Henk J. M. Bos. 2006. "Pure Mathematics." In Park and Daston 2006, 696–723.

Anderson, Benedict. 1983. *Imagined Communities: Reflections on the Origin and Spread of Nationalism*. London: Verso.

Arbizzoni, Giulio, Antonio Brancati, and Maria Rosaria Valazzi, with Maria Letizia Brancati, eds. 1998–2001. *Pesaro nell'età dei Della Rovere*. 2 vols. Venice: Marsilio.

Ardissino, Erminia. 2001. *Il barocco e il sacro: La predicazione del Teatino Paolo Aresi tra letteratura, immagini e scienza*. Vatican: Libreria Editrice Vaticana.

Arrighi, Gino. 1982. "La matematica fra bottega d'abaco e studio in Toscana nel Medioevo." In *Università e società nei secoli XII–XVI*, 107–17. Pistoia: La Sede del Centro.

Ash, Eric H. 2004. *Power, Knowledge, and Expertise in Elizabethan England*. Baltimore: Johns Hopkins University Press.

Atkinson, Catherine. 2007. *Inventing Inventors in Renaissance Europe: Polydore Vergil's De inventoribus rerum*. Tubingen: Mohr Siebeck.

Bachielli, Rolando, ed. 2003. *Polidoro Virgili e la cultura umanistica europea: Atti del convegno internazionale di studi e celebrazioni*. Urbino: Accademia Raffaello.

Baffetti, Giovanni. 1994. "Federico Borromeo e i Lincei: La spiritualità della nuova scienza." In *Mappe e letture: Scritti in onore di Enzio Raimondi*, ed. Andrea Battistini, 85–102. Bologna: Il mulino.

Bagatti-Valsecchi, F., ed. 1875. *Famiglie notabili milanesi*. 4 vols. Milan: n.p.

Baiardi, Giorgio Cerboni, ed. 1986. *Federico da Montefeltro: Lo stato, le arti, la cultura*. Rome: Bulzoni.

Baldini, Ugo. 1983. "Christopher Clavius and the Scientific Scene in Rome." In *Gregorian Reform of the Calendar: Proceedings of the Vatican Conference to Commemorate its 400th Anniversary*, ed. G. V. Coyne, SJ, M. A. Hoskin, and O. Pedersen, 137–66. Vatican: Specola Vaticana.

———. 2003. "The Academy of Mathematics of the Collegio Romano from 1553 to 1612." In *Jesuit Science and the Republic of Letters*, ed. Mordechai Feingold, 47–98. Cambridge, MA: MIT Press.

Barbero, Giliola, Massimo Bucciantini, and Michele Camerota. 2007. "Uno scritto inedito di Federico Borromeo: L'Occhiale celeste." *Galilaeana* 4:309–41.

Bardovagni, G. 1903. "Cenno storico sulla casa paterna di Raffaello Sanzio." *Rassegna bibliografica dell'arte italiana* 6:97.

Baroncelli, Giovanna. 1983. "*Lo specchio ustorio* di Bonaventura Cavalieri." *Giornale critico della filosofia italiana*, 6th ser., 3, no. 2: 153 72.

Barsali, Isa Belli. 2000. *Ville e committenti dello stato di Lucca*. Lucca: Pacini Fazzi. (Reprint of 1983 edition.)

Barzman, Karen-edis. 1991. "Perception, Knowledge, and the Theory of *Disegno* in Sixteenth-Century Florence." In *From Studio to Studiolo: Florentine Draftsmanship under the First Medici Grand Dukes*, ed. Larry J. Feinberg, 37–48. Oberlin College, Allen Memorial Art Museum.

———. 2000. *The Florentine Academy and the Early Modern State: The Discipline of Disegno*. Cambridge: Cambridge University Press.

Baxandall, Michael. 1972. *Painting and Experience in Fifteenth-Century Italy: A Primer in the Social History of Pictorial Style*. Oxford: Clarendon Press.

Becchi, Antonio. 2004. *Q. XVI: Leonardo, Galileo, e il caso Baldi: Magonza, 26 marzo 1621*. Venice: Marsilio.

———. 2006. "Eggs, Turnips and Chains: Rhetoric and Rhetoricians of Architecture." In *Practice and Science in Early Modern Italian Building: Towards an Epistemic History of Architecture*, ed. H. Schlimme, 97–112. Milan: Electa.

Bedini, Silvio A. 1994a. " La biblioteca di Bernardo Facini, fabricante di strumenti scientifici a Venezia e Piacenza (1665–1731)." In *Science and Instruments in Seventeenth-Century Italy*, 75–84. Aldershot: Ashgate.

———. 1994b. "The Makers of Galileo's Scientific Instruments." In *Science and Instruments in Seventeenth-Century Italy*, 89–115. Aldershot: Ashgate.

———. 2001. "The Barocci Dynasty: Urbino's Artisans of Science 1550–1650." In *The Science of the Dukedom of Urbino*, ed. Flavio Vetrano, 7–98. Urbino: Accademia Raffaello.

Bedoni, Stefania. 1983. *Jan Brueghel in Italia e il collezionismo del Seicento*. Florence and Milan: n.p.

Bell, Maureen. 1996. "Women in the English Book Trade 1557–1700." *Leipziger Jahrbuch zur Buchgeschichte* 6:13–45.

Bellini, Amadeo, ed. 2006. *Il fondo di carte e libri "Raccolta Beltrami" nella Biblioteca d'Arte del Castello Sforzesco di Milano*. 2 vols. Milan: n.p.

Belloni, Luigi. 1969. "Testemonianze dell'anatomico Bartolomeo Eustachio per la storia del 'compasso geometrico e militare.'" *Physis* 11:69–88.

Bennett, James A. 1986. "The Mechanics' Philosophy and the Mechanical Philosophy." *History of Science* 24:1–28.

———. 1987. *The Divided Circle: A History of Instruments for Astronomy, Navigation and Surveying*. Oxford: Phaidon/Christie's Limited.

———. 1991a. "The Challenge of Practical Mathematics." In *Science, Culture and Popular Belief in Renaissance Europe*, ed. Stephen Pumfrey, Paolo Rossi and Maurice Slawinski, 176–90. Manchester: Manchester University Press.

———. 1991b. "Geometry and Surveying in Early Seventeenth-Century England." *Annals of Science* 48:345–54.

———. 1998. "Epact Unpacked: The Sundials of Miniato Pitti." *Sphaera. The Newsletter of the Museum of the History of Science, Oxford*, no. 8: 4–5.

———. 2000. "Harriot's Place on the Map of Learning." In *Thomas Harriot: An Elizabethan Man of Science*, ed. Robert Fox, 137–52. Aldershot: Ashgate.

———. 2002. "Geometry in Context in the Sixteenth Century: The View from the Museum." *Early Science and Medicine* 8:214–30.

———. 2003. "Knowing and Doing in the Sixteenth Century: What Were Instruments For?" *British Journal for the History of Science* 36, no. 2: 129–50.

———. 2006. "The Mechanical Arts." In Park and Daston 2006, 673–95.

Bennett, James A., and Domenico Bertoloni Meli. 1994. *Sphaera Mundi: Astronomy Books 1478–1600*. Cambridge: Whipple Museum of the History of Science.

Bennett, James A., and Stephen Johnston. 1996. *The Geometry of War (1500–1750)*. Oxford: Museum of the History of Science.

Bermingham, Ann. 1995. "The Consumption of Culture: Image, Object, Text." Introduction to *The Consumption of Culture 1600–1800: Image, Object, Text*, ed. Ann Bermingham and John Brewer, 1–20. London: Routledge.

———. 2000. *Learning to Draw: Studies in the Cultural History of a Polite and Useful Art*. New Haven: Yale University Press.

Berengo, Marino. 1965. *Nobili e mercanti nella Lucca del Cinquecento*. Turin: Einaudi.

Bertoloni Meli, Domenico. 1989. "Federico Commandino and His School." *Studies in History and Pilosophy of Science* 20, no. 3: 397–403.

———. 1992. "Guidobaldo del Monte and the Archimedean Revival." *Nuncius* 7, no. 1: 3–34.

———. 2006. *Thinking with Objects: The Transformation of Mechanics in the Seventeenth Century*. Baltimore: Johns Hopkins University Press.

Bertoni, Alberto. 1996. "Morazzone." In *Grove Dictionary of Art Online*, ed. Jane Turner. Oxford: Oxford University Press. (Accessed 2005.)

Biagioli, Mario. 1989. "The Social Status of Italian Mathematicians, 1450–1600." *History of Science* 27:41–95.

———. 1992. "Scientific Revolution, Social Bricolage, and Etiquette." In Porter and Teich 1992, 11–54.

———. 1993. *Galileo, Courtier: The Practice of Science in the Culture of Absolutism*. Chicago: University of Chicago Press.

———. 2006a. "From Print to Patents: Living on Instruments in Early Modern Europe." *History of Science* 44, no. 2: 139–86.

———. 2006b. *Galileo's Instruments of Credit: Telescopes, Images, Secrecy*. Chicago: University of Chicago Press.

———. Forthcoming. "Galilei v. Capra: Intellectual Property between Paper and Brass." *History of Science*.

Bianchi, A. 1999. "Cultura scolastica a Milano nei primi decenni del XVII secolo." In *Il giovane Borromini: Dagli esordi a San Carlo alle Quattre Fontane*, ed. Manuela Kahn-Rossi and Marco Franciolli, 45–51. Milan: Skira.

Biermann, Hartmut. 2002. "War Leon Battista Alberti je in Urbino?" *Zeitschrift für Kunstgeschichte* 65:493–521.

Bietenholz, Peter. 1966. *History and Biography in the Work of Erasmus of Rotterdam*. Geneva: Libraire Droz.

Black, Christopher H. 2001. *Early Modern Italy: A Social History*. London: Routledge.

Blunt, Anthony. 1940. *Artistic Theory in Italy, 1450–1600*. Oxford: Clarendon Press.

Bortolotti, A. 1880. "Artisti urbinati in Roma prima del secolo XVIII." *Il Raffaello* 12, no. 18: 273–74.

Brancati, Antonio. 2001. "La stampa a Pesaro tra XVI e XVII secolo." In Arbizzoni et al. 1998–2001, 2:3–35.

Brackenridge, J. Bruce. 1982. "Kepler, Elliptical Orbits, and Celestial Circularity: A Study in the Persistence of Metaphysical Commitment." *Annals of Science* 39, nos. 2 and 3: 117–43 (pt. 1), 265–95 (pt. 2).

Bragaglia, Anton Giulio. 1952. *Nicola Sabbatini e Giacomo Torelli scenotecnici marchigiani*. Pesaro: Ente artistico culturale.

Bredekamp, Horst. 1995. *The Lure of Antiquity and the Cult of the Machine: The Kunstkammer and the Evolution of Nature, Art, and Technology*. Trans. Allison Brown. Princeton, NJ: Princeton University Press.

———. 2001. "Gazing Hands and Blind Spots: Galileo as Draftsman." In Renn 2001, 153–92.

———. 2007. *Galilei der Künstler: Der Mond–Die Sonne–Die Hand*. Berlin: Akademie Verlag.

Brioist, Pascal. 2009. "'Familiar Demonstrations in Geometry': French and Italian Engineers and Euclid in the Sixteenth Century." *History of Science* 47, no. 1: 1–26.

Bruster, Douglas. 2001. "The New Materialism in Renaissance Studies." In *Material Culture and Cultural Materialisms in the Middle Ages and Renaissance*, ed. Curtis Perry, 225–38. Turnhout: Brepols.

Bucciantini, Massimo. 2008. "Federico Borromeo e la nuova scienza." In *Tra i fondi dell'Ambrosiana: Manoscritti italiani antichi e moderni*, ed. Marco Ballarini, Gennaro Barbarisi, Claudia Berra, and Giuseppe Frasso, 355–75. Milan: Cisalpino.

Buchdahl, Gerd. 1970. "History of Science and Criteria of Choice." In *Historical and Philosophical Perspectives of Science*, ed. Roger H. Stuewer, 204–30. Minneapolis: University of Minnesota Press.

Buchli, Victor. 2002. "Introduction." In *The Material Culture Reader*, 1–22. Oxford: Berg.

Burioni, Matteo. 2008. *Die Renaissance der Architekten: Profession und Souveränität des Baukünstlers in Giorgio Vasaris Viten*. Berlin: Gebr. Mann.

Burke, Jill. 2006. "Sex and Spirituality in 1500s Rome: Sebastiano del Piombo's Martyrdom of Saint Agatha." *Art Bulletin* 88, no. 3: 482–95.

Burke, Peter. 2005. "The Renaissance Translator as Go-Between." In Höefel and von Koppenfels 2005, 17–31.

Burnett, D. Graham. 2005. *Descartes and the Hyperbolic Quest: Lens Making Machines and Their Significance in the Seventeenth Century*. Philadelphia: American Philosophical Society.

Burns, Howard. 1974. "Progetti di Francesco di Giorgio per i conventi di San Bernardino e Santa Chiara di Urbino." In *Studi Bramanteschi: Atti del congresso internazionale*, 293–311. Rome: De Luca.

———. 1979. "A Drawing by L. B. Alberti." *Architectural Design* 49, nos. 5–6: 45–56.

———. 1980. "Un disegno architettonico di Alberti e la questione del rapporto fra Brunelleschi e Alberti." In *Filippo Brunelleschi: La sua opera e il suo tempo. Atti del Convegno*. 2 vols., 1:105–23. Florence: Centro Di.

Bury, Michael. 2001. *The Print in Italy 1550–1620*. London: British Museum Press.

Butters, Suzanne. 1996. *The Triumph of Vulcan: Sculptors' Tools, Porphyry, and the Prince in Ducal Florence*. 2 vols. Florence: Leo S. Olschki.

Büttner, Jochen, Peter Damerow, Jürgen Renn, and Matthias Schemmel. 2003. "The Challenging Images of Artillery: Practical Knowledge and the Roots of the Scientific Revolution." In *The Power of Images in Early Modern Science*, ed. Wolfgang Lefèvre, Jürgen Renn and Urs Schoepflin, 3–27. Basel: Birkhäuser.

Calzini, E. 1916. "Dei Barocci costruttori d'istrumenti matematici ed astronomici." *Rassegna bibliografica dell'arte italiana* 19, nos. 1–5: 31–32.

Camerota, Filippo. 2000. *Il compasso di Fabrizio Mordente: Per la storia del compasso di proporzione*. Florence: Leo S. Olschki.

———. 2003. "Two New Attributions: A Refractive Dial of Guidobaldo del Monte and the 'Roverino Compass' of Fabrizio Mordente." *Nuncius* 18:25–38.

———. 2004. "Galileo's Eye: Linear Perspective and Visual Astronomy." *Galilaeana* 1:143–70.

———. 2006. "Teaching Euclid in a Practical Context: Linear Perspective and Practical Geometry." *Science & Education* 15:323–34.

———. 2008. "La Tradizione dell'Abaco." In Camerota and Miniati 2008, 23–30.

———, ed. 2001. *Nel segno di Masaccio: L'invenzione della prospettiva*. Florence: Giunti.

Camerota, Filippo, and Mara Miniati, eds. 2008. *I Medici e le scienze: Strumenti e macchine nelle collezioni granducali*. Florence: Giunti.

Canino, Mario. 2002. "La Libreria Ducale di Casteldurante da Federico Commandino a Bonaiuto Lorini: Geometria, matematica e tecnica della misurazione nel Rinascimento italiano." In Cleri et al. 2002, 3:143–72.

Carruccio, Ettore. 1971. "Cavalieri, Bonaventura." In *Dictionary of Scientific Biography*, ed. Charles Coulston Gillispie, 3:149–53. New York: Charles Scribner's Sons.

Chambers, David S., ed. 1970. *Patrons and Artists of the Italian Renaissance*. London: Macmillan.

Chandler, Bruce, and Clare Vincent. 1969. "Three Nürnberg Compassmacher: Hans Troschel the Elder, Hans Troschel the Younger, and David Beringer." *Metropolitan Museum Journal* 2:211–16.

Chartier, Roger. 1998. *Cultural History: Between Practices and Representations*. Trans. Lydia G. Cochrane. Cambridge: Cambridge University Press.

Chatelet-Lange, Liliane. 1976. "La 'forma ovale si come costumarono li antichi romani': Salles et cours ovales en France au seizième siècle." *Architectura* 6, no. 2: 128–47.

Cheles, Luciano. 1986. *The Studiolo of Urbino: An Iconographic Investigation*. University Park: Pennsylvania State University Press.

Chesters, Timothy. 2010. *Ghost Stories in Late Renaissance France: Walking by Night*. Oxford: Oxford University Press.

Chiapelli, F., ed. 1985. *The Fairest Flower: The Emergence of Linguistic National Consciousness in Renaissance Europe*. Florence: Accademia della Crusca.

Christiansen, Keith, ed. 2005. *From Filippo Lippi to Piero della Francesca: Fra Carnevale and the Making of a Renaissance Master*. New York: Metropolitan Museum of Art; New Haven: Yale University Press.

Ciaravino, Joselita. 2004. *Un Art Paradoxal: La notion de* Disegno *en Italie (XVème-XVIème siècles)*. Paris: L'Harmattan.

Cifoletti, Giovanna. 1993. "Mathematics and Rhetoric: Jacques Peletier, Guillaume Gosselin and the Making of the French Algebraic Tradition." PhD diss., Princeton University.

———. 2009. "Oronce Fine's Legacy in the French Algebraic Tradition." In Marr 2009b, 172–90.

Cipolla, Carlo M. 1952. *Mouvements monétaires dans l'Etat de Milan, 1580–1700*. Paris: Colin.

Clark, Stuart. 2007. *Vanities of the Eye: Vision in Early Modern European Culture*. Oxford: Oxford University Press.

Cleri, Bonita, Sabine Eiche, John E. Law, and Feliciano Paoli, eds. 2002. *I Della Rovere: Nell'italia delle corti.* 4 vols. Urbino: Quattroventi.

Clough, Cecil H. 1963. "Sources for the History of the Court and City of Urbino in the Early Sixteenth Century." *Manuscripta* 7, no. 2: 67–79.

———. 1981a. *The Duchy of Urbino in the Renaissance.* London: Variorum Reprints.

———. 1981b. "The Library of the Dukes of Urbino." In Clough 1981a, chap. 6.

Clucas, Stephen. 2000. "Thomas Harriot and the Field of Knowledge in the English Renaissance." In *Thomas Harriot: An Elizabethan Man of Science*, ed. Robert Fox, 93–136. Aldershot: Ashgate.

Clulee, Nicholas H. 1998. *John Dee's Natural Philosophy: Between Science and Religion.* London: Routledge.

Cochrane, Eric, ed. 1970. *The Late Italian Renaissance 1525–1630.* London: Macmillan.

———. 1981. *Historians and Historiography in the Italian Renaissance.* Chicago: University of Chicago Press.

Cole, Michael W. 2002. *Cellini and the Principles of Sculpture.* Cambridge: Cambridge University Press.

———. 2009. Review of Horst Bredekamp, *Galilei der Künstler: Der Mond–Die Sonne–Die Hand. Art Bulletin* 91, no. 3: 381–84.

Collection Spitzer. 1893. *Catalogue des Objets d'Art et de haute Curiosité, Antiques, du Moyen Age & de la Renaissance Composant l'important et précieuse Collection Spitzer.* Paris, April 12–15, 1893.

Collobi, Licia Ragghianti. 1974. *Il Libro de' disegni del Vasari.* Florence: Vallecchi.

Comincini, Mario. 2010. *Jan Brueghel accanto a Figino: La quadreria di Ercole Biauchi.* In Curia Picta.

Connors, Joseph. 1990. "*Ars Tornandi*: Baroque Architecture and the Lathe." *Journal of the Warburg and Courtauld Institutes* 53:217–36.

Conti, Lino, ed. 1992. *La matematizzazione dell'universo: Momenti della cultura matematica tra '500 e '600.* Assisi: Porziuncola.

Cook, Harold J. 2007. *Matters of Exchange: Commerce, Medicine, and Society in the Dutch Golden Age.* New Haven: Yale University Press.

Cools, Hans, Marika Keblusek, and Badeloch Noldus, eds. 2006. *Your Humble Servant: Agents in Early Modern Europe.* Hilversum: Verloren.

Coppa, Simonetta. 1977a. "Note d'archivio su Ingegneri-Architetti Collegiati di Milano dei Secoli XVI–XVIII." *Arte Lombarda* 47–48:145–58.

———. 1977b. "Due opere di Ambrogio Figino in una donazione del 1637." *Arte Lombarda* 47–48:143–144.

Cremonini, C., ed. 2003. *Teatro genealogico delle famiglie nobili milanesi. manoscritti 11500 e 11501 della Biblioteca Nacional de Madrid.* 2 vols. Mantova: Arcari.

Crombie, Alastair C. 1994. *Styles of Scientific Thinking in the European Tradition: The History of Argument and Explanation Especially in the Mathematical and Biological Sciences.* 3 vols. London: Duckworth.

Cuomo, Serafina. 1997. "Shooting by the Book: Notes on Niccolò Tartaglia's *Nova Scientia*." *History of Science* 35:155–88.

Dal Poggetto, Paolo, ed. 2004. *I Della Rovere: Piero della Francesca, Raffaello, Tiziano.* Milan: Electa.

Damianaki, Chrysa. 2000. *Galileo e le arti figurative.* Roma: Vecchierelli.

D'Amico, Stefano. 1994. *Le contrade e la città: Sistema produttivo e spazio urbano a Milano fra Cinque e Seicento.* Milan: FrancoAngeli.

———. 2001. "Rebirth of a City: Immigration and Trade in Milan, 1630–59." *Sixteenth Century Journal* 32, no. 2: 697–721.

Daston, Lorraine. 2004. "Introduction." In *Things That Talk: Object Lessons from Art and Science*, ed. Lorraine Daston, 9–24. New York: Zone Books.

Daston, Lorraine, and Michael Otte, eds. 1991. "Style in Science." Special issue. *Science in Context* 4, no. 2.

Daston, Lorraine, and Katherine Park. 1998. *Wonders and the Order of Nature, 1150–1750*. New York: Zone Books.

Davis, A. E. L. 1975. "Systems of Conics in Kepler's Work." *Vistas of Astronomy* 18:673–85.

Davis, Natalie Zemon. 1983. *The Return of Martin Guerre*. Cambridge, MA: Harvard University Press.

———. 1989. "Beyond the Market: Books as Gifts in Sixteenth-Century France." *Transactions of the Royal Historical Society*, 5th ser., 33:114–19.

———. 2000. *The Gift in Sixteenth-Century France*. Oxford: Oxford University Press.

Dear, Peter. 1995. *Discipline and Experience: The Mathematical Way in the Scientific Revolution*. Chicago: University of Chicago Press.

Dekker, Elly. 2000a. "The Demongent Tradition in Globe Making." In *Globes at Greenwich: A Catalogue of the Globes and Armillary Spheres in the National Maritime Museum*, ed. Elly Dekker, 69–74. Oxford: Oxford University Press.

———. 2000b. "The Phenomena: An Introduction to Globes and Spheres." In *Globes at Greenwich: A Catalogue of the Globes and Armillary Spheres in the National Maritime Museum*, ed. Elly Dekker, 3–12. Oxford: Oxford University Press.

De Marchi, Neil, and Hans J. van Miegroet. 1994. "Art, Value, and Market Practices in the Netherlands in the Seventeenth Century." *Art Bulletin*, no. 86: 451–64.

———, eds. 2006. *Mapping Markets for Paintings in Europe, 1450–1750*. Turnhout: Brepols.

De Mullenheim, Marie. 2002. "Le système de brevets d'invention à Florence fin XVIème–XVIIème siècle." MA diss., Université François Rabelais, Tours.

Dempsey, Charles. 1980. "Some Observations on the Education of Artists in Florence and Bologna during the Later Sixteenth Century." *Art Bulletin* 62, no. 4: 552–69.

Dennistoun, James. 1851. *Memoirs of the Dukes of Urbino*. 3 vols. London: Longman, Brown, Green and Longmans.

De Renzi, Silvia. 2000. *Instruments in Print: Books from the Whipple Collection*. Cambridge: Whipple Museum of the History of Science.

De Vivo, Filippo. 2007. *Information and Communication in Venice: Rethinking Early Modern Politics*. Oxford: Oxford University Press.

Devlieger, Lionel. 2005. "Benedetto Varchi on the Birth of Artefacts: Architecture, Alchemy and Power in Late-Renaissance Florence." PhD diss., University of Ghent.

Díaz, José Simón. 1952–59. *Historia del Colegio Imperial de Madrid*. 2 vols. Madrid: Consejo Superior des Investigationes Científicas.

Diefendorf, Barbara B., and Carla A. Hesse, eds. 1994. *Culture and Identity in Early Modern Europe (1500–1800): Essays in Honour of Natalie Zemon Davies*. Ann Arbor: University of Michigan Press.

Diemer, Dorothea. 1985. "Giovanni Ambrogio Maggiore und die Anfänge der Kunstdrechselei um 1570." *Jahrbuch des Zentralinstituts für Kunstgeschichte* 1:295–342.

———. 1996. "Giovanni Ambrogio Maggiore." In *Grove Dictionary of Art Online*, ed. Jane Turner. Oxford: Oxford University Press. (Accessed 2005.)

Dijksterhuis, Fokko Jan. 2007. "Constructive Thinking: A Case for Dioptrics." In Roberts, Schaffer, and Dear 2007, 59–82.

Donati, Claudio. 1988. *L'idea di nobiltà in Italia secolo XIV–XVII*. Rome: Laterza.

Dooley, Brendan. 1991. *The Social History of Skepticism: Experience and Doubt in Early Modern Culture*. Baltimore: Johns Hopkins University Press.

Drake, Stillman. 1969. "Introduction." In Stillman Drake and I. E. Drabkin, *Mechanics in Sixteenth-Century Italy: Selections from Tartaglia, Benedetti, Guido Ubaldo, and Galileo*, 3–60. Madison: University of Wisconsin Press.

Drake-Brockmann, Jenniffer. 1994. "The *perpetuum mobile* of Cornelius Drebbel." In *Learning, Language and Invention: Essays Presented to Francis Maddison*, ed. Willem D. Hackmann and Anthony J. Turner, 124–47. Aldershot: Ashgate Publishing.

Duhem, Pierre. 1905–6. *Les origines du statique*. 2 vols. Paris: A. Hermann.

Dupré, Sven. 2003. "The Dioptrics of Refractive Dials in the Sixteenth Century." *Nuncius* 18, no. 1: 39–68.

———. 2005. "Ausonio's Mirrors and Galileo's Lenses: The Telescope and Sixteenth-Century Practical Optical Knowledge." *Galilaeana* 2:145–80.

———. 2006. "Visualization in Renaissance Optics: The Function of Geometrical Diagrams and Pictures in the Transmission of Practical Knowledge." In *Transmitting Knowledge: Words, Images, and Instruments in Early Modern Europe*, ed. Sachiko Kusukawa and Ian Maclean, 11–39. Oxford: Oxford University Press.

———. 2009. "Printing Practical Mathematics: Oronce Fine's *De speculo ustorio* between Paper and Craft." In Marr 2009b, 64–82.

Dupré, Sven, and Michael Korey. 2006. "The Use and Re-use of Optical Instruments: Creating Knowledge in the Dresden *Kunstkammer*." In *Who Needs Scientific Instruments? Conference on Scientific Instruments and Their Users, 20–22 October 2005*, ed. Bart Grob and Hans Hooijmaijers, 75–80. Leiden: Museum Boerhaave.

Dupré, Sven, and Christoph Lüthy, eds. 2010. *Silent Messengers: The Circulation of Material Objects of Knowledge in the Early Modern Low Countries*. Berlin: LIT Verlag.

Dutschke, Dennis. 1981. "The Anniversary Poems in Petrarch's *Canzoniere*." *Italica* 58, no. 2: 83–101.

Eagleton, Catherine. 2006. "Medieval Sundials and Manuscript Sources: The Transmission of Information about the Navicula and the *Organum Ptolomei* in Fifteenth-Century Europe." In *Transmitting Knowledge: Words, Images, and Instruments in Early Modern Europe*, ed. Sachiko Kusukawa and Ian Maclean, 41–71. Oxford: Oxford University Press.

———. 2009. "Oronce Fine's Sundials: The Sources and Influences of *De solaribus horologiis*." In Marr 2009b, 83–99.

Eamon, William. 1991. "Court, Academy, and Printing House: Patronage and Scientific Careers in Late Renaissance Italy." In Moran 1991, 25–50.

———. 1994. *Science and the Secrets of Nature: Books of Secrets in Medieval and Early Modern Culture*. Princeton, NJ: Princeton University Press.

Edgerton, Samuel Y., Jr. 1984. "Galileo, Florentine 'Disegno' and the 'Strange Spotted-nesse' of the Moon." *Art Journal* 44, no. 3: 225–32.

———. 1991. *The Heritage of Giotto's Geometry: Art and Science on the Eve of the Scientific Revolution*. Ithaca: Cornell University Press.

Eiche, Sabine. 1993. "An Unknown Document and Drawing for the Cathedral of Urbino." In *Studi per Pietro Zampetti*, ed. Roberto Varese, 180–82. Ancona: Lavoro Editoriale.

———. 1996. "Muzio Oddi." In *Grove Dictionary of Art Online*, ed. Jane Turner. Oxford: Oxford University Press. (Accessed 2004.)

———. 2003. *Il barco di Casteldurante all'epoca dell'ultimo duca d'Urbino*. Urbino: Quattroventi.

———, ed. 2005. *I Gheribizzi di Muzio Oddi*. Urbino: Accademia Raffaello.

Eichenberger, Thomas. 1987. *Patria: Studien zur Bedeutung des Wortes im Mittelalter (6.–12. Jahrhundert)*. Sigmaringen: Jan Thorbecke.

Eisenstein, Elizabeth S. 1979. *The Printing Press as an Agent of Change: Communications and Cultural Transformations in Early Modern Europe*. 2 vols. Cambridge: Cambridge University Press.

Elkins, James. 1996. "Style." In *Grove Dictionary of Art Online*, ed. Jane Turner. Oxford: Oxford University Press. (Accessed 2005.)

Emerson, Patricia. 1991. "Grazia." *Renaissance Studies* 5, no. 4: 427–60.

Evans, R. J. W. 1973. *Rudolph II and His World: A Study in Intellectual History, 1576–1612*. Oxford: Clarendon Press.

Evans, R. J. W., and Alexander Marr, eds. 2006. *Curiosity and Wonder from the Renaissance to the Enlightenment*. Aldershot: Ashgate.

Fahy, Connor. 1993. *Printing a Book at Verona in 1622: The Account Book of Francesco Calzolari Junior*. Paris: Foundation Custodia.

Farago, Claire J. 1991. "The Classification of the Visual Arts in the Renaissance." In *The Shapes of Knowledge from the Renaissance to the Enlightenment*, ed. Donald R. Kelley and Richard H. Popkin, 23–48. Dordrecht: Kluwer Academic.

Favaro, Antonio. 1910. "Amici e corrispondenti di Galileo Galilei. XXIII. Federico Borromeo." In *Miscellanea Ceriani*, 5–24. Milan: Hopeli.

———. 1983. *Amici e corrispondenti di Galileo Galilei*. Vol. 20, *Fulgenzio Micanzio*. Florence: Salimbeni.

———. 1992. "Galileo e Guidobaldo del Monte." In *Scampoli galilaeiani*, ed. Lucia Rossetti and Maria Laura Soppelsa. 2 vols., 2:716–23. Trieste: Lint.

Feingold, Mordechai. 1984. *The Mathematicians' Apprenticeship: Science, Universities, and Society in England 1560–1640*. Cambridge: Cambridge University Press.

Field, J. V. 1997. *The Invention of Infinity: Mathematics and Art in the Renaissance*. Oxford: Oxford University Press.

———. 2005. *Piero della Francesca: A Mathematician's Art*. New Haven: Yale University Press.

Filipczak, Zirka Zaremba. 1987. *Picturing Art in Antwerp 1550–1700*. Princeton, NJ: Princeton University Press.

Findlen, Paula. 1991. "The Economy of Scientific Exchange in Early Modern Italy." In Moran 1991, 5–24.

———. 1996. *Possessing Nature: Museums, Collecting, and Scientific Culture in Early Modern Italy*. Berkeley: University of California Press.

———. 1998. "Possessing the Past: The Material World of the Italian Renaissance." *American Historical Review*, no. 103: 83–114.

Finocchiaro, Maurice A. 2005. *Retrying Galileo, 1633–1992*. Berkeley: University of California Press.

Fiocca, Alessandra. 1995. "'Libri d'Architettura et Matematica nella biblioteca di Giovan Battista Aleotti." *Bollettino di Storia delle Scienze Matematiche* 15, no. 1: 85–132.

———, ed. 1998. *Giambattista Aleotti e gli ingegneri del Rinascimento*. Florence: Leo S. Olschki.

Fiocca, Alessandra, Daniela Lamberini, and Cesare Maffioli, eds. 2003. *Arte e scienza delle acque nel Rinascimento*. Venice: Marsilio.

Fletcher, J. M. 1981. "Change and Resistance to Change: A Comparison of the English and German Universities during the Sixteenth Century." *History of Universities* 1:1–36.

Fondazione Treccani degli Alfieri. 1953–62. *Storia di Milano*. Milan: Fondazione Treccani degli Alfieri.

Franci, Raffaella, and Laura Toti Rigatelli. 1982. *Introduzione all'algebra mercantile del medievo e del Rinascimento*. Urbino: Quattroventi.

Frangi, Francesco. 1996. "Milano *circa* 1620: L'Accademia di Federico Borromeo e gli esordi di Daniele Crespi." *Nuovi Studi* 1:125–49.

Frasca-Spada, Marina, and Nick Jardine, eds. 2000. *Books and the Sciences in History*. Cambridge: Cambridge University Press.

Gage, Frances. 2010. "Giulio Mancini and Artist-Amateur Relations in Seventeenth-Century Roman Academies." In *The Accademia Seminars: The Accademia di San Luca in Rome, c. 1590–1635*, ed. Peter M. Lukehart, 247–87. Washington, DC: National Gallery of Art.

Galileo Galilei. 1989. *Galileo Galilei e gli scienziati del ducato di Urbino: Atti del Convegno* (editor unknown). Pesaro: n.p.

Galluzzi, Paolo. 1996. *Renaissance Engineers: From Brunelleschi to Leonardo da Vinci*. Florence: Giunti.

Gamba, Enrico. 1994. "Documenti di Muzio Oddi per la storia del compasso di riduzione e di proporzione." *Physis* 31:799–815.

———. 1998. "Guidobaldo del Monte: Matematico e ingegnere." In *Giambattista Aleotti e gli ingegneri del Rinascimento*, ed. Alessandra Fiocca, 341–51. Florence: Leo S. Olschki.

———. 2001. "Le scienze fisiche e matematiche dal Quattrocento al Seicento." In Arbizzoni et al. 1998–2001, 2:75–110.

———. 2007. "Galileo e l'ambiente scientifico urbinate: Testimonianze epistolari." *Galilaeana* 4:343–60.

Gamba, Enrico, and Roberto Mantovani. Forthcoming. "Gli strumenti scientifici di Guidobaldo del Monte." In *Guidobaldo del Monte*, ed. Domenico Bertoloni Meli, Antonio Becchi, and Enrico Gamba. Florence: Leo S. Olschki.

Gamba, Enrico, and Vico Montebelli. 1988. *Le scienze a Urbino nel tardo Rinascimento*. Urbino: Quattroventi. (Abbreviated in notes as *LSU*.)

———. 1989. "Memorie, conti, lavori di Muzio Oddi, architetto e matematico urbinate dell'epoca galileiana." In *Galileo Galilei e gli scienziati del Ducato d'Urbino, atti del convegno, Pesaro, 14 October 1989*, 35–62. Pesaro: n.p.

———. 1995. *Macchine da teatro e teatri di macchine*. Urbino: Quattroventi.

Gatti Perer, Maria Luisa. 1965. "Fonti per la storia dell'architettura Milanese dal XVI al XVIII secolo: Il Collegio degli Agrimensori, Ingegneri e Architetti. L'Archivio di Cancelleria e le nomine degli architetti dal 1564 al 1734." *Arte Lombarda* 10:115–30.

———. 1997. "Nuovi argomenti per Francesco Borromini." *Arte Lombarda* 121:5–42.

———. 2004. "Per l'avanzamento degli studi sulla difesa della Lombardia spagnola: Il contributo della Raccolta Ferrari." In *La difesa della Lombardia Spagnola*, ed. Graziella Colmuto Zanella and Luciano Roncai, 23–36. Milan: Ronca Editore.

Gay, Hannah. 1977. "Noble Gas Compounds: A Case Study in Scientific Conservatism and Opportunism." *Studies in History and Philosophy of Science* 8, no. 1: 61–70.

Geertz, Clifford. 1973. "Thick Description: Towards an Interpretative Theory of Culture." In *The Interpretation of Cultures: Selected Essays*, 3–30. New York: Basic Books.

Geison, Gerald L. 1998. "Research Schools and New Directions in the Historiography of Science." *Osiris*, 2nd ser., 8 ("Research Schools: Historical Reappraisals"): 226–38.

Gensini, Stefano, and Arturo Martone, eds. 2002. *Ingenium propria hominis natura.* Naples: Liguori.

Gille, Bertrand. 1964. *Les ingénieurs de la Renaissance*. Paris: Hermann.

Gingerich, Owen. 2009. "The Curious Case of the M-L Sidereus Nuncius." *Galilaeana* 6:141–66.

Ginzburg, Carlo. 1980. *The Cheese and the Worms: The Cosmos of a Sixteenth-Century Miller*. Baltimore: Johns Hopkins University Press.

———. 1993. "Microhistory, Two or Three Things That I Know about It." *Critical Enquiry* 22, no. 1: 10–35.

Giusti, Enrico. 1993. *Euclides reformatus: La teoria della proporzioni nella scuola galileiana*. Turin: Bollati Boringhieri.

Gliozzi, G. 1960. "Cardano, Gerolamo." In *Dizionario Biografico degli Italiani*, 19:758–63. Rome: Istituto della Encyclopedia Italiana, 1960–.

Godoy, José A., and Silvio Leydi, eds. 2003. *Parures Triomphales: Le Maniérisme dans l'art de l'armure Italienne*. Geneva: Musées d'art et d'histoire; Milan: Continents Editions.

Goldberg, Benjamin. 1985. *The Mirror and the Man*. Charlottesville: University Press of Virginia.

Goldgar, Anne. 1995. *Impolite Learning: Conduct and Community in the Republic of Letters, 1680–1750*. New Haven: Yale University Press.

———. 2007. *Tulipmania: Money, Honor, and Knowledge in the Dutch Golden Age*. Chicago: University of Chicago Press.

Goldthwaite, Richard A. 1972. "Schools and Teachers of Commercial Arithmetic in Renaissance Florence." *Journal of European Economic History* 1:418–33.

———. 1987. "The Empire of Things: Consumer Demand in Renaissance Italy." In *Patronage, Art, and Society in Renaissance Italy*, ed. F. W. Kent and Patricia Simons, with J. C. Eade, 153–75. Oxford: Clarendon Press.

———. 1993. *Wealth and the Demand for Art in Italy, 1300–1600*. Baltimore: Johns Hopkins University Press.

González de León, Fernando. 1996. "'Doctors of the Military Discipline': Technical Expertise and the Paradigm of the Spanish Soldier in the Early Modern Period." *Sixteenth Century Journal* 27, no. 1: 61–85.

Gorman, Michael John. 2000. "Interior with Personifications of Painting (Pictura) and Drawing (Disegno), Elements of an Interpretation." (Formerly posted at http://www.stanford.edu/~mgorman/picturaweb/report.htm.)

———. 2003. "Mathematics and Modesty in the Society of Jesus: The Problems of Christoph Grienberger." In *The New Science and Jesuit Science: Seventeenth Century Perspectives*, ed. Mordechai Feingold, 1–120. Dordrecht: Kluwer Academic.

———, ed. 2009. *A Myserious Masterpiece: The World of the Linder Gallery*. Florence: Alias.

Gorman, Michael John, and Alexander Marr. 2007. "'Others see it yet otherwise': *Disegno* and *Pictura* in a Flemish Gallery Interior." *Burlington Magazine* 149, no. 1247: 85–91.

———. 2009. Catalog entry for the *Linder Gallery Interior*. In *Galileo: Images of the Universe from Antiquity to the Telescope*, ed. Paolo Galluzzi, 388–89. Florence: Giunti.

Gould, Penelope. 1900. *The Ivory Sundials of Nuremberg 1500–1700*. Cambridge: Whipple Museum of the History of Science.

Gould, Cecil. 1952. "Leonardo's Neptune Drawing." *Burlington Magazine* 94, no. 595: 289–95.

Goulding, Robert. 1999. "Studies on the Mathematical and Astronomical Papers of Sir Henry Savile." PhD diss., Warburg Institute.

———. 2010. *Defending Hypatia: Ramus, Savile, and the Renaissance Rediscovery of Mathematical History*. Berlin: Springer.

Grendler, Marcella. 1980. "A Greek Collection in Padua: The Library of Gian Vincenzo Pinelli (1535–1601)." *Renaissance Quarterly* 33, no. 3: 386–416.

Grendler, Paul F. 1989. *Schooling in Renaissance Italy: Literacy and Learning 1300–1600*. Baltimore: Johns Hopkins University Press.

———. 2002. *The Universities of the Italian Renaissance*. Baltimore: Johns Hopkins University Press.

Grossi, Carlo. 1856. *Degli uomini illustri di Urbino commentario*. Urbino: Vincenzo Guerrini, 1856. (1st ed., 1819.)

Guarnieri, Gino. 1963. *Il principato mediceo nella scienza del mare*. Pisa: U. Giardini.

Hadden, Richard W. 1994. *On the Shoulders of Merchants: Exchange and the Mathematical Conception of Nature in Early Modern Europe*. Albany: State University of New York Press.

Hadfield, Andrew. 1994. *Literature, Politics and National Identity: Reformation to Renaissance*. Cambridge: Cambridge University Press.

Hale, John R. 1976. "The Military Education of the Officer Class in Early Modern Europe." In *Cultural Aspects of the Italian Renaissance: Essays in Honour of Paul Oskar Kristeller*, ed. Cecil H. Clough, 440–61. Manchester: Manchester University Press.

———. 1977. *Renaissance Fortification: Art or Engineering?* London: Thames & Hudson.

———. 1983. "Military Academies on the Venetian *Terraferma* in the Early Seventeenth Century." In *Renaissance War Studies*, 285–308. London: Hambleton Press.

Hall, Bert S. 1997. *Weapons and Warfare in Renaissance Europe: Gunpowder, Technology, and Tactics*. Baltimore: Johns Hopkins University Press.

Hall, Rupert. 1959. "The Scholar and the Craftsman in the Scientific Revolution." In *Critical Problems in the History of Science*, ed. Maurice Crosland, 3–23. Madison: University of Wisconsin Press.

Hambly, Maya. 1988. *Drawing Instruments 1580–1980*. London: Sotheby's Publications.

Hanlon, Gregory. 1998. *The Twilight of a Military Tradition: Italian Aristocrats and European Conflicts, 1560–1800*. London: UCL Press.

Harkness, Deborah E. 1997. "Managing an Experimental Household: The Dees of Mortlake and the Practice of Natural Philosophy." *Isis* 88, no. 2: 247–62.

———. 2007. *The Jewel House: Elizabethan London and the Scientific Revolution*. New Haven: Yale University Press.

Härting, Ursula. 1989. *Frans Francken II: Die Gemälde*. Freren: Luca.

———. 1993. "Doctrina et Pietas: Über frühe Galeriebilder." *Jaarboek Koninklijk Museum voor Schone Kunsten Antwerpen*, 95–133.

———. 1996. "Pictures of Collections." In *Grove Dictionary of Art Online*, ed. Jane Turner. Oxford: Oxford University Press. (Accessed 2003.)

Hay, Cynthia, ed. 1988. *Mathematics from Manuscript to Print, 1300–1600*. Oxford: Clarendon Press.

Hay, Denys. 1971. "The Italian View of Renaissance Italy." In *Florilegium Historiale: Essays Presented to Wallace K. Ferguson*, ed. John G. Rowe and W. J. Stockdale, 3–17. Toronto: University of Toronto Press.

Headley, John M. 1997. *Tommaso Campanella and the Transformation of the World*. Princeton, NJ: Princeton University Press.

Heawood, Edward. 1950. *Watermarks, Mainly of the 17th and 18th Centuries*. Holland: Paper Publications Society.

[Henninger-]Voss, Mary J. 1995. "Between the Cannon and the Book: Mathematics and Military Culture in Cinquecento Italy." PhD diss., Johns Hopkins University.

Henninger-Voss, Mary J. 2000. "Working Machines and Noble Mechanics: Guidobaldo del Monte and the Translation of Knowledge." *Isis* 91, no. 2: 233–59.

———. 2002. "How the 'New Science' of Cannons Shook up the Aristotelian Cosmos." *Journal of the History of Ideas* 63, no. 3: 371–97.

———. 2004. "Measures of Success: Military Engineering and the Architectonic Understanding of Design." In Lefèvre 2004, 143–69.

———. 2007. "Comets and Cannonballs: Reading Technology in a Sixteenth-Century Library." In Roberts, Schaffer, and Dear 2007, 11–31.

Henry, John. 2005. "National Styles in Science: A Factor in the Scientific Revolution?" In *Geography and Revolution*, ed. David N. Livingston and Charles W. J. Withers, 43–74. Chicago: University of Chicago Press.

———. 2008. "Ideology, Inevitability, and the Scientific Revolution." *Isis* 99, no. 3: 552–59.

Herrmann-Fiore, Kristina. 1982. "'Disegno' and 'Giuditio': Allegorical Drawings by Federico Zuccaro and Cherubino Albani." *Master Drawings* 20, no. 3: 247–56.

Hessen, Boris. 1931. "The Social and Economic Roots of Newton's 'Principia.'" In *Science at the Cross Roads*, 151–212. London: Kniga.

Hill, Katherine. 1998. "'Juglers or Schollers'? Negotiating the Role of a Mathematical Practitioner." *British Journal for the History of Science* 31: 253–74.

Hobson, Anthony. 1971. "A Sale by Candle in 1608." *The Library* 26, no. 3: 215–33.

———. 1984. "Two Early Sixteenth-Century Binders Shops in Rome." In *De Libris Compactis Miscellanea*, ed. Georges Colin, 79–98. Aubel: P. M. Gason; Brusells: Bibliotheca Wittockiana.

Höefel, Andreas, and Werner von Koppenfels, eds. 2005. *Renaissance Go-Betweens: Cultural Exchange in Early Modern Europe*. Berlin: De Gruyter.

Holman, Beth L. 1997. "Introduction." In *Disegno: Italian Renaissance Designs for the Decorative Arts*, ed. Beth L. Holman, 1–14. Dubuque: Kendall/Hunt Publishing.

Honig, Elizabeth. 1995. "The Beholder as Work of Art: A Study in the Location of Value in Seventeenth-Century Painting." *Nederlands Kunsthistorisch Jaarboek* 46:252–97.

———. 1998. *Painting and the Market in Early Modern Antwerp*. New Haven: Yale University Press.

Houghton, Walter E., Jr. 1942. "The English Virtuoso in the Seventeenth Century." *Journal of the History of Ideas* 3, nos. 1 and 2: 51–73, 190–219.

Hoyningen-Huene, Paul. 1993. *Reconstructing Scientific Revolutions: Thomas S. Kuhn's Philosophy of Science*. Trans. Alexander T. Levine. Chicago: University of Chicago Press.

Høyrup, Jens. 1994. *In Measure, Number, and Weight: Studies in Mathematics and Culture.* Albany, NY: State University of New York Press.

———. 2007. *Jacopo da Firenze's* Tractatus Algorismi *and Early Italian Abbacus Culture.* Basel: Birkhäuser.

Ilardi, Vincent. 2007. *Renaissance Vision from Spectacles to Telescopes.* Philadelphia: American Philosophical Society.

James, Frank A. L., and J. V. Field, eds. 1993. *Renaissance and Revolution: Humanists, Scholars, Craftsmen and Natural Philosophers in Early Modern Europe.* Cambridge: Cambridge University Press.

Jardine, Lisa. 1996. *Worldy Goods: A New History of the Renaissance.* London: Macmillan.

Johns, Adrian. 1998. *The Nature of the Book: Print and Knowledge in the Making.* Chicago: University of Chicago Press.

Johnson, Francis R. 1942. "Thomas Hood's Inaugural Address as Mathematical Lecturer of the City of London (1588)." *Journal of the History of Ideas* 3, no. 1: 94–106.

Johnston, Stephen. 1991. "Mathematical Practitioners and Instruments in Elizabethan London." *Annals of Science* 45:319–44.

———. 1994. "Making Mathematical Practice: Gentlemen, Practitioners, and Artisans in Elizabethan England." PhD diss., University of Cambridge.

———. 1996. "The Identity of the Mathematical Practitioner in 16th-Century England." In *Der "mathematicus": Zur Entwicklung und Bedeutung einer neuen Berufsgruppe in der Zeit Gerhard Mercators,* ed. Irmgard Hantsche, 93–20. Bochum: Brockmeyer.

———. 2007. Review of Eric H. Ash, *Power, Knowledge, and Expertise in Elizabethan England. Isis* 97, no. 2: 348–49.

Jones, Matthew L. 2006. *The Good Life in the Scientific Revolution: Descartes, Leibniz, and the Cultivation of Virtue.* Chicago: University of Chicago Press.

Jones, Pamela M. 1993. *Federico Borromeo and the Ambrosiana: Art, Patronage and Reform in Seventeenth-Century Milan.* Cambridge: Cambridge University Press.

Joost-Gaugier, Christine L. 1985. "Poggio and Visual Tradition: *Uomini Famosi* in Classical Literary Decription." *Artibus et Historiae* 6, no. 12: 57–74.

Kang, Eun-Sung. 2006. "Raphael's 'Annunciation' Predella Panel and a Perspective Drawing." *Burlington Magazine* 147, no. 1241: 545–48.

Kappner, S. 1992–93. "Die Grundlegung seines architektonischen Stiles in der mailander Jahren wahrend seiner Ausbildungnert an der Dombahatte." PhD diss., University of Berlin.

Karpinski, L. P., and F. W. Kokomoor. 1928. "The Teaching of Elementary Geometry in the Seventeenth Century." *Isis* 10, no. 1: 21–32.

Karr Schmidt, Suzanne. 2006. "Art—a User's Guide: Interactive and Sculptural Printmaking in the Renaissance." PhD diss., Yale University.

Kaufmann, Thomas DaCosta. 1993. *The Mastery of Nature: Aspects of Art, Science, and Humanism in the Renaissance.* Princeton, NJ: Princeton University Press.

Keblusek, Marika. 2006. "Introduction: Profiling the Early Modern Agent." In Cools, Keblusek, and Noldus 2006, 9–15.

Kellenbenz, Hermann, ed. 1991. *Precious Metals in the Age of Expansion.* Stuttgart: Klett-Cotta.

Keller, Alexander C. 1950. "Zilsel, the Artisans, and the Idea of Progress in the Renaissance." *Journal of the History of Ideas* 11:235–40.

Keller, Vera. 2008. "Cornelis Drebbel (1572–1633): Fame and the Making of Modernity." PhD diss., Princeton University.

Kemp, Martin. 1990. *The Science of Art: Optical Themes in Western Art from Brunelleschi to Seurat*. New Haven: Yale University Press.

———. 1991. "Intellectual Ornaments: Style, Interpretation and Function and Society in Some Instruments of Art." In *Interpretation and Cultural History*, ed. Joan H. Pittock and Andrew Wear, 135–52. London: Macmillan.

Kennedy, Teresa. 1996. *Elyot, Castiglione, and the Problem of Style*. New York: Peter Lang.

Kennedy, William J. 2003. *The Site of Petrarchism: Early Modern National Sentiment in Italy, France, and England*. Baltimore: Johns Hopkins University Press.

Kenny, Neil. 2004. *The Uses of Curiosity in Early Modern France and Germany*. Oxford: Oxford University Press.

Kiely, Edmond R. 1947. *Surveying Instruments, Their History and Classroom Use*. New York: Bureau of Publications, Teachers College, Columbia University.

Kitao, Timothy K. 1974. *Circle and Oval in the Square of Saint Peter's: Bernini's Art of Planning*. New York: New York University Press.

Klinger Aleci, L. S. 1998. "Images of Identity: Italian Portrait Collections of the Fifteenth and Sixteenth Centuries." In *The Image of the Individual: Portraits in the Renaissance*, ed. Nicholas Mann and Luke Syson, 67–79. London: British Museum Press.

Knight, David C. 1965. *Johannes Kepler and Planetary Motion*. London: Chatto & Windus.

Knorr, Wilbur. 1983. "The Geometry of Burning-Mirrors in Antiquity." *Isis* 74, no. 1: 53–73.

Korey, Michael. 2007. *The Geometry of Power: Mathematical Instruments and Princely Mechanical Devices from around 1600*. Munich: Deutscher Kunstverlag.

Krautheimer, Richard. 1994. "The Panels in Berlin, Urbino and Baltimore Reconsidered" in *The Renaissance from Brunelleschi to Michelangelo: The Representation of Architecture*, ed. Henry A. Millon and Vittoria Magnago Lampugnani, 233–57. London: Thames & Hudson.

Kristeller, Paul O. 1951–52. "The Modern System of the Arts: A Study in the History of Ideas." *Journal of the History of Ideas* 12, no. 4 (1951): 496–527 (pt. 1); 13, no. 1 (1952): 17–46 (pt. 2).

Kuhn, Thomas S. 1962. *The Structure of Scientific Revolutions*. Chicago: University of Chicago Press.

———. 1977. "Mathematical versus Experimental Traditions in the Development of Physical Science." In *The Essential Tension*, 31–65. Chicago: University of Chicago Press.

Laird, W. Roy. 1983. "The *scientiae mediae* in Medieval Commentaries on Aristotle's Posterior Analytics." PhD diss., University of Toronto.

———. 1986. "The Scope of Renaissance Mechanics." *Osiris*, 2nd ser., 2:43–68.

———. 1991. "Archimedes amongst the Humanists." *Isis* 82, no. 4: 629–38.

———. 1997. Galileo and the Mixed Sciences." In *Method and Order in Renaissance Philosophy of Nature*, ed. D. A. Di Liscia, E. Kesller, and C. Methuen, 253–70. Aldershot: Ashgate.

Lamberini, Daniela. 1990. *Il Principe Difeso: Vita e opere di Bernardo Puccini*. Florence: Editrice La Giuntina.

———. 2007. *Il Sanmarino: Giovan Battista Belluzzi architetto militare e trattatista del Cinquecento.* 2 vols. Florence: Leo S. Olschki.

Landon, William J. 2005. *Politics, Patriotism and Language: Niccolò Machiavelli's "Secular patria" and the Creation of an Italian National Identity.* New York: Peter Lang.

Landau, David, and Peter Parshall, eds. 1994. *The Renaissance Print, 1470–1550.* New Haven: Yale University Press.

Langer, Ullrich. 1994. *Perfect Friendship: Studies in Literature and Moral Philosophy from Boccaccio to Corneille.* Geneva: Libraire Droz.

Lefèvre, Wolfgang, ed. 2004. *Picturing Machines 1400–1700.* Cambridge, MA: MIT Press.

Lennox, J. G. 1996. "Galileo, Aristotle, and the 'Mixed Sciences.'" In *Reinterpreting Galileo*, ed. William A. Wallace, 29–52. Washington, DC: Catholic University of America Press.

Levenson, Jay A. 1978. "Jacopo de' Barbari and Northern Art of the Early Sixteenth Century." PhD diss., New York University.

Livingston, David N. 2003. *Putting Science in Its Place: Geographies of Scientific Knowledge.* Chicago: University of Chicago Press.

Long, Pamela O. 2001. *Openness, Secrecy, Authorship: Technical Arts and the Culture of Knowledge from Antiquity to the Renaissance.* Baltimore: Johns Hopkins University Press.

Love, Harold. 1993. *Scribal Publication in Seventeenth-Century England.* Oxford: Oxford University Press.

Lualdi, Alberto. 2000. "Repertorio dei costruttori Italiani di strumenti scientifici secoli XVI–XVIII." *Nuncius* 15, no. 1: 169–234.

Lytle, Guy Fitch. 1987. "Friendship and Patronage in Renaissance Europe." In *Patronage, Art, and Society in Renaissance Italy*, ed. F. W. Kent and Patricia Simons, with J. C. Eade, 47–61. Oxford: Clarendon Press.

MacCarthy, Ita. 2009. "Grace and the Reach of Art in Castiglione and Raphael." *Word and Image* 25, no. 1: 33–45.

Mackinnon, Nick. 1993. "The Portrait of Fra Luca Pacioli." *Mathematical Gazette* 77:130–219.

Maclean, Ian. 1991. "The Market for Scholarly Books and Conceptions of Genre in Northern Europe, 1570–1630." In *Die Renaissance im Blick der Nationen Europas*, ed. Georg Kauffmann, 17–31. Wiesbaden: Harrassowitz Verlag.

———. 2002. *Logic, Signs and Nature in the Renaissance: The Case of Learned Medicine.* Cambridge: Cambridge University Press.

———. 2009. *Learning and the Marketplace: Essays in the History of the Early Modern Book.* Leiden: Brill.

Maclean, Paul D. 2007. *The Art of the Network: Strategic Interaction and Patronage in Renaissance Florence.* Durham, NC: Duke University Press.

Maffioli, Cesare. 2003. "Tra Girolamo Cardano e Giacomo Soldati: Il problema della misura delle acque nella Milano Spagnola." In Fiocca, Lamberini, and Maffioli 2003, 105–36.

Mahoney, Michael S. 1994. *The Mathematical Career of Pierre de Fermat, 1601–1665.* Princeton, NJ: Princeton University Press. (1st ed., 1973.)

Maltese, Corrado. 1987. "Raffaello e la cultura scientifica e tecnologica del suo tempo." In *Studi su Raffaello: Atti del congresso internazionale di studi*, ed. Micaela Sambucco Hamoud and Maria Letizia Strocchi, 441–53. Urbino: Quattroventi.

Mallett, John V. G. 2007. *Xanto: Pottery-Painter, Poet, Man of the Italian Renaissance.* London: Wallace Collection.

Mallett, Michael. 2003. "Condottieri and Captains in Renaissance Italy." In *The Chivalric Ethos and the Development of Military Professionalism*, ed. D. J. B. Trim, 67–88. Leiden: Brill.

Malmanger, Anna Lange. 2000. "From *Scientia* to *Disegno*: New Ideals in Cinquecento Art." In *Innovation and Tradition: Essays on Renaissance Art and Culture*, ed. Dag T. Anderssen and Roy Eriksen, 75–85. Rome: Edizioni Kappa.

Manaresi, C. 1957. "La famiglia Serbelloni." In *Studi in onore di Carlo Castiglioni*. Milan: Giuffrè.

Mandler, Peter. 2006. "What Is 'National Identity'? Definitions and Applications in Modern British Historiography." *Modern Intellectual History* 3, no. 2: 271–97.

Manno, Antonio. 1986. "Architettura e Arte Meccaniche nel Fregio del Palazzo Ducale di Urbino." In Baiardi 1986, 94–96.

Mantovani, Roberto. 2006. "Le scienze matematiche e fisiche." In *L'Università di Urbino 1506–2006*, ed. Stefano Pivato. Vol. 2, *I Saperi fra tradizione e innovazione*, 245–66. Urbino: Quattroventi.

Marchi, Paola. 1998. "L'Invenzione del punto di fuga nell'opera prospettiva di Guidobaldo dal Monte." Tesi di Laurea, Università degli studi di Pisa.

Marciari, John, and Ian Verstegen. 2008. "'Grande quanto l'opera': Size and Scale in Barocci's Drawings." *Master Drawings* 46:291–321.

Marietti, Marina, ed. 1990. *Quêtes d'une identité collective chez les Italiens de la Renaissance.* Paris: Université de la Sorbonne Nouvelle.

Marr, Alexander. 2004a. "'Curious and Useful Buildings': The 'Mathematical Model' of Sir Clement Edmondes." *Bodleian Library Record* 18, no. 2: 108–50.

———. 2004b. "Understanding Automata in the Late Renaissance." *Journal de la Renaissance* 2:205–22.

———. 2005. "Muzio Oddi's Milanese Period." In Eiche 2005, 69–79.

———. 2006a. "Introduction." In Evans and Marr 2006, 1–20.

———. 2006b. "*Gentille curiosité*: Wonder-working and the Culture of Automata in the Late Renaissance." In Evans and Marr 2006, 149–70.

———. 2006c "The Production and Distribution of Mutio Oddi's *Dello squadro* (1625)." In *Transmitting Knowledge: Words, Images, and Instruments in Early Modern Europe*, ed. Sachiko Kusukawa and Ian Maclean, 165–91. Oxford: Oxford University Press.

———. 2008a. "'A Duche graver sent for': Cornelis Boel, Salomon de Caus, and the Production of *La perspective avec la raison des ombres et miroirs*." In *Prince Henry Reviv'd: Image and Exemplarity in Early Modern England*, ed. Timothy Wilks, 212–38. London: Paul Holberton Publishing.

———. 2008b. "A Renaissance Library Rediscovered: The 'Reperotrium librorum Mathematica' of Jean I du Temps, *The Library* 9, no. 4: 428–70.

———. 2009a. "Introduction." In Marr 2009b, 1–12.

———, ed. 2009b. *The Worlds of Oronce Fine: Mathematics, Instruments, and Print in Renaissance France.* Donington: Shaun Tyas.

———, ed. 2010a. "Picturing Collections in Early Modern Europe." Special issue. *Intellectual History Review* 20, no. 1.

———. 2010b. "The Flemish 'Pictures of Collections' Genre: An Overview." In Marr 2010a, 5–25.

Martinelli, Roberta, and Giovanni Parmini. 1991. *A Renaissance Fortification System: The Walls of Lucca*. Lucca: Maria Pacini Fazzi.

Martinelli, Roberta, and Giuliana Puccinelli. 1983. *Lucca: Le mura del Cinquecento*. Lucca: Matteoni.

Martinoni, Renato. 1983. *Gian Vincenzo Imperiale: Politico, letterato e collezionista genovese del Seicento*. Padua: Editrice Antenore.

Massey, Lyle, ed. 2003. *The Treatise on Perspective: Published and Unpublished*. New Haven: Yale University Press.

Maurice, Klaus. 1985. *Der Drechselnde Souverän: Materialen zu einer fürstlichen Maschinekunst*. Zurich: Ineichen.

Maurice, Klaus, and Otto Mayr. 1980. *The Clockwork Universe: German Clocks and Automata, 1550–1650*. New York: Neale Watson Academic Publications.

Mauss, Marcel. 1954. *The Gift: Forms and Functions of Exchange in Archaic Societies*. Trans. Ian Cunnison. London: Cohen and West.

Mazzanti, Bonvini. 1995. "Il territorio del Ducato: Cenni storici." In *La Terra del Duca: Realtà e propsettive*, 5–12. Urbino: n.p.

McAllister, James W. 1996. *Beauty and Revolution in Science*. Ithaca: Cornell University Press.

McKendrick, Neil, John Brewer, and John H. Plumb, eds. 1982. *The Birth of a Consumer Society: The Commercialization of Eighteenth Century England*. London: Hutchinson.

McMullin, Ernan. 1990. "Conceptions of Science in the Scientific Revolution." In *Reappraisals of the Scientific Revolution*, ed. David C. Lindberg and Robert S. Westman, 27–92. Cambridge: Cambridge University Press.

Meadow, Mark A. 2001. "Merchants and Marvels: Hans Jacob Fugger and the Origins of the *Wunderkammer*." In Smith and Findlen 2001, 182–200.

Melion, Walter S. 1991. *Shaping the Netherlandish Canon: Karel Van Mander's* Schilder-Boek. Chicago: University of Chicago Press.

Mellon Evans, Thomas. 1998. *Important Old Master Paintings from the Thomas Mellon Evans Collection*. Christie's New York, May 22, 1998.

Mendelsohn, Leatrice. 1992. *Paragoni: Benedetto Varchi's* Due Lezzioni *and Cinquecento Art Theory*. Ann Arbor: UMI Research Press.

Meskens, Ad. 1996. "Mathematics Education in Late Sixteenth-Century Antwerp." *Annals of Science* 53, no. 2: 137–55.

———. 1997. "Michiel Coignet's Contribution to the Development of the Sector." *Annals of Science* 54, no. 2: 143–60.

Micheli, Gianni. 1992. "Guidobaldo del Monte e la meccanica." In Conti 1992, 87–104.

———. 1995. *Le origini del concetto di macchina*. Florence: Leo S. Olschki.

Miller, Peter N. 2000. *Peiresc's Europe: Learning and Virtue in the Seventeenth Century*. New Haven: Yale University Press.

Miniati, Mara. 2000. "'Un fabbro che sia buon maestro' La produzione di strumenti scientifici a Firenze nel Cinquecento." In *La grande storia dell'artigianato*, ed. Franco Franceschi and Gloria Fossi. Vol. 3, *Il Cinquecento*, 263–95. Florence: Giunti.

Molho, Anthony. 2002. "Cosimo de' Medici: *Pater Patriae* or *Padrino*?" In *The Italian Renaissance: The Essential Readings*, ed. Paula Findlen, 64–90. Oxford: Blackwell.

Montebelli, Vico. 2001. "Muzio Oddi e la matematica applicata strumentale." In *Scienziati e tecnologi marchigiani nel tempo: Atti del convegno storico-scientifico*, 109–28. Ancona: Consilio regionale delle Marche.

Montevecchi, Benedetta. 2001. "'Arti rare' alla corte di Francesco Maria II." In Arbiz-zoni et al. 1998–2001, 2:323–73.

Moran, Bruce T. 1981. "German Prince-Practitionres: Aspects in the Development of Courtly Science, Technology, and Procedures in the Renaissance." *Technology and Culture* 22:253–74.

———, ed. 1991. *Patronage and Institutions: Science, Technology, and Medicine at the European Court 1500–1750*. Rochester: Boydell Press.

Morandotti, Alessandro, and Francesco Frangi. 2006. *Maestri del '600 e del '700 lombardo nella Collezione Koelliker*. Milan: Mazzotta.

Moranti, Luigi. 1942. "Contributo sull'arte tipografia in Urbino del secolo XVI." *La Bibliofilia*, 1–42.

———. 1967. *L'arte tipografia in Urbino (1493–1800) con appendice di documenti e annali*. Florence: Leo S. Olschki.

Morgan, Luke. 2006. *Nature as Model: Salomon de Caus and Early Seventeenth-Century Landscape Design*. Philadelphia: University of Pennsylvania Press.

Mosley, Adam. 2000. "Astronomical Books and Courtly Communication." In Frasca-Spada and Jardine 2000, 114–31.

———. 2006. "Objects of Knowledge: Mathematics and Models in Sixteenth Century Cosmology and Astronomy." In *Transmitting Knowledge: Words, Images, and Instruments in Early Modern Europe*, ed. Sachiko Kusukawa and Ian Maclean, 193–216. Oxford: Oxford University Press.

———. 2007a. *Bearing the Heavens: Tycho Brahe and the Astronomical Community of the Late Sixteenth Century*. Cambridge: Cambridge University Press.

———. 20007b. "Introduction." In "Objects, Texts and Images in the History of Science." Special issue. *Studies in History and Philosophy of Science* 38:289–302.

———. 2009. "Early-Modern Cosmography: Fine's *Sphaera mundi* in Content and Context." In Marr 2009b, 114–36.

Motley, Mark. 1990. *Becoming a French Aristocrat: The Education of the Court Nobility 1580–1715*. Princeton, NJ: Princeton University Press.

Napolitani, Pier Daniele. 1997. "Le edizioni dei classici: Commandino e Maurolico." In *Torquato Tasso e l'univesità*, ed. Walter Moretti and Luigi Pepe, 119–41. Florence: Leo S Olschki.

———. 2001. "Federico Commandino e l'Umanesimo matematico." In *Scienziati e tecnologi marchigiani nel tempo: Atti del convegno storico-scientifico*, 39–58. Ancona: Consilio regionale delle Marche.

Navarro-Brótons, Víctor. 2006. "The Teaching of the Mathematical Disciplines in Sixteenth-Century Spain." *Science & Education* 15:209–33.

Naylor, Ronald H. 1976. "Galileo: The Search for the Parabolic Trajectory." *Annals of Science* 33, no. 2: 153–72.

Neale, Katherine. 1999. "The Rhetoric of Utility: Avoiding Occult Associations for Mathematics through Profitability and Pleasure." *History of Science* 37:151–78.

Neilson, Nancy Ward. 1996a. "Cerano." In *Grove Dictionary of Art Online*, ed. Jane Turner. Oxford: Oxford University Press. (Accessed 2005.)

———. 1996b. *Daniele Crespi*. Soncino: Edizioni dei Soncino.

———. 1996c. "Procaccini." In *Grove Dictionary of Art Online*, ed. Jane Turner. Oxford: Oxford University Press. (Accessed 2005.)

Nenci, Elio. 1998. "Introduction." In Bernardino Baldi, *Le vite de' matematici*, ed. with commentary by Elio Nenci, 13–52. Milan: FrancoAngeli.

———, ed. 2006. *Bernardino Baldi (1553–1617) studioso rinascimentale: Poesia, storia, linguistica, meccanica, architettura*. Milan: FrancoAngeli.

Nocenti, Luca. 2003. "Kircher, Schott, Buffon e gli specchi di Archimede." *Studi Settecenteschi* 23:61–76.

Nuovo, Angela. 1998. *Il commercio libraio nell'Italia del Rinascimento*. Milan: FrancoAngeli.

O'Malley, Michelle, and Evelyn Welch. 2007a. "Introduction." In *The Material Renaissance*, ed. Michelle O'Malley and Evelyn Welch, 1–8. Manchester: Manchester University Press.

———, eds. 2007b. *The Material Renaissance*. Manchester: Manchester University Press.

Paci, Renzo, Marilena Pasquali, and Ercole Sori, eds. 1982. *Ancona e Le Marche nel Cinquecento: Economia, societa, instituzioni, cultura*. Ancona: Comune di Ancona Pinacoteca Francesco Podesti.

Panicali, Roberto. 1988. *Orologi e orologiai del Rinascimento Italiano: La Scuola urbinate*. Urbino: Quattroventi.

Panofsky, Erwin. 1956. *Galileo as a Critic of the Arts. Isis* 47, no. 1: 3–15.

———. 1968. *Idea: A Concept in Art Theory*. Trans. Joseph J. S. Peake. New York: Harper and Row.

Pantin, Isabelle. 2009. "Oronce Fine's Role as Royal Lecturer." In Marr 2009b, 13–30.

Park, Katherine, and Lorraine Daston, eds. 2006. *The Cambridge History of Science*. Vol. 3, *Early Modern Science*. Cambridge: Cambridge University Press.

Parsons, William B. 1939. *Engineers and Engineering in the Renaissance*. Cambridge, MA: MIT Press.

Pedersen, Olaf. 1968. "Sagredo's Optical Researches." *Centaurus* 13:139–50.

Pepper, Simon. 2003. "Artisans, Architects and Aristocrats: Professionalism in Renaissance Military Engineering." In *The Chivalric Ethos and the Development of Military Professionalism*, ed. D. J. B. Trim, 116–47. Leiden: Brill.

Pepper, Simon, and Nicholas Adams. 1986. *Firearms and Fortifications: Military Architecture and Siege Warfare in Sixteenth-Century Siena*. Chicago: University of Chicago Press.

Pérez-Ramos, Antonio. 1988. *Francis Bacon's Idea of Science and the Maker's Knowledge Tradition*. Oxford: Clarendon Press.

Pezzini, Grazia Bernini. 1985. *Il fregio dell'arte della guerra nel Palazzo Ducale di Urbino: Catalogo dei rilievi*. Rome: Galleria Nazionale delle Marche.

Pinelli, Antonio, and Orietta Rossi, eds. 1971. *Genga architetto: Aspetti della cultura urbinate del primo 500*. Rome: Bulzoni.

Pissavino, Paolo, and Gianvittorio Signorotto, eds. 1995. *Lombardia Borromaica, Lombardia Spagnola, 1554–1659*. 2 vols. Milan: Bulzoni.

Polanyi, Karl. 1944. *The Great Transformation*. New York: Farrar and Rinehart.

Polanyi, Michael. 1958. *Personal Knowledge: Towards a Post-Critical Philosophy*. Chicago: University of Chicago Press.

———. 1966. *The Tacit Dimension*. New York: Doubleday.

Pollard, John Graham. 2007. *Renaissance Medals*. Vol. 1, *Italy*. Oxford: Oxford University Press.

Pomian, Krzysztof. 1991. *Collectors and Curiosities: Paris and Venice 1500–1800*. Trans. Elizabeth Wiles-Portier. Cambridge: Polity Press, 1991.

Porro, Giulio. 1884. *Catalogo dei codici manoscritti della Trivulziana*. Turin: Fratelli Bocca.

Porter, Roy, and Mikulás Teich, eds. 1992. *The Scientific Revolution in National Context*. Cambridge: Cambridge University Press.

Presas i Puig, Albert. 2002. "Ostilio Ricci, the Practical Education and the Canon of Technical Knowledge at the Beginning of the Italian Renaissance." *Max-Planck-Institut für Wissenschaftsgeschichte Preprint*, no. 200.

Procissi, Angiolo. 1960. "Ancora sulla corrispondenza di Bonaventura Cavalieri." *Physis* 2:101–34.

Promis, Carlo. 1848. "Vita di Muzio Oddi." *Anthologia Italiana*, 577–600.

———. 1874. *Biografie di ingegneri militari dal secolo xiv al metà xviii*. Turin: n.p.

Puttfarken, Thomas. 1991. "The Dispute between *Disegno* and *Colorito* in Venice: Paolo Pino, Lodovico Dolce and Titian." In *Kunst und Kunsttheorie 1400–1900*, ed. Peter Ganz, Martin Gosebruch, Nikolaus Meier, and Martin Warnke, 75–99. Wiesbaden: Otto Harrassowitz.

Ragni, Nadia. 2001. *Francesco Paciotti: Architetto urbinate (1521–1591)*. Urbino: Accademia Raffaello.

Rambaldi, Enrico I. 1989. "John Dee and Federico Commandino: An English and an Italian Interpretation of Euclid during the Renaissance." In *Italy and the English Renaissance*, ed. Sergio Rossi and Dianella Savoia, 123–53. Milan: Edizioni Unicopli.

Redondi, Pietro. 1989. *Galileo: Heretic*. Trans. Raymond Rosenthal. Harmondsworth: Penguin.

Reeves, Eileen. 1997. *Painting the Heavens: Art and Science in the Age of Galileo*. Princeton, NJ: Princeton University Press.

———. 2008. *Galileo's Glassworks: The Telescope and the Mirror*. Cambridge, MA: Harvard University Press.

Remmert, Volker. 2005. *Widmung, Welterklärung und Wissenschaftslegitimierung: Titelbilder und ihre Funktionen in der Wissenschaftlichen Revolution*. Wiesbaden: Harrassowitz.

Renn, Jürgen, ed. 2001. *Galileo in Context*. Cambridge: Cambridge University Press.

Renn, Jürgen, Peter Damerow, Domenico Giulini, and Simone Rieger. 2001. "Hunting the White Elephant: When and How Did Galileo Discover the Law of Fall." In Renn 2001, 29–149.

Repishti, Francesco, and Richard Schofield. 2004. *Architettura e Contrariforma: I dibattiti per la faccia del Duomo di Milano 1582–1682*. Milan: Electa.

Riccardi, Pietro. 1974. *Saggio di una bibliografia Euclidea*. Hildesheim: Georg Olms Verlag.

Richardson, Brian. 1999. *Print Culture in Renaissance Italy: The Editor and the Vernacular Text, 1470–1600*. Cambridge: Cambridge University Press.

Ridolfi, E. 1882. *L'Arte in Lucca studiata nella sua cattedrale*. Lucca: B. Canovetti.

Roberts, Lissa, and Simon Schaffer. 2007. "Preface." In Roberts, Schaffer, and Dear 2007, xiii–xxvii.

Roberts, Lissa, Simon Schaffer, and Peter Dear, eds. 2007. *The Mindful Hand: Inquiry and Invention from the Late Renaissance to Early Industrialisation*. Amsterdam: Edita, Royal Netherlands Academy of Arts and Sciences.

Rohde, Alfred. 1923. *Die Geschichte der Wissenschaftlichen Instrumente vom beginn der Renaissance bis zum ausgang des 18 Jahrhunderts*. Leipzig: Verlag von Klinkhardt & Biermann.

Romano, Antonella. 1999. *La contre-réforme mathématique: Constitution et diffusion d'une culture mathématique jésuite à la Renaissance (1540–1640)*. Rome: Ecole française de Rome.

Rosand, David. 2002. *Drawing Acts: Studies in Graphic Expression and Representation.* Cambridge: Cambridge University Press.

Rose, Paul L. 1968. "The Origins of the Proportional Compass from Mordente to Galileo." *Physis* 10:53–69.

———. 1970. "Renaissance Italian Methods of Drawing the Ellipse and Related Curves." *Physis* 12:371–404.

———. 1975a. *The Italian Renaissance of Mathematics: Studies on Humanists and Mathematicians from Petrarch to Galileo.* Geneva: Libraire Droz. (Abbreviated in notes as *IRM*.)

———. 1975b. "Professors of Mathematics at Padua University, 1521–1588." *Physis* 17:300–304.

———. 1976. "Giacomo Contarini (1536–1595), a Venetian Patron and Collector of Scientific Instruments." *Physis* 18:117–30.

Rosen, Edward. 1968. "The Invention of the Reduction Compass." *Physis* 10:306–8.

Rossi, Giovanni. 1877. *Groma e Squadro ovvero storia dell'agrimensura italiana dai tempi antichi al secolo XVII.* Turin: Ermanno Loescher.

Rossi, Paolo. 1970. *Philosophy, Technology, and the Arts in the Early Modern Era.* Trans. Salvator Attanasio. New York: Harper and Row.

Rotondi, Pasquale. 1949. "Contributi urbinati a Francesco di Giorgio." In *Studi artistici urbinati*, 87–106. Urbino: Istituto d'arte per il libro.

Sangiorgi, Fert. 1993. "Fermignano a Bramante 'Hastrubaldino.'" In *Castrum Fermignani, castello del Ducato di Urbino*, ed. M. Luni, 231–63. Pesaro: n.p.

Scaglia, Gustina. 1974. "Newly Discovered Drawings of Monasteries by Francesco di Giorgio Martini." *Architectura* 4:112–24.

———. 1978. "Architectural Drawings by Giovanbattista Alberto in the Circle of Francesco di Giorgio Martini." *Architectura* 8:104–24.

———. 1988. "A Vitruvianist's 'Thermae' Plan and the Vitruvianists in Rome and Siena." *Arte Lombarda* 85–86:85–101.

———. 1992. *Francesco di Giorgio: Checklist and History of Manuscripts and Drawings in Autographs and Copies from ca. 1470 to 1687 and Renewed Copies (1764–1839).* London and Toronto: Associated University Press.

Scalessi, Tommaso. 1998. "Le fortificazioni roveresche." In Arbizzoni et al. 1998–2001, 1:213–229.

Schechner, Sara. 2001. "The Material Culture of Astronomy in Daily Life: Sundials, Science, and Social Change." *Journal for the History of Astronomy* 32:189–222.

Schemmel, Matthias. 2006. "The English Galileo: Thomas Harriot and the Force of Shared Knowledge in Early Modern Mechanics." *Physics in Perspective* 8, no. 4: 360–80.

———. 2008. *The English Galileo: Thomas Harriot's Work on Motion as an Example of Preclassical Mechanics.* Berlin: Springer.

Scher, Stephen K., ed. 1994. *The Currency of Fame: Portrait Medals of the Renaissance.* New York: Harry N. Abrams.

Schmitt, Charles B. 1975. "Science in the Italian Universities in the Sixteenth and Seventeenth Centuries." In *The Emergence of Science in Western Europe*, ed. Maurice Crosland, 35–56. London: Macmillan.

Schneider, Ivo. 1981. "Forms of Professional Activity in Mathematics before the Nineteenth Century." In *Social History of Nineteenth Century Mathematics*, ed. Herbert Mehrtens, Henk J. M. Bos, and Ivo Schneider, 93–104. Basel: Birkhäuser.

Schöner, Cristoph. 1994. *Mathematik und Astronomie an der Universität Ingolstadt im 15. und 16. Jahrhundert*. Berlin: Dunker & Humboldt.

Scotti, Aurora. 1983. "Il Collegio degli Architetti, Ingegneri ed Agrimensori tra il XVI e il XVIII secolo." In *Costruire in Lombardia: Aspetti e problemi di storia edilizia*, ed. Aldo Castellano and Ornella Selvafolta, 92–108. Milan: Electa.

Secord, James A. 1993. Introduction to "The Big Picture." Special issue. *British Journal for the History of Science* 26:387–89.

Segre, Michael. 1991. *In the Wake of Galileo*. New Brunswick, NJ: Rutgers University Press.

Sella, Domenico. 1979. *Crisis and Continuity: The Economy of Spanish Lombardy in the Seventeenth Century*. Cambridge, MA: Harvard University Press.

Serjeantson, Richard. 2006. "Proof and Persuasion." In Park and Daston 2006, 132–75.

Serrai, Alfredo. 2002. *Bernardino Baldi: La vita, le opere, la biblioteca*. Milan: Edizione Sylvestre Bonnard.

Servolini, Luigi. 1932. "Muzio Oddi: Architetto urbinate del Seicento." *Urbinum*, year 6, 2nd ser.: 7–27.

Settle, Thomas B. 1990. "Eganzio Danti and Mathematical Education in Late Sixteenth-Century Florence." In *New Perspectives on Renaissance Thought: Essays in the History of Science, Education and Philosophy*, ed. John Henry and Sarah Hutton, 24–37. London: Duckworth.

Shapin, Steven. 1987. "History of Science and Its Sociological Reconstructions." *History of Science* 20:157–211.

Shapin, Steven, and Simon Schaffer. 1985. *Leviathan and the Air Pump: Hobbes, Boyle, and the Experimental Life*. Princeton, NJ: Princeton University Press.

Sharratt, Peter. 1966. "La Ramée's Early Mathematical Teaching." *Bibliothèque d'Humanisme et Renaissance* 28:605–14.

Shaw, Christine. 2000. *The Politics of Exile in Renaissance Italy*. Cambridge: Cambridge University Press.

Shearman, John. 1983. "A Drawing for Raphael's 'Saint George.'" *Burlington Magazine* 125, no. 958: 15–25.

Simi, A., and Laura Toti Rigatelli. 1993. "Some 14th and 15th Century Texts on Practical Geometry." In *Vestigia Mathematica: Studies in Medieval and Early Modern Mathematics in Honour of H. L. L. Busard*, ed. Menso Folkerts and Jan P. Hogendijk, 453–70. Amsterdam: Rodopi.

Simms, Dennis L. 1977. "Archimedes and the Burning Mirror of Syracuse." *Technology and Culture* 18, no. 1: 1–24.

Simonetta, Marcello, ed. 2007. *Federico da Montefeltro and his Library*. Milan: Y Press and Bibliotheca Apostolica Vaticana.

Smith, Pamela H. 1994. *The Business of Alchemy: Science and Culture in the Holy Roman Empire*. Princeton, NJ: Princeton University Press.

———. 2004. *The Body of the Artisan: Art and Experience in the Scientific Revolution*. Chicago: University of Chicago Press.

Smith, Pamela H., and Paula Findlen, eds. 2001. *Merchants and Marvels: Commerce, Science, and Art in Early Modern Europe*. London: Routledge.

Sohm, Philip. 2001. *Style in the Art Theory of Early Modern Italy*. Cambridge: Cambridge University Press.

Sorci, Alessandra. 2006. "Federico Commandino tra innovazione e recupero dell'antico: Il restauro del corredo illustrativo delle edizioni degli Elementi di Eu-

clide." In *L'artiste et l'oeuvre à l'épreuve de la perspective*, ed. Marianne Cojannot-Le-Blanc, Marisa Dalai Emiliani, and Pascal Dubourg Glatigny, 43–66. Rome: Ecole Française de Rome.

Sparrow, J. 1968. "Daniele Crespi: Portraits Lost and Identified?" *Arte Lombarda* 13, no. 2: 63–66.

Speth-Holterhoff, S. 1957. *Les peintres flamands de cabinets d'amateurs au 17e siècle*. Brussels: Elsevier.

Spike, John T. 1985. *Baroque Portraiture in Italy: Works from North American Collections*. Sarasota: John and Mable Ringling Museum of Art.

Spinelli, Salvatore. 1956. *La Ca' Granda, 1456–1956*. Milan: Antonio Cordani.

Spiriti, Andrea. 2006. "Daniele Crespi: La conquista del classicismo." In *Daniele Crespi: Un grande pittore del Seicento lombardo*, ed. Andrea Spiriti, 29–57. Milan: Silvana Editoriale.

———, ed. 2002. *L'Occhio nuovo: Occhiali, micriscopi e cannochiali, arte e scienza fra '600 e '700*. Milan: ISAL.

Sprang, Felix. 2007. "'Trite and fruitlesse Rhapsodies'? The Rise of a New Genre in the Light of National Identity: Vernacular Science Writing in Early Modern England." *Anglia: Zeitschrift für Englische Philologie* 124, no. 3: 449–473.

Starn, Randolph. 1982. *Contrary Commonwealth: The Theme of Exile in Medieval and Renaissance Italy*. Berkeley: University of California Press.

———. 1986. "Reinventing Heroes in Renaissance Italy." *Journal of Interdisciplinary History* 17:67–84.

Steck, Max. 1981. *Bibliographia Euclideana*. Hildesheim: Gerstenberg Verlag.

Stevens, Kevin M. 1992. "Printers, Publishers and Booksellers in Counter-Reformation Milan: A Documentary Study." PhD diss., University of Wisconsin–Madison.

———. 1996. "A Bookbinder in Early Seventeenth-Century Milan: The Shop of Pietro Martire Locarno." *The Library*, 6th ser., 18, no. 4: 306–27.

Stevens, Kevin M., and Paul F. Gehl. 1994. "Giovanni Battista Bosso and the Paper Trade in Late Sixteenth-Century Milan." *La Bibliofilia* 96, no. 1 (1994): 43–90.

Stroffolino, Daniela. 1999. *La città misurata: Tecniche e strumenti di rilevamento nei trattati a stampa del Cinquecento*. Rome: Salerno.

Summers, David. 1981. *Michelangelo and the Language of Art*. Princeton, NJ: Princeton University Press.

———. 1987. *The Judgment of Sense: Renaissance Naturalism and the Rise of Aesthetics*. Cambridge: Cambridge University Press.

Tallon, Alain, ed. 2007. *Le sentiment national dans l'Europe méridionale aux XVIe et XVIIe siècles (France, Espagne, Italie)*. Madrid: Casa de Velàzquez.

Tavernor, Robert. 1998. *On Alberti and the Art of Building*. New Haven: Yale University Press.

Taylor, E. G. R. 1954. *The Mathematical Practitioners of Tudor and Stuart England*. Cambridge: Cambridge University Press.

Taylor, Robert Emmett. 1980. *No Royal Road: Luca Pacioli and His Times*. New York: Arno. (1st ed., 1942.)

Tedeschi, John A. 1991. *The Prosecution of Heresy: Collected Studies on the Inquisition in Early Modern Italy*. Binghampton, NY: Medieval and Renaissance Texts and Studies.

Thomas, Ben. 1996. "The *Paragone* Debate and Sixteenth-Century Italian Art." 2 vols. DPhil. diss., University of Oxford.

Thorndike, Lynn. 1949. *The Sphere of Sacrobosco and Its Commentators*. Chicago: University of Chicago Press.

Thornton, Dora. 1998. *The Scholar in His Study: Ownership and Experience in Renaissance Italy*. New Haven: Yale University Press.

Tucker, Hugo. 2003. *Homo Viator: Itineraries of Exile, Displacement and Writing in Renaissance Europe*. Geneva: Libraire Droz.

Turner, Anthony. 1973. "Mathematical Instruments and the Education of Gentleman." *Annals of Science* 30, no. 1: 51–88.

———. 1987. *Early Scientific Instruments: Europe 1400–1800*. London: Sotheby's Publications.

———. 2007. *Istituto e Museo di Storia della Scienza: Catalogue of Sun-dials, Nocturnals and Related Instruments*. Florence: Giunti.

Turner, Gerard L'Estrange. 1995. "The Florentine Workshop of Giovan Battista Giusti." *Nuncius* 10, no. 1: 131–71.

Turner, Henry S. 2006. *The English Renaissance Stage: Geometry, Poetics, and the Practical Spatial Arts, 1580–1630*. Oxford: Oxford University Press.

Ulivi, Elisabetta. 1987. "Le fonti di Bonaventura Cavalieri: La costruzione delle coniche fino allo *Specchio ustorio* (1632)." *Bolletino di storia delle scienze matematiche* 7, no. 1: 117–79.

Valleriani, Matteo. 2008. "Galileo Engineer." PhD diss., Max-Planck-Institut für Wissenschaftsgeschichte. (Published, while the present book was in press, as *Galileo Engineer* [Berlin: Springer, 2010].)

Vaes, M. 1926–27. "Le Journal de Jean Breughel II." *Bulletin de l'Institut Historique Belge de Rome* 7:152–223.

Van Cleempoel, Koenraad. 2005. *Astrolabes at Greenwich: A Catalogue of the Astrolabes in the National Maritime Museum, Greenwich*. Oxford: Oxford University Press.

Van Dyck, Maarten. 2006. "Gravitating towards Stability: Guidobaldo's Aristotelian-Archimedean Synthesis." *History of Science* 44:373–407.

Van Eck, Caroline A., James W. McAllister, and Renée van de Vall, eds. 1995. *The Question of Style in Philosophy and the Arts*. Cambridge: Cambridge University Press.

Van Egmond, Warren. 1976. "The Commercial Revolution and the beginnings of Mathematics in Renaissance Florence, 1300–1500." PhD diss., Indiana University.

———. 1980. *Practical Mathematics in the Italian Renaissance: A Catalogue of Italian Abacus Manuscripts and Printed Books to 1600*. Florence: Istituto e Museo di Storia della Scienza.

Van der Krogt, Peter. 1993. *Globi Neerlandici: The Production of Globes in the Low Countries*. Utrecht: HES.

Van Helden, Albert, and Thomas L. Hankins. 1994. "Introduction: Instruments in the History of Science." *Osiris* 9:1–6.

Van den Heuvel, Charles. 1991. *"Papiere Bolwercken": De introductie van de Italiaanse stede-en vestinbouw in de Nederlanden (1540–1609) en het gebruik van tekeningen*. N.pl.: Canaletto.

Veblen, Thorstein. 1912. *The Theory of the Leisure Class: An Economic Study in the Theory of Institutions*. New York: Macmillan.

Vérin, Hélène. 1993. *La gloire des ingénieurs: L'intelligence technique du XVIe au XVIIIe siècle*. Paris: Albin Michel.

Vernarecci, Augusto. 1881. *Ottaviano de' Petrucci da Fossombrone, inventori dei tipi mobili metallici.* Fossombrone: F. Monacelli.

———. 1889. "Della colpa e prigiona di Muzio Oddi." *Nuova Rivista Misena* 2:103–8, 122–26.

Verrier, Frédéric. 1997. *Les armes de Minerve: L'humanisme militaire dans l'Italie du XVIᵉ siècle.* Paris: Presses de l'Université de Paris–Sorbonne.

Verstegen, Ian F., ed. 2007. *Patronage and Dynasty: The Rise of the Della Rovere.* Kirksville, MO: Truman State University Press.

Vincent, Clare. 1989. "A Beam Compass by Cristoph Trechsler the Elder and the Origins of the Micrometer Screw." *Metropolitan Museum Journal* 24:209–22.

Wadsworth Atheneum. 1949. *Pictures within Pictures.* Exhibition catalog. Hartford, CT: Wadsworth Atheneum.

Walton, Steven A. 2005. "Mathematical Instruments and the Creation of the Scientific Military Gentleman." In *Instrumental in War: Science, Research and Instruments between Knowledge and the World*, ed. Steven A. Walton, 17–46. Leiden: Brill.

Warner, Deborah Jean. 1990. "What Is a Scientific Instrument, When Did It Become One, and Why." *British Journal for the History of Science* 23, no. 1: 83–93.

Warwick, Genevieve. 1997. "Gift Exchange and Art Collecting: Padre Sebastiano Resta's Drawing Albums." *Art Bulletin* 79, no. 4: 630–46.

———. 2003. "Introduction." In *Collecting Prints and Drawings in Early Modern Europe, c. 1500–1750*, ed. Christopher Baker, Caroline Elam, and Genevieve Warwick, 1–8. Aldershot: Ashgate, in association with Burlington Magazine.

Weber, Ralph, and Sharon Larner. 1993. "The Concept of Proportion in Architecture: An Introductory Bibliographic Essay." *Art Documentation* 12, no. 4: 147–54.

Webster, Charles. 1976. *The Great Instauration: Science, Medicine, and Reform, 1626–1660.* London: Duckworth.

Wehey, A. Sutherland, and H. E. Wehey. 1980. "Titian: Two Portraits of Noblemen in Armour and Their Heraldry." *Art Bulletin* 62, no. 1: 76–96.

Welch, Evelyn. 2005. *Shopping in the Renaissance: Consumer Cultures in Italy, 1400–1600.* New Haven: Yale University Press.

Welti, Manfred. 1998. *Die europäische Spätrenaissance.* Basel: Friedrich Reinhard.

Wessely, Anna. 1991. "Transposing 'Style' from the History of Art to the History of Science." In Daston and Otte 1991, 265–78.

Westman, Robert S. 1975. "The Melanchton Circle, Rheticus and the Wittenberg Interpretation of Copernican Theory." *Isis* 66, no. 2: 165–93.

———. 1980. "The Astronomer's Role in the Sixteenth Century: A Preliminary Study." *History of Science* 18, no. 2: 105–47.

Whitlow, G. J. 1988. "Why Did Mathematics Begin to Take Off in the Sixteenth Century?" In Hay 1988, 264–69.

Wilding, Nicholas. 2006. "Galileo's Idol: Gianfrancesco Sagredo Unveiled." *Galilaeana* 3:229–45.

Williams, Robert. 1997. *Art, Theory and Culture in Sixteenth-Century Italy: From Techne to Metatechne.* Cambridge: Cambridge University Press.

Winner, Matthias. 1957. "Die Quellen der Pictura-Allegorien in gemalte Bildergalerien des 17. Jahrhunderts zu Antwerpen." PhD diss., Cologne University.

Wolfe, Jessica. 2004. *Humansim, Machinery, and Renaissance Literature.* Cambridge: Cambridge University Press.

Woodward, David. 1996. *Maps as Prints in the Italian Renaissance: Makers, Distributors & Consumers. The Panizzi Lectures, 1995*. London: British Library.

Woodward, W. H. 1963. *Vittorino da Feltre and Other Humanist Educators*. New York: Teachers College Press.

Yates, Frances A. 1947. *The French Academies of the Sixteenth Century*. London: Warburg Institute.

Zervas, Diane Finiello. 1975. "The Trattato dell'Abbaco and Andrea Pisano's Designs for the Florentine Baptistry Doors." *Renaissance Quarterly* 28, no. 4: 485–503.

Zilsel, Edgar. 1942. "The Sociological Roots of Science." *American Journal of Sociology* 47:544–62.

———. 2000. *The Social Origins of Modern Science*, ed. Diederick Raven, Wolfgang Krohn, and Robert S. Cohen. Dordrecht: Kluwer Academic.

Zöllner, Frank. 1987. *Vitruvs Proportionsfigur: Quellenkritische Studien zur Kunstliteratur des 15. und 16. Jahrhunderts*. Worms: Wernescher Verlagsgesellschaft.

Index

Page numbers in bold type indicate illustrations.

Linder, Peter (*continued*)
191–92; Oddi's bequest to, 217; personal and business life of, 303n45; and production of Oddi's *De gli horologi solari*, 117–18, 127, 279n40, 280n41; as pupil of Oddi, 75, 228

Linder, Peter, and *Mutio Oddi and Peter Linder* (Crespi), 7–8, **8**, 85–86, **97**; attribution of, 87; beam compass, 98–99; as celebration of friendship, 87–88; date of composition, 90; geometrical diagram, 96–98, **99**, 100–102, 103, 274n47; identity of sitters, 270n4; interpretation of, 86, 96–97, 103–4; Koelliker fragments, 86–**87**; mirror in, 97–98; teaching context, 103; versions of, 86–87, 88

Linder Gallery Interior, **191**, **197**; allegorical figures in, **201**, 201–3; and Antwerp/Milan interactions, 200–201; artists imitated in, 198; attribution of, 200, 306n71; books portrayed in, 203–4; Brueghel family involvement with, 200; Caravaggio on, 193–94, 198; as celebration of friendship of Oddi and Linder, 200; as collaboration between Oddi and Linder, 194–95; commissioning of, 191–92; and connoisseurship, 198, 201; cosmological significance of books portrayed in, 208–9; and cosmology, 192–93, 208–9, 210, **211**; diagram of cosmic system, **192**, 207–8; and *disegno*'s dependence on mathematics, 203–7; as hybrid genre, 198; Linder's portrayal in, **197**, 197–98; and mathematical culture, 213–14; model for *Disegno* and Arts and Virtue, 209–10, 308n99; objects portrayed in, 203, **204**, **205**, **206**; Oddi's involvement in, 191, 193–95, 206; personification of *Disegno* and Arts and Virtue, **201**, 201–3, **208**; and "pictures of collections" genre, 193, 303n41; portrait medals in, 193–94, **195**, 195–96, 304nn52–53; portrayal of Linder in, **197**, 197–98; provenance of, 303n40; relationship

with *Cognoscenti in a Gallery Interior*, **199**, 199–200; Rubens's involvement with, 306n68; significance of, 192; as summary of Oddi's principles, 206–7; themes of, 198; and vision, 198–99

Locarno, Pietro Martire, 281n59
Lomazzo, Giovanni Paolo, 173, 297n19
Lorini, Buonaiuto, 81, 175–76, 268n63, 296n8
Lucca, and Oddi's exile: contrast with Milan, 45–46; Oddi as chief fortifications engineer, 45, 46–48, 177, **178**, 251n51, 253n80, 298n1; sterile intellectual environment, 46
Lumaldo, Girolamo, 298n3

MacBeth, Rhona, 307n85
Machiavelli, Niccolò, 49, 255n97
Maclean, Ian, 121
Maggiore, Giovanni Ambrogio, 156, 293n86; *Stacking Boxes*, **158**
Magini, Giovanni Antonio, 40, 64, 91, 291n58; and burning mirrors, 100, 272n23, 272n24, 273n32
Magone, Giulio, 129, 234
Mahoney, Michael, 15
maker's knowledge tradition, 154
Mander, Karel van, 206
Mandler, Peter, 245n2
Mannheim, Karl, 26
Marini, Alessandro, 284n101
Marliani, Cristoforo, 233
Marliani, Francesco Bernardino, 73, 121, 129, 226, 231, 268n75
Marliani, Giovanni, 226
Martini, Francesco di Giorgio, 30, 257n112; and design for church facades, 182, **184**, 301n22; Vasari on, 302n27
material culture: and history of science, 17; and mathematics, 105; meaning of, 17; and social relationships, 18
mathematical community: and markets, 18; nature of, 10; and social relationships, 18
mathematical culture: characteristics of, 5; and conspicuous consumption,